A WORLD HISTORY OF ART

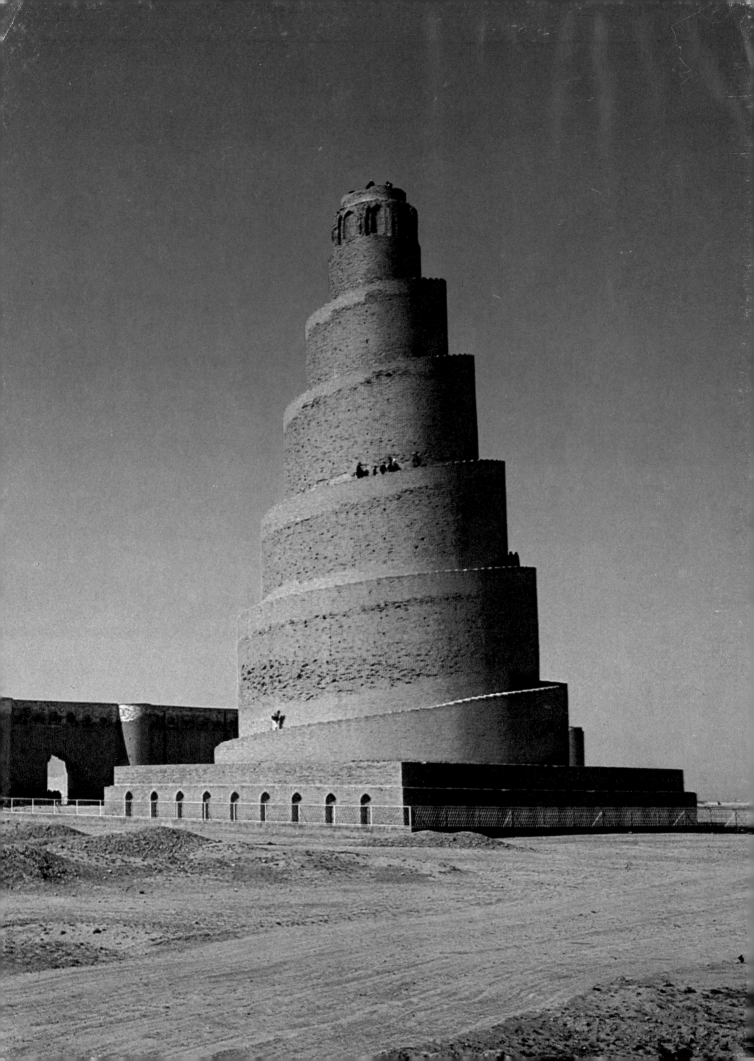

A WORLD HISTORY OF ART

PAINTING SCULPTURE
ARCHITECTURE DECORATIVE ARTS

By Gina Pischel

Incorporating a new
Introduction
and a new chapter
Art Since 1940

By Henry A. La Farge and Catherine Bernard

SECOND REVISED EDITION

Newsweek Books, New York

*Roman mosaic, detail
(Aquileia Museum)*

PAGE 2: *Minaret tower of
the Mosque of Samarrah*

© Copyright 1966, 1968, and 1978 by Arnold Mondadori Editore, Milano
English Translation © Copyright 1968 by Arnold Mondadori Editore,
Milano. © Copyright 1975 Revised Edition, and © 1978 Second Revised
Edition by Arnold Mondadori Editore, Milano

Published by Newsweek Inc., 444 Madison Avenue, New York, New York 10022

Library of Congress Cataloguing in Publication Data

Pischel-Fraschini, Gina.
 World History of Art.
 Translation of Storia universale dell'arte.
 Bibliography: p.
 Includes index.
 I. Art—History. I. Title.
N5300.P6513 1978 709 78-55593
ISBN 0-88225-258-5

Printed and bound in Italy
by Arnold Mondadori, Verona

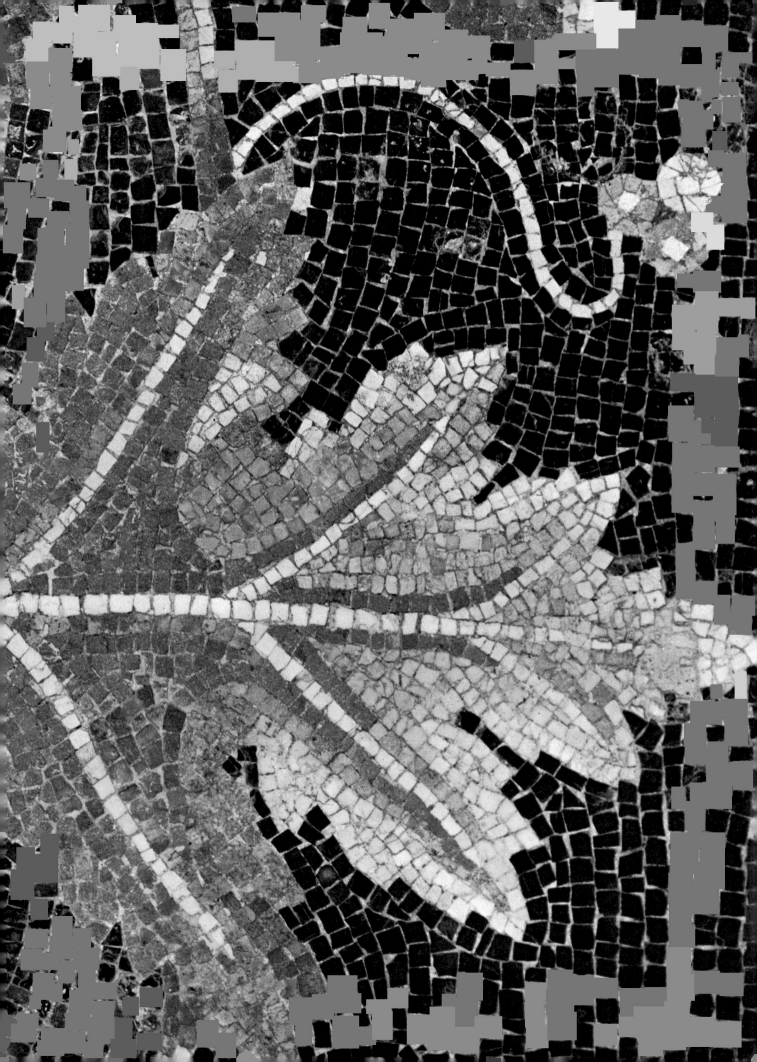

INTRODUCTION

With the inexaustible literature on every aspect of world art available today, there is yet a need to unite in one coherent synthesis all the strands of creative activity, from primeval times to the present. The need is brilliantly met in this survey which offers to the student and the general reader the essence of great cultures and civilizations, the interrelation of styles and periods, the transformations of concepts, the developments in the uses of art.

Because art is primarily a visual experience, more than half the space in these pages is devoted to reproductions, all in color. These illustrations are closely keyed to the text and offer a wealth of information not otherwise available. Many of the works are reproduced from pictures taken under optimum conditions of lighting, revealing otherwise hidden or poorly illuminated subjects, so that often more is shown than can be seen with the naked eye, whether the bisons in the dim recesses of prehistoric caves, the Bayon at Angkor Thom emerging from the jungles of Cambodia, or the gigantic steel arches spanning the base of the Eiffel Tower in Paris.

It happens that Eiffel's arcing supports are direct descendants of the Roman arch, which continued to be developed through the Middle Ages. In fact the permanence and evolution of certain forms and themes can here be traced to the present. As far as the arch is concerned, the complex and inexhaustibly varied applications of vaulting in the Romanesque period is beautifully exemplified in these pages by the interiors of the Ste Madeleine at Vézelay, Durham Cathedral, Sant' Ambrogio in Milan and the basilica of San Marco, Venice. Then suddenly early in the 12th century, in the Ile-de-France, a dynamic new type of construction was initiated in the ogival arch and cross-vaulting of Gothic architecture. The daring structural solutions of the great cathedrals permitted the soaring rhythms and walls of stained glass that created a mystical combination of limitless space and light.

From this the reader is brought to the achievements of the Renaissance, which not so much reenacted as challenged the splendors of Greece and Rome. The question may be raised why such a disproportionate amount of space is devoted to the Italian 15th and 16th centuries, at the expense of other great moments of world art. The truth is that Italy was the birthplace of humanism, which led to rational perception of reality, and the expression of modern art forms. It was also the time when the artist gained an autonomous position in society as an independent agent of creative activity. That is not to say that Phidias in 5th-century Greece or the Chinese painters of the T'ang and Sung dynasties did not enjoy similar status. But compared to what we know of these and their works we have the masterpieces of Leonardo, Raphael, Titian, Michelangelo and Palladio at hand to see and study. Painting, sculpture and architecture in Florence, Venice, Rome suddenly take center stage, initiating the great movements which were to follow in the next three centuries.

Today both continuing archaeological research and modern art itself have immensely widened and deepened our appreciation of the art of the past. Through them we have been initiated to cultures and civilizations barely known a century ago. Even in Greek art, which had been the continuing focus of inquiry ever since the early Middle Ages, we have been able to overcome the idea of perfection formulated by the Neo-Classicists toward the end of 18th century.

By a singular paradox, the experience of 20th-century art—which expressly turned its back on what had gone on before—has sharpened our vision. By a return to the colors of the spectrum, to African art, to fundamental structures, to primary dreams and myths, dormant sensibilities have been awakened and new values discovered: these contributed to the development of art historical criticism. Primitive art, which had previously been the exclusive province of ethnologists, now arouses curiosity and admiration as an autonomous art form. The sense of volume as an abstract entity brings into focus the extraordinary manipulations of space in Baroque and Rococo architecture; similarly, Surrealist dimensions are recognized in the haunting world of Hieronymus Bosch, while the severe order of the Doric temple is found again in the spare geometry of Minimal art. Thus as the modern age has opened up new frontiers, we become aware of the permanence of certain driving forces and ideals.

HENRY A. LaFARGE

CONTENTS

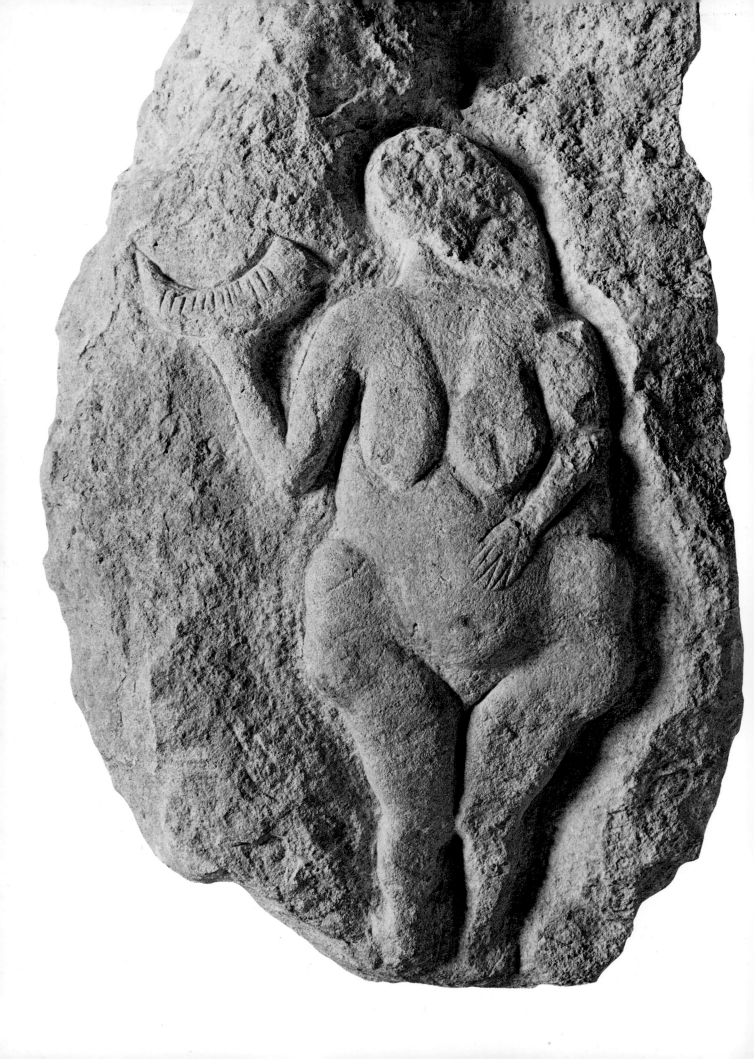

PREHISTORIC ART

Paleolithic art: the age of chipped stone

In the dark night before the dawn of history, man discovered fire and the use of rough, sharpened stones. In his struggle to survive and multiply, however, he gave no expression to his humanity in art forms, but devoted his energies to finding and fashioning the flints that were his indispensable weapons.

Forms of expression

It was only about 40,000 years before the birth of Christ, particularly where the continent of Europe was concerned, that there was a turning point which marked a distinction from preceding ages. Man began to create forms that reproduced the reality in which he lived and expressed the dark anguish and all-pervading dread that dominated his existence. Prehistoric art was born. Its manifestations were many and may, in modern terminology, be grouped into sculptural and pictorial forms. We are dealing here with forms which are alike in content but which spring from widely differing geographical settings. In fact paleolithic forms (that is, those dating from the age of rough stone) have been found not only in south-west Europe but also in the Mediterranean basin, and in central northern, as well as eastern, Europe. It follows, therefore, that there was no uniform, simultaneous development of prehistoric civilisations in various parts of the world, and that it is possible for art forms, alike in subject matter and in stylistic character, to have been created at widely separated periods of time, as witness certain examples from Oceania in the 20th century which have been produced in modern times by a civilisation that is still virtually in a prehistoric phase of development.

The significance of paleolithic art

The question which comes immediately to mind in connection with paleolithic art is: why did man create it? Certainly he did not do so in order to have beautiful images to contemplate, since this impulse made itself felt only against a background of culture, not against a background

Opposite page: *The Venus of Laussel (Musée d'Aquitaine, Bordeaux)*

Magdalenian bison carved on reindeer bone (Musée des Antiquités Nationales, Saint-Germain-en-Laye)

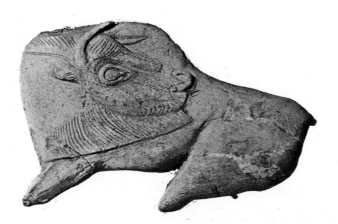

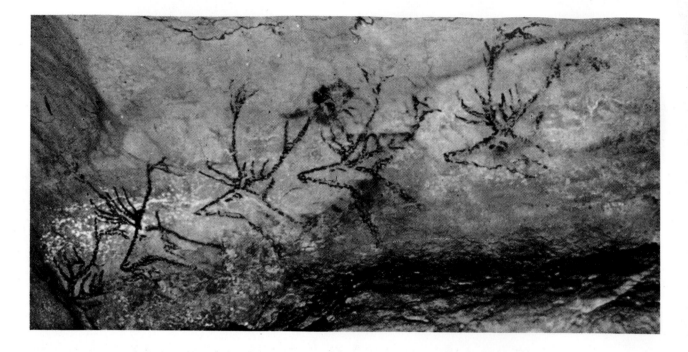

of life lived by instinct. Neither did the art have a utilitarian purpose, for one should rule out the hypothesis, still held in the 19th century, that the animals painted or scratched in the caves must have been intended as a lure for living beasts. The most important cycles of these paintings are spread over the ceilings and walls of caves cut off from the outside world by long dark passages, into which wild animals would have been able neither to see nor to penetrate. There is only one answer to the question: prehistoric art forms chiefly reproduced reality and were manifestations of primitive man's desire to create. They were born of his aspiration to 'make' from nothing and from his desire to give visible form to some aspects of his confusion of mind and of the anguish that assailed him. In this sense, cave art expresses primitive man's view of the reality which surrounded him and the magical concept he had of his world.

The oldest art form of the Paleolithic Age is sculptural and dates from about 40,000 B.C. onwards. Leaving aside the various rough flint or bone tools (harpoons, awls, rings) which bore some decoration or symbolic signs, the most eloquent contact we have with this remote art is through statuettes with obvious feminine characteristics. The 'Venus' of the period (sometimes small enough to fit into the palm of the hand) was visibly a fertility symbol and a mother. Its main characteristics were the large breasts and swollen buttocks, while less attention was paid to the shaping of the head and arms. It is difficult to put a date to these so-called 'Venuses' in soap-stone or ivory because, as they

were easily transported, they could have been moved from their original site by natural means or by human migration. Some ten examples have been found in Europe, especially at Lausel, Lespugne, Willendorf and, in Italy, near the River Panaro (the 'Venus' of Savignano). These 'Venuses' are truly sculptural, but other objects, such as small flakes of flint, show evidence of attempts at incised decoration. Another art form of the Paleolithic Age is that obtained by the impression of the open hand on soft walls (Gargas caves, 30,000 B.C.). The impression is sometimes outlined in red shading which was perhaps blown on from the mouth. The fact that the hand imprints sometimes show mutilation of the fingers lends weight to the theory that there may have been a link with sacrificial rites.

It was a long, hard road which led from these early artistic endeavours to the amazing paintings in the Lascaux caves. Indeed, 15,000 years passed by, a period that must have been rich in developments. In the Franco-Cantabrian region, examination of the layers has shown that, in addition to reindeer and bison, there were cattle and horses and that man was hunting with various types of weapon. Here, painting was preceded by expressive drawings of animal shapes. We see this same type of thing again in the cycle of paintings at Lascaux and its confidence, modulation and variety justify the use of the word 'modern' to describe prehistoric cave art.

The Lascaux cycle dates from the period 14,000–13,500 B.C. and was discovered, quite by

chance, only in 1940, although scientific excavations in other paleolithic caves had already been carried out between 1826 and 1832. The cycle consists of three areas: an access corridor, a chamber with etchings and the 'Hall of the Bulls', which is the most interesting. On the walls of the latter are depicted six bulls, each about fifteen feet long, with black outlines which render in a remarkable way their springy action. A broken, red-painted background gives the illusion of relief. Their distribution and arrangement is not the result of conscious composition but a repetition of the natural stance of the animals in the wild. From any point of view these paintings have a dynamic realism which springs from a passionate contact with reality as seen by the artist. Further examination of the walls reveals another complex of figures on a lower level, consisting of running deer with branching horns. These earlier drawings have been respected by the painter of the bulls, which proves that the area, by its very nature, was dedicated exclusively to the representation of figures and had assumed, through its all-pervading magical influence, the characteristics of the chief place for figural creation. The artist-sorcerer is at times represented as having an animal-sorcerer shape – that is, with human and animal characteristics combined, and has created his art here simply for the sake of creating from nothing and of 'making' by renewing the already completed creative works

Late Magdalenian line of stag heads (Lascaux Caves)

Handprint (Gargas Caves)

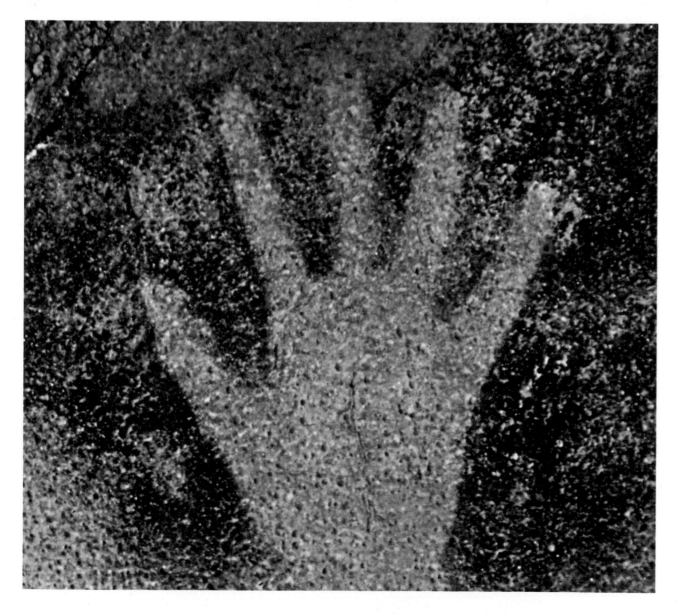

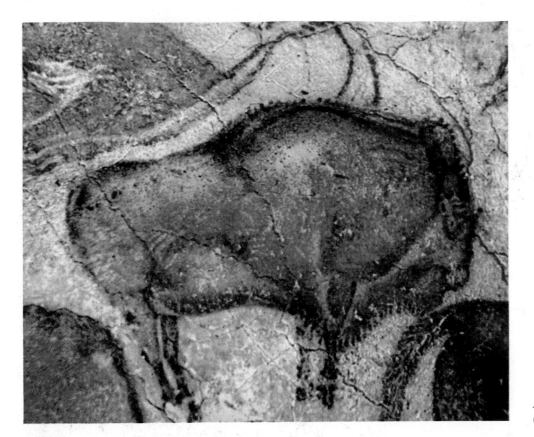

Middle Magdalenian bison
(Altamira Caves)

of others. In another site, in the Niaux caves, an artist-sorcerer has created a form of art inspired by nature. He has made use of the cavities in the rocks to serve as wounds for an animal which he has outlined, adding further emphasis by the later addition of painted arrows.

The pictorial cycle in the caves at Altamira, in Spain, is also very significant. Discovered in 1879, it is a paleolithic cave cycle of the period 14,000 to 9500 B.C., the figures being spread over the ceiling of the hall (fifty-nine feet by thirty feet). Enormous bison stand out from the drawings, but they are mostly motionless, trapped or wounded. Animal-sorcerer figures are mingled with the animals, which heightens the magical atmosphere of the pictorial creation and bears witness to the extent of man's domination over animals at that time. The outline is brownish-black, while shading in red and other earth colours is used to give an impression of relief. The new emphasis is on the magical force which emanates from the blocked, tight, compact shapes. This evidence of the dominion of man over animal is proof of primitive man's awareness of his physical strength and also of his intelligence.

Contemporary with these Franco-Cantabrian artistic developments, there was in Europe evidence of abstract art or stylistic synthesis which showed similar characteristics in different places, perhaps because of the dissemination of patterns traced on wood or skins. In eastern Europe small plaques have been found – with a V and a zig-zag motif in the Ukraine and with plait designs in Moravia. Other examples of the genre occur also in the Mediterranean area (the Romanelli cave in Puglia and the 'Red Terrace' cave at Ventimiglia).

Neolithic art: the age of polished stone

In the Neolithic Age or the new age of smooth stone which began about 10,000 B.C. man was to a far larger extent master of his fate, even if he lacked security in the face of the forces of nature. Cave art loses its unified character and begins to speak with different voices. In Europe, along the valley of the Rhine, in Scandinavia and in northern Russia stylised representation of figures prevailed between 6000 and 2000 B.C. and in the Cogul caves in Spain the human form appeared, singly and in groups. In about 4000 B.C. flat, dynamic human figures made their great irruption into the cave-art cycles of Tassilli, in the Sahara, in scenes containing several people. In Italy, in the Grotta dell' Addaura on Monte San Pellegrino overlooking Palermo, vast paleolithic-style engravings have been found, with groups of figures, possibly

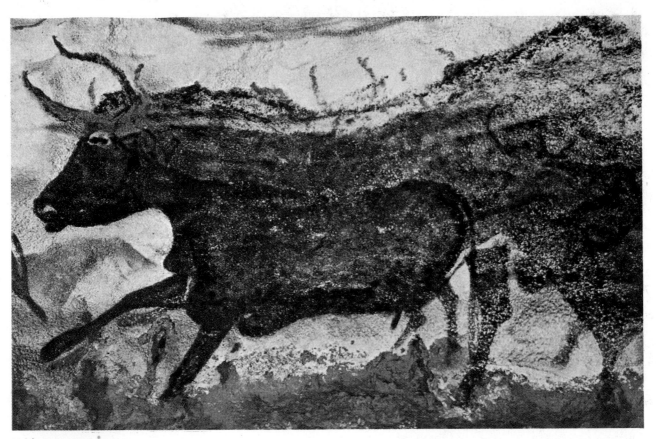

Magdalenian bull (Lascaux Caves)

Late Magdalenian bison fighting (Le Portal Cave)

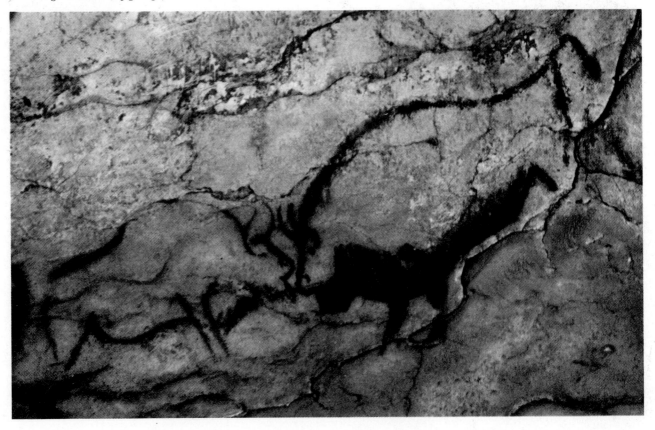

13

representing scenes from some ritual. Sometimes on a single level and sometimes superimposed one on top of another, human figures are intertwined with realism and vivid rhythmic sense. Almost everywhere, too, there appeared, particularly in the later neolithic period, a more or less developed pottery with sketchy geometric designs either painted or scratched on it, and these show characteristics peculiar to the various different settlements.

After the paleolithic and neolithic eras, which cover many thousands of years, there come the ages of metals, which are more restricted in their chronological limits. After the relatively brief and instable Copper Age came the Bronze Age, which was to be decisive in the fate of humanity and was the period of transition to the historical civilisations. Already known and worked in the East, perhaps even as early as 3500 B.C., bronze began to appear in the West

(in Egypt) in about 2500 B.C. Subsequently the Bronze Age developed and eventually came to an end within the 1st millennium, giving way to the Iron Age. The Iron Age itself moved from East to West, flourishing in the West about 1000 B.C., hand in hand with the development of historical civilisations.

The discovery and working of metal constituted a great technological and human revolution. It led to the clearing and regular cultivation of the land and, as a result, favoured the start of an agrarian civilisation on a permanent basis. But it marked, too, the discovery of new and more powerful weapons for aggression and conquest. Side by side with, rather than in the place of, the modest prehistoric pottery, there came into widespread use such objects as metal utensils, cups, pots and ornaments, as well as tools and weapons. With new plastic effects, either cast or in relief, these enriched the

Rock-drawings from Valcamonica (left and right)

Bisons and horses in the 'Great Hall' of Santimamiña Cave

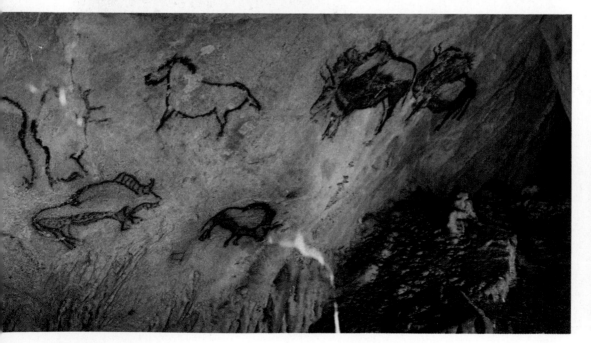

decorative repertoire of symbolic designs (spirals, double spirals, swastikas and rings) or of linear or angular geometric motifs. Although the primitive character of the prehistoric village with its precarious and simple structure, persisted, the standard of living rose. In the field of figurative art this has been confirmed to some extent by the discovery, in the Bardal cave in Norway, of a stylised ship scratched on the rock, which clearly bears witness to maritime activities. In India, too, near Manikpur, there is an engraving of a wheeled cart – testimony of ancient agrarian pursuits. It is upon these themes that the figurative art of historical civilisations also was founded.

To the Bronze Age must be attributed the vast complex of cave engravings which surround the summit of Monte Bego, in the Maritime Alps, now in French territory. Here the figures, which are quite numerous, show a marked tendency to strict stylisation, thus becoming gesticulating threadlike shapes. The extreme stylisation of the rock carvings in the Camonica valley, near Breno in Italy, is somewhat more realistic in the representation of fir trees, grazing cattle and transport waggons.

Megaliths

At some time during the period between the 3rd and 2nd millennia, there appeared in Europe the first examples of architecture, though this was dedicated to sacred rather than practical ends. This architecture consisted of huge complexes of heavy vertical stone blocks, reaching a height of over eighty feet, as at Locmariaquer in France, or spreading out over nearly two miles, as at nearby Carnac. At Stonehenge, in England, they were placed in a ring, enclosing an area of twenty-five acres. When erected in isolation the

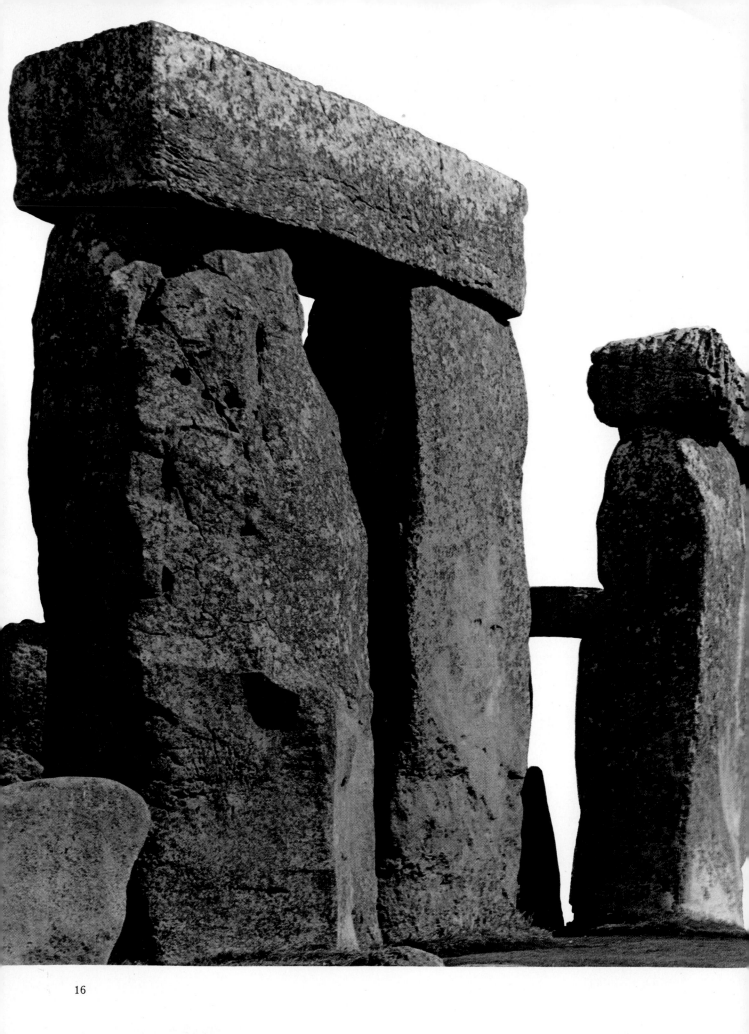

stones are called *menhirs* (*men* stone, *hir* long), or if a third stone is placed horizontally upon two uprights, *dolmens* (*dol* table, *men* stone). *Cromlechs* are menhirs placed one after the other to form a circle surrounding an enclosed area. These constructions are connected with primitive, perhaps native-inspired, cults about which we know nothing. Some are to be found in Scandinavia, some in Germany and odd, rare examples in Italy near Bisceglie in Puglia and near Melendugno di Lecce.

The coming of the Bronze Age in Europe, especially after 2000 B.C., had extremely powerful repercussions, both social and historical. The appearance of bronze was, in fact, the external dynamic event which broke up the primitive stagnation, the tribal isolation, the precarious economy and the haphazard search for a means of subsistence which characterised the sluggish neolithic period. Bronze now became the pathway, though not always a peaceful one, first for contact and later for barter. The dissemination of bronze articles, from the most elementary and utilitarian, like axes, hoes, blades and weapons, to the more aesthetically evolved, such as vases, bowls and ornaments, came about by sea as well as by land. It also led to the search for minerals, particularly tin, and put them into circulation through primitive industries. Bronze opened up new horizons – spiritual, technological, historical and equally important, geographical.

Bronze was carried westward from the East where it was previously employed in Chinese art, by either of two racial movements. One was the slow migration towards the West and the shores of the Mediterranean by those Indo-European races whose final settling was to be one of the decisive components of the historical civilisations. The other comprised the nomadic wanderings of the so-called 'people of the steppes'. Bronze thus became one of the dynamic factors which, so to speak, precipitated the historical period, ending the chapter of pre-history and ushering in the great historical civilisations of the eastern Mediterranean. Bronze manufacture was to be the pivot upon which the powerful influence and superiority of the tiny territorial domains of Crete and Mycenae turned. Bronze was to be the basis of the power of the Etruscans who, once they had pushed into

Italy, overcame the less developed and scanty Villanovan civilisation – though the Etruscans in their turn were to contribute to the emergence of the Iron Age.

Sometimes bronze manufacture moved in a more complex way and by more complicated routes. After bronze came into use by way of the 'people of the steppes', who had settled between Rumania and the Ukraine, to the north of the Black Sea, it travelled up the Danube valley. There it gave new life to work and products among the peoples who, in neolithic times, had settled across Yugoslavia, Hungary and Bohemia. From the Danube valley it later passed into Austria and central Germany, finding new centres and spheres of influence, especially in the Ore Mountains of southern Saxony. Northwards from there it travelled along the German rivers and, on the shores of Jutland, in Denmark, reached the source of the other ancient traffic – that in precious amber which crossed Europe in the opposite direction to bring to the powerful Helladic monarchs a much-prized raw material for ornaments. It is therefore hardly surprising that along this route are found not only utensils and weapons, but also vessels of various kinds, basins, cooking pots, armlets, and brooches with ornamental motifs of scrolls, spirals and plaits. Votive statuettes and statuettes of warriors have also been found, as well as a most unusual piece in bronze: a votive carriage which was an offering to a deity. A similar example is to be found in the Graz Museum. It is a four-wheeled cart, full of gesticulating huntsmen, dominated by a

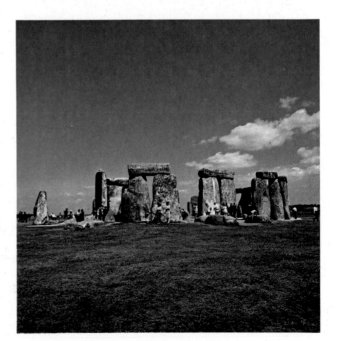

The megalithic circle of Stonehenge, detail and (right) general view

Iron Age terracotta vessels (Bari Museum)

female idol bearing a dish upon a tripod. In the Copenhagen Museum there is a little bronze horse pulling a cart carrying a golden solar disc, which was found at Trundholm and dates from the period 1400–1200 B.C. This alone, with its almost Greek elegance, gives ample testimony to the heights reached by bronze art in Denmark. With these fore-runners to guide us, it is easier to understand how, in contrast to Etruscan art, there grew up in Europe the two most important but widely separated centres of artistic production of the Iron Age which was to follow. They are the Hallstatt centre in Austria (8th–5th centuries B.C.) and the La Tène centre in France (5th–1st centuries B.C.), which had such a great influence on Celtic civilisation.

At other times, on the other hand, contacts were made by sea. It was in this way that the use of bronze spread to Spain, especially to Catalonia, where it is associated with communal tombs in the form of tumuli or dolmens. Certainly it was by sea that bronze found its way to

Sardinia, where there developed an agrarian civilisation, insular and separate. At that time the island was extremely heavily populated and the basis of the civilisation was the small agricultural village with its characteristic architectural element, the *nurago*. This was a truncated cone construction, on a circular base, built by placing huge stones one on top of the other. Along the *nurago*'s massive walls ran defensive galleries with embrasures and *piombatoi* (orifices in the corbelling of battlements to enable the defenders to throw stones, etc., down onto assailants). Inside the *nurago* a door with an architrave led into a room on a circular base with a rough dome-shaped roof constructed of concentric, tapering circles of stones. Sometimes the *nurago* stands alone like a protective tower to defend an entire village, but at Barumini it is linked to the whole structure of the village, including huts built on circular bases, and has a manifestly defensive function. The museum at Cagliari in particular, is rich in patinated bronze statuettes, a huge store of which has been found during the excavation of the *nuragi* which are scattered in their thousands throughout Sardinia. Although this nuragic sculpture is extremely simple, it shows quite a vivid sense of characterisation and portrays the everyday themes of the nuragic agrarian world: shepherds leaning on their crooks, warriors with shield and

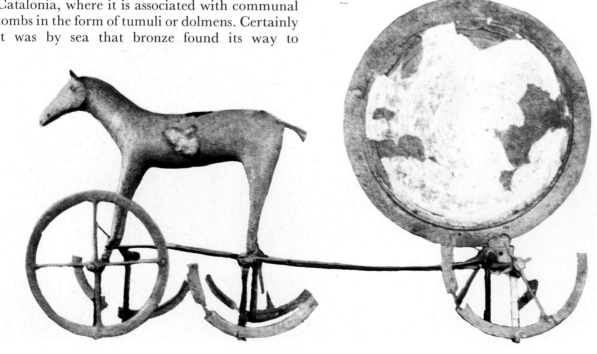

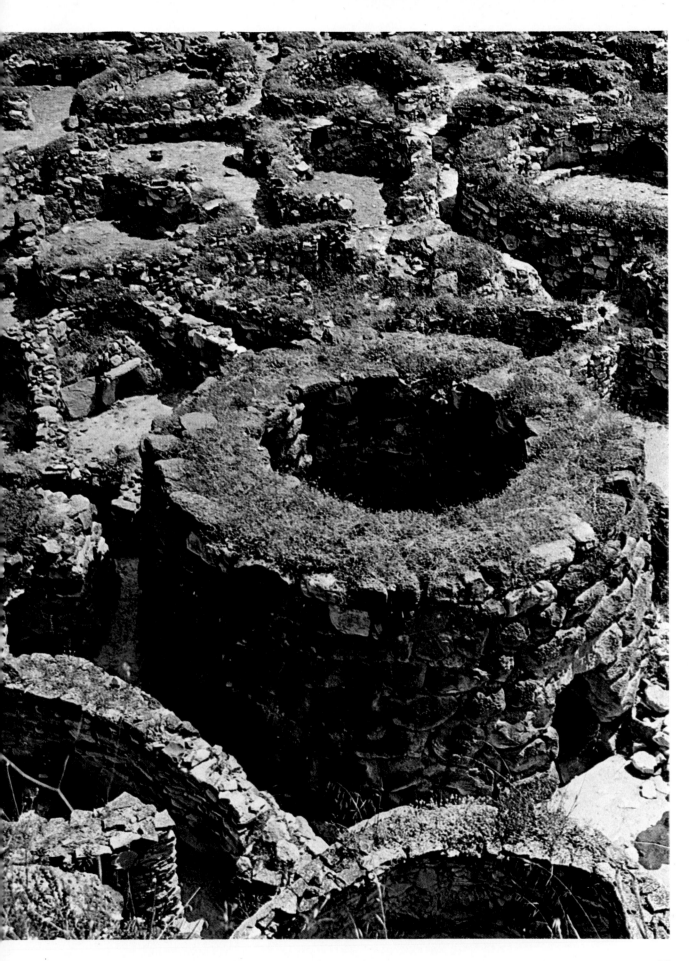

sword or in the act of drawing a bow, women and the tragic theme of a mother lamenting her fallen son. We are now at the very limits of the civilisations which lie outside history.

The art of the steppes

This review of prehistory and the first phase of European history would be incomplete without giving due attention to the people whom it is usual to call the 'people of the steppes'. The enormous expanse of plain and steppe which spreads from present-day Rumania to the north of the Black Sea and the Caspian, as far as Baikal and Siberia in southern and eastern U.S.S.R., has great importance for Europe itself from the point of view of anthropology, history and art. Travelled over, rather than occupied, by nomadic and unsettled peoples, these boundless steppes acted as a highway and a means of contact akin to that of the sea – a solid sea of scanty grass – in an epoch when navigation upon the waves was still an impossibility or, at best, a frightening adventure. The steppes are a crucible as well as a dynamic element. It was here, in a remote era – in the 3rd, if not the 4th millennium B.C. – that the tribes of Indo-Aryan origin spread and mingled with others from this area or from even more remote parts of Asia and founded a 'proto-Aryan' stock. It was from here, in the course of the 3rd millennium, that there came the intermittent, hesitant movement westwards of this nomadic population. Their slow migrations led them into the region where Western civilisation later developed. It was from here, again, in historical times, that there came what we are accustomed to call the 'barbarian invasions', set in train by the

Bronze animal figures from Asiatic Russia
Elk
Horse
(British Museum, London)

pressure of movements further east and which were destined ineluctably to sweep away the structure of the Roman Empire. It was from here, finally, that the Bronze Age was to receive a decisive impetus in terms of tools, weapons and ornaments, marking a profound technological revolution. This revolution found its ore supplies in the deposits and early minings in the Altai Mountains, in the region of Minussink and of Andronovo, on the borders of Siberia.

At the risk of over-simplifying a situation characterised by dynamism and nomadism, it is possible to distinguish two polarisations of these people. One group went westward to the north of the Black Sea across the Danube and the Volga, giving rise to the legendary race of Cimmerians upon whom, in the 7th century B.C. the power of the Scythians and later the Sarmatians was based. The other went eastwards, across Kazakhstan and Siberia, mingling with the Mongols and developing more slowly. Later (8th – 7th centuries B.C.), they made up the confederation of the Huns, which began to move westwards only in the 4th century A.D.

The interesting thing from the artistic point of view is that, by contrast with a relative variety of arms and tools in bronze, this area saw the birth of a form of art with constant characteristics, namely 'animal art'. This was bronze work – sometimes tiny, single statuettes of animals, which were easy to transport, but more often shield bosses, decorative ornaments for brooches, handles for weapons or lamps, ornaments for helmets or quivers and harness decorations. This animal art seemed to drain the plastic creativity of the steppe tribes, for plant decorations are rare, human figures exceptional and representations of gods almost non-existent.

But within this restricted representational ambit there is considerable variation of motif. Many pieces do not go beyond a realistic approach. They are intended to represent horses, deer, rams, oxen or wolves in their natural state or caught in some significant attitude. A more interesting development, because of its originality of expression, without equal in East or West, is the representation of animals, singly or in combat with each other, which shows considerable freedom and fantasy. Often this gives rise to an extremely lifelike, dynamic, springy form which almost reaches abstract art with its interplay of tensions and torsions, flexions and leaps, space and line. It reaches its apotheosis sometimes in the open dynamic forms, such as the animal caught in a 'flying gallop', or sometimes in tight closed shapes, such as the animal gathering itself to attack, or the figures of animals in combat.

Because it was readily transportable, this animal art was widely disseminated towards the West, but two streams which accompanied the migrations of the tribes appear particularly significant. First of all, there was the migration of the people who crossed the Iranian plateau and settled in Luristan on its west central side. Between 1500 and 800 B.C., the animal art of Luristan was endowed with great fantasy and constituted a lively precedent for Persian goldwork. To the East, however, the peoples from the Altai Mountains crossed the Gobi desert and their beautifully harmonious animal art is centred on Ordos, in the bend of the Yellow River, to the north of the Great Wall. There it persisted from the 15th to the 3rd centuries B.C. It was by this route that, from the Chou period, it came to inspire Chinese art.

THE ART OF MESOPOTAMIA

While Europe was languishing in the Neolithic Age, a great civilisation was developing in western Asia, in Mesopotamia, that vast and fertile territory between the Tigris and the Euphrates. It was a civilisation which rivalled, and perhaps surpassed, in duration that of Egypt. First emerging before 5000 B.C., it came to an end only in 330 B.C. with its conquest by Alexander the Great, ushering in the civilisation of western Greece. In contrast to the civilisation of Egypt, which was relatively homogeneous and coherent, that of Mesopotamia was, historically, more complex and uneven. It was marked by the alternating predominance of various peoples and races, by their different values, by a more precarious and fleeting political unity and by more contacts with other peoples.

Bronze statue of an orante (worshipping figure) from Ur, 3rd millennium B.C. (Louvre, Paris)

Ceramic cup, 4th millennium B.C. (Louvre, Paris), in the style of Susa

What may be called the proto-history of Mesopotamia lasted for about 2000 years. Archaeological discoveries reveal it to have been a fairly evolved civilisation; traces have been found of simple dwellings which, since stone was unknown in this area, were constructed of such perishable clayey material as was to hand. The characteristic art form of this civilisation is seen in the elongated figurines of clay with slender bodies, which showed only the briefest of anatomical features and had terrifying serpentine heads. This has led to the belief that they had a religio-superstitious significance connected, perhaps, with the myth of the Mother-goddess. Another and more developed art form in lower Mesopotamia was that of ceramics, which was centred on various places, notably Hassuna and Samarra, and which, at Susa, further to the east, actually came to be produced in workshops. It was composed of light, ivory-coloured pottery, worked by hand into plates, cups and small vessels with ornamental motifs painted in burnt ochre. It is interesting to note how the figurative elements of animals, small palm trees or the human form were reduced to extreme stylisation, while to an even greater extent the abstract motifs of bands, checks, comb-patterns and circles predominated.

At the end of this prehistoric period, perhaps in about 3500 B.C., a great inundation, which has come down to us as the Bible story of the Flood, swept across southern Mesopotamia, in some places covering everything with a layer of mud twenty-five feet deep.

The Sumerians

The historical phase of this area, begins about 3000 B.C., when the Sumerians, a race of Asiatic origin which had migrated from the tableland beyond the Caspian Sea, gained dominance over the southern part of the country. The Sumerians brought with them a fairly advanced agrarian civilisation which was quick to adopt the use of metals and which created rich, stable cities. These Sumerian cities of Ur, Uruk, Nippur, Eridu and Lagash were independent city-states, each with its own king and the urge for independence always took

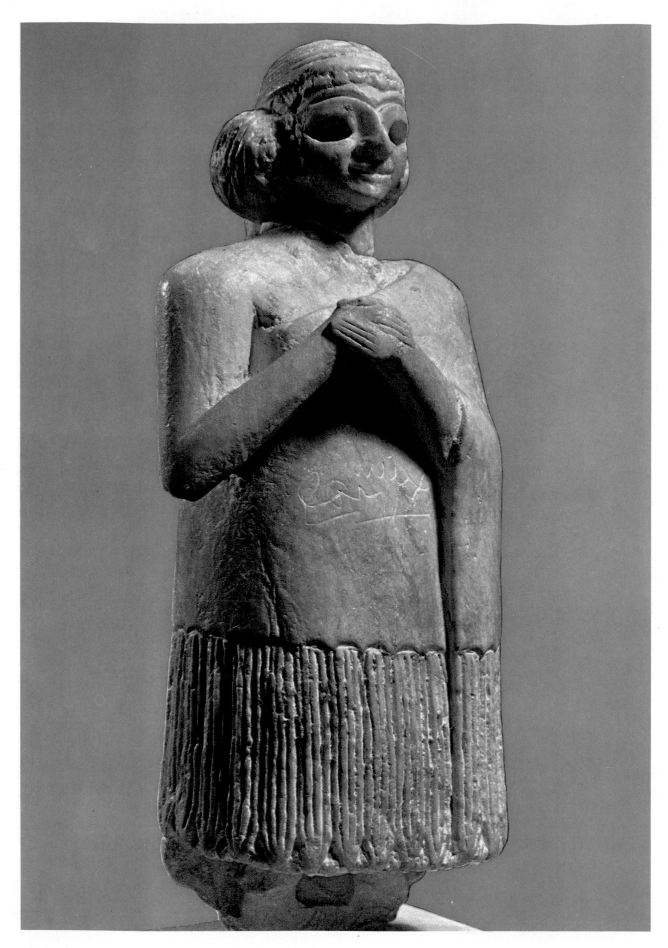

precedence over the need for national unity.

The principal characteristic of Mesopotamian civilisation was the commercial intercourse which existed both in the interior and with surrounding regions. An early aid to commerce was the use of writing, which soon became formalised in the cuneiform characters carved on the tablets and cylinders, and one of the means by which we may reconstruct and study the civilisation. Writing was entrusted to groups of specialists, the scribes, and became the great highway along which the Sumerian people passed towards civilisation and unification. Sumerian life was deeply pervaded by a transcendental belief in multiple, mysterious deities – personifications of the forces of nature – whom man could propitiate by means of devotional practices and whose will could be divined according to the course of the stars. This gave great power to the priestly caste which controlled the vast territories owned by the kings and by the temples. On the other hand, it also favoured the development of astronomy and mathematics, of which Sumeria was the cradle.

Uruk, near the mouth of the Euphrates in the Persian Gulf, was the first centre of Sumerian expansion. It gained dominance in about 3500 B.C. with the establishment of a strong dynasty. Here, perhaps better preserved than in the other, later settlements, we find the imposing remains of that most characteristic Sumerian architectural form, the ziggurat. This was an artificial hill of clay supported by geometric terraced walls of crude, sun-dried brick. In the

Sumerian art, alabaster statue of a Sumerian woman, about 3000 B.C. (British Museum, London)

Sumerian art, votive table of Urnanshe, ensi *of Lagash (Louvre, Paris)*

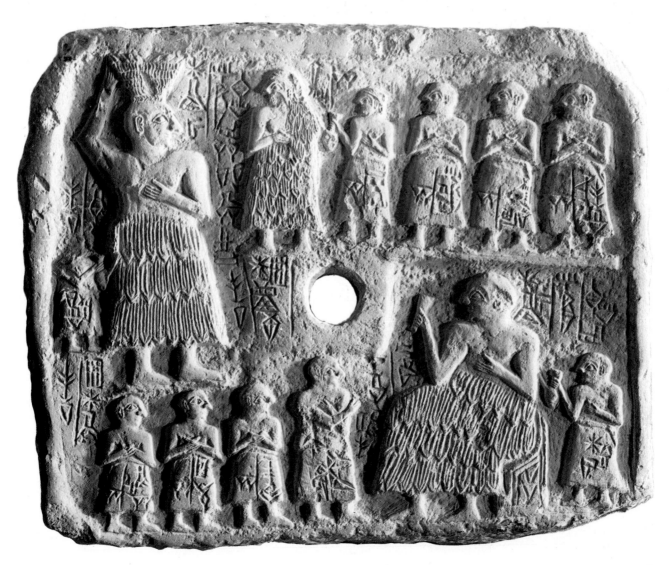

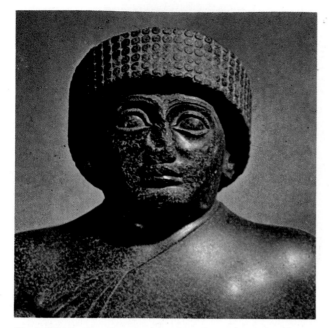

Head of Gudea from Lagash (Louvre, Paris)

most famous ziggurat in Uruk, the White Temple, a long flight of white steps rises from the terraced levels towards the summit, giving to the faithful an impression of a stairway to heaven. In contrast to the Egyptian pyramids,

The 'ram caught in a thicket' from Ur (British Museum, London)

which were intended as tombs, the less well-preserved ziggurats of Sumeria performed the function of immense altars, solemnly rising towards the deity who would come down to dwell there for a while.

Sumerian sculpture is also of some significance. It is static, hieratic and oppressive, heavy with a sense of fear and strangeness, even when it has a symbolic or abstract content, or when it is transformed by that stylisation which, as we shall see, is the secret of Egyptian sculpture. There is an abundance of statues but they are in poor material, at best sculpted in limestone. There are a great many statues of gods and goddesses, of kings and important functionaries and sometimes of ordinary people. Among the latter is the seated figure from Ur-Nina (Damascus Museum) which has been given, perhaps for its wealth of expression, the name of 'The Great Singer' by the archaeologists to whose work, particularly in the 20th century, we owe the discovery and evaluation of the art of the whole Mesopotamian area. The most common representation is, however, that of the devout 'orante' or worshipping figure. His posture is rigidly frontal and absolutely static, the hands joined on the breast in an attitude of prayer and he wears the full, flounced skirt common to them all. These statues sometimes represented family groups and found their way into the temples almost as a liturgical 'substitute' for the person they represented. At first sight they seem to be a realistic interpretation of a quite varied human race. There are women and boys, clean-shaven men and men with solemn tapering beards, and no distinction is made between gods and mortals, between king and subject. However, a demanding expressionism animates all these figures. They represent the religious concentration, the terrified intensity, of the subject's devotions, the dominant note being the enormous staring eyes, surrounded by a bituminous oval that sets off the white of the cornea.

A characteristic medium for Sumerian plastic art was the limestone cylinder, which also helped to spread the use of writing. Such cylinders were deeply incised so as to leave an impression when they were rolled on a flat bed of fresh clay. Associated with them over many centuries were abstract decorative motifs such as mysterious symbolic figures, single or multiple animal shapes, sometimes executed with a fantasy which turned them into monsters. Sometimes also there were designs incorporating mythical tales, war or realistic scenes of everyday life or customs. The kind of lively figure work in relief which can be seen on the Stele of the

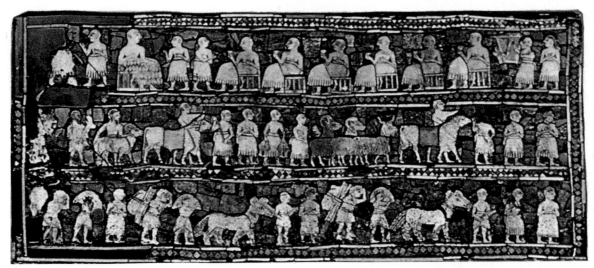

The 'standard' of Ur (British Museum, London)

Detail of the 'standard' of Ur

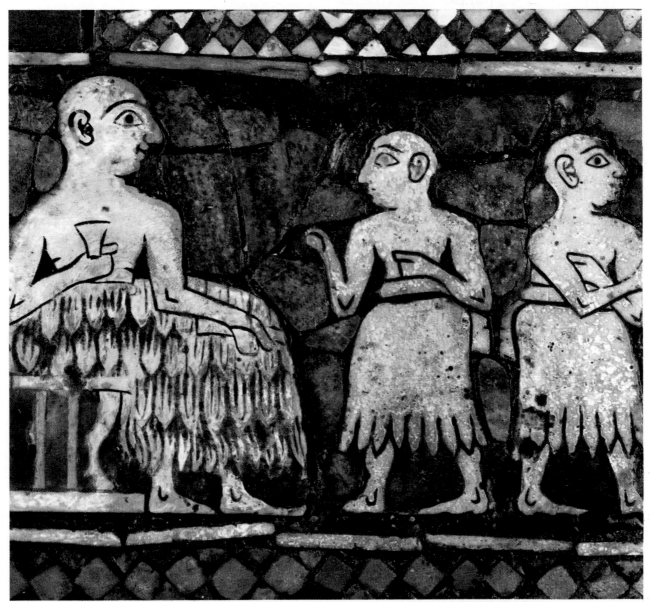

Vultures (Louvre, Paris) is, however, more rare.

Scarcely had the age of metals begun than notable achievements were made in the production of animal figures in copper, and superb pieces in enamelled gold. Typical of Sumerian products were the ornamental double-sided tablets, erroneously called 'standards', consisting of a foundation of lapis lazuli with encrusted figures intagliated in mother-of-pearl. There is a splendid example of this art from Ur in the British Museum in London.

This first period of Sumerian dominance came to an end in 2470 B.C. when the Sumerians were overthrown by the Accadians, a semitic race from western Mesopotamia under the warlike leadership of their ruler, Sargon. The two centuries of Accadian domination (2470–2285 B.C.) saw the establishment of a single monarchy much given to pomp and warlike enterprises, although it had no settled capital. Semitic sensitivity, which expressed itself with more freedom and fantasy, infiltrated artistic work, alleviating Sumerian severity without, however, causing any significant rupture. This influence can be seen particularly in two works of art. One is the powerful head, in gilded bronze, of this same Sargon, which is in the museum at Baghdad and which, in its strength of expression and plastic synthesis, marks the high point of Sumerian goldwork. The other is the pink stone stele which tells, with a realism full of freedom and fantasy, of the warlike exploits of Naram-Sin, one of Sargon's successors (Louvre, Paris).

The Neo-Sumerians

After this historic interlude, the Sumerians once again seized power and towards 2150 B.C. the Neo-Sumerian Age became fully established with its lively and prolific artistic production. Art flourished again under the auspices of local princes, particularly in the southern cities of

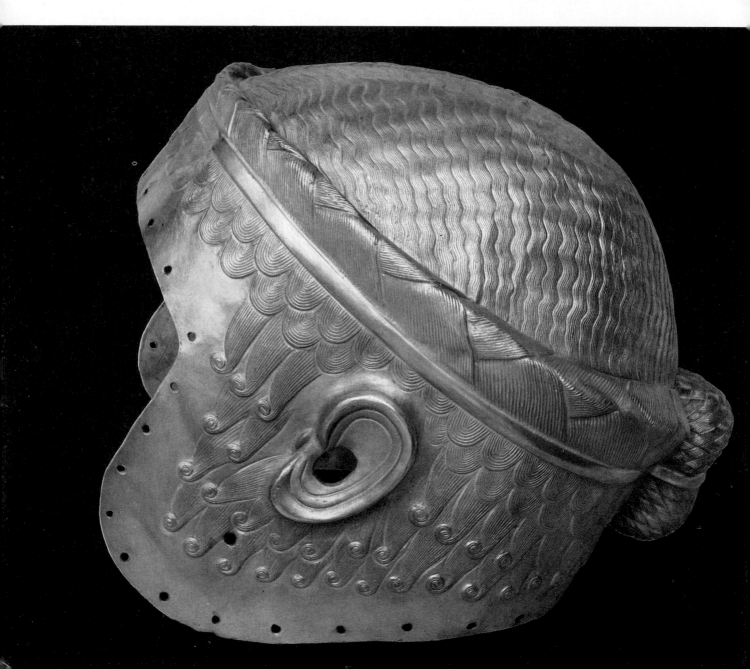

Lagash, Ur, Uruk and Eridu. Ur, in particular, was to become famous for its ziggurats, which became even more imposing and ambitious, as can be seen from their remains. It is from here that we have the Bible story of the Tower of Babel, 'whose top reached unto heaven'.

Sumerian sculpture continued to develop. In Lagash it showed particular genius in the numerous statues in gleaming black or greenish diorite of the enigmatic Gudea, the religious and political head of the city who, it seems, always refused to assume the title and dignity of kingship. He is portrayed seated and standing, his rounded head enclosed in a circular, stitched turban. With his hands ritually clasped in fervent prayer and wearing the heavy mantle adorned with cuneiform script, Gudea represents at once the two ideals of compact Sumerian sculptural form and of deep religious fervour.

Around 2000 B.C., Sumerian predominance finally waned, under the renewed hegemony of the semitic peoples who found their new centre of power in Babylon. The process was, however, a complicated one, with rival local sovereigns squabbling over the division of the vast domains that had belonged to the Sumerians. Archaeological research within the last thirty years has revealed the splendour of one region – that of Mari in the middle Euphrates area – during the transitional period which also marked the rise of Babylon. In this area are the ruins of an immense palace, covering an area of some eight-and-a-half acres, and bearing a marked resemblance to the great ancient palaces of Crete that we shall discuss in a later chapter. Built of crude brick, this palace bristled with buildings around a central courtyard adjoining the king's residence. Almost a city in itself it contained a sacred quarter, an administrative area where the functionaries worked and where archives with piles of inscribed tablets were found, and a servants' quarter with huge store-rooms, kitchens and craftsmen's workshops. Some important sculptures dating from the 18th century B.C. were found in its vast ruins. Two of the most interesting of these are now in the Aleppo Museum. One is a warrior's head with its chinstrap. The other is the figure of a goddess wearing a curious costume and headdress and bearing an overflowing vessel, ingeniously decorated, from which the water of fertility flows down her gown in a cascade. The palace of Mari is more important, however, in the insight

it gives us into some notable Mesopotamian painting that depicts realistic scenes, especially one showing the robing of the king.

The city was destroyed by King Hammurabi of Babylon (1792–1750 B.C.), who established the Babylonian hegemony. He imposed his laws throughout the vast empire and we find a symbol of this in the great blocks of black basalt (Louvre, Paris) showing, in the upper part, a flowing relief depicting the king inspired by the Sun God while underneath are inscribed the 282 laws of his 'Code'.

This splendour was, however, of brief duration. After a long war, in about 1595 B.C., Babylon fell to the Cassites, a barbarian mountain people, themselves later replaced by the Elamites. None of these events stifled the art of the conquered territory completely, because the newcomers had little to offer artistically. The area was, however, exposed over five centuries to a period of substantial upheavals and it was

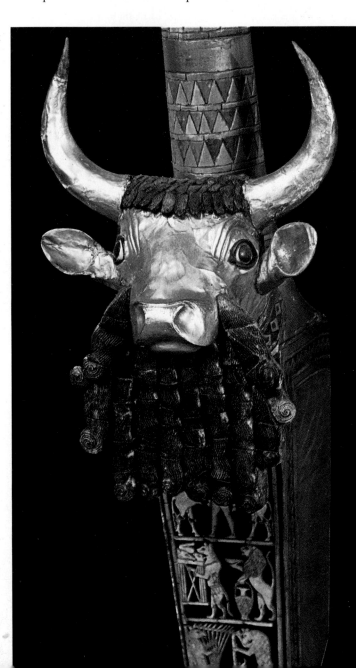

Gold helmet from Ur (Iraq Museum, Baghdad)

Detail of harp frame with bull's head in gold (University of Philadelphia)

only in isolated places, like Susa, that artistic expression was kept alive.

The Assyrians

The situation changed, however, when the Assyrians, established from the earliest historical times in the foothills and mountains in the Upper Tigris valley, took control of the whole country. They left their mark on the art of the entire Mesopotamian region over many centuries, until their sudden downfall. Their natural centre of gravitation was the region known as the 'Assyrian triangle' between the Tigris and its tributary, the Zeb. Here stood the Assyrian cities of Chorsabad, Nineveh and Nimrud,

while a little further south, on the Tigris, was the city of Assur. The Assyrians had patiently suffered the rule of their Mesopotamian overlords or had tried to avail themselves of some relative independence. They had also absorbed much of the religious beliefs and artistic expression of their rulers. But during the constant struggle for power they had been preparing a new regime whose power was to be given full rein from the 13th century B.C. It was a despotic, totalitarian state, bent on war and conquest, which formed the base for a predatory economy. Its might was concentrated in the figure of its

Right: Assyrian relief of a stag hunt with nets (British Museum, London)

Below: Stele (upright slab or pillar, often as memorial) of Naram-Sin from Susa, 4th–3rd millennium B.C. (Louvre, Paris)

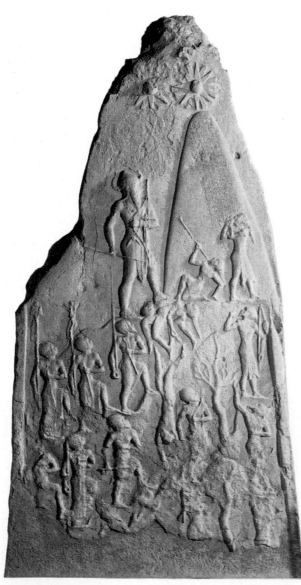

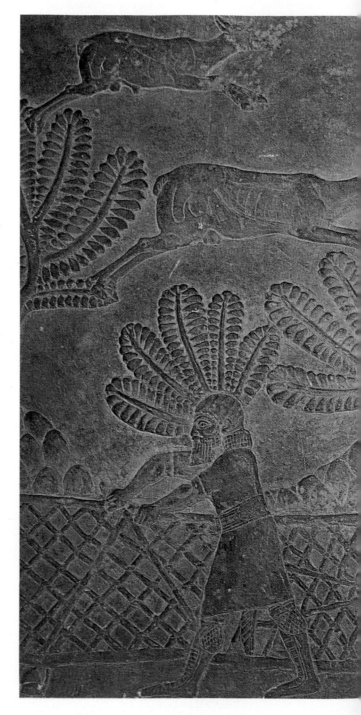

tyrannical and ruthless kings; it possessed a powerful and noble army, strictly disciplined and equipped with the arms which were the privilege conferred by the age of metal upon those who had, from the first, seen how best to avail themselves of the new methods.

Under such kings as Assurnasirpal, Assurbanipal and Sennacherib, the Assyrians, found the conquest of Babylon an easy undertaking and soon spread their dominion over the rest of the region, from the Persian Gulf to the Mediterranean. Once established in these new bases, they were moved to more ambitious conquests,

extending from the mountains of Armenia to Palestine, and penetrating in depth to beyond Thebes to attack the age-old enemy, Egypt.

A radical change took place also in Assyrian art. Enriched by the spoils of war and by an unlimited mass of slaves, the Assyrian cities of Assur, Nineveh and Chorsabad found new magnificence. Homage to the gods was there in plenty. Multi-level ziggurats rose to unprecedented heights, with paths spiralling to the summit. But of equal importance was the glorification of the king and the grandiose pomp of the court. Immense royal palaces arose. The

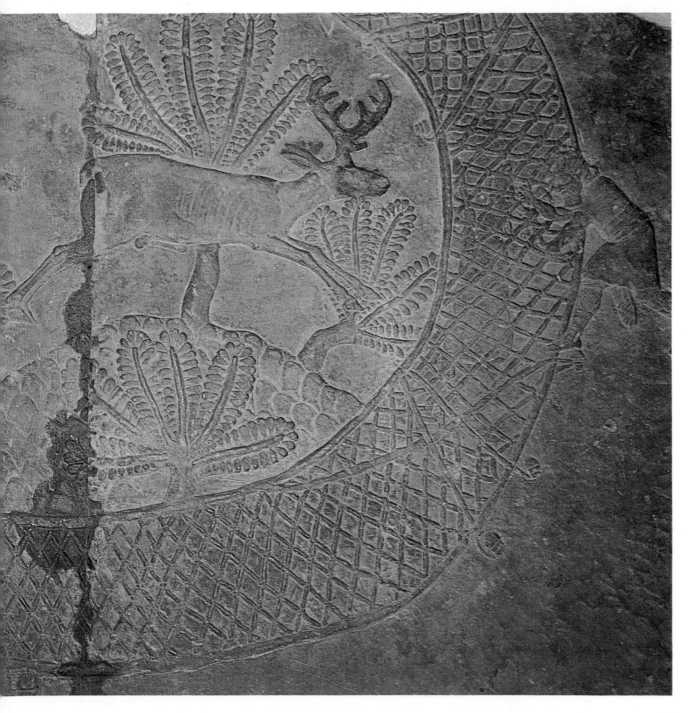

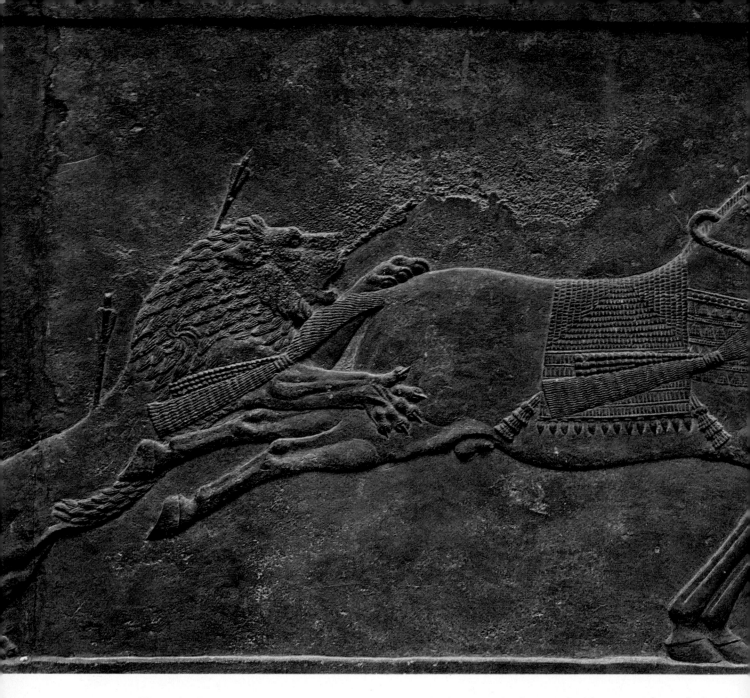

one at Chorsabad covers nearly twenty-one acres and has more than two hundred halls, separated by spacious courtyards.

Assyrian art was dedicated to the embellishment of these palaces rather than to the production of independent works of sculpture, though what did exist consisted mainly of effigies of the monarch with stylised beards and robes. Because of their function as splendid royal monuments, these palaces called for representations of the animals and spirits which would guard the king. The most original sculptural contribution to art of this genre were the winged, five-legged bulls with human face, flowing beard and noble crown. Similarly new were the rich and picturesque glazed tile decorations of the palaces. Here also, side by side with gold-

work, in a land where suitable stone abounded, there was an enormous growth of carving. The palace rooms are covered with bas-reliefs glorifying the king (at a later period there were also to be bas-reliefs cast in bronze). Again and again there are effigies of the king, impersonal and almost conventionalised in their Oriental style, with their long beards divided or tasselled, their mitres and carefully detailed robes. The king is portrayed performing religious rites or civil ceremonies and receiving tribute from subjects or from vanquished foes. But this art was intended to set him apart in his function of exercising power. It contrasts sharply with the splendour of scenes depicting his bloody acts of war, the battles, the razing and sacking of conquered cities, the massacre of prisoners, the

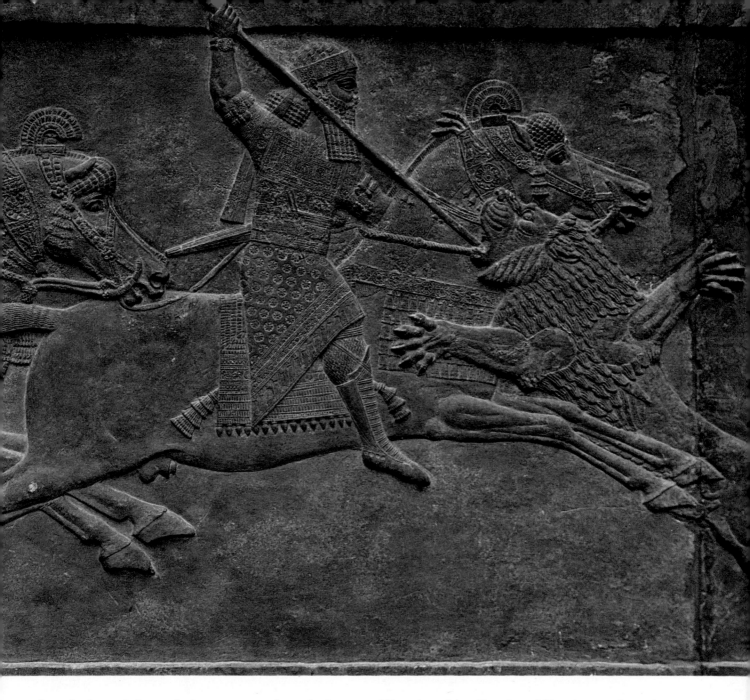

forced deportation of the conquered and the long columns of booty. Just as striking are the hunting scenes, on horseback or in chariots, where the Assyrians threw off all convention and caught with powerful realism and intuitive sensibility the behaviour of the hunted beast. Bas-reliefs from the palaces of Assurnasirpal and Sennacherib at Nineveh are preserved in the British Museum in London, while in Paris, at the Louvre, can be seen those from the palace of Assurbanipal at Chorsabad. Recent archaeological discoveries have also revealed that in the palaces there existed vast pictorial decorations with similar characteristics, of exceptional freedom and dynamism, like the one from Tell Barsip, dating from the 8th century B.C. and now at Aleppo Museum.

The Assyrian Empire fell when, after the death of Assurbanipal, a coalition of Medes and Chaldeans based upon Babylon, seized power. Nineveh subsequently fell in 612 B.C., taking with it all that was left of the Assyrian Empire.

The Neo-Babylonian hegemony lasted for less than a century, however. It was founded on the power of kings like Nabopalassar and Nebuchadnezzar, the latter being famous for the campaign which he mounted to conquer Jerusalem. It was he, also, who determined to make of Babylon a

Assyrian Art: King Assurbanipal hunting lions, from the palace at Nineveh (British Museum, London)

splendid and fabulous city. Spanning the Euphrates, it stood within two encircling walls and its grandeur was enhanced by imposing royal palaces. Through it ran a sacred processional road which started at the Gateway of Ishtar, now reconstructed in the Berlin Museum, and led to the temple of the god Marduk, a slender ziggurat on seven levels, about 330 feet high, surmounted by a blue temple. The city's terraced palaces were green with hanging gardens. One typical feature of Babylon, but one which recalls the splendours of Assyria, was the use of small bricks enamelled in vivid colours as a facing for the crude bricks of the walls. Figures of symbolic animals, such as bulls,

Cuneiform script. Gold plate from the Treasure of Darius at Persepolis (Archaeological Museum, Teheran)

Glazed-brick relief of lion from Babylon (Louvre, Paris)

lions and dragons stand out in clear, warm colours against a background of blue or green.

The Persians

In 539 B.C., Babylon was, in its turn, overthrown by a new empire in the making. This was the empire of the Persians, and it marked the final phase of the independent civilisations of Mesopotamia. The Persians were a people of Indo-European stock and had penetrated into the area more than 100 years earlier by way of the passes through the Caucasus and across the Iranian plateau. Until this time the Persians had had some difficulty in finding unity and

The Ishtar Gate at Babylon, reconstruction (Former State Museums, Berlin)

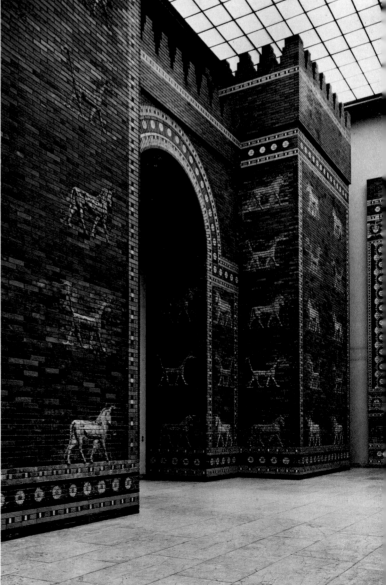

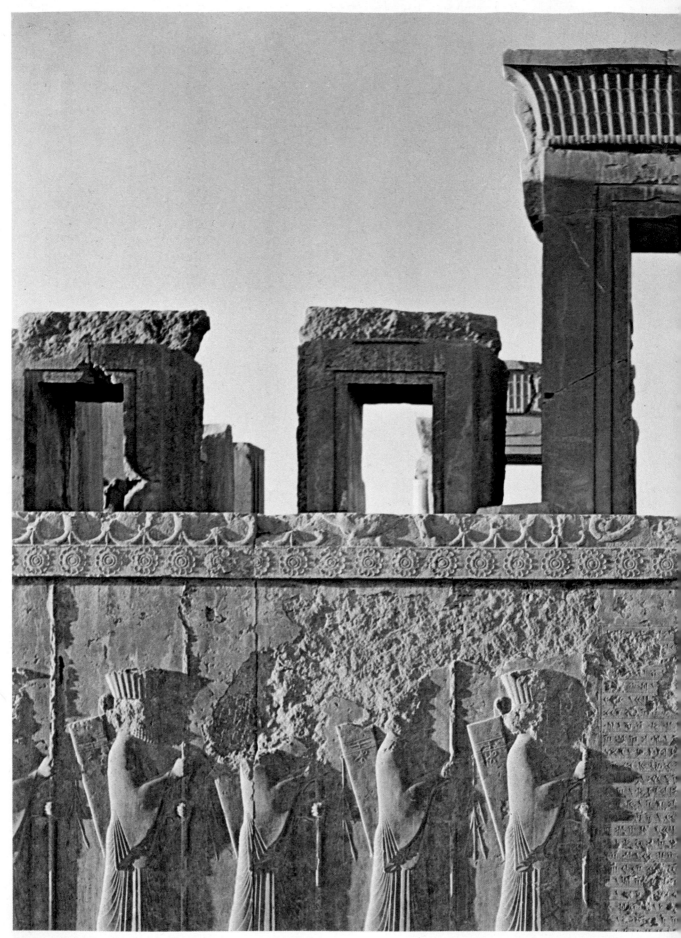

Ruins of the palace of Darius at Persepolis

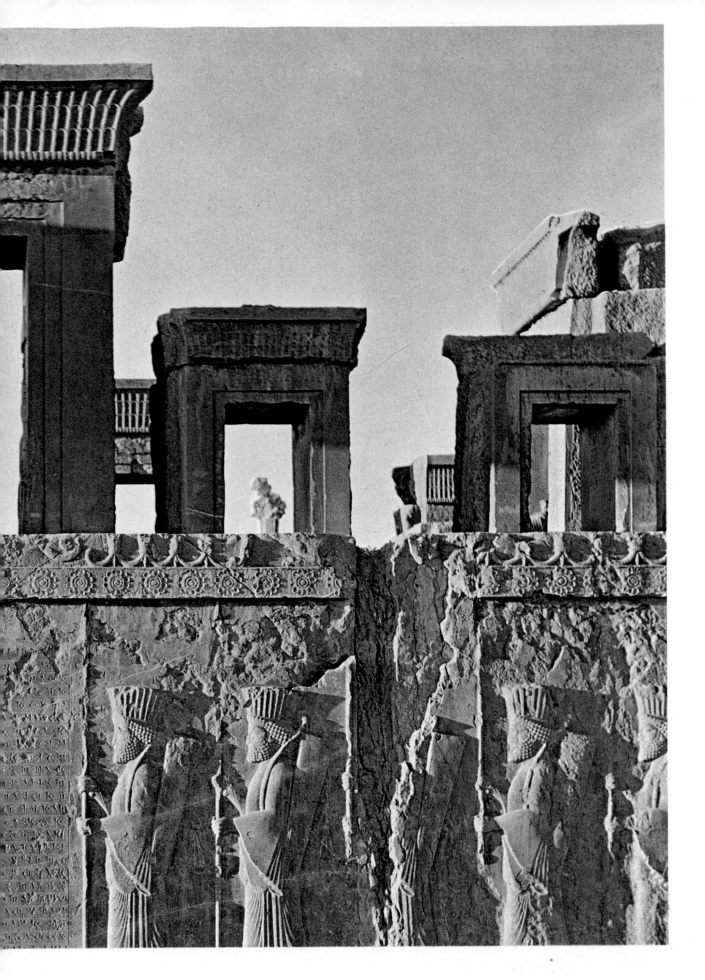

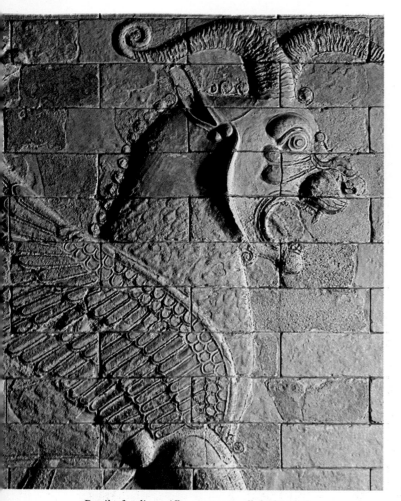

Detail of a lion-griffin on an enamelled-tile relief in the palace of Darius at Susa (Louvre, Paris)

showed a surprising lack of architecture and figurative religious art, and were centred upon the size and splendour of the royal palaces which were built of stone and magnificently decorated. They were set upon artificial terraces and were suitable for use for both civil and religious ceremonies. One of the chief characteristics is the importance given in these palaces to the arcades and to the *apadanas*, the great throne room which was roofed and pillared.

The Achaemenids showed great wisdom in not destroying the artistic manifestations of the individual civilisations of their vast empire. Persian art therefore became a melting-pot into which flowed various, often diverse streams, and which enhanced its splendour. In addition to columns and palmiform decorations which immediately call to mind the art of Egypt, we find extremely tall slender columns with capitals of squatting bulls of great sculptural power. These are a recapitulation of Assyrian art, as are the winged, human-headed bulls to be found guarding the palaces.

Also inspired by Assyrian art are the bas-reliefs carved in stone or in relief in bricks. These celebrate the king's majesty, even if here military expeditions do not take precedence over the receiving of homage from subjects and tribute from all parts of the empire. What is new is the more stylised, clear-cut and sculptural rhythm. More than anywhere else, it is on the bases of the terraces that we find the recurrent rhythms of long files of single figures. Finally, the more contemporary Babylonian art inspired the monumental friezes in coloured brick, one of which, from the palace of Darius at Susa, has now been transferred to the Louvre in Paris. These show symbolic animals and elegant heraldic gryphons or ranks of the famous 'immortal' archers of the Imperial Guard. The royal rock tombs are also decorated with famous bas-reliefs across the colonnaded quadrangle.

A more distinctive and original contribution to art was made through Persian goldwork, which was of the highest standard. It sprang, perhaps, from the old tradition of lively animal art which had inspired the people of Luristan in the western part of the Iranian plateau. The Persian craftsmen in gold and bronze have left a rich heritage of incomparable skill and refinement. Here the imprint of realism and the stylistic symbolism in both cast and chased work, as well as the plastic sense and tasteful colouring, are combined with rare breadth in works of exceptional beauty.

As we know, the Persian Empire sought to continue its expansion beyond the seas in a

civilisation. These matured quickly, however, with the founding of the Achaemenid dynasty in the 6th century B.C., and especially under the guidance of the greatest of their sovereigns and leaders, Cyrus. It was an authoritarian, military state, founded on the absolute power of the king but also on a wide-ranging delegation of administrative authority to a restricted circle of qualified bureaucrats established in the provinces as satraps. This new political structure was, from the outset, as stable as it was articulate. In two centuries of dynamic expansion it established the vast empire of East Asia, reaching from the Iranian plateau to include the whole of Mesopotamia, from the banks of the Indus to the shores of the Mediterranean, until it gravitated towards the borders of Egypt.

It was with this empire that the fame of Cyrus, Darius and Xerxes was linked. Its heart was in the Elam region, to the east of the Tigris and of Mesopotamia. Here the various Persian kings founded their splendid royal cities of Pasargadae, Persepolis and Susa. These cities

direct confrontation with the West. This led to the invasion of Greece by Darius and, later, by his son, Xerxes. But, after initial success, this great exploit met its defeat at sea at Salamis (480 B.C.) and on land at Plataea (479 B.C.). In an historic encounter the West was saved and the Oriental world of the Persians was counterbalanced by the development of the values of classicism. It was left to Alexander the Great, a century and a half later, to wreak the vengeance of the West in overthrowing the Persian Empire, which by this time was threatened from within by the satraps, and stretched as far as fabled India. Finally Mesopotamian art came to an end,

infiltrated by Western art – first Hellenic, then Roman.

This survey of events in the Near East would not be complete without reference to two other civilisations – the Hittite and the Phoenician – which, although of fairly limited importance, played a significant part in the development of the West and whose discovery and interpretation are of recent date.

The Hittites

Before 2000 B.C., the Hittites had settled in the central part of Anatolia, to the north. This was

One of the two human-headed bulls guarding the east doorway of the triple gatehouse of Xerxes at Persepolis

Archer of the royal guard, relief in glazed brick from the palace of Susa (Louvre, Paris)

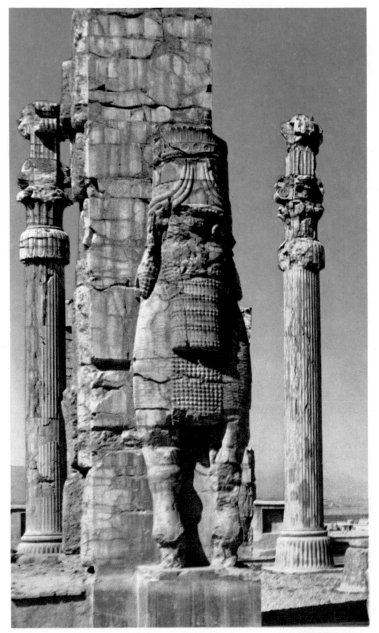

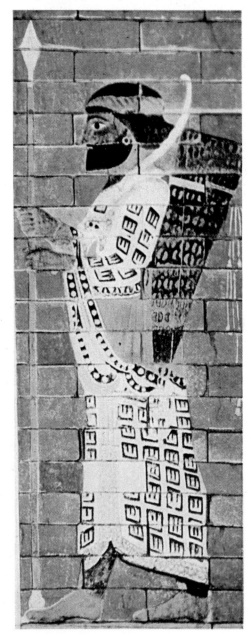

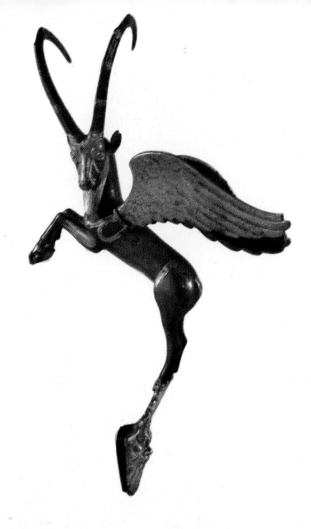

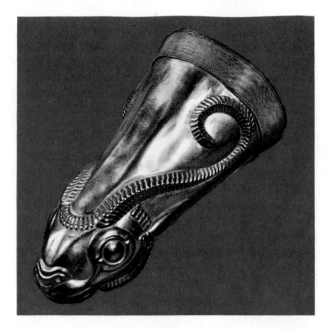

Achaemenid Persian rhyton (drinking vessel) in gold with head of gazelle, from Persepolis (Louvre, Paris)

Left: *Achaemenid Persian vase handle in the form of a winged goat (Louvre, Paris)*

Mesopotamian cylinder seal impressions (Louvre, Paris)

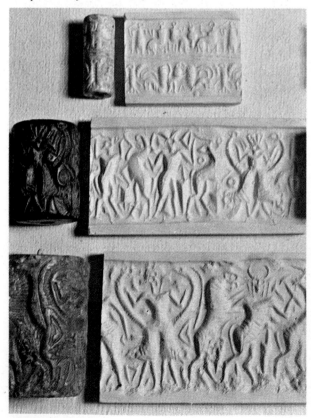

an Indo-European and Asian race which had probably come from beyond the Caucasus. The Hittites rapidly developed a mature civilisation and used a form of written language in cuneiform script. Between 1800 and 1300 B.C., the Hittite Empire, with its capital at Hattusa (present-day Bogazköy), expanded over the whole Anatolian region, finally absorbing Syria, until it fell later before the onslaughts of the so-called 'people from the sea'. Ancient Hattusa and other Hittite settlements reveal some fine architecture in stone, including strong walls with gateways, vast royal palaces with wooden columns, temples and shrines, Already there are signs of the demands of technical skill and of town planning. The contribution to sculpture is conspicuous in the rock bas-reliefs of Iasili-Kaya, in the decoration of gates and walls, in the ornamented stele with rare free-standing statues or with some bronze animal art. The narrative content is more fluid and pleasing than in Mesopotamian art, often showing serene domestic scenes with children. Its ceramic works and gem-engravings are also noteworthy. This empire was later succeeded by the Neo-Hittite era (1200–700 B.C.), founded on a federation of small unstable

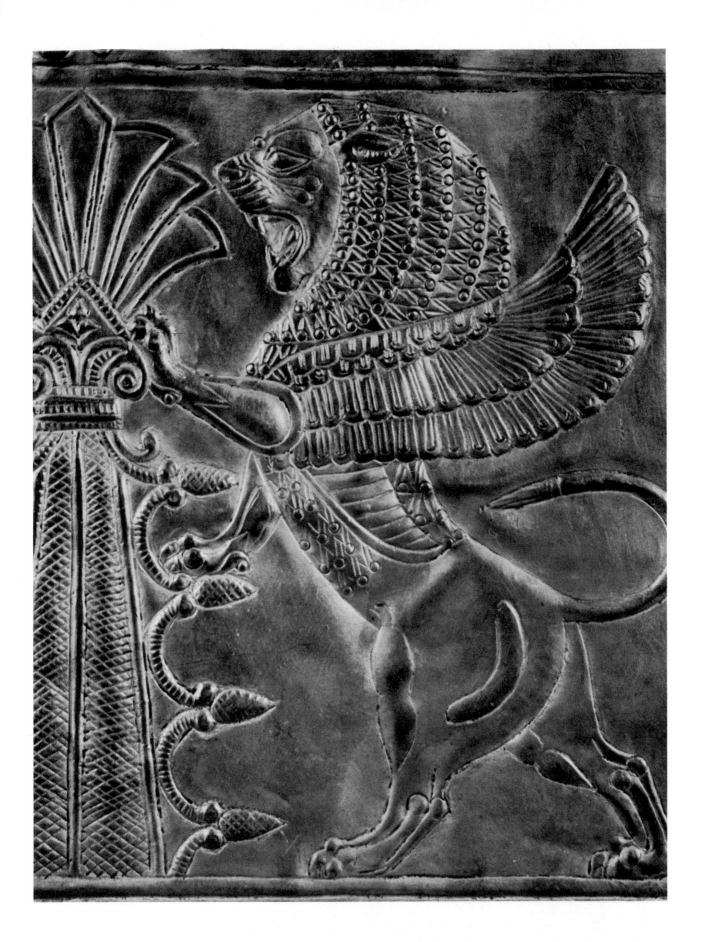

Cast-gold relief from Ziwiye, 7th century B.C. (Private Collection)

kingdoms and finally absorbed by the Assyrians. Its artistic tradition continued, however, and became more sophisticated. The acropolis of Sendjirli, in the southern part of the area, is a great architectural complex, while the decorative arts and sculpture were perfected and became more articulate. Outside the field of art, the Hittites made a conspicuous contribution to metallurgy, which brought about the early diffusion of bronze, gold and iron, in which they were intensely active.

The Phoenicians

On the eastern coast of the Mediterranean, on the other hand, the Phoenician civilisation emerged and extended in quite a wide arc between 2750 and 550 B.C. It was a region which was undergoing a period of transition and interpenetration of diverse ethnic and artistic influences. The Phoenicians seized the opportunity early on of becoming predominantly a nation of navigators and merchants and were

Triple-spouted Hittite vessel (Louvre, Paris)

Opposite page, above: Procession, Hittite relief from the shrine at Iasili-Kaya

Opposite page, below: Detail of the Lion Gate at Boghaz Köy

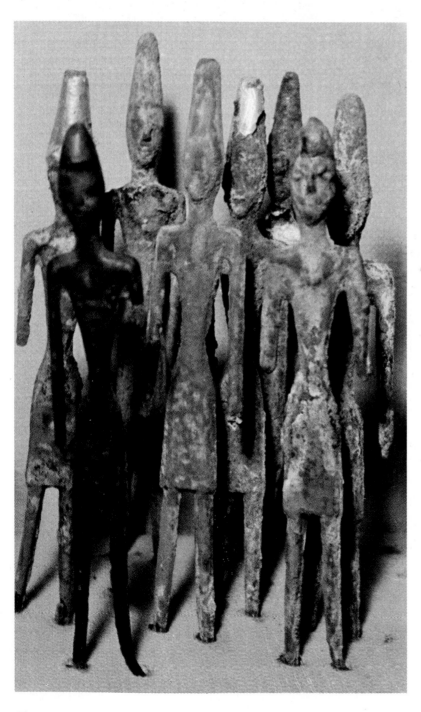

Phoenician votive statuettes from Byblos

doubtless assisted in this by their flexible alphabet. At an even earlier time, Ugarit (the modern Ras Shamra) was, with its origins as a port, the centre of a lively civilisation which flourished from about the 15th to the 14th centuries B.C. and to which its stele and sculptures bear witness. Although Phoenician art has its own stylistic characteristics, its importance lies in the way it assimilated the civilisations which were drawn towards it, from that of Egypt to those of Mesopotamia and the Hittites, and in its function as a highway for the spread of Phoenician products by sea. In this respect, Phoenicia's ivories are of great importance, as are her sacred or votive statuettes in bronze, which greatly encouraged the spread of the Bronze Age over the Mediterranean. Also outstanding is Phoenician goldwork, particularly the funerary masks cast in gold subsequently found at Mycenae. It was this function of dissemination that made Phoenician art so profoundly different from the enclosed and inward-looking art of Palestine.

In an arid and difficult land, the agricultural and pastoral regime of Canaan flourished to some extent between 2000 and 1500 B.C., giving rise to the Biblical stories of the patriarchs. It gave way in about 1250 B.C. in the face of invasion by the Philistines, who came from the sea to the west coast, and by the poor, nomadic Hebrews, who came from the East. According to the Bible, Abraham was commanded by God to leave his native Ur, in Mesopotamia. When he reached the land of Canaan, God appeared to him and announced 'Unto thy seed will I give this land'. When it had subdued and assimilated the Canaanites, the newly created kingdom of Israel, under the leadership of David, defeated the Philistines and reached the height of its power under Solomon. It was in this way, sometimes through catastrophic historical events, that the Hebrew civilisation came to maturity, but its tribal structure prevented true political unity.

The strictly monotheistic religion, with its Biblical 'covenant', mediated and guaranteed by Moses, strengthened the bond between God and His 'chosen people' and set them apart from the surrounding civilisations. However, by the prohibition implicit in the second commandment, it also precluded, or nearly so, the development of any figurative art. It is no paradox, therefore, that the spiritual vigour of this civilisation was allied to a paucity of art. It is not by chance that the typical religious symbol, represented by the Ark of the Covenant, was long kept within a portable tent, and that the most significant remains of this civilisation are the ruins of Jericho and the foundations of the temple of Solomon at Jerusalem.

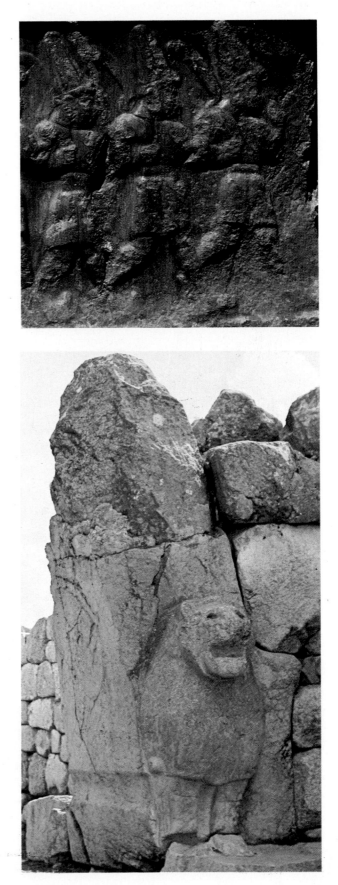

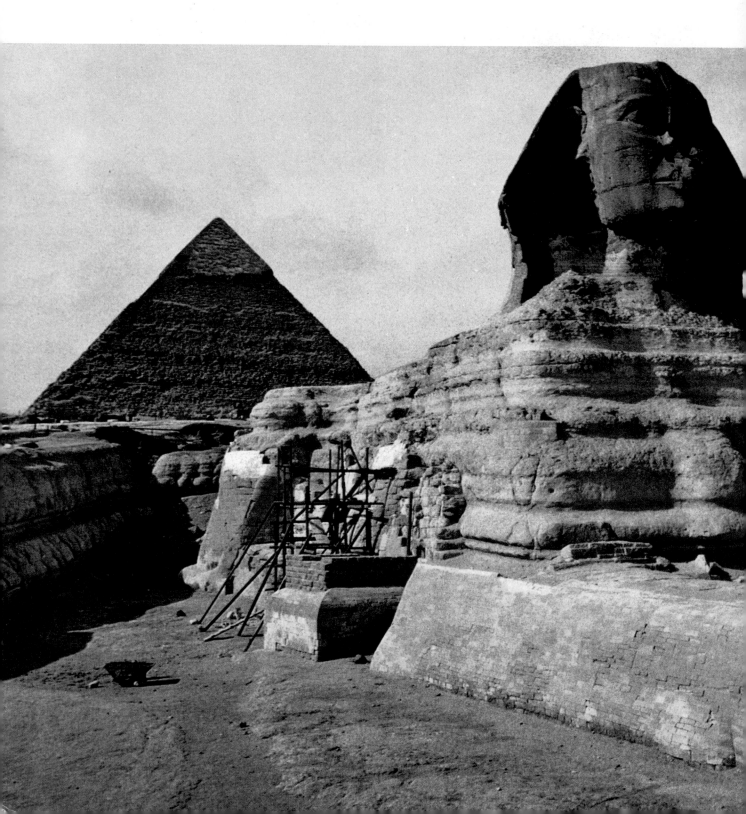

The first inhabitants of the Nile valley

In about 3000 B.C. the vast region of the Nile valley and delta stood on the threshold of that period of its recorded history which was to span, in a parabolic curve, the following three millennia. Behind the Egyptian people, however, stood a long period of civilisation, still little known, which already bore the characteristics fundamental to the life of Egypt: to the systematic organisation of community life and of human labour designed to develop to a very high degree the techniques of water control and land irrigation. From the artistic point of view this civilisation was already expressing itself in a language marked by the distinctive order which was later to be the dominant characteristic of Egyptian art. Its hieroglyphic script, the regular network of canals and the ordered life necessary to maintain them found a natural parallel in the graphic expression of the people and in the orientation of their ideas. The few prehistoric remains which exist along the

Sphinx and pyramids of Chephren (left) and Cheops (right). Giza, 27th century B.C.

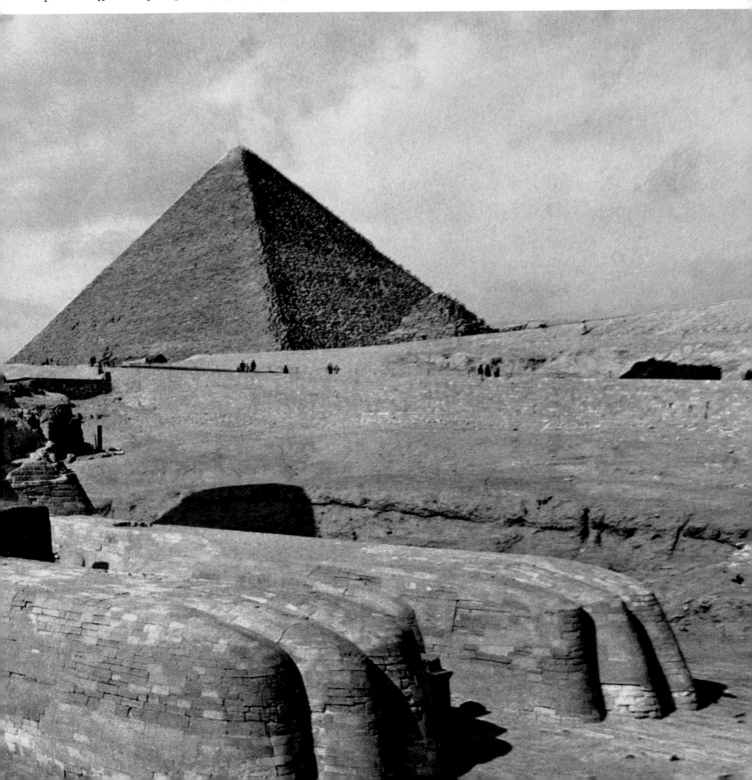

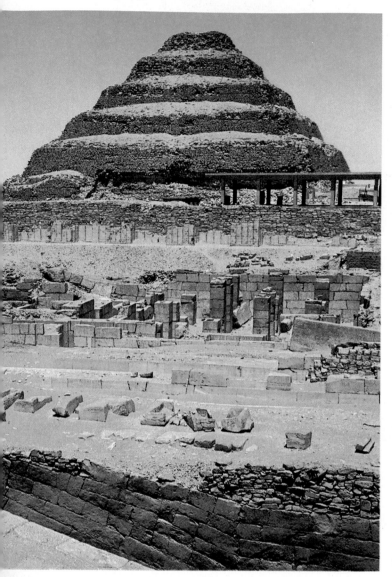

Pyramid of Zoser at Sakkara, 27th century B.C.; in the foreground, remains of the mortuary temple of King Unas, Vth Dynasty

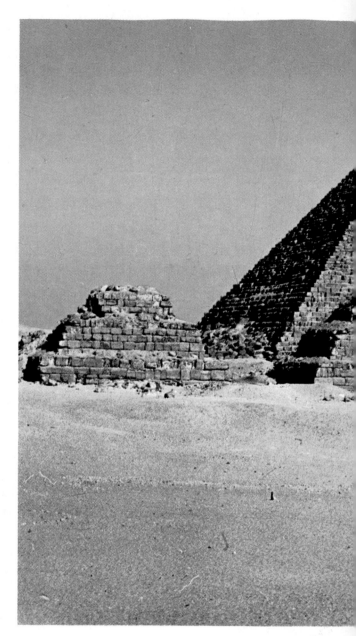

Pyramid complex at Giza (Cheops, Chefren and Mycerinus), 27th–26th centuries B.C.

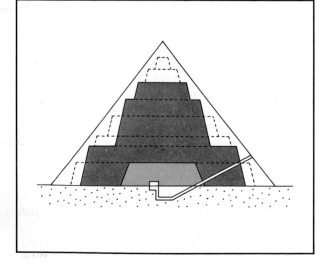

Cross-section showing the development of the northern (unfinished) pyramid of Snefru at Dahshur, IVth Dynasty

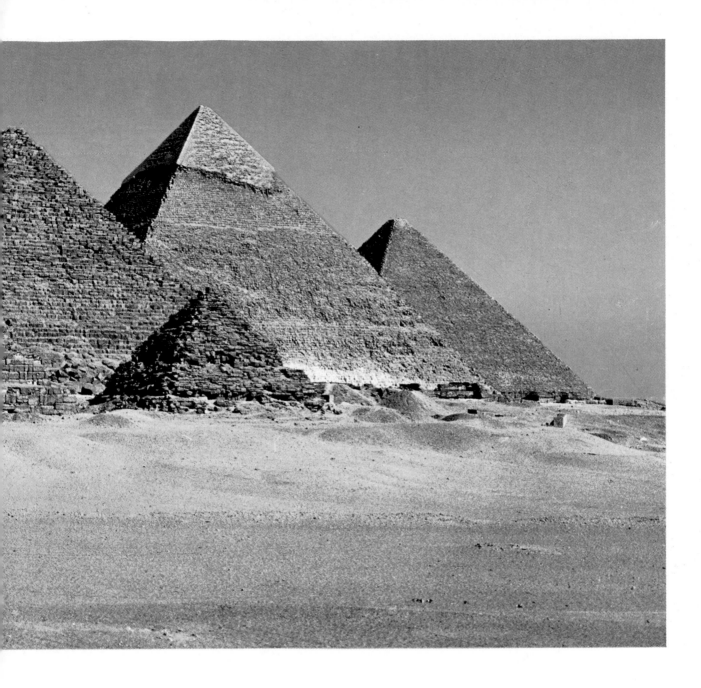

valley of the Nile are chiefly at el Amra and el Badari, while those in the delta are near to el Omari and el Ma-adi. A group of rock engravings of elephants and giraffes, similar to those of Fezzan, has been discovered in the southern part of the Upper Nile valley. These have been ascribed to the pastoral rather than to the hunting period. A certain number of dark red vessels have been found in el Amra and there are others, this time with red figures, attributed to the Naqada culture of 3000 B.C. A few fragments of painted linen, intended as bandages for mummies and showing hunting and dancing scenes, have been found in a tomb at el Ghebelen. Finally, a large number of pieces of ivory have been recovered which show human and animal figures and which were used to decorate tablets, handles or stele (standing stone monuments).

Egyptian civilisation developed more clearly in the Thinite period (2850–2650 B.C.: Ist and IInd dynasties) when it changed from a patriarchal society to a bureaucratic state. The great contribution of Egyptian civilisation to the West lies in the durability of this state system, which was able to organise its affairs on a large scale, guarantee the reliable maintenance of the canals and dams, recruit the necessary labour and make money and materials available. It was because of the specific tasks imposed by a land where riches were not produced spontaneously, but only from the systematic utilisation of the Nile waters, that Egyptian civilisation, from earliest times, needed

to create, and continually perfect, a comprehensive and efficient bureaucratic apparatus. By this means it could always exercise or ensure, by one means or another, strict control over the life of the society, the work of its people and the country's economic resources. Out of these circumstances, too, arose the need to establish the concept of the king-Pharaoh as a god, elevated above the people, wielding unlimited power and, most important of all, having complete possession of the land. Already in this distant time the Pharaohs found themselves engaged, on the one hand, in warding off neighbouring tribes who aspired to settle in the fertile Nile valley and, on the other, in developing commercial intercourse. Especially important was the import of timber vital for the construction of the royal tombs being erected at Abydos and Memphis. These were architectural structures intended for the sepulchre of the Pharaoh and for Pharaoh worship, which was entrusted to a powerful priestly caste and supported by offerings and state funds.

Structurally, the funerary monuments of the Ist Dynasty consisted of brick-walled sepulchre chambers lined with wood and supporting a covering of beams upon which a tumulus (artificial mound of earth) was raised. This form reflected funerary customs of both Upper and Lower Egypt in an attempt to reinforce the unifying authority of the Pharaoh. The form of the contemporary tombs of Memphis, in process of construction at this time, recalled that of the royal palaces. The sculpture of the time was reserved for the decoration of the stele placed on the eastern side of the tumulus, where the offerings were made during the worship of the king. Because of this effigies became obligatory, and even in distant times they were made with the face in profile and the body facing the front. The most significant kind of sculpture of the Thinite period, however, is found in the free-standing, life-size statues in wood or stone which, in terms of strict proportion and fixed gestures, were to become the pattern for centuries. The necropolises of Abydos and Memphis contained, among other things, jewels, wooden and ivory

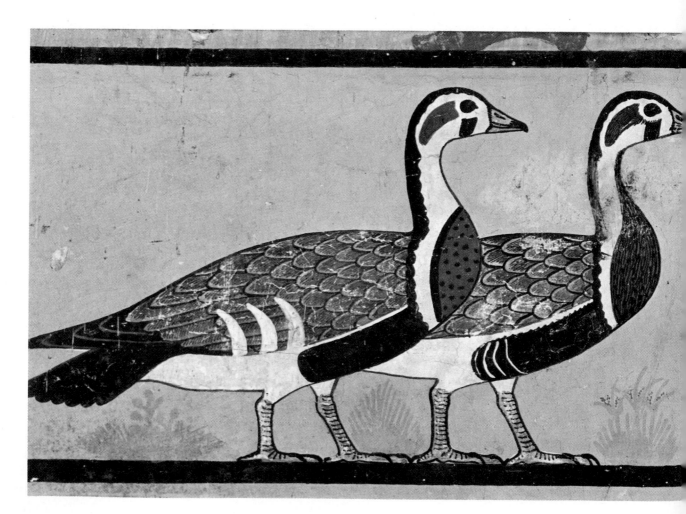

furniture and stone jars for storing ointments. All this is evidence of notable skill in the use of fine, valuable materials in a sophisticated society.

First-hand evidence of Thinite architecture is sparse and study of it limited to reproductions. Relatively well preserved, however, are the groups of funerary structures of the IIIrd Dynasty, begun under King Zoser in 2650 B.C. at the opening of the eventful historical period known as the Old Kingdom. They are found in the area which included Abu Roash, Giza Sakkara and Meidum.

Paintings from the rock tomb of Sebekhotep at Aswan

Frieze of geese from the mastaba of Ita at Meidum, 2700 B.C. (Egyptian Museum, Cairo)

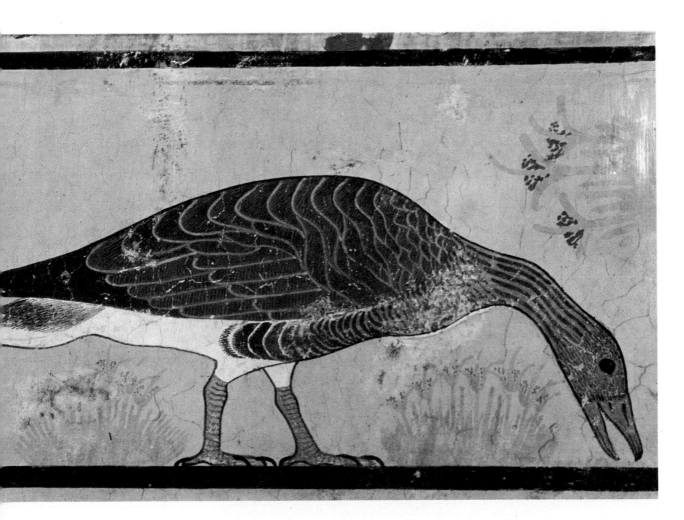

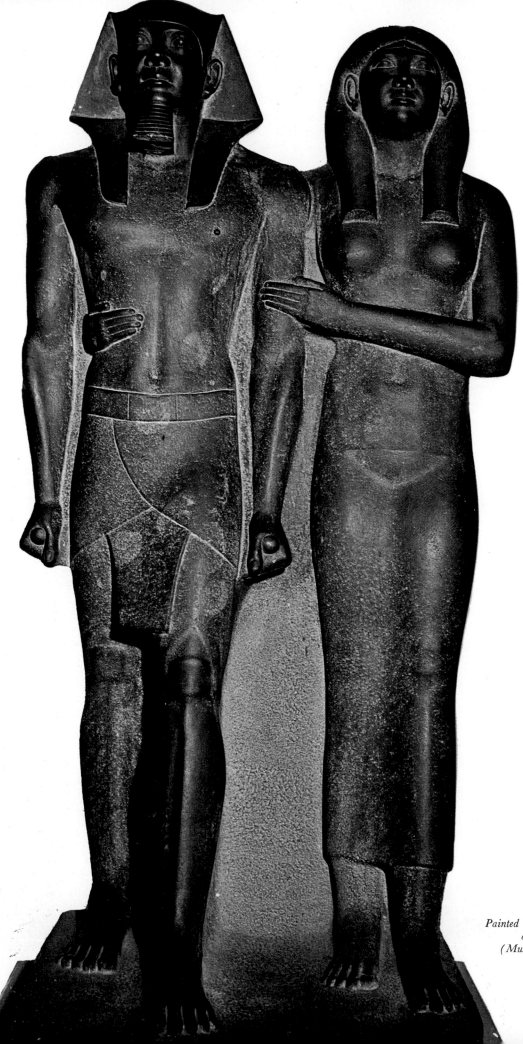

*Painted schist statue of Mycerinus
and his wife, IVth Dynasty
(Museum of Fine Arts, Boston)*

Memphis, the capital, was already a splendid city. It stood on the site of the ancient temple of Ptah, the inventor, according to local tradition, of the building technique held in such high regard in the IIIrd, IVth, Vth and VIth dynasties. Its layout was not unlike that of many lesser Egyptian towns, i.e. in chess-board pattern. The town was built upon the ruins of previous buildings, for in the past centuries all town buildings, both private and public, had been constructed of perishable crude brick. This led to their total destruction either in war or as a result of the flooding of the Nile, so that the fabric of each new settlement was placed on top of the old. Memphis was in an excellent commercial position. A centre of river traffic and of the production of ships designed for many and varied uses, it was protected by military defences. But it was also noted for the legendary life of its royal palaces and for its Serapeum, built, like the tombs, in granite and intended to receive in specially prepared sarcophagi the sacred bulls called Apis.

At this time, too, at Sakkara, near Memphis, there arose an enormous, solemn stone structure with a definite functional purpose. This was a complex of buildings surrounded by a white limestone wall, rectangular in shape, some thirty-

Statue of a scribe from Sakkara, end of IVth Dynasty (Louvre, Paris)

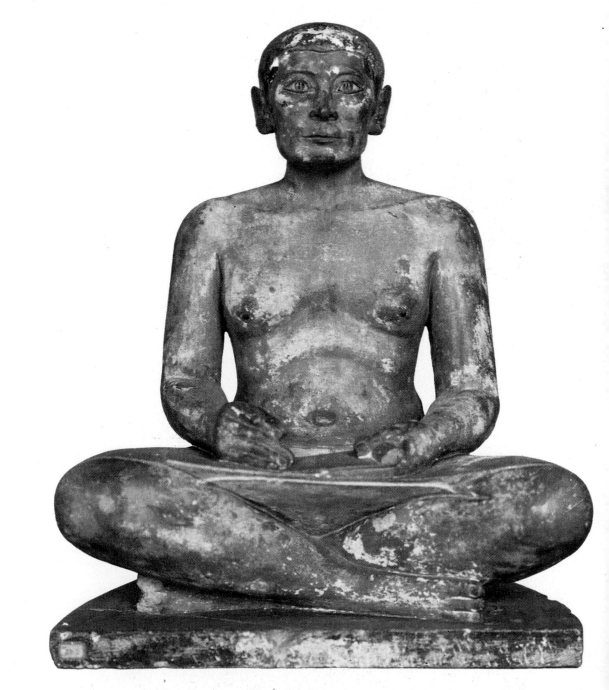

two feet high and about a mile in perimeter.
Within the wall stood a 195-foot pyramid of the
older Egyptian kind, a step pyramid, which
covered an even older tumulus of the South
Egyptian type. The entrance portico, chapels,
administrative rooms and courtyards are inte-
grated with the pyramid into one vast monument.
The form of this pyramid is essentially compact,
with the stones strictly disposed in horizontal
courses. It is completely lacking in ornamentation,
and symbolises, in the relationship between its
ascending rhythms and its broad base, the
absolute authority of the Pharaoh – cut off from
the world, with his face towards heaven but with
his feet securely on the ground. The chancellor-
architect, Imhotep, who conceived this integrated
monument, initiated a form combining a strict
geometric sense with superbly audacious planning
which was to be the model for the whole of
Egyptian architecture. The other buildings within
the retaining wall were in stone or brick, and
reflected older forms in wood in the styles of both
Upper and Lower Egypt. There were columns of
squared rocks like tree trunks, columns encased

Falcon hieroglyph and detail of the limestone stele of Nefertiabet at Giza, IVth Dynasty (Louvre, Paris)

in the walls with the shape of papyrus stalks and flat ceilings whose curved sections recalled the shape of logs of wood.

From every point of view this ancient Egyptian architecture was already so permeated by those values of heavy and compact monumentality, of inter-relationship of parts, of synthesis of elements and of functional style as to justify the impression that Egyptian architecture was by then completely formed. In the parts of the structure above ground statues were to be found everywhere. In one passage a superb limestone statue (now in Cairo Museum) of King Zoser was discovered,

still with some ancient characteristics, but noble and expressive. In the subterranean parts, however, decorations in relief are most prevalent, particularly in the recessed doorways.

If the pyramid of Sakkara extols the authority of the Pharaoh, it is another contemporary authority – that of the court dignitaries – that is in evidence in the mastaba or 'table' (a primitive, flat-roofed tomb with a mummy chamber) at Hesire. The massive brickwork of this tomb, though much altered, can still be seen. On the eastern, recessed, side it is painted with abstract motifs, and in ten of the recesses there were

Temple of Queen Hatshepsut, XVIIIth Dynasty at Deir el Bahri (near Thebes)

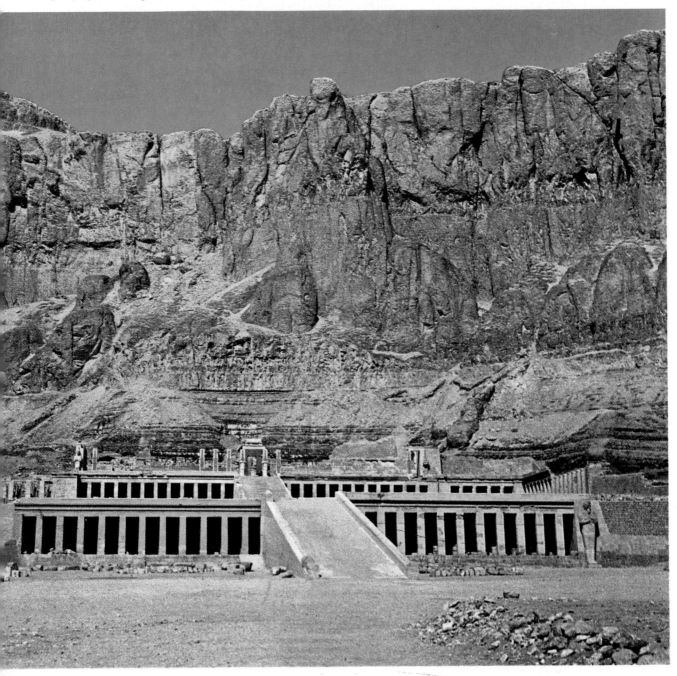

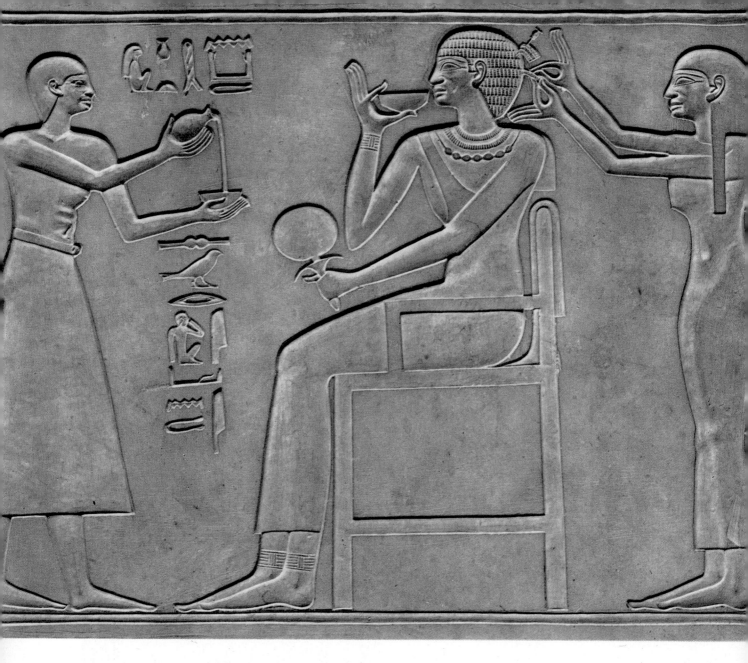

Detail from the sarcophagus of Queen Kawyt at Deir el Bahri, XIth Dynasty (Egyptian Museum, Cairo)

tablets of wood (now in Cairo Museum) carved in bas-relief with linear representations of the dignitary springing from them. The figure is sensitively modelled, though still with the alternating frontal and profile positions. The pictorial reliefs tell of the elaborate ceremonies of the cult of the dead and of life after death. The colours are of mineral origin, red and yellow being reserved, respectively, for the skin of male and female figures, with blue for water and green for plants.

It is from the Sakkara complex that we have the first examples of statues made in accordance with the strict and distinctive rules of static positioning. The man, seated or standing, always has one fist closed, a crown on his head and a ceremonial beard. The woman, richly jewelled, has her legs together and wears her hair puffed out and blocked into two heavy, falling bands. From Sakkara, too, came stocky polychrome female statues vibrant with strength and surrounded with an aura of moral authority.

The builders of the pyramids: the Old Kingdom

The IVth Dynasty (2600–2480 B.C.) saw the highest, and certainly the best known, period of the art of the Old Kingdom. Against the background of this historico-artistic period stand the three pyramids of Cheops, Chefren and Mycerinus and the huge Sphinx. Rising from the plateau of Giza and silhouetted against the luminous intensity of the sky, these pyramids are the essence of Egypt. Now that the outer covering of fine limestone has disappeared their function

54

as monuments is plain to see, and the ornamental structure of the stonework is enhanced.

In relation to the earlier step-pyramids of Sakkara, those at Giza show a fusion of those forms, reduced to the simplest geometry. The interior galleries of the pyramid of Cheops and the pillars and pink granite architraves of the lower temple of Chefren, have a functional structure and purity of form unspoiled by distracting decoration. The dimensions (the pyramid of Cheops is about 476 feet high and that of Chefren a little less) become more a measure of the relationships between the elements than of size, an expression of their function rather than of grandeur. At Giza, the mastabas for the princes and dignitaries are placed to the east and west of the pyramids.

Statues of the Pharaoh, now dispersed to the major museums of Cairo and of the world, were prominent in the royal tombs. They expressed his absolute authority, which was enhanced by the quality of the materials used. The purpose of the Egyptian statue was to represent, but also, in a certain sense, to 'be' the Pharaoh. It is for this reason that it is not uncommon to find realistic statues, which served as portraits, coming close to being idealised statues, serving as a symbol of a 'Pharaonic concept'. Hard stone and limestone, as well as wood, were used to render the immobilised life-force of the subject. The figure of Chefren, seated squarely on his throne, in the diorite statue in Cairo Museum, is a completely integrated work, while the throne is rich in detail. The arms terminate in lion's paws and the back is dominated by the god Horus in his customary representation as a falcon, while the sides are decorated with nymphs and papyrus, symbolising the union of Upper and Lower Egypt. The face of the Pharaoh is striking and immobile under its geometric headdress; one hand is extended, the other clenched to express alternate benevolence and authority. The effect of the statue as a monument is not dissimilar to that of the pyramids themselves. In the twin standing statue of Mycerinus and his wife (Museum of Fine Arts, Boston), on the other hand, the emphasis is on naturalism, a perennial theme in Egyptian sculpture. Here it portrays the vibrant vitality of the king's expression and the placid sensuality of the woman.

The huge Sphinx (190 feet long and 65 feet high), hewn out of the living rock near the temple of Chefren, stands halfway between architecture and sculpture. Majestic, watchful, enigmatic – such is the mythical interpretation of every age

Obelisk of Tuthmosis I at Karnak, XVIIIth Dynasty

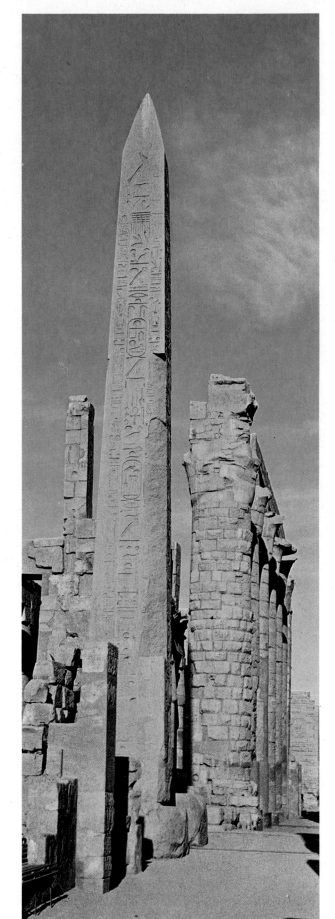

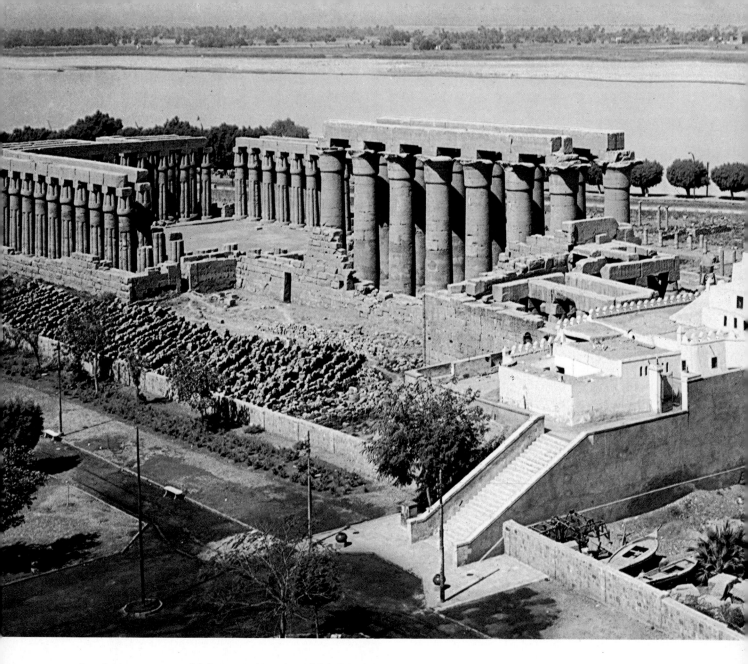

for this creature which crouches, head high, eyes fixed upon the sun, bathed in the light of the desert, its face haloed by the stiff conical hair. It is essentially an architectural form, but at the same time is full of human contact.

The 'lesser arts', too, had developed greatly during the IVth Dynasty. We see evidence of this in the tomb complex of the mother of Cheops. This contained a bed, a litter and caskets in sheet gold decorated with cornelians, turquoises and lapis lazuli, as well as imitation fabric in sheet gold which formed part of a tent. There was also a large quantity of finely glazed faience and fittings in gold-ornamented ivory.

The complex of Giza permits us to reconstruct contemporary Egyptian urban lay-out only in the most indeterminate way – apart, that is, from the temples and tombs of the Pharaohs – for nothing is left of the buildings intended for the peasants, artisans and soldiers, that great anonymous mass which made up the fabric of the great Egyptian cities, usually agricultural settlements with a very low standard of living. The shape of what can be called the 'royal city of Giza' is punctuated by four essential nuclei: the entrance, or temple of the valley; the covered slope which ran from the base up to the desert plateau; the mortuary temple and the pyramid in solitary eminence. Along the principal road lay the grouped mastabas as tombs and dwellings for the dignitaries. These were still simple and austere during the IVth Dynasty but became invested with solemnity and pomp in the Vth and VIth dynasties as the authority of the functionaries grew. These men were related by kinship to the Pharaoh and were interested in the exaltation of authority and divine power so that they, in their turn, could obtain from their sovereign gratitude,

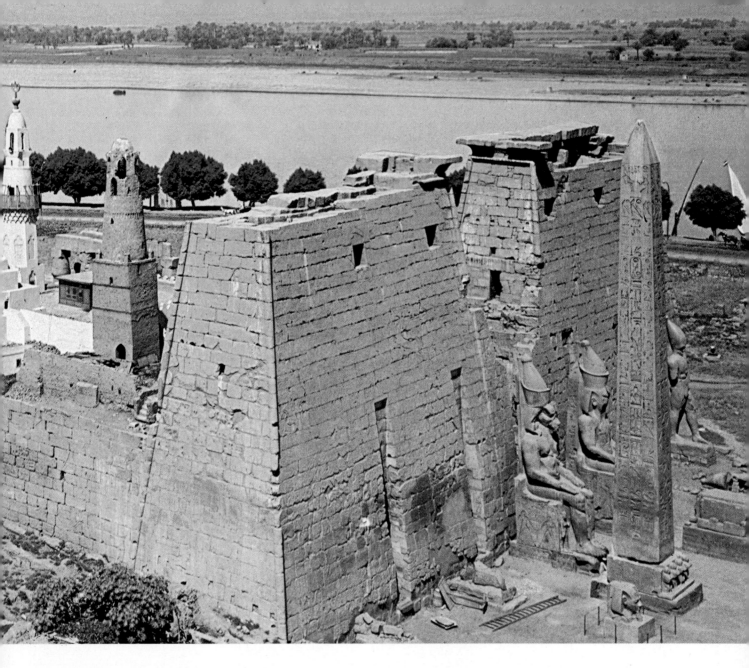

General view of the temple of Amon at Luxor, XVIIIth Dynasty

riches and honours, in a period which saw the political and economic power of the king pass into the hands of privileged noblemen. It was during this time, in fact, that there emerged, through the inheriting of appointments and through privilege, a dominant class chosen by birth and not by merit. This led to a marked decline in quality. As in any analogous historical situation, a vast class of nobles emerged who, realising the deficiency of the central government took delight in undermining its authority.

The art which accompanied the development of the Vth Dynasty (2480–2350 B.C.) reflected the prevailing authority of priests and dignitaries: these, in fact, arrogated to themselves such power that they were the sole electors of the Pharaohs Weserkaf, Sahura and Kakai. The royal tombs no longer symbolise absolute authority and, because they were built with less grandeur and

majesty, fell more rapidly into ruin.

On the other hand, the statuary of this period was of greater interest, for this art form rendered tangible the authority of the nobles who arrogated to themselves the cults and religious practices formerly reserved for the Pharaoh. Alongside the stone statuary there was also a great upsurge of statues in wood. Possibly the finest example of these is the group of a functionary and his wife, in the Louvre, Paris. The realistic spontaneity of this group and the customary stylistic severity in the carving of the wood combine extremely well the essential quality of the medium with liveliness of expression. Equally well known is the wooden statue from Kaaper (also in the Louvre), the so-called 'village headman'; its great realism led

Second coffin of Queen Merit Amon, detail. XVIIIth Dynasty (Egyptian Museum, Cairo)

Priest with God Amon as a ram (Egyptian Museum, Turin)

the workmen who discovered it to identify it with one of their living contemporaries. The figures of clumsy and inarticulate slaves working a millstone are in the same vein of realism. They were placed near the tombs and signified continuity of service to the king. These examples show us another aspect of the way in which reality was rendered, and enable us to grasp the many-sided versatility of Egyptian art, which is wrongly and superficially taken to be monotonous and static over the centuries. Certainly, to our modern eyes, there is richness to be found in the statue of a scribe in coloured limestone (Louvre, Paris), with its attentive air, the severe symmetry of the arm and leg positions and the glittering eyes made of rock-crystal and silver set in copper.

The walls of the mastabas of Ti and Ptahneferer near Sakkara (Vth–VIth dynasties) are covered with limestone plaques, painted originally on successive horizontal courses. These set out to portray in lively fashion scenes of domestic life, of hunting, fishing, of wading in a papyrus marsh. Their great rhythmic effects are combined with realism, and confirm the tendency of Egyptian art towards synthesis.

The decline of the Old Kingdom

However, the political crisis which had been spreading during the VIth Dynasty became so serious, between the VIIth and IXth dynasties, as to bring about a profound transformation of social relationships. The literature of the time makes a notable contribution to our information on the subject. It tells how the authority of the nobles waned and the advance of the poor was obtained by the means typical of a bureaucratic state, with the increased authority of the Pharaoh and the strengthening of the impersonal bureaucratic machine. As a consequence, the spread of the myth of Isis and Osiris brought into the unsettled religious scene of Egypt the concept of divine judgment after death and hence the need for a moral code of responsibility to which everyone, rich or poor, must adhere. Herakliopolis, the capital of the IXth and Xth dynasties, fell in

Women mourners, fresco in the tomb of Rameses at Thebes

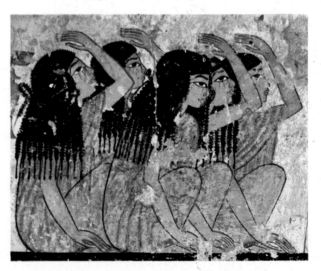

about 2050 B.C. at the hands of Mentuhotep II, who is portrayed in a delightful series of reliefs from Deir el Bahri, near Thebes. Here, scenes of war showing the slim, supple figures of warriors alternate with glimpses of life and customs like those on the sarcophagus which show Queen Kawit drinking, while her hairdresser binds her curling hair.

The period of the Middle Kingdom, which opens with the XIIth Dynasty, was in fact made possible by the work of the XIth Dynasty ruler Mentuhotep. When he had subdued Middle Egypt and expelled the Bedouin he re-established

Unfinished head of Queen Nefertiti from Tel el Amarna (Egyptian Museum, Cairo)

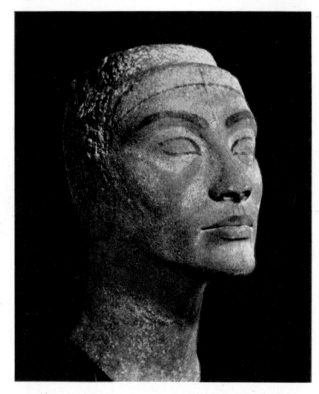

Female acrobat, 12th century B.C. (Egyptian Museum, Turin)

a central administration and put an end to the hereditary tendencies developing in provincial administration. At this time Thebes, the site of the tomb of Osiris, became the capital of the united kingdom.

The XIth Dynasty kings were great builders but little remains of their work since later generations plundered the sites for raw materials. However the bas-reliefs which decorate the few remaining temples show that the Egyptian artists of the period had lost little of their technical fluency and retained their outstanding decorative talents.

The temple erected to the memory of Mentuhotep himself must have been a building of considerable charm, though little remains today save shapeless ruins. The architects utilised the contours of the land to lay out a series of colonnaded terraces above which rose the royal pyramid.

The tombs of the court functionaries of the XIth Dynasty have been destroyed. Statuettes which have been recovered show that the vogue for such figurines continued and during this period they were executed with such skill and excellence that some of these little figurines can be regarded as among the finest examples of Egyptian art.

Little is known of Mentuhotep's successors. Amenemhet the senior minister of the last of the XIth Dynasty rulers usurped the kingdom and, adopting the name of Amenemhet I became the founder of the XIIth Dynasty, one of the most glorious in Egyptian history.

The great conquerors: the XIIth Dynasty

The XIIth and XIIIth dynasties saw the start of the Middle Kingdom proper (1991–1570 B.C.), which was one of the peaks of Egyptian civilisation. Among its Pharaohs Amenemhet I, himself, fortified the eastern delta, Sesostris III conquered Nubia, and Amenemhet III promoted the reclamation of the Fayum. Thebes, which, in the words of Homer, was the fabled city of one hundred gateways, the new capital of Upper Egypt, was the centre of the cult of Amon, even though the god's temples were at Karnak and Luxor. It remained a spiritual centre of great interest and the burial place of the Pharaohs, and, in the way that Rome did later for another era, came to symbolise Egyptian civilisation, even after the destruction it suffered through internal strife and foreign invasion. The ruins of its monuments, although less imposing than those at nearby archaeological sites, and less classic because of Roman influence, assume the quality of a legend and have a particular fascination.

The art of the period was forced to recapitulate the technical and expressive experience of the past for which it betrayed considerable nostalgia, and this period may be regarded as neo-classic. There are, however, very few architectural remains of any kind.

On the other hand, carving flourished in the XIIth Dynasty, with high relief and sunk relief existing side by side. The figures have a moving clarity based on faultless design. The symbols are clear and a pillar in a building of Sesostris I from Karnak shows this most beautifully. The statuary also is dominated by the attention given to the abstract qualities of mass. The best known are placed out of doors and are sculpted in black stone or pink granite. They are very expressive in the contrast between the brilliance of the mass and the intense shadow of the eye-sockets, a fact which is well exemplified in the statue of Sesostris I from Tanis (Cairo Museum), which sharply contrasts the dark skin with a white robe and a red crown.

Sculpture spoke with a new voice at the time of Sesostris III. The portrait statues of the king show a lively and dramatic thoughtfulness, a sense of heroism and humanity. The portrait statues of Amenemhet III, especially the one from Hawara nel Fayum (Cairo Museum), also indicate a sense of human responsibility. Among the various

Fresco from the tomb of the sculptors Nebamum and Ipuki at Deir el Medina, Thebes

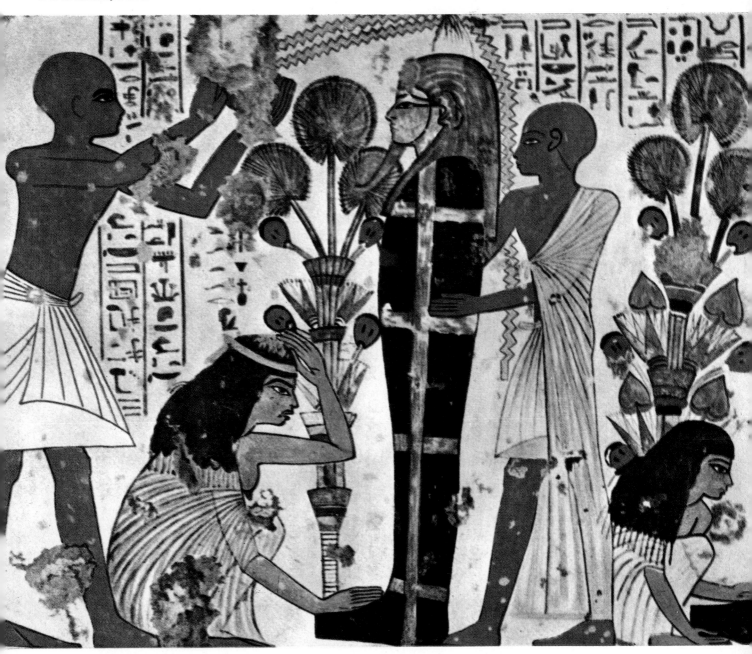

61

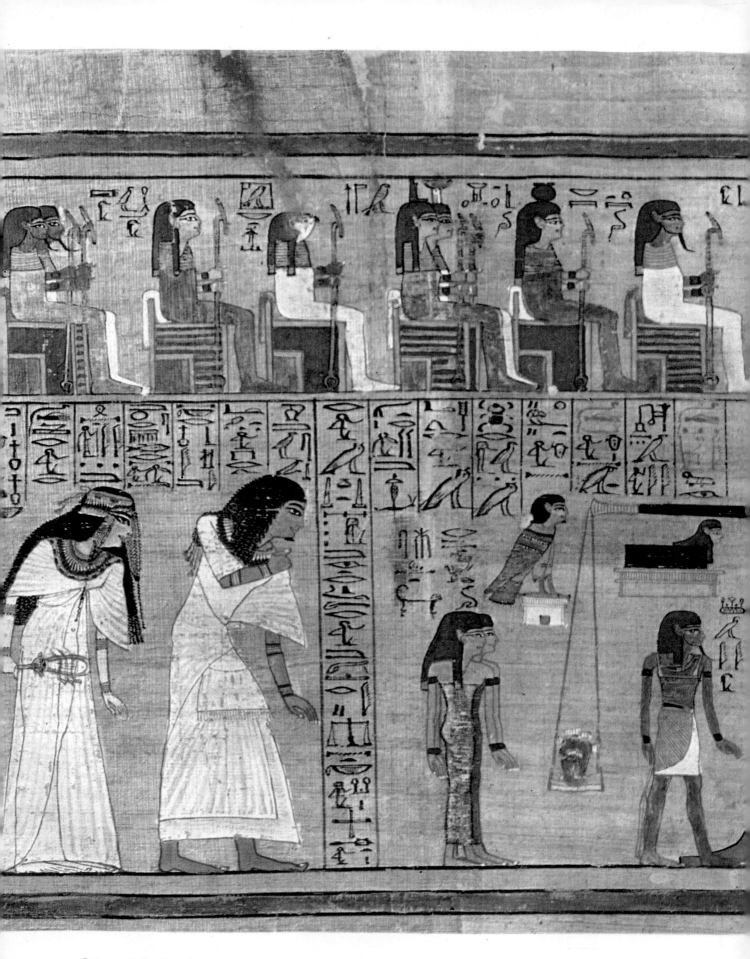

Papyrus painting from the 'Book of the Dead' by the scribe Anis, XIXth Dynasty (British Museum, London)

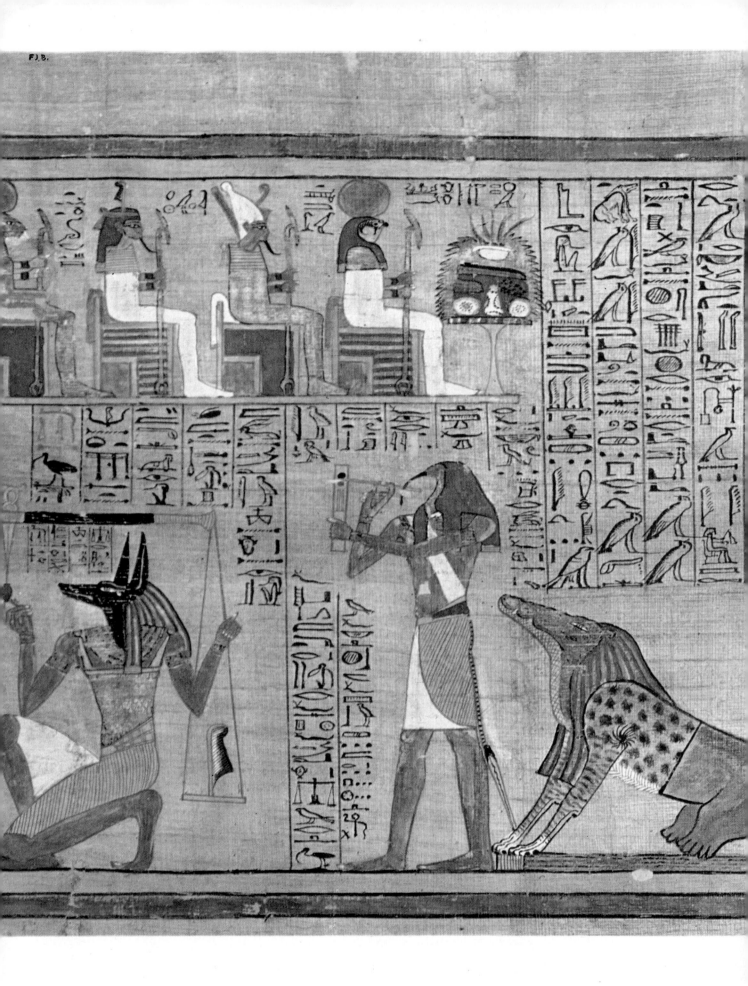

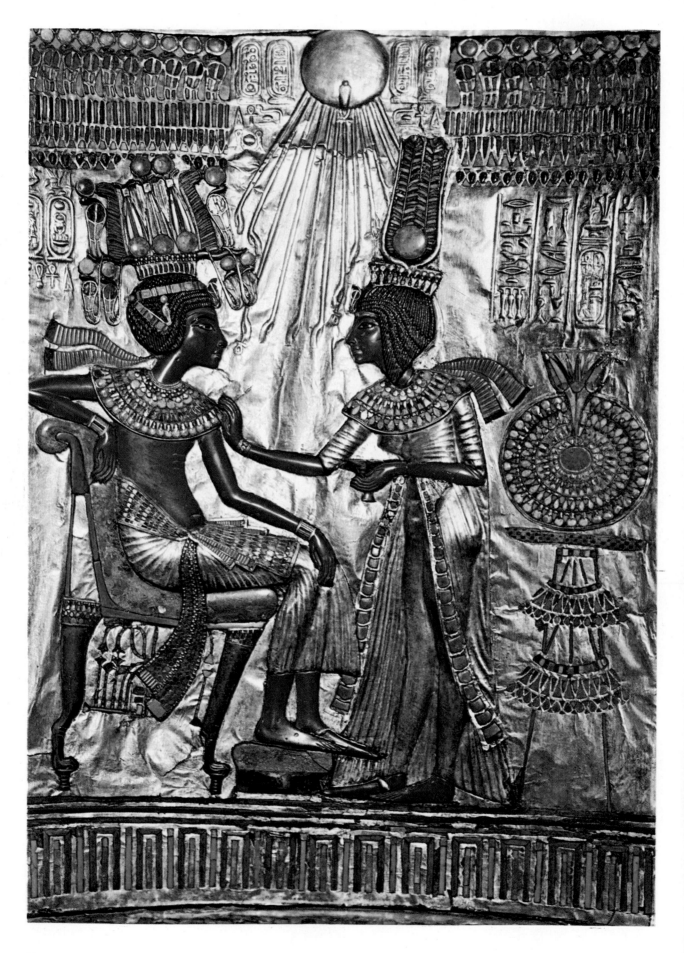

64

types of statue at this period we find examples of cube-like statues where the person is set into the block and has his arms crossed. There was also at this time an increase in the range of small statues in faience and copper of both male and female, as well as of hippopotami in faience and of water plants and monkeys. The most common goldwork from the tombs of the XIIth and XIIIth dynasties consists of pectorals, medallions and jewellery with thread-like gold filigree.

However fresh historical events were about to overtake Egypt. The legitimate aspirations of the individual had been stifled, the priests and officials had succeeded in staving off the seizure of power by a leaderless populace and internal strife had been subdued by calls to faith – when upon Egypt there fell the invasion of the Hyksos, the 'shepherd kings'. These, like all nomads, brought ruin upon the advanced Egyptian agriculture and established a multitude of overlords in the once-unified Nile valley in place of the balanced Egyptian state machine. It was a hard blow for Egypt, but once again the demands of agriculture rallied the peasants around the leading bureaucratic class and around the monarch, and their triumph over the invaders opened the door to a splendid era for Egypt.

The New Kingdom

This was now the New Kingdom which, during three dynasties, the XVIIIth, XIXth and XXth, saw Thebes blossom into splendour as the spiritual centre of the whole of Egypt. The artistic growth during these centuries reflects the magnificent character of the period. From the empire of the XVIIIth Dynasty to the end of the reign of Amenhotep we see a return to classicism, with emphasis on intellectualism and sophistication. In the second period, during the reigns of Amenhotep III and Amenhotep IV (Ikhnaton), which coincided with a great religious crisis, Egyptian civilisation was shaken, and its art showed extremes both in form and content, as well as in the expression of psychological factors and in romantic emphasis. In the third period, the Rameses era – which was a period of war to defend the fatherland – art was chiefly concerned with huge works whose style was academic and often employed earlier material.

Thebes, el Amarna and Tanis, on the delta, each in turn became centres for the creation of the great artistic works of the period. The prime centre of architectural interest is Thebes, but

Back of throne of Tutenkhamen (Egyptian Museum, Cairo)

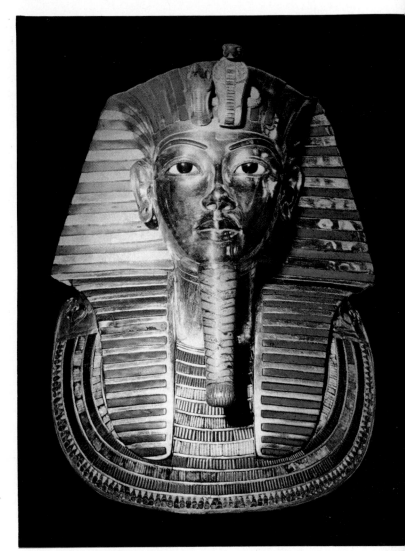

Gold mask of Tutenkhamen, XVIIIth Dynasty (Egyptian Museum, Cairo)

great works went up at Luxor, Karnak, Assuan and beyond, ending in the Upper Nile valley at Abu Simbel. The first of these, chronologically, (1500 B.C.) was the *aedicula* of Amenhotep I at Karnak. This was built in blocks of alabaster. It was relatively small because it was enclosed in a room of a larger building and was intended for the preservation of the 'divine barque' upon which the effigy of the god-Pharaoh could be placed so that it could be moved within the temple or carried in procession outside. The *aedicula* is in the form of a prism enclosed by an area of slats with cornices, and with a flat roof and no ornamental frieze. It has no naturalistic elements and left free range to the extended incisions which follow one another like the pages of a book.

The Temple of Amon, which is of the same period, is severe and imposing and, with the tomb of Queen Hatshepsut, forms the complex of

monuments at Deir el Bahri (early 15th century B.C.) which typifies the Egypt of the XVIIIth Dynasty. It is carved from the rock itself and rises in terraces, linking the life of Thebes with the thoughts of death engendered by the Valley of the Kings. By its very nature the funerary temple reflects the construction of the ancient empire, without copying its language or spirit, in that it seeks to create impressive effects in the juxta-position of architecture and natural surroundings. The interior is especially noted for the right-hand atrium where superb reliefs and paintings recount incidents in the life of the queen – her conception through the god Amon with the aid of Toth, the god of wisdom, her birth and her dedication to Amon. The entire complex is scenically specta-cular, being laid out with the central shrine as its focal point to which it leads without distractions of any kind. When the temple was roofed the light struck through ingeniously arranged slits in the walls so as to illuminate the statues and the sacred recesses with great effect. The contrast of light and shade must have induced a sense of great mystery.

The great obelisks at Karnak also belong to the beginning of the XVIIIth Dynasty and to the same Queen Hatshepsut and Prince Tuthmoses. The first of these is nearly 100 feet high, with a vertical and horizontal inscription glorifying the queen, and gold plating on the summit. The second, over 70 feet high and with additions made by Rameses IV, is imposing and well preserved.

A spectacularly imposing and highly coherent work is that of the Temple of Amon, Mut and Horus at Luxor, built by the Pharaoh Amenhotep III. There is a severe unity about this complex, which starts with a solemn court possessing a double line of columns and unfolds across wide corridors, chambers and chapels towards the furthest shrine. Its appearance is essentially that of a monument, but there are certain naturalistic details. Lotus bud columns seem to swell under the pressure of the cubic capitals, while the statues of the Pharaohs look out from between the columns with vivid, lifelike expressions.

In the third phase of the XVIIIth Dynasty, Amenhotep IV, who later assumed the name Ikhnaton, attempted to introduce a new con-ception of a monotheistic faith. In contrast to the forms of the Theban cult of Amon, this faith was concentrated on Aten, the Sun God, repre-sented as a disc. At Karnak, but not in the part which was sacred to Amon, he erected a court containing huge royal statues. In the sixth year

Colossi at the Temple of Rameses II, XIXth Dynasty, at Abu Simbel

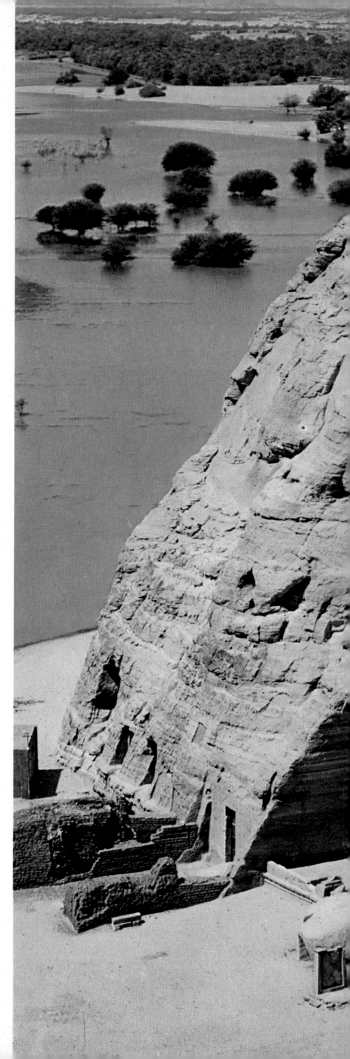

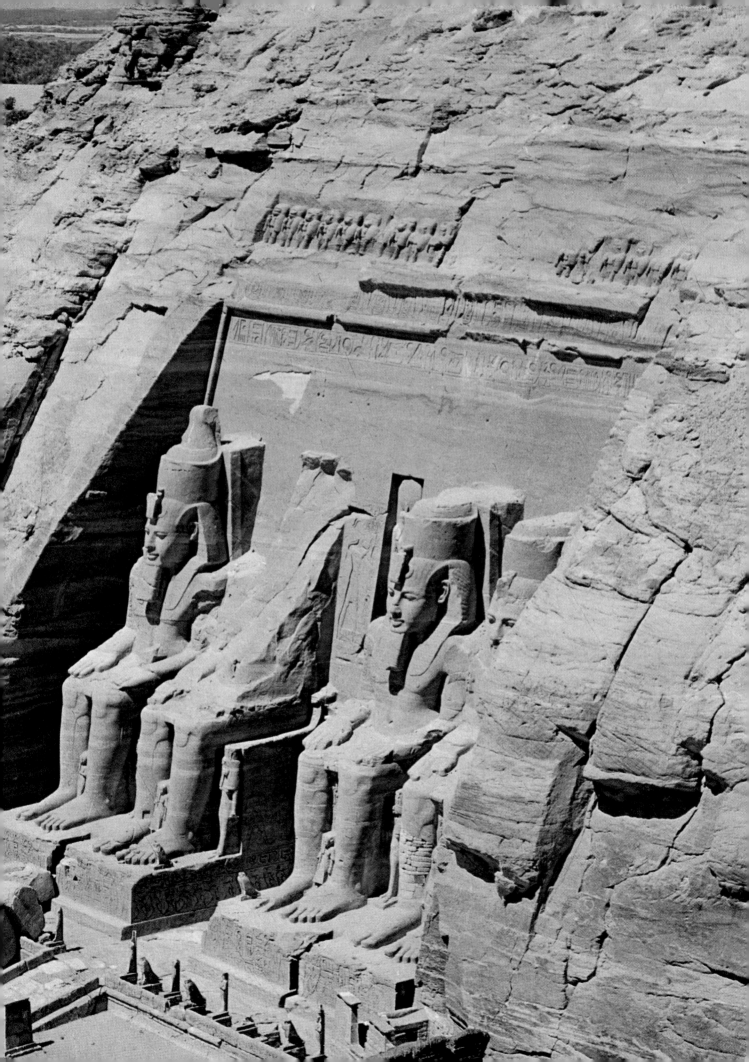

Fresco from the tomb of Cha and his wife Merie at Deir el Medina, XVIIIth Dynasty (Egyptian Museum, Turin)

of his reign he abandoned Thebes for el Amarna where he sacrificed on open-air altars and discarded the old pantheon.

The Amarna period

El Amarna, in Middle Egypt, was reconstructed on flat land enclosed by the Nile and a ring of hills, and was without walls. It was here, in a mystical and exalted atmosphere, that Ikhnaton and Nefertiti had their court, surrounded by courtiers and disciples. In architectural form the royal palace was a seat of politics rather than of private life. A row of monuments runs like an artery between this centre of the cult of Aten and the royal residence proper. From the surviving remains we can deduce the existence of ceremonial open-air palaces for the new god. This religious heresy met bitter opposition, especially from the traditional priestly caste, and when a whole series of misfortunes swept Egypt in addition to the religious dispute, life at el Amarna for Ikhnaton and Nefertiti became increasingly concentrated on family affection. It is still possible to see quite clearly, in a chamber of the Pharaoh's tomb, a scene depicting the grief of the king and queen over the death of a small daughter. In general the scenes betray the anguished atmosphere which weighed on the heretics from the moment when the tide of history turned against them.

True sculpture tended towards idealisation of the subject. The best-known example of this style is the statue of Amenhotep IV (1365 B.C., Cairo Museum), which comes from the temple of Aten at Khartoum. The king's majesty was now idealised to excess, while the thoughtful face was long, lean, and worried, with the extended lines accentuated by the crown and robes.

It was also at Thebes and during the XVIIIth Dynasty that painting took on a new importance.

Although its development was somewhat restricted in content and form by the use of incised slabs, it showed a lightness of touch and a strong sense of colour. When the pictures were intended for tombs, they were inspired by the books of the dead – those famous papyri which describe the charms and ceremonies and the form of worship. The remains of the chapel of Tuthmoses give us a clear example of this, while there are similar characters and descriptions in the great series of paintings in the tomb of Rehmire in Thebes. Here we see the bearers of offerings, the draught oxen, the biers with their symbols of Isis and Osiris, the barque and the mummy standing before the tomb. The story they tell is made vibrant by the delicate rhythms of the invocatory maidens with their brown hands and arms upraised against the azure sky. The pictorial fragments from the tombs of the sculptors Nebamum and Ipuki in Thebes, at the time of Amenhotep IV, introduce enchanting gardens into the funeral scene. A fragment of a picture from the end of the XVIIIth Dynasty (Turin Museum) is richly evocative. It shows a slender dancing girl with her slim and sensitive naked body bent in an arc. The outlines are soft and her hair falls in a brown cascade which echoes the band around her hips. The felicitous combination of formal synthesis and realism speaks, as always, with the unequivocal accents of Egyptian art.

Sculpture, meanwhile, was following its superb parabola. Nefertiti, the wife of Amenhotep IV, had her likeness taken in two magnificent and sophisticated heads, one from el Amarna and the other from an unknown workshop. One of these, in brown quartzite, is incomplete and still shows the marks of the hammer. It is without the gold cap to cover the top of the head, and the eyebrows and lashes are lined in black. Its formation and expression reveal a moving modernity. The internal balance glows through the vibrant planes

Anubis embalming a dead man in the shape of a fish (Tomb of Khabekhnet at Deir el Medina)

of that beautiful face whose contours make an interplay of light and shadow. The other head, in painted calcareous stone, is twenty inches high and is only a model for a sculpture in painted limestone. The eyes, in black wax covered with rock crystal, are deeply luminous; the crowned cap is a symbol of royalty and the necklace forms a natural frame for the intense immobility of the facial expression, glowing with that religious expectancy which typifies the period.

Tutankhamen, the son-in-law of Amenhotep IV and Nefertiti, found himself in different historical circumstances. His father-in-law's religious revolution did not last and the cult of Amon and all the former complex pantheon took on renewed vigour. El Amarna had to be abandoned because

against Syria and Palestine. The reign of Rameses II, which coincided with the period of the siege of Troy, was a time of great architectural works, known as the works of the Ramessides. Even in the time of Sethos I, father of Rameses II, Abydos, a place sacred to Osiris and the cult of the dead, gave birth to a new kind of architecture in response to the religious demands of the worship of seven great gods. These works are well pre-

The god Shu holding aloft the body of Nut, papyrus painting, XXIst Dynasty (British Museum, London)

Frieze with hunting scene (Tomb of Menes, Thebes)

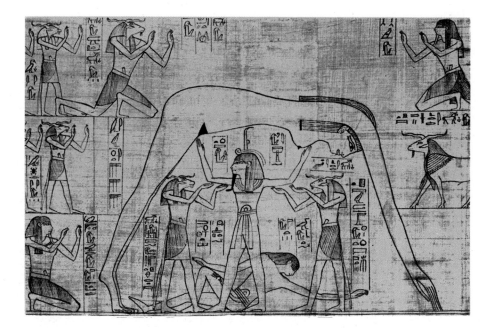

of its links with the heretical period and Thebes once more became the capital.

The disproportionate fame of Tutankhamen is due to the fact that in 1922 an archaeological mission to the Valley of the Kings at Thebes found the young king's tomb and treasury in a perfect state of preservation. It yielded precious objects in metal, jewels, furniture, engravings, and paintings such as the human eye had never seen. Most of the works are now on exhibition in Cairo Museum and confirm our judgment of the end of the XVIIIth Dynasty as a period of extreme sophistication, splendour, skill and virtuosity in many different fields.

The Ramessid period

The XIXth and XXth dynasties saw the armies on the march once more, particularly

served, but the total impression is one of coldness, an impression heightened by the fact that the volutes are undecorated. The second hall in the temple is famous for the bas-relief in which four spectacular goddesses render homage to Osiris.

The most complete example of Egyptian civil building is to be found in the temple of Rameses II. Although its brick-built structure has largely crumbled, this temple shows evidence of crude-brick store-rooms and administrative offices. The consecration of the two temples at Abu Simbel also belongs to the time of Rameses II. They can be briefly explained as a transference of the open-air temples into the rock and underground, with the necessary structural adaptions. The façades emerge from the rock with their huge statues a good sixty-five feet high. Looking out from the cornice is a realistic band of stone monkeys who seem to greet the rising sun. The interior is reduced to the bare essentials: a hall with columns, a shrine and two smaller chambers. Fortunately, in the interests of the preservation of ancient art, these two temples were removed in 1966 from the pathway of waters rising behind the new High Assuan Dam and placed upon safe ground above the original site.

The funerary temple of Rameses III at Medinet Habu dates from 1175 B.C. We are now in the XXth Dynasty, which was sparse in creative originality in every field but is worthy of consideration for its defensive architecture. The design of the temple of Rameses III itself is a

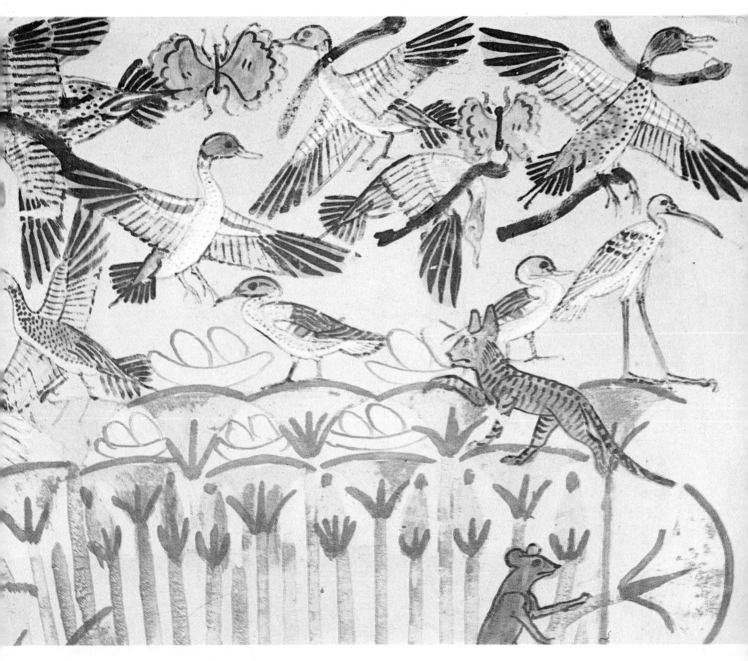

superb example of this field of external military fortification. Its defences consist of two inter-related walls – a small one of stone-covered brick and an enormous one some thirty-two feet thick and sixty feet high.

The last years of glory and the decline: the arrival of Christianity

The following period, that of the XXIst and XXIInd dynasties, was the most dramatically eventful, internally and externally. Economic crisis manifested itself in famine and inflation, scandals, revolts and pillaging which give some indication of the catastrophic state of affairs. In a large part of the country the priests had more authority than the Pharaoh, and the army, composed of mercenaries, was the arbiter of every political situation. The time was ripe for the kind of feudal-anarchic solution which was to come about through the Assyrian invasion and the destruction of Memphis (670 B.C.) and Thebes (660 B.C.). Such art as there was at this time was reserved for the glorification of military per-sonages, one of whom was Mentuemhat, who had risen from the priestly caste of Thebes to be governor of the Thebaid. His tomb is the prime example of this art. A fine statue has survived which represents him in the artistic style of the XVIIIth Dynasty. It was not until after the conquest by Alexander the Great and the start of the Ptolemaic period (321–30 B.C.) that Egyptian art regained its originality.

Alexandria was the last great centre of Egyptian history, but it also marked the break with its multi-millenial civilisation. The city was founded in 332 B.C. in honour of Alexander the Great. Afterwards, when he had broken the power of Persian military might, the Macedonian king received a triumphant welcome in Egypt, whose ruler he became. Situated in a splendid geo-graphical position on the narrow peninsula between the Mediterranean and the tidal lake, it grew enormously, especially in the period between the reign of Ptolemy II and the rule of Augustus. However, few traces of the old city remain. Under Roman rule Alexandria came under the fiscal and economic structure of Rome. Civil life was given a new order and the city was embellished with great highways and perspectives which had their origins in both Roman magni-

ficence and Egyptian pomp. The statuary was chiefly of portrait type and made use of emphatic poses. Ptolemy II built the Pharos (lighthouse), the Museum and the famous Library. Its final vicissitudes hinge upon the name of Cleopatra and have assumed the proportions of a legend of intrigue and passion.

Greek culture had already penetrated into Egypt with the armies of Alexander the Great, but it was only during the three centuries of Ptolemaic rule that the two greatest civilisations of the Mediterranean basin met upon Egyptian soil. Alexandria became the centre of that magnificent culture known as Hellenist or Alexandrian. The high level reached by architecture may be seen in the Temple of Horus at Edfu which was begun in 237 B.C. and finished, so far as the decoration was concerned, in 57 B.C. The essence of its severity of modulation is in its frescoed porches, its flat towers and in the portal which opens the enfilading view of the columned halls. The capitals are decorated with water-plant leaves which give spontaneous life to the columns. The somewhat later incisions on the stone, however, no longer have the fascination of those from earlier epochs. The temples of Kom Ombo, dedicated to the gods Solk and Harveris, and the Temple of Dendera which was finished in the time of Tiberius, are of less significance. Architecture gives way to carving, decoration runs riot over everything, covering architraves and eaves, columns and corner edges, and spreads its rhythms over the walls both inside and out.

The Egyptian gods now became mere cyphers and the ancient religion was swept away by the practical interests of the new Graeco-Egyptian bourgeoisie, while administrative posts went to the highest bidder. The temple, as such, was still powerful in that the priests assured protection to the authorities who, in return, conferred privileges, exemption from taxes and the direction of building contracts. The cult of the dead was still under a ceremonial severity which had reduced to a codex the charming myths of the past. Funerary masks covered the faces of the dead, introducing psychological nuances into the modelling, and hieroglyphic script became almost an art form in itself in the delicate carving or painting on the wooden sarcophagi. This is not a question of the minor arts which, in any civilisation, outlive major artistic creations, whose absolute values they are not called upon to continue. The Roman conquest played no part in the fate of Egyptian artistic culture which had already ended with the Hellenistic period. The most profound impression which the visitor from the West brings back from a journey to the art centres of ancient Egypt is that of monumentality, solidity and essentiality, and it is on these formal values that our judgment of Egyptian art as modern and contemporary rests. But it is from these plastic, compact, inward-looking values in architecture as in sculpture and painting, that there emanates an essence which is mysterious to us, with a mystery that is akin to magic. This element of mystery is the most authentic expression of an artistic culture in which number and magic represent the perennial values.

Pillar with reliefs from the Temple of Horus at Edfu

AEGEAN ART

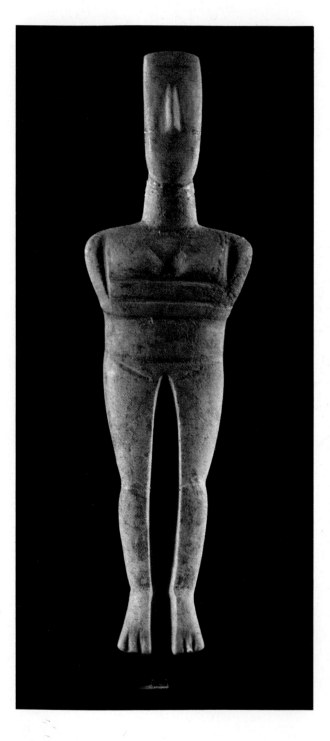

Cycladic marble idol (Private Collection, Paris)

The earliest Greek art: Cycladic art

Only within the last hundred years have excavation and archaeological research modified our view of the relative scope of Greek civilisation and enabled us to see it in perspective. It was the most important and magnificent culture to grow up along the shores of the Mediterranean, and it left a lasting imprint on the development of the West. Yet this new perspective showed us that Greek civilisation was not, as had been formerly thought, of very great antiquity, directly related to pre-history. In fact, there had been great and advanced civilisations before it with different ways of life and different customs, if not with different peoples and races.

Almost a century ago a German businessman, Heinrich Schliemann, was obsessed by the idea of proving that when Homer (8th–7th centuries B.C.) wrote of the events leading up to the destruction of Troy (about 1200 B.C.), he was not repeating some fanciful legend but describing real events and people. He therefore gamely set out to unearth Troy and, later, Mycenae. He caused great excitement when he claimed to have retrieved from a tomb at Mycenae the gold mask which had been placed on the face of Agamemnon, victim of that ancient family drama which gave so many plots to the great Greek tragedians. However, what he attributed in Troy to Priam and in Mycenae to the Atrides turned out to be manifestations of a much older civilisation which had already ended at the time of the siege of Troy. At the beginning of this century an Englishman, A. J. Evans, with archaeologists from all over the world hard on his heels, discovered the existence of a great civilisation in Crete, much older than that described by Homer. More recently, other archaeologists have brought to light the contribution made by the Cyclades islands, scattered like stepping stones between the Anatolian coast and the Greek mainland.

So we can nowadays speak of an Aegean civilisation and art, even though it was quite diversified and lacking in unity. The difference between it and the great civilisations of Egypt and Mesopotamia lies in its maritime nature, which rendered it open to contact and trade.

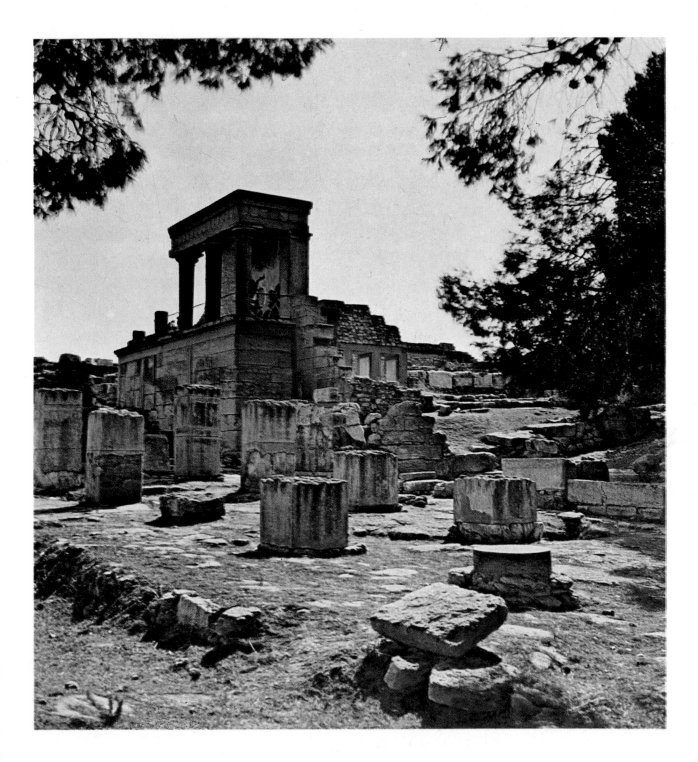

Palace at Knossos, entrance

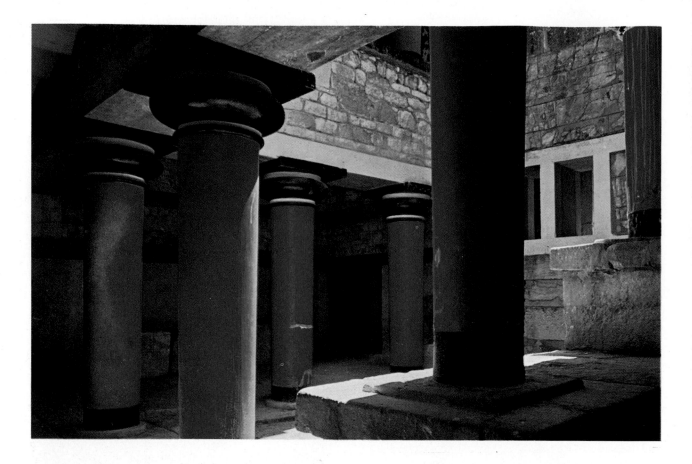

Palace at Knossos, a room on the ground floor. Below: *Plan of the palace*

The Cycladic civilisation was the most restricted in ambit as well as being the oldest, for it flourished between the 3rd and 2nd millennia B.C. Its source can be traced to a restricted but heavy coastal trade, mostly due to the exploitation of obsidian, a volcanic crystalline rock from the island of Milos which was particularly highly prized, before the discovery of metals, for the manufacture of weapons and tools. The remains of Cycladic buildings show them to be rough and primitive, made of stones placed one on top of another, but already with stone floors. The advanced level of this remote Cycladic civilisation is, however, demonstrated in other ways. One of these is through its pottery, which consisted of vessels, jars and boxes in elegant shapes, with ornate abstract decoration using linear, curvilinear or spiral geometric motifs. At a later period the decoration also included natural motifs of uniformly stylised birds and flowers.

Another and more typical art form is that of small marble idols whose significance is not very clear, but which were probably related to the Mediterranean devotion to the Mother-goddess. The free-standing figurines are smooth and flattened with what almost amounts to a refusal to exploit the full sense of volume. Somewhat later they are simple shapes, with the arms joined on the breast, but by this time they fully portray human figures in a human way. Their chief characteristic is a singular insistence on abstract rendering. The head is egg-shaped with no carved features except for the distinctive triangular nose. It is no surprise, therefore, to find that this insistence on synthesis and abstraction led to

these idols becoming quite deformed when they were used for vessels with handles, which are reminiscent of the shape of a violin. Even later we find statues of lyre or flute players, standing or seated on stools, which, though echoing reality, still betray this extreme synthesis.

From the third millennium, Troy, standing in an important and strategic trading position on the Anatolian coast, near the entrance to the Dardanelles, showed many diverse characteristics. A common interest in ridding themselves of this key point, rather than revenge for the rape of Helen, led the Achaean monarchs to join forces in the first decade of the 12th century B.C. and to undertake the ten-year siege immortalised by Homer. The city, which may have begun as an agricultural community, later prospered as a result of the heavy trade in metals, from gold and silver to copper and bronze. The successive strata of the hill on which it was set reveal the strength of the sturdy walls and Cyclopean structures. It is obvious that the Trojans were preoccupied with defence in order to protect those treasures which they had accumulated, even by 2000 B.C., and of which we can catch a glimpse in the Trojan goldwork which has survived. By the time it was finally destroyed, Troy had absorbed and taken on a distinctly Creto-Mycenaean flavour. Nevertheless, very old remains have been found of a type of building construction which was to be more fully developed in ancient Greece. This was the aristocratic mansion which was paved, and which had as its focal point the *megaron* (principal room) into which led an entrance hall with a great central hearth covered with a gabled roof.

Cretan civilisation

Of a very different importance is the civilisation which, about halfway through the third millennium, grew up in Crete, and from which Greek culture was to draw its myths and legends. Passing rapidly over its proto-historic stage, we find that Cretan civilisation matured at the beginning of the second millennium because of its position in the centre of the Mediterranean and its consequent function as a meeting point for western Asia, Egypt and Europe. Its growth was founded upon the seafaring nature of the Cretan people, being based upon trade and contacts rather than by territorial expansion and military conquest. Crete was able to take full advantage of the advent of the Bronze Age, which offered special commercial and economic prospects. Thus the island left its mark pretty

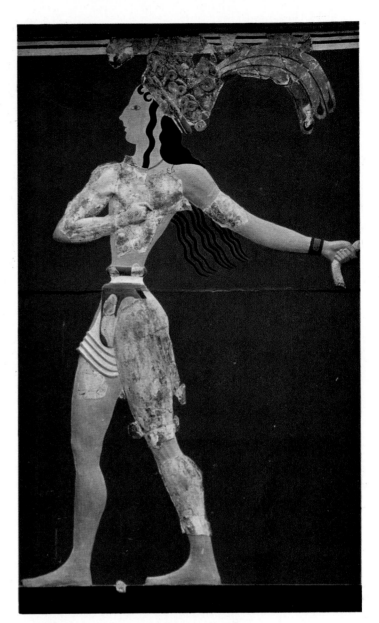

The Prince of the Lilies, fresco from the palace at Knossos (Archaeological Museum, Heraklion [Candia])

well all over the eastern Mediterranean basin. Its seafaring activities were supplemented by agriculture, which was favoured by the fertility and varied produce of the island, and by handicrafts – factors which gave it a social balance rare in that epoch.

It was not a unified state, though the King of Knossos seems to have had greater prerogatives than the others. The island would seem to have been divided into local princedoms, whose rulers were jealous of their independence but were entirely free of the tendency to despotism, absolute power and myth-ridden sovereignty that predominated in Egyptian and Asian civilisations. Thus Cretan civilisation offered, in contrast to the others, a rare prescription for

serenity, liberty and pleasure in life. This found concrete expression in its art.

Two special features contributed to making Cretan culture somewhat exceptional in relation to the others. Above all – and it is not necessary to underline the divergence from the art of Egypt and Sumeria – Cretan art seems to have been largely profane. Cretan religion was essentially inspired by nature and was satisfied with the direct veneration of the Mother-goddess and a certain Olympiad of divinities. Cretans did not erect temples to their gods, though there were some sacred grottos and one or two places of worship in the palaces. There were no sacred statues and they avoided the representation of divine themes, even on the narrative level of mythology. The few examples of idols and votive statuettes had no specifically sacred attributes and were largely decorative. The picturesque serpent goddesses in the museum at Heraklion (Candia) have nothing terrifying or sacred about them, and are portrayed above all as court ladies in their characteristic dress. The other special feature is the non-existence of military themes. No work of art glorifies or records a

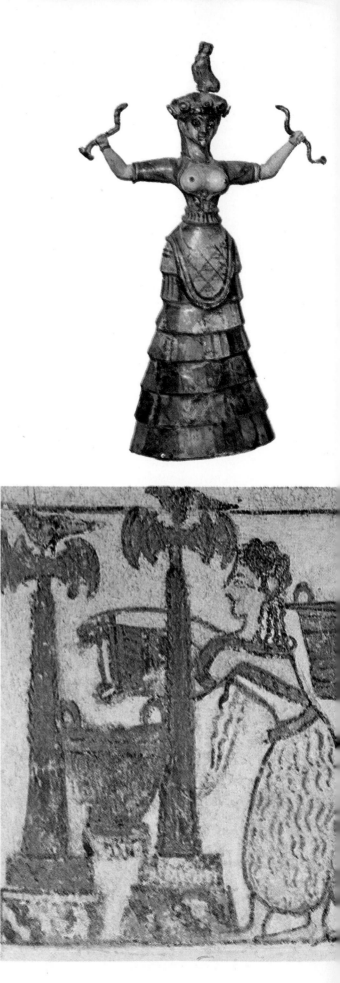

Above right: Cretan snake goddess (Archaeological Museum Heraklion [Candia])

Right: Procession of tribute-bearers from the sarcophagus at Hagia Triada (Archaeological Museum, Heraklion [Candia])

Below: Cretan vessel with polyp (cuttle-fish) decoration (Archaeological Museum, Heraklion [Candia])

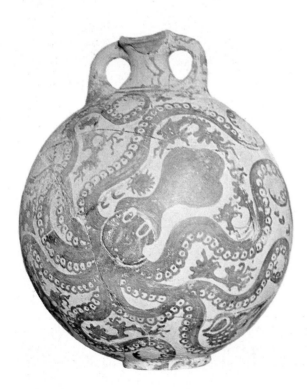

military undertaking. No sovereign is venerated for his fame as a warrior. The very weapons themselves, like the ubiquitous double-bladed axe, seem to be designed with elegance of decoration rather than aggressive function in mind. Still more typical is the absence of military or defensive architecture. The great Cretan palaces have no military garrisons and look more like villas than strongholds.

The Cretan palace

Crete's main contribution to architecture is in the creation of great palaces. The palaces of Knossos and Malia were set on hills not far from the sea in the northern part of the island. Like the palace of Festo, in the south, they are small, organic urban complexes rather than just residences for the local princes, though there were also isolated aristocratic mansions and inhabited settlements as well. The stone construction of the palaces can be traced back to about 2000 B.C. They continued to serve until about 1750–1700 B.C., when some mysterious catastrophe (either an earth tremor, an invasion, or a peasants'

revolt) led to their destruction. At Knossos, the pre-eminence of the Minoan Dynasty continued to gain strength and when the palaces were reconstructed, in about 1600 B.C., there was an opportunity for an even vaster and more complex architectural development, though still using the previous bases. This second phase, the so-called Late Minoan, was, however, of short duration. Perhaps another terrifying and destructive natural catastrophe (there was a volcanic eruption on the island of Tera in about 1520 B.C.), followed shortly afterwards by an Achaean invasion from the mainland, led to the destruction of the palaces in about 1450 B.C. Cretan civilisation was at an end, except for rare local manifestations.

The architecture of the Cretan palaces was marked by a sense of liberty, empiricism and practicality. They were vast and intricate, giving rise, in fact, to the myth of the Labyrinth and of Theseus, who had to trust to the thread given to him by Ariadne to find his way out. They were built to no preconceived plan and, above all, were not intended to be imposing or to display gaudiness or pomp. More concerned with interior comforts than with external coherence, they

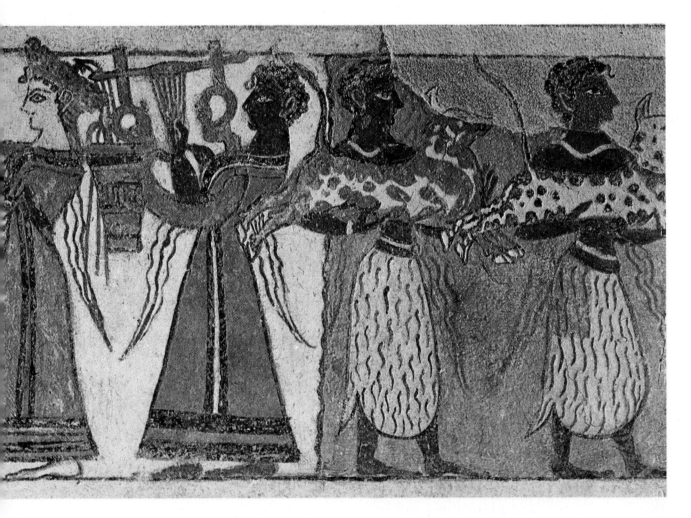

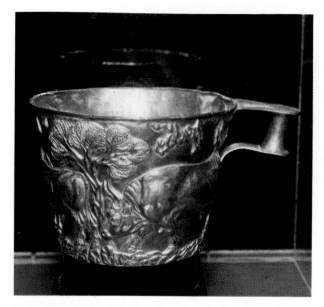

Cast-gold goblet from Vaphio (National Museum, Athens)

Harvester's vase (Archaeological Museum, Heraklion [Candia])

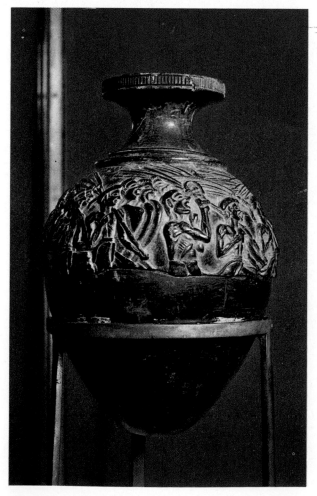

Mycenae: tomb circle

included the beginnings of protection from heat, through the development of complicated but cool corridors, of ventilation shafts and terraces. They had to overcome steep, uneven gradients and overhangs, and the buildings were constructed on mounting terraces linked by passages and flights of steps. In an attempt to lighten the weight of the intervening walls and to support them, the architects introduced the squat Cretan columns, wider at the top than at the base, with their compressed, rounded capitals. The palaces were arranged in various ways, the royal quarters being set against the gynaeceum or women's quarters, and the imposing store-rooms, with all their accessories, against the administrative quarters. The technical inventiveness shows great

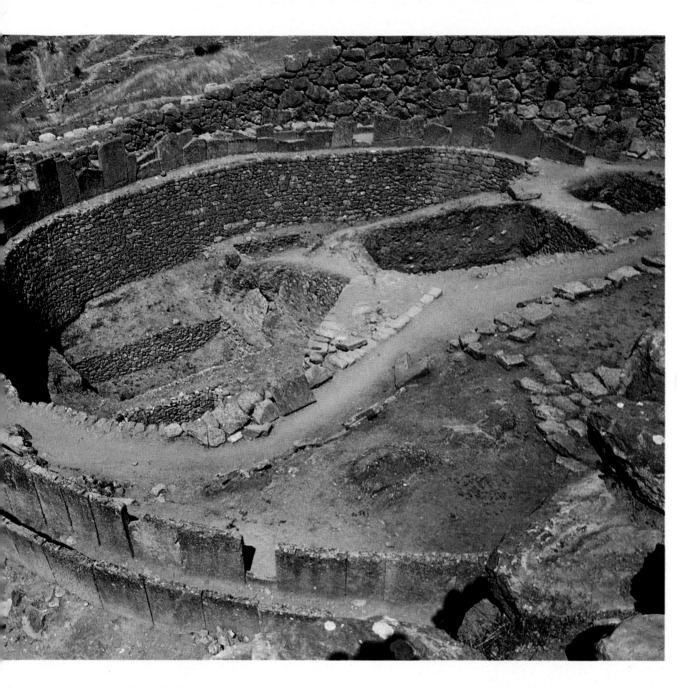

shrewdness, and included drains, piped water, and ventilation shafts which are interesting precursors of more modern inventions. At Knossos wide steps were set against one another at an angle and formed an ideal area for an open-air theatre where king, court and people took part in feasts, bull-dances and religious ceremonies.

Such complexes were more intended for joyful good living than for the pomp of kingship, but were nevertheless richly decorated. The plastic decorations were often carved bas-reliefs of paired bull-horns, which were also used as a rhythmic decoration for the roof ridges. The colour decorations were mostly murals, painted on fresh stucco in the liveliest of contrasting colours. The walls of the rooms, corridors,

passages and stairways had brightly coloured plaster backgrounds on which stylised double-bladed axes and lilies were superimposed in repetitive patterns or, as in the throne room at Knossos, floral and animal motifs were painted on bright red walls. Particularly in the Late Minoan period, such simply ornamental functions came to affect figure painting. These strange mural paintings were flat and two dimensional with no sense of depth. They have such exceptional virtues of free imagination that one is tempted to describe them as Impressionist.

Some masterpieces of Cretan painting from Knossos can be seen fairly well preserved in the museum at Heraklion (Candia). There, for example, one may see the undulating gait and

ample gestures of the feather-bedecked *Prince of the Lilies*, in profile against a red background; the heavily made-up and caparisoned female now known as '*La Parisienne*'; the acrobats and the highly popular bull-dance. There are fragments that reveal the amazing attention with which the Cretans looked at the world of nature: at grass, at flowers, at birds, at fish. There are minute frescos, almost like miniatures, which describe feasts, court scenes and religious processions.

The minor arts

Crete had no sculpture, or, to be more exact, no statuary. It did, however, make a very rich contribution to the minor arts, both in its sense of plastic values and in its love of colour. This is particularly true in ceramics, from the pottery statuettes, often vividly painted and with popular characterisation, to the art of vase-painting. During the period of the reconstruction of the first palace – that is, 2000 B.C. – Kamares ceramics came into prominence. This was turned pottery in fine thin clay, lavish in elegance of form and variety of vessels: pitchers, bowls and handled jars. Ornamental motifs in white, or with a hint of colour, stand out against a background of dark-grey glaze. There is a rare perfection in the relationship between the form of the vessel and the ornamentation which enhances it. This stylised ornamentation is sometimes in the form of abstract designs of stars, spirals or checks and sometimes in the form of natural motifs of flowers, leaves or fish. In the later types of ceramics, between the 17th and 16th centuries B.C., which were still very fine, the tendency towards themes from nature was to prevail, skilfully bending reality in animal and floral motifs into an ornamental function. The later 'palace style' was to veer towards the conventional schematisation of this highly developed decorative sense.

Above all, in the field of minor arts, Crete manifested a sophisticated plastic sensitivity which sometimes achieved exceptional results. An example of such work is the rounded soapstone vessel known as the 'Harvesters' vase' (about 1500 B.C.). The relief, which is of a vigorous procession of reapers with their tools, winds its way about the top of the vessel to give an impression of rhythmic pursuit with clear articulation of the individual figures in the crowd.

Cretan goldwork is also noteworthy. It is mainly in the form of small trinkets, typical of

A gallery in the wall at Tiryns

Mycenae: Secondary entranceway to the citadel

Mycenae: Entrance to the Treasury of Atreus

Mycenae: The Lion Gate in the citadel

the older period, where natural motifs, such as pairs of bees, are used for decoration. Sometimes, however, cast gold was used with great effect, as in the gold goblet, found at Vaphio near Sparta and dating from 1500 B.C.; its design of bulls breaking their bonds with their horns is full of realism and expressive vigour. Cretan gem-carving was unusual in character, being used for the making of numerous seals in which elegance of naturalistic forms alternates with exquisite ornamental sense.

Mycenaean art

At the very moment when Cretan civilisation began to shudder and fall, in about 1500 B.C., another civilisation, itself owing much to Crete, took its stand – this time on land – in Argolides, on the Peloponnesian coast. This is the civilisation which we call Mycenaean, although it includes both Mycenae and nearby Tiryns.

It was a distinctly different civilisation in that, by contrast with Crete, it was territorial, military and warlike and originated from the Aryan race which came from the north across the Balkans. Yet, through conquest and the spoils of war, it was to bear the deep imprint of Crete, even to

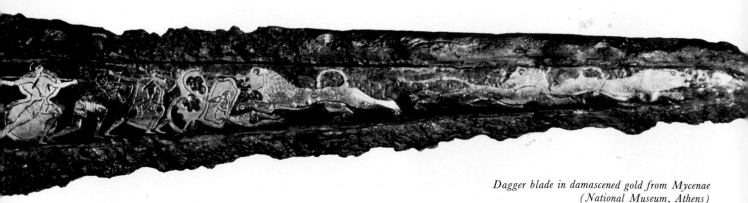

Dagger blade in damascened gold from Mycenae
(National Museum, Athens)

the point of becoming almost a different version of Cretan civilisation.

The greatest point of difference was architecture. Mycenae revealed the nature and the tendencies of the Achaean dynasty, the Atrides, in that it was a warlike citadel, in a strategic position and tightly enclosed within the Cyclopean walls of rough, irregular blocks of stone. The Lion Gateway, with its heavy trilithic structure (the two vertical jambs support a horizontal architrave weighing thirty-five tons), displays no ornamental grace, not even in the powerfully carved pair of opposing lions, now mutilated, which stand on either side of the central column. The steep-sloping inner area must have looked more like a fort than a rich city. The royal palace of the Atrides, at the summit, consisted of fairly simple buildings surrounding a courtyard. The most important structure was the great gable-roofed *megaron*, approached by way of a portico with two columns and vestibule, with a great plaster-floored hall having four columns and a central hearth. In the lower part of the city, inside the walls, was a wide circle of burial chambers dating from the 16th century B.C. It was here that Schliemann claimed to have dug up the remains of Agamemnon. The most important architectural construction in Mycenae is in fact the underground tomb of Atreus. From the entrance gate, the tomb is reached through a *dromos* (corridor), between jutting walls with regular stone courses. The interior is a circular *tholos* tomb forty-seven feet in diameter, with a 'beehive' vault made up of tapering rings of regular jutting stones placed one on top of the other. Examples of similar 'beehive' constructions have been found from prehistoric times, but the tomb of Atreus, by virtue of its perfection, regularity of technique and the grandeur of its structural strength, remains a monument of great

artistic significance, the most notable vaulted construction prior to the Pantheon at Rome.

Perhaps even more important, from the point of view of military defences, are the Cyclopean walls which surround the modest heights of Tiryns and which here also protect the royal palace erected over a *megaron*. Galleries and casemates (vaulted chambers with embrasures) are cut into the massive thickness of the walls to form false, steeply arched vaults.

The remaining forms of art in Mycenae, however, show in their development a close connection with the art of Crete, which sometimes makes us wonder how much of it is original Mycenaean work and how much was simply spoils of war following the Achaean conquest of Crete. All that is certain is that after the destruction of the cultural centres of Crete, in about 1400 B.C., Mycenae itself became the artistic and cultural centre of the whole of the Aegean and spread its influence to Cyprus and beyond, to the Asiatic coast and to Egypt.

Mycenaean craftsmen excelled in goldwork. An evocative and unusual contribution to this field was in the gold funerary masks with their sibylline expressions. They were found in the tomb of the Atrides at Mycenae and are now in Athens Museum. Other examples of Mycenaean goldwork are the gold *rhyton* (drinking vessel) with its powerful lion shape, the masterly damascened dagger blades with their rhythmic, springy patterns of wild beasts, as well as the cast-gold cups dug up at Vaphio. Even so, we are still left with the problem of whether they came directly from, or were simply influenced by, Cretan goldwork.

Another fertile field of Mycenaean art is pottery. Here also, as in Crete, we reap a rich and expressive harvest of statuettes and small idols in terracotta with strange fantastic shapes

and vivid ornamentation. Of even greater interest, however, are the vases, in spite of their obvious continuation of Cretan taste. They are varied and elegant in form and have painted decorations with motifs drawn from nature, such as the common design of a dark octopus with spiralling tentacles. These were later turned into elegant stylisations, and the human form appeared for the first time, schematised and almost like a caricature.

Mycenae was the nucleus of the Achaean expedition against Troy and suffered decline afterwards. It vanished in about 1100 B.C., probably overcome by invasions from new races from the north. The cycle of the Mycenaean and the earlier Cretan civilisations had been completed when Homer, over the span of the centuries, wrote his great epic evoking their final pomp. But they still constitute a prototype of human civilisation and artistic creativity which, although without direct continuity, paved the way for the Helladic civilisation and the world of classicism.

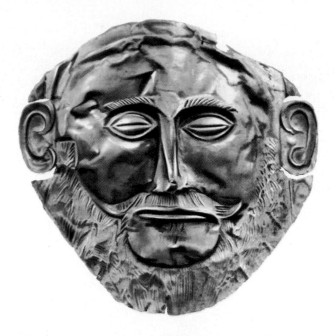

Gold funeral mask, said to be of Agamemnon, from Mycenae, 16th century B.C. (National Museum, Athens)

Gold funeral mask from Mycenae, 16th century B.C. (National Museum, Athens)

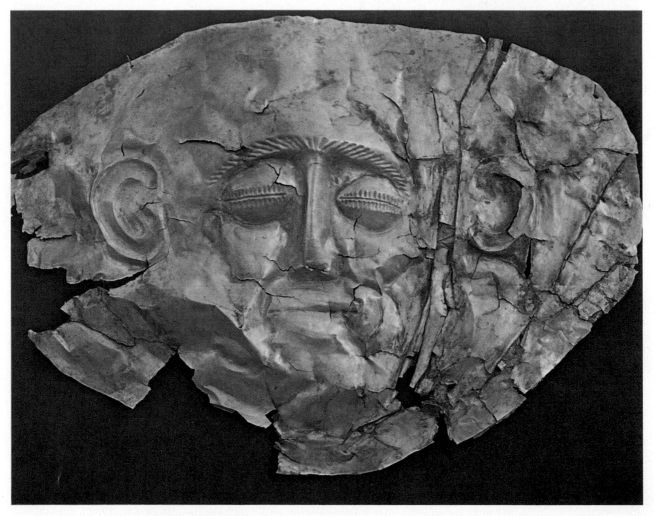

GREEK ART

The archaic period

No civilisation or country has given a more decisive and essential contribution to the concept of classicism than has Greece. It is to her, or rather to that relatively brief period between the fifth and fourth centuries, that we turn to see it in its highest, purest and most prolific form.

In such an imposing river, the purity of the source is lost because of the effects of the many other tributaries, both positive and negative There are two dangers to a future art in this situation. On the one hand there is the tendency to imitation; and on the other there is the reduction of what was once a live, artistic creation to academic principles and rules. In order properly to distinguish the authentic Greek classicism from a broader and more confused classicism, we must look for its essential values. Its quality is of such a high order that we are able to discern a strength and a lucidity of expression to which our reactions are strong.

Although it is important for us to seek to identify the values of Greek classicism, the search is not easy. Greek architecture is represented only by ruins, some so complete that we can merely guess as to their original structure. All the most famous sculptures have been lost and many of those that remain are mutilated or exist only in fragments. Many works are known to us only through copies, some Greek and some Roman, and they are not always faithful to the original. In some cases the dimensions and proportions have been altered, and often an original bronze has been reproduced in another material, such as marble. As to Greek painting, we must rely on such indirect evidence as vase paintings and mosaics.

Greek classicism gives us, for the first time, an example of an art form which grew and spread solely because of the efficacy and obviousness of its intrinsic values of form and expression, the values of balance, harmony, order, proportion and moderation. Set against the bright background of a multifarious and elevated Greek culture, which was founded more on intelligence than on power, the classic period of Hellenic art represents the victory of values which were at that time new and unknown but which have since become essential in the history of man. It was an art which upheld the importance of man in his own right, considering him, as Protagoras

Amphora with geometric design and black figures in funeral cortège (National Museum, Athens)

Paestum: Temple of Poseidon

did, as 'the measure of all things'. It was an art founded on the clear, sound principles of rationality, on man's desire to be aware of the outside world by imposing his laws upon it.

Preoccupations with the supernatural play no part in Greek art, which sought to extol life's warmth and beauty, not the world beyond the grave. The Greeks did not deify or attribute especial glory to a monarch, nor did they experience the herd instinct of a mass of subject people because Greek art was almost entirely devoted to civic and religious purposes. In the civic field it was manifested through the collective activities of free men in the service of the community; in the religious field in the expression of an anthropomorphic religious attitude, itself of human dimensions and on a human scale. In Greek art the gods, far from removing themselves to some remote heaven, took part in the human world, with the form, the dress and the behaviour of men, so that the noble beauty of the human form became the most convincing image of the idea of the divine principle.

The Hera of Samos (Louvre, Paris)

Opposite page: Vase, black-figure style (Archaeological Museum, Florence)

The 'Moschophorus' or calf-bearer (Acropolis Museum, Athens)

Finally, it was an art which, more than any other, looked intently at reality and sought to capture its natural state and its natural movements. However, in the name of the superiority and the serenity of reason, it imposed upon reality its laws of order, balance and clarity, by

dint of a spirit which sought to dominate external reality and not to be led by it. Thus was born an ideal of beauty which was the first to mature as a source of artistic inspiration. However, the secret of this inspiration was found in that same careful attitude towards the relationship between reality and the ideal, between form and reason, and between the world of things and the domain of the human spirit. Although the Greek classic ideal was of this nature at its maturity, the course of its development towards that ideal was more complex and tortuous.

We have already seen the significance of Cretan and, later, Mycenaean civilisation, both in themselves and in their influence. But the history of Greek civilisation began as theirs was breaking up and the continuity was broken. The long period between the end of the 13th century B.C. and the beginning of the eighth century, which is usually classified as 'the middle ages of Greece' or the 'dark ages', represents just the time of dissolution for the heritage of Crete and Mycenae because of internal crises and external events. The decisive factor was the fresh invasion of Greece by the Dorians in about 1200 B.C., coming from the north across the Balkans. According to tradition, they spared only Attica, overthrowing and sweeping away the last vestiges of the Achaean and Mycenaean dynasties. The hard, disciplined military regime of the Dorians, and with it the Iron Age, forced the Greeks back across the sea to the opposite coasts of Anatolia. This was the beginning of the coastal settlements which gave birth to the Ionian cities, the chief of which were Ephesus and Miletus. In contrast with the Doric world, they formed the other, and antagonistic, element of the Greek ethos – freer, more restless, more graceful and imaginative.

The slow amalgamation of the old peoples with the new, and of the ancient traditions and myths with the newer concepts, lasted for many centuries. But gradually the peoples came to realise that they belonged to the same civilisation. The lack of territorial and political unity and the fragmentation into many small, mainly autonomous cities did nothing to prevent this. Their awareness of having become Hellenes was clear in the eighth and seventh centuries when they compared themselves with the stammering 'barbarians'. They felt they belonged to the Hellades, which was entirely Greek through language, culture, religion, customs and philosophic values. Several very varied tributaries ran together here. There were the poems of Homer and the humanistic verse of Hesiod. There was the emergence of shrines common to all the Greek peoples at Delphi, Olympia and,

to a lesser degree, the island of Delos. There was the renewal of the Olympic Games which bore witness to a pan-Hellenic competitiveness which did not only exist in the field of sport.

The extreme poverty and precariousness of economic life, exacerbated by the privileged position of a few powerful families who took the place of the former kings, led to a migration which enlarged the ambit of the Hellenic world. Many Greek cities sought an outlet for their exuberant populations in the transfer of large groups overseas to the newly founded colonies. These became autonomous Greek communities which were richer and more important than their cities of origin, to whom they remained linked solely by bonds of sentiment. In about 750 B.C., the first migratory wave towards the west began – into the Ionian islands, into Sicily and along the Ionian coast of southern Italy (the so-called Magna Graecia). Further spearheads settled on the Tyrrhenian coast, founded Marseilles and reached the shores of Libya. It was these Ionic cities, more than any others which, about a century later, started the migratory movement towards the Thracian coast, the Bosporus and the Black Sea.

Art would seem to have paid the price for this period of gestation. It is extremely scanty and its

few manifestations are of interest only to the archaeologist. For centuries there was no plastic art outside of ceramics, which were purely for practical and utilitarian purposes. We must go to the beginning of the 9th century to see the spread, especially in the Attic ceramic art from Athens, of a specific style – the geometric. An extreme and rigorous severity marked the vase-painting, especially the funerary urns. On the horizontal bands of decoration all the naturalistic, curvilinear or spiral motifs were replaced by geometric rectilinear designs, sometimes continuous, sometimes broken, with hard, sharp angles where the simple forms of triangles, lozenges, checks and swastikas alternated with Greek fret or Greek key designs. Greek art, which was later to be so diverse, seems to have started by entrenching itself within the strictest abstraction, in an intellectual mode of rhythmic ornamentation akin to a neutral and impersonal geometry. Corinth was a successful challenger to Athens in ceramics, and it was only here that vase decoration took on a freer and more liberal ornamentation. It was in Athens in the 8th century that the human form was first used for vase decoration. Even so, this was strictly within the limits of that same inflexible geometric style. Between bands of abstract designs appeared human figures, particularly in scenes of funeral rites or communal mourning, but the figures are flat black shapes, showing extreme synthesis, and with the rhythmic repetition of schematically rendered postures. The bronze or terracotta

Head of the so-called 'Rampin Horseman' (Louvre, Paris)

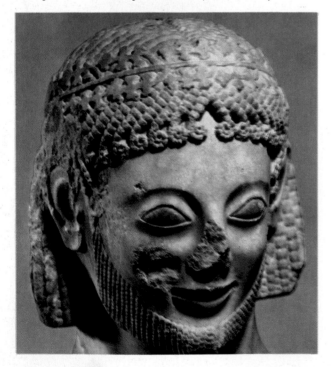

statuettes of this period reveal similar tendencies, far removed from realism.

In the course of the 7th century, the geometric style came to be replaced by what is usually called 'orientalised' style. This seems to be in even greater contrast to Greek taste and tendencies so that, if it had not spread as it did and had not been so promptly taken up by Greek craftsmen, one might have regarded it simply as an obsession with a foreign fashion. Contacts between Greece and the Syrio-Assyrian culture of the East were becoming more numerous because of the seafaring nature of the people. The export route for oriental decorative materials passed through the islands of the Aegean and through Rhodes, Cyprus and Crete. The Greek mariners must have shown examples of that brilliant ornamental heritage to their admiring fellow-citizens. For a long period, Greek craftsmen were seduced by the exuberant fantasy of oriental products, by materials and techniques, by the contrast of colours, by the designs of stylised animals or intertwined monsters, resulting in much imitative work. Miletus, Rhodes and, on the mainland, Corinth produced vast numbers of vases in a style, or with designs, of Oriental inspiration. A similar tendency is noticeable in the bronze statuettes and ornaments which have come to light chiefly in the excavation of shrines (Delphi and Olympia) and which were votive offerings from various centres in Greece. This tendency is also seen in the decoration of the great bronze shields produced in Crete.

On the other hand, a coherent development of the characteristics peculiar to Greek art – with a variety of local emphasis but with unity of purpose – took place in the archaic period, in the years between 650 B.C. and 480 B.C., the date of the Persian invasion and the sacking of the Acropolis of Athens. It was an intensely formative period, not only in the field of artistic, spiritual and cultural values, but also in the structural elements of Hellenic civilisation, bringing about a fusion of its elements. The city-state was its fulcrum, in spite of its limitations. Externally, these limitations lay in the obstacles preventing the growth of a wider and more harmonious political unity. The internal ones, which were many, were those of a society which preserved a a slave system and in which there were marked social contrasts between the poor, hard-working existence of the 'many' and the privileges of the 'few', and discrimination between citizens and outsiders. The city-state conferred on the different

'Kore' (Acropolis Museum, Athens)

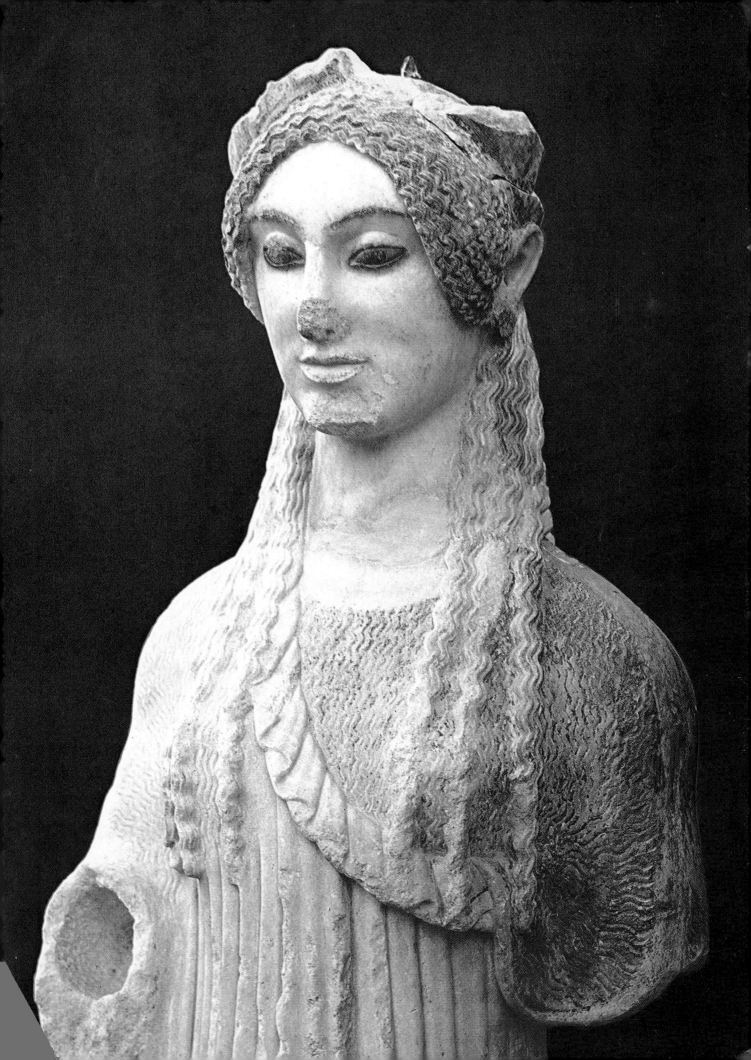

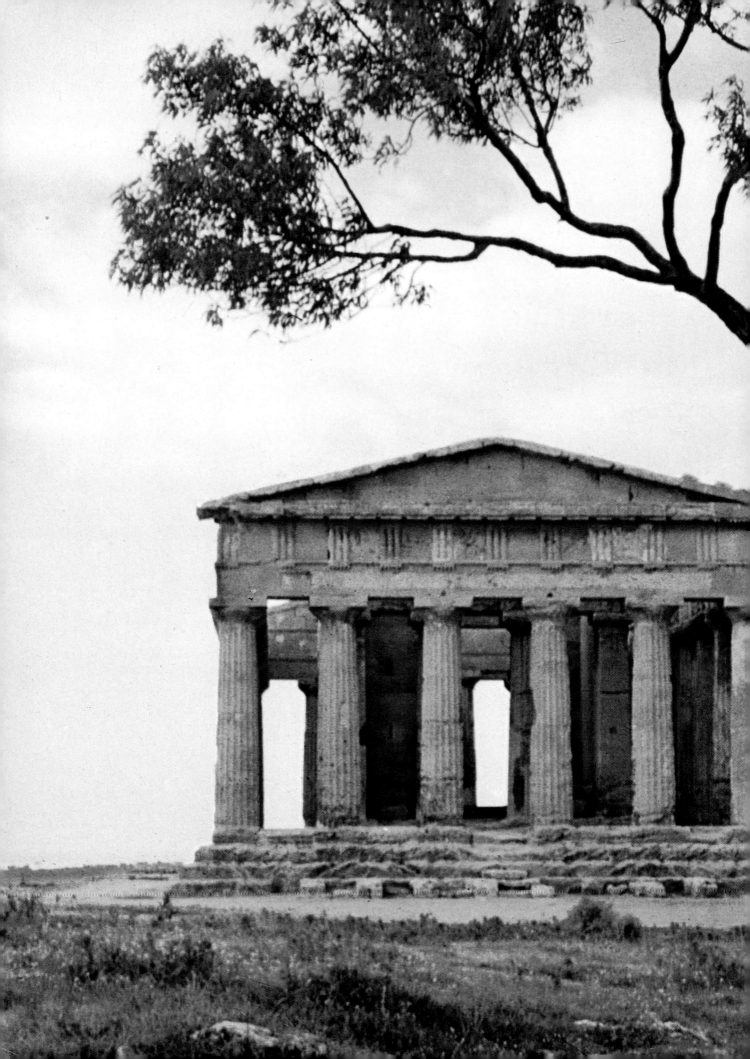

Hellenic centres an autonomy of development which is also reflected in the arts. Nevertheless, this autonomy concealed a wide variety of political and structural solutions, sometimes with internal arrangements which were far from simple and which were later to recoil upon the course of Greek history. There was not only the antagonism to the totalitarian, militaristic, state-worshipping structure of Sparta, whose influence in the whole of the Peloponnese was very great, but there was also the uneasy co-existence of conservative and aristocratic regimes and regimes moving towards a relative democracy. Similarly, there were regimes going through that strained interlude of the 'tyrants', who achieved a strong and often merciless despotism and who also made innovations (not only in the field of art). And there were regimes where shrewd and prudent 'legislators' began to carry out different constitutional reforms.

Architecture

In the archaic period, Greek art, though intensely active in the field of ceramics and the minor arts, began to bring its own solutions to the major arts as well.

Temple of Concord, Agrigentum

Plaque from Locri, 470-460 B.C. (National Museum, Taranto)

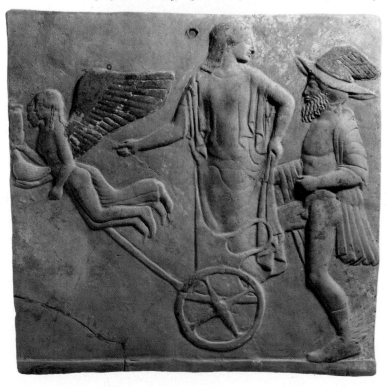

93

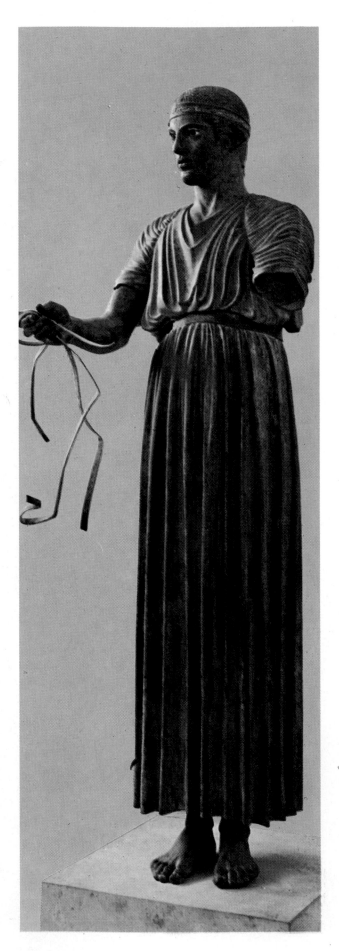

In architecture, we see the birth of the Greek temple. It was the transformation, in a structural and monumental sense, of the more rudimentary edifices formerly erected to give an elementary 'house' to the god and to shelter his wooden image. At first they were little more than wooden huts made of boughs, but later little stone passages covered with a gabled roof and with two trunk-like columns at the front formed a modest atrium. The structure became more sophisticated, and not only because stone and marble were replacing wood (except for the roofing). The temple was erected on a sloping platform (stilobate) on a rectangular plan. As can be seen even from the temples which have been reduced to ruins, it was a solidly constructed form, with a predominantly horizontal development and with dimensions and proportions calculated in such a way as to impose the rationalised geometry of the architect's plan upon the disorderliness of nature. Columns, which became common from then on, were first used to decorate the front part; counterparts to them later appeared at the back. Finally, except in small, minor temples, columns came to be used on the larger sides of the stilobate, too, so creating porticos all round the *cella* (shrine for the statue of the god). In this style of architecture, where the arch and the vault were unknown, the column was used to support the architecture, which was used in a way that clinched the effect of horizontality. At the same time, the column became an isolated, more delicate, individual element and the whole effect was of a rhythm in which the number of columns, their height, and the space between them had a rational function in the aesthetic effect. To complete the horizontal effect, a gabled roof was placed over the architrave in a way vaguely reminiscent of the Mycenaean *megaron*. Also, on the front façade, the triangle between the span and the architrave left space for the empty pediment. A new structure, then, and a new kind of monument. The characteristics of the archaic period are in the imposing dimensions, the grandeur of the proportions and in the large number of columns. Nevertheless, the Greek temple preserved one characteristic from its distant origins, namely that it was related more to external than to internal space. Its internal structure was not like that of Western churches, intended to accommodate the great mass of the faithful. It had a narrow central chamber *(naos)* intended as a dwelling-place for the god and where his statue was

The Charioteer (Delphi Museum)

Woman playing the flute, from the Ludovisi Throne (Museo delle Terme, Rome)

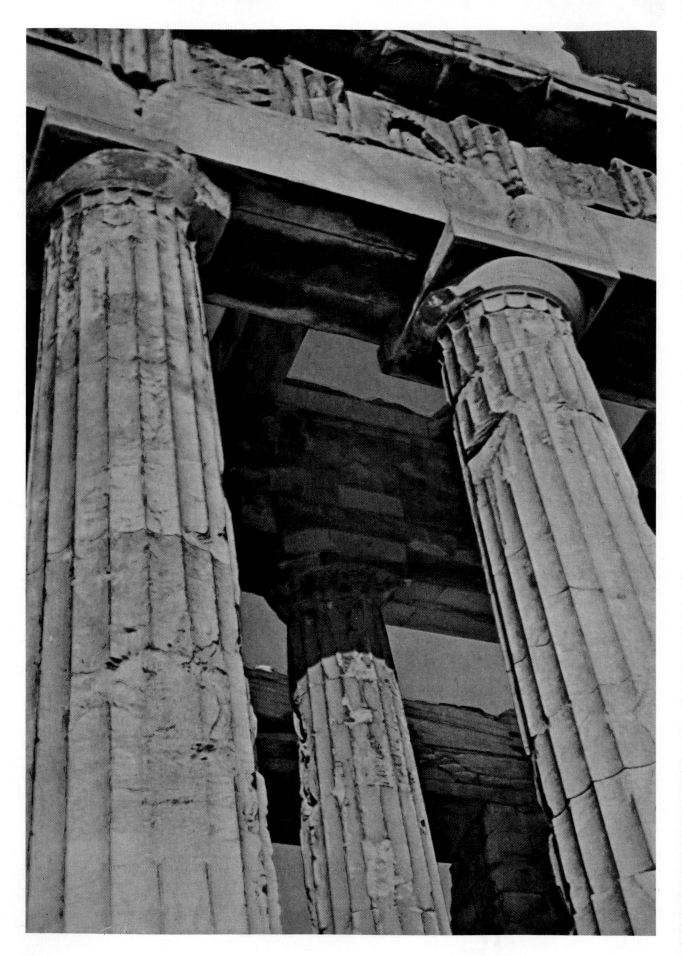

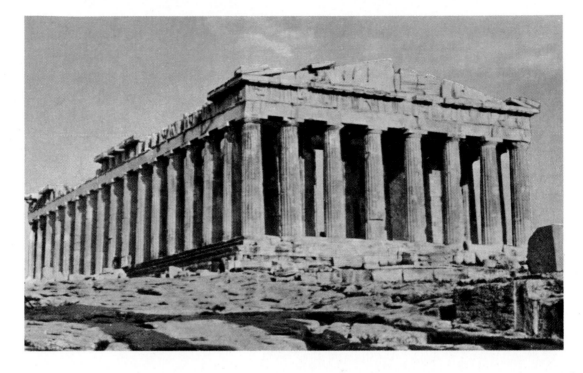

sometimes placed. At most a second narrow chamber was included to house the paraphernalia of the cult. As far as the faithful were concerned, the place was made to be looked at as a whole and to be visited for the offering of sacrifice and homage and was not for 'going in'.

There were two different interpretations of this structure; the Doric and Ionic. The first of these was dominant in mainland Greece, in Magna Graecia and in Sicily; the second in Ionia to the east of the Aegean and, somewhat rarely, in the western regions. Essentially, there were two distinctions between them. One is in the column with a related capital. In the Doric style, this rested directly on the stilobate and was solid and

powerful, narrower at the top than at the bottom with sharply defined fluting. The fluting varied the light and shade of the shaft which was slightly wider *(entasis)* in the central part. It terminated in a geometric sculpted capital divided into two elements: a sort of small curvilinear cushion-like swelling, the echinus, which widened towards the top, and a square flat slab, the abacus, which supported the architrave. In the Ionic style, on the other hand, the column rose from a suitable base with circular moulding. It was more slender, appeared to be more cylindrical, and had more fluting. It supported the typical Ionic capital with two symmetrical curling volutes. The other element of difference is the architrave. In the Doric order it is smooth and compact in the lower part and surmounted by a distinctly rhythmic frieze with alternating vertically grooved triglyphs and square or

Athens: Parthenon, columns and architrave
Plan of the Parthenon and view of the Acropolis

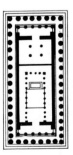

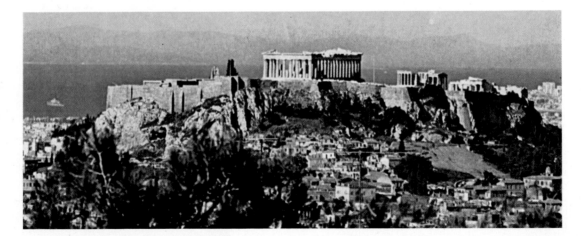

rectangular metopes. In the Ionic order, enhancing the horizontal effect, the architrave was in three inter-related parts surmounted by a continuous ornamental frieze, a design element which was perhaps of oriental origin.

The most imposing archaic Ionic temples, those of Hera at Samos and Artemis at Ephesus, are now complete ruins. It is easier to find examples of Doric temples, even though the oldest of them, the temple of Hera at Olympia, is also falling into ruin. In Greece, the best-known are the temples of Apollo at Corinth and Artemis Aphaea at Aegina and the small building at Delphi called the Athenian treasury, which has columns at the front only. The style is also to be found in the west in the structure of the 'basilicas' and in the temple of Ceres at Paestum, ancient Posidonia, and in the older temples of Selinunte.

Sculpture

The archaic period was also a great period for sculpture and demonstrates the real feeling that the Greeks had for the plastic arts. The human form now became a subject for volumetric sculpture and the very attempt to give plastic form to the human figure – largely with complete indifference as to whether the sculptor was portraying gods and goddesses or simply boys and girls – led to the fine sculpture to be seen in the *kouros* and *kore*. The *kouros*, a statue of a naked boy, is a new and liberal concept of athletic strength. The boy has his left leg forward as if anxious to be off, and his face bears that mildly astonished 'archaic smile', a mark of felicity. This is the first tentative step towards psychological sensibility. The statues of the graceful maidens, *(korai)*, on the other hand, are strictly clothed, and are dressed in the fashion of the day, with the folds and draperies rendered even more attractive by the use of polychrome. Excellent examples of the masculine prototype are: the *kouros* in the museum at Delphi; those from Sunium and Milo in the Athens Museum; the 'Milan' statues in the Archaeological Museum at Florence; the so-called Apollo of Tenea at Munich; the Strangford *kouros* in the British Museum in London, and, finally, the Apollo of Piombino in the Louvre, which is exceptional in that it is made of bronze. The museum in Athens is unsurpassed for the quantity and fascination of its *korai*. Other statues show a more articulate evolution. The mutilated Hera of Samos is Ionic in style and the fall of the thick folds of the gown gives it the appearance of a dying tree, while the arms seem to come to life,

Athens: Erechtheum, the Caryatid porch

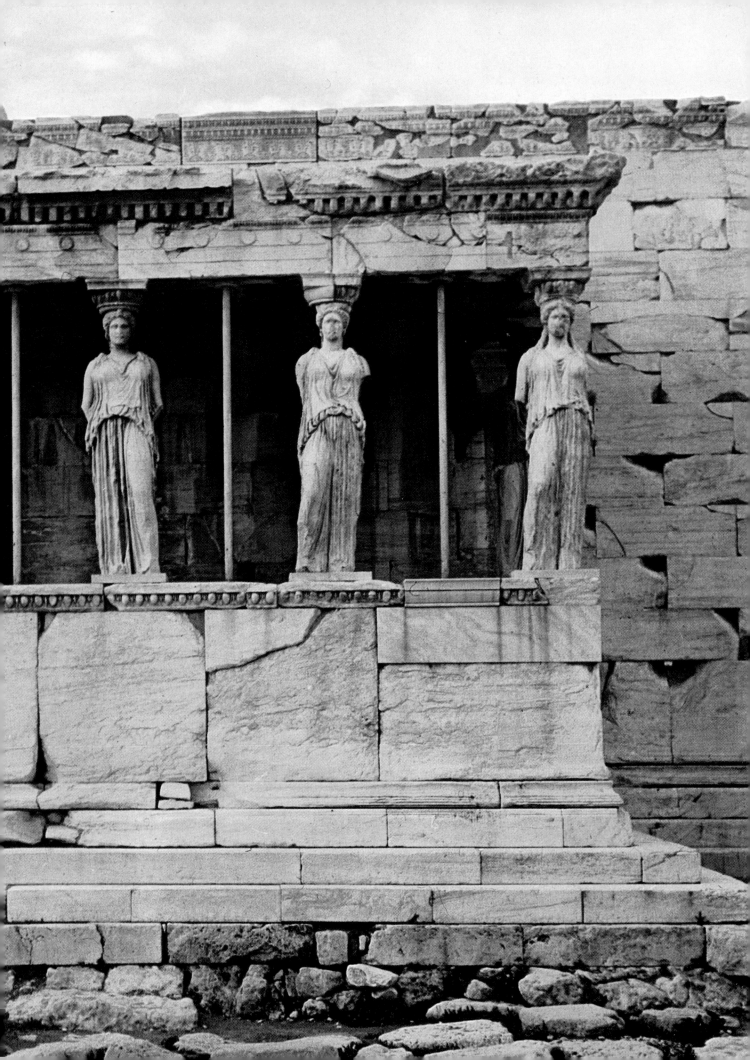

springing, as it were, from the body. The *Calf-bearer* in the museum at Athens is of compact composition. He carries on his shoulders the little sacrificial calf and is the forerunner of the Christian Good Shepherd. The Rampin Horseman is now in two parts: the sharply defined head is in the Louvre and the agile horseman's body remains in Athens.

There were other, later, developments in sculpture, which drew on the inexhaustible repertoire of mythology in order to perform the strictly ornamental function of providing ornamented metopes and pediments in architectural constructions. Pride of place among the metopes must be given to those from the temples of Selinus in the Palermo Museum, for their expressive power, unity of composition and elevation of spirit. So far as pediment sculpture is concerned, the large figures from Hecatompedon (Acropolis Museum, Athens) and the large, well-preserved complex of façade statues from Aegina at Munich are of a very high order in their dramatic contrast of movement. Real Ionic grace and sensitive plasticity are to be found in the bas-relief and free-standing statues of the façades and frieze of the Siphian treasury, once in the shrine at Delphi and now in its museum.

The passage from the archaic period to the classic, which occupied the late fifth and fourth

centuries B.C., does not represent a qualitative 'leap' but a gradual acquisition of maturity, freedom, self-confidence and a desire to get to the heart of things. The archaic conventionalities of frontal positioning disappeared because of the greater mastery of the presentation of the human figure. There was a similar movement away from symmetry, from repetition of a prototype and from the 'archaic smile'. The line which separates the archaic *kouroi* from the nude statue of the young Apollo in the Kassel Museum, or the Apollo of the Tiber (Museo delle Terme, Rome) or from the characteristic head of the Fair Ephebe (Acropolis Museum, Athens) would

Vase, black figure style (British Museum, London)

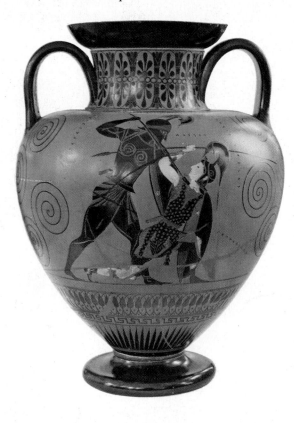

The twelfth labour of Hercules and the capture of Cerberus, vase-painting (British Museum, London)

100

seem to be a very tenuous one, but it signifies a victory over the full formality of former times.

It is customary to refer to a 'pre-classical' or 'severe style' period of transition, before a truly classical one. In the Greek world, this would correspond to the time when many of the Ionian cities, in spite of their rebelliousness, were subjected to Persian rule. But it would almost seem that western Greece was seeking its salvation through art. Architectural growth was prolific, though the Doric temple predominated from this period, with its careful attention to proportion. In mainland Greece, the most famous construction was the now-ruined temple of Zeus at Olympia (465–456 B.C.). This prolific period had repercussions also in overseas Greece, as witness the temple of Poseidon at Paestum, the later, ruined temples at Selinus and the better-preserved ones at Agrigentum. The major sculptural complex is the collection of free-standing figures on the pediments of the temple of Zeus at Olympia, particularly the one representing the 'Battle between the Centaurs and the Lapithae' at the feet of the erect and dominant figure of Apollo (Olympia Museum). To this period (c. 460 B.C.) belongs the so-called Ludovisi Throne (Museo delle Terme, Rome) with, on the back, the bas-relief showing Aphrodite, aided by

'Apollo and the Centaur', from the west pediment of the Temple of Zeus (Olympia Museum)

maidservants, rising towards the light from the waves of the sea. On the sides are the compact, carved figures of a nude female flautist and a veiled woman tending a lamp. In bronze sculpture, the most famous example and one of noble static simplicity, is the 'Charioteer' in the Delphi Museum.

It is usual to place the beginning of the true classical period in the middle of the fifth century B.C. It is marked by the predominance which Athens assumed in artistic creation. This is the period known as the 'century of Pericles', a period which, in reality, was restricted to little more than two generations. The 'century of Pericles' reflected, if somewhat belatedly, the pride of the Athenians in having been, through their naval power, the decisive factor both in the battles fought by the Delphic League against the two mighty Persian invasions, and in the victory over the Persians which, in 480 B.C., saved the West, though Athens herself was destroyed. Here we see the manifestation of that dominant position which Athens had acquired – with undoubted advantages – both financial as well as political – by placing herself at the head of the Delphic League. It also reflects her position as a

strong naval power acting as a shield against the Persians. However, it also expressed, within its limitations, the affirmation of a democratic regime which, for more than thirty-odd years, found in Pericles a leader who concerned himself not only with the political future of his city, but with its splendours and comforts.

It was at Pericles' instigation that Athens prepared herself, just after 450 B.C., to undertake the almost symbolic reconstruction of the Acropolis which had been devastated during the Persian siege. Pericles found in Phidias (c. 500–430 B.C.) an exceptional interpreter for his plans. High and steep, cut off like the superstructure of a ship, the Acropolis, whose monuments were all completed within about forty years, represents the zenith of Hellenic classicism. Although Ictinus and Callicrates were its architects, the Parthenon was entirely the brainchild of Phidias and, in the chastity of its Parian marble and in its horizontal line, expresses those characteristic values of strength and rhythm peculiar to the Doric order. Those values, however, are here made more contained, more flexible and are in incomparable proportions.

It is in this work for the Parthenon that we see Phidias' contribution to great sculpture. Both in the treatment of nudes and in the soft winding of the drapery, he displays a full sense of shape and form. He was responsible for the two pediments, fragments of which are now in the British Museum in London and which represent the 'Birth of Athene' and the 'Dispute between Athene and Poseidon'. He was responsible, too, for the compact composition of the ninety-two metopes. Inside the porticos, at the top, and right round the temple, he placed a continuous frieze, 490 feet long. It was decorated with a bas-relief showing variously individuals and groups of people in the Pan-Athenaean procession which, with the aid of the gods, brought to Athene the woven *peplos* of the Athenian maidens. This frieze is now divided between the British Museum in London, the Louvre in Paris and the Acropolis Museum in Athens. It shows the most exemplary values of Hellenic classicism. Finally, Phidias raised an isolated and colossal bronze statue, representing the armed Athene Promachos, onto the platform and placed in the *cella* of the temple the great statue of Athene Parthenon, which was made in precious gold and ivory, and of which nothing is left but the record of its existence. A similar fate befell the gigantic Promachos statue, and also the 'chryselephantine' (with gold

The 'Diskobolos' by Myron (Museo delle Terme, Rome)

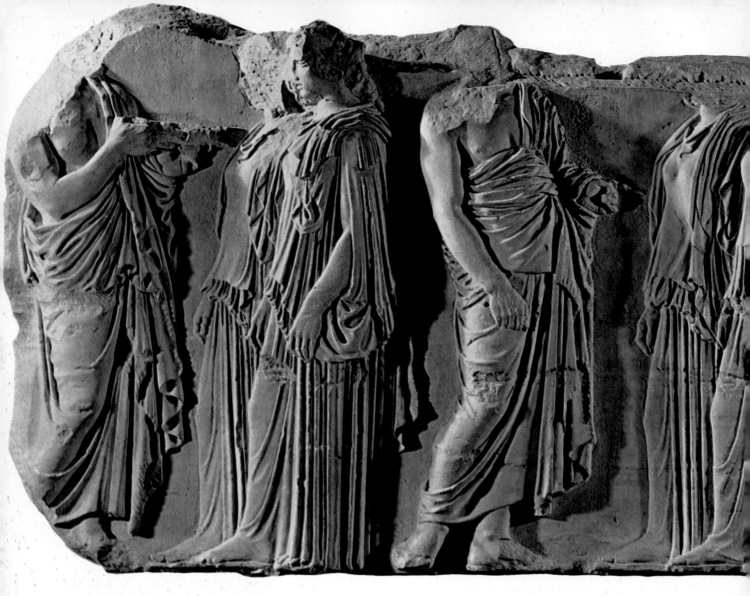

and ivory overlaid on wood) which Phidias, at the end of his life, when he had been banished from Athens, made as a sublime glorification of Zeus for his temple at Olympia.

The Acropolis was laid out according to a carefully thought-out plan, and included other monuments. The Propylaea of Mnesicles (437–432 B.C.) was especially well designed and intended to be seen from below. With its combination of Doric and Ionic elements, it formed a suitable introduction to the whole complex. Next came the small temple of Athene Nike (about 425 B.C.), which projected below a small slope and was a splendid example of the Ionic order. Its continuous frieze and some fragments like 'Victory lacing her sandal' (Acropolis Museum, Athens) from the ancient entablature, are important contributions to classical sculpture. The Erechtheion is a later (407 B.C.) and more complex structure because it had to unify a number of sacred places on different levels. It, too, is Ionic and brought in a new element in the form of a porch supported by sculpted statues of caryatids

which break the solemn severity with their grace.

Architecture developed intensively, not only in Athens but in the whole Greek area, and there were some innovations even in the 4th century B.C. at the end of the classical period. The most important of these was the creation of permanent structures for theatres. These were characterised by the aesthetic and functional geometric unity of the steep rise of the steps of the semi-circular arena, by the flat development within the semi-circular or circular area of the orchestra, cut off from the fixed scenery. The theatre of Dionysus at Athens on the slopes of the Acropolis; the theatre at Delphi; the perfect theatre at Epidaurus and, in the west, the one at Syracuse are the most splendid examples. There is another novelty which belongs to the fourth century and which was destined to be developed both by Hellenist and Roman architects. This was the new order, the Corinthian, which was a compromise form derived from Ionic. Substantially, it substituted for the Ionic capital another type with curling acanthus leaves. It first appeared in the round

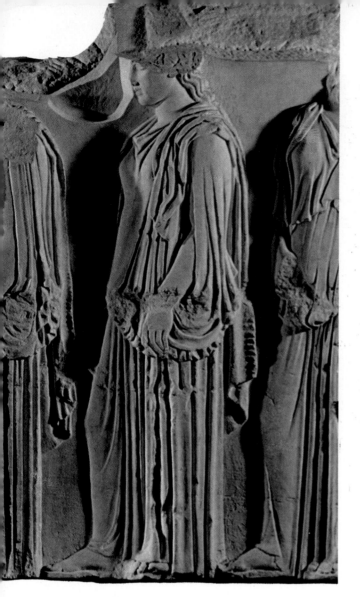

Greek contribution to painting. That pictorial heritage, whose existence is vouched for by the fame of Polygnotus, fifth century, and of the Hellenistic painter Apelles, has totally disappeared. Only the vase-painting survives, and we know of great artists in this genre both from Athens, where it finally achieved great heights, and from other provincial or peripheral centres, including Magna Graecia. Vase-painting, which had already developed in the archaic period, made vivid use of figures, even if, on the flat, painted background, they were devoted essentially to the expressive values of design and sensitivity of line. It passed gradually from the technique of black figures on a red ground to red figures on a black ground and, later, to the funerary urns with a white background decorated with evocative and flowing designs.

The end of the fifth century marked a profound change in the history of Greece. Athens became involved in the thirty-year Peloponnesian war, and its defeat, in 404 B.C., after the catastrophic expedition against Syracuse, marked the end of its sway, although victorious Sparta did not succeed in replacing it. A period of crisis and anarchy ensued. It ended only when, after the battle of Cheronea in 338 B.C., Philip of Macedonia, a foreign king, imposed his dominion on mainland Greece, bringing with him political unification under the umbrella of the monarchy and reinforcing the values of Greek civilisation.

Hellenic classicism continued to proliferate,

temples at Delphi and Epidaurus, but was more widely applied later on.

In sculpture, of which there was a great deal, other sculptors, outside the vast sphere of influence of Phidias, made innovations. There is a sharp contrast between the Peloponnesian, Polycleitus and Myron. The latter, with his famous discus-thrower, typified the engagement of sculptors since the beginning of the classical period in the portrayal of figures expressing to the full not only athletic tension but movement in action, too. Polycleitus, especially in his static *Doryphorus*, or javelin-bearing athlete, sought to fix the canons for the perfect proportions of the human form. Peonios, at Olympia, created a fine 'Victory' soaring up on wings. The original for the Esquiline Aphrodite, by an unknown sculptor, gave concrete form to the ideal of beauty represented by the naked Aphrodite. Finally, the sculpture of the intimate funerary steles is worthy of at least a mention, if only for the human values of calm pathos they embody.

We can make no pretensions to the study of the

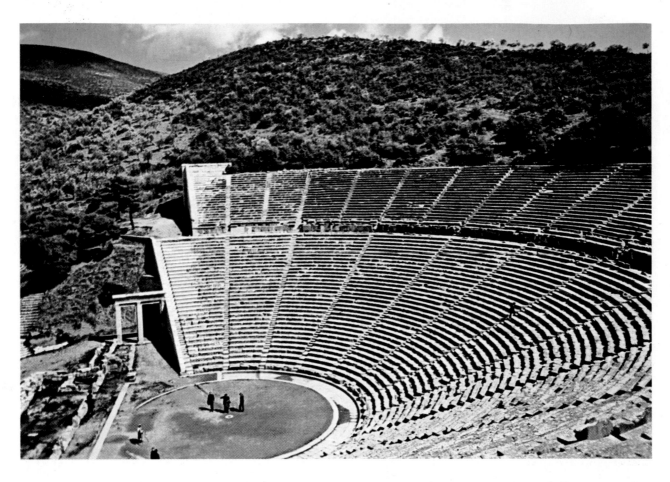

showing, in its formal dignity, some signs of a second classicism. But it existed in a world which, from then on, was shaken to its foundations. Sculpture, particularly, reached a high level. At the end of the fifth and start of the fourth centuries B.C., the sculpture of Scopas, of which very little remains, broke the serene balance of the classical period with dramatic passion and with a curious sense of extreme unease and psychological anguish. The greatest sculptor of the fourth century B.C., Praxiteles, already gave a foretaste of the end in his retreat into a languid grace and into that voluted harmony which inspired the masterpieces, copies of which have come down to us. His genius is seen in the abandon of the 'Satyr at rest'? in 'Hermes playing with the infant Dionysus'; the 'Apollo *Sauroctonus*' who leans his slender body against the tree trunk as he waits to strike the lizard emerging from it; and in the placid and compelling figure of the Aphrodite of Cnidus. The sculpture of the Peloponnesian Lysippus, especially that in bronze, belongs to a later time, parallel with the brief and brilliant parabola of the Macedonian Empire of Alexander the Great. Also from this period we have the weighty figure of the *Apoxiomenos*, the athlete who is cleaning himself after the race, and the relaxed study of 'Hermes seated in repose', both of which are known to us through Roman copies. A new field, flowering particularly in the Hellenist era, was portraiture, which showed definite signs of psychological characterisation.

The Hellenistic period

The Hellenistic period was the zenith of Greek art. It began before the end of the 4th century, in 323 B.C., with the premature death of Alexander the Great and with the dissolution of the vast Macedonian Empire which, in his efforts to overcome the Persians, he had expanded by conquest as far as India and Egypt. The Empire was divided among the three dynasties of the Antigonides in Macedonia, the Seleucides in Asia and the Ptolemies in Egypt. The dating of the end of the Hellenist period is less certain and corresponds only roughly with the beginning of the Christian era. From the artistic point of view, in fact, it did not disappear with the political conquest of Greece by Rome. Indeed, this event led to the Roman obsession for Greek art and culture and to the transfer to Rome of many Greek artists and craftsmen. Thus Roman art was infiltrated by Hellenist influence. ('Greece, the conquered, enslaved the rude conqueror', said Horace.) In any case, Hellenist

traditions persisted tenaciously in the peripheral settlements, even under different political regimes.

The Hellenistic period was a time of great expansion of the Hellenist sphere of influence so that it 'burst' the traditional bounds. To the north, it incorporated Epirus, Macedonia and Thrace; to the east, it included Persia, Mesopotamia and Syria; and, above all, there arose, on the Anatolian coast, on the site of ancient Ionia, such splendid centres as Pergamum, Ephesus, Alicarnassus, Rhodes and Antioch, on the border of Syria. In its heyday, Hellenism incorporated Egypt and was vitally concerned in the founding of the splendid city of Alexandria, which became almost a new Hellenic capital. As a result of this expansion, a far-reaching, eccentric motion was set in train. In Greece, the autonomous structure of the city-states was wiped out by the rise of a monarchy which had many affinities with the East, even to the deification of the sovereign, and which became empty and impoverished through having to sus-

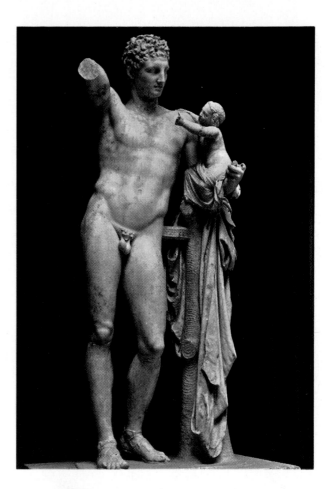

Opposite page: *Epidaurus, the Theatre*

Hermes and Dionysus, by Praxiteles, copy (Olympia Museum)

Venus of Milos, detail (Louvre, Paris)

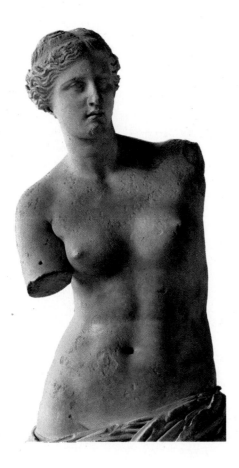

tain the power and the culture of that immense area of the new Greek dominion and of its numerous courts. For their part, the multifarious centres broke what had been the spiritual unity of classical Greece, because their own specific cultural and artistic talents were differently inspired, often through infiltrations from other culture, particularly eastern ones.

Hellenistic art, therefore, is fairly complex and could, erroneously, be considered as the fruit of decadence or dissolution. There was a tension between elements that were disparate, heterogeneous and, compared with the classical period, innovatory. There was no particular repudiation of the past, whose greatness and exceptional qualities were recognised. However, these qualities came to be viewed, intellectually, through the veil of a culture which, in the name of tradition, codified the principles and the norms of the artistic process, outlined the academic and purist aspects and marked the passage from the spontaneity of the classical age into the inward-looking conservatism of false classicism. Besides, other insidious aesthetic demands, corresponding to changes in society, made themselves felt. These ranged from the exterior exigencies of elegance, refinement, pomp and eroticism to the

more inward ones of the passionate search for realism and free movement.

In architecture, there was a less prejudiced employment of the traditional orders, which were sometimes used in combination. The Corinthian order was greatly developed, both in temples of traditional structure, like the temple of Olympian Zeus at Athens (second century), and in the gracefully elegant circular edifices like the votive monument built by Lysicrates at Athens (close of fourth century). Architecture was also applied in a new way to porticos, gymnasia, libraries, theatres and funerary monuments. But we must look to the great centres beyond the Aegean for new developments in terms of grandeur, variety of structure and technique, though almost all that went to make up the splendour of Alexandria was lost. Some examples may be found in the great temple-altar of Zeus, built in 180 B.C. at Pergamum and now reconstructed indoors at the museum in East Berlin; in the *bouleterion*, or senate, at Miletus; in the mausoleum at Alicarnassus, with its high base; and in the severe layout of the towns of Priene and Alexandria.

The field of sculpture is more varied still and very prolific. Famous works, like the 'Apollo Belvedere' (Vatican Museum, Rome) – which, chronologically, marks the division between classical and Hellenist – are still classical in mood, touched by a compelling beauty and grace. So also are the many nude Aphrodites which are derived from the one by Praxiteles and which culminate in the Aphrodite of Syrene (Museo delle Terme, Rome) and in the Aphrodite of Milos (Louvre, Paris). But the terms 'baroque' and 'anti-classical' spring to mind to describe the effect of the hurricane which seems to have swept across the figures in the great friezes around the base of the altar at Pergamum, now in the museum in East Berlin. The same influence seems to have caused the complicated entanglements of shapes and forms, line and space in the Pharnesian Bull (Naples Museum) and in the arabesques and contortions of the Laocoön group (Vatican Museum, Rome). The latter came from fervid Rhodes, and at the beginning of the 19th century was wrongly seen as one of the peaks of classicism. For intensity of impetuous emotion, outside of classicism, the 'Victory of Samothrace' (Louvre, Paris), breasting the wind and solemnly beating its great wings, is unsurpassed. A new aspect of bronze and marble sculpture in this period was the seeking after realism. This is shown in the tendency to draw on types and figures from everyday life (the most significant example is the 'Knife grinder' at the Uffizi, Florence), though this tendency carries with it the risk of superficiality. This same search for realism is also seen in picturesque genre scenes and in a tendency towards extreme, sometimes theatrical, dramatisation. Such trends can be noted in the 'Dying Gaul' (Capitol Museum, Rome), the Menelaus and Patrocles under the Loggia dei Lanzi at Florence and the group consisting of a Gaul, holding his dead wife, about to kill himself (Museo delle Terme, Rome). In the minor arts, the polychrome terracottas of Tanagra are vivid and fascinating. A delightful selection of figurines of fashionably elegant ladies has survived, showing them in such activities as trying on garments or trying out the steps of a dance.

By the early 300s, vase-painting was finished. There was certainly a renewal of great painting, apart from the fame achieved by Apelles in the time of Alexander the Great. This is confirmed by the preference for pictorial rather than plastic effects. However, all evidence of such painting is lost, except for a mosaic copy of a Hellenistic original depicting Alexander at the battle of Issus (National Museum, Naples), which came from Pompei. Hellenist painting gave much life and inspiration to Roman wall-painting.

Nike (Victory) of Samothrace (Louvre, Paris)

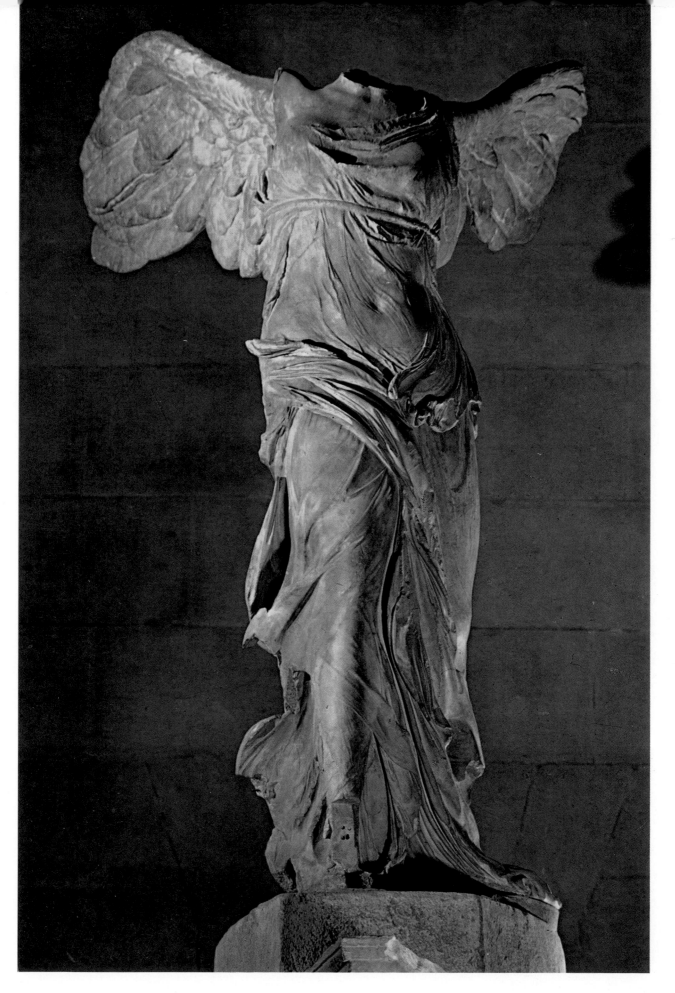

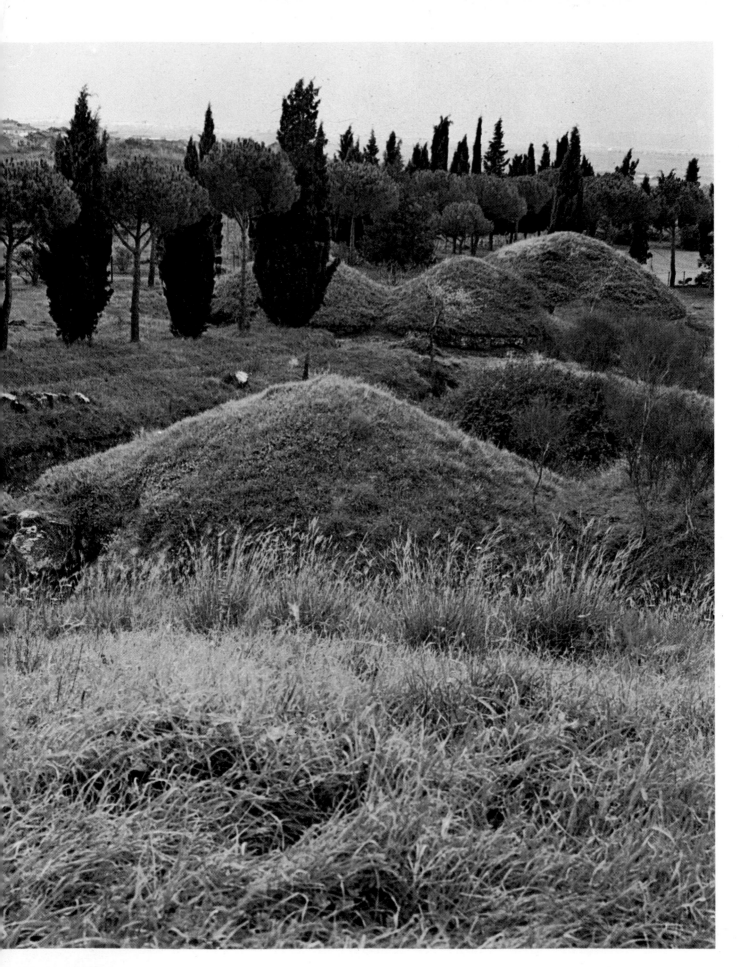

ETRUSCAN ART

Opposite page: Tumulus tombs at Cerveteri. Below: *'Capitelli' Etruscan tomb at Cerveteri; tomb covering with circular plan*

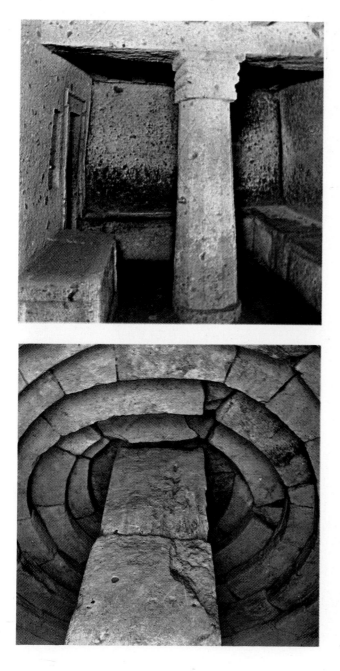

The art of Rome was rediscovered in the 16th century, while the peak of interest in Greek art was reached in the 19th century. But the first research into Etruscan art and civilisation took place in the 18th century – even though to begin with, it led merely to arbitrary and curious conclusions. The 18th century was a period of great interest in language, epigraphy (the study of inscriptions) and all forms of art. It was, however, not until the 19th century that this kind of study was based on historical knowledge, with its consequent critical rigour. It was especially after the unification of Italy that excavations undertaken at Tarquinia, Vulci, Chiusi, Vetulonia, Bologna and other settlements, yielded such a vast amount of fundamental evidence as to permit serious study, leading to the establishment of systematic collections and the undertaking of excavations still in progress today.

The civilisation and artistic work of the Etruscans had their origins in Etruria, between the Tyrrhenian Sea, the Arno and the Tiber. The main cities were Veio, Chiusi, Perugia, Cortona, Arezzo, Fiesole and Volterra. Between the seventh and sixth centuries, Etruscan influence spread south (to Rome and into Campania) and, between the sixth and fifth centuries, northwards (to Cesena, Spina, Parma, Piacenza, Mantua and Marzabotto). The influence of Etruscan artistic creativity on this vast area was so great that it survived to determine, in part, the art of the Romans. This occurred despite the Etruscans' defeat as a sea power on the Mediterranean by the contemporary naval forces of Greece and Carthage, and their overthrow as a political power when Veio fell to the Romans in 396 B.C. The Romans adopted most of the constructional forms of Etruscan architecture, as well as the more significant aspects of sculptural realism. They perpetuated it while, at the same time, adapting it to different architectural demands and to a different historical authority. A problem of fundamental importance, and one which is an essential preliminary to any investigation of Etruscan art, is that relating to the classicity or anti-classicity of its artistic expression. The solution of this problem, expressed in the simplest of terms, lies in the distinction between the Etruscan creative spirit, which had undoubted

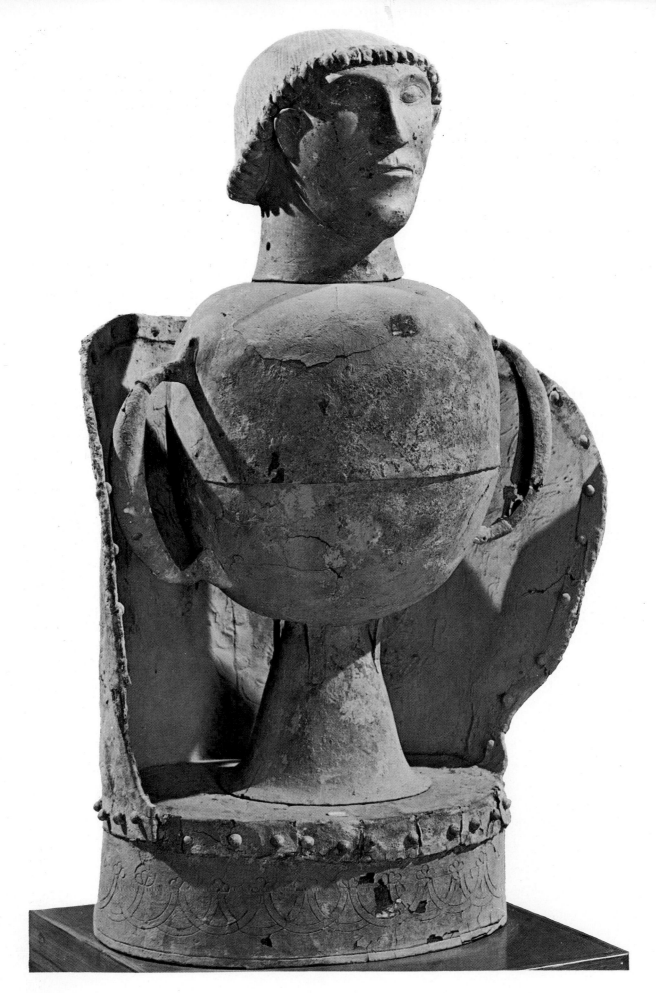

originality in its refutation of the measure and harmony of classical Greece, and the acceptance, in autonomous forms of the exterior aspect of Greek art. This acceptance is easily understood when it is remembered that examples of Greek art were then widely disseminated in southern Italy and Sicily following the establishment of Greek colonies there.

The most beautiful Etruscan art (8th–7th centuries B.C.) came, broadly speaking, from the very ancient cities of Tarquinia, Vulci, Vetulonia and Chiusi, and is represented by funerary ornaments in bronze or terracotta. These reveal a primitive clumsiness which is justifiable against a background almost of pre-history. But they are also characterised by middle-Asian refinement engendered by the contacts of seafaring peoples. Almost all of this artistic activity is bound up with the concept of the after-life which, until the fourth century, was understood as a continuation of earthly life in its serenity and affections. The most common objects are cineraria of cast bronze with geometric motifs and possessing lids decorated at the top with figurines of dancers or warriors bearing lance, shield and cudgel. Even more indicative, though, of the proto-Etruscan style are the cineraria, sometimes called 'canopi', in terracotta. One of these, from the Chiusi district (Chiusi Museum), consists of an urn placed on a kind of armchair, almost as if to suggest the restful life beyond the tomb. It is completed with a cover in the shape of a head with eyes and mouth shut tight, as if to signify the absolute distance which separates death from earthly things.

Architecture

Etruscan architecture dates mainly from the sixth century. The examples that have come down to us are tombs rather than religious or secular buildings. The reason is that the tombs

Etruscan burial urn from Dolciano (Chiusi Museum)

Flautist, fresco from the Triclinium tomb (Tarquinia Museum)

Volterra: Etruscan arched gateway

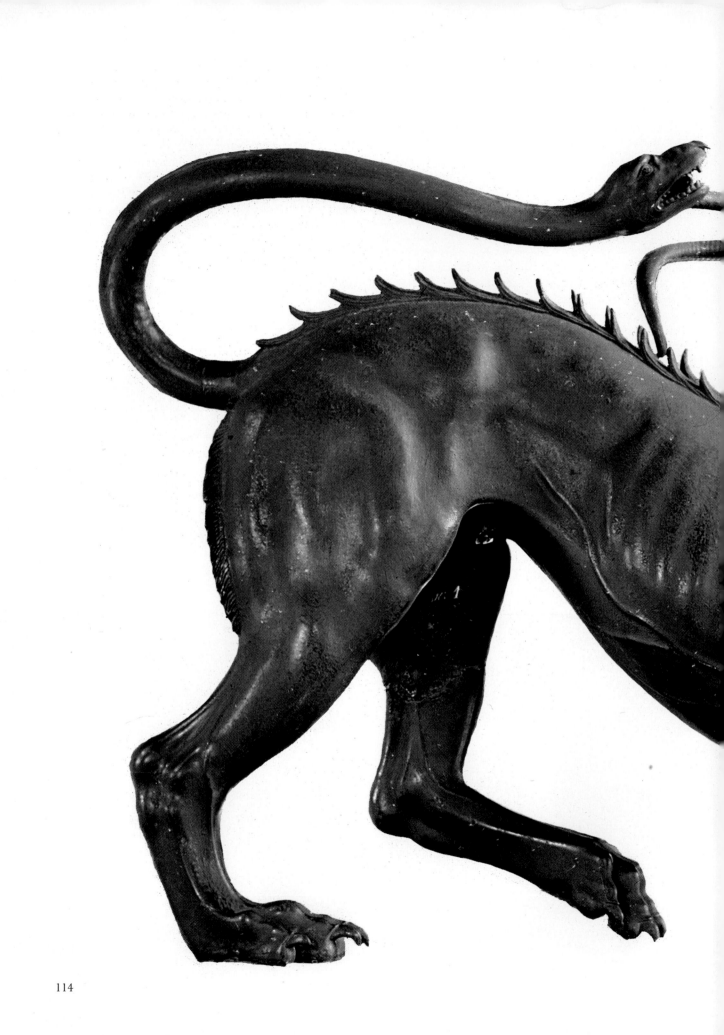

114

Bronze chimera from Arezzo (Archaeological Museum, Florence)

were made of stone whereas temples and dwellings included in their construction light, easily perishable materials like wood or polychrome terracotta. Nevertheless, it is relatively easy to reconstruct the layout of particular towns, both in relation to their position, which was always on high ground where there was natural protection, and in relation to their form. The towns were always oriented according to the points of the compass and were enclosed within imposing walls with

115

related gateways. On the outside of these stretched the necropoli, characterised by rock tombs and by regular access carriage routes.

The excavations at Marzabotto, near Bologna, led, among other things to the identification in the Etruscan city of the main north-south road, of the *decumen* (main gateway) and of the streets. The latter were a good fifty feet wide, bounding the *insulae* of houses which were, perhaps, for communal habitation. The acropolis at this site shows that there were three temples of the kind

described by the Roman architect Vitruvius. These were intended to house the *haruspex*, who interpreted and divined coming events by examining animal entrails, and observing the occurrence of thunderbolts or the direction of birds' flight. The structures have an affinity with the archaic Greek temple in the rectangular box plan raised on a podium, and to which access was made by way of a colonnaded atrium. The columns, known as 'Tuscan columns' have a note of originality in the smooth surfaces and in the circular base and rounded echinus. The terracotta decorations on the architraves are free from

Dancers, fresco in the Tomb of the Lionesses at Tarquinia

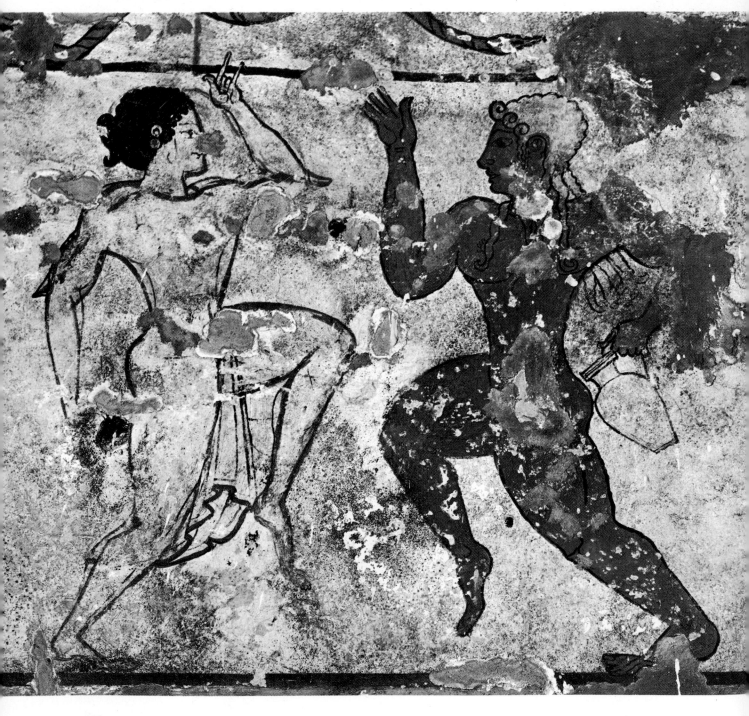

classical influence, as are the famous antefixes, among which must be mentioned the one from Veio from the sixth to fifth centuries. It portrays a female face, in a halo of shells with the aristocratic ringlet hairstyle and earrings, and is significant in its taut, penetrating expression. There are also antefixes with statue groups made from baked clay like that of 'Selene and a maenad dancing together' (from Satrico) which is unrestrained and uninhibited. It is thought to date from the sixth century, and shows certain Asiatic influences.

Sculpture

One of the most fascinating pieces of Etrusco-archaic sculpture comes from the Temple of Portonaccio at Veio, where it used to be on the top of the gable. It is the head from a statue of the god Hermes, sculpted in about 500 B.C. by the creator of the Apollo of Veio. Although inspired by Ionic art, the sculpture gives a vibrant, springing vigour to the mass of the Hermes, but this vigour is controlled by the delicate, though firm, outline. Essentially linear (the strong jaw, the flowing hair), its rhythm is broken only by the fanciful detail of the curls, to return in the modelling of the eyebrows, the eyes and the open lips, on which plays the 'Etruscan smile' customary in Ionic-Asiatic work. The red-brown of the skin, the yellow of the wings on the helmet and the black of the contours have a vitality which makes this piece a most valid argument in favour of the anti-classicity of the Etruscan work of the sixth century. Nevertheless, the *chef d'oeuvre* is the Apollo of Veio (Museo di Villa Giulia, Rome), attributed by the most ancient writers to Vulca, who was also known as the Master of the Apollo of Veio. The statue is the surviving piece of a group which showed the struggle between the god Apollo and Hercules for the possession of a hind. The young god is just about to throw himself forward and the balance is wholly in the diagonal line of the back leg and the small, out-thrust head. The essence of the work is the sculptural tension which lacks the compulsion of realism and the distraction of decoration. A strict sense of unity governs every part of the body so that the jutting chest, the leg muscles and the fall of the ringlets all express the same tension. The enigmatic smile, too, is fused into this formal conception, with a talent for transfiguration which is the most noble aspect of Etruscan work. It is this poetic content which

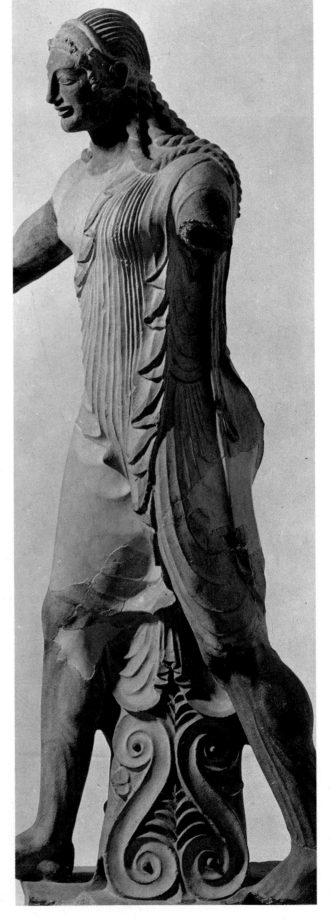

The Apollo of Veio (Museo di Villa Giulia, Rome)

117

upholds the thesis of originality in Etruscan art, even though, as in the Apollo of Veio, the firm drapery is of Ionic derivation.

The same anti-classical concept is evident in the carvings on the sarcophagi covers, which were modelled as triclinia showing the deceased at the banquet table in the after-life. The most famous example is the Cerveteri sarcophagus (Museo di Villa Giulia, Rome), dating from the second half of the sixth century. There are noble bust-portraits emerging clearly, and with a heavy sculptured form, from slim bodies which are so slender in the thighs and legs that they hardly show under the drapery which covers them. The cheerful, affectionate gestures reinforce the intense expression of the faces which have clear-cut edges defining the outlines of the slanting eyes, the enigmatic mouth, the shape of the hair and the lines of the headgear. Their vivacity and psychological overtones are markedly anti-classical, and are constant in every aspect of Etruscan art work, but they are especially noticeable in the sculpture of the 6th century. The bronze sculpture of the Ionic period shows the same characteristics. Proof of this can be seen in the small bronzes like the Minerva Promachos of the Estense Museum at Modena and the Capitoline Wolf (Capitol Museum, Rome). The latter has an extremely sharp outline, with a taut, shining coat and schemati-

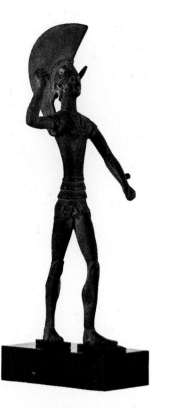

Bronze statuette of an Etruscan warrior (Private Collection, Paris)

Terracotta sarcophagus, depicting a man and wife at Cerveteri (Museo di Villa Giulia, Rome)

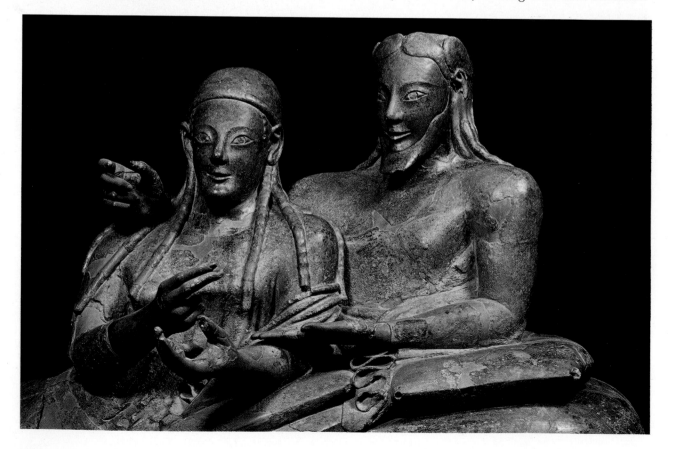

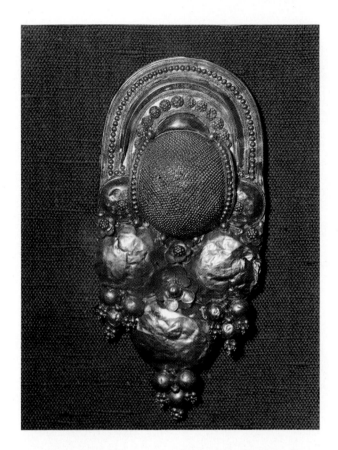

Etruscan goldwork ear-ring, 4th century (British Museum, London)

Etruscan gold necklace from Ruvo di Puglia (Archaeological Museum, Naples)

cally decorative curled mane. The savage head is sharply turned and the damp muzzle of the beast snarls fiercely.

Architecture, as we have noted, was mainly concerned with tombs. There the problems posed by the covering of the circular or rectangular plan tombs had been resolved respectively by 'thelos' vaults, as at Casale Marittimo, not unlike those on Crete and at Mycenae, and by underground vaults completely cut out of the rock, covered with a tumulus of earth. Generally speaking, however, the Etruscan tombs are less famous for their architectural significance than for the great cycle of wall-paintings begun as early as the sixth century and continued up to the first century. These are the oldest frescos on Italian soil. They are very important as source material for the investigation of the religious sensibilities, culture and concept of life of a people whose language is still a closed book and who therefore must speak to us through their art forms.

Painting

The oldest Etruscan pictorial tomb decoration (sixth century) is that of the 'Bull' tomb at Tarquinia. It concerns the myth of Achilles, which was handed down in Italy as part of the heritage of Greek poetry but which, in the

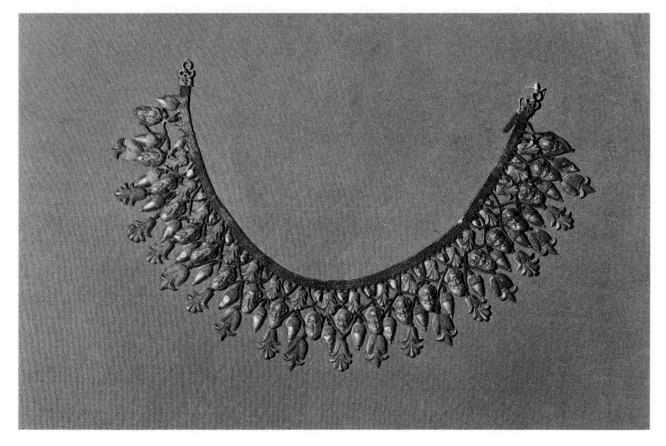

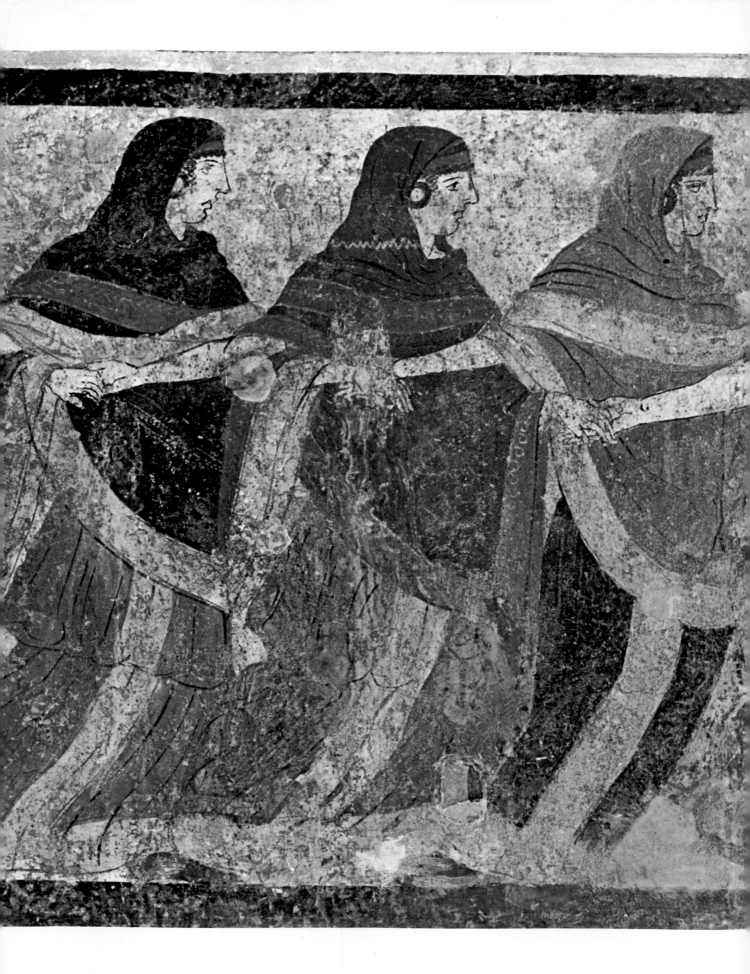

painted form, is markedly Etruscan. Here, in the encounter between Achilles and Troilus, horses and riders are presented in profile with a delicate freedom of line which suggests that the drawing was done free-hand, without the help of models. Ingenuous, stylised trees suggest naturalistic ideas without ever falling into mere imitation of nature. Similar characteristics, but with notable stylistic development, are to be seen in the wall-paintings in the tomb of the Augurs at Tarquinia, built in 530 B.C. The subject matter has nothing to do with mythology, being an illustration of the order of succession of the funeral ceremonies: the leave-taking, the eloquent gestures of the people beside the closed door and the games and dances which, on the side walls, reiterate the deceased's earthly pleasures. The wrestlers, in the centre of the left-hand wall, are burly brown shapes whose massive raised heads have only schematic features. Black outlines make the profiles stand out on a clear background, while beards and hair are flat compact masses. In the vast amount of painting belonging to the sixth century, the tomb at Tarquinia with its paintings showing scenes of hunting and fishing is of particular significance. It is, in fact, a complete description of a Mediterranean coastal scene, with different species of birds and fish in vivid colours, in full movement and in the most modernistic rhythms.

The fifth century brought Etruscan painting to that level which has made its anonymous painters worthy of the epithet 'masters of the severe style'. The masterpiece is in the 'Leopard' tomb at Tarquinia, dating from about 470 B.C. On the back wall three couples are reclining on a couch, elegantly clothed and crowned, their gestures an invitation to enjoyment. On the side walls, musicians, dancers and cup-bearers move towards them, separated from one another by schematised flowering shrubs with multicoloured blossoms, to evoke the rebirth of spring. The brown skins stand out in flat contrast to the flowing drapery and the profiles are laid on roughly against a clear monochrome background, the contour lines so confident as to lend support to the theory that these pictures had been worked out beforehand in cartoon form. The rhythms are free-flowing and the composition is lively and spontaneous. Here, Etruscan painting is writing what is, perhaps, its lengthiest and most serene chapter, for, from the fourth century, it was invaded by a sense of anguish and terror spread by the Greek concept of Hades. Thus, the pictures in the 'Ogre' tomb at Tarquinia show demons and serpents which strike terror in the faces of the dead. This was also a technical turning point in the adoption of chiaroscuro forms in relief, imitated from the figures on the classical Greek vases which came into Etruscan territory largely with the spread of the new spiritual climate.

Sculpture, too, between the fourth and second centuries, lost that absolute originality which had characterised it in previous ages. This was not a chance transformation. First of all, it was a reaction against the return to Hellenism which manifested itself in a more rigid return to the past with, in consequence, more archaic or crudely truthful forms. Later, there was complete abandon, until the adoption of formulae and schemes which were more academic than classic. The first of these two movements is well exemplified in the sarcophagus covers with full-length portrait sculptures – sleek, fat and sluggish, realistically stretched out and sometimes enlivened by the addition of mannered drapery. The few original works, like the torso of Apollo of Civita Castellana (third to second centuries, Museo di Villa Giulia, Rome) give some indication of the state of affairs in the later period.

The bust-portraits or simple portrait-heads in bronze, terracotta or stone were an altogether separate development, as can be seen from the so-called Brutus (Capitol Museum, Rome) or from the heads of young men at Florence or Fiesole. Here, as in the better-known statue of an orator (Archaeological Museum, Florence), we see the new element of the psychological insight into the subject, whose spirit is expressed in the interplay of light and shade on the modelled surfaces. This was the last stage of Etruscan statuary, which then passed into the heritage of the Roman world, as, in the field of architecture, did the invention of the centralised arch applied by the Etruscans to the gateways in their curtain walls. Indeed, one of the basic structures of the Roman architecture which followed was derived from the arch of Volterra and the arch of the Marzia Gate at Perugia, and was founded on the curve of the vault, in clear and direct contrast with the Greek styles.

ROMAN ART

Architecture to the beginning of the 2nd century A.D.

The greatest thing the Romans built was the Roman state. As the early monarchy gave way to the Republic, and the Republic to the Empire, this solid, yet flexible organisation grew from a modest league of rural tribes in the Latium region of central Italy into the power which absorbed the Etruscans and unified Italy, destroyed Carthage and established Roman domination over the Mediterranean, and embraced that huge array of nations synonymous with Western culture in Europe, Asia, and Africa. Throughout this vast territory all were Roman citizens, and the Roman way of life prevailed, buttressed by the sense of right and a subtle mixture of authority and democracy.

The needs of the Roman world enforced a practical outlook towards life in all its various aspects. It is not surprising then, that Roman art bore a practical stamp. To facilitate communications and the movement of troops, highways were paved with stone, and a solid structure of stone or brickwork was the formula for bridges – a formula repeated in the case of aqueducts which, raised on arches, brought water to the cities. These amenities, developed at an early stage in the history of Rome, were the first fruits of Roman architecture which, as time went on, acquired a monumental character. But if the graceful and the elegant gave way to the solid and the imposing, this was not merely because the Romans considered grandiosity a symbol of power. More important was the necessity to cater for the needs of the masses with huge forums, huge public baths, huge theatres and circuses.

The study of the stylistic idiom and historical development of Roman art must start from the premise that whereas Rome began her political and civic life in the 8th century B.C., she had to spend long centuries overcoming practical problems and assimilating foreign influences before her artistic activity acquired a poetry of its own and attained classical stature. In fact Rome absorbed ideas from both the native Italic and the Graeco-Oriental traditions, that twin source of the vital

General view of the Forum, Rome

substrata which had a lasting influence on her art, even when she took ideas directly from classical Greece. Consequently Roman art as such was a child of the Augustan age (43 B.C.–A.D. 14). For all its late birth, however, it proved sturdy and, during the twenty-seven years of Flavian rule (70–96), prepared the way courageously and fruitfully for the advent of imperial art proper. This spread to Asia Minor, Africa, and central Europe, acquiring an idiom worthy of the imposing reality that gave life to it.

The contribution of pre-Roman culture to the birth of Roman art provides a most interesting prelude to the study of what was achieved by Roman artists in Republican days. Italy emerged from the Bronze Age without any attempt at political unity having been made. As a result its artistic output was uneven in quality and varied in range. Direct contact with the cultured Greek colonies meant the attainment of high levels for Etruria, Campania, and certain other parts of the South (Sicily and Magna Graecia must be excluded, because they developed independently). On the other hand, vast areas of northern Italy passed almost imperceptibly from pre-history to the age of Roman domination and the acceptance of Roman art. Again, there were some zones whose art betrayed more distant influences. In Apulia, artists turned to Illyria and Crete for inspiration, whilst those in Picenum (the modern Marches) looked still further afield to the lands around the Danube. In the fifth century, Liguria was still diffusing Celtic culture.

To pinpoint examples among so many different art forms is difficult because archaeological digs usually reveal a variety of styles. One find in the Abruzzi, however – the Warrior of Capestrano (Chiusi Museum) – is certainly Italic. Dating from the middle of the sixth century, though discovered only in 1934, this example presents an abstract, plastic vision of reality in concrete form, rigidly assembled, and boldly finished with the crested helmet of Picenum. Also Italic, but of another kind, is a fresco depicting dancers, dating from the end of the fifth century and found at Ruvo di Puglia. It is now in the Naples Museum. There is no hint in this fresco of mythological influences, no conformity to classical convention. The whole picture breathes realism: faces peeping out from black shawls, hands making symbolical gestures.

In the eighth century, when Rome began her historical existence on the Capitoline, the slopes of the Palatine, and in the valley where the Forum would eventually be built, she took for her first plan that of an Etruscan walled city with gates and, inside, dwellings built to an elliptical plan. The 'City of Romulus' with its round hut sites unearthed by archaeologists on the Palatine has revealed this. Further evidence of Etruscan influence is supplied by the barrel-vaulted sewer, the Cloaca Maxima. The original conception of

The Temple of Fortuna Virilis, Rome

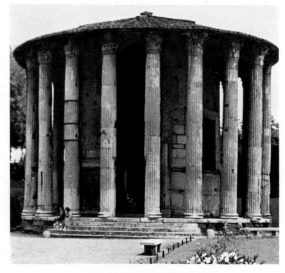

The Temple of Vesta, Rome

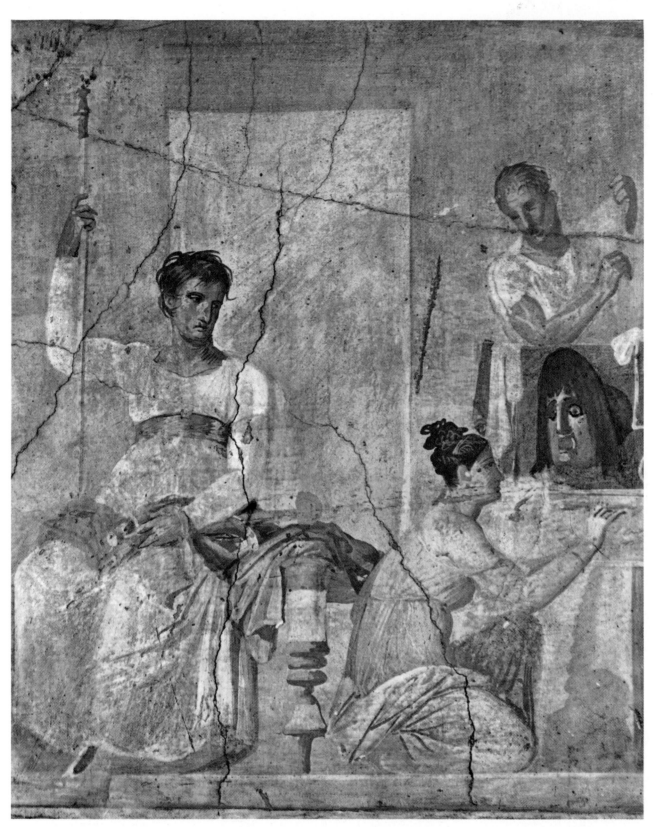

'*The Actor*', *fresco from Herculaneum (National Museum, Naples)*

Remains of the Pons
Aemilius, first stone bridge
in Rome

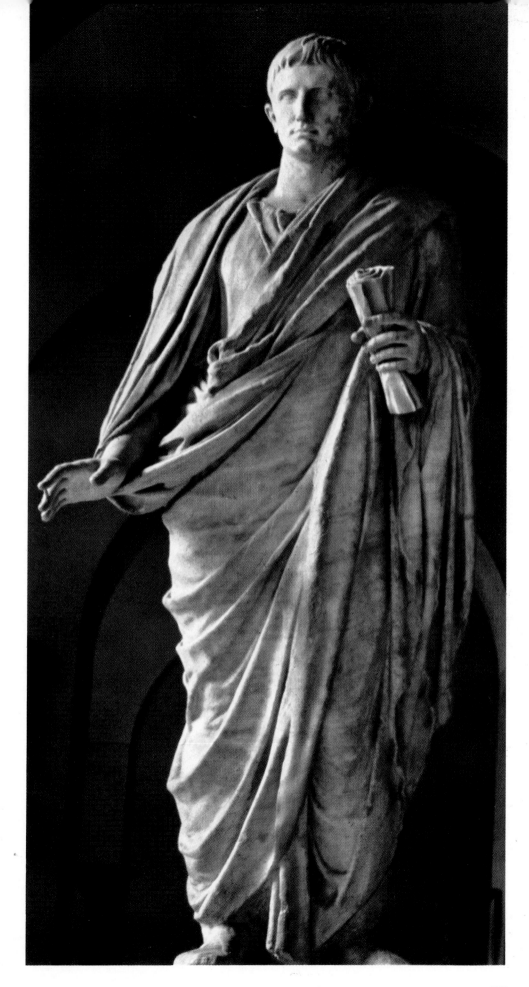

*Statue of Augustus
(Louvre, Paris)*

the temples of Saturn (497 B.C.), Bacchus, Ceres and Prosperine (494 B.C.) and of Castor and Pollux (482 B.C.) bears an Italic stamp. The network of roads crossing the Via Sacra which runs up to the Clivus Capitolinus is Etruscan. But the practical Roman hand is evident in the lay-out of the Forum: the Rostra (the speakers' platform) and the Curia (assembly hall) for governmental business, and a sacred area between the Regia (headquarters of the priesthood) and the Temple of Capitoline Jove (the modern Campidoglio). Roman, too, is the hand that raised the aqueducts and the bridges (the Ponte Rotto, for example, 179 B.C.). And the same is true of the highways, those magnificent roads built on the principle of stratification, none more famous than the Via Appia (312 B.C.) which led from Rome to Brindisi.

In the construction of her temples during the late Republican period, Rome passed from Etruscan borrowings to Greek models. This fact is clearly demonstrated by the temples in the present-day Piazza Argentina, those in the Forum Holitorium, that of Fortuna Virilis (first century) and that of Vesta (first century) in the modern Piazza di Bocca della Verita. In lay-out, structure, and the use of sculpture for decoration, the temples in Cori and Tivoli reveal the same trend. During the autumn of the Republic, colossal buildings adding to the general scenic effect appeared not only in Rome but outside the city as well – for example, the sanctuary of Fortuna Primigenia at Palestrina and the sanctuary of Hercules at Cori. In the planning of piazzas, Rome followed the Graeco-Oriental style with surrounding porticos. Private dwellings of the second and first centuries adopted the Etruscan and Greek tradition of a peristyle and blank exterior. Inside, the walls were adorned with paintings modelled largely on the murals at Pompei dating from 100 B.C. to A.D. 79. (It was in 79 that the ill-fated city was buried by an eruption of Vesuvius, one happy consequence of which was the preservation of many murals.) These paintings fall into four styles, the first two of which belong to the Republican era. As a rule they were done in tempera, encaustic (in which the pigment was applied by burning in), or fresco.

During the second century and the first half of the first century, Roman painting was the

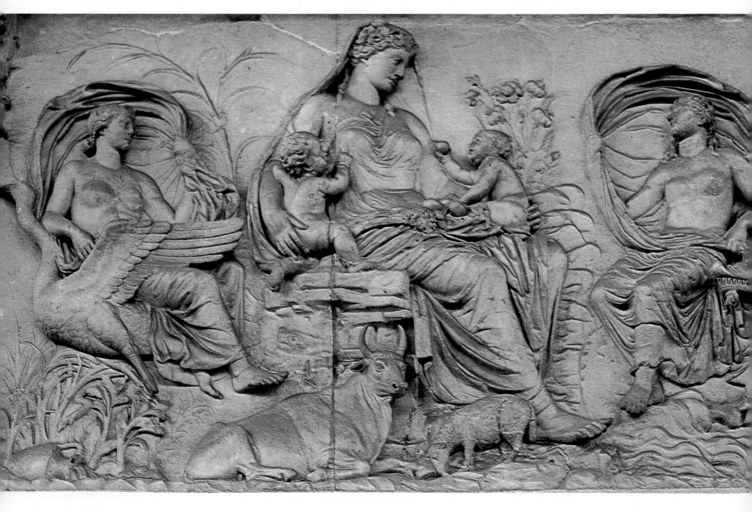

handmaid of architecture. Its brightly coloured stucco pictures formed a series of contrasting geometrical patterns giving movement to the surface of the walls. From the first half of the first century, however, painting was used to suggest perspective and give an illusion of vastness. Later, when paintings were conceived as hanging pictures – landscapes with tiny figures – they gave the effect of windows opened onto the surrounding countryside. Artists used an abridged technique, and their quick, undefined strokes gave their work a movement which almost smacks of Impressionism.

In the Republican age, sculpture also was largely practical. With the abandonment of clay and the use of marble, architectural sculpture borrowed less from Etrusco-Italic sources and, for both geometrical and naturalistic motifs, turned to Greece and the East. More interesting, and more problematic, is the question of non-architectural sculpture, and above all portraiture. There are no examples for the period up to 200 B.C., and for the second century there are only coins, where the portraits are largely expressionist in style but abbreviated in technique,

portrait of Pompey (Museum of Sculpture, Copenhagen) and that of Julius Caesar (National Museum, Naples). To these must be added the anonymous but most beautiful examples in the Lateran Museo Profano and the Vatican. The change of style from the realistic to the classic shows the evergrowing influence of the statues brought to Rome from vanquished Athens. From the available evidence it seems that, although the realism of Roman portraiture derived from Italic sources, its style remained linked to the particular interpretation of realism with which Greek sculpture was experimenting.

The golden age

Having completed its cycle of research and selection in the Republican era, Roman art was now mature, ready with an idiom all its own to express itself classically in the golden Augustan age. The ancient meeting place for the Latin community on the Palatine and the Sabine community on the Quirinal, the Forum now presented an orderly arrangement of streets, boasted porticos and, finest touch of all (though

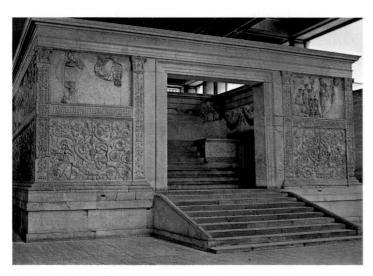

The Ara pacis (Altar of Peace) of Augustus, Rome. General view
'Saturnia Tellus' detail, relief from the Ara Pacis

　　　　The Arch of Augustus, Rimini

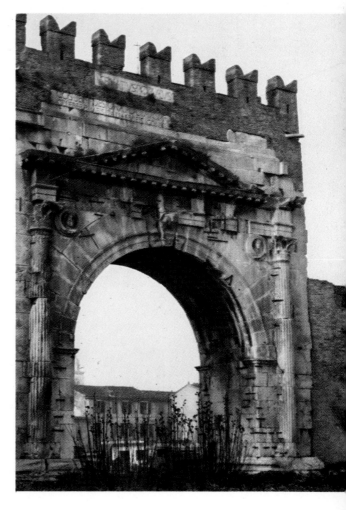

as a result of both Etrusco-Italic and Hellenic influence. After the Roman conquest of Greece in the middle of the second century, Greek influence grew stronger, as is evident in the bronze statue of a king (National Museum, Rome), dated between 150 and 140 B.C. Original Roman portraiture came into being between the time of Sulla and that of Caesar. Among the many superb examples that have come down to us is the

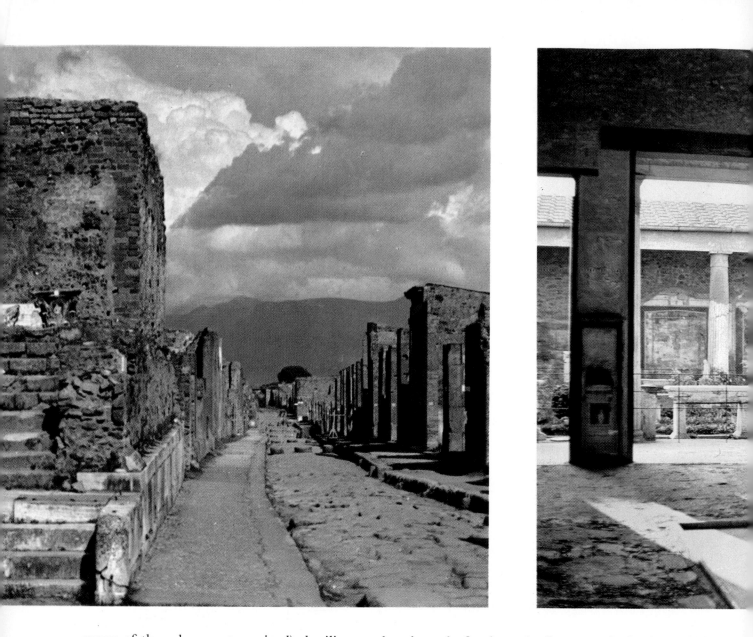

many of them have not survived), basilicas and temples. Protected by the Capitoline, witness of so many political and religious events, it had become a place for public activities, the setting for the bitterest political struggles and the debates on the decisions that brought greatness to the Republic of Rome.

In 29 B.C., Augustus closed the Temple of Janus, the god of beginnings and victory in battle – a gesture that announced to the world at large that, for both East and West, the long-awaited age of peace had begun. For Augustus, the empire was a command symbolising the union of two contrasting authorities, the Senate and the Roman people, and from this two-fold source he drew his power as commander. Although no mystic, he concerned himself with public worship and assumed the office of *Pontifex Maximus* or High Priest. Once internal strife had ceased, and the provinces of Africa and Asia had been

brought firmly under Roman rule, he donned his military cloak and set out to subjugate the lands around the Rhine and Danube. As emperor he played his role with dignity and showed no interest in the personal display of magnificence so dear to Eastern potentates. At the same time, however, aware that he represented the greatest empire on earth, he was determined to give Rome the splendour due to her as 'Mistress of the World'. She must become the centre of culture and, through her art, exalt imperial might. It was a vast undertaking and one which, incidentally, benefited the masses. The new laying-out of the city, with new and immense buildings, gave employment to thousands. During the Battle of Philippi, so it is said, Augustus had conceived the idea of avenging the death of Julius Caesar by building a temple to Mars Ultor in Rome. Whether the legend is true or not, one of his first acts as emperor was to erect that sanctuary.

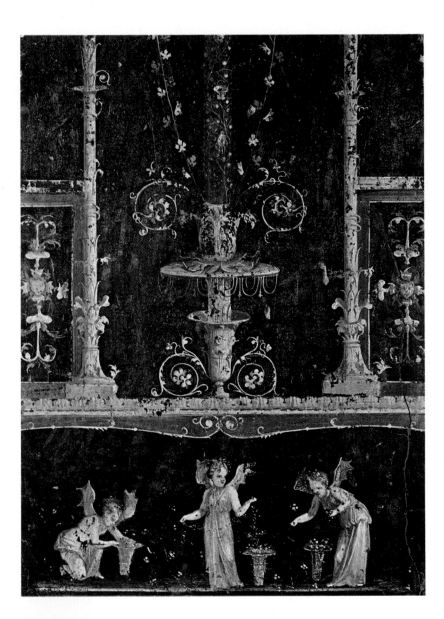

Above, left to right:
The Via dell'Abbondanza, Pompei
Peristyle, Casa dei Vettii
Wall decoration, Villa of the Mysteries

Still life, from Herculaneum (National Museum, Naples)

It was a noble structure enclosed in two great hemicycles with a high porch having eight columns. A fitting backdrop to the Forum, it was surrounded by a wall, and in this area there also rose the Forum Augusteum, a small, solemn affair of political significance rather than of any urban importance.

Not so the *lex de urbe augenda*, the city extension law. This was a measure undertaken by Augustus for the development of new sites as a solution to the problem of overcrowding. One such site was that where, in 28 B.C., Augustus began the Julia

131

walls of great suppleness. Obtained by the use of cement, the unusual dimensions of this marble-faced theatre heralded the daring Flavian constructions on the Palatine – the immense basilica, the *aula regia* (royal palace) and the *triclinium imperiale* (state dining-hall) – rivals of the Hippodrome and the Circus Maximus.

Sculpture

Though used for a variety of purposes, Augustan sculpture expressed itself best in portraiture, and the best examples reflect the balanced fusion of the live, expressive realism of Italic tradition with the classical insistence on serenity. The most frequent, most nobly executed subjects were Augustus and the Julian family, and the Augustan concept of portraiture is nowhere better demonstrated than in the *ara pacis Augustae*, the Altar of Peace built by Augustus between 13 and 9 B.C. In the carving of the imperial procession at the dedicatory ceremony the faces are realistic if not too accurate in detail, and the drapery of the figures in solemn step shows complete mastery of rhythm. But the procession

Spring, from Stabia (National Museum, Naples)

Initiation to the mysteries of Dionysius, fresco
Villa of the Mysteries, Pompei

Matron and servant, detail of a fresco, Villa of the Mysteries, Pompei

mausoleum, his own family tomb. It was a bold construction, cylindrical in shape, and built of brick faced with travertine. Ascending by concentric stages, it was surmounted by a statue of the emperor. In brief, a highly original structure with an imposing, plastic, dynamic shape – the very antithesis of the static, rectangular forms dear to Greek architecture. In their turn, the triumphal arches of the Augustan age – that at Rimini, for example, or those at Aosta and Pola – used the barrel vault, deep arch and dynamic columns to express the Roman determination to dominate space and achieve both volume and compactness. Another instance of this breaking away from Greek tradition is illustrated in Rome by the Theatre of Marcellus (A.D. 11). Despite its having aged so badly, its serried sequence of masses, its play of light and shadow still please the eye. Instead of digging into a hillside as the Greeks would have done, the Romans built up this structure from the ground curving as they went, level by level, and supporting the huge, regularly proportioned mass on

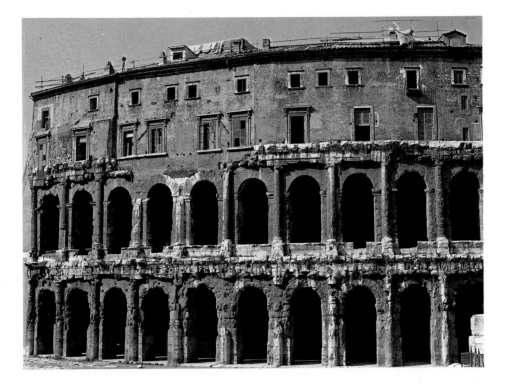

has nothing of the lofty, poetic, procession of the Panathenaea on the Parthenon – that example of pure Greek classicism – as is obvious immediately when one considers the pictorial treatment of the background and the unhappy abbreviation of the middle distance. As a composition, the panel representing *Saturnia tellus* (the 'saturnine earth' or golden age) is more classical and, with their bunches of grapes, arabesques and candelabra, the decorative friezes on the walls surrounding the altar show remarkable inventiveness.

Full-length statues of the period reveal classical influence in the figure but retain a realistic, even idealised treatment of the face. This is especially true of the so-called Primaporta statue of Augustus (20–10 B.C.) now in the Vatican Museum, and of Augustus as *Pontifex Maximus* (A.D. 14) in the National Museum, Rome. The vague echo of the rhythm of Polycleitus' *Doryphorus* (lance-bearer) in the Primaporta Augustus is enlivened by the spontaneous vivacity of a man in the act of making a speech. In the touching Augustus as *Pontifex Maximus*, the elaborate drapery echoes classical over-refinement.

Still tied to the perspective manner in the House of Livia on the Palatine, Augustan painting assumed a new style in the Villa of the Mysteries at Pompei (30 B.C.–A.D. 14). Here, plastic figures with lively, passionate faces stand out against the prevailing red background. Nude or nobly draped, they have volume.

Opposite page: *Detail of the Colosseum at Rome*

They are free and move with ease. Obviously, the artists who painted them were fascinated by the Greek sculptures which by this time were a common decoration in the pleasure villas spread over the Roman countryside.

In the reigns of Tiberius and Claudius, and that of Nero up to A.D. 68, art derived its inspiration from the Augustan age. The *domus Tiberiana* was the first of the imperial residences on the Palatine, and Nero's *domus aurea*, of which some painted vaults and stucco friezes still survive, must have been of vast dimensions, a prelude to the large-scale imperial architecture that was to come.

The great artistic revival between 70 and 96, embracing in particular the rebuilding of Rome after Nero's attempt to destroy it, was the work of the Flavian emperors, Vespasian, Titus, and Domitian. The most famous, most imposing architectural undertaking of the period was the Flavian amphitheatre (A.D. 80) later called the Colosseum. An engineering feat of great daring, it was 617 feet long, 512 wide, and 160 high. Externally, the spectacular oval structure was divided into four orders or storeys, and the enormous pit inside could hold 50,000 spectators in the three sections of seats sloping down towards the arena, including a *maenianum summum* ('gods') for poorer members of the public. Outside, the succession of Tuscan, Ionic, and Corinthian orders was perfectly balanced, as was also the relationship of light and shadow in the alternation of deep arches and dividing pillars.

135

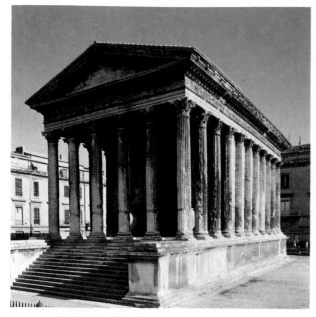

The Maison Carrée, Nîmes

The flat crown of the high wall checked the vertical thrust and, with its jutting cornice, completed the dynamic appearance of the almost smooth surface. In its heyday, with the seating accommodation divided geometrically into tiers, the interior had an ordered air that stressed both the plastic dimensions of the building and the beauty of the materials.

Imperial Roman art

The Arch of Titus (A.D.90), with its pilasters and Attic coping, presents a happy blend of architecture and sculpture and, as such, constitutes the most important of all Flavian buildings. Livelier, more immediate, less rhetorical than the procession in the *ara pacis*, the carvings illustrating the victory of the Romans over the Jews show a skilful use of space animated and created by the presence of human beings – human beings in action, human beings giving vent to their passions. No other contemporary work in Rome has the balance of this masterpiece.

Although of dissimilar nature, the contributions to art made by Trajan (98–117) and Hadrian (117–136) were the highlights of the period from Nerva to Commodus (96–193). Just as architecture and sculpture at the time of Vespasian

The Arch of Trajan, Benevento

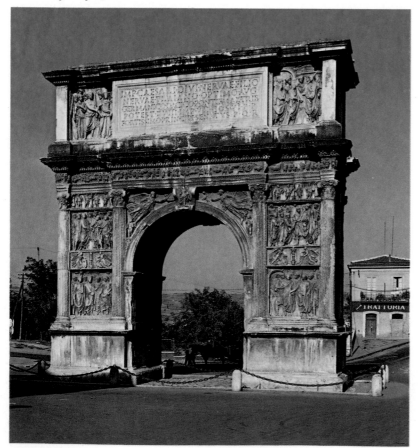

Plan of the Pantheon, Rome

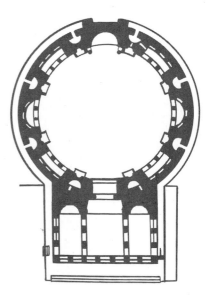

and Titus show mastery of space in individual buildings and mastery of the suggestion of space in carvings, so during the age of Trajan both the way in which flat areas were enclosed by buildings and that in which buildings were deployed on elevated ground reveal the happy relationship between architecture and town-planning – the start of what is called imperial Roman art. A good example of this style is, not surprisingly, the Forum of Trajan. At the highest point were the markets and shops; on the slope were the roads leading down to the Forum and the dominating Ulpia basilica flanked right and and left by a public library with superimposed loggias. Nearby rose the Temple of Trajan and the still surviving Column, nearly 120 feet high. The sight that met the eye must have been one of a great mass of masonry gently descending in restful spirals, and of niches full of shadow that accentuated the lightness of the flat surfaces. The credit for this masterpiece goes to Apollodorus of Damascus. As its architect he successfully translated the idioms of Greece and the East into pure imperial Rome. Trajan's Column is one of the finest surviving Roman monuments. Built in 113, it tells a story in stone over 650 feet long spiralling round and round from top to bottom. The theme is the victories of Trajan over the

Dacians, and it is unfolded in a striking series of single or collective feats.

In their fashion, the sculptures on the Rostra in Rome and on the Arch of Trajan in Benevento also relate history, while the buildings in Leptis Magna (North Africa) testify to the rapid diffusion of the imperial Roman style beyond the capital.

One of the finest and best preserved buildings of Imperial Rome, the Pantheon, also nobly exemplifies the classically nostalgic age of Hadrian. Constructed by Hadrian on an Augustan model, it brings together in harmony two distinct worlds – the great, colonnaded porch crowned with a triangular, Greek-style tympanum and the cylinder surmounted by a dome open in the centre to the skies of Rome. Inside, the Pantheon has a serene and balanced atmosphere – an effect achieved not only by the equality of height and width (some 140 feet) but also by the orderly deployment of the two planes. Of these the lower is an alternation of colonnaded niches and clear surfaces, while the higher is a succession of blank windows and corniced marble panels. The evenly diffused light and the ascent of the dome with its geometrical pattern of compartments enhances the note of serenity and equilibrium. Outside, the building is all curved

Interior of the Pantheon, Rome

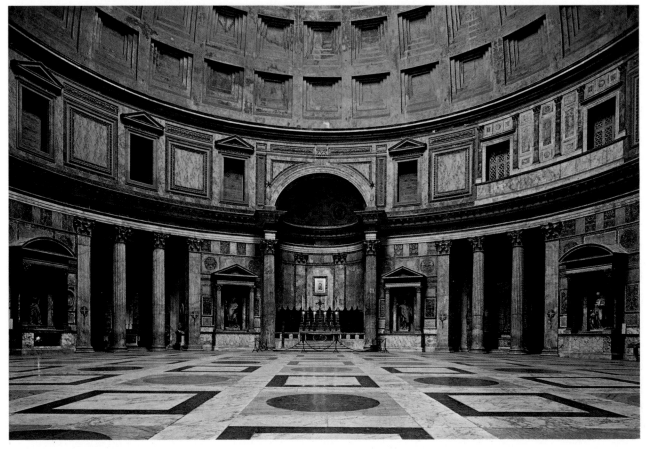

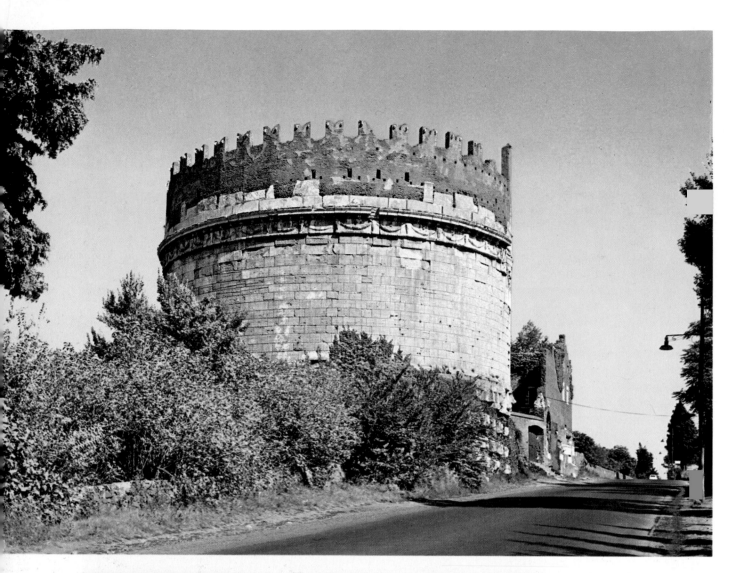

The Tomb of Caecilia Metella
on the Appian Way at Rome

Sarcophagus of St. Elena
(Pio-Clementino Museum, Rome)

brickwork, nearly twenty feet thick, in the simple, rigorous Roman tradition already followed in the Tomb of Cecilia Metella and Hadrian's mausoleum, now the Castel Sant'Angelo.

There are several portraits of Hadrian's circle and court extant. Hadrian himself was responsible for the diffusion of the portraits of his favourite, Antinous, in idyllic, Hellenistic vein, which are not uncommon in the museums of Rome today. In their own day they found little favour, nor did they inspire much imitation.

The last, great phase in the expansion of the Roman Empire was the conquests of Trajan. When Hadrian succeeded him, he contented himself with reinforcing the vast boundaries and remaining a diligent custodian. He was, however, a great traveller, appreciative of what he saw. If he took Roman imperial art to Britain, Spain, and Asia Minor, he returned from those parts determined to copy some of the more impressive buildings there. His villa at Tivoli is an example of this. It was laid out with Oriental splendour, the terrain being developed at different levels with great scenic effect, and as such providing an excellent foil for the baths, stadiums, terraces with gardens, woods and water courses, all contrived with marvellous skill.

Abroad, far from Rome, the buildings of Hadrian's time were not immune to local influence. In Athens, Hadrian's Gate smacked nostalgically of classicism, and the Temple of Ephesus blended Greek architectural forms with decorations of Oriental flavour.

Marcus Aurelius (161–180), the emperor-philosopher who foresaw the danger to pagan Rome that barbarian invasion and toleration of Christianity would constitute, lives on for us astride his horse upon the Campidoglio – a magnificent example of the type of equestrian statuary in which Roman sculptors must have had wide experience.

Septimius Severus (193–211) and Caracalla (211–217), two emperors elected by the army, ruled a Rome where classical Roman art gave way to an art-form which, judged by its proportions, its inventiveness and its decorative innovations, might well be called Roman Baroque. Begun by Septimius in 206, the Baths of Caracalla spoke in what architects and town-planners would call a monumental idiom. The buildings could hold 1,600 clients at a time. Even now, the site presents one of the finest sights of Rome – a vast, green background with the remains of what once the *frigidarium*, the *tepidarium*, a stadium, libraries, and gymnasiums nestling among gardens and woods.

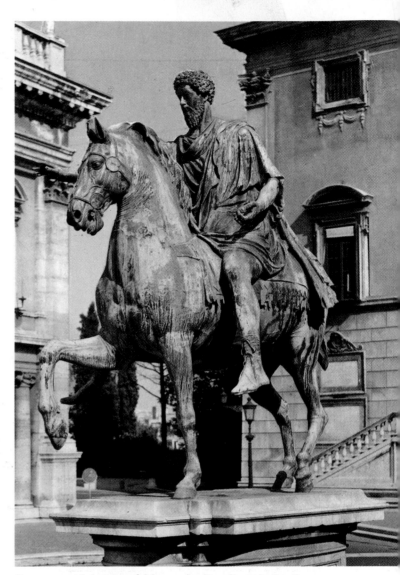

Bronze equestrian statue of Marcus Aurelius, Campidoglio, Rome

Mosaic pavement, Villa Imperiale, Piazza Armerina

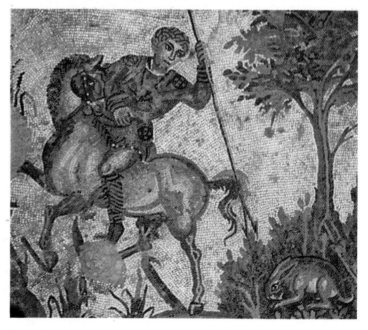

139

Like the Baths of Caracalla, the Circus Maximus, set between the Palatine and the Aventine with a seating capacity of 300,000 was built to allay and sidetrack political and social unrest by providing tired, impoverished Rome with an inviting rendezvous for recreation and entertainment. In the Forum rose the Arch of Septimius Severus, a richly ornamented triple-arched structure (203). To meet the city's growing needs, the shipyards and wharves on the Tiber were enlarged, similarly the food depots. In everything she built, third-century Rome revealed her eagerness to surprise by a display of magnificence. This does not mean, however, that the great glories of the past were spurned. When Diocletian (284–305) rebuilt the Curia, he ordered his architects to keep to the dimensions recommended by Vitruvius, the great classical architect. And when he built the palace of Spalato, he borrowed from classical Roman models. On the other hand, in the construction of the baths that bear his name, he set out to make them bigger than those of Caracalla, by erecting a complex of buildings linked to an expanded central block.

In Rome round buildings proliferated. Some were modelled on the nearby Nimphaeum Licinianum on the Esquiline or the Villa of the Gordiani on the Via Appia, others on the distant Temple of Baalbek. Such was the political situation, however, that thought also had to be given to the defence of the city, and engineering works were undertaken to strengthen the walls that had been erected by Aurelian in 260.

As such, the art of the age of Constantine is of little significance in Rome. The most imposing project launched by the emperor was the Basilica of Maxentius. Completed in 312, it was an immensely wide building with massive walls sustaining the cross-vaulting, an innovation at that time. The Arch of Constantine, however, is a decadent work. Its plastic form shows little originality, and the sculptured panels popular in an earlier age are mingled arbitrarily with those of the fourth century that are barely in relief.

By the time Christianity received legal recognition (Edict of Constantine, 313) and started to spread throughout the entire Roman world, Roman art had already completed its cycle.

Female figure, fresco (National Museum, Naples)

EARLY CHRISTIAN ART

The Christian religion, the greatest formative influence in western European civilization, was at first merely one of many radical changes in the history of mankind. This is more than can be said of the other new cults and religions coming in to the Roman world during the first century A.D. at a time of decadence in and disbelief in the traditional pagan religion. But Christianity had certain unique features. It preached belief in one omnipotent, heavenly God to whom every man stood in the relationship of creature to Creator. It preached the certainty of an afterlife and salvation for all believers in a world beyond this short-lived, transitory one. Above all Christianity evolved a corporate organization which gave it coherence and durability as an institution. Indeed it inculcated a sense of solidarity, of belonging to the intimate community of the faithful – that evergrowing band of men and women who constituted the Church even before it took on its visible organization.

Geographically, the starting point was Asia Minor, an area of mixed cultures. The part of Palestine called Judaea, where Christ was born, carried out His ministry and was crucified, was a Roman province. But sharing as it did the arid tract of Mediterranean coast on the south with its next-door neighbour, Egypt, it was subject to Alexandrian and Hellenistic influences. On the north it bordered Syria, and so received a Middle-Asian stamp also.

The Christian Gospel spread rapidly, thanks to the missionary activity of the Apostles, into adjacent parts of Asia Minor, Greece and Rome. Before long it penetrated deeply into parts of Roman Africa, Spain and Gaul. Wherever it was heard, this Gospel produced a profound revival of spiritual values.

One effect of this revival was the emergence of what we call Early Christian art, a style which affected architecture, painting, and sculpture in the sixth and seventh centuries. As can be seen, it began comparatively late. Judaea has little to offer that comes within this category. Archaeolo-

gically, its yield shows a fusion of Jewish and Roman styles – for example, the remains of Herod's fortress at Masada, the King of Israel's palace at Samaria, a dozen second- and third-century synagogues spread throughout Galilee (Chorazin, Capharnaum), and some groups of tombs hewn out of the sheer rock.

In the event, Early Christian art started with a definite Roman stamp, although its first essay in architecture, painting, and sculpture was a

The Good Shepherd (Lateran Museum, Rome)

Symbolic mosaic in the ambulatory of Sta Costanza, Rome

143

novelty for Rome – the construction and the decoration of that subterranean complex which came later to be called the catacombs.

The technique of this new style was the same as that employed by contemporary pagan art in Rome and, as time went on, subject to the same evolution. Where it differed from the latter was in its content, and this, obviously, was dictated by Christian thinking. For the Christian, the goal of life on earth was God, and Christ was the means of revelation and salvation through grace. Man must undergo spiritual purification, achieved by meditation rather than by rites that need only be superficial, for these were only a symbolic preparation, signifying the transcendental values

Still-life, catacombs of S. Callixtus, Rome
Above: *Head of a prophet, catacombs of Peter and Marcellinus*

of Christianity. The spirit of Early Christian art, therefore – especially figuration – was symbolic, allusive, and it had to express itself with absolute simplicity because its object was to instruct and edify every believer, as did the Gospels, the Acts of the Apostles and the Epistles of St Paul. In an age when miracles and mysteries permeated the air breathed by pagan and Christian alike, there was nothing surprising in the fact that large numbers of believers, many of them poor and uneducated, could gaze upon an uncomplicated symbol and be led to accept complex Christian truths. To every Christian, those simple signs were a confirmation of the certitude he felt of the love borne by God the Father for all His sons, of the certitude that all men were brothers united by faith, hope, and charity – the three things which stressed the transitory nature of life on earth and the certitude of eternal life. Small wonder then that Christian artists broke away from classical Graeco-Roman art, the expression of so very different an outlook.

Catacomb painting

Before looking at Early Christian painting, one should first consider one of its most important sites, the catacombs. Most of these were in Rome, or rather, outside the city walls along the main roads, as were all other types of burial places and monuments to the dead, since this was a legal stipulation. Originally they were not intended as a rendezvous for clandestine meetings, and the word 'catacomb' is of late and uncertain origin (9th century). It is a Greek term and may mean 'near the precipice' because, in the first instance, it was applied to a group of underground tombs dug out in a dip in the Via Appia, where the church of S. Sebastiano now stands. These underground tombs consist of a series of galleries excavated from the volcanic rock on several levels, for a total distance of over ninety miles. Each gallery is just over a yard wide, and its walls are lined with recesses one above the other, each one a receptacle for a body. It is estimated that from about the 1st to the 9th century, a full 750,000 Christians were buried in these catacombs. A special burial spot was reserved for the martyrs in the form of an arched niche, and their tombs were used as altars for the Eucharist. It was in such niches – on the vaults, lunettes and walls – that there appeared the first Early Christian paintings of any great interest, stylistic or otherwise.

It is possible that some of the catacomb paintings which survived date from the first century; certainly there are examples in the

Corridor in a catacomb, with burial niches

third century and continuing up to the ninth. In kind, they vary according to the development of religious ideas and, as we have already established, their style was that of contemporary pagan art. The earliest nearly always shun realism in favour of the symbolic and the allegoric. At first, the most common themes were the Cross (symbol of the sacrifice of Christ), the palm (martyrdom), the anchor (salvation), and the fish, because the letters of the Greek word for fish signify 'Jesus Christ, Son of God, Saviour'. Without any perceptible pause, there then came the dove, the peacock or stags, which represented desire for the cleansing waters of baptism. From the third century, there was an abundance of figures but always of allegorical significance: the Good Shepherd (catacombs of Sta Priscilla), the *Orante* or worshipper (catacomb of the Vigna Massimi), the group of the Virgin and Child and the Prophet Isaiah (cemetery of Sta Priscilla), and a picture heralding the salvation of mankind through the intercession of the Blessed Virgin and her Divine Son. As a rule, the painting was summary in style and rapidly executed in bright colours with plenty of high lights, as might be expected in the gloom below

ground. Here and there, the artist has attempted to draw people as they really were and to reproduce their clothes exactly, but he never moulded them to obtain plasticity. His main purpose was to render emotions through the symbol, to express mystical expectation.

Beyond Rome, groups of catacombs are to be found in Campania, Sicily, Sardinia, Egypt, Cyrenaica, Tunisia and Algiers, thus forming a wide arc round the Mediterranean. What with the difference of terrain, however, and local historical development, no two are alike.

Sarcophagi

The most noteworthy examples of Early Christian sculpture are the stone sarcophagi, a form of coffin common in pagan Rome long before the advent of Christianity. Between the third and fifth centuries, the idiom of Early Christian sculpture was hardly original. Unlike painting, the medium did not lend itself readily to abstractions. Christian sculptors, therefore, contented themselves with borrowing from their pagan fellow artists. Thus, what was for the pagan a statue of a young boy carrying a sheep

became, in its Christian form, the Good Shepherd. As such, this theme could be a subject in itself (the third-century Good Shepherd in the Lateran Museum, Rome), or it could form part of a composition repeated again and again between vine-leaf and grape motifs (the third-century sarcophagus in the Lateran Museum, Rome). The fourth-century sarcophagus of Junius Bassus (Vatican Grottoes, Rome), that of Jonah (Lateran Museum), that of Adelphia (National Museum, Syracuse), and that of Stylicus (S. Ambrogio, Milan) form another group which, although Christian in theme, is pagan Roman in style with borrowings from the classical idiom of Constantine, and from provincial or popular art.

Given the irreconcilable nature of their respective ideologies, it was inevitable that, sooner or later, Christianity and the 'Mistress of the World' should come into violent conflict. History has recorded the more dramatic moments of that encounter, ending the tale on a note of triumph for the 'Kingdom not of this World' – a triumph won only after a long, drawn-out struggle and in the reign of Constantine when, fearing the combined strength of the Christians, the Roman Empire had come to terms with them.

Basilicas

By granting Christians freedom of worship and the right to the restitution of their goods, the so-called Edict of Milan (313) brought about a most important change, with consequences beneficial not only to Christianity as a religion but to its art forms as well. From that moment, basilicas and baptistries began to rise, painters and sculp-

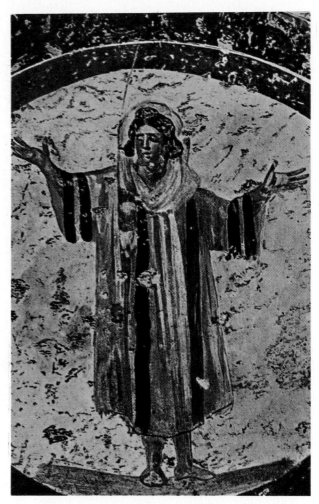

Worshipper, from a fresco in the catacombs of S Callixtus, Rome

Opposite page: *Worshipper, from a 5th-century mosaic from Gerasa*

Sarcophagus of Junius Bassus (Vatican Grottoes, Rome)

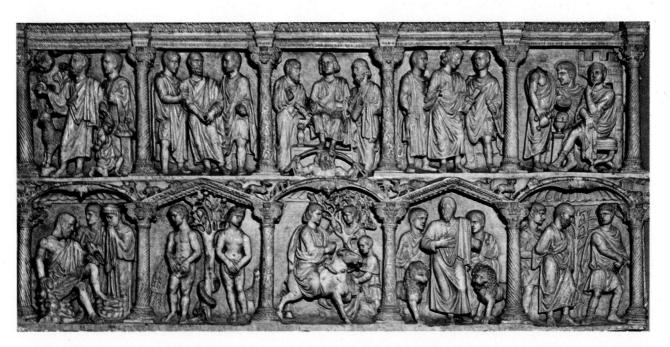

147

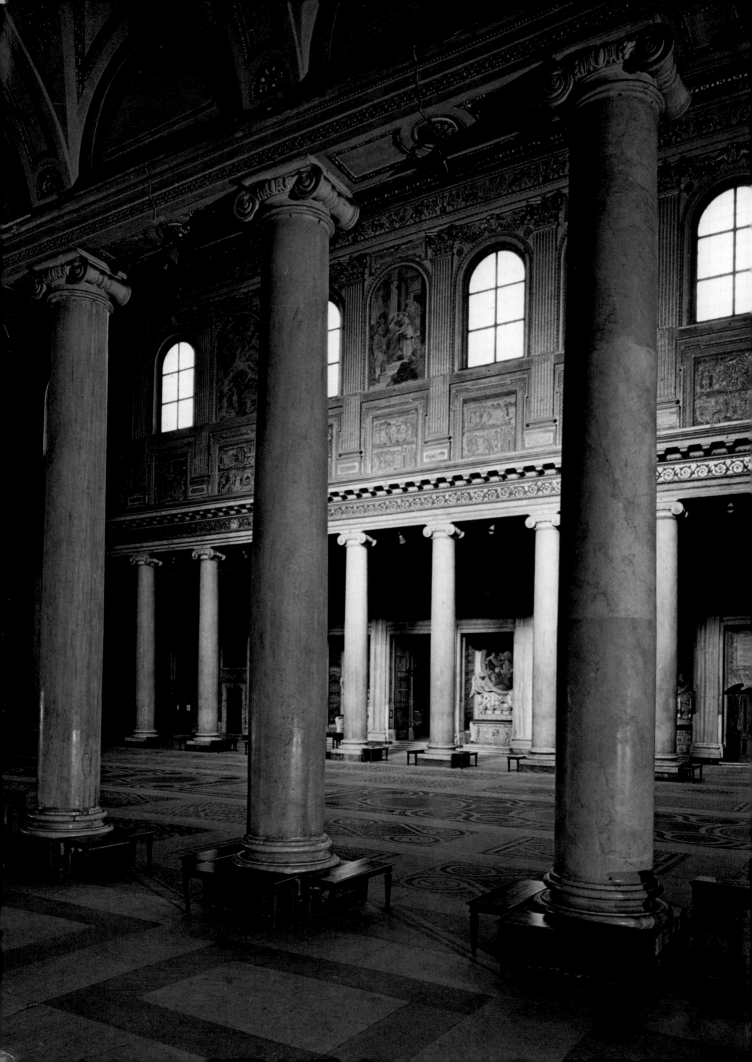

tors began to work in them, goldsmiths and ivoryworkers made rich furnishings. From 380, the year in which Theodosius issued his edict recognising Christianity as the state religion, the Emperors themselves hastened the construction of great Christian churches, thereby putting into practice the theory of Eusebius of Caesarea that all authority stemmed directly from God. The interest taken by the Emperors in the House of God explains the use of rich marble and the introduction of mosaics.

Architecturally, the churches were intended to exalt the triumph of Christianity, but the main concern of the planners was to create an intimate, compact atmosphere, softly lit to inspire the congregation to devotion and draw their attention down the length of the nave to the sanctuary.

Before the solemn great basilicas came into being, services had been conducted in private houses, the *domus ecclesiae* of the first Christians. When Christianity gained its freedom and had to choose a form of building big enough to hold large congregations, it picked that of the Roman tribunal hall, the basilica. But instead of using the building width-ways as did the Romans, the Christians employed it lengthways, with the main entrance not at the side, where it used to be, but at one end. Opposite, in the apse, they placed the presbytery or chancel, raising the floor there so that the altar could be clearly seen. Sometimes

they added a quadrangular portico. For practical reasons, however, they always built a separate baptistry. In those days, baptism by immersion was the custom and this necessitated a very large font which had to be walled round and roofed.

Fourth-century Rome witnessed the building of S. Pietro (St Peter's), S. Paolo, S. Lorenzo and S. Giovanni in Laterano (St. John Lateran), today all rebuilt and heavily restored. Better preserved is Sta Maria Maggiore, whose calm, well-spaced architraves and columns were taken from damaged Roman buildings. The roof, which is not the original, tends to deaden the light but this, in its turn, is warmed by the mosaics on the triumphal arch and down the nave. Altogether it is a fine example of an Early Christian church. The dominating features of Sta Sabina are the rhythm of its arches and the poetical Early Christian handling of space.

In Milan, capital of the Roman Empire for a brief span, there once stood the Basilica Vetus and the Basilica Major. But now, in order to see what the most ancient form of this type of church looked like, one must study S. Simpliciano and SS Apostoli (S. Nazaro). Recent digs have revealed the original fourth-century outer wall of S. Simpliciano, and the restoration work at the SS Apostoli has brought to light the cruciform plan with the transepts lower than the nave.

S. Lorenzo, also in Milan, provides the most

Interior of Sta Maria Maggiore, Rome

Interior of Sta Sabina, Rome

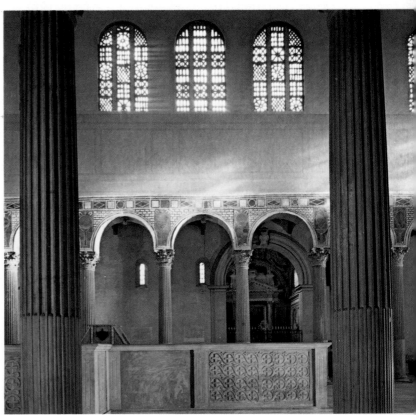

Reconstruction of an Early Christian basilica

solemn, best-preserved example of Early Christian architecture, although the central portion with its spacious dome (135 feet in diameter) and the ambulatory supporting the high gallery above are Byzantine in plan.

In Rome, as in Milan, baptistries rose alongside the basilicas. Round in shape and, as we have seen, furnished with a large font inside for baptism by immersion, they were lit on a functional basis. The strong light pouring down from above symbolised the descent of grace on those about to be baptised, whilst the ring of shadow accentuated the spirit of recollection in which the rest of the congregation stood. In Rome the finest examples of baptistries are to be found at S. Giovanni in Laterano and S. Stefano Rotondo. But baptistries rose all over Italy. Those at S. Aquilino in Milan, S. Salvatore in Spoleto, S. Angelo in Perugia, and S. Giovanni in Fonte in Naples all have the same form but differ in detail. On account of its link with the Eastern Empire, Ravenna built its basilicas and baptistries with Byzantine characteristics all of their own.

Mosaics

When the adornment of the catacombs with frescoes was abandoned, Early Christian painting went back to what painting had already been used for in Imperial Rome – large-scale decoration. But now, the favourite medium was mosaic. It was resistant, rich, luminous, colourful, easily adapted to architecture, and eminently suitable for the combination of figurative and decorative forms. Portrayed in mosaic, the human figure has being. It moves, gives expression to feeling.

By their very nature, mosaics use many idioms. With its framed medallions and little symbolic motifs, the ring-shaped vault of Sta Costanza in Rome recalls a piece of oriental silk. In other parts of the same church, the classical Roman idiom is spoken with naturalistic accent – in the dense vine-leaves and bunches of grapes (symbols of the sacrifice of the Cross) and the detailed scenes of the wine harvest. The vault, now destroyed, seems to have been decorated with a candlestick motif which accented the architecture of the structure.

The well-preserved mosaics in Sta Maria Maggiore fall into two groups distinct in style and theme. Those in the main nave represent Old Testament scenes, and were executed between 420 and 430. The figures are well moulded, and those in the foreground have coloured shading. Though indicated more sketchily, the middle and far distances are carefully worked out pictorially, as was often the case in con-

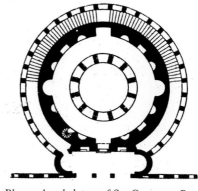

Plan and ambulatory of Sta Costanza, Rome

temporary sarcophagi. The faces might almost be portraits, and the details of the clothes are accurately observed. The composition and the calm distribution of forms show the classic proportions of the Constantine age. The mosaics on the triumphal arch, however, were executed some time after that date (as can be seen from the motif of the veneration of the Blessed Virgin, a doctrine confirmed by the Council of Ephesus in 331). Though of richer colour than those in the nave, they lack plasticity. Stiff and flat, with rhythmic gestures and sumptuous Oriental robes, the figures look like cut-outs. Even the mock architectural divisions are spoilt by the urge to express rich material. The walls of the Heavenly Jerusalem are set with precious stones, and the mock votive crosses over the portals are of gold.

Fifth-century mosaics such as the procession of the twenty-four elders on the triumphal arch in S. Paolo, Rome, are just rigid patterns of flat figures conventional in gesture and repetition of faces. The classic style has been replaced by the contemporary provincial, smacking of the Byzantine. But in S. Aquilino, in Milan, there is a splendid lunette with a picture of Our Lord between the Apostles which shows the high standard of classical culture in that city at the time of Theodosius and St Ambrose. The realistic treatment of the faces, the moulding of the figures, the flowing garments, the handling of space and landscape show the trend to Constantinian classicism which, at that time, still found favour in the court of Milan. The mosaics of S. Vittore in the chapel annexed to S. Ambrogio belong to the fifth century. The saints covering the unbroken walls stand out against a blue background, hieratic, flat, but unexpectedly enlivened by the cadence of their steps.

In the realm of sculpture, Early Christian goldsmiths produced some fine work even if, with the mannerisms, the prevalence of soft lines, and the elongated forms (like those on the shrine of St Nazarus in the treasury of Milan cathedral), it does not strictly come within the domain of Early Christian art.

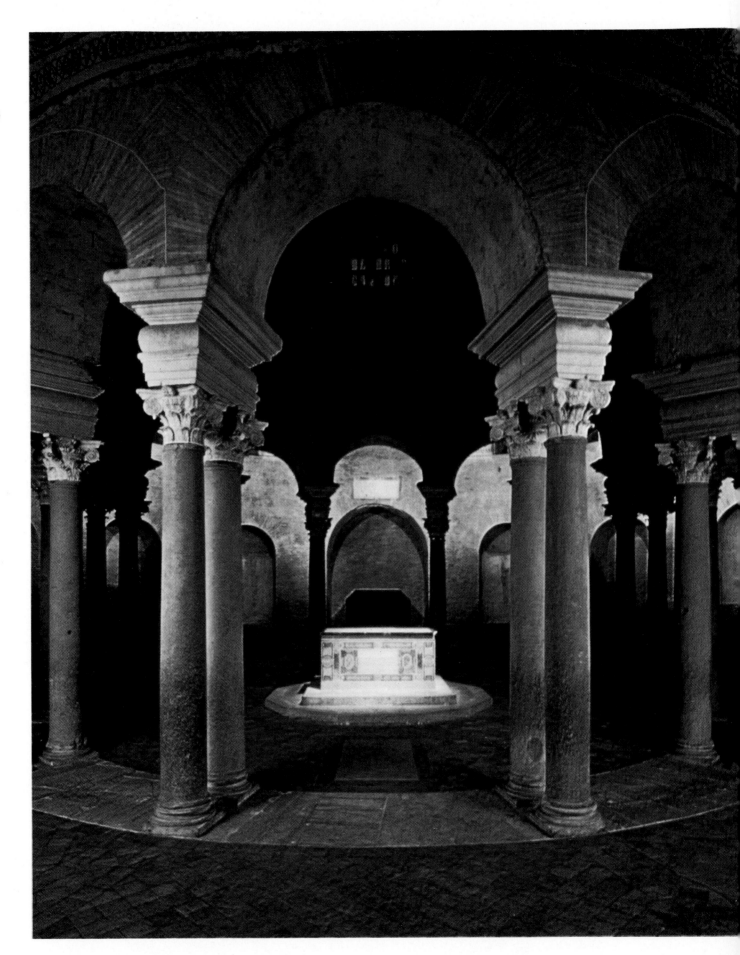

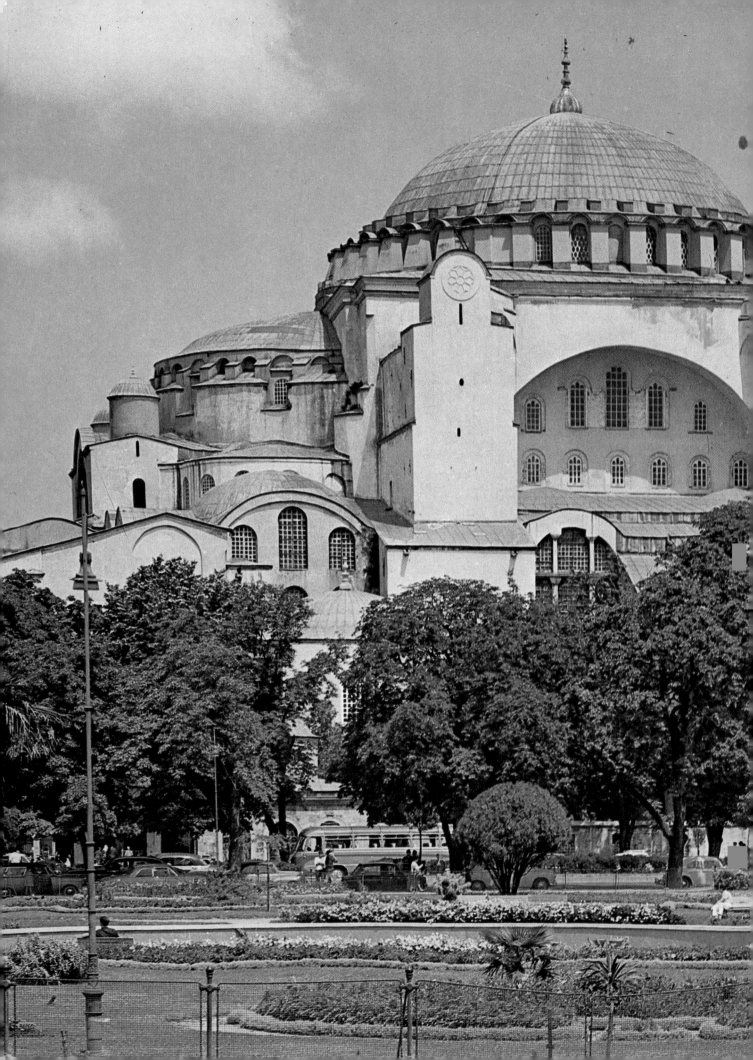

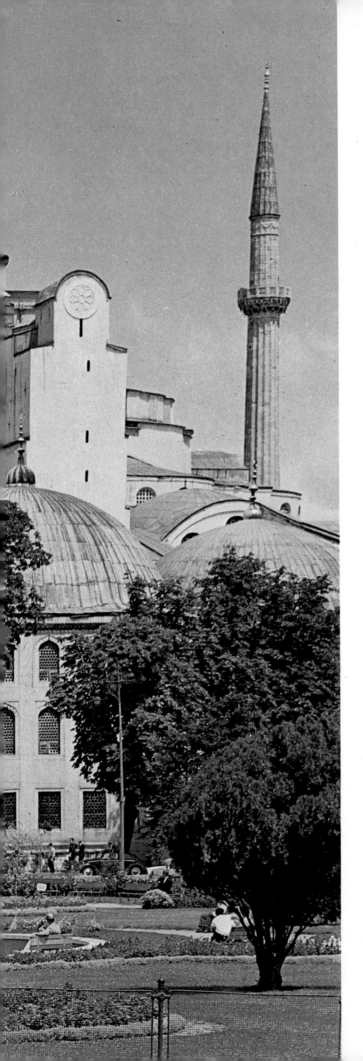

BYZANTINE ART

Ancient and oriental influences at Byzantium

Originating in Byzantium (present-day Istanbul), Byzantine art spread to Asia Minor, Greece, Yugoslavia, the Balkans, Russia, and Italy. Launched in the 4th century in the age of Constantine, who renamed the ancient city Constantinople, it thrived under Theodosius (401–450), sparkled with originality during the reign of Justinian (483–565) and, despite the Iconoclastic controversy from 726 to 843, continued up to the days of the Comnenus dynasty (12th century).

The fundamental and enduring characteristics of Byzantine art were splendour, abstraction, full use of light and colour, rejection of space and plasticity, and rhythm in the grouping of figures and draping of costumes. In one sense, it was the expression of an aristocratic culture which had great depths. In another, it was the elaboration of models gathered from the ancient Mediterranean and Slav areas of Europe – models characterised by transitions in art and changes of style.

Recent studies and discoveries in the field of architecture, painting, miniatures, and the minor arts have permitted close scrutiny of the sources and development of Byzantine art, and these show how it affected the confluence of Roman provincial, Barbarian, and Hellenistic art in the Mediterranean basin before the Carolingian renaissance.

After 330, the year in which Constantinople became the capital of the Eastern Empire, Byzantine architecture flourished enormously, and its chief glory was the Early Christian basilica. Of those which still survive (some better preserved than others), St John in Studio (463), SS Sergius and Bacchus (527–536), and Santa Sophia, all in Constantinople, are of great importance because they are in pure Byzantine style. On the other hand, St Demetrius and Santa Sophia in Salonika, and the basilicas in

Exterior of Santa Sophia, Istanbul

153

Ephesus, Antioch, and Athens show unmistakable signs of local influence.

Santa Sophia

It was in the reign of the power-loving, magnificent Justinian that the basilicas so remarkably unlike those in contemporary Rome and Milan were built. At Constantinople they were roofed with domes which rested ultimately on a square base. They were serried, compact structures enclosing immense, abstract spaces. To a minor degree, St John in Studio and SS Sergius and Bacchus illustrate this type, but the most complete example is Santa Sophia. Begun in 532 and finished with surprising speed in five years, its immense walls of brick and mortar are crowned by the flattish, solemn dome resting on four piers and four great arches. The side naves flow into the central area, and there is a wonderful effect of perspective as the eye travels up from the pillars at ground level, past the gynaeceum, or women's galleries, right up to the great dome. Through the windows ringing the base of the dome, and in the lunettes beneath, the sun pours into the building, lighting up the marble and the mosaics which sparkle everywhere. The marble pillars are crowned with rich capitals, exquisitely carved in abstract patterns. Nicely proportioned, cleanly composed, carved deep into the stone, these typically Byzantine capitals betray no sign of decadence or lack of technical skill. They give the lie to the claim made up to recent times that Byzantine art lacked creative power. Not all Santa Sophia, however, is pure Byzantine. The splendour of the materials, the scenic effects and the lighting indicate Syrian and Alexandrian influences; the mosaics differ in age and quality, as well as revealing opposing stylistic and theological trends, and the Arabic script and graphic signs added by the Moslems when the basilica was turned into a mosque are yet another extraneous element.

Contemporary Byzantine sculpture found many outlets. Though prone to Roman influence,

the Byzantine blending of the naturalistic and the abstract sometimes produced portraiture of great originality. A case in point is the beautiful head in the Museo del Castello, Milan. Whether it represents Theodora or not, there is no doubting its wonderfully expressive immediacy, its plasticity. Full face, hieratic, eyes wide open, lively yet inert, it indicates both delicacy and strength. In the decoration of sarcophagi and screens, Byzantine sculptors preferred symmetrical compositions, but in the best examples, such as the Adoration of the Magi on the sixth-century sarcophagus in S. Vitale, Ravenna, clearly cut figures stand out from a completely flat background in static, spiritual poses and, ignoring the question of relief, they recall contemporary mosaics in Ravenna.

In the minor arts – carved ivory, gold- and enamel-work, miniatures, textiles and wood-carving – the Byzantine achievement is of exceptional interest. From the 4th century on, Byzantium became the leading centre for these activities in the Mediterranean, and it retained its pre-eminence longer than any other city. There is no doubt that, at the height of the Renaissance (15th century), the work done in Byzantium still rivalled the then new French and Italian work in realistic styles. The golden age of the Byzantium minor arts was between the 9th and 10th centuries, after which time production continued to evolve, but it modelled itself on past glories. Miniatures and pictures on panels – i.e. non-monumental painting – also flourished from the 9th to the 12th centuries.

Icons were a popular feature in Byzantine monasteries, and were the most common ambassadors of first Byzantine and then Byzantine-inspired art. From the fifth century, monasteries throughout Russia, Yugoslavia, Macedonia, Greece, and the Mediterranean islands, as well as Italy, France, and the Rhineland, collected both classical Byzantine icons and Byzantine-provincial examples that were influenced by a need for abstraction that was particularly Syrian. What the West admired most in Byzantine icons was the delicacy of line, luminosity, the transcendentally hieratic figures portrayed full face, the glistening colours, the iridescent velatur, the extremely economical use of space. Among the thousands and thousands preserved in European monasteries and museums, it is impossible to single out individual examples.

Used as it was for the illustration of both

Plan of Santa Sophia *Interior of Santa Sophia, Istanbul*

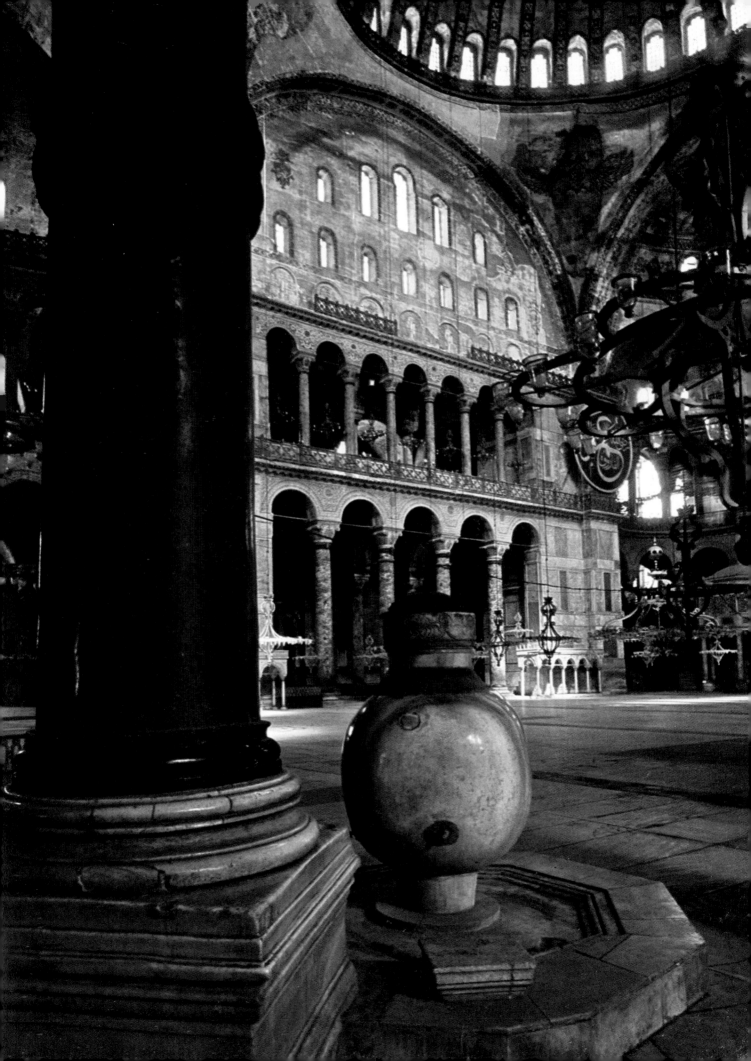

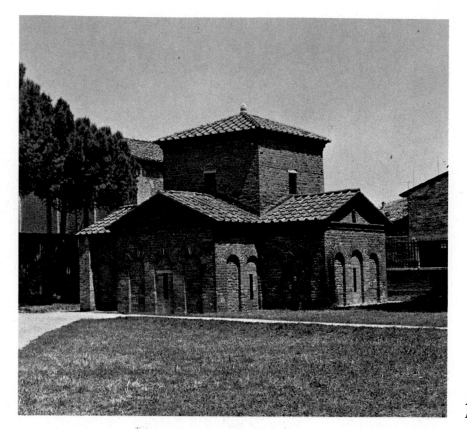

*Mausoleum of Galla Placidia,
Ravenna, from the east*

sacred and secular books, the miniature was far
more common than the icon. Long since known
in Egypt, Greece and Rome, and painted on
papyrus or parchment, its importance is immense

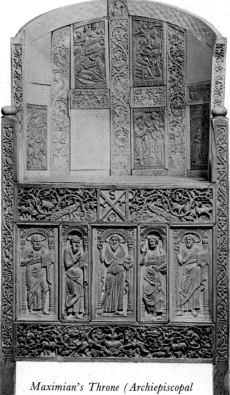

*Maximian's Throne (Archiepiscopal
Museum, Ravenna)*

since, besides giving us an idea of a stylistic idiom
at a given moment, it is a documentary of the
tastes, culture and social life of the places con-
cerned. To some extent, Byzantine artists were
indebted to the refined, aristocratic work of the
Greeks in this field, but what enhanced the
Byzantine miniature was its colour and use of
light. Request after request for miniatures poured
into Byzantium from Syria, the Coptic lands,
Armenia and Russia. The Carolingians, Otto-
nians and Normans inherited this treasure and
used it as a source of inspiration. Italian
monasteries, such as Bobbio and Montecassino,
became the depositories of many an illuminated
manuscript now preserved in museums or cathe-
dral treasuries. One outstanding example is the
set of Gospels known as the *Codex Purpureus* in the
Archiepiscopal Museum at Rossano in Italy,
which resembles the Syrian Rabula Gospels and
the Vienna Genesis. The bold drawing, vivacious-
ness and warm colours show Syrian influence, but
the accentuation of the gestures and the compo-
sition and treatment of the costumes are an
excellent record of the more universal demands
of Byzantine art at the height of the 6th
century.

Right from the beginning of its career as the
seat of the Eastern Empire, Byzantium was the
centre for a unique aspect of Byzantine art –
carved ivory. Naturally, examples of fourth- and

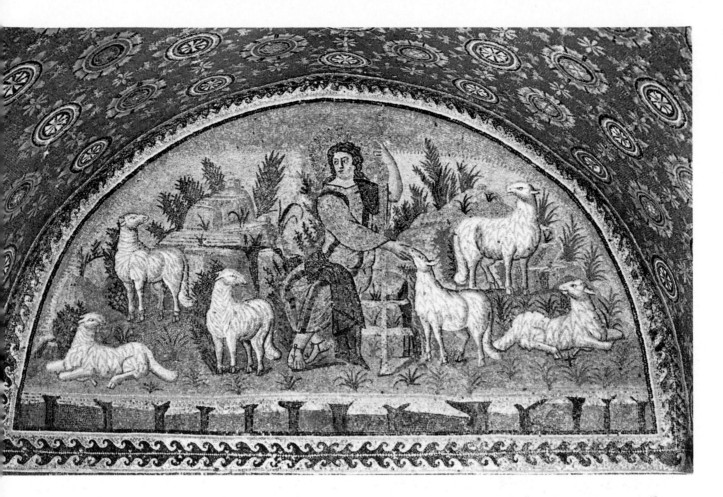

early fifth-century work show classical influence, especially Syrian and Alexandrian. For mastery of composition, handling of space, plasticity of relief, and supple, elongated forms showing elegant treatment of gesture and drapery, one of the best early examples is the Stilicho Diptych (two tablets fastened by a hinge for filing consular documents) now in the Treasury of Monza Cathedral. But at this time, Christian themes already predominated, a fact evident from a splendid reliquary casket in the Museo Civico at Brescia – a calmly spaced piece of work with depth and precise, naturalistic characterisation of the figures. At the end of the fifth century and during the sixth, ivory carvings reveal more especially Byzantine characteristics. There is no spaciousness and, instead of plastic figures, static men and women are grouped without

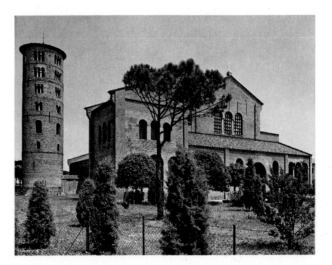

Above and right: *Plan of S. Apollinare in Classe, Ravenna, and general view*

Top: *The Good Shepherd, mosaic lunette in the Mausoleum of Galla Placidia, Ravenna*

157

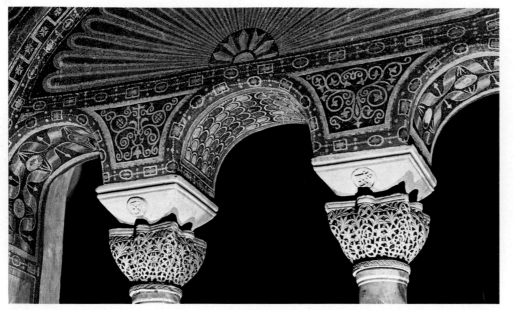

perspective. There is an exasperating insistence on details of clothing, and the figures stand out from the background gesticulating mechanically, portrayed full-face, eyes wide open, poised in the air, their feet not touching the ground. This is how the two consuls – later transformed into David and St Gregory – appear on one of the late fifth-century diptychs in Monza Cathedral Treasury. Made between 546 and 553, the famous Throne of Maximian (Archiepiscopal Museum, Ravenna) shows a mixture of styles. Its wealth of figures, its deep relief and the austerity of the costumes have suggested Egyptian inspiration, while other features point to Syria and Constantinople.

In the working of silver and gold, as well as enamel, whether sacred or secular, two styles obtained, the one traditional and classical, the other more obviously Byzantine. An example of the first is the portrait group on gilded glass inserted into a cross (Museo Civico, Brescia). Of the second there are some splendid examples in the Treasury of St Mark's, Venice, and the reredos of the cathedral itself.

Ravenna

Between the 300s and the 600s in Italy, the Byzantine buildings, sculptures, and paintings in Ravenna made that city the centre of Byzantine art. The Adriatic cities of Parenzo and Grado reflected the influence of Ravenna, and so did more distant Milan (the basilica of S. Lorenzo and the mosaics in S. Ambrogio and S. Vittore in Ciel d'Oro). Rome, also, saw Byzantine

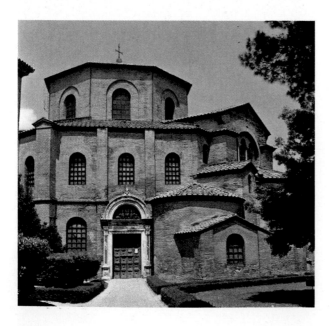

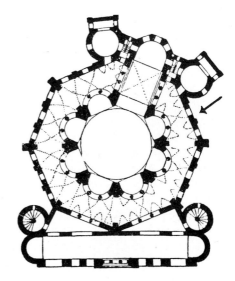

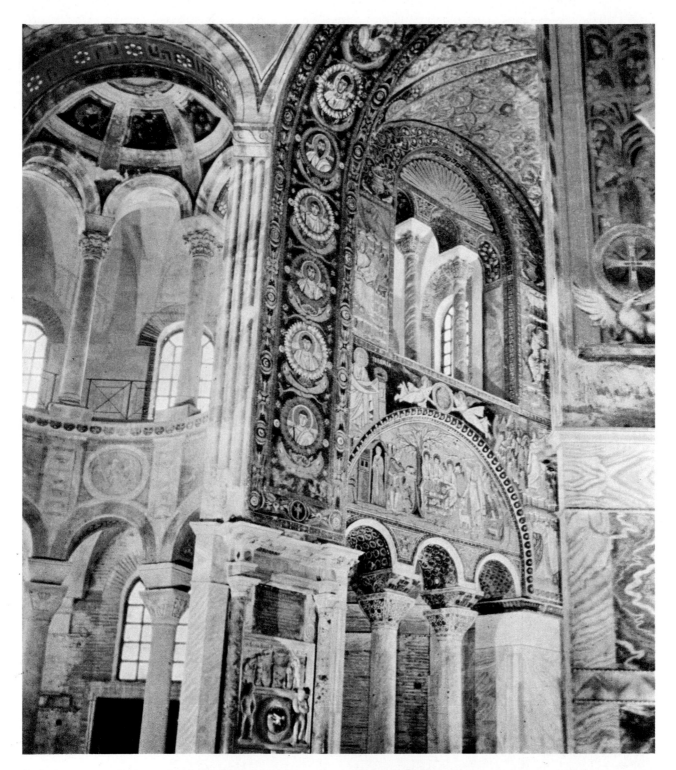

influences, as the mosaics in Sta Agnese demonstrate.

In Ravenna, the great patroness of Byzantine art was the Empress Galla Placidia who came from Byzantium to Italy during the third decade of the fifth century. By the time she arrived in Ravenna, Bishop Ursus had already built the cathedral (begun in 402) in Early Christian style, but only the crypt and campanile have survived; the present structure is largely 18th-century.

Bishop Ursus was also responsible for the Orthodox Baptistry, a round building with no pillars inside and a high dome rising on an octagonal base in Byzantine style. But the most famous, most characteristic Byzantine building in the city is the Mausoleum of Galla Placidia. Externally it is a simple, cruciform brick structure with blind arcades in the walls and cornices underneath the tympanums. The central portion rises in a cube surmounted by a little dome.

Small, intimate, softly modelled by the mosaics, the interior is the finest example of a mortuary chapel in Italy. The blue which dominates the background of the mosaics on the vaults with their abstract, Oriental patterns, seems to diffuse into the atmosphere attenuating the naturalistic, classic splendour of the festoons of fruit inside the arches. At the same time the dim light gives an other-wordly air to the figures in the lunettes: the Good Shepherd, classic in style with its handling of space and the monumentality of the Christ; St Lawrence, and the Apostles, whose white robes glow with abstract light.

At the start of the sixth century, Theodoric the Barbarian came to Ravenna. Although an Ostrogoth, he was an admirer of Byzantine and Roman culture, and built S. Apollinare Nuovo, the Arian Baptistry, and his own mausoleum. S. Apollinare Nuovo no longer retains its original external appearance because the apse was rebuilt. Inside, however, this ancient palatine basilica (adjacent to what was once Theodoric's palace) still retains its Early Christian plan inherited from Constantinople. The volume of this structure is centred in the main nave, with its marble pillars and their magnificent capitals. At the time of Bishop Agnellus (about 560), the basilica passed from Arian to Catholic hands, and in the change-over, the mosaics in the main nave suffered to some extent. The first and final episodes in the processions of Virgins and Martyrs are originals, along with the harbour with its ships at anchor and its defence towers; Theodoric's palace with its solemn, classic columns, its rich Oriental curtains on runners and background of contemporary buildings (a detail of great documentary interest); the Virgin and Child adored by the Magi, and Christ among the Angels. All dating

The Stilicho Diptych, Cathedral Treasury, Monza

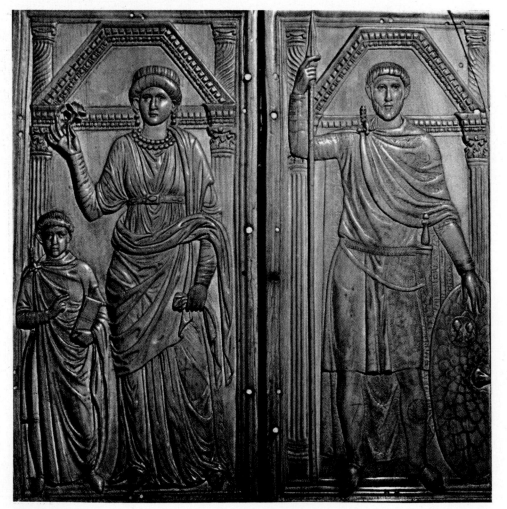

The Emperor's Palace, detail of a mosaic in S. Apollinare Nuovo, Ravenna

from the first half of the 6th century, they give Byzantine art the chance to show a freshness of narrative and illustration so different from the mysticism of the mosaics in the Mausoleum of Galla Placidia. In Ravenna the processions of the Virgins and Martyrs (the former happier and, technically, the better) are masterpieces of Byzantine art. Following the usual pattern, they make no attempt at perspective, plasticity of form, or individualisation of face or gesture. But the colours glisten, the light is abstract, the composition is full of rhythm. These mosaics have a triumphal expression of abstract, melodic beauty not unlike that inspired by the chanting of a litany.

To this same period belong the mosaics around the dome in the Orthodox Baptistry. Here we see the Apostles, static in their gestures but walking in a metaphysical light above a zone of altars and thrones in architectural settings. The standard of such work leaves no doubt of the importance reached by Ravenna in the 6th century through direct contact with Byzantium.

The most maturely Byzantine of the basilicas in Ravenna belong to the age of Justinian. A lone, majestic sight on the plain that slopes from Ravenna gently down to the sea, S. Apollinare in Classe is one of the finest examples of an Early Christian basilica. Its sheer mass of volumes proclaims its eastern origin in its blind, rhythmic arcades, its polygonal apse, and two apsidal chapels. The campanile (a later addition) soars high in the thin, cold light of the Lower Po valley without dispelling the charm of the pinkish-

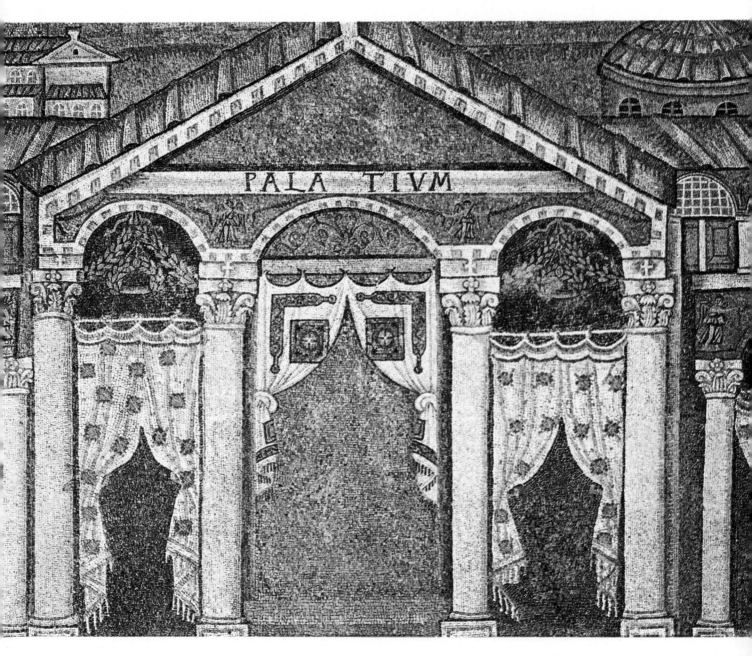

Miniatures from the 'Codex Purpureus', Rossano cathedral

grey pile. Compared to S. Apollinare Nuovo, the interior of S. Apollinare in Classe is vaster, more solemn. The atmosphere has something of that infinite quality of the sea, and, as the hours steal on, the bright, vibrating, joyful light dims to a haze of soft shadow. At the far end of the nave, the mosaic in the wide yet compact bowl of the apse glows green with the light from the meadow where sheep graze beneath a Cross that is aligned with other symbols. This fine mosaic dates from the second half of the 6th century. It reflects the characteristics of contemporary mosaics in Byzantium, more colourful, more glistening than ever.

The last of the great Byzantine achievements in Ravenna was S. Vitale, a round building revealing both classical Roman and Byzantine influences. With its massive pile, its luminous surfaces, its polygonal apse, its prothesis (chapel), and its diaconicon (sacristy), the exterior recalls Constantinople. The many effects of perspective and descriptive scenes almost recall Baroque Rome in search of contrast of light and shadow. The effect of the mosaics is that of a mass of

glittering gems, and the superb stucco-work recalls not only Byzantium but the Orient as well. Other influences have been at work in the great cycle of mosaics in the sanctuary. The landscape episodes are Hellenistic, and the Biblical episodes are treated idyllically, most happily worked out in an impressionistic manner vibrating with white light. The imperial figures from the East, half dream, half reality, are groups of court ladies and dignitaries accompanying Justinian and Theodora. They move towards the altar against a glittering background.

Though seen full face, the very feminine ladies are moving from right to left and, for all their splendid dresses and sumptuous jewellery, they are outshone by the superb, Oriental splendour of Theodora. The members of Justinian's entourage have virile faces. The slow step of the figures, the gestures of their luminous hands holding gifts, the soft flow of water into a golden cup are details which extend the action, whilst the heavy, mosaic borders which frame the scenes of the procession strongly recall Byzantine tapestries woven with gold thread.

BARBARIAN ART

In the 5th century Rome suffered two shattering catastrophes, causing the disintegration of the Empire and the dissolution of the classical world, which thereafter survived only in Byzantium in a theocratic, Orientalised version of its own.

The first upheaval was of domestic origin and took the shape of a serious crisis, a rapid decadence. The second came from abroad. Having long menaced and overcome the furthermost outposts of the Empire, which was far too extensive an area to be guarded effectively, the Barbarians hurled themselves through the gates of Italy and penetrated deep into the country.

The internal crisis had many causes, and Christianity itself was one of them. The Church, now recognised and protected officially, had good reason to regard herself as the heiress of Rome – as indeed she was in a sense. In the name of true religion, however, Christianity had destroyed the pagan foundation on which the classical world was based. In the name of transcendent values, she had denied the supreme authority of the state. The Imperial power was tottering. No longer supported by a political class, it was kept in being by the army which often included large detachments of Barbarians.

Trade declined rapidly, and agriculture disintegrated as a result of the general impoverishment and the crisis in the slave labour system, the mainstay of Rome. The population of the cities began to dwindle, and the cities themselves declined. Outside the Imperial establishment, the men who wielded political power were busy making money, though not with any prospects of permanent gain. In any case, such men constituted only a tiny, privileged class which had long lost all sense of shame or dignity in an endless round of intrigue and corruption.

Christian thinking, contributed largely by such outstanding men of provincial origin as St Augustine of Hippo, in Africa, had an injurious effect on the old, pagan culture. Schools and centres of the pagan culture were in decline, if not in fact abolished, and paganism had no means or hopes of revival. More and more the preserve of clerics and small circles of privileged laymen, Latin became corrupt and, as a result, gave birth to the Romance tongues, the living languages of the masses. Within the Church, several people retired from the world to dedicate themselves to monastic asceticism or lead a conventual life.

In the field of art, the unsettled times produced a decline from classical standards both in Italy and the provinces. This was not so refined as earlier styles, it is true, but was nevertheless of imposing proportions and, especially in the East, was the innovator of the apse, the niche, the vault, and curvilinearism in architecture. From the temples and arenas of Nîmes to the amphitheatre of Arles, from the aqueducts of Segovia and Le

Opposite page: *Agilulf's votive cross (Cathedral Treasury, Monza)*

St Gregory's Diptych (Cathedral Treasury, Monza)

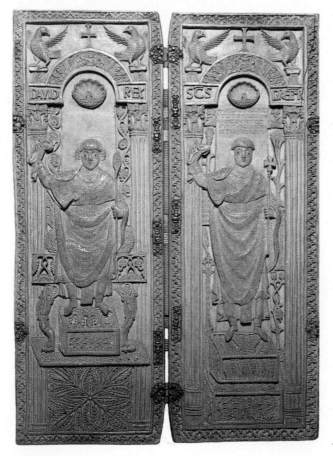

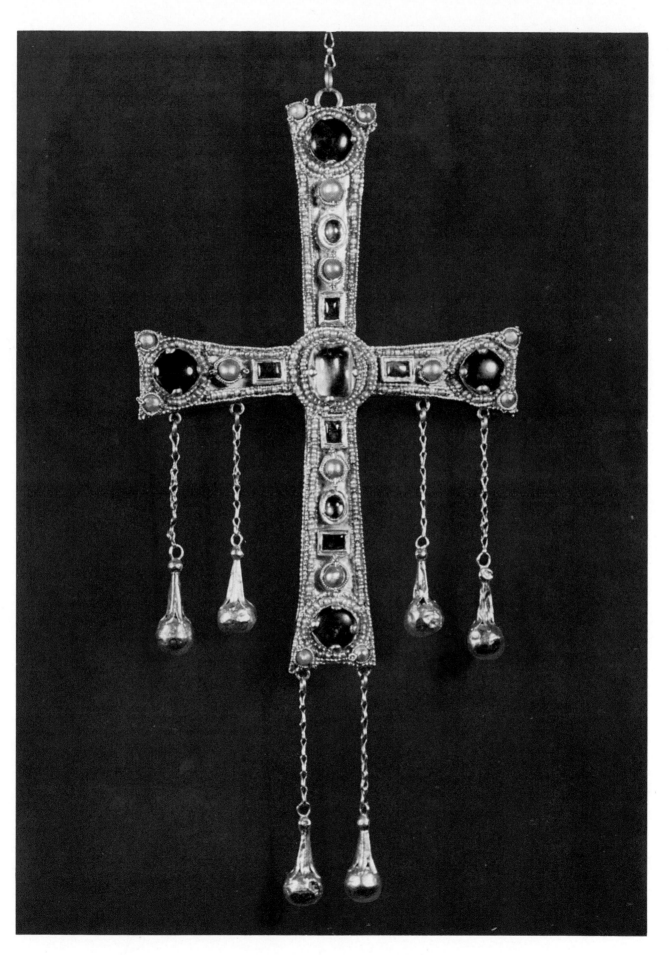

165

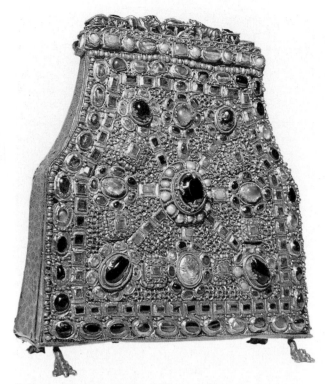

Reliquary of a tooth (Cathedral Treasury, Monza)

Gard to the Porta Nigra at Tries, late Roman provincial art left its mark throughout Italy and other parts of Europe. To Africa it bequeathed cities such as Timgad, Leptis Magna, and Cirene; to Asia Minor, Baalbek, Palmyra, Doura-Europos, and far-off Petra. In this period of decline neither public buildings nor private dwellings were being erected. The same was true of Christian churches, too. There was little point in building in cities that were being emptied of their inhabitants. Builders closed their yards and skilled workmen were dispersed. If any construction did take place, it was of the most elementary nature, with materials looted from existing buildings. Deprived of strength and inspiration, both sacred and secular painting became more and more neglected. Sculptors abandoned statuary almost completely, and their sarcophagi or ornamental friezes grew heavy, lost any sense of composition and proportion, and strayed into a maze of laboured decoration with little or no plastic quality. To speed up their production, sculptors frequently used a drill instead of a chisel.

As if being the victim of an internal crisis were not enough, Rome now became the prey of foreign aggressors – the invading Barbarians who, without much difficulty, finally destroyed the Empire. However, this great migration of peoples, a curtain-raiser to the Middle Ages, was not sparked simply by indomitable hatred of Rome and consequent insurrection. Entire nations and their primitive civilisations had been under pressure for a long time from the Far East. From being extremely precarious, their situation had eventually become impossible. They had been forced to flee in search of lands where they could settle under better conditions.

In the vanguard of the migrants were the Huns, a race of Tartar origin. Repelled first by the Chinese, who built the Great Wall to keep them out, and then by the Mongols, they crossed the steppes and southern Russia, and hurled themselves upon the West. Under Hun pressure, the Ostrogoths and Visigoths to the north of the Black Sea set out, the latter with Alaric at their head, to invade Greece. Repelled by Byzantium, they turned towards Italy. After taking Rome in 410, they turned back along the north-west coast, crossed through Provence, and poured into Spain. Next came the Vandals, a Germanic people who devastated Gaul, crossed Spain and invaded North Africa. Like the Visigoths, they too attacked Italy and, under their leader Genseric, also captured Rome (455). The Burgundians, of Scandinavian origin, and the Germanic Alemanns, spread through Gaul, inducing the Franks in the north to break with Rome and, in their turn, expand their territories. Having reached Hungary by the start of the 5th century, the original migrants, the Huns, had made an unsuccessful attempt under Attila to take Constantinople (443). Turning west, they too invaded Gaul. No more victorious there than in Greece, they penetrated into Italy and, under their great king, Theodoric, defeated Romulus Augustulus, the last Emperor of the West (493). The next invaders of Italy were the Lombards, a race of Baltic stock expelled by the Asiatic Avars from the Danube region, where they had settled. Following upon the heels of the Lombards came the Franks. While all this large-scale migration was in progress, smaller migrations were taking place, like that of the Angles, Saxons and Jutes from Denmark and Germany, who invaded Britain, the most remote of all Roman provinces in Europe.

The details of this vast migration and its gradual stabilisation are highly complex. Its impact on art was unquestionably a shock which spelt rupture. Not that the immigrants were deliberately adverse to the classical or late-classical world. It simply did not appeal to their aesthetic sensibilities. In their own limited, primitive way, they looked on art as something purely decorative and ornamental. The art forms they found surrounding them must have been a

Architecture

source of bewilderment. Their own had a completely different application.

To start with, they had no idea of architecture in the true and proper sense. For the most part they were nomads or semi-nomads, and their conception of a building was a precarious structure in wood, usually temporary. Once installed in Europe, however, the Barbarians accepted the local architectural forms they now lived with and gave little or no thought to style. The only leader to adopt a different attitude was Theodoric – not surprisingly, perhaps, seeing that he was the most cultured of all Barbarian monarchs. He certainly appreciated classical architecture, although what he built at Ravenna was steeped in the art of Byzantium. His lone, imposing tomb – walled with blocks of marble at the base and adorned with eight arches on which the dynamic, cylindrical mass rises – evokes a Roman tomb, but the style is late Roman provincial. The only Barbarian, almost Oriental feature, in it is the immense, low, monolithic dome.

For chronological reasons the term 'Barbarian' cannot correctly be applied to other buildings

Theodelinda's cross of crystal (Cathedral Treasury, Monza)

The Iron Crown (Cathedral Treasury, Monza)

Bronze clasp (British Museum, London)
Top of page: *Laminated gold saddle ornament (Museo dell' Alto Medioevo, Rome)*

constructed during the unstable early Middle Ages. Even during the crisis that befell the Empire, such buildings revealed a mixture of the most varied styles, from Early Christian to Byzantine and the precursor of Pre-Romanesque, which we shall discuss later. Moreover, this mingling of styles was due to the rough, popular touch that resulted from the amalgamation of native and foreign peoples, a process in which the Church played no small part.

Examples of the architecture of the time are to be found in the sixth-century baptistry of Lomello, late antique in style with rectangular or semicircular chapels; the eighth-century basilica of S. Salvatore at Brescia, which stands between late Early Christian and anticipated Pre-Romanesque in style; and the contemporary Lombard church at Cividale dei Friuli with a square main body and triple barrel-vault over the sanctuary. It was here, in the ninth century, that some of the few remaining craftsmen – certainly not Barbarian artists – added the arch with vine motifs on the frieze and the large stucco figures of the six eastern-looking women. More original in style, but rustic Early Christian rather than Barbarian, is the little church of Sta Maria Foris Portam (possibly 7th century) in the once important Lombard centre that is now Castelseprio near Gallarate. The splendid frescoes in the apse depicting the childhood of Our Lord are not the work of some Barbarian craftsman, but a cultured artist remarkably influenced by the Neo-Alexandrian school.

What little Barbarian art gave to sculpture was as meagre as its contribution to architecture.

Warrior, stone-drawing from Möjebro (National History Museum, Stockholm)

Take, for example, the Triumph of Agilulf, a seventh-century work on copper now in the Bargello, Florence. It certainly is Lombard in style, but the workmanship is that of some inexperienced local craftsman. Similarly the sarcophagus of Theodata (eighth century) in the museum at Pavia is little more than a popular caricature of Byzantine motifs. On the other hand, a seventh-century transom in S. Colombano at Bobbio shows refined development of Barbarian ornamental motifs. The eighth-century fragment of the altar of Duke Ratchis (Museo Cristiano, Cividale) shows a mixture of Lombard and late Roman influences from the Danubian provinces,

especially the scene of the Adoration of the Magi, which is interwoven with abstract motifs. With its flattish but expressionistic relief work, the transom of Sigwald (7th century) from the canopy over the baptistry altar is more Barbarian in style.

As a rule, Barbarian art showed little taste for figuration, a fact which gives special significance to certain objects made in northern Europe, particularly Scandinavia. Of a style largely immune to classical influence, these runic stones, as they are called, are decorated not only with cryptic writing but with graffiti of figures as well. In the Stockholm Museum is a mounted warrior engaged in combat, and there is a fine example of eighth-century Viking art showing a ship with billowing sails, laden with warriors.

The minor arts

The most important contribution of the Barbarians to art as a whole was in the field of the minor arts, a vast territory allowing full play to the conception of art as an ornamental function, to the love of glittering materials, to a flair for colour, and for purely decorative and abstract patterns.

Of the two sources from which this Barbarian contribution stemmed, the first was Celtic, the civilisation predominant in west central Europe. It was a civilisation which, when the prehistoric La Tène period gave way to the Hallstatt period, had passed with credit from the handling of bronze to an intense output of ironwork. Celtic civilisation had persisted even in districts later occupied by the Romans, and this gave rise to those curious mixtures of Gallo-Roman or Celtic-Roman art, examples of which are found mostly on weapons, ornaments, goldwork and vases. In metalwork, the Celts fought shy of realism or figuration and concentrated on abstract themes, not always geometrical. Their speciality was a rhythmic ornamentation done with fluid, continuous ribbon-like lines twisting and intertwining.

Noticeably Eastern, and concerned chiefly with small-scale goldwork and jewellery, the second source was the art of the peoples of the steppes – an art already discussed (see p. 000). Inspired by animal forms, it was, with its intertwinings and incrustations, stylistically more complex than the Celtic. Its flair for bright, polychrome orna-

mentation and inset gems or hard stones stemmed from the East – particularly Luristan, and perhaps, Persia and the Hittite lands. The Barbarians soon learned how to cut gems, set them in cloisonné manner and cover the metal with exuberant decoration.

Barbarian art produced a wealth of small but exquisite gold ornaments such as clips, brooches, clasps, necklaces and earrings. But its real contribution, of which several magnificent examples have survived, was the creation of crowns. These ranged from votive crowns made for hanging in churches, such as the Visigoth examples of Guarrazar in Spain and now in the Musée de Cluny in Paris and the Museo Nacional in Madrid, to the more simple crown of Theodelinda, Queen of the Lombards, or the dazzling, historic Iron Crown (Cathedral Treasury, Monza). Next come precious crosses, such as the cross of Adaloald, presented, it is thought, by Pope Gregory the Great to Theodelinda, in 603. These crosses and crucifixes range in size and importance up to the resplendent votive cross of Agilulf with its pendants. Together with the ninth-century pectoral cross of Berengarius, it can now be seen in the Cathedral Treasury at Monza. Then there are other valuable objects such as, for instance, the Gospel-book cover, a gift of Theodelinda (Cathedral Treasury, Monza). Adorned with a geometrical pattern, it is further embellished with precious stones and cameos. No less remarkable is the Merovingian reliquary coffer (St Maurice d'Agaune, Switzerland), a gift of Theodoric and a masterpiece of the cloisonné technique. Another priceless possession of Monza Cathedral Treasury is a richly ornamented reliquary of a tooth (circa 800), while, in the Louvre, Paris, is the splendid copper, iron and gold helmet with a vine motif relief from Amfreville.

If only for their perfection, Barbarian goldwork and jewellery from Scandinavia deserve a special mention. Particularly noteworthy are the great sixth-century decorated gold medallion from Gotland and the superb filigree and granulated gold necklace of the 9th century (now in the Stockholm Museum). With examples such as these for models, it is not surprising that the Vikings, those adventurous men of the North who set forth in fast ships upon their expeditions, should have created an ornamental world of their own, rich in beauty and variety.

Celtic art: the 'Helmet from Amfreville', bronze covered with gold foil and with enamel inlay (Louvre, Paris)

170

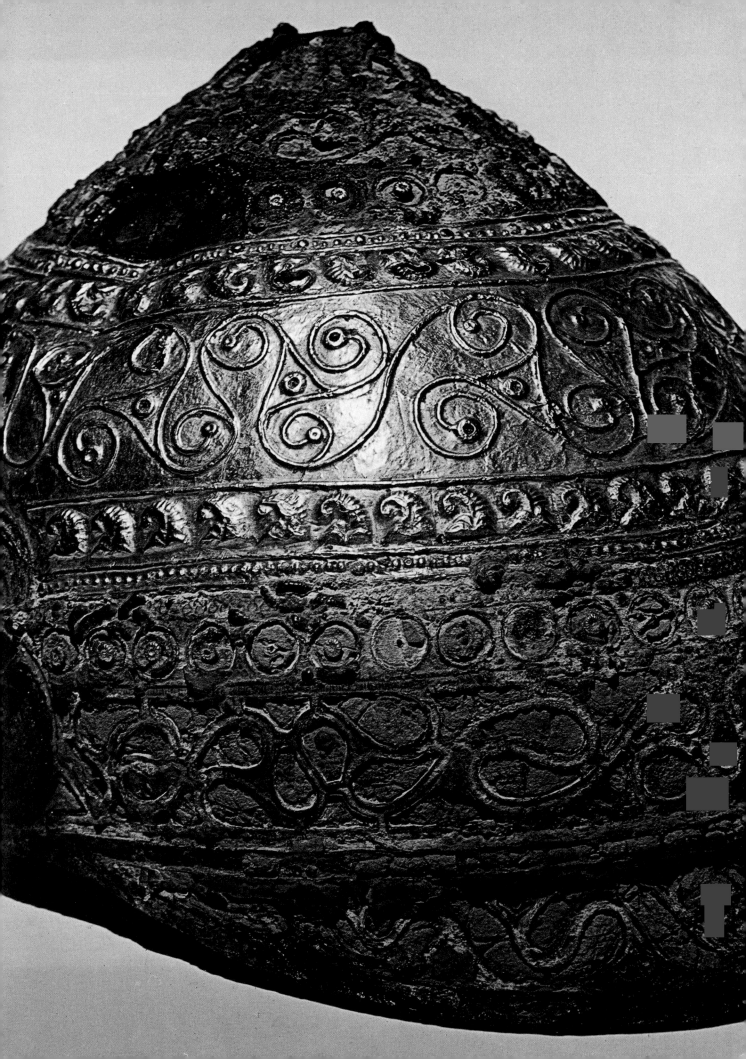

ISLAMIC ART

For seventh-century Europe the mighty eruption of Islam on the opposite shore of the Mediterranean meant not only a terrible threat that would soon be followed by aggression, but the presence of a disquieting rival as well.

Islam began with Mohammed, the 'prophet of the revelation', as he was called (he was never hailed as a divine being or the Son of God). He had gone first to Mecca, then to Medina, preaching a monotheistic, spiritual religion which proclaimed the omnipotence of Allah. Consecrated by the Koran, Islam claimed as its first converts the poor, nomadic bedouins of Arabia, a people without a vestige of civilisation. Yet, for all this humble start, Islam soon became equated with fanatical expansionism. Even in lands formerly subject to Rome, and each with its degree of Roman civilisation, the new religion spread like wildfire, claiming millions of converts. Compared to a Europe in decadence, a Europe tending to extinction in the closed, stagnant economy of the Middle Ages, a Europe crumbling under feudalism, Islam represented not only a civilisation on the move, in the ascent, but a powerful, unifying force that spelt death to national as well as racial barriers.

Not that Islam was a homogeneous civilisation. It bore traces of older cultures and some complicated adaptations, too. Intransigent in matters of faith, Arab rule proved otherwise indulgent, however. After its first flush of glory – in the 7th, 8th, and 9th centuries – the long story of Islam tells of eccentric, sometimes heretical trends, of events within individual Moslem states which destroyed the original structure. But nothing could destroy the ideal which formed the common heritage. Nor could anything break the bonds that united all Moslems in one spirit and one faith.

Thanks to the fanatical aggressiveness of the Arabs, only some fifty years passed after the death of Mohammed (632) before Islam became one vast empire. From Byzantium it snatched Palestine and Syria and, at the same time, the

The Mosque of Omar or Dome of the Rock, Jerusalem

173

Courtyard of the Mosque of Ibn Tulun, Cairo

buildings with vaults, domes and apses which first the Greeks and then the Romans had erected there. Next it invaded the whole of Lower Mesopotamia and conquered Upper Iran, bringing about the fall of the Sassanians, successors of the Parthians. Last of the Persian dynasties, the

Portico of the Mosque of Tari Khane, Damghan

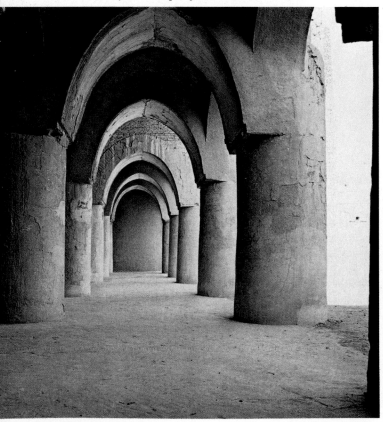

Sassanians, from the 3rd century B.C., had been great builders and prolific exponents of the Eastern-style minor arts.

The next victim of Islamic expansion was India. In the opposite direction, Islam conquered Egypt, penetrated south and engulfed the Copts, and spread along the shores of the Mediterranean as far as Tunisia and down to Magreb. From there, starting with the conquest of Spain (711), it crossed over into Europe.

On the heels of conquest came organised government, with the central authority vested in the person of the hereditary Caliph. A vast network of peripheral rulers echoed their master's sumptuous court life and were assisted in the work of administration by an efficient bureaucracy. From Arabia, the centre of power shifted to Syria where, in 661, the first Umayyad Dynasty settled in Damascus and rebuilt the city. The bloody revolution of 750 which ousted the Umayyads in favour of the Abbasids, entailed shifting the capital again, this time to Baghdad, the round city on the Tigris in what is now Iraq. For Islamic art, this move meant a greater infiltration of Persian and Sassanian influence.

The mosque

Islam's particular contribution to architecture was the mosque. In general, this structure consisted of a vast, rectangular courtyard, usually containing porticos and often also a fountain for ritual ablutions. In addition, there was a solemn hall used for meetings or common prayer. There were also one or more minarets, and from the top of one of them the muezzin summoned the faithful to prayer.

Such was the usual, functional plan, but the regulations governing it were elastic. One of the most splendid undertakings of the Umayyads was the Mosque of Omar or Dome of the Rock in Jerusalem (691). However, the central octagonal edifice of this Mosque with its high dome seems to have had Byzantine antecedents. Another fine example, the Great Mosque at Damascus, with its three naves, is a transformation of a building, previously a Christian church.

Two features, each developed in the course of time with great variety, give the mosque its distinctive character. The first is of a structural nature; the attempt to lighten the architecture and widen the available space. A typical manifestation of this is the Islamic horse-shoe arch, which, if it loses something in robustness, nevertheless dissipates any impression of heaviness

Opposite page: The 'Great Mosque' at Damascus

174

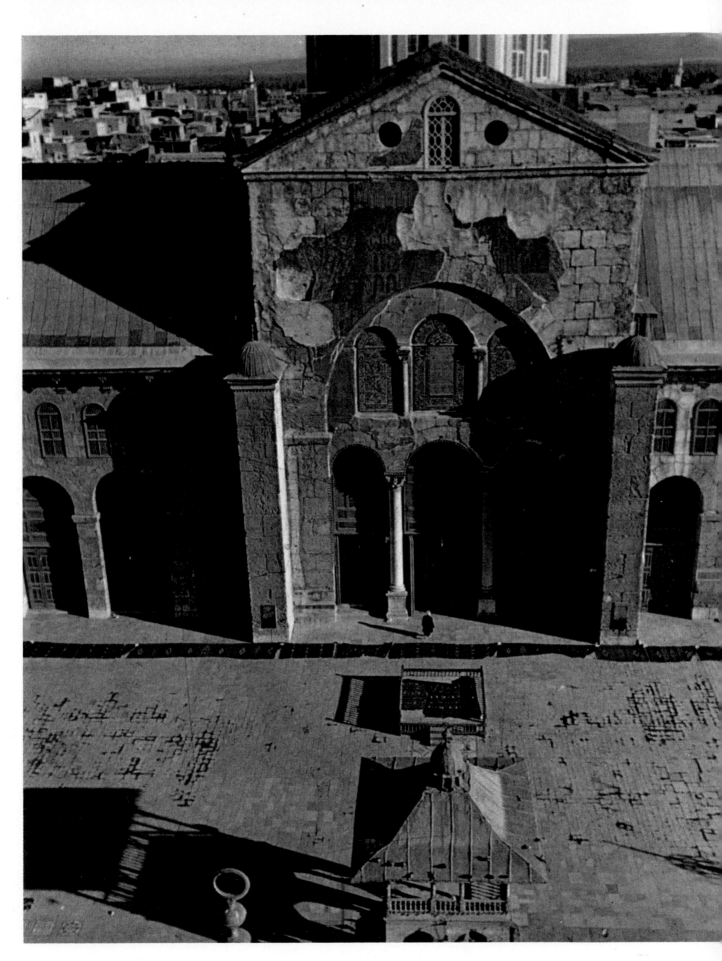

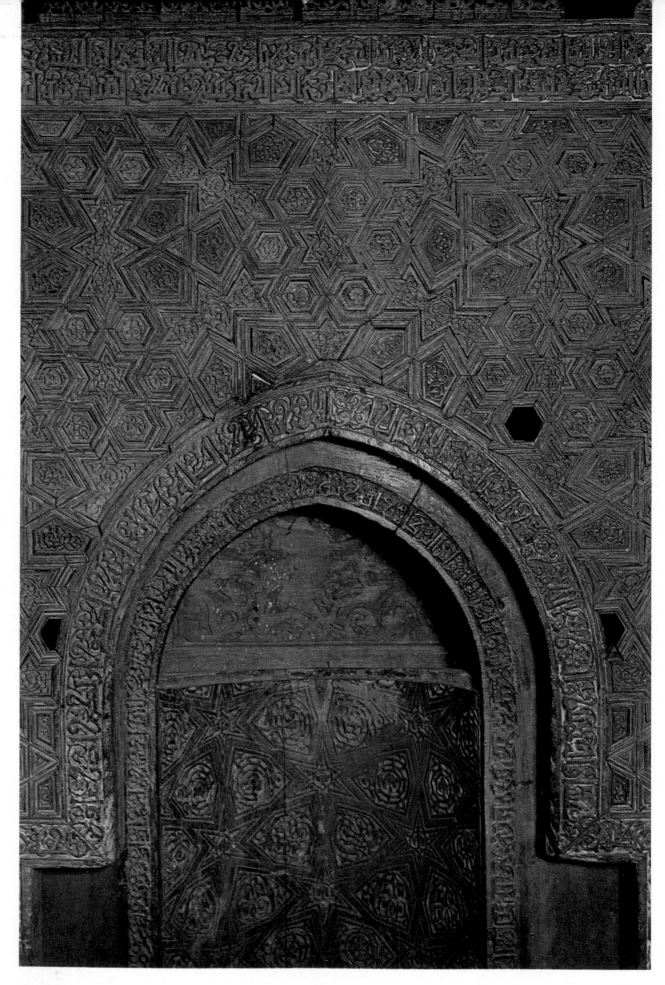

by its upward thrust, which occasionally resolves into a pointed arch. Another manifestation of the same goal is the increase in size and height of the dome built on a wooden skeleton. The second distinctive feature of the mosque lies in the variation in decoration. A mosque is essentially an unfurnished building. It has no altars, no statues, no pictures of the Deity or the saints. The only detail which interrupts the functional geometry is the modest *mihrab*, the arched niche in the wall indicating the direction of Mecca. Whether mosaic or marble, wood or stucco, all the vivid, possibly superfluous decoration is given over to abstract motifs, not figuration.

After the mosques built by the Umayyads at Damascus, Medina, Jerusalem, Aleppo, and Fostat (present-day Cairo, which was originally an Arab foundation) came those constructed by the Abbasids. They range from the large mosque at Kairouan in Tunisia (9th century) and Ibn Tulun's mosque in Cairo (9th century) to the now ruined mosque in far-off Samarra on the borders of Chinese Turkestan. A feature of the latter is its massive, spiral minarets built to withstand stresses. There are also the mosques built at a much later age, when Islam was extending its boundaries still further. In this category come the mosques built by the Turks in Constantinople after its conquest in 1453, when Byzantium was extinguished for ever. In 1610 the glittering 'Blue Mosque' of Sultan Ahmed was begun there. With its many domes of increasing size, it rose alongside the Byzantine Santa Sophia, which was itself converted into a mosque. There were also important mosques in Persia erected by the Safavid Dynasty, which came to power after the Mongol invasions under Tamerlane and Genghis Khan at the beginning of the 16th century. With its pointed dome of green majolica, the 'King's Mosque' at Isfahan is a superb example.

In the course of their development and the loss of their original plans, Arab cities have been left without the slightest trace of the most ancient Caliphs' palaces – those built during the Umayyad and Abbasid dynasties, and the subject of many a glowing description in Arab literature. Still extant, however, are the typical, vast, complex, fortified villas erected by the first Islamic sovereigns on the very edge of the desert, if not in the desert itself. Other surviving examples of early secular architecture are the market buildings, although these, because of their very nature, have necessitated frequent

Islamic ceramic (Islamic Museum, Cairo)

The 'mihrab' of the Mausoleum of Saigda Rukaja (Islamic Museum, Cairo)

177

Bronze jug. 7th-century Islamic art (Islamic Museum, Cairo) 13th-century Islamic miniature

alteration. Also extant are various types of military fortifications. More important, however, are examples of the *madrasah*, a sort of university college for the teaching of Islamic law, both sacred and secular, and the *medersah*, a less imposing type of Koranic school. The best examples of these buildings date from the reappearance of the Seljuk Dynasty after the 11th century.

Decoration

The development of the other arts, especially painting and sculpture, was hampered from the start not so much by explicit prohibition as by the repugnance felt by Islam for representations of the human figure, sacred or secular alike. To the Islamic mind, they encouraged idolatry. As a result of this handicap, therefore, Islamic art strove to find an outlet in decoration. This it did with so much brilliance, so much enchantment and originality, such clever association of repeated formal rhythms and of contrasting and harmonising colour effects, that decorative work became the mainstay of Islamic painting in particular and the main contribution of Islam to painting in general – a contribution esteemed and often envied by the West. Exceptionally,

however, Islamic painters used realistic animal or vegetable motifs, adapting them to the requirements of decoration or stylising them in ornamental fashion.

As a rule, Islamic painters preferred abstract, geometrical, graphic, or linear motifs. Abstract motifs were treated with inexhaustible invention. Geometric themes ranged from the simplest of forms to the most complicated and involved interwoven and superimposed patterns. Of rare elegance and flexibility, graphic art sometimes included Arabic lettering stylised in a variety of ways. Linear motifs showed a preference for the arabesque, the ornamental use of the continuous line, winding, twisting, intertwining, always fluid, alternating between isolated themes and repetitions.

During its thirteen centuries of life, this decorative aspect of Islamic art found numerous applications, both sacred and secular. These ranged from mosaics to wall-painting, carved marble, majolica inlay, fretwork in wood or marble, decorations in the shape of festoons, and hanging curtains or 'stalactites'. Being so well served by Islamic craftsmen who had to meet the needs both of a resplendent court and an intense export trade (which, after the Crusades, catered for the West as well), the minor arts

could hardly have failed to flourish in Islam. In fact, there were so many centres where they were pursued, such a variety of tastes and styles, that the history of Islamic art is permeated with them.

As a rule, metalworkers neglected gold and silver ware in favour of highly decorated vases, jugs, cups, and plates in bronze and copper. Potters created fine new types of jars, bottles and vases, a credit to their technique not only in form but in enamel and glaze finish as well. Weavers produced ornate, elaborate textiles. Later on, in Persia and, to a lesser degree, Ottoman Asia Minor, they produced carpets of a standard – especially in Persia – that has never been bettered. Islamic art may have been confined to the decorative but, in compensation, it achieved rare refinement and distinction.

The miniature

In 1258, after the Abbasids had fallen from what had degenerated into merely nominal power, the ban on figuration weakened and, as an adjunct to the fantastic literary output of the day, an art form came into being that was new for Islam. The miniature, in the hands of Islamic painters, became a lively, colourful medium, and one that showed remarkable freedom in its treatment of nature and perspective. The schools adopted it, so did the workshops. In the Arab-Moslem world Baghdad became its most important centre, but Persia produced the best work, especially during the 14th century at Tabriz. Retrospectively, one could say that the Mongol invasions under Genghis Khan seem to have bequeathed to the Persians ideas first culled from the great Chinese civilisation and its exquisite painting. Cultivated as a courtly art, the Persian miniature told a pleasing story with a splendour of colour and an almost unbounded freedom of composition. Small wonder it flourished as it did.

The fall of the Abbasids meant the rise of several other regimes, each with its own relatively independent artistic stamp. Originally from Turkestan, the Seljuks descended into Mesopotamia from Iran and installed themselves in Baghdad. Although successful in restricting the power of Byzantium, they failed to contain the Mongol invasion of Iran under Tamerlane. Starting in 1250, the Mamelukes ruled Egypt for two-and-a-half centuries. The Mosque of Sultan Hassan in Cairo still bears witness to their luxurious tastes. From 1501 to 1722, Persia was ruled by the Safavid Dynasty, whose capital was Isfahan. There they erected imposing buildings and encouraged the ornamental arts. After the conquest of Constantinople in 1453, the Ottomans, masters of Anatolia, reconstituted Islamic unity and infiltrated into Europe. By the 16th century, the imposing Mosque of Suliman and that of Ahmed I in Constantinople rivalled even the magnificence of Santa Sophia.

A young man asleep, 16th-century Persian painting (Cleveland Museum, Ohio)

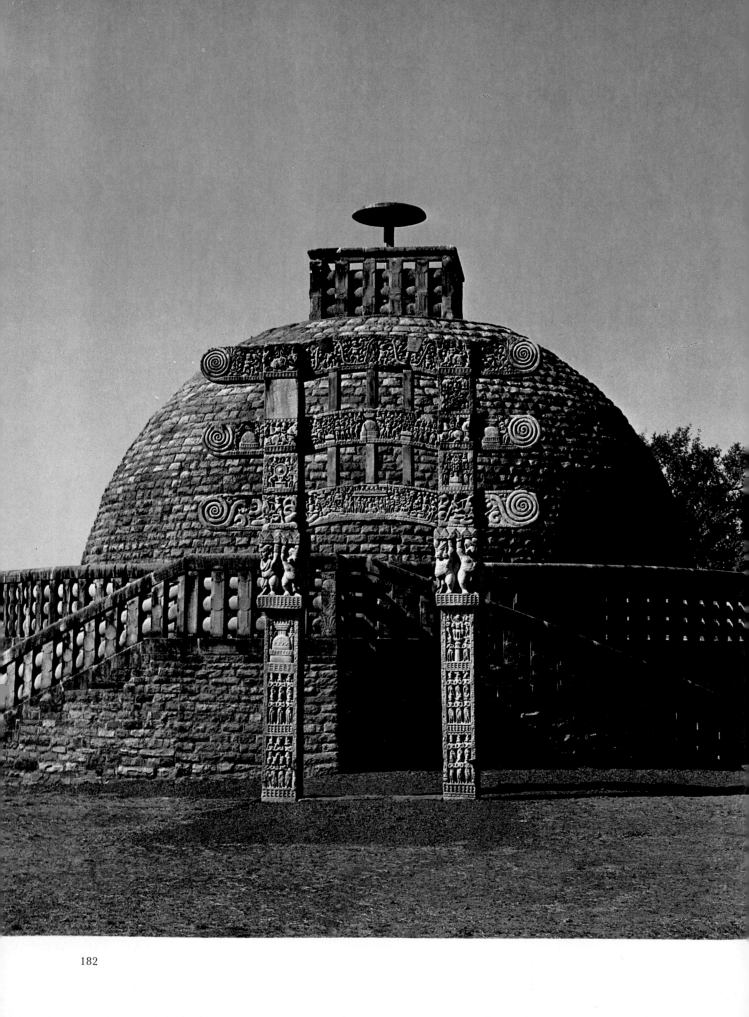

INDIAN ART

In its art, India reflects its own complex, often contradictory characteristics. As large as a continent, it is a divided, unstable land where sharp disparities of development owe much to a climate that seems to encourage excess. It is populated to saturation point, with peoples of different races, at different levels of different civilisations, each with a history of its own. It is a country split by the artificial barriers of the centuries-old caste system, a country where a handful of rich people have long enjoyed an

Opposite page: *View of the Stupa 3 at Sanchi*

Yakshinī holding a branch of the Ashoka-tree. Sculpture from the Great Stupa of Sanchi

accumulation of wealth, while countless hungry masses have lived in misery and despair. To counteract tradition it has sought, and still seeks, inspiration and fresh ideas from abroad. Unlike any other Asiatic country, it has a national unity welded together by the lofty standards of its religious beliefs, its philosophy, its culture. But this is a nagging, oscillating, tormented unity, a unity not strengthened by external influences.

To these fundamental contrasts deriving from the world that gave it birth, and of which it is the mirror, Indian art has added others – and not only by virtue of its continually interrupted existence, in the course of which it has acquired aspects that seem paradoxical to the outsider. Judged by its purely Indian appearance (foreign influences apart), Indian art is relatively simple and limited because it is predominantly a sacred art. Yet the first thing that strikes Western eyes in particular is its predominantly secular and earthy character. Its tortuous, symbolic, and mystic meaning is above all a reflection of spiritual, even ascetic thought. It is an expression of Buddhist philosophy, the outlook which has permeated Indian thinking from the sixth century B.C., the spur which makes the devotee give himself to meditation and so receive the spiritual enlightenment which enables him to rise above the contradictions and impermanence of reality – or, in other words, attain nirvana. At the same time, however, Indian art is obviously vital, rapidly capturing a mood or recording a fleeting impression. It is exuberant, sensual, and determined to live. It goes about its task with unparalleled vivacity.

At the dawn of Indian history (3rd millennium B.C.), a civilisation was developing in the valley of the Indus, with its chief centres at Mohenjo-Daro and Harappa. Not many traces of it remain, but the style of some surviving terracotta statuettes of deities shows an affinity with the Mesopotamian and Sumerian world, and this relationship is confirmed by the style of numerous seals or tablets with carvings of various animals.

About 1400 B.C., this native civilisation was overthrown by the Aryan invasion, an influx of nomadic peoples from central Asia. The two civilisations fused, forming the foundation of the

Indo-Aryan civilisation. The result was a fairly homogeneous people. The Indo-Aryans were skilled in the use of metals. They spoke a fully evolved, rich language, Sanscrit, which enabled them to embark upon a great, literary output beginning with the Vedas. In the sixth century, they witnessed the birth of Buddhism, the mystical movement which eventually spread throughout a large part of Asia. Although scholars have blamed the fragility and perishability of the materials employed, it is strange that a civilisation which maintained so high a standard for over a thousand years should have passed away leaving nothing more than insignificant traces of its art.

There is little evidence of an artistic output that expressed established religious or spiritual ideas before the Maurya Dynasty, which began in 322 B.C. By then the repercussions of the Graeco-Macedonian expedition led by Alexander the Great into the valley of the Indus had ceased to be felt, and, for the next hundred years and more (up to 185 B.C.) the new dynasty made one of the most complete (but ephemeral) attempts at Indian political unity. In the third century, Ashoka, greatest of all the Mauryan monarchs, embraced Buddhism and encouraged its spread even beyond the confines of India.

Though content to use styles of preceding ages Ashoka was a prolific builder. There is indirect testimony of this in the fine, symmetrical sculpture on the parapet of the stupa at Bharhut (Calcutta Museum) and the colossal capitals dominated by figures of animals, singly or in groups, which Ashoka placed at the entrances to cities or in front of temples. When the Mauryans fell from power, their art was carried on by the Shunga Dynasty in the North. At Sanchi in particular, this dynasty continued to erect and perfect the typical Buddhist building already encouraged by Ashoka – the hemispherical stupa of stone that rose from a circular drum with a parapet and had an umbrella on top symbolising the vault of heaven. Both the Shungas and the Satavahanas who succeeded them paid particular attention to the gateways – isolated structures composed of uprights and crossbeams covered in sculpture. Vigorously carved in relief, this adornment took sacred symbols or episodes in the life of the Buddha for its themes and treated them with open-minded fidelity to nature and reality, although – such is the peculiarity of Indian art –

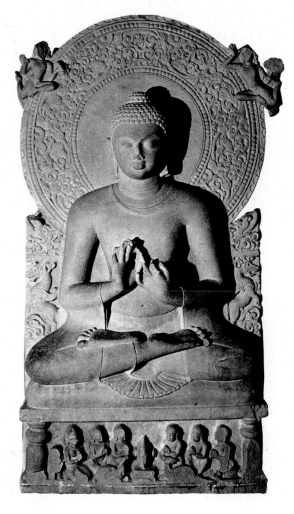

Sandstone statue of the Buddha in meditation, 5th century (Archaeological Museum, Sarnath)

Man contemplating a flower, fresco in the Ajanta caves

The Ajanta caves, 2nd to 6th century

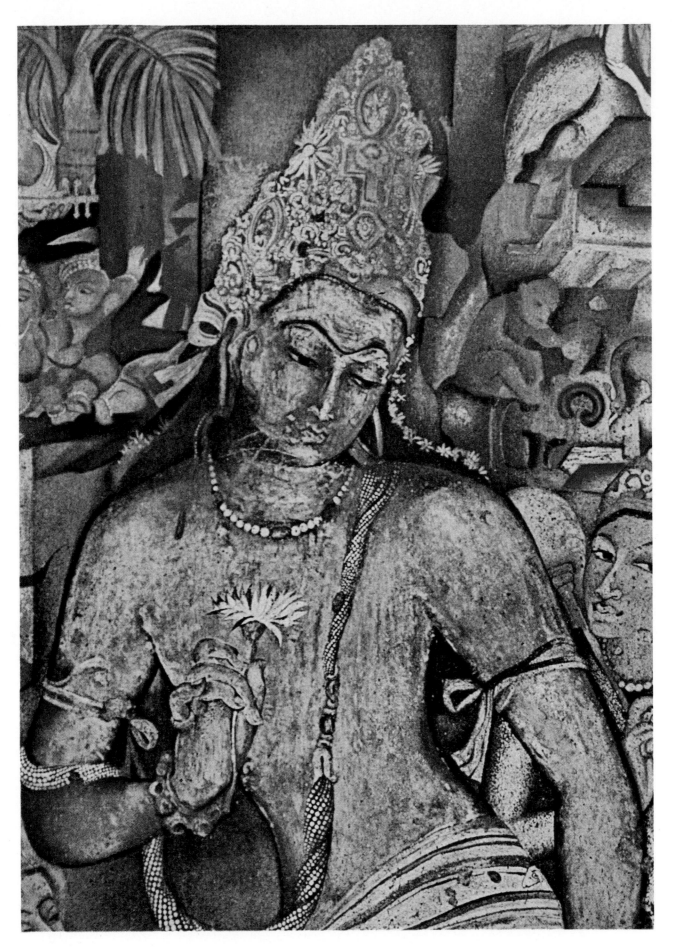

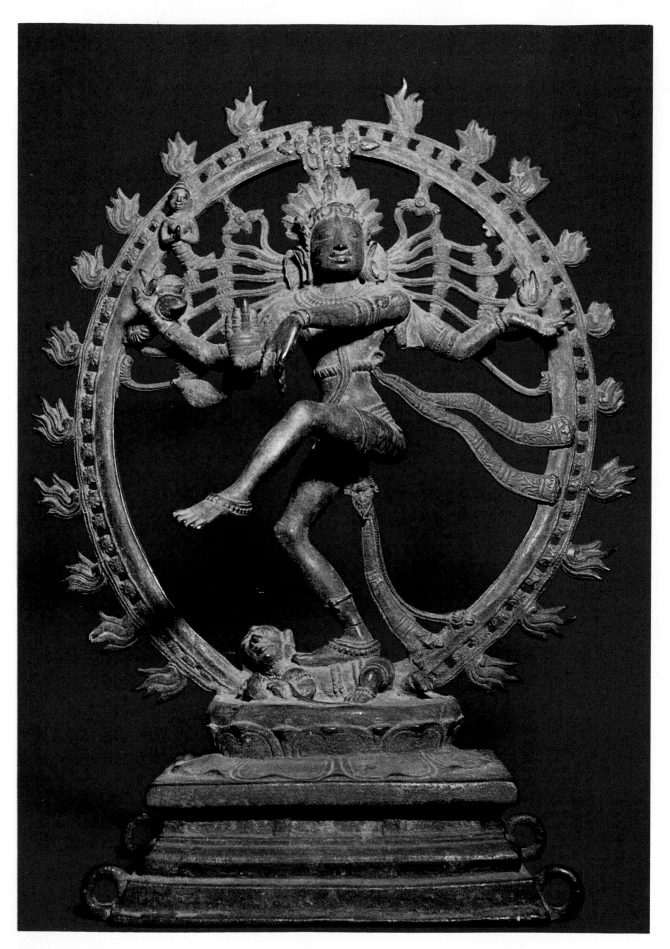

186

certain ritual or dance poses of a symbolic nature remained invariable.

At Bhaja and Karli, the Satavahanas left amazing examples of their special contribution, another typical product of Indian art: the cave-temple. It was hewn out of the solid rock and, like the stupa, completely covered with sculptured figures.

During the somewhat confused period which followed the Kushans, the ruling dynasty in the Upper Ganges, gave the last impulse to Buddhism and turned their capital, Mathura, into a flourishing art centre. Here, between the 1st and 7th centuries, a distinguished and greatly varied type of statuary was brought to perfection. One of its first themes was the Buddha himself, or the Bodhisattva. The prototype soon became a model to be copied again and again. It represented the Buddha as a monk in an attitude of meditation. His gestures, or *mudra*, had a symbolic meaning, and these, in their turn, inspired statues of the Buddha in different attitudes: the Buddha contemplating, the Buddha teaching, and the Buddha praying.

At Kabul on the north-west frontier, the Gandhara school also produced fine statuary. Unlike their predecessors, the sculptors there paid more attention to realism in the treatment of the human form. But, owing perhaps to the presence of foreign artists, the work betrays Hellenistic influence transmitted through Iranian-Persian sources and, less obviously, late Roman provincial influence as well. As a result, the three centuries that correspond to the first three centuries of the Christian era witnessed a remarkable but transitory compromise between Western realism and Indian mysticism, between the Western idea of beauty and the frenzy of Indian figuration.

The Gupta dynasty: the golden age

The golden age of Indian art, the classical moment of vigorous cultural as well as artistic advance, came with the rise of the Gupta Dynasty. Including the post-Gupta dynasties, it lasted from 320 to 650 and, geographically, embraced the valleys of the Ganges and the Indus. In the event, it proved a triumph for Hinduism, for although Buddhism survived in the region, there was an intense revival of the cult of the Hindu gods, and artists were kept busy making statues and pictures not only of the Brahmin 'Trinity' (Vishnu, Krishna, and Siva), but of all the multiple minor deities and their many incarnations as well.

The great impulse thus given to sculpture and

Relief from a pediment of the Banteay Srei. Cambodian art (Musée Guimet, Paris)

Opposite page: *Bronze statue of Siva Nataraja, 12th to 13th-century (Nelson Gallery, Kansas City)*

painting was soon reflected in architecture. Buddhist stupas continued to appear, but they were given colossal dimensions. The drum was enlarged, the dome-shaped roof carried higher still, and the entire structure covered with sculptures. More significantly, temples dedicated to the Hindu deities were built everywhere. These temples were tall, terraced towers with a cell-like sanctum and a surrounding portico, and they differed in plan from the stupa. As time went on, the tower grew taller still, in a variety of shapes that recalled pyramids, parabolas or campaniles, rising in steps like a mountain to symbolise the universe. The temple built in 526 to Buddha at Bodh-Gaya, where he received his enlightenment, is a typical example of this type of structure which was later to grow still more gigantic.

Different from the Gupta type of temple was the cave-temple. Hewn from the solid rock, it served either as a *vihara* (monastery), or a *chaitya* (sanctuary), where the faithful could assemble in the galleries, which were adorned with a forest of carved pillars and statues. During this golden age of Indian art, the Ajanta caves in Hyderabad, with their twenty-nine sanctuaries, reached their full glory. They were adorned inside and out with a mass of narrative and ornamental Gupta sculpture, but with a more balanced, more compact sense of sculptural volumes, and a more graceful rhythm in their composition. The Ajanta caves introduce Gupta mural-painting as well, which is a revelation for the uninitiated. The theme is the various incarnations of the Buddha, treated in an extremely secular manner with all

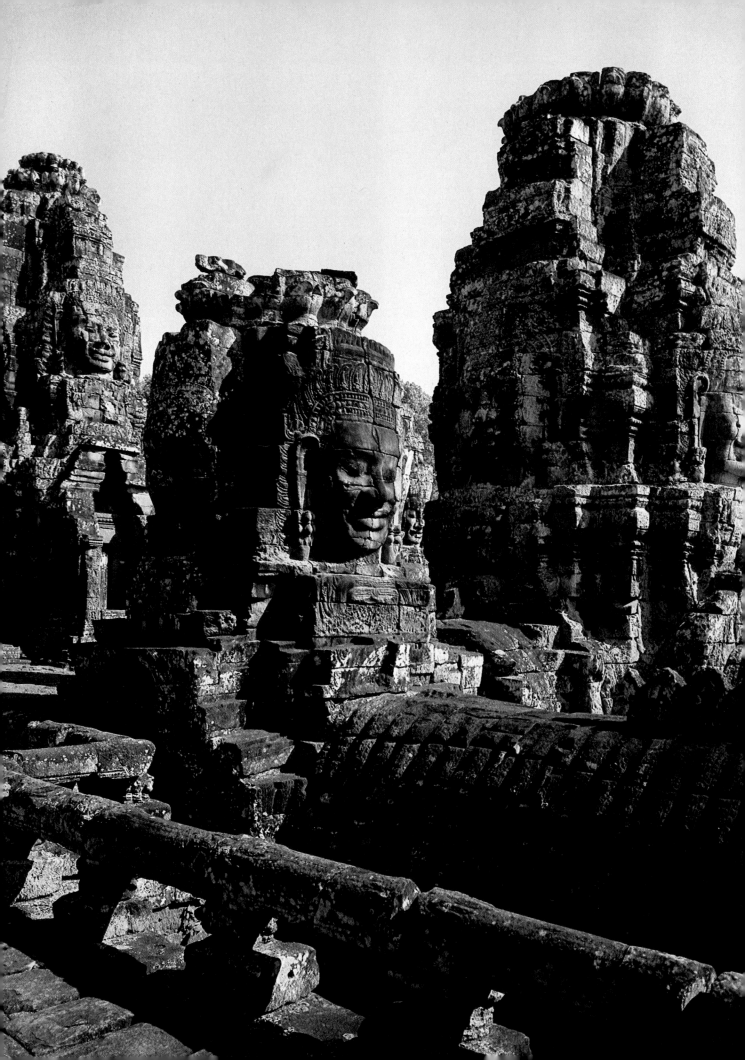

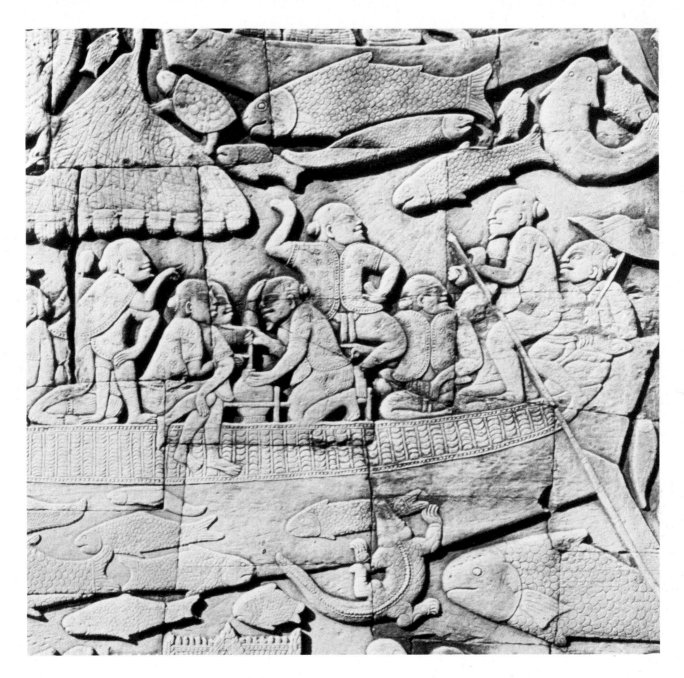

The exploits of Khmer, 12th to 13th-century relief. Bayon at Angkor Wat

Opposite page: *Detail of the Bayon at Angkor Thom*

the refinement of a court art. The drawing is surprisingly 'modern', especially the figures of the women.

The fall of the Gupta Dynasty may have meant the end of the golden age, but it was far from being the knell of artistic production. This continued between the 7th and 10th centuries under the Chalukya, Rashtrakuta, and Pallava dynasties in the Deccan and the southern part of the peninsula. Thanks to these new patrons, some of the most spectacular monuments in India came into being: the Elephanta caves near Bombay, the monolithic temples of Mamalla-puram, and the imposing temples of Ellora hewn directly out of the solid rock. Moreover, sculpture grew in popularity. Throwing immobility to the winds, sculptors went all out for movement, rhythm, and gestures and stances inspired by dances.

During the so-called 'Middle Ages', the political upheavals affecting the ruling dynasties increased, but with no detriment to artistic production. Taller than ever before, more intricate, more heavily adorned, the imposing Hindu temples in Orissa and the Jain temples of Mount Abu were built. In the South, the Chola Dynasty erected the soaring, decorated pinnacles of the temples of Tanjore and Darasuram.

Portraying dynamic Hindu gods or repeating static Buddhas, sculpture reached untold-of heights in bronze statuary.

But, signalling the end of pure, native art, the wheel of destiny was turning once again for India. In the fifth century she survived the Hun invasion, yet from the eighth she lived under the threat of invasion by Islam. One unstable reign followed another, and she was consequently in no position to offer effective defiance when, in 1196, Sultan Aybek penetrated as far as Delhi and inaugurated a new India, Moslem India. Wasting no time, Moslem art put its stamp on India in the shape of the famous fluted Kuth Minar tower near Delhi, then penetrated Indian art violently. The anti-Moslem reaction in India – which was reflected in art, too – gave the appearance of a renaissance, but proved to be merely transitory. In the North, between the 14th and 15th centuries, the Rajputs took advantage of their brief spell of power to carry out large building programmes at Mount Abu and Ranakpur. In the 17th century, during a second period of recovery, the Vijayanagar kings displayed an almost Baroque panache in the construction of the highly ornate temples of Seirangam and Madura. During the first period of Moslem rule, and again during the second which started in 1526 with the Moghul Dynasty, Islamic art was influenced by the Indian imagination, and the result was that exquisite example of elegance: the Taj-Mahal at Agra (1630). The specifically Moslem contribution to Indian art, however, especially during the Moghul period, was the miniature. Yet, here again, Indian imagination influenced both colouring and design, features which had characterised Arab and Persian miniatures.

The diffusion of Indian art

This brief résumé of Indian art would be incomplete without some reference to the extent to which that art spread beyond the confines of India proper, using Buddhism as its vehicle. In general, contact with lands of a more pronounced Asiatic character meant that while the structural element of the Indian prototype was developed, the ornamental element simply proliferated. But when the expanding Hindu-Buddhist art met Chinese art expanding from the opposite direction, the two crossed and a compromise was reached.

The movement started early on with Indian art in full flower. In the North it reached Afghanistan, a country in close contact with the Persian world and, through the latter, with Hellenism. Then, taking the Silk Route – the exhausting caravan road linking the West to far-off China – it allowed Indian and Chinese art to come to an agreement and, together, contribute to the monastic art of Tibet, 'the roof of the world'.

In the south-east, Indian art reached the islands which today form Indonesia. There it collaborated with local art and helped to produce the unrestrained, capricious Indonesian art. In the north-east, it penetrated the Indo-Chinese peninsula. There, although Chinese art proved the dominant influence in what is now Vietnamese art, Indian art harnessed the resources of the local arts in Siam and Cambodia, thus making itself the dominant influence in what became Siamese and Cambodian art. But whereas Siamese art, with an excess of local decorative tendencies and pictorialism, amalgamated the architecture of the Buddhist stupa and the pagoda, Cambodian art pursued another course. In a region which has now reverted to jungle, it found favour between the 5th and 14th centuries with the expansionist and aggressive Khmer Dynasty. The Khmers built many temples. But the twelfth-century Angkor Wat, with its arcades, its multi-level terraces and pyramidal towers, is perhaps the most beautiful temple in the world. No less imposing with its vertical sweep of huge towers is Bayon, the chief temple of the Khmer capital, Angkor Thom. Here the idea of a building that is both temple and mountain finds its most striking expression.

Khmer sculpture is of the highest standard. From India it derived the tendency to lose itself in the descriptive, but the great bas-reliefs recording the military campaigns of the Khmer have outstanding orderliness and rhythm. Khmer statuary is of superlative nobility. The harmonious, powerful heads and figures of divinities and the Buddha, the work of anonymous Khmer craftsmen, reach a rare standard of classicism in the vast field of Buddhist art.

Bas-relief of dancing girls (Angkor Wat)

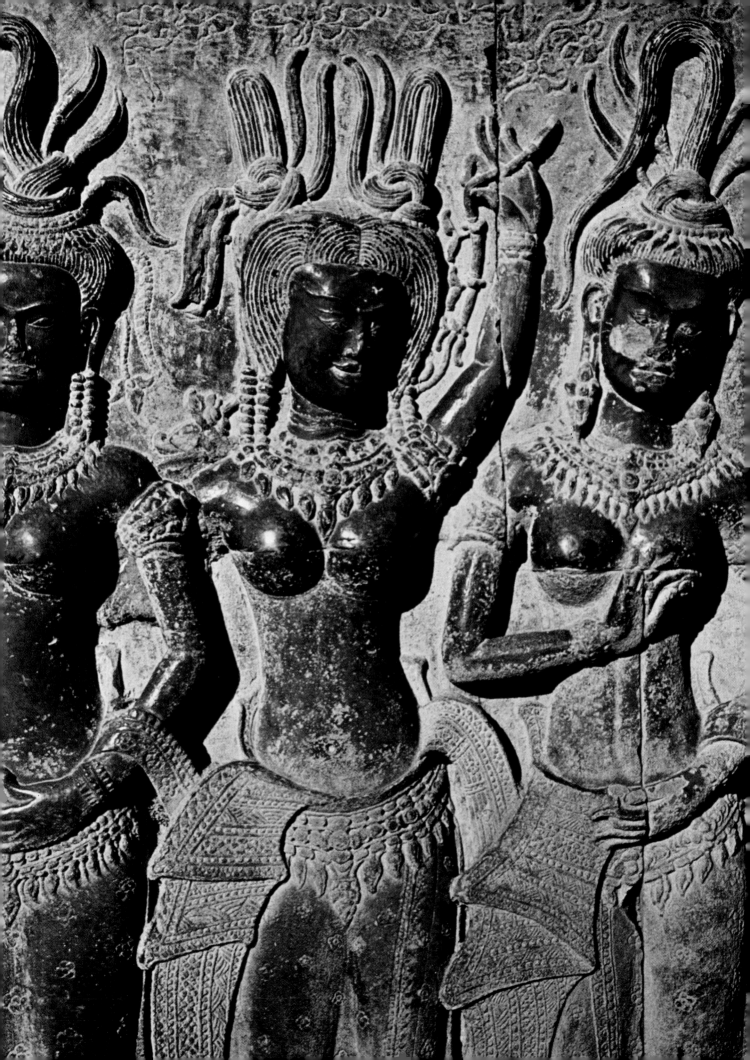

CHINESE ART

Opposite page: *Terra-cotta vase with painted decoration from Kansu, 2500–2000 B.C. (National Museum, Tokyo)*

The basic characteristic of Chinese civilisation has always been unity. From the very beginning, and throughout a history of marvellous continuity, it has been the spur bringing men together to work for the common end of transforming nature and for subjecting her to the needs and demands of the community. In the course of this development man and nature alike have undergone a change and become mutually conditioned. Man has developed the necessary qualities for cultivating the soil of China – tenacity, the capacity for hard work and the knack of co-ordinating labour for the implementation of large schemes in agriculture and irrigation. In her turn, nature has taken on an orderly appearance. Even when seen from the air, this effect of man's domination strikes one as being the most typical, most moving mark of Chinese civilisation.

Chinese civilisation started in the valley of the Yellow River. The first historical account of it tells of compact, organised communities united by a common ethic, and all engaged in the task of gradually extending the regularly cultivated and irrigated farmland, making dams and reservoirs, felling trees and stumping new fields. In this society, the power of the sovereign, here as elsewhere associated strongly with religious and magical practices, was determined first and foremost by its holder's function as co-ordinator of the work of dominating nature and as the guarantor of order in the community. This gave rise to many legends praising the wisdom and industry of the first emperors because they were men who could control human passions, men who were patient masters and tireless builders of dykes vital to the country's agriculture.

At the dawn of history (the Hsai and Shang dynasties, 1989?–1558? B.C. and 1523?–1028 B.C.), political unity had its moments of lapse. The guarantee of its being maintained was determined more by the needs of the Chinese people than by a strong government. Later on, in the 11th century B.C. when the Chou Dynasty came to power, it gave more impetus to the development of society and civilisation by providing more land and by raising the standard

Bronze 'chung' of the Chou Dynasty (National Museum, Tokyo)

of living, cultural as well as economic. But, as in feudal Europe later on, the government was still decentralised. In the second Chou period, the Spring and Autumn era, further extension of the area of land occupied led to the rise of more local problems and, to cope with these, more local, often rival, governing bodies. As time went on, these divergent forces began to multiply, especially after the adoption of iron in the manufacture of military weapons and agricultural implements. This innovation strengthened the military potential of the various local governments that were by now totally independent of the original central power. But it also had another result. The population started going further afield, breaking new ground for cultivation in the valley of the Blue River which, eventually, became the second great centre of the Chinese nation. This took place during what is known as the period of the Warring States (480–221 B.C.), a period when, despite the unrest,

agriculture continued to flourish and civilisation was striding ahead. Throughout these periods of tension and fruitful initiative, the Chinese people were being helped and guided by great thinkers such as Confucius, Lao Tzu, Mo Tzu, and Han Fei-tzu. They were gathering and consolidating a common, stable and complex store of ethical and political experience destined to find full expansion when the whole of China was united in the Ch'in Dynasty (221 B.C.). At no time, however, did Chinese civilisation flourish as during the splendid four hundred years of Han rule, the dynasty that made China what it was, and what it is still. Chinese culture attained such a standard of refinement that the China of those days could well be ranked alongside ancient Athens and Imperial Rome.

Chinese art, from the Anyang ceramics to the paintings of our contemporary, Ch'i Pai-shih, covers a period extending a good 5000 years, and just as China has always been tireless in assimi-

Low relief with dance and kitchen scenes, detail. Eastern-Han Dynasty (National Museum, Tokyo)

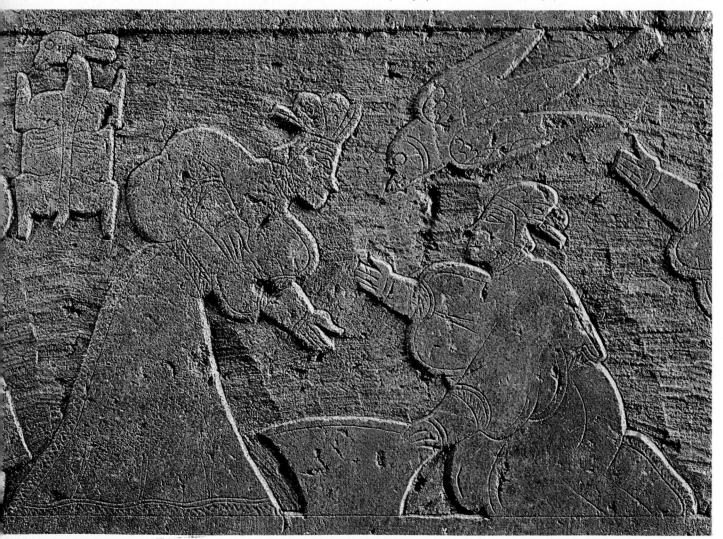

lating different civilisations, so Chinese art has never been slow to borrow and transform whatever the art of other countries put in its way. The sheer size of the country, and the persistence of the creative spirit century after century explains the difference of styles, the alternating from moments of rest to moments of intense creative activity, from straying in the wrong direction through bad influence to unexpectedly discovering new techniques and methods of expression. One of the peculiarities of Chinese art was group production, by school or region. This explains why certain types of ceramic are classified according to the 'family', and why some paintings have a common ancestor from whose style no departure is made. This approach to art generated the practice of copying, which to the Chinese mind signifies neither inferiority nor lack of originality in the copier. One of the most constant aspects of Chinese art is a continuous run of forms with no obvious pause or transition.

A problem on its own, yet linked to this approach to other art forms, is that presented by architecture. The materials used in building were light, perishable substances such as wood, lacquer and majolica. In consequence, there was a constant call for repair work, but this was always done by inserting fresh material into the original edifice, whether it harmonised or not. Another Chinese idiosyncrasy was attachment to fine materials. Even as late as the Han period, great consideration was given to ancient bronzes simply because of the special patina they had acquired in the making. This prizing of material for its own sake also explains the importance the Chinese attached to jade objects, which foreigners would classify as minor art.

All Chinese art had a secular stamp, even the Buddhist contribution. In China, art was hedonist, geared to the pleasure to be derived from naturalistic contemplation and the transfiguration of reality. The best proof of this was Chinese painting, but in every art form the Chinese revealed a tendency to virtuosity. Not content with a single transparent glazing of ceramics, they would add several more. They damascened their metalwork, added high lights to their lacquer. It was for their exquisite finish that certain Chinese products won fame even at the dawn of history. Demands for Chinese silks and majolica came from Egypt and Persia. Later on, in Western Europe, Chinese porcelain and

Chinese lacquer were among the most sought-after imports. Eighteenth-century Europe admired the skill, the detail, the exotic aspect of chinoiseries, those small *objets d'art* from China that collectors earnestly sought to acquire.

The neolithic period

The story of Chinese art starts in the neolithic age where there is definite, though somewhat

Painted wooden 'ming-ch'i', Chou epoch (Nelson Gallery, Kansas City)

fragmentary, evidence that architecture, sculpture and painting were already known to the Chinese. From the results of a find made by archaeologists of the Chinese People's Republic in 1953 at Pan-po in Shensi, dating from about 2500 B.C., it was possible to reconstruct a type of dwelling round or square in shape. Despite the paucity of the remains, it seems certain that these dwellings had floors and walls of pressed earth covered with stucco. In the surviving traces of wall there were holes showing where the structural skeleton once stood. In the same area, the site of a large building called the Chou house was found, some sixty feet long and thirty-six feet wide. It was approached by a raised entrance, and there was evidence that a hearth had once stood in the centre.

So far, only two kinds of Neolithic sculpture have come to light. The first consists of a number of round lids with notched rims, and adorned with crude figures. Undoubtedly these lids were covers for vases made at Yang-hao (Kansu). The second type consists of statuettes a few inches high. They include a roughly modelled sitting figure in terracotta from Shih-chia-ho (Upeh).

Of Neolithic ceramics there is much more evidence, as was discovered by Swedish archaeologists in 1920. The finds were named after the sites where they were dug up. The oldest belong to the Yang-shao period and date from 3000 B.C. to about 2200 B.C. The finds made at Pan-po in Shensi belong to another period which followed quickly upon the first. They include a cup decorated with stylised naturalistic motifs. The tombs of Pan Shan (Kansu) revealed painted fragments with geometrical motifs coloured in red and black which, perhaps, had some symbolical meaning. On a site at Hsin-tien, the finds dated from 1500 B.C. and showed less technical skill; the zigzag, meandering and sawtooth symbols are fairly distinct but the shapes are rough. This group and, in general, similar finds in the regions of Honan and Iöss and the basin of the Yellow River, were handmade without the use of a wheel. But examples of Lung Shan pottery found scattered along the north-east coasts and in northern China were turned. They are thinner, painted black as a rule, and have that plastic form which was adopted by the metalworkers when they first used bronze (Shang epoch).

The Shang dynasty

Historical China began with the Shang Dynasty (1523?–1028? B.C.), but artistic China at this period was already so alive, and so maturely creative, that archaeologists felt justified in carrying out research to try and prove that the earlier, legendary Hsia Dynasty (1989?–1558? B.C.) had not, in fact, been entirely a myth.

In 1950, excavations in the Honan region to discover the original Shang capital led to the identification of Ch'eng-chou, the city where the Shang dwelt for two hundred years before their sovereign, P'an Keng, transferred his court to Anyang. To the delight of the archaeologists, the digs confirmed the facts of Shang civilisation, recorded on pieces of bone in archaic signs which were afterwards identified as the oldest forms of Chinese ideograms. But the great revelation about Shang art derived from the bronzes. They represented the zenith of Chinese bronzework, a level maintained during the next dynasty, the

'Ku' type bronze recipient, Shang Dynasty
(Metropolitan Museum, New York)

Bronze vessel in the shape of an animal, 2nd millennium B.C.
(Musée Cernuschi, Paris)

197

Chou. Already in the 11th century A.D., anti-quarians were collecting Shang and Chou bronzes with an avidity no less pronounced than that of twentieth-century collectors.

Once the area originally occupied by the Shang had been discovered, archaeologists soon learnt to distinguish between what was Shang art and what was not, but they were then faced with the problem of how to determine dates and development of style. Their only yardstick was the technical quality of the metal and the inscriptions, neither of which spoke volumes. The man who hit on the solution was the Swedish archaeologist, B. Karlgren. Confining himself first to the decorations on the finds, he separated the Ch'eng-chou from those whose source was Anyang. Then, dividing the oldest pieces from the later, i.e. those decorated all over from those decorated in part, he labelled the first group, Bronzes A, and the second, Bronzes B. Next he examined Bronzes A, comparing the deep relief of the t'ao-t'ieh (a stylised animal mask) with the remarkably plastic geometric motifs. On repeating the process with Bronzes B, he observed that there was only a slight difference

The Great Wall

Jade disc, Chou Dynasty (Nelson Gallery, Kansas City)

in relief between the *t'ao-t'ieh* and the ornamental woven motifs.

A close study of types led to the conclusion that whereas all these bronze pieces were of ritual character, some were used for cooking or storing food, and others as containers for wine or water for drinking or religious purposes. Shapes vaguely resembling soup bowls were called *ting*, *le*, or *hsien*. Those shaped like wine glasses were *ku* or *tsun* while *A-yi* resembled salt cellars.

Many problems concerning Shang bronzes still remain to be solved, especially that of the affinity between Chinese symbols and those used in the Pacific, or the question of the derivation of Shang bronzes from preceding forms in ceramic or carved wood. For Westerners, the nobility of Shang bronzes lies in the softness of their outline and curves, the close relationship between plastic form and decorative relief and, above all, in the patina, so delicate that sometimes the bronzes seem bathed in moonlight. Chronological details have been gleaned from texts naming the sovereign for whose tomb the various pieces were made.

The Shang period also produced remarkable statuary – figures of animals in full relief used, perhaps, as guardians in the tombs of the sovereigns. But from now on, next to bronzes, the most popular art form was jadework. In general, this comprised small, highly prized objects, rarely engraved because of the hardness of the material, but always beautifully formed, polished to perfection, and sometimes almost worn away by constant handling. The Chinese classed objects made in jade as jewels and wore them on their clothes or person as a sign of regal or intellectual authority. Jade objects also formed part of funeral requisites. That is why so many of them have been found in tombs. When modelled in certain prescribed shapes, they were primarily of symbolic significance. Thus the *pi*, a sort of flat disc with a hole in the middle, signified the cycle of time while the *t'sung*, a drilled prism-like object, stood for the earth. The dragon is the most common of the animal shapes, but there are also many tigers and owls among the examples that have come down to us. Colours are a mere suggestion applied with transparent layers of opaline green or gold, but varying according to the material used. In the Shang epoch it was nephrite.

The Chou dynasty

The passage from Shang art-forms to those of the Chou Dynasty (1027 B.C.–A.D. 256) was slow, almost imperceptible. Although it was more mature than the Shang, the Chou epoch was less unified. For this reason, even in the field of art, we must distinguish between an Early, a Middle, and a Late Chou period.

Early Chou bronzes (up to 900 B.C.) were not greatly distinguishable from the Shang bronzes of the Anyang period. Gradually, however, differences in detail crept in – the waving or festooning of borders, for example – and the shapes, particularly the animal shapes, became

Opposite page: Terracotta model of a house, Han Dynasty (Nelson Gallery, Kansas City)

Young Mongol, 4th-3rd centuries B.C. (Museum of Fine Arts, Boston)

201

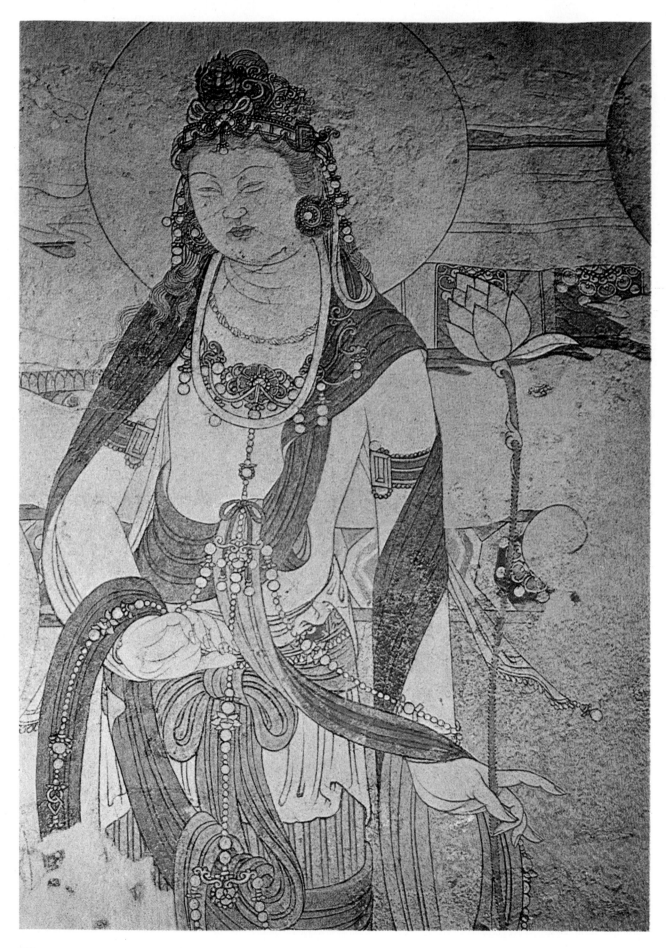

squat and weakly articulated. In the Middle Chou period, however, a noticeable transition took place in the decoration with the introduction of woven motifs and the ultra-stylisation of the *t'ao-t'ieh*. In 1952, excavations in the village of T'ai-p'u (Honan) brought to light a large group of Middle Chou bronzes of monumental character. Towards the end of the 6th century B.C., the Middle Chou period passed unnoticeably into the Late Chou which produced bronzes of a style that more or less suggests a nostalgic return to the Shang. Late Chou *t'ao-t'ieh* were monumental, but their decoration was decadent, almost a Baroque version of the original. At the same time they lost their symbolic meaning and became mere ornaments. The influence of the art of the Steppes was noticeable in the cord or tress motifs which now appeared on vases and mirrors, the latter appearing, somewhat timidly, for the first time. Recently archaeologists have renewed their researches in the territory occupied by the Chou, and the most interesting finds are the Shou-hsien tomb, those at Ch'ang-t'ai-knan (Honan), and those at Ch'ang-sha. At Ch'ang-t'ai-knan, there were also brought to light thirteen bells (6th century B.C.) with decorative animal motifs not unlike those on contemporary bronze vases.

From the 5th century B.C., the influence of Steppe art on Chinese bronzes grew more and more noticeable; friezes became a series of geometrical dots or a rough representation of hunting scenes. In the Late Chou period, wide use was made of different metals for inlay or, where gold and silver were concerned, for decoration enhanced with inset turquoise. Unfortunately too few examples have survived to allow a study of styles. On the other hand, mirrors dating from 600 B.C. have survived in sufficient numbers for us to classify them easily. Some are square, some are round. Some combine two parts, one smooth and the other embossed, and some have only one disc. The style and amount of decoration varies around the foot of the boss or handle projecting from the centre of the back, which is about four inches in diameter. Inlay, relief and engraving follow the stylistic development of the corresponding techniques on contemporary vases. The clear embossing in relief gradually subsides until it becomes fine, calligraphic ornamentation.

The origin of Late Chou ceramics is uncertain. Some scholars claim that they derive from contemporary bronze forms. In support of this there is the fact that the olive-green jars of the type discovered at Chin-ts'un (Honan), and assignable to some period between the 5th and 3rd centuries B.C., certainly recall bronzes by their colour. On the other hand, the black

Engraving on a stone, 10th – 11th centuries (Nelson Gallery, Kansas City)

Bronze Buddha, Early T'ang Dynasty (Metropolitan Museum, New York)

Lung Shan ceramics continued without any noticeable variation, differing at the most in the style of carving.

One of the more interesting products of the Late Chou period is the *ming-ch'i*, statuettes ranging in size from about four to twenty inches. Considerable numbers of them were found in the tombs of the emperors where they had been placed instead of human beings to serve and cheer the dead in the life beyond the grave. One tomb near Ch'eng-chou yielded a host of clay horses, cats, dogs and birds, and a terracotta duck that moves its tail and flaps its wings when a simple, mechanical device is worked. In the tombs near Ch'ang-t'ai-knan figures of women were discovered, wearing long dresses with elegant, flowing sleeves.

The stylistic development of jade was similar to that of bronze. In the Middle Chou period it became static, and the same motifs were repeated

Dancing girl, 'ming-ch'i' in painted terracotta, T'ang Dynasty (Nelson Gallery, Kansas City)

again and again. In the Late Chou period, the connection of jade with magic and the symbolic meanings of the precious stone were gradually abandoned in favour of a purely decorative role. Among other things, jade was made into clasps for cloaks or used like a jewel and set in metal. In this latter connection, the association of stone and metal recalled the art of the Steppes, which had infiltrated into China, bringing with it the use of clips surmounted with a model of an animal's head or engraved with animal figures.

Judging by the age of the site where it was found (Ch'ang-sha), the first known example of Chinese painting on silk is Late Chou. The subject is a woman turning to face an attacking dragon. The style does not suggest analogies, but the painting itself deserves mention here, if only for its pride of place and its exceptionally fine state of preservation.

The Chou Dynasty came to an end with the death of the last sovereign in 256 B.C. and was followed by the Ch'in Dynasty. During the thirty troubled years that followed, the struggle for a united China intensified. Finally, however, the reign of the Emperor Shih Huang-ti, followed by the rule of the splendid Han Dynasty, brought China to the zenith of its art, history and philosophy.

The unification brought about by the Ch'in Dynasty (256–206 B.C.) through the abolition of feudal institutions, the centralisation of military power and control of the country's water resources led eventually (in spite of sharp social distinctions) to the establishment of peace, which is vital for the development of a great age of art. Towards the end of the Ch'in Dynasty the Great Wall was built – that Cyclopean structure along the northern border of the country designed to keep the inhabitants closely united and to protect them from invasion by the Mongol hordes. It stretches for some 1500 miles, is 10 to 18 feet wide, and up to 52 feet high, with a series of fortified positions at intervals. Built of earth faced with pebbles, this immense ribbon-like construction stretches over mountains and valleys – arid Mongolia on one side, and the fertile China on the other.

The Han dynasty

Despite the favourable conditions created by the Ch'in Dynasty, it was only under Han rule, however, that imperial art began to be produced on a grand scale. Even today, traces of its splendid architectural achievements remain at Hsian, the Han capital. Although the tombs of the emperors have long since been reduced to mere mounds

Woman with mirror, T'ang Dynasty (Victoria and Albert Museum, London)

Scene at court, painted tile from a tomb at Lo-yang, Han Dynasty (Museum of Fine Arts, Boston)

covered with vegetation, the approaches to them are still flanked with huge, symbolic sculptures. Inside each tomb is a paved corridor with funeral chambers to right and left in varying numbers, each containing decorative brick panels of great interest. In one of the rooms stands a raised bench on which were placed the votive bronze vases and the terracotta *ming-ch'i*. During the Han Dynasty these usually represented young dancing girls, horsemen, and peasants, all covered with shining glaze.

Among the *ming-ch'i* of this period, we must include the little models of houses whose function was to remind the dead of the life they had left behind. They give us an idea of buildings that have disappeared, especially the ordinary dwelling house with its blank exterior walls, its four-sided roof and its interior quadrangular courtyard which gave access to the various rooms.

But the information about old China to be gained from the emperors' tombs does not end here. Far more eloquent are the terracotta tiles and carvings or graffiti on stone. During the last century, many of them were taken out of China by European antiquarians. Today, those which come to light in archaeological digs are kept on the original sites or sent to local museums. They show what court life was like in the days of the Han, with invaluable details of costume and

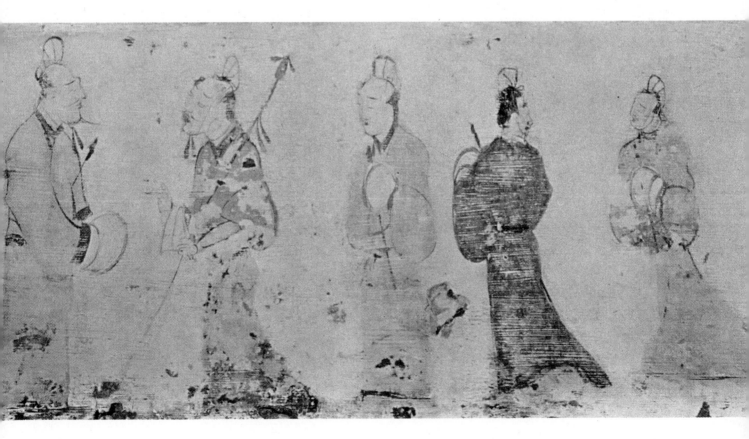

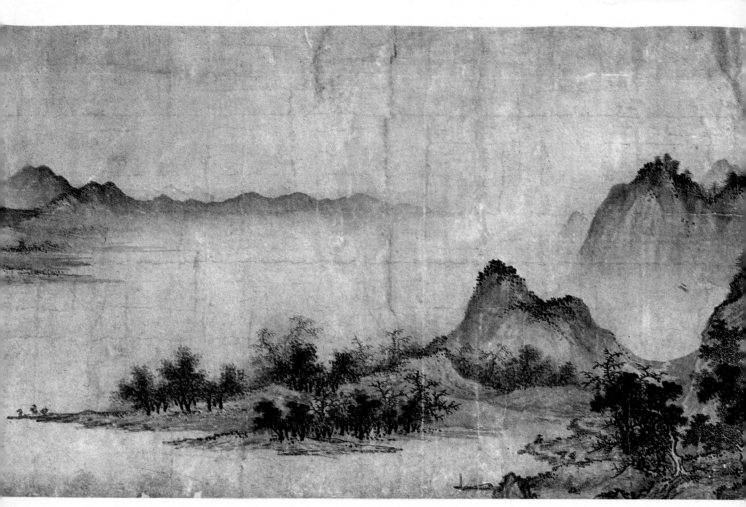

Tung Yüan (?), 'Clear Weather in the Valley' (Museum of Fine Arts, Boston)

social customs, architecture and furniture. In the museum at Ch'eng-tu there are several panels representing a procession of light carriages with large wheels drawn by high-spirited horses, which their young riders are finding hard to manage. Panels made between 50 B.C. and the first century A.D. not only have a lighter, more exact touch, but show greater skill in their fine delineation of figures. The affinity between these carvings and contemporary painting is obvious, and there is written evidence to confirm this.

While continuing the production of bronze votive vases, Han art introduced a novelty: bronze mirrors characterised by the geometrical severity of their decoration. The thread-thin lines engraved so patiently are a yardstick of the possibilities of abstraction in Chinese art but, by way of contrast, the frames are heavy and sculpted. In addition to mirrors, other dressing-table articles began to be made in bronze, such as perfume-burners and little boxes and bottles, which gave the craftsman infinite scope. Moreover, the very purpose for which such articles were intended

justified refinements such as gilding, inlaid work, and setting with precious stones.

In the minor arts great use was made of lacquer, the sap of the lac tree refined and thinned down until it could be easily worked with a brush. Then it was applied to pre-shaped gauze or canvas and, after the slow process of drying, became waterproof and glazed. The gleaming surfaces and infinite variety of ornamentation of lacquer cups, trays, jewel cases, parts of musical instruments, saddles and decorative panels added to the refined atmosphere of the rich man's home.

Towards the end of the Han Dynasty, with China now threatened much as Rome was to be by the extent of its territory, governmental bureaucracy, peasant revolts, and continual clashes with the barbarians on the frontier, Buddhism made its appearance. The caravan trails of central Asia were the routes by which it travelled to China, and the men who brought it were the merchants and missionaries, bearers of an ideology and, at the same time, introducers of art forms. East of the Great Wall, however, ideas

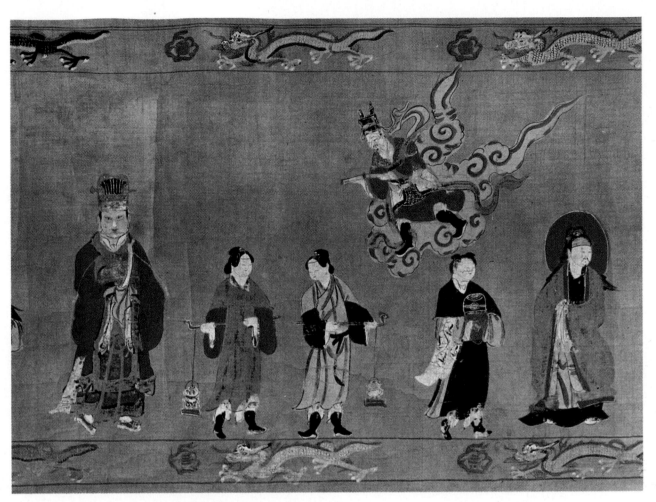

Tao procession, painting on silk (Metropolitan Museum, New York)

Embossed and engraved silver plate (Nelson Gallery, Kansas City)

and art forms soon lost their Indian characteristics. The Chinese adapted them to their own way of thinking, their own sensibility. The first signs that we have of the presence of Buddhism in China are the pictures of the Buddha engraved on third-century mirrors recently discovered in a tomb at Ma-hao in Szechwan. For the first Buddhist statues of noticeably Chinese character we must turn to the 4th century, the time when assimilation and transformation of Indian thought was at its height in China, a fact clearly demonstrated by the current representations of the Buddha. These, while preserving the symbolic drapery and gestures of Indian derivation, have typically Chinese faces.

The year 523 B.C. saw the building of the pagoda of Sund-yueh (Honan). But the most representative structures of the time were the cave-temples, particularly at Yün-kang near Ta-t'ung and Lung-men (Honan). The latter were begun in 453, the year in which the Emperor Wen Ch'eng-ti embraced Buddhism officially. These temples are immense caves with

207

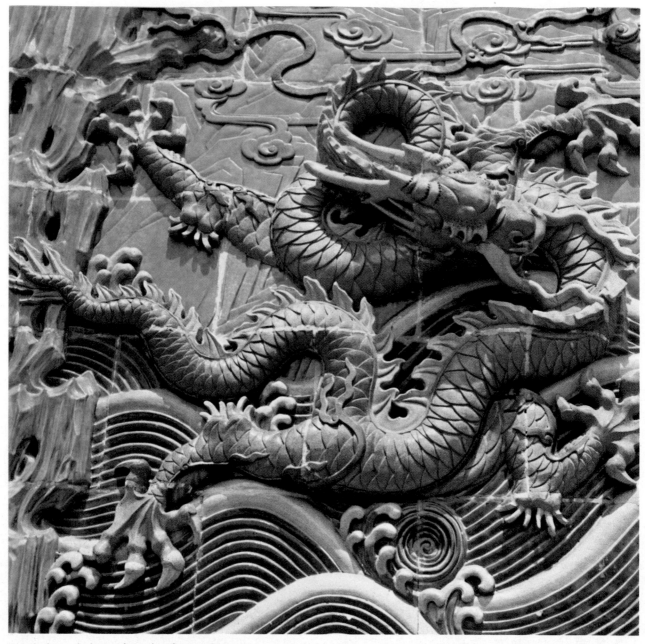

Detail of ceramic dragon decoration, Summer Palace, Peking

cells dug out of the rock here and there. In the cells are numerous statues of the Buddha in attitudes of meditation and prayer. The decorated, moulded ceiling is supported by pillars like slim pagodas.

It was at this period that the characteristic features of statues of the Buddha were established: nimbus, tuft of hair on the nose, protuberance on top of the head, hands with open palms, nude body frequently soft and naturalistic, and visual expression full of feeling but not without affectation. In addition to stone Buddhas there was a large production of bronze Buddhas, none more famous than the Sakjamuni Buddha (388), now in Europe; the Tokyo Buddha, and, in Italy, the Berenson Buddha at Florence (529).

The T'ang dynasty

The T'ang Dynasty saw the second period of fine, classical production. China had recently enlarged its borders by incorporating Mongolia and pushing on into central Asia. With an ever-increasing display of wealth, luxury, and intellectual activity, art was called upon to serve a refined, sensitive society which gave a classical stamp to all its art forms.

The centre of T'ang architectural activity was

Courtyard and first building of the
T'ai-ho Men (Gate of Supreme Harmony)
Summer Palace, Peking

Dragon, fresco from a tomb in Korea

Ch'ang-an, the ancient capital, but the legendary pleasure palaces were located in country districts where woods and gardens, rivers and lakes were all superbly incorporated in the planning. The villas themselves were light structures built of splendid materials and with unrestrained decoration. The roofs soared skywards like wings, covered in ceramics and lacquer.

Apart from Buddhist architecture and painting, there was some notable secular sculpture at this time, particularly the famous group of stone panels (some now in Philadelphia, others in the museum at Hsian) originally made for the tomb of the Emperor T'ai-tsung, who died in 648.

They constitute the most classical treatment of the horse, variously shown champing at the bit, bounding forward, or under control – symbolic, in a way, of Mongol power tamed by the civilised T'ang. Judging by the realism of the figures and the accuracy of line, some critics have attributed them to Yen Li-pen, the greatest painter of a great period.

During the T'ang Dynasty painting had already made its mark, but unfortunately few T'ang pictures have survived. The Chinese painted on paper or silk in the shape of a horizontal scroll which could be rolled up and secured with string. Portraiture was very popular,

but T'ang painting gained particular fame for its rendering of horsemen, of broad landscapes with horses at the gallop, of meetings between knights and their ladies. One famous work, now in the Freer Gallery, Washington, is a masterpiece by Han Kan (741–756), showing Mongols paying tribute in horses.

The horse was a favourite subject for the *ming ch'i* as well, and Mongol steeds with slender hoofs and thin heads were made for that purpose. Other examples show cavalcades of young women wearing sumptuous clothes and playing polo, one of the favourite sports of the T'ang court. The glistening blues, greens and muted ochres indicate the range of the sensitive colouring.

The Sung dynasty

Chinese painting reached its zenith during the Sung Dynasty (960–1279), and in the opinion of both Chinese and European experts the most famous of all Sung paintings are the landscapes. According to the then current Ch'an philosophy, contemplation of the infinity of space led the mind to meditation, and the purpose of landscape painting was to exalt space in order to arouse in the beholder a sense of exaltation through being immersed in it. In other words, especially with the addition of varnishing, Sung landscapes were paintings of a mood – romantic painting in the spirit of the not-so-distant 19th-century Western painting.

Continuing the development of their art, the makers of ceramics started using pea green and light olive in their colour schemes at this time. Then they turned to gold and silver to give their work greater value. Made for direct export to Japan, ceramics found their way to Africa and thence to Europe.

Finally, the heyday of urban architecture came first with the Yüan Dynasty (1279–1368) then (and more importantly) with the Ming Dynasty (1368–1644). The finest examples of the building of the time are the Temple of Heaven and the Summer Palace in Peking, and the Imperial Palace in Nanking.

The Temple of Heaven, Peking

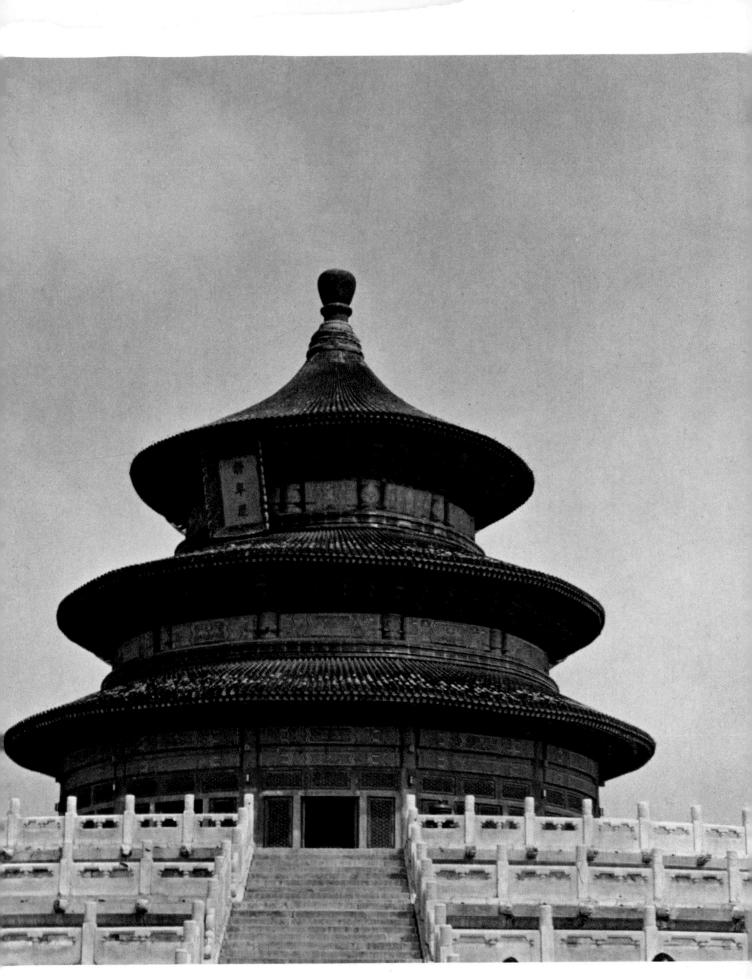

JAPANESE ART

Oriental art found an important fulcrum in the Japanese archipelago. Being an island civilisation, however, Japan can claim neither the antiquity nor the originality of its vast, next-door neighbour where art is concerned. Not once, but several times, like other nearby lands, she has had to turn to China for inspiration, either directly, or indirectly through Korea. However, her aloofness became an advantage. What she had borrowed she could study with a fresh eye and then, adding originality to the re-creation, give it that particular fascination which characterised her output.

Japan opened her shores to art relatively late. Her prehistoric age lasted up to the 6th century A.D. and was immediately preceded by the Jomon age, which had taken her up to the beginning of the Christian era with a Neolithic culture and a nomadic population largely devoted to hunting. Some of these primitive people also made pottery, using only their hands to shape the pots, and a piece of cord pressed into the wet clay to make patterns on them. They also made terracotta statues for ritual purposes – crude, flat figures with deformed heads and limbs. The next period, the Yayoi, concerned chiefly the western part of the archipelago where, influenced by the peoples on the mainland, the inhabitants turned their hands to farming. The Yayoi period merged into the so-called Great Tomb period (third to fourth century A.D.), so called from the custom then common of burying people in huge, mound-shaped tombs, as did the Chinese. In these tombs, archaeologists have found large numbers of *haniwa*, the Japanese equivalent of the Chinese *ming-ch'i*, and used for the same purpose – to comfort the sleep of the dead. Simply modelled with a piece of stick, these terracotta statuettes stood on cylindrical pedestals. They all had remarkably vivacious expressions – animals, warriors, court ladies alike.

The Asuka period

With the Asuka period (538–645), Japanese art emerged from its prehistoric phase. Through contact with Korea, the Imperial Japanese court at Yamato embraced Buddhism and, at the

'Haniwa' statuette in terracotta (British Museum, London)

Japanese gold coin with ideograms (Museum of Eastern Art, Venice)

Temples and monasteries (general view), Kyoto

same time, admitted Chinese-Korean art. Budd-
hism became the official religion, an event which,
while raising the spiritual and cultural standard,
also meant the acceptance of new art forms, all
of them sacred in intent. Periodically tradi-
tional buildings were reconstructed, and the
monastery of Horyuji at Nara (607) shows the
structures characteristic of the earliest Japanese
architectural style. Built on a square foundation,
the temples were single-storied, and had hori-
zontal roofs supported by wooden pillars and
corbels. The roofs were covered with tiles and
turned up at the corners. On the other hand, the
pagodas were multi-storied. Each storey had its
own protruding roof, and the uppermost was
crowned with a steep pinnacle.

Buddhist sculpture was of a remarkably high
level. The most famous example is the Sakayamuni
'Trinity' at Horyuji, attributed to Tori, the
grandson of a Chinese immigrant. It is a large,
bronze group which combines plastic vigour

with stylisation of drapery. At Horyuji there is
also the wooden Miroku or 'Buddha of the future'
in delicate, meditative pose, a work of purely
Sino-Korean derivation.

The Nara period

The Nara period (645–794) witnessed the
establishment of the capital at Nara, a city laid
out on the rectangular Chinese plan with regular
blocks of buildings. At that time Buddhism was
at its most flourishing period, and contact with
the China of the T'ang at its most intense, and
Nara acquired several monuments. Within the
sacred enclosure of Horyuji rose the Hall of
Dreams, an octagonal pavilion on a stone base
with a widely projecting roof. In Yakushiji, the
pagodas soared in a soft rhythm of roofs placed
one above the other, their corners rising steeply.
If little remains of the much rebuilt grand
Todaiji except the central edifice, the Hall of the

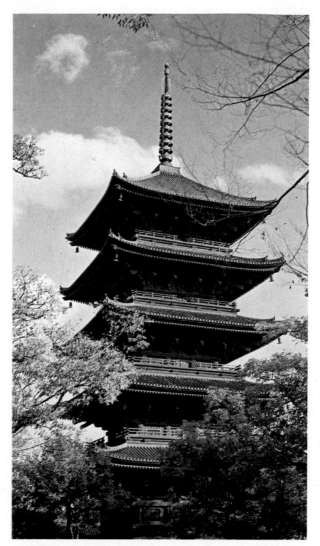

The Yakushi-ji Pagoda, Kyoto

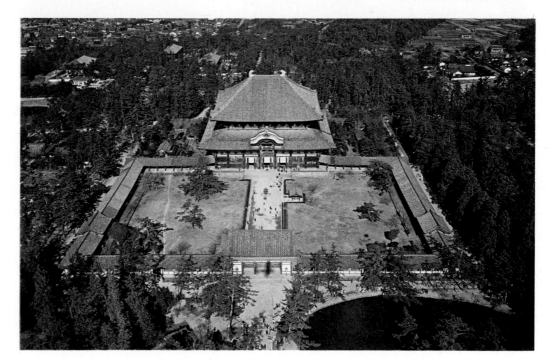

Temple at Nara

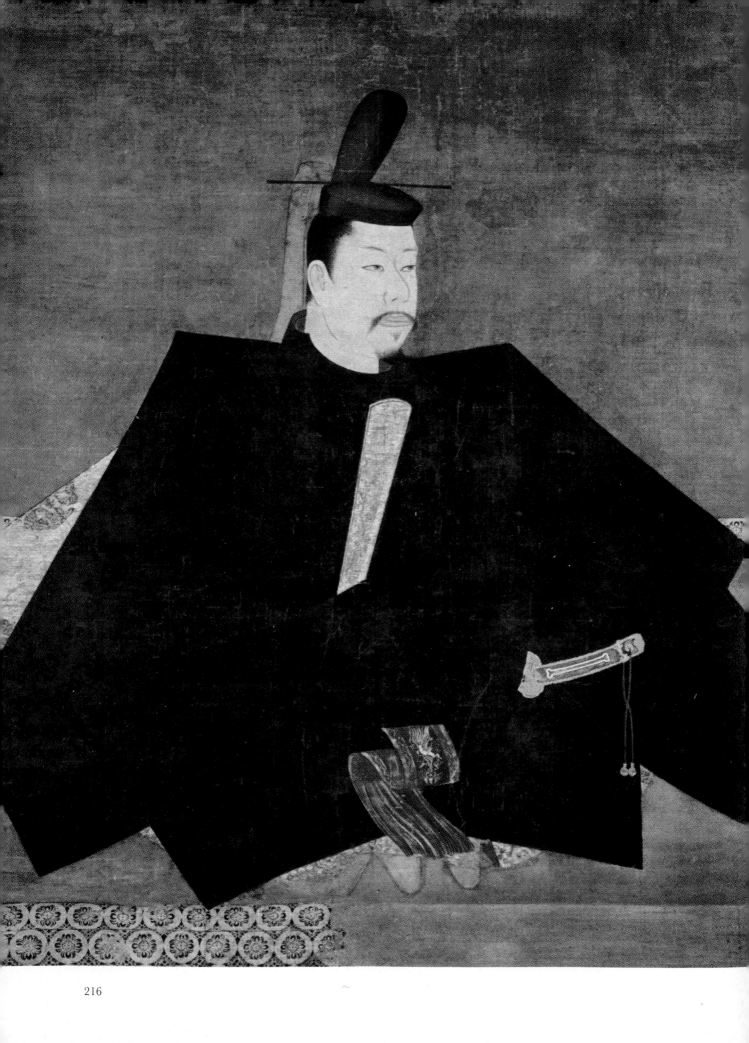

Great Buddha, it is still the largest wooden structure in the world.

Statues of bronze, wood, and lacquer adorn the temples. One particularly imposing example is the Yakushi Buddha (Nara), a work of plastic strength indicating by that very fact that the precious stylisations of the Asuka period were a thing of the past. Remarkably expressive are the great, grotesque masks worn by dancers and the terrifying statues of temple 'guardians'. Although heavily influenced by Chinese models, it was at this point that Japanese painting made its debut, including wall-painting with religious themes, as exemplified in Horyuji.

The Heian period

The Heian period (794–1185) began at the end of the 8th century when, to escape the encroachment of the Buddhist monks, the emperor built the new Capital of Heian-Kyo (modern Kyoto). Like the former capital of Nara, Heian-Kyo was also laid out on the Chinese plan.

The decline of the T'ang in China meant another period of isolation for Japan. At the same time, however, it gave Japanese art a chance to consolidate and perfect itself. The style which Japanese architecture adopted for residential buildings can be guessed from those of the Byodoin at Uji, particularly those of the Hall of the Phoenix reflected in the lotus pool. The Daigoji at Kyoto, the slender pagoda with five superimposed roofs supported by corbels and pillars of vivid red, is the prototype of a pagoda in pure Japanese style.

It would seem that when the Fujiwara clan came to power they deliberately exploited the resources of art to compensate for the break in the traditional contacts with China. This was followed by the formation of new religious sects

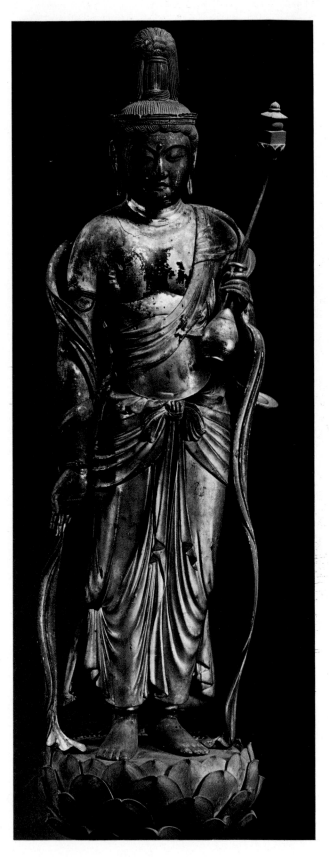

Right: *Kaikei: 'Miroku Bosatsu', 1189 A.D. (Museum of Fine Arts, Boston).* Below: *Minamoto no Yoritomo, coloured-wood statue (National Museum, Tokyo).* Opposite page: *Portrait of Minamoto no Yoritomo (Jingo-ji, Kyoto)*

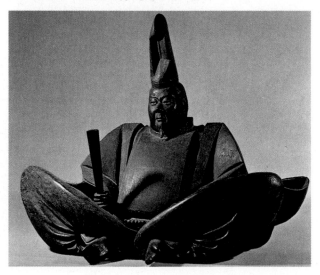

and a move towards the cult of the Amida Buddha, which was why, in the Hall of the Phoenix at Uji, the highly individual statue of the Amida Buddha by Jocho is surrounded by a phalanx of deities.

Painting gained a richness and refinement, particularly in sacred art, where it found numerous new subjects for iconography. It extended to decoration also, starting with painted screens. At first it relied on Chinese landscapes for inspiration, but later developed a definite Japanese style, as is evident from the representation of the Four Seasons on a silk screen now in Kyoto (Toji). In secular painting the flowering of poetry and the novel produced, fresh, elegant, romantic narrative scenes on scrolls, such as the 'Story of Prince Genji' (Goto Museum, Tokyo). Drawn in ink with fine strokes and set out diagonally to increase the impression of space, the composition is a bird's eye view onto the houses, revealing all that is going on inside.

A cause of jealousy and rivalry among the lesser nobles in the provinces and a source of discontent among the oppressed peasant masses, the harsh, overbearing rule of the Fugiwara ended in revolt and civil war. When they were finally ousted in 1185, the new emperor, Minamoto no Yoritomo, set up the Bakufu, a dictatorial, military regime. The old aristocratic class was dispossessed by a new, often dominating military class, and the capital was shifted to distant Kamakura near Tokyo.

The Kamakura period

This marked the beginning of the Kamakura period (1185–1338). Besides renovating the monuments of Nara which had been damaged during the recent struggles, the new military masters revealed their taste for traditional architecture in the Temple of Engakuji near Kamakura. Taking its cue from architecture, sculpture returned to the Nara tradition, although the sculptors Unkei and Tankei were certainly influenced by the Chinese Sung style. Even when their statues are animated they have a sensitive, expressive realism ranging from the lifelike Patriarch Mujaku (Nara, Kofukuji) to the almost Baroque statue of the deity Nio by Unkei in the Todaiji of Nara. These statues are the last flights of the great, classical period of Japanese sculpture. In the 14th century it returned to stereotyped models and, with the minor arts assuming more and more importance (one of the important uses of lacquer was to be the decoration of arms and armour), sculpture at its most vigorous ended up in the theatre in

Kakiemon plate, 18th century (Victoria and Albert Museum, London)

the dramatic, sometimes terrifying, masks in use then. By now interest was concentrated on painting and, beginning with the portrait of the Emperor Minamoto no Yoritomo (Jingoji, Kyoto), launched into a genre previously unexplored.

Victors in another civil war, the Ashikaga removed the capital to Muromachi near Kyoto and there, soon abandoning their military preoccupations, they began to encourage the arts. Under subsequent Muromachi rule (1338–1573), Zen Buddhist influence became dominant. One picturesque result of this was the appearance of marvellous parks and pools and the greatly admired gardens, none more famous than those of Deisenin and Ryoanji in Kyoto.

It was also at Kyoto that the elegant and exquisite Pavilion of Gold and Pavilion of Silver were built. A great impetus was given to painting

Detail from a decorated screen of eight panels (Museum of Eastern Art, Venice)

by the need for ornamentation in the calm, well-designed interiors of the new luxury residences. Owners wanted individual pictures, painted screens, and paintings on the sliding paper doors. Encouraged by the spirit of Zen, landscape painting won overwhelming popularity. Some artists preferred the vivid, resonant colours of what had come to typify a national school. Others such as Shubun and Sesshu in the 15th century, taking their inspiration from China, adopted the calligraphic, incisive style of monochrome ink painting with its enchanting effects of atmosphere and distance. Kano Motonobu (1475–1559), founder of the Kano school which lasted several centuries, achieved a synthesis of styles that subsequently influenced the decorative arts in their treatment of panels, screens and fans.

The brief Momoyama period (1573–1615) took its name from the palace near Kyoto built by the two dictators who, once the Ashikaga lost control of the provinces, ousted them from power.

Chiselled dagger blade (Museum of Eastern Art, Venice)

219

During a phase of political unrest and violence, the overlords in the capital and the local lords in the provinces took to building great, fortified castles such as Himeji and Nagoya. But there was no lack of artistic splendour in the immense reception rooms. Artists were busy painting murals, screens and panels, and it was in this context that the Kano school revealed its versatility. Birds, flowers and landscapes were painted in typical stylised ornamental rhythm. In ink paintings on silk, fleeting shapes of pine trees appear through the rising mist. The Hasegawa Tohaku screen now in the National Museum, Tokyo, is a classic example of the school's work.

The Momoyama period prepared the way for the despotic, centralising rule of the Tokugawa, which lasted from 1615 to 1867. In art it is called the Edo period after the place where, to escape pressure from rivals, the Tokugawas established their capital, in a little village destined to become modern Tokyo. The Tokugawa shut the door of Japan to outside influences. Although they left the local landlords free to enjoy their luxurious way of life and individual power, at the same time they smashed the crippling burden of feudalism and thus gave rise to an artisan and merchant class in which certain families grew rich enough to have a decisive say in their country's fortunes. Tokyo became the seat of power but the centre of artistic life remained in Kyoto. Near Kyoto, at Katsura, the emperor's son, Prince Tomohito, built himself a palace whose elegant buildings, sited in a splendid garden, have an almost geometrical spaciousness of refined proportions and undisturbed repose.

Another great monument in Kyoto is the feudal castle of Nijo, a typical example of a nobleman's residence built in a delicate, ornamental style. But in addition to palaces and castles, architects at this time were beginning to design homes for the aristocracy and the upper middle class, as well as villas and tea houses. In the decoration of such places painters, potters, weavers and lacquer workers vied with each other in introducing form, colour and rhythm. However, they did not abandon the tradition of painted scrolls illustrating poems and novels.

The painter Ogata Korin (1638–1716), in the freedom of his forms, his restless deities, his rich decorative irises on a golden background, reflects Zen inspiration. But, by now, alongside the painting which followed the traditional and purely Japanese style, there came into being a fashion called *ukiyo-e* which, with its scenes of everyday life, was aimed at a much wider public. In the second half of the 18th century, *ukiyo-e* gave birth to the popular, middle-class painting. Through prints and engravings, this art-form provided the Western world with one of its greatest reasons for admiring Japanese art once the country opened its doors again to the outside world and (after 1850) welcomed modern civilisation.

The legend of Huge Hoju no Tama, detail of a six-panel screen,
18th-century (Museum of Eastern Art, Venice)

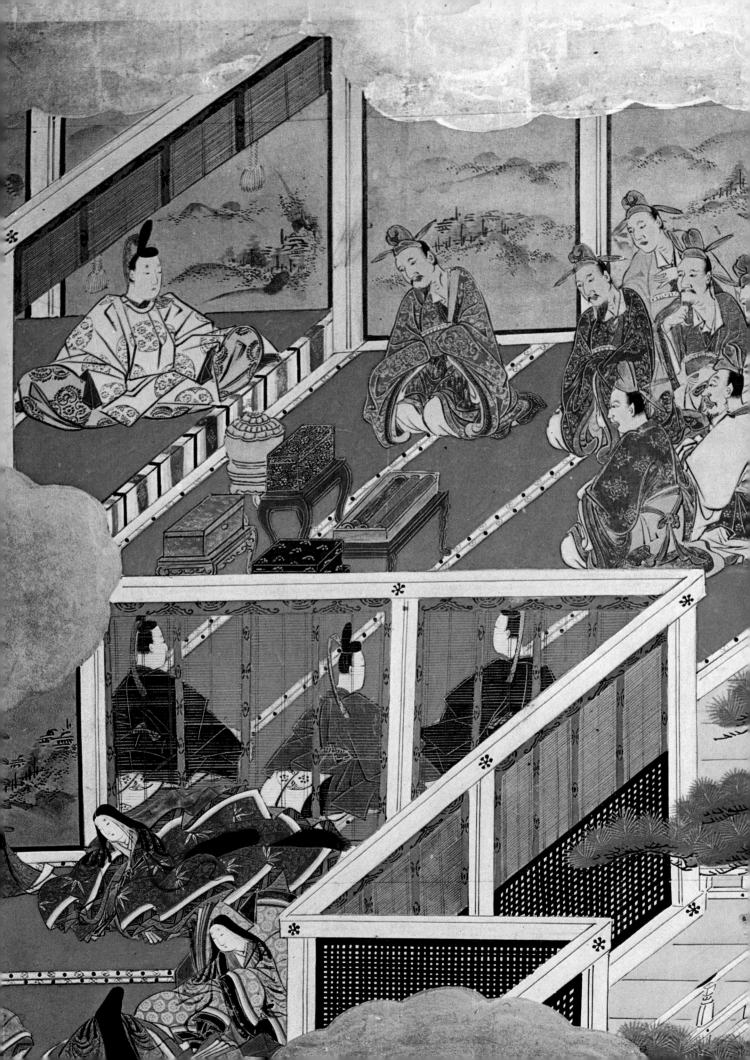

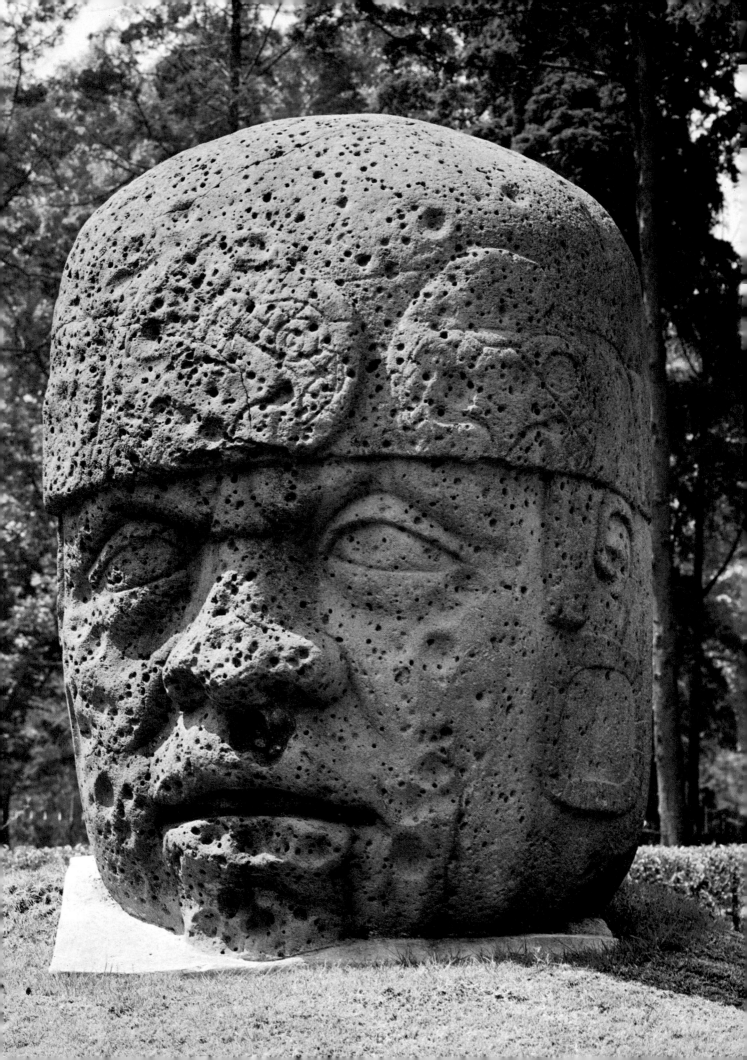

PRE-COLUMBIAN ART

The art which developed in America before the discovery, or rather the conquest, of that continent by the Europeans presents special problems. Chronologically, we are dealing with civilisations far younger than those which we have dealt with so far. Classical art had declined before they came into being. In fact, by the time that all these nations – there was no unity among them – emerged from their prehistoric period and reached maturity, the Christian era was centuries old and Europeans were well into the Middle Ages. But if some of them had only just disappeared, others were still in existence when, in the middle of the 16th century, the European conquerors arrived, Spaniards in the lead, and were astonished by the rich civilisations which lay at their mercy and open to plunder.

It is only right to include these ancient civilisations in a universal history of art, although they completed their cycle in total isolation and were completely independent and cut off from the outside world. But if they were outside the pale of the artistic and spiritual values known to other nations, they had their own world of representation, a world full of meaning to them.

These old civilisations were not just a handful of primitive tribes. The art of pre-Columbian America represents the labour of great, organic and consistent civilisations. Leaving out of consideration what other less stable or sparser peoples of America contributed to art in prehistoric days or at the dawn of history, let us concentrate upon the contribution made by the more evolved, but diverse and changeable civilisations. Geographically, these were concentrated in two vast locations. One lay to the North between the southern part of Mexico and the isthmus of Central America. The other was in South America, in Peru. There was little affinity between the two, nor were contacts or exchanges frequent. Each was a world in itself.

The Mayan civilisation

In Mexico, a much larger territory then than now, the history of the different peoples and their cultures is much more chequered and complicated because of frequent invasions by nomadic races from the North. To find a settled home the Mayas who inhabited the region had to flee to the tropical south, to Guatemala, Honduras and, chiefly, the vast, fertile Yucatan peninsula which juts out into the Gulf of Mexico. Though subject to disturbances and mysterious migrations, the Maya civilisation proved the longest-lived. It was also the most developed, the most 'classic' of all Mexican civilisations, if not the most stable. From 1000 B.C. to A.D. 300, it passed through what we might call an 'archaic' period. Its 'classic' age ran from A.D. 300 to a little after A.D. 1000. After a period of decadence and fusion, it continued as the Maya-Toltec civilisation, traces of which remained beyond the Spanish Conquest.

Essentially an agricultural people locked in

Opposite page: *Olmec head (National Anthropological Museum, Mexico)*

Aztec mask (Ethnographic Museum, Rome)

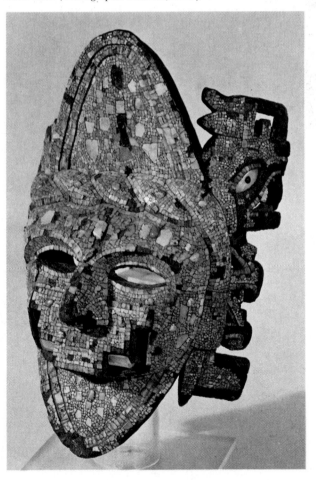

struggle with the forest for land on which to grow their staple food, maize, the Maya followed a strict religion and, under the guidance of their priests, who were also the ruling class, worshipped a host of deities good and evil. The Maya evolved a hieroglyphic script of their own with the signs aligned or in columns. They also had some knowledge of astronomy and invented a rigid calendar. At Uxmal and Kabah in Yucatan, at Palenque in Chipas, and at Copan in Honduras, they built huge, monumental cities, each recognisable by two characteristic structures. The first was the terraced pyramid ascended by flights of steps. On top stood a single-storey, one- or two-celled rectangular temple with a carved pediment and, often, a high finial. The second type of building was the palace, which was rectangular and, as a rule, one-storied. Sometimes it stood on a base or was approached by a flight of steps. In adorning the high front with its strange, geometrical patterns, the Mayas let their imaginations run wild. Both types of building have the characteristic false vault, pyramidal or pointed, and constructed by the progressive superimposition of jutting stones. Maya carving is very rich, whether purely decorative work, on free-standing steles at the foot of temples, or in separate reliefs. It is done in limestone or stucco, and one of its basic motifs is the coiling

and uncoiling of the snake, entwined round the exotic figures and hieroglyphs – a theme repeated with every possible variation and all the exuberance of Baroque. Both the technique and the colouring of Maya pottery are most refined, and the recent discovery of a cycle of frescos at Bonampak, 'the city of the painted walls', has given us a rare example of Maya painting – violent colours, dynamic forms and splendidly fantastic ornamentation.

The Toltecs

Toward the ninth or tenth century a new and warlike people, the Toltecs, came from the North. Their culture was centred on the mythical Quetzalcoatl, 'the plumed serpent', half soldier of fortune, half god. The Toltecs have left imposing evidence of their prowess as builders at Tollan (Tula) and Xochicalco, especially the pyramid temples and those with supporting pillars shaped like figures, almost like Greek caryatids. Eventually the Toltecs intermingled with the Maya, and this resulted, towards A.D. 1000, in the Maya-Toltec period. The new capital was the superb Chichen Itza (Yucatan), containing the stone-faced temple of Kukulkan and the Temple of the Jaguars with its court for the game of pelota which, in addition to being a

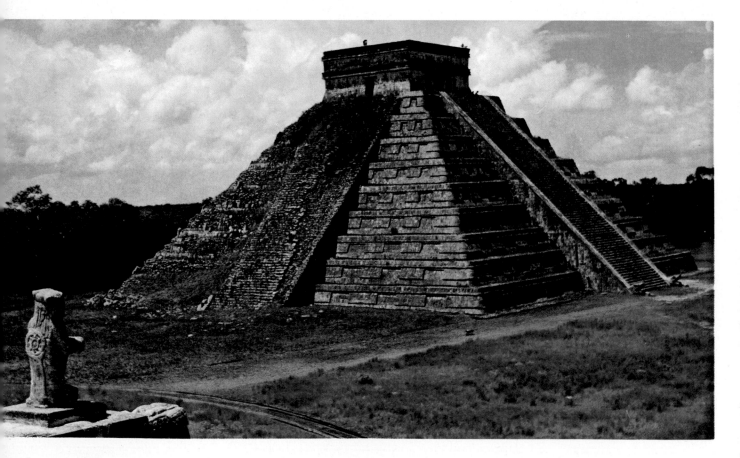

recreation, also had a ritual significance. Further enhancing this richly decorated city was the Temple of the Warriors.

There were other civilisations that contributed to the sum and total of Mexican art. The oldest of them, perhaps, was the Olmec (500–400 B.C.), which flourished on the coasts of the Gulf of Mexico in the state of Vera Cruz. There, towards the 7th century A.D., it experienced a remarkable renaissance. The Olmecs were quite talented sculptors, and often worked in rare materials such as basalt, serpentine, and jade. Although somewhat crude, their carvings were not without a certain tense, dramatic quality.

Towards the west coast, in the state of Oaxaca, lived the Zapotecs, whose civilisation flourished between A.D. 400 and 1000. Set on Monte Alban, their capital commanded a dominant position and, being primarily a religious centre, had many temples. Like Chichen Itza, it had its pelota court, but in Monte Alban it was terraced. As with the Olmecs, the Zapotecs left a permanent record of themselves in their carving, an art in which they were certainly masters of expression.

Vast and densely populated Teotihuacan, on the central plateau, was the capital of the Teotihuacans (A.D. 300–1000) and a centre of great importance, both religious and political. The city was crossed by the wide, impressive Way of the Dead and had two buildings of imposing dimensions: the Pyramid of the Sun and the Pyramid of the Moon. To match their skill and imagination in architecture, the Teotihuacans showed remarkable ability in sculpture and the minor arts.

The Aztecs

From A.D. 1329 to 1521, a period when other ancient Mexican cultures were either in a state of decay or political crisis, the Aztec civilisation flourished. An aggressive, warlike race from the North, the Aztecs were notorious for their mass sacrifices of prisoners and other victims to the gods. From the capital of the Aztec Empire, Tenochtitlan, on Lake Texcoco the priestly and warrior castes exercised merciless power under the guidance of the sovereign, who was considered a god. Tenochtitlan was enormous and well planned. Imposing pyramid temples rose there, alongside palaces and luxurious private dwellings. Not surprisingly, given their inhuman record, the Aztecs developed the already pronounced ten-

Aztec statuette of Xochipilli, god of flowers, the dance, and games (National Anthropological Museum, Mexico)

Pyramid of Kukulkan at Chichen Itzà

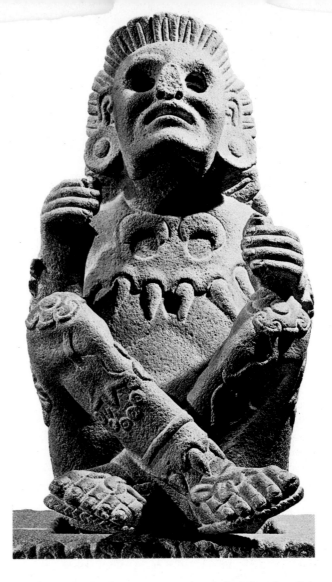

dencies of Mexican art to the full. The fearful, terrifying expressions of figures carved in full relief became more fearful and terrifying still. More emphasis was placed on the motifs in the decoration of stonework in the temples, more insistence on the malevolent plumed serpents, skulls, and birds of prey.

Although, in general, the artistic output of the Central American peoples along the isthmus was more unstable, of minor duration, and of less importance, one happy exception was the gold- and silverwork of Costa Rica and Panama.

Travelling south with an eye for what ancient peoples contributed to art, the cultural atmosphere is completely different from and inferior to that of Mexico. The little that Ecuador, Chile, the Argentine, and many other countries have to show is of poor quality. Colombia has its huge, carved monoliths in the region of San Agustín, but in the whole of South America, only one country Peru, excites interest.

The story of the artistic development of this beautiful, mountainous land on the West coast is both long and involved. Apart from the

monumental ruins and the archaic sculptural forms of the sacred city of Chavin de Huantar, there were three centres which showed remarkable development during the initial centuries of the Christian era. The first lay along the coast to the North, the territory occupied by the Mochicas, a race of farmers and fishermen. In the field of art, they deserve mention not so much for their pyramidal structures of adobe as for their output in the minor arts. Their goldsmiths produced fine jewellery and bracelets; their potters, beautifully worked vases in the shape of human heads or animals, others with a handle in the form of a stirrup. The second centre also lay along the coast, but farther south, and the people there were the Nazca. In the decoration of their pottery, their woven goods and their goldware, they preferred forms and patterns of bold, geometric type. Like the first, the third centre was also in the North, but inland. There the Recuay made figure-vases as did the Mochicas but, unlike those of their neighbours, the Recuay products were more exaggerated. The most favourite animal model seems to have been the cat.

On the shores of Lake Titicaca, which borders on Bolivia, there appeared after A.D. 1000 a civilisation that took its name from the city of Tiahuanaco (A.D. 1000–1300). A few traces of the city still survive: the monolithic Gate of the Sun with angular decorations based on human forms, and the massive, schematically carved standing stones representing worshippers. Tiahuanaco pottery and woven goods introduced

new, brightly coloured motifs in their decoration and abstract broken patterns, sometimes with pumas and condors.

Far more refined than the art of the Tiahuanacos was that of the Chimús (1300–1438), who supplanted the Mochicas in the North. Traces of Chimú monumental art remain, as do also the ruins of Chimú defence works, but the forte of Chimú artists lay in the minor arts. Chimú potters specialised in globular vases with figures in relief and stirrup-shaped handles, highly imaginative vases inspired by human or animal shapes, and groups of statuettes engaged in day-to-day activities. The magnificent Chimú gold- and silverware included belts, necklaces, vases, idols, ceremonial knives and funeral masks, to name but a few items. Styles and shapes varied from the realistic to the completely abstract, the totally round to the flat. Products appeared in a serried succession of ornamental rhythms inset with colourful gems.

The Incas

The last civilisation in South America before the coming of the Spanish with their exterminating swords was that of the Incas (A.D. 1438–1538). Based on the Upper Andes, the Incas imposed agrarian collectivism and founded a powerful empire extending beyond the confines of present-day Peru. In artistic production proper, the Incas were relatively weak. They produced little or no sculpture, showed no great refinement in their gold- and silverware, and produced simple

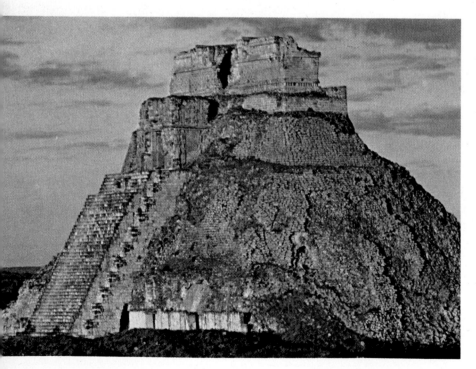

The nose of Chaaca, the God of Rain, detail from the temple at Uxmal, Yucatan

Opposite page, above left: *Peruvian goldsmith's art, two idols (Private collection).* Above right: *Aztec mask (National Anthropological Museum, Mexico City).* Below: *Detail of an Aztec sun stone, 1324–1521 A.D. (National Anthropological Museum, Mexico City)*

The Pyramid of the Sorcerer at Uxmal, Yucatan

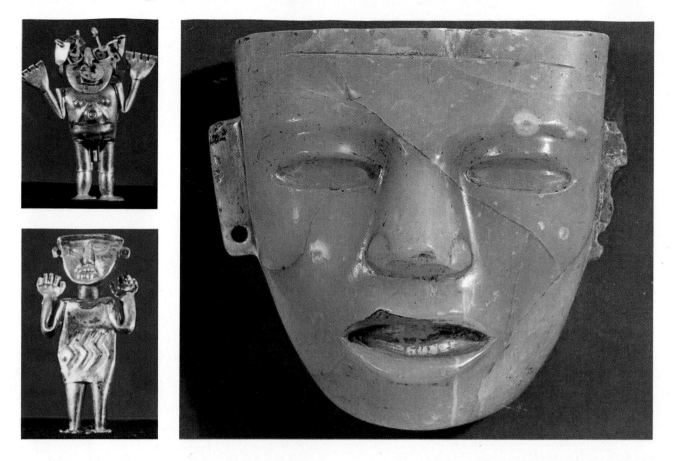

pottery with brightly coloured decorations on a dark red background. Where the Incas excelled was in their grandiose architecture. Rational, homogeneous and severe, it was carried out on high ground in Cyclopean blocks of stone and, on the coast, in simple adobe – bricks of sundried clay. The buildings were remarkably imposing but no less simple and functional, decoration being confined to the entrances or the trapezoidal niches. Inca architecture reached its zenith with Cuzco, the coherent, well-planned capital, 3000 feet above sea level; in the Fortress of Sacsayhuaman with its huge walls and outworks, and in the impenetrable Machu Pichu, high on its mountain peak. Within the walls of these impressive structures the Incas stored their vast treasures, especially the gold- and silverware which amazed the Spanish conquerors.

Compared with the art of other civilisations, what is usually labelled pre-Columbian art strikes one immediately by its diversity and its extremes. It is full of irrationalities, and reveals a world racked by obsession and anguish, a world where religion and ritual walk hand in hand with magic. Pre-Columbian art speaks directly and firmly, however, and never more so than when it drops into Mexican idiom. It expresses the fearful, the terrifying and the macabre, for it prefers death to a life of peace, anguish to

hope, pitiless impassiveness to even a glimpse of human feeling. Overwhelming, exasperating, it is the very antithesis of classical art. Pre-Columbian art may be another world, but for all its colourful moods and the shock of its expressions, it is no insignificant or banal world.

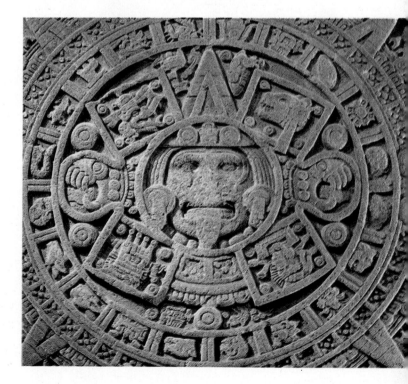

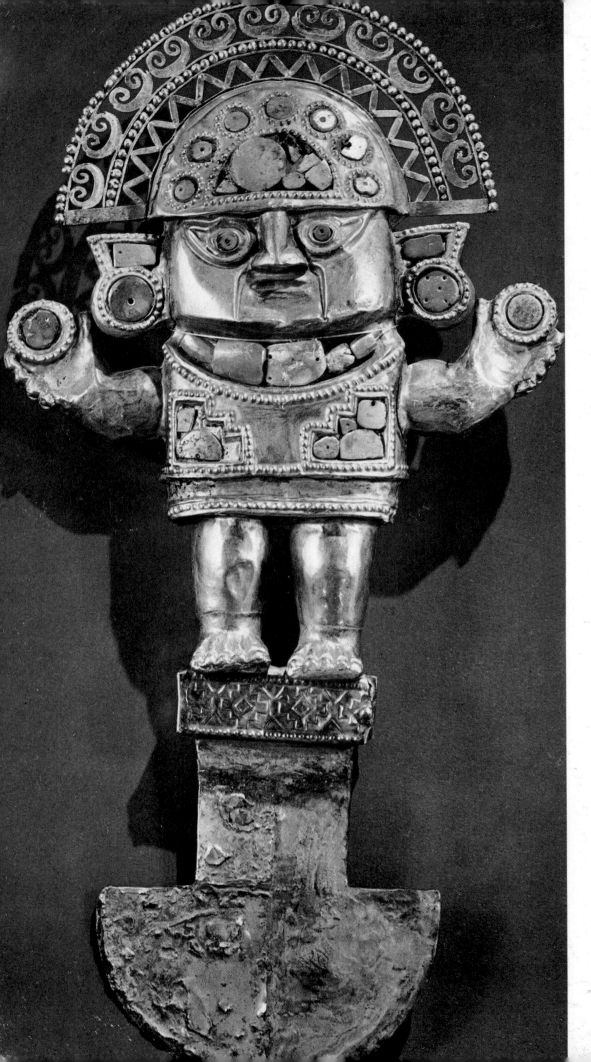

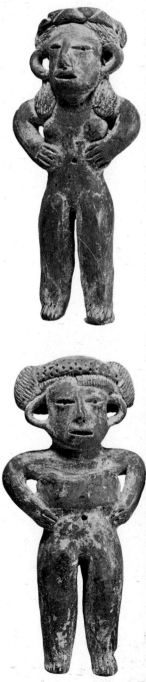

Chimú culture: a ceremonial gold knife ('tumi') from Illimo (Mujica Gallo Collection, Lima)

Two clay female figures with large circular ear-rings, from Jalisco. Classic Period, 300–650 A.D. (Private collection)

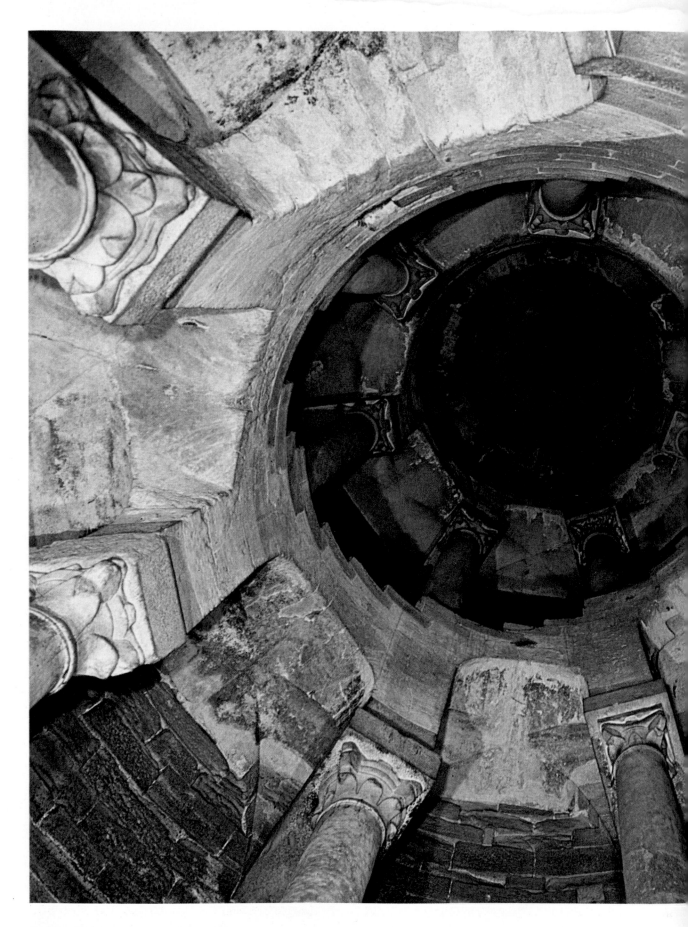

Interior of the Campanile of S. Nicola, Pisa

230

*Painted wardrobe door with decoration in relief, from Mont-
-Quentin, 14th century (Doucet Coll., Musée des Arts Décoratifs, Paris)*

WESTERN EUROPE: CHARLEMAGNE TO THE YEAR 1000

The fall of the Roman Empire put an end to the peace, unity and even the stability of the European social scene. The Barbarian kingdoms which replaced it were not only at war among themselves, but were often overthrown in their turn by the subsequent arrival of new migratory waves of peoples, bringing pillage, defeat and destruction. At the same time Islam was making inroads from the South. But more serious still was internal instability. This encouraged the growth of feudalism. Autonomous centres of power and influence gradually concentrated around the great estates of the nobles (of Barbarian or Roman origin), and the peasants, in exchange for security and stability committed themselves to labour duties on the estates, which later became fiefs.

Agriculture was poor and primitive and there was no movement of wealth, people, or ideas; it was a world hard hit by immobility and insecurity, misery and oppression. And yet below the surface, a strong and positive process of amalgamation was gradually and silently taking place. There was a gradual fusion of peoples once dominated by Rome with those of the Barbarian invaders, an interpenetration of diverse customs, mutually contrasting ways of life and work and opposing modes of thought. The nostalgia for classicism, with all that it implied of order and reason, mingled with the passionate intensity of Barbarian art with its wealth of irrational vitality; from the appeal of the colourful pomp of Byzantium to the first hints of the strange, new world of Islam. Slowly and laboriously, new values were established and took on a European dimension. When this process of amalgamation was complete, at the beginning of the 9th century, the time was ripe for a new European civilisation – the Romanesque broke vigorously onto the scene.

The centuries that preceded the achievement of this synthesis saw the slackening and decadence of artistic activity. Cultural centres vanished without trace, while the Church, and in particular the monasteries, had the monopoly of the little that was being read or written.

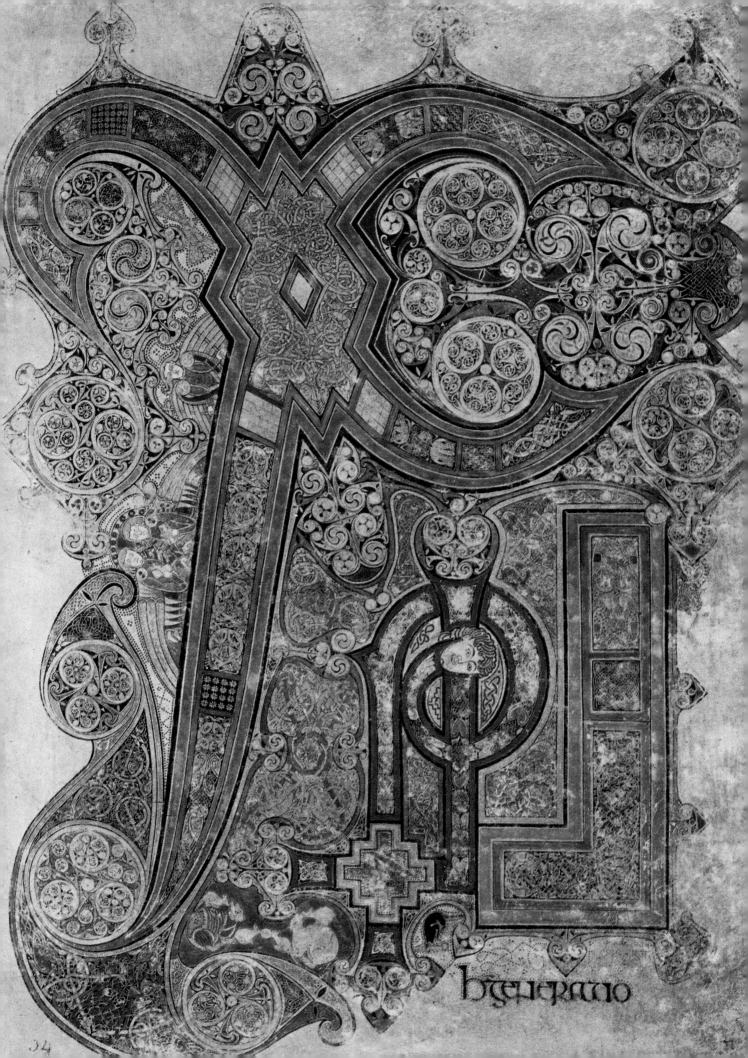

hgenamo

Illuminated manuscripts

The elaborate illuminated manuscripts are thus even more precious; those of the eighth and ninth centuries particularly were the product of a time of vigorous religious expansion and which came, to some extent, from monasteries and abbeys in England, but chiefly from those in Ireland. It was above all monastic art, and was the work of the monks and other members of monastic communities in their capacity as missionaries. This art form, however, developed a style all its own, not only capable of absorbing the abstract, anti-figurative and purely ornamental qualities of the more recent Barbarian art, but also the more distant Celtic style and taste. It was a miniaturist art founded basically on abstract, flowing rhythms, with no kind of geometric angularity. It made use of linear and curvilinear motifs in ribbon-like bands which intertwined, wound round each other and crisscrossed. The highly imaginative decoration of the initial letters became the dominant feature, while the rare figurative themes reveal a loss of expressionistic shape. The Lindisfarne Gospels (British Museum, London), which date from the end of the seventh century, and, to a still greater extent, the later Book of Kells (Trinity College, Dublin) represent the culminating point of the prolific Anglo-Irish miniaturist art. This art form spread considerably over the European continent as well, thanks to the links between monasteries, and especially through the foundation of the great Abbey of St Gall, in Switzerland, which became its major channel.

Opposite page: *Illuminated initial from the Book of Kells (Trinity College, Dublin)*

Plan and interior of the Palatine Chapel at Aachen

The first attempt at political and cultural rebirth came with Charlemagne, although the state structure which he built upon the vast domains that comprised France, Germany, Austria and northern Italy, and which was hemmed in by exterior threats from the Moslem Empire and the Oriental barbarians, was precarious in the extreme. Nevertheless from his coronation as Emperor by Pope Leo III on Christmas Day A.D. 800, the idea of a medieval empire took its birth. On balance a modest bureaucratic and cultural machine of the Carolingian period represented a new and positive approach. The attempt to create a state organisation centred upon the palace, with ecclesiastics replaced the fragmentation of power with unity and for a time subordinated the feudal system to the authority of the monarch. It gave the newly emerging empire the significance of a humanistic renaissance. It imposed upon the rough Imperial court the need to claim its rights to nobility in the revitalisation of cultural and artistic values.

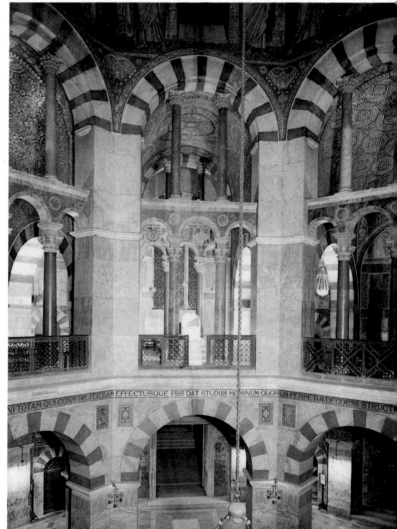

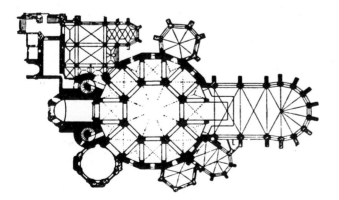

What we usually call the Carolingian Renaissance is the artistic fruit of, in particular, the centre of the empire, between the Seine and the Rhine. But, particularly because of the ecclesiastical links and the relationship between monasteries, and because of the multiplicity of abbeys, it gave new stimuli over a large radius.

Architecture

There was a revived impetus in architecture, but because of destruction or fundamental alterations, which the greater part of Carolingian

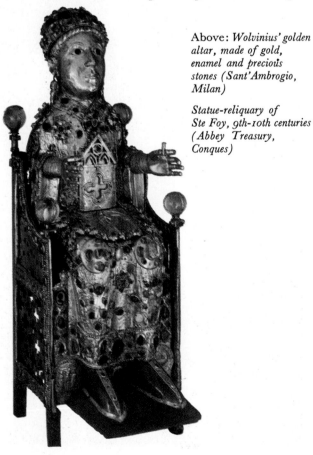

Above: *Wolvinius' golden altar, made of gold, enamel and precious stones (Sant'Ambrogio, Milan)*

Statue-reliquary of Ste Foy, 9th-10th centuries (Abbey Treasury, Conques)

architecture suffered at a later date, only the Palatine chapel remains of the palace which Charlemagne built at Aachen. This is a tight, solid construction, laid out round a central octagonal area. Eight great, rounded arches support a slender double gallery, arcaded on the underside, and divided into three by columns. S. Vitale at Ravenna shows where Charlemagne had found the inspiration for his classicism. Yet it is in basilica construction rather than in the centrally planned structure that Carolingian architecture is seen in its most powerful form – for example, in the original abbey of St Denis near Paris, which was later replaced by the present Gothic cathedral; the Imperial abbey of Lorsch, on the upper Rhine; the convent church of St Emmeranus at Ratisbon, on the Danube. Here, as in other Carolingian buildings, there appear some structural novelties. Some churches have a side entrance and an enclosed nave, with a western transept and apses at both east and west terminations (Fulda abbey, St Gall abbey). Others developed that singular effect known as *Westwerk* which was destined to last on German soil: a forepart of the church, consisting of a high façade, was tightly enclosed within two lateral towers and opened, in the interior, into a great open-sided gallery, reserved for the Emperor and his suite, overlooking the nave. The most significant surviving example is the monastery church at Corvey, on the Weser. Finally, this period also saw the beginning of crypt construction, circular in shape to begin with, as at Ratisbon, and later wider and vaulted (Auxerre, Ivrea, Sta Maria in Cosmedin at Rome).

Sculpture and frescoes

Sculpture continued to be unpretentious – the statue of Charlemagne on horseback (Louvre, Paris) is typical – and, so far as decoration is concerned, did not venture far beyond the ribbon motifs and wicker-like tracery of Barbarian tradition. But the sculptural motif of the human figure, with a tendency towards classicism which brought together Byzantine inspiration and local traditions, appeared in the minor arts – often of conventional origin – in objects in gold and ivory. Vuolvinio reached a high level of artistic creation in his work on the gold altar in the basilica of S. Ambrogio at Milan, where, amongst filigree, precious stones and enamel work in Barbarian style, reliefs predominate with their calm, clear composition.

Wall-painting was rare, and the demand for pictures was satisfied by miniatures (characteristic of the religio-literary culture of the Carolingian

world), produced in great numbers in the Imperial and monastic workshops, such as the Tours school. They reveal a desire for figurative expression and concern for composition in the laborious efforts at classicism, delighting in wandering away from sacred themes to the portrayal of the Emperor or of his deeds. Thus they represent an alternative attitude to the abstract taste of Anglo-Irish miniaturist art.

However, the Imperial structure created by Charlemagne fell apart after his death, and the partition Treaty of Verdun (843), dividing his lands between his grandsons, marked this disintegration and prepared the ground from which the nations of Italy, Germany and France were to grow. While France was busy confronting the inroads made by the Normans coming in from Scandinavia, the rest of Europe was suffering the invasions of the Avars who came in from Hungary, and the piratical sea-borne incursions of the Saracens from across the Mediterranean.

In the 10th century, however, in Germany, the Saxon dynasty of the three Ottos succeeded in restoring order by driving back the invaders from the East and by trying to find a more stable system than that of feudalism. Otto I reaped the benefit by having himself crowned Emperor in Rome in 962, while in France, in 987, Hugh Capet founded a dynasty which in fact was to establish the French monarchy.

In the arts the German Ottonian revival was in fact nothing more than a continuation of the Carolingian tradition, and received its impetus from the court or palace, reinforced by ecclesiastic and conventional contributions. An additional impetus came with the founding of the Benedictine abbey of Reichenau on Lake Constance. As far as architecture was concerned, Carolingian styles were improved upon and better articulated, until they came to constitute an immediate precursor to the Romanesque period into which the Ottonian era (which ended with the death of Henry II of Saxony in 1024) was later to merge. Ottonian churches are numerous: St Gertrude at Nivelles in Belgium, St Pantaleon at Cologne, the typical dome structure of Trèves and St Cyriacus at Gernrode, to mention but a few. But they are all outdone in imposing complexity by the abbey of St Michael at Hildesheim, in Saxony, with its double apses and its *Westwerk*. Here, Bishop Bernward commissioned in 1015 the masterpiece of Ottonian sculpture: the great bronze doors. Figures in full relief stand out from a flat background which has no sense of depth, and the emphasis on human form betrays a nostalgia for a lost classicism. The doors employ what Carolingian miniaturist art had fore-

Reliquary in the shape of an arm, wood plated with silver-gilt, 1120-30 (Church of St Gereon, Cologne)

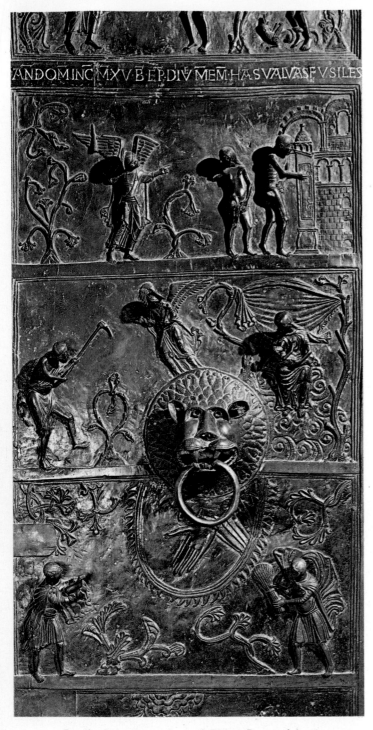

Detail of the bronze doors of Bishop Bernward in the Basilica of St Michael, Hildesheim

Opposite page, above: St Mark the Evangelist, from the Ebbo Gospels, Reims (Library, Epernay)

Opposite page, below: Gold altar-front fo (Cluny Museum, Paris)

The Rhine centres, especially Cologne, made notable contributions to the abundant Ottonian goldwork. But it was in the conventual centre at Reichenau that the most outstanding work was produced, namely the altar destined for Basle cathedral and now in the Cluny Museum in Paris, with its classical moderation and the full sculptural power of the figures in gold-leaf on cedar wood. There was also a wealth of ivory-work; here, perhaps more than elsewhere, one is conscious of the proximity to Byzantine art, the spread of which was favoured by the marriage of Otto II to the Greek princess Theophano.

Except for the complex of frescoes in the church at Oberzell, directly inspired by the abbey of Reichenau, the predominant feature of the Ottonian period was the art of illuminating manuscripts. It is in this art form that the swing between the varying elements of the Ottonian period can be most clearly seen. Byzantine inspirations, with almost classical composition, appear in the Sacramentary of Gero, Archbishop of Cologne, and in the vivid miniature of the enthroned Emperor in the Chantilly Museum. The sensitivity and expressionistic verve which was already present in the Fulda Sacramentary, and which came to full fruition in the Gospels of Otto III, gave a foretaste of the Romanesque.

Although, because of their courtly origin, the artistic manifestations of the Carolingian and Ottonian revivals tended to flourish most at the centres of their respective empires, reverberations of these renaissance movements were also felt in foreign countries. In Christian Spain the Carolingian period saw the construction of S. Julian de los Prados at Oviedo, in Asturias, and the solitary S. Miguel de Lillo at Naranca. Italy was fairly rich in its own particular contributions to the beginnings of the Romanesque style. The remains of what must have been the notable contribution made by Barbarian architecture are unfortunately scanty, and all certain traces have been lost of the work of the Lombards in the seventh century, particularly in the case of the churches and palace of Pavia, capital of Lombard Italy, and the basilica of Monza, founded by Theodelinda. There was complete inertia in Rome after its fall save, in the seventh century, for the frescoes in the ruined church of Sta Maria Antiqua in the Roman Forum, which have great vigour, possibly because of local survivals. At the end of the eighth and start of the ninth centuries, there was a certain amount of building in Rome, but it was marked by a return to Early Christian styles, which inspired Sta Prassede, Sta Cecilia and Sta Maria di Dominica. Carolingian influence can be seen in S. Donato at Zara, the style of

shadowed, particularly in the Tours school. Above all they reveal a dramatic and highly strung German expressionism.

which was inspired by the central structure of
the Palatine chapel of Aachen, and in the small
chapel of the church of S. Satiro at Milan, which
was commissioned by Archbishop Ansperto. The
ground plan of this chapel is cruciform, with
lobate walls and vaults supported on columns.

Already, by this time, the guilds of artisan-
masons – the *Maestri Comacini* – had gained the
recognition of the Lombards and were active
in Lombardy, whence their activities spread over
the whole of Europe. There is some controversy
as to whether the name should be taken to
imply that they originated in Como or whether
it was an abbreviation of *cum machinis*, which
would indicate that they had a mastery of
specialised and mechanised techniques. It is to
the Maestri Comacini, both in the problems
they faced and in the solutions they devised, that
we owe the works that precede Romanesque
building proper. The buildings in question are
the baptistry of Biella with its four apses; the
baptistry of Galliano with its curving external
wall and its unusual internal structure, and the
solitary and ponderous building of S. Pietro al
Monte, above Civate, with its counterbalancing
apses. However, the work which best reveals the

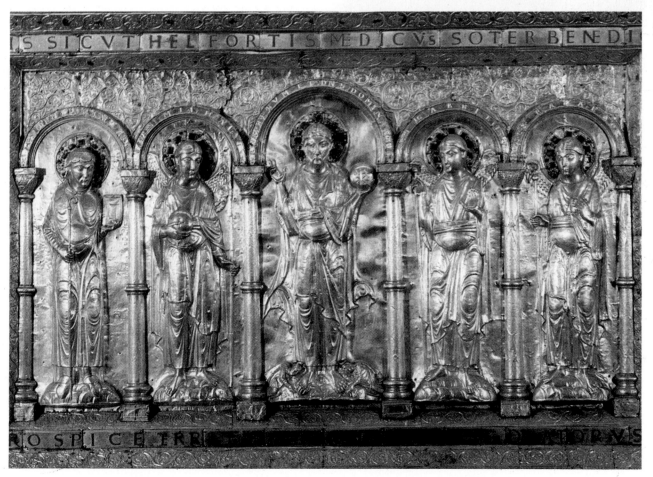

typical wall construction (pilasters and blind arches) of the Maestri Comacini is the apse of S. Ambrogio at Milan, dating probably from about the middle of the 10th century. Especially notable are the corona of recesses in the upper part and the clear-cut semicircular walls with flat pilasters. If it is really contemporary, the ciborium (canopy) above the altar in S. Ambrogio shows an unexpectedly strong sculptural sense in its carved stucco figures which show Ottonian derivation.

Interior of the Basilica of S. Tomè, Almenno S. Salvatore

Below, left: *Exterior of the baptistry, Galliano*

Below, right: *School of Reichenau. Detail of the 'Crown of the Holy Roman Empire' (Kunsthistorisches Museum, Vienna)*

Italian Pre-Romanesque painting was both derivative and based on popular forms, as is evident in the Carolingian pathos and regional expressionism which are combined in the frescoes of S. Vincenzo at Volturno; in the Ottonian expressionism of the prophets at S. Vincenzo at Galliano, dating from 1007, and in the Warmondo Missal, or Sacramentary, at Ivrea, as well as in the Byzantine quality of the older frescoes of S. Angelo in Formis, which were inspired by the nearby abbey of Montecassino.

Above: *Carolingian fresco showing a donor offering a chapel, Malles Venosta*

Detail of the ivory cover of the 'Lorsch Gospels' (Victoria and Albert Museum, London)

240

BYZANTIUM AND ISLAM IN EUROPE

Romanesque and Gothic art were relatively unified movements that spread over much of Europe. There were, however, two other artistic currents which were, by contrast, mainly foreign to Europe, and which impinged upon it from outside the Islamic and the Byzantine.

Islamic culture penetrated into Spain and, more fleetingly, into Sicily. This inevitably led to a direct confrontation between the characteristic artistic values of Islam and those of the West, and at a time of serious crisis in Western religious and political affairs.

Moslem Spain

After conquering North Africa, the Moslems invaded Spain in 711, occupying it from Seville to Catalonia, and overthrowing the kingdom of the Visigoths. In 720 they moved into France, conquered Toulouse, entered the Rhône valley and pushed as far as Tours. But Charles Martel defeated the Moslems near Poitiers (732), and successive French kings and Charlemagne himself drove them back across the Pyrenes, where they consolidated their hold over Spain. When the Abbasids overthrew the first dynasty of the

Arched cupola of a chapel in the Mosque, Cordova

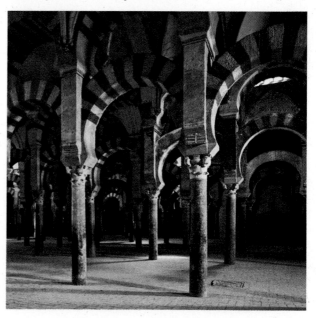

Interior of the Grand Mosque, Cordova

241

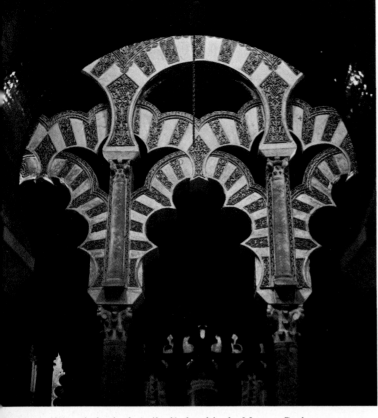

Arches in the 'mihrab' chapel in the Mosque, Cordova

Spanish 15th-century polychrome flask (Museum of Glass, Murano)

Capital in the 'sala de las Canas' in the Alhambra, Granada

The Mexuar patio in the Alhambra, Granada

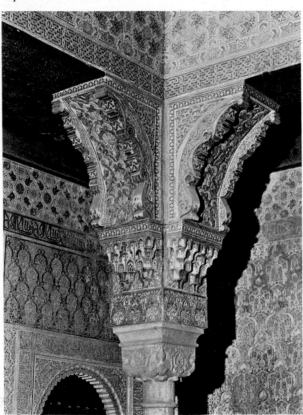

Umayyads in 750, one of the latter succeeded in escaping to Cordova, where he founded a rival state which lasted from 755 to 1009, giving Spain a relative independence.

It was at Cordova that the first great Islamic monument was built. In 785 work began on the Grand Mosque, and although it was enlarged many times in the succeeding centuries, it still preserved its original inspiration. Enclosed within high walls which, like the doors, were lavishly covered with vivid Hispano-Moorish abstract decorations, was the characteristic courtyard with porticos and the hall of prayer, subsequently widened on several occasions, with its ten rows of columns. From the capitals, which are of Visigoth origin, spring two orders of arch, each enlivened by two-coloured decorative bands. The lower order is the typical Moslem horse-shoe shape, while the upper one is round-headed on a very tall pedestal base. The forest-like effect of the columns is associated with that lightness of structural elements that was one of the characteristics of Islamic architecture. Arabesque decorations are scattered everywhere in rich profusion, and in the *mihrab* (the niche which

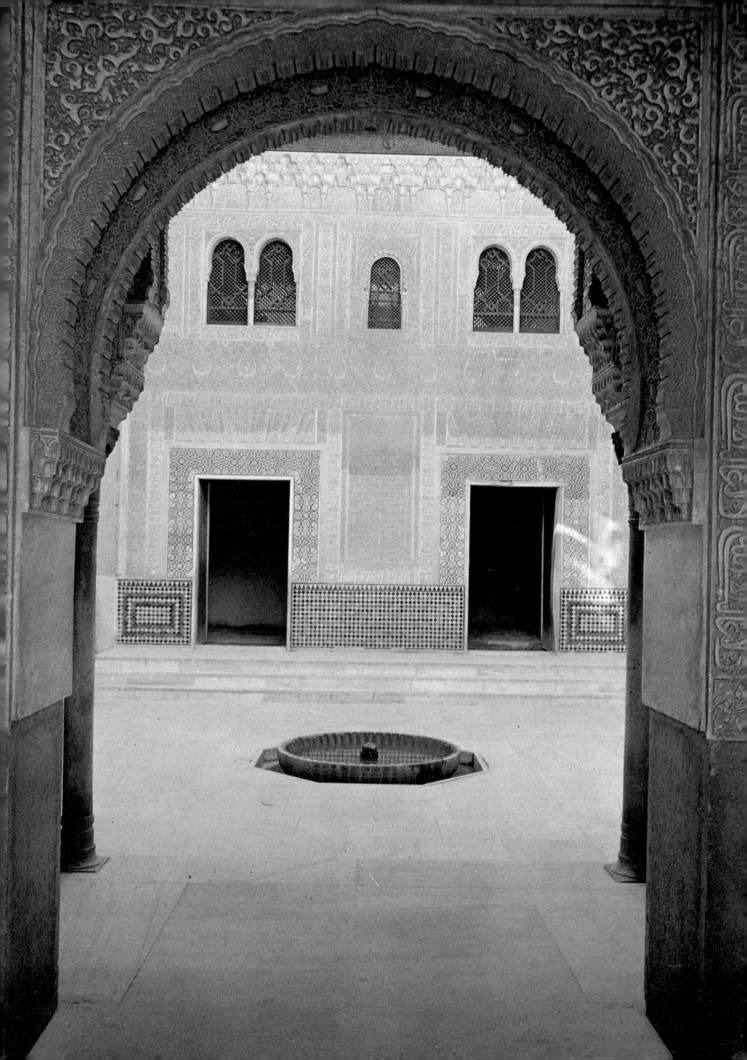

indicates the direction of Mecca), finely decorated with exquisite abstract carvings, they clearly owe something to Byzantine mosaics. Later alterations, especially those of the 10th century, were not merely concerned with extensions. Articulated arches were developed, intersecting and overlapping one another, and designed with many lobes and in many colours. On the other hand, there was also the Hispano-Moorish tendency to prefer dome-like constructions. This tendency was taken up on the African coast throughout the entire Mahgreb. The same type of construction is found in the nine cupolas of the mosque at Toledo, later transformed into a Christian church. At Cordova, however, these interior cupolas are light and airy because the weight is spread over solid and functional intersecting ribs in a style which was well ahead of its time.

The Moslem civilisation of Andalusia was magnificent, and of a high cultural level. With great tolerance, it permitted the Christians to practise their religion – thus paving the way for compromise and mutual influence – and also welcomed the intellectual contributions made by the Jews. Both at Cordova and in the other centres of Spanish Islam, the many branches of the minor arts were developed, especially for the decorative purposes that were such a feature of Islam. This was due to the high level of craftsmanship, in which immigrant artisans were integrated with local master craftsmen.

The fall of the Caliphate of Cordova, in the first half of the 11th century, marked a period of anarchy among the small local chiefs. However, this did not put a stop to artistic output, in particular the highly ornamented work carried out in the palace of Aljaferia, at Saragossa. The danger (though it was then only a potential one) of Spain's being reconquered by the Christians led, in the 11th century, to the intervention from Africa of the Berber nomads known as the Almoravides and, in the 12th century, of the Almohades from the mountains of Morocco. These peoples were rougher and more sectarian, but it was this new force in Spain that caused Islamic civilisation there to reach its highest point in literature, science and philosophy with Averroes, who introduced into the Christian world the heritage of Aristotle. This was the epoch which, after the building of the Alcazar of Segovia, produced, in Seville, the Arab quarter of the Alcazaba and the imposing palace-fortress of Alcazar, which bristled with walls and towers. The great mosque, later transformed into a Christian cathedral, has remarkable structural power, and the Patio de los Naranjos and the Puerta del Perdon are richly decorated. The Giralda, its old minaret (1171), is an imposing structure with an ornamental motif of linked lozenges. Some fine examples of Hispano-Moorish art remain in Toledo, in the Puerta del Sol and the 13th-

The Zisa Palace, Palermo

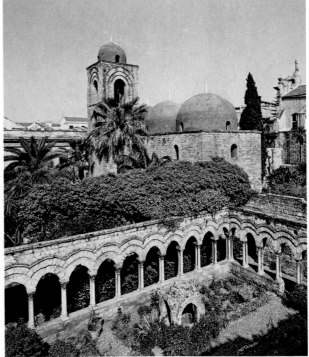

S. Giovanni degli Eremiti, Palermo

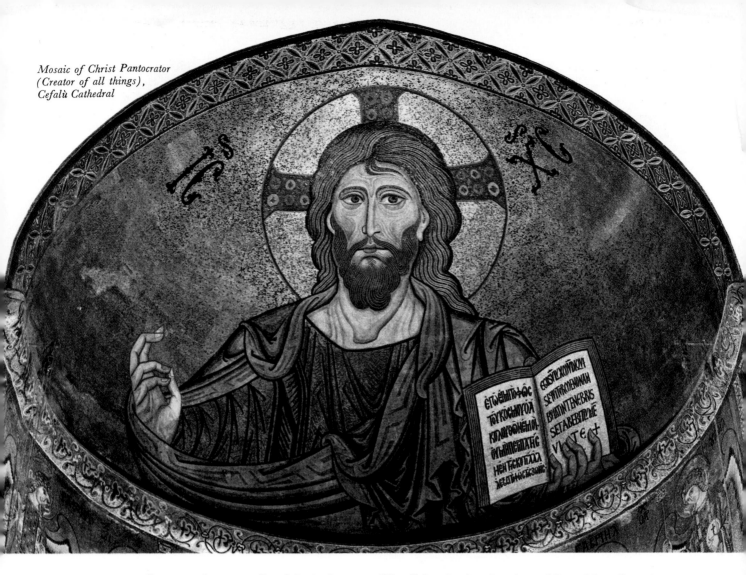

Mosaic of Christ Pantocrator
(Creator of all things),
Cefalù Cathedral

century mosque (later to become Sta Maria la Blanca) with the clean lines of its distinctly horse-shoe arches.

It was, however, at Granada, which under the Nasrid dynasty (1232–1492) was to be the last centre of Islamic resistance against the re-conquest by Christendom, that Islam has left its most fascinating mark. Here the Moslem works of art are numerous. The most famous monument is the 14th-century Alhambra, where the extreme sophistication of Islamic decoration runs wild in the light of the southern sun. The complex of buildings pivots on the two colonnaded patios of the Court of Myrtles and Court of Lions: the first with raised circular arches, the second with a profusion of festooned archways and the famous lion fountain in the centre. The exteriors of these courts and the ornamentation of the Comares Tower show decoration of surprising delicacy. But it is in the interiors that we see the Alhambra's full splendour. The Chamber of the Two Sisters has a magnificent honeycomb ceiling and the Hall of the Kings is perhaps the finest example of the type of ornamentation using stalactites and hanging garlands.

The Islamic domination of Spanish soil ended with the fall of Granada in 1492. This did not, however, mean the end of the repercussions of Islamic style which, outside of the minor arts, where it survived for a long time, was manifested in the so-called *mudejar* style. This style was encouraged both by the *moriscos* – that is, the Moslems who chose to remain in Spain – and by the Christians themselves, who acquired the taste through familiarity with the style and through its long duration. There was, of course, some attempt at compromise.

Sicily and Italy: Moslem and Byzantine influences

The effective penetration of Islam into Sicily was of considerably shorter duration and of less artistic relevance. The Arabs settled there and made Palermo their base between the 9th century and 1072, when they were driven out by the Normans. The strange thing is that the buildings left by the Arabs (almost exclusively at Palermo) belong not so much to the time of their domination as to the first Norman period,

245

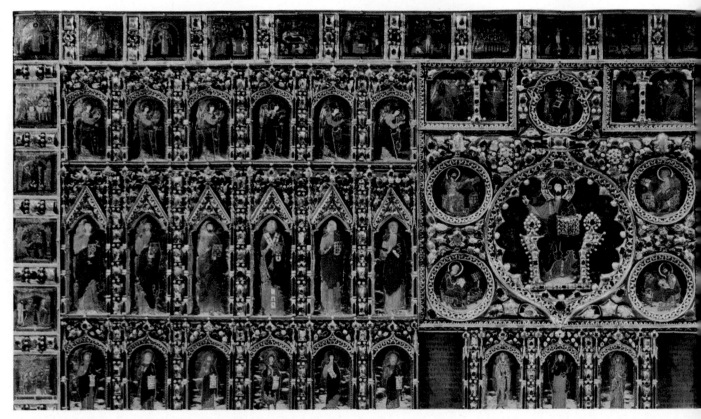

The gold reredos in the Basilica of St Mark, Venice

when the new invaders made efforts to save the artistic work of the Arabs. The buildings are of a rather more fundamental type than those in Spain, and the prototype may be found in the Cubula or the Cuba (1180). These are cubic buildings of continuous walls with arched openings, on which hemispherical cupolas are placed geometrically. The fascinating church of S. Giovanni degli Eremiti (1142) which took the place of a mosque, repeats this Arab structure in its prismatic shape surmounted by five hemispherical red cupolas. The Zisa palace, in the magnificent park of the Norman kings, is almost contemporary with the church. Outside, the Arab influence is seen in the somewhat abstract geometry, relieved only by the two projecting foreparts. But the interior porch, with its Moorish decoration – stalactite ornamentation alternating with classic columns and Byzantine mosaic – is highly interesting. There are also echoes of Arab influence in the honeycomb and stalactite ceiling in that incomparable jewel, the Palatine chapel in the Norman palace, which was constructed on the site of an Arab fortress.

The second foreign element in the artistic growth of Romanesque and Gothic Europe is that of Byzantine art. Byzantium represents an historical movement and a stylistic experience, both of which are totally different from those of the Moslems. In fact, Islam was to remain Byzantium's great antagonist, especially after the menacing invasions of the Turks in the 11th century, when the Asiatic Byzantine possessions were gradually eroded and when, with the fall of Constantinople in 1453, the Byzantine Empire itself finally perished.

The claim to be perpetuating the Roman Empire conferred upon Byzantium a special stamp, even a kind of cultural authority. But the historical reality is different. After the reign of Justinian, the Byzantine Empire became even more centred on the palace – and at the same time more theocratic. Its system of Caesaro-Papism concentrated political and religious power in the Emperor and its Oriental features of sumptuous autocracy, tightly bound within an ideology of political and theological conformism, rendered the Emperor a remote figure.

Art – in particular painting, both in fresco and in the intensely prolific mosaic work – was deeply influenced by this orientation, and creative freedom was restricted within limiting stylistic formulae which governed both form and content. In the matter of form, formulae were

both scholastic and categorical, resulting in an increasing tendency to flat, two-dimensional representation typical of the Byzantine style. In the iconographic field – especially after the uproar caused by the iconoclastic period and its destruction of sacred images – inviolable figurative rules were adopted, with complicated theological schemes steeped in symbolic significance and hierarchy of representational themes. From Constantinople, increasingly limited by such developments, this influence spread west.

The most orthodox Byzantine schemes are to be found in the great 11th-century Norman constructions in Sicily: in the cupola of the church of the Martorana; in the brilliant apse of the cathedral at Cefalu with its imposing Christ Pantocrator (Creator of All Things): in the intriguing Palatine chapel in the Norman palace, and in the cathedral of Monreale, where the first sign of Western mosaic influence is to be seen. A splendid example of Byzantine mosaics may be found in Rome, in the little chapel of S.

Detail of the enamel work on the gold reredos in the Basilica of St Mark, Venice

Zenone, in Sta Prassede, especially in the stylised figures of the white angels. Distinctly Byzantine overtones are visible in the apse of the cathedral of Torcello, where the Virgin forms a background in the gold above the procession of saints. Finally, there is the mosaic decoration in St Mark's, Venice, where Byzantine and local influences can be seen side by side.

The output of minor art forms was very rich indeed. Goldwork tended to take pride of place over work in ivory, which declined from this time on. It is in the West that perhaps the most brilliant masterpiece of Byzantine goldwork is to be found, in the great gold reredos above the altar of St Mark's, Venice, which was altered many times between the 10th and 13th centuries. In this work, the inlaid enamel hieratic figures of

248

Exterior of the Byzantine monastery, Daphnis

the saints reveal all the glory of Byzantine light and colour.

Byzantine art and its diffusion

There is no need to reiterate the historical importance of Byzantium in the later history of the Roman Empire and in the resistance to the Barbarian invasions, nor to point out the originality of the best of Byzantine art, the many areas into which it penetrated, and its role as a bulwark against the extinction of ancient classicism. The main concern here is the consideration of another and higher aspect of Byzantine art, namely that renewal or renaissance which came about under the Macedonian Emperors (867–1081) and, later, under the

Transportation of the relics of St John Chrysostom, Church of the Apostles at Constantinople

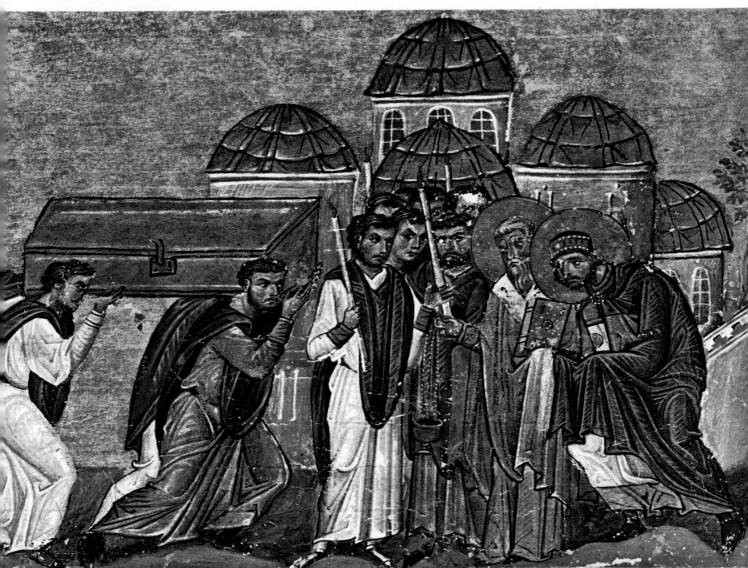

Comnenes (1081–1185). This occurred after the grave crises of the eighth century, which were not only political and artistic but religious as well, because of the effect of the iconoclastic movement and the outlawing of images. From the artistic point of view, this renaissance reached such a pitch in the creation of new forms of expression that, though they were firmly rooted in Byzantine tradition, one may speak of a Deutero-Byzantine or Secondary-Byzantine art.

Somewhat more than in the preceding period, this artistic development was specifically Byzantine, but took place in an ambit which was from then on only peripheral to Europe. The manifestations and penetrations of Deutero-Byzantine art in Europe occurred over a fairly wide area – from Macedonia to Greece, from the Balkans to Yugoslavia, from Roumania to Russia – but they always remained the intervention of an art and a taste so profoundly alien to European experience that they were virtually antagonistic to it.

Interesting transformations were brought about in the field of architecture. There was a return to the central structure, often consisting of a Greek cross, with arms of equal length. This was enclosed in a square or rectangle, with blind cupolas at the points of intersection and a vast, well-lit cupola in the central space, which gave ideal surfaces to be covered by the mosaic decoration so dear to Byzantine tradition. The compact mass of the external structure, either faced in marble or left as bare brick, was articulated into apses or niches which were often lightened by the addition of tall, narrow, arched or mullioned windows. The cruciform arrangement of the cupolas could be seen from the outside, dominated by the central dome on a high, fenestrated, circular or polygonal tiburio or base. This basic plan was repeated by Basil I in the New Church of Constantinople, now destroyed. There are, however, other examples of the style in continental Europe, not so much in the Imperial capital as in the church of the Theotokos (1028) and the 14th-century church of the Holy Apostles, both at Salonika; in the Little Metropole cathedral (11th century) at Athens; in St Theodore (1296) and in the church of the Aphendiko (14th century) in that prolific centre of Byzantine art, Mistra, in the Peloponnese, and in St Clement at Ochrid, in Yugoslavia. Monastic architecture, the most famous complex of which is to be found in the monasteries on Mount Athos, was more severe, more traditionalist, but also less significant, from the artistic point of view. This style of architec-

Above: *Church of St Sophia, Novgorod, begun in 1052*

Centre: *Onion domes on the church at Rostov*

Opposite page: *Icon of the Old Testament Trinity by A. Rublev, 1411 (Tret'yakov Gallery, Moscow)*

ture was, however, widely spread over the Greco-Balkan area and even pushed towards Asia as far as Armenia and Georgia. It is strange

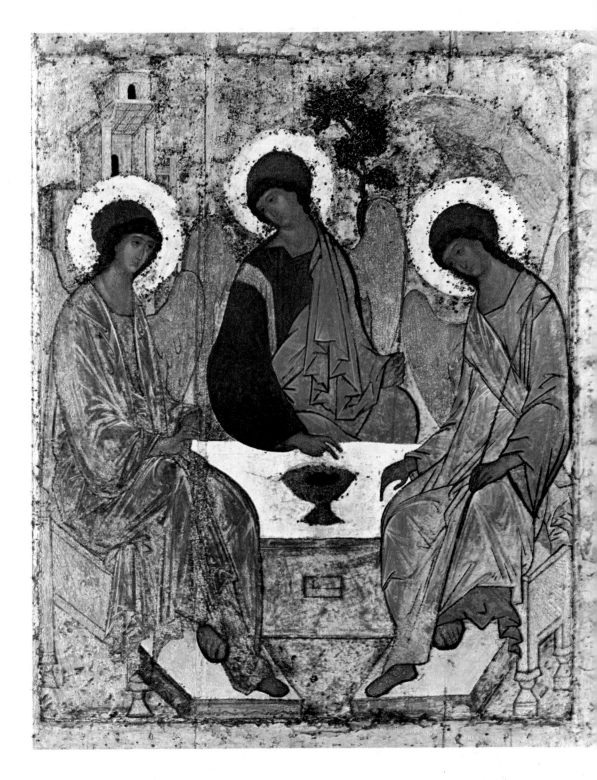

to find echoes of it on the Calabrian coast in the Cattolica of Stilo (12th century), with its curious little drum cupolas, and in the church at Rossano with its three apses.

Painting, mosaics, frescoes and icons

It is easy to understand how, after the interlude of iconoclasm had passed, painting once more regained its full impetus. Mosaic work dominated with its emphasis on light-pictures and colour-pictures which, as we have seen, were a feature of Byzantine art. St Luke at Phocis (10th century), the Nea Moni on the Island of Chios (11th century), and particularly the church at Daphnis, near Athens (end of 11th century) mark the culminating point of an activity which continued, one might say, over the whole area affected by Byzantine art.

Orthodox theology made for a prearranged

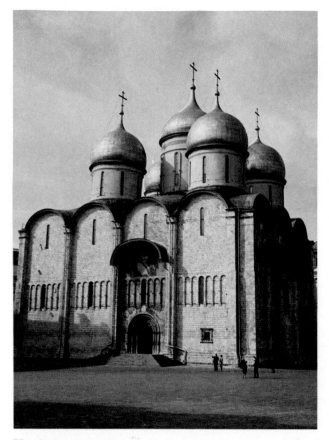

The Cathedral of the Ascension in the Kremlin, Moscow, built by Fioravanti da Bologna

these the mosaics of the church at Daphnis in Greece should again be mentioned. They are full of delicate humanity and an elegance reminiscent of Hellenism.

A contrast to this general tendency to a reduction to static canons and stereotypes can be seen in two fields, which are in themselves mutually incompatible. The first consists of the special and vibrant note achieved by fresco-painting, especially in the area which was farthest from the more direct and conformist domination of the Byzantine capital. In the characteristic Deutero-Byzantine centre of Mistra, in the Peloponnese, the 14th-century frescoes in the church of the Peribleptos seem to seek freedom of movement, and the very stylisation takes on a fluid expressiveness. The evolution which Byzantine painting achieved earlier in Yugoslavia is more important, especially that in the church at Nerez (1164) and in Santa Sophia at Ochrid (11th century). The figures have a dynamic tension with a large degree of popular expressionism, even to the point of excess. The other field is that of painting on panels. Russian art made a great contribution to this art form, particularly in the elaboration of hieratic, flat icons, sometimes with sinuous designs and vivid colours. This was due to the local schools of Novgorod, Pskov and Moscow. The conversion of the Slav peoples by the Byzantine missionaries meant that the immense area of Russia was now open to the influence of Byzantine art. The basilica church structure, if not that of the church with the central plan and Greek cross, was a later development. The churches of Santa Sophia at Kiev (1037) and Santa Sophia of Novgorod (1052) confirm the expansion of Byzantine art, although they were full of picturesque local elements, like the onion domes with their vivid colours and twisted columns. Sculpture at this time was of little significance and there was in fact no attempt at the making of statues, which became, from then on, chiefly decorative in function.

order in the distribution of subject matter. This may be seen in the dominant figure of Christ Pantocrator in the centre of the cupola, with the symbols of the Evangelists in the shallow vault of the apse. We then pass to the subordinate position of the Madonna; the procession of hieratically rigid saints, and sometimes to themes showing biblical figures. There is, moreover, an increasingly two-dimensional treatment. The flat figures are roughly cut within the outlines, while rigid lines of light highlight the draperies. Cycles of pictures are rare, especially in mosaics, which avoided the general tendency to formal schematisation and theological symbols. Among

Thirteenth-century icon (National Gallery, Sofia)

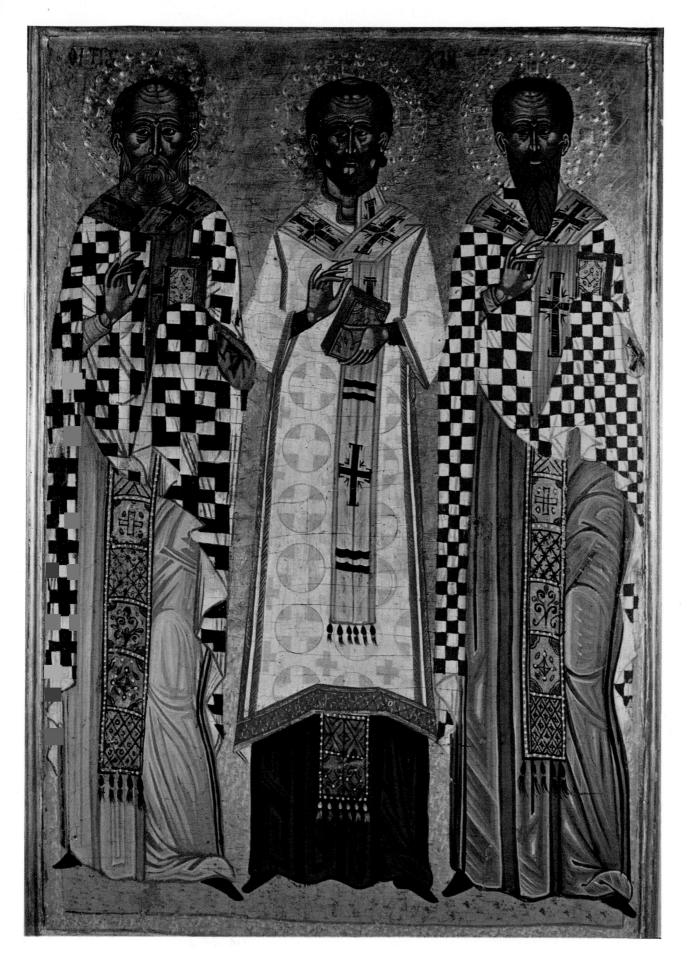

ROMANESQUE ART IN EUROPE

Romanesque art and architecture blossomed like a summer without a spring. Although it was foreshadowed by laborious attempts at innovation during the preceding centuries, it became apparent in a sudden and unprecedented fervour for building. This was obvious even to a contemporary, the unpretentious monk of Cluny who, in the rough Latin of his chronicle, and with an ingenuous attempt at dating, noted: 'About the third year after the year 1000, there was a renewal over almost all the land, but especially in Italy and France, of the building of basilicas. The faithful were not content merely to reconstruct the cathedrals, but also restored the churches in the monasteries and even the little churches in the villages. One might almost say that the world shrugged off its old rags and clothed itself in a white mantle of basilicas'.

In attempting to explain this phenomenon, it is not enough merely to enumerate the many external elements in its favour. New events had certainly taken place: a new security came after the last Hungarian invasions had been countered and the Barbarian invasions had ceased, and a slow economic recuperation stimulated exchange and trade and gave new life to the cities. The feudal system settled into the conception of static and unchangeable orders which set each man in his place in society. The Imperial dynasties in Germany and the newer Capetian dynasty in France grew in strength and began to pave the way for a form of nationalism. There was a widespread religious fervour which found expression in great works, in the activities of the great monastic orders and in those massive undertakings, the crusades. There was the rise of influential abbeys (the Benedictine abbey of Cluny, founded in 909, was of particular importance to the whole Western world), which were religious and cultural as well as economic and artistic centres. There was the influence of famous abbots and prelates (Bernward at Hildesheim, William of Volpiano at Dijon, St Hugh at Cluny) who were not only religious reformers but also industrious and competent builders, and proud of it.

In reality, however, the roots of the phenomenon went much deeper. It had a collective, almost popular, origin and was historical as well as spiritual. With the advent of Romanesque, in fact, a new type of man appeared who had achieved consciousness and was soon to reach maturity. He was the result of a long historical process of the merging of many different streams and of the working out of many different sets of values, and henceforth his outlook and attitudes were to form the basis of Western civilisation. He was, of course, still subject to all the limitations of an unsophisticated civilisation and an hierarchical society, dominated by a transcendental God, and not yet free from obscure fears. But already he possessed a sound, coherent view of reality and of the universe into which, in spite of many adverse circumstances, he saw himself entering as a participant. Romanesque art arose at a time when vernacular and national languages were gradually taking the place of Latin (henceforth to remain the prerogative of the Church) and provided a convincing and common

General view of the Benedictine Abbey of St-Martin-du-Canigou (Eastern Pyrenees), which includes an 11th-century early-Romanesque church

Christ in majesty, fresco from Berzé-la-Ville

voice for this humanist recovery. The extent to which it flourished during the course of the 11th and 12th centuries is surprising. The desire to give concrete expression to such a common heritage was irresistible, and form and image was most consonant with this expression.

The Romanesque movement had several basic characteristics that should be emphasised. First of all, although the movement sprang mainly from France and Lombardy, it reached European dimensions through the substantial amount of common ground in vision and intent. In the second place, although Romanesque was a style with common characteristics, it was not crystallised into rules or theories, but appeared in a large variety of regional and local forms. Thus each example, even where there were other influences and traditions present, was an original creation, while still remaining the fruit of a common Romanesque 'spirit'. In the third place, Romanesque style took on such a marked and consistently popular imprint. It was no longer palace-based and aristocratically inspired art but came from the vast and illiterate mass of the population. It spoke their language, even in its most refined works of art. It was addressed to the

people, and this was seen in city cathedrals, where the new building was an indication of their reawakening. It was seen in the modest little country churches built by impoverished communities. It was seen in the churches scattered along the traditional pilgrim routes, which were even more imbued with an atmosphere of sincere devotion. Finally, it was also seen in abbey or convent churches which, more than the others, reflected an organic inspiration and the character of a given monastic order.

The desire for concrete artistic expression found its outlet in building, in the most elementary sense of laying one stone firmly upon another to create a stable and coherent whole. But to build was, almost exclusively, to raise a monument to God, namely a church in which people would recognise each other and in which they would share. Hence the absolute preponderance of architecture in Romanesque art, and religious architecture in particular. This does not mean that the rest is of no account. Other art forms, especially sculpture, made great progress. In fact their development was encouraged, because they served as a kind of absolution by externalizing the hidden fears of men.

This was not a simple function, it is true, because the world had no common culture and was still in a state of unrest. Art representation varied widely. It ranged from biblical themes (which were a means of substituting for the scarcely accessible written text a visible portrayal which came to be regarded as the 'poor man's

Apse of Sovana cathedral

Opposite page: *View of Anagni cathedral*

Church of St Nectaire (Puy-de-Dôme)

Bible') to the terrifying and anguished visions of the most fearful eternal torment that awaited the sinner. Sculptural representation ranged from pious devotional statues to the most varied, often entirely profane, subject matter. The signs of the Zodiac, personification of the months, the trades and the arts were portrayed as though the illustrative purpose were to provide an encyclopedia for illiterates. Hand in hand with this almost pedagogic activity went the obsessive conjuring up of monstrous animals which, though forced back into the shadows, were always ready to pounce. However, both sculpture and painting were of lesser importance than architecture. Architecture stimulated them, but determined their form and setting; it prompted them, but then limited them in terms of space, situation and effect; often it affected composition through the shape of the 'frame' or setting, whether it was a capital, an architrave or a lunette to which the artist was obliged to adapt his subject matter.

In a world that was seeking stability and security, Romanesque architecture responded with a static firmness in its buildings. It extolled the values of robustness, consistency and weight. Romanesque architecture was able to return to the

Early Christian basilica structure, but only by transforming it substantially. This was not particularly a matter of constructional detail – such as the intersection of the nave by a transept, the raising of an octagonal-based cupola on corbels at the centre of this intersection, or the development which occurred in the choir and in the apse complex. Rather it took the form of a modification of values. There was a sense of physical limitation, of bounds being set, of arresting open spaces within the thick, heavy walls; this interrupted the flow of light by restricting the window space, plunging the interior into gloom and a rarified atmosphere.

There was now a sense of the volumetric mass of the construction. Even when it was more articulated in plan, or when it was more elevated, the construction remained compact, integrated and oppressive, with those values of compactness, enclosed space and solidity which characterise Romanesque architecture. There was also a new sense of the gravitational pull of weight which the use of stone and the effect of the bare, undecorated walls seemed to underline, and which the robustness of the rounded arches accentuated. The Romanesque church was now a

calculated balance of thrust and counter-thrust, of mass bearing down and of a corresponding upthrust of the supporting elements. But the mass of weight and the mass of resistance were set against each other in a static way, strength against strength, without that interplay of dynamically resolved tensions that came with the Gothic style.

However, the most significant feature of Romanesque architecture was its integrated structure. It aspired to a church that was completely organised, complete and unified in its construction and layout. This meant that it required a solution, with its solid and continuous walling, to the problem of roofing which, from the architectural point of view, was an unresolved legacy from the Early Christian basilica (and some Romanesque churches, too, where the problem was not even tackled). It was at this point, in fact, that the work of the builders was interrupted and could go no further because, when the top of the walls was reached, carpenters had to be called in to insert the wooden beams across the nave to support the plain span-roof, which was not an organic part of the building.

The problem was solved, though not without some initial difficulties, with what was the greatest achievement of Romanesque, namely the throwing of the characteristic cross vault in brickwork over the central nave. So it was the Romanesque church alone up to this time that achieved an integrated construction, an unbroken stretch of masonry. The best examples of the solution to the problem, dating from the late 11th and early 12th

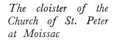

The cloister of the Church of St. Peter at Moissac

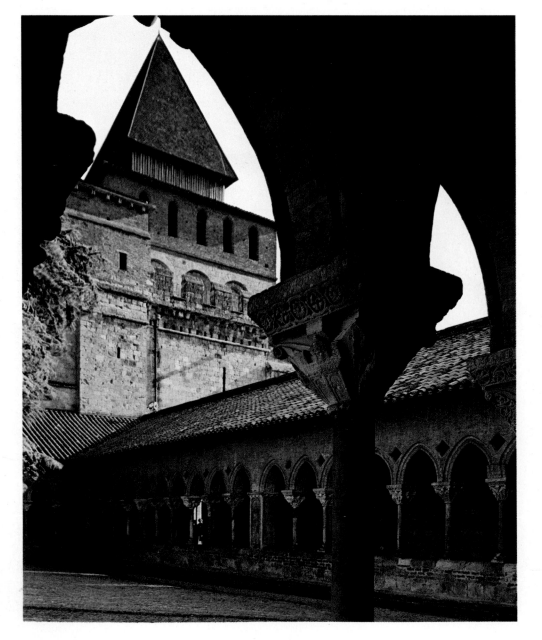

centuries, are the basilica of Sant' Ambrogio in Milan and the cross vaults of Durham cathedral, England. French Romanesque architecture is interesting because it shows the steps which led to the final solution of the problem. Sometimes the architects avoided the problem of a main nave by building smaller naves or aisles with half barrel vaults and quadrants, or cross vaults. Sometimes the cross vaults were only a partial solution, as, for example, at the abbey of Tournus, in the roof over the single narthex or railed-off portico, which dates from shortly after A.D. 1000. As a result, as at Ste Foy at Conques (mid-11th century), a central nave was built which was quite high but also fairly narrow, and was covered by a barrel vault which distributed the weight along the whole length of the walls. A later develop-

ment, which first appeared in St Etienne at Nevers (second half of the 11th century) and later, after 1120, in Ste Madeleine at Vézelay, was the use of a series of round-headed arches across the largest nave so as to form a solid link between the walls and to lighten the stress of the barrel vaults, thus turning the latter into individual bays. It is obvious that only the cross vault, the use of which became systematic during the 12th century, provided a rational solution to the problems of weight and stress. Formed by the intersection of two barrel vaults, the cross vault concentrates the whole of the weight and stress along the corner edges (which, for this very reason, are strengthened with ribs) and spreads it over the four vertical angles of the bay. However, the solution was not confined exclusively to roofing in

Interior of the basilica of Ste Foy, Conques

Enamelled book-cover (Spitzer Collection, Cluny Museum, Paris)

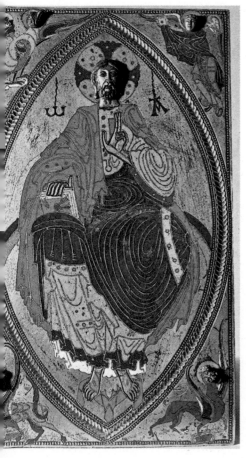

brick, but played an integral part in the general structure of the Romanesque church. The central nave was broken up into square bays corresponding to the vaults, and in order to take and spread downwards the weight concentrated on the four angles of the vault, the architects replaced columns, which were far too slender, with robust stone pillars. This made it necessary for the aisles and exterior walls to be brought in to exercise a counter-thrust on the walls of the nave, especially when they were higher than the aisles.

The Romanesque style flourished in the 11th and 12th centuries, and although as early as the middle of the 12th century it began to be supplanted by Gothic in the Ile-de-France, it tended to persist elsewhere. While Europe was engaged upon this great artistic experience, events of great historical importance were taking place: the conflict between Church and Empire; the maturing of the autonomy and privilege of the cities, which was putting an end to the organisation of smaller communities; the crusades, which brought into conflict (but also into contact) the Christian and Moslem worlds; the rise of the Italian sea-faring republics of Venice, Amalfi, Pisa and Genoa. When Gothic

Remains of the abbey church of Cluny, showing the south transept

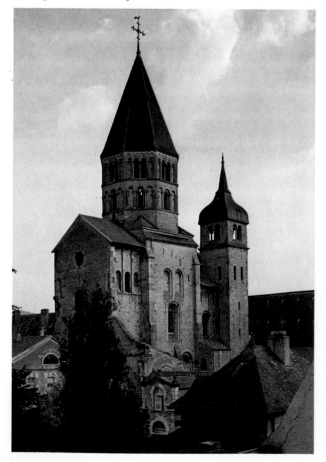

succeeded Romanesque, which had by then reached its zenith, it did so in a Europe very different from that which saw the coming of Romanesque.

Romanesque France

Romanesque architecture in France, where the most stimulating philosophical argument of the time was taking place in Paris and the various monastic centres, developed particularly early. It was also rich in important new ideas that gave rise to a large number of buildings. Naturally there were several regional variations that modified the broader, national tendencies.

The Benedictine abbey of Cluny, in Burgundy, was the centre of the rebirth and renewal of the Church through its 2000 monasteries and 10,000 dependent monks. It was an imposing complex of buildings which included cloisters, chapter houses, libraries, workshops, store rooms and the abbey church of St Peter, unfortunately altered by ill-advised demolition and modification at the beginning of the last century. This first basilica at Cluny was a prototype. So also the second basilica, erected during the latter part of the 10th century and consecrated in 981. This basilica had three naves, an ample choir, together with apses and a separate transept surmounted by a high lantern tower on an octagonal base. At the end of the 11th century St Hugh undertook a reconstruction which gave the church even more imposing dimensions, adding radiating apsidal chapels to the choir, and the prominent lantern towers with pyramidal roofs to the exterior. The church of Paray-le-Monial, in the Haute Loire, has close affinities with the third basilica of Cluny, with which it is contemporary.

There are three Romanesque structures which reflect the influence of Cluny. Ste Madeleine of Vézelay, whose reconstruction was not undertaken until 1120, is robust and brilliant, already in mature Romanesque style. The strong relief of the capitals in the nave is a splendid example of Romanesque sculpture and a fine testimony to the vigorous sculptural values of the Burgundy school. The tympanum (the space over a door between the lintel and the arch) leading to the cross-vaulted narthex is justly famous. On this typanum, the dominant figure of Christ, in an almond-shaped mandorla which breaks the surrounding semicircle of sculpture, transmits to the apostles their new power. The sculptural vigour is combined with entangled and sinuous lines. Almost contemporary with Ste Madeleine is the church at Autun, also unfortunately considerably altered. However, the

Initial P from a 13th-century manuscript of the Old Testament (Bibliothèque Nationale, Paris)

Façade of Notre-Dame-la-Grande, Poitiers

tympanum of the doorway – the work of Gislebertus (*c.* 1130) – must not be overlooked. Around the lofty figure of Christ in the mandorla, there is a highly dramatic Last Judgment, with the resurrected dead hurrying towards it along the architrave. On one side the bewildered figures of the blessed are elongated and bent in distorted expressionism, while, on the other, as the archangel bends over to weigh the souls, the howling figures of the damned twist and turn among fearful demons. Further west, St Etienne at Nevers, which dates from the end of the 11th century, is interesting for its architectural rigour. This is exemplified in the interior by the strength and clarity of the arches and of the mullions in the gallery, with its round-headed arches; and on the exterior by the circular arrangement of the apses, corresponding to the radiating chapels of the choir.

Further west still, coming from the Loire, one can still follow the route, marked by churches at frequent intervals, that was taken by pilgrims to distant Santiago de Compostela in Spain. St Martin at Tours, which has been reconstructed many times, is one of the oldest and most typical

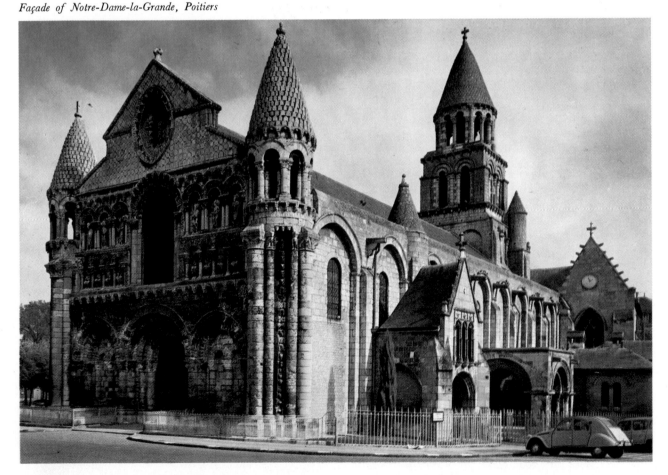

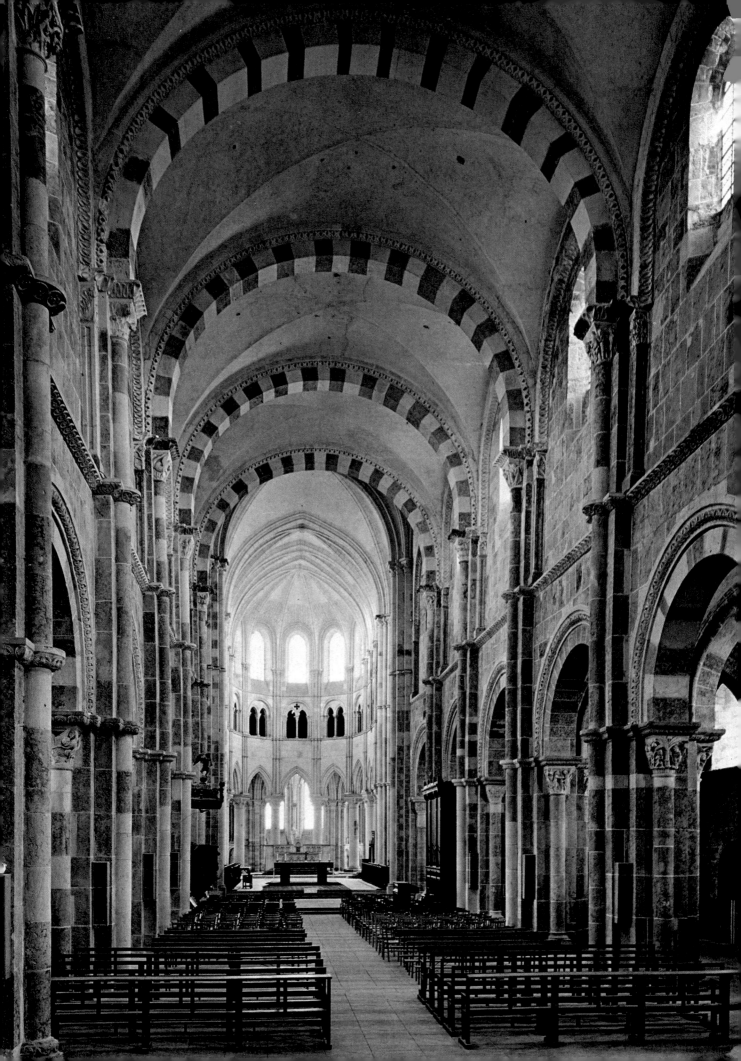

examples of a church containing a choir with double ambulatory and radiating chapels. The inland route passed through Limoges and Conques, with the isolated mass of Ste Foy, but there was also a more westerly route through Poitiers, where Notre-Dame-la-Grande has a façade closely framed by curious lantern campaniles whose conical roofs are supported on pillars and arches that have almost ceased to be a structural element and become sculpture instead. St Pierre of Angoulême was next on the route, with its firm, square outlines and the robust sculpture of the tympanum and the upper part of the façade (1125). Further on, at Périgeux, there rose St Front – a typical product of the architectural school of Périgord – whose ground plan is a Greek cross surmounted by five tall, almost Oriental cupolas on drums with two-colour bands. With this plan, where the cupola rises from blind galleries, the interior problem of the vault is avoided.

The cupola also appeared in the church at Souillac in Languedoc, but more interesting in this building is the first example of the Aquitaine school of sculpture. This is seen in the fantastic, intertwined surrealist shapes on the central pillar of the portal (c. 1130) and the figure of the prophet Isaiah, who seems to be doing some kind of mystical dance. The pilgrim would thus be prepared in advance for seeing

Interior of the basilica of Ste Madeleine, Vézelay

Detail of the Bayeux Tapestry (Bayeux Museum)

263

Capital showing Noah's Ark, St Lazare Cathedral, Autun

Capital showing the Adoration of the Magi, St Lazare cathedral, Autun

what is possibly the greatest example of southern French sculpture at that time, in the church at Moissac (1100–20) on the Garonne. The apocalyptic vision of Christ, in the tympanum of the doorway, is a mixture of heraldry and mystery. Christ is dressed almost as if He were an Oriental monarch, and twenty-four seated biblical elders turn their heads towards Him. Sensitive and relaxed figures of the apostles appear on the central pillar of the doorway. In the cloister, which is one of the most beautiful Romanesque cloisters in France, the firm relief of the carving which decorates the four-sided basket-shaped capitals and the angular pillars is of a high quality. Finally, at the last long French stage of the pilgrimage, there is the beauty of the red-brick church of St Sernin at Toulouse, begun in about 1075, with its five-storeyed tower and interplay of circles in the apses.

Provence was also on the pilgrimage route,

though relatively apart. One of the most interesting churches is that of Les-Stes-Maries-de-la-Mer with its nave, standing like a rock fortress to withstand the Saracens. At Arles there is St Trophîme, with a very beautiful cloister. This church shows how Provençal sculpture, so richly influenced by Italian Romanesque, was grafted onto architecture, particularly in the balanced order of its compact, double doorway. Similar to St Trophîme and, moreover, its inspiration, is the church of St-Gilles-du-Gard, further to the west, where the façade is richly decorated with sculpture.

The Ile-de-France and the northern part of France are less rich in Romanesque architecture. Little remains of what must have been a fairly powerful abbey at St Germain-des-Prés, in Paris itself, while St Pierre in Montmartre has been heavily altered. In Chartres, although the great Gothic cathedral later incorporated the Roman-

Giselbertus: The Damned, architrave of the tympanum over the main doorway of the cathedral at Autun

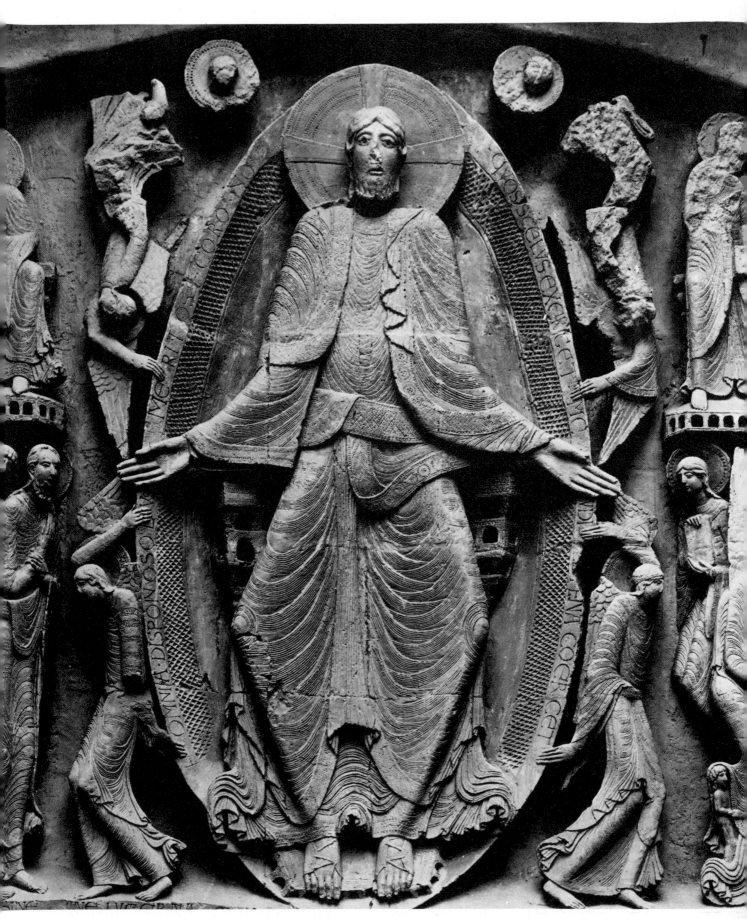

Giselbertus: Christ in Judgment central mandorla of the tympanum over the main doorway of the cathedral at Autun

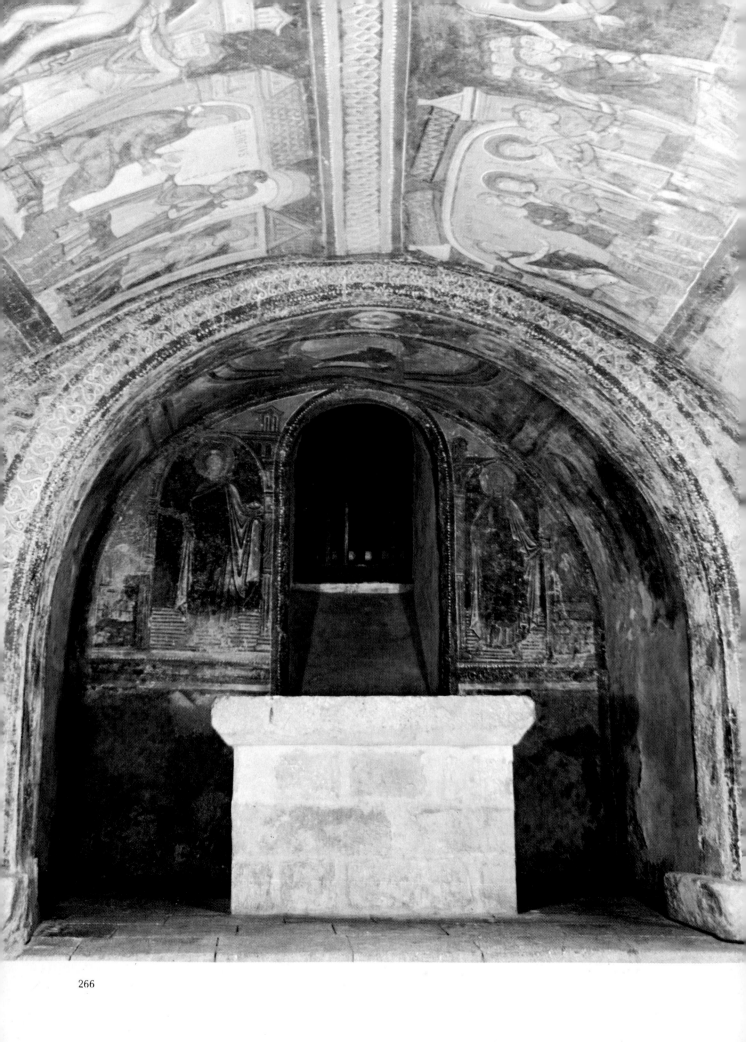

esque part, we find the finest testimony to the refined and cultivated Romanesque sculpture of the Ile-de-France in the Royal Portal, on the western façade, which was erected between 1145 and 1155. The powerfully sculpted figure of Christ in Majesty dominates the central tympanum within a mandorla surrounded by the symbols of the Evangelists. On either side of the three doors are hieratic figures of the saints, elongated out of their natural proportions into 'statue-columns'. The capitals, with relief scenes of great expressive power, form a continuous frieze beneath an indented cornice.

A region of France which stands by itself is Normandy, the territory where the invading Normans, descendants of the northern Vikings, had at that time established a realm which extended into newly conquered England. A noble and severe architecture may be seen at Bayeux in the ruined abbey of Jumièges, and at Caen in the two cathedrals of La Trinité and of St Etienne, the latter built in about 1070 by William the Conqueror. The vertical emphasis of this architecture, which recalled the tall, block-like elements of Romanesque architecture, such as solid towers, was to be the specific characteristic of the Normans, especially in England. It was a form of architecture that had many problems and discovered many solutions. The architects seem to have been willing to adopt the traditional elements, such as the multi-storeyed

façade confined within two high campanile towers, square at the base and polygonal at the top, which was a re-elaboration of the Rhino-Carolingian *Westwerk*. They were also quick to absorb other elements from French Romanesque, such as the choir with ambulatory, sometimes with radiating chapels, and the tall lantern tower over the crossing of the transept. They favoured a simple clarity in the stone walls, which derived from Italian Romanesque, introduced by great Italian abbots such as William of Volpiano, Lanfranc of Pavia and Anselm of Aosta. In some respects the architecture of these churches might be regarded as a forerunner of Gothic.

The end of the 11th century saw the foundation of the Cistercian Order which, from' its centre at Cîteaux, gave rise to the four affiliated centres of La Ferté, Pontigny, Clairvaux and Morimond. This order was interested in practising agriculture, and consequently built several monasteries in country districts. Under the leadership of St Bernard especially, it spread throughout France and elsewhere. The Cistercians assumed a position of reaction against what seemed to be excessive affectation. They preached absolute simplicity, functional utility, and modesty in religious buildings. The churches inspired by these principles radiated a profound desire for simplification and extreme clarity.

Though reflecting similar views and similar sentiments, Romanesque painting in the various

Fresco showing Noah's Ark in the nave of the early church at St Savin-sur-Gartempe

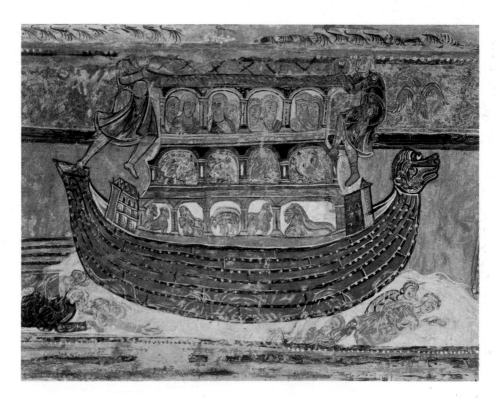

Painted scenes from the lives of St Savin and St Cyprian in the crypt of the abbey at St Savin-sur-Gartempe

countries of Europe performed a less essential function than that assumed by architecture and sculpture. The reason is that the two latter were more adapted to expressing, in their solid volumetric mass, the rough and powerful desire for form of the Romanesque style.

Thus Romanesque painting in France held a subordinate position and, unfortunately, has suffered grave losses in the past. Romanesque frescoes are found chiefly in the central region and appear, for the most part, in minor centres, which explains their expressive character and the simple, popular note which is their hallmark. The most significant examples are the narrative frescoes in St-Savin-sur-Gartempe (12th century), those in the crypt of St Nicolas at Tavant and finally those of Notre-Dame of Montmorillon, dating from as late as the 13th century and showing the influence of chivalry.

The frescoes of Benedictine inspiration in the chapel at Berzé-la-Ville are of less impact, but give some idea of what the lost pictorial decoration of the nearby abbey of Cluny must have been like. Miniature work was fairly prolific, absorbing varied experiences and developing many contacts, chiefly in the busy centres of Limoges, Paris and in Normandy.

France made a very large contribution to the minor arts. In goldwork, which reached a very high level, this period saw the beginning of enamel work at Limoges, with vivid colour effects, and employing the new technique (*champlevé*) of hollowing the metal and filling it

with colours. A typical product of Norman minor arts is the extremely long tapestry (*c.* 1080) preserved at Bayeux.

Romanesque Spain

In the Christian part of Spain a combination of factors enabled Romanesque art to put down firm roots. They included eager acceptance of the crusades for reconquest of the Moslem-held territories – a movement revived by the spirit of chivalry and encouraged by the intensely religious fervour which led the great masses of pilgrims – especially French pilgrims – to the shrine of Santiago de Compostela. Consequently a style developed which made it possible to overcome, in a widespread manner, both the compromises of the transition from Mozarabic style and the primitive and rough elements that remained in Spanish Pre-Romanesque.

Catalonia represented an early development which, in plain, severe forms, adopted ideas of Lombard derivation with a decisive approach to vault construction (as early as 1026 in St-Martin du Canigou) and to the use of the dome on the vaulted basilica structure, as in Ripoll Monastery, near Gerona (1040). Otherwise the inspiration came from France, in particular from Cluny, by way of the pilgrims. The major buildings are the cathedral of Jaca, S. Martín at Frómista, where the façade is framed by two angular towers, and S. Isidoro at León, with a barrel vault linked by transverse arches, and a narthex,

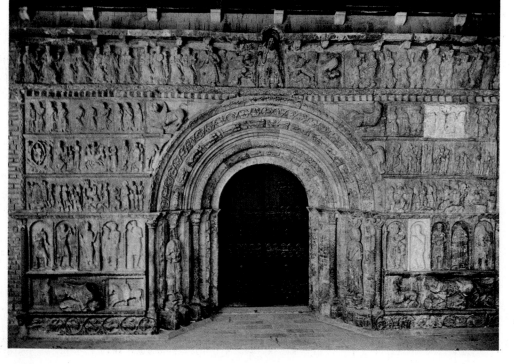

Doorway of the monastery church at Ripoll

The Hand of God, fresco from St Clement of Tahull (Museum of Catalan Art, Barcelona)

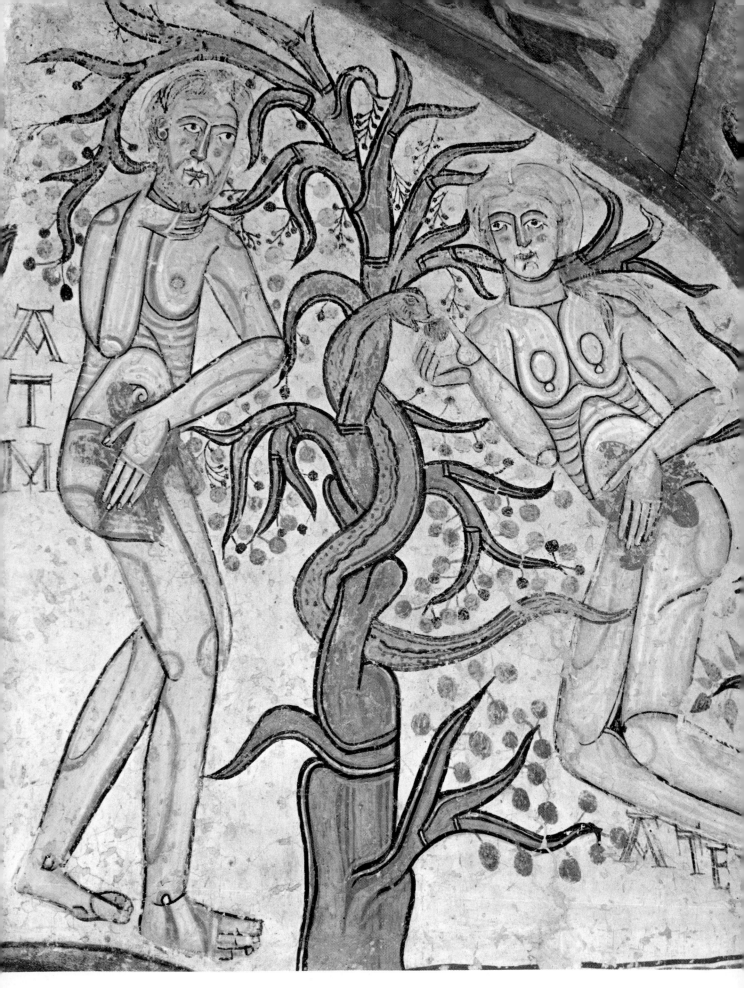

Cupola of the cathedral at Zamora

The Temptation of Adam, fresco from the Hermitage of
Maderuelo (Prado, Madrid)

271

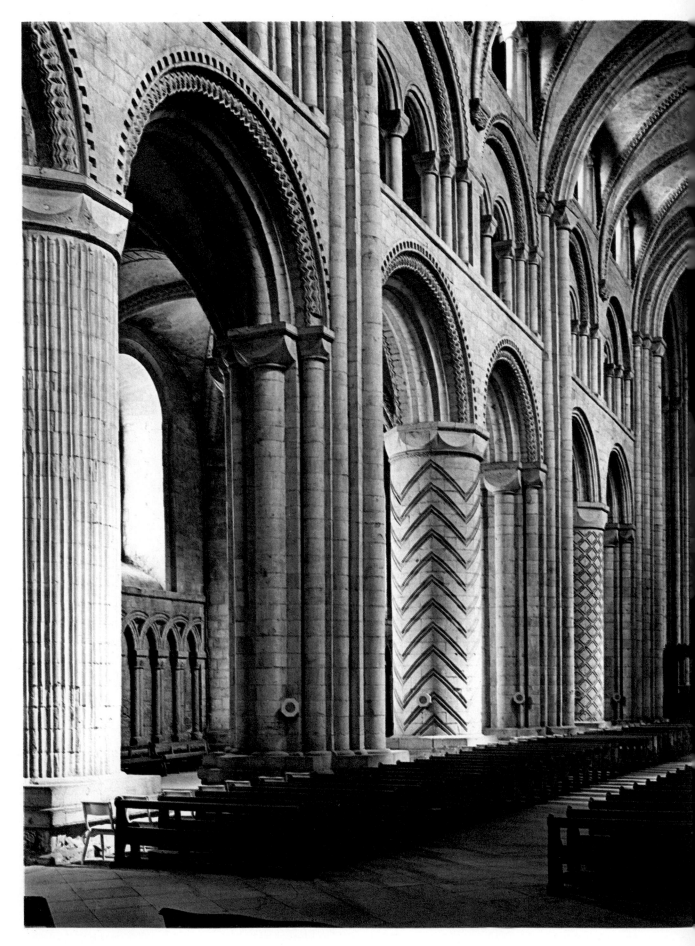

dating from 1063, which constitutes the *Panteon de los Reyes* or King's Pantheon. The most famous church, begun in 1078, at the tip of Galicia, is Santiago (St James) de Compostela which is a repetition of the type of French pilgrim church with gallery and barrel vaults linked by transverse arches. The raising of the arches on high pedestals, however, demonstrates that, even in this most frequented sanctuary, the builders were not insensible to Moslem influence. The high, crescent-shaped bastions of the walls of Ávila (12th century) are one of the most notable examples of contemporary civil architecture.

Romanesque sculpture in Spain was of high quality. The capitals of the *Panteon de los Reyes* date from the second half of the 11th century and have a simple, almost sharp dynamic cast. They recall, in a similar way to those of the sarcophagus and the capitals of Jaca, Italian Romanesque sculpture, especially of Modena, and represent the strong and cultivated contribution of Aragonese sculpture. The great *Puerta de las Platerias* (Silversmiths' Portal) of Santiago de Compostela, dating from about 1120, like the slightly later and humanistic *Pórtico de la Gloria* (Glory Portal), are connected with the better French sculpture, while the reliefs in the cloister of S. Domenico at Silos reveal their derivation from the doorway at Moissac. In Catalonia, the vast façade of Sta María at Ripoll, surrounding the powerful doorway, has justly been called the 'triumphal arch of Christianity'. Both French and Lombard influences are blended in the great vigour and beauty of its horizontal reliefs.

The originality and immediacy of its many painted decorations make Spain's contribution to this art form quite noteworthy. At León, in the *Panteon de los Reyes*, the vault is decorated with frescoes of vigorous rural themes on a light background and with evangelical scenes of a popular kind. The contribution of Castile in the chapels of Maderuelo and Berlanga is also impressive. The painting of Catalonia is, however, more characteristic. All the complex of elements – not excluding hints of Byzantine and Mozarabic art, which form the base of all Spanish Romanesque painting – is here let loose in a popular language with a vigorous and unhampered expressionism.

Romanesque England

English Romanesque (generally known as) Norman) was, at least in its major manifestations, the particular speciality of the Normans, who arrived in 1066. Norman bishops and abbots were confronted with an ambitious programme of building designed to glorify the new conquerors, and had to call upon workmen from Normandy. This explains the affinity that exists between Anglo-Norman architecture and the architecture of Normandy, although in the former the accent

Opposite page: *Durham cathedral, detail of the interior*

The Gloucester candlestick (Victoria and Albert Museum, London)

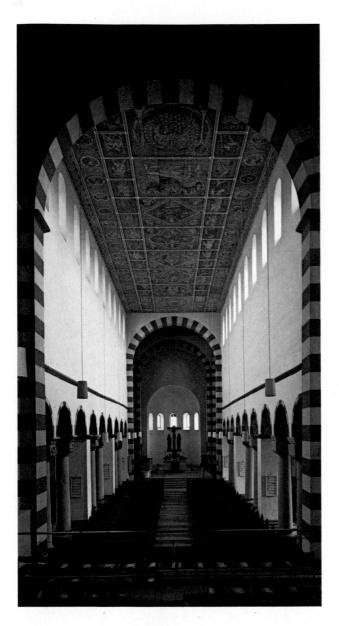

is on square geometrics (sometimes with the complete elimination of the apse development) and on the vertical thrust of the square towers. An example of this is the great cathedral at Canterbury, started in 1070 (here, since the work continued until 1500, the crypt is the most authentic Romanesque part). The cathedrals of Winchester, Norwich, Ely and Lincoln all date from the last quarter of the 11th century and indicate, by their exteriors, that building was carried on to a greater or lesser degree in the Gothic period. Internally, however, they reveal a rigorous system of construction, with bays intersected by piers and a central nave with a gallery and a clerestory, or third level, with windows. The most important building is Durham cathedral, started in 1093. There the early application of the cross vault gives the whole interior a dynamic impetus with the alternation of imposing piers and massive columns decorated with grooves or herring-bone motifs. There was a great proliferation of Cistercian churches and abbeys (the most significant example is Fountains abbey, in Yorkshire), where the accent tended to be on simplicity and austerity. Rochester castle in Kent, and Hedingham castle in Essex, date from the 12th century and their high, square shape bears witness to the development of civil architecture. In contrast to continental Europe, however, English sculpture was both scanty and poor.

England is also relatively poor in Romanesque wall-paintings. There is some Byzantine influence, with expressive local characteristics, in the frescoes in the crypt of Canterbury cathedral, while a certain naturalistic tone found its way into those in Winchester cathedral.

Thanks to the deep-rooted tradition of Anglo-

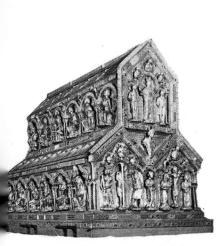

Reliquary casket of the Magi in Cologne cathedral

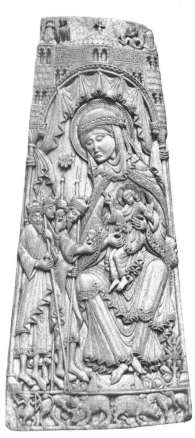

The Adoration of the Magi, carving on whale-bone (Victoria and Albert Museum, London)

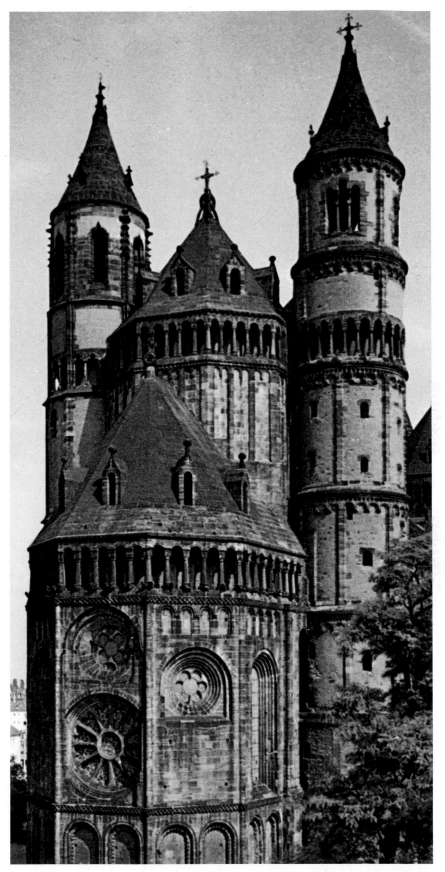

Apse of Worms cathedral

Irish miniature art, this art form continued at a high level – even in Norman times – and, in the 12th century, was centred on Winchester. The Winchester Bible and Psalter (British Museum) both represent the culminating point of liberal imagination, which showed an extremely expressive lack of inhibition. This form of artistic expression was unhampered and yet intricate, ready to make careful attempts to capture reality and yet throw off all restraint in imaginary themes. The many products of the minor arts were also notable, and one splendid example is the gilded bronze Gloucester candlestick.

Romanesque Germany

Germany played a primary role in Romanesque architecture. The incisive mass and grandeur of the cathedrals, the dominant, upward movement, and the determination to make these buildings great and lasting constructions in stone put them in a class above those of France. On the other hand, there was less eagerness for new ideas and

'Stavkirke' (wooden church) in Gudbrandsdal Valley, Norway

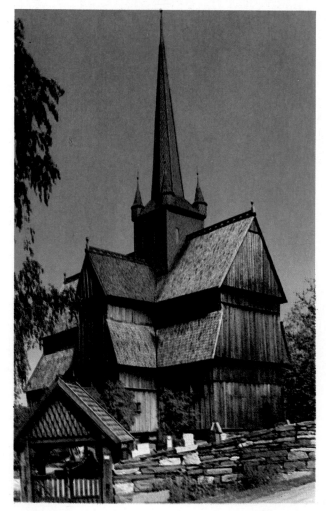

fewer innovations. In Germany there was no real continuity between Carolingian, Ottonian and Romanesque. The double apse, a modified derivative of *Westwerk* with a façade (or apses) between two towers or campaniles, and the clearly defined transepts, with a lantern tower over the intersection with the nave, are in fact present in all the German Romanesque buildings, such as the cathedrals of Mainz, Worms, and Bonn, and in the abbey church of St Maria Laach. Lombard inspiration was also essential to the development of German Romanesque, and workmen and master builders of the Maestri Comacini fraternity were often employed. This is proved by the predilection for rough-hewn stone, the spacious semicircular termination of apses and transepts, the pilasters supporting the arches and the round-headed blind galleries which crown the apses and spread out along the walls. The best example of this inter-penetration of ideas is Speyer cathedral, built on a basilica plan. It was begun in 1027 but was later reconstructed at the end of the 11th century by Henry IV as the pantheon for his dynasty. Perhaps as a consequence of Lombard influence, it was the first building where the cross-vault was used on a large scale (nearly 35 feet wide and 165 feet high). There is also a strong, clear-cut cross-vault in the cathedral of Mainz, which dates from the first quarter of the 12th century.

Cologne is a particularly important Romanesque centre. Near the entrancing church of St Maria im Kapitol there is an imposing complex of construction consisting of St Gereon (1191) with its semicircular Lombard-style apse framed by two high towers; St Pantaleon, which was already an important Benedictine monastery, with its powerful Ottonian *Westwerk*; the church of the Holy Apostles (1219), with a basilica interior of vigorous, rhythmic brilliance, and the turret-flanked lantern towers of the Gross St Martin, overlooking the Rhine.

It was because of such mingling of old and new structural ideas; because of the common currency of ideas that resolved so rationally, and with such daring vigour, the problem of the cross vault; because of the imposing dimensions which distinguished the cathedrals, high above the walled cities, that German Romanesque gave its characteristic vigorous and solid impression of strength and order.

It was, above all, this clear solidity of German Romanesque which favoured its diffusion over a wide area. The Romanesque monuments of Ratisbon, on the Danube, marked the direction of its development towards the countries of the east: Bohemia (Klandrau), Hungary (Pécs),

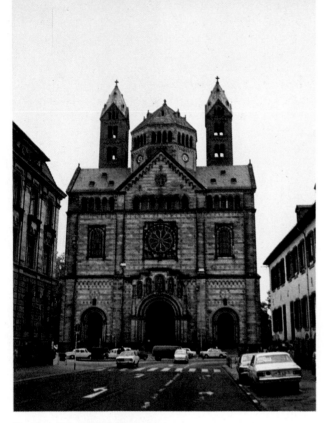

Façade of the cathedral at Speyer

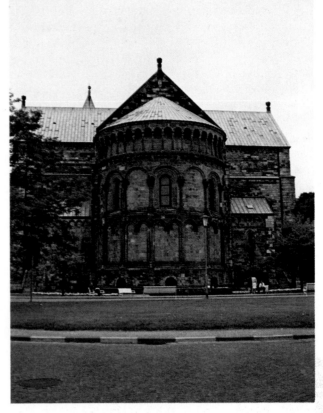

Exterior of the cathedral at Lund

Candlestick from Hildesheim (Louvre, Paris)

Poland and Transylvania. Switzerland, on the other hand, was exposed to the overlapping of Lombard influence (not only in the Comacini-type church at Giornico, but also in the beautiful church at Romainmôtier), of Franco-Clunaic influence (basilica of Payerne, or Peterlingen) and German influence (the Romanesque parts of the cathedrals of Zürich and Basle). Northern Europe was, above all, influenced by German Romanesque. This may be seen in the cathedrals of Ribe and Viborg in Denmark, Bergen in Norway and, particularly, Lund in Sweden. The cathedral of Tournai, in the Low Countries, is an isolated case, for it combined both German and French influences, but it was of late construction (end of the 12th century) and has a vertical movement that foreshadows Gothic.

German Romanesque sculpture, on the other hand, is relatively poor. One example is the

doorway of St James at Ratisbon, which is singularly evocative of S. Michele in Pavia. At Gernrode, the stucco figurines in the chapel of the Holy Sepulchre are of Ottonian derivation, while the statue of Bishop Metron shows strong popular expressionism.

The marble enclosure of the choir of Bamberg (1225) with its sinuous, matching statues of prophets, is worth noting for its originality and expressive vigour. Ornamental sculpture was subordinate to architecture, less original and susceptible to foreign influence, especially Italian. The great fame of German bronzesmiths may have been due to Ottonian tradition, and in 1152 orders came from distant Santa Sophia in Novgorod for two bronze doors to be made at a workshop in Magdeburg. In these magnificent doors, German vigour is allied to echoes of the doors of S. Zeno in Verona, and to reminiscences of the French sculpture of Aquitaine, with a cumulative effect of intimate frankness. Another example of bronze-work, which shows great vigour in its moulding, is the rich baptismal font in the cathedral of Hildesheim, dating from about 1250. Wood-carving was abundant but inconsistent, very often animated by an expressionism in which popular and artistic traditions were blended.

German Romanesque painting has, to a large extent, been lost. However, for the most part it was of no great consequence. The most outstanding works in this field consist of a chapel in Ratisbon cathedral and the frescoes of biblical scenes in the church at Schwarzrheindorf, near Bonn. At Zillis, in Switzerland, there is an entire ceiling which is subdivided into 150 panels in a free and popular style. The production of miniatures amply made up for the modesty of pictorial output, and works of high quality proliferated in the various miniaturist schools of Swabia, Bavaria, Salzburg, Bohemia and Saxony, where a deeply rooted tradition developed through new contacts.

Romanesque Italy

The contribution made by Italy to the development of Romanesque art was extremely important and had many regional variants. The architecture of this period was especially linked to the rebirth of the cities and to the liberal communities, whose gradual formation as a bulwark against feudalism was based on the struggle between Church and Empire. The popular and communal nature of Italian Romanesque art is therefore all the more marked.

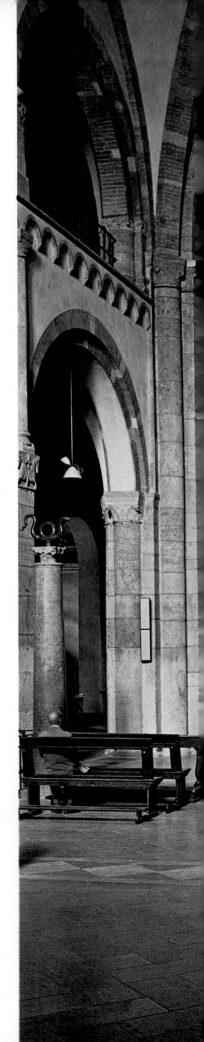

Ground-plan and interior of Sant' Ambrogio, Milan

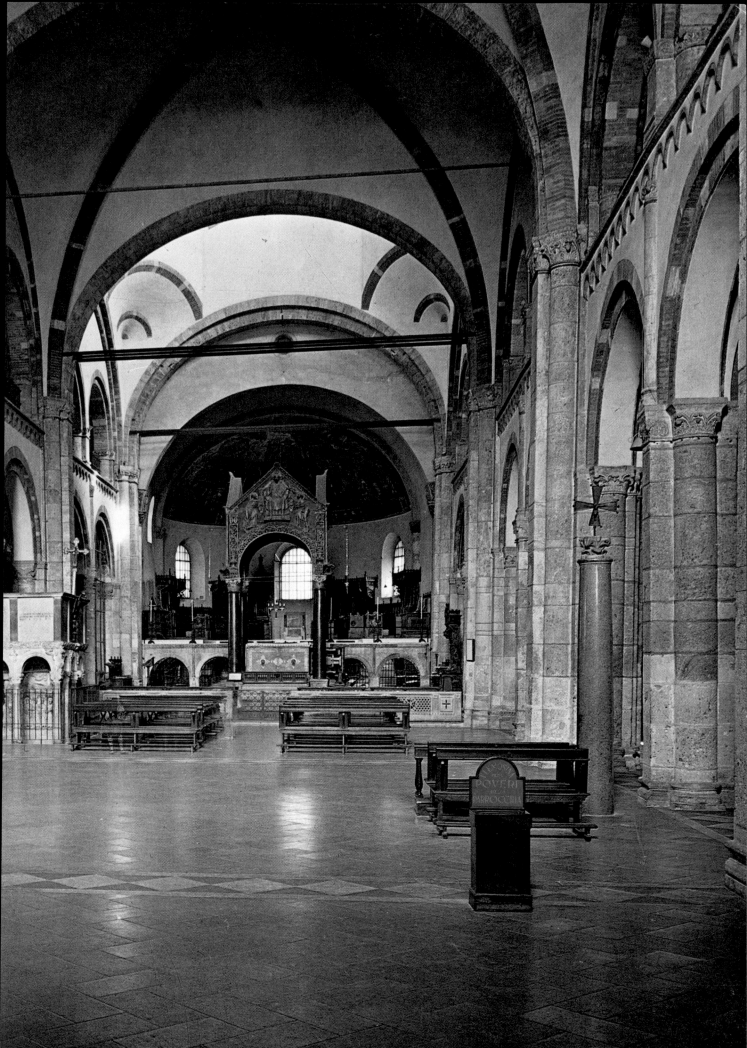

Lombardy

Because of its specialised craftsmanship, Lombardy, as it was by then called, was in a position to export to the rest of Europe, from Germany to Catalonia, the earliest examples of clearly defined Romanesque constructional and stylistic values, especially in wall construction. The continuity between Pre-Romanesque and Romanesque buildings is evident at Milan, in S. Vincenzo in Prato and, outside the city, in the basilicas of S. Pietro at Agliate and of Sta Maria Maggiore at Lomello.

The basilica of Sant' Ambrogio (whose apsidal parts and cross-vaulted presbytery had been built earlier) is a typical example of Lombard Romanesque in its structure, essential character, weight and enclosed spaces. It is approached by a large, cross-vaulted cloistered atrium. The triple-arched portico has a richly carved doorway, and in the upper storey, under a wide gable, another triple arch allows the light to shine obliquely through into the church. The interior, which dates from the end of the 11th century, has a nave and two aisles. Supported on solid pillars, the three bays of the nave have cross vaults and ribs whose values of structural integration and continuity are peculiar to Lombard Romanesque. Each bay of the nave has two corresponding ones in the aisles, surmounted by the gallery. Each of the round-headed arches of each bay in the nave contains the double arch of the aisle and of the gallery above, with its more slender pillars. Towards the end of the 12th century the fourth bay was roofed in with an octagonal lantern over embrasures, and on the outside the lower part is decorated with blind arcading. The carvings on the doors and capitals are closely linked to the architecture of the building. The pulpit, however, is a powerful, independent work, dating from the first half of the 12th century, with angular, caryatid-like sculptures and hunting motifs.

A similar development is found at S. Michele at Pavia, but with a more vertical movement and with the addition of a transept. The façade is gabled, divided from top to bottom by two tall clusters of pilasters and crowned by a stepped blind arcade which gives relief to the compact mass. The horizontal bands of sculpture across the façade also help to relieve its austerity.

The architecture of Como is linked to a long-standing tradition of compact and clear-cut walls, as in Sant' Abbondio and S. Fedele, where the longitudinal body with its three aisles is grafted onto the central structural plan of a trefoil, or triapsidal, choir surmounted by a high lantern.

Any survey of the sculpture of Como should

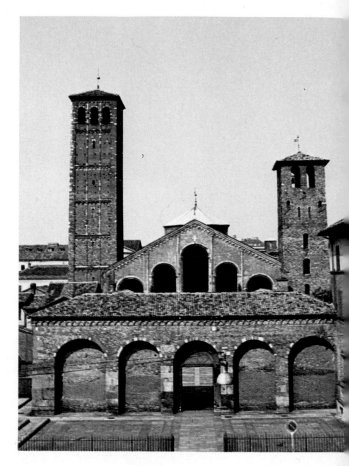

Exterior of Sant' Ambrogio, Milan

Opposite page, above: *The cloistered atrium of Sant' Ambrogio, Milan*

Opposite page, below left: *Decorative motifs in the cloistered atrium of Sant' Ambrogio, Milan.* Below right: *Carvings from the vestibule of Sant' Ambrogio, Milan*

include the powerful, black marble ambo (a kind of pulpit) in the church of S. Giulio on the little island in Lake Orta. This work dates from the first decades of the 12th century and is decorated with monstrous animals with bared teeth, the symbols of the Evangelists, and with the realistic figure of an abbot, perhaps William of Volpiano, the founder of the abbey.

Lombard influence was also felt in the surrounding regions: in the apse of Sta Maria Maggiore at Bergamo with its blind loggias; in the central plan and cubic capitals of the baptistry of S. Pietro at Asti and in the baptistries of Brescia and Mantua; in Sta Maria del Prato and Sta Maria di Castello at Genoa; in the great airy mass of the monastery of Sagra di S. Michele at Sant' Ambrogio, high on a mountain-top in Val di Susa; and in the cathedral of Trent which was begun in 1212 by

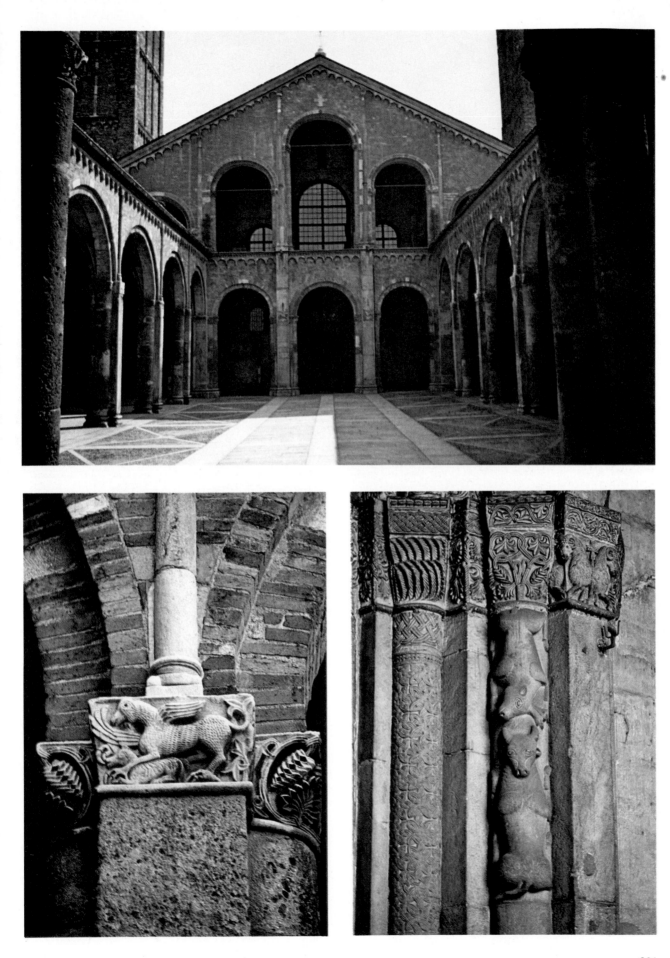

Doorway in S. Zeno, Verona

Adamo di Arogno and altered later in the Gothic period.

Verona is rich in architecture and may be regarded as a centre in its own right. The beautiful basilica of S. Zeno, built between 1120 and 1130, with its buttressed stone façade broken up by pilasters and dominated by the magnifi-

cent campanile, brings together extreme Lombardic influences, the direct inspiration of the cathedral at Modena; it also shows a preference for chromatic effects, rather than volumetric mass, reflecting the imprint of Venice. S. Zeno is also of great importance in the field of sculpture. Under the beautiful portico near the magnificent bronze doors ëwithout doubt the most important example of Ottonian art in Italy) Nicolò, in association with Maestro Guglielmo, left his last work (*c.* 1138) in some magnificent marble reliefs.

Venice

Romanesque art of Venice and the surrounding district is steeped in a sense of colour, and of colour effects, and in Byzantine traditions. The centralised structure of S. Fosca at Torcello has definite Byzantine overtones; the cathedral of Torcello, like S. Donato at Murano, is allied to Early Christian architecture and that of Ravenna. Above all else, in terms of splendour, stands St Mark's in Venice, which was reconstructed in the second half of the 11th century on the site of the Palatine chapel. Inspired by the church of the Holy Apostles in Constantinople, St Mark's basilica repeats the Byzantine Greek cross plan surmounted by five hemispherical cupolas, with the addition of a narthex at the front and on one side. Considerations of colour effects rather than effects of mass are evident on the façade, if one ignores the florid Gothic additions. The same

Relief from the bronze door of S. Zeno, Verona

Opposite: *Interior of S. Zeno, Verona*

Lion bearing a pillar, from the vestibule of Cremona cathedral, Italy

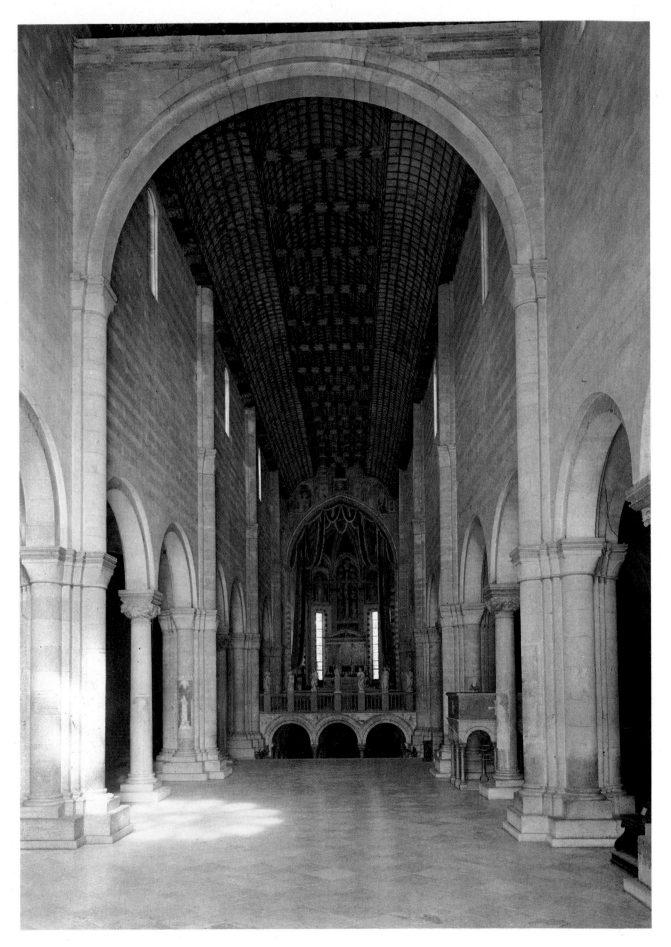

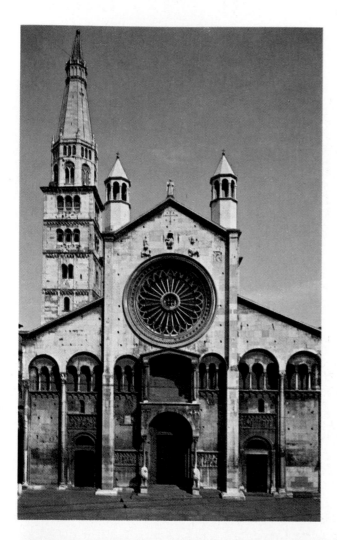

is true of the interior, where structural forms and mosaic decorations blend to create – in some ways, in opposition to typical Romanesque values – a buoyant, vibrant and luminous sense of space. St Mark's is also important from the sculptural point of view, both for the many Byzantine works and the influence of Benedetto Antelami, especially in the doors.

The Romanesque architecture of Emilia, though related, has a stylistic independence. Its most important monument is the cathedral of Modena, started by the architect Lanfranc in 1099 and built of stone rather than of brick, following Paduan custom. The façade has projections which repeat, on the outside, the division of the naves, and is broken up by buttressed piers supporting the portico surmounted by an open-sided gallery. The façade is relieved by arcading with a succession of triple arches, and a similar compact decoration runs the length of the sides and the apse. The cathedral is flanked by the Ghirlandina, a tall, beautiful bell-tower. The interior is roofed with successive pointed Gothic arches and is strikingly vertical and limpid. The strength of the arches corresponds to the neatness of the mullion windows of the gallery, while the

Façade of the cathedral at Modena

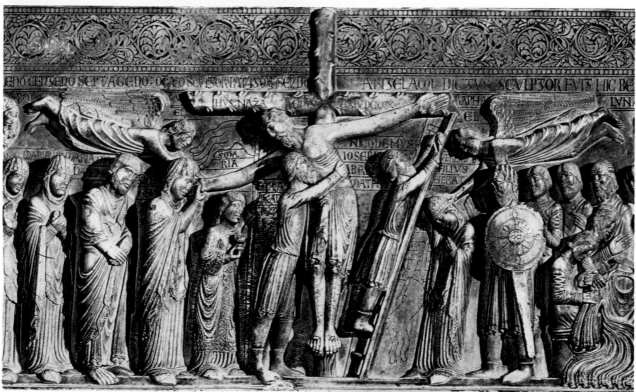

presbytery is on a higher level, over the roomy crypt. The cathedral of Modena was to have profound repercussions upon the whole of Emilian architecture. It was the direct inspiration for the abbey of Nonantola and for Cremona cathedral. It is re-echoed, with Gothic alterations, in the cathedral of Piacenza, though there the gabled roof with blind gallery was adopted, following Lombard principles. Similarly, its influence can be seen in Parma cathedral, though the original part of this building is to be found in the square apsidal parts.

Modena cathedral also shows the high quality of the Emilian school of sculpture, founded by Wiligelmo, whose solemn, compact statues of the prophets in the niches on the jambs, and whose four magnificent reliefs of the Genesis story on the façade, date from between 1100 and 1110. Wiligelmo's contacts with the great French sculpture of Aquitaine – particularly that of Toulouse and Moissac – is clear. But there is also evidence of the influence which survivals from ancient times must have exerted upon him, and which produced a coherent and powerful style, with a terse, narrative sense based on the expressiveness of the solid figures which are

Right: **'September',** *13th-century relief (Museo dell'Opera del Duomo, Ferrara)*

Opposite page, below, and here above: *Benedetto Antelami, 'Deposition from the Cross' and detail (Parma cathedral)*

carefully defined. It was a pupil of Wiligelmo whose lively story of the legend of S. Geminianus appears on the last south portal near the choir; yet another of his pupils, more influenced by Aquitaine models, sculpted the four great prophets in the doorway of Cremona cathedral. The influence of the Burgundian school, with its more elongated and freer figures, which had already been seen in the abbey of Nonantola, is also evident in the reliefs on the south side of Modena cathedral, as well as the reliefs on the Fishmarket Door. Here the so-called 'Maestro di Artu' combines a free-flowing story of the legends of chivalry with niched figures symbolising the months of the year.

The art of 'Nicolao scultore' derives from the sculpture of Oltrape and Wiligelmo but has a more flowing and discursive manner. It is this Nicolò who worked for a time at the Sagra di S. Michele, and whom we find again in about 1123 at Piacenza, engaged in the decoration of the right-hand door and instigating the creation of a Piacenza school. His best work is to be seen in the portrayals of the Guilds on the columns

Cathedral and campanile, Pisa

of the cathedral. Later he went to Ferrara, where he executed the relief of St George on horseback and the figures of the prophets on the jambs of the main doorway, and finally to Verona.

Provençal influence occurred again in the greater, more mature master of the second half of the 12th century, Benedetto Antelami. It is revealed in the relief of the Deposition (1178) in Parma cathedral, and in the later vigorous statues of David and Ezekiel in Fidenza cathedral. The

Opposite page, below: *Façade of St Martin's cathedral, Lucca*

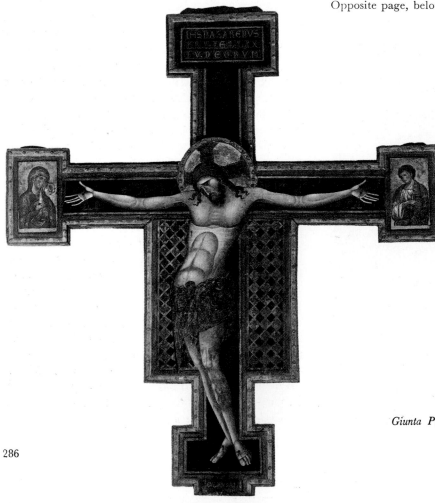

Giunta Pisano, Crucifixion (S. Domenico, Bologna)

286

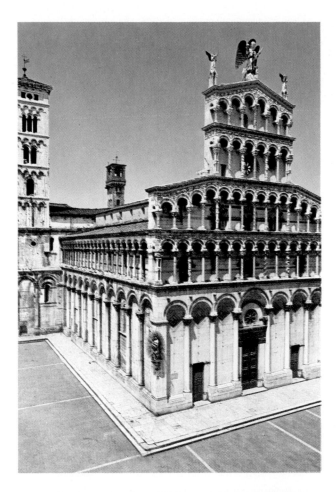

Detail of the bronze door by Bonanno, Pisa cathedral

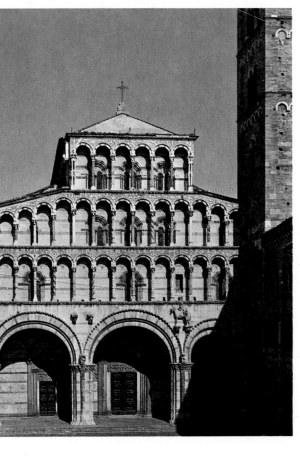

Left: *St Michael's church, Lucca*

most engaging work by Antelami, which dates from 1196, is the sculptural decoration of the octagonal baptistry at Parma, with its tiered galleries and internal cupola. Beside the lunettes of the door – with its fine, free narrative scenes, like the Adoration of the Magi – stand the firm, powerful and rounded figures of the Months and Seasons, the prophets and arch-angels, and Solomon and the Queen of Sheba. The narrative lunettes of the doors of Sant' Andrea of Vercelli are somewhat later, perhaps dating from 1225. The Antelami style, with its balance and clarity, its adherence to the sculptural mass and its search for naturalism, spread over a wide area. More or less direct echoes of it can be found in the sculptural works of the 13th century: in the portrayal of the Months which formerly embellished a doorway in Ferrara cathedral (now in the Opera del Duomo); in the more narrative and popular style of the Months in the archivolt of the parish church at Arezzo; in the triple arch of the main doorway in St Mark's in Venice (*c.* 1260); in the equestrian statue of Oltrado da Tresseno, on the Broletto at Milan, and in the admirable equestrian group of St Martin and the Beggar on the façade of the cathedral at Lucca.

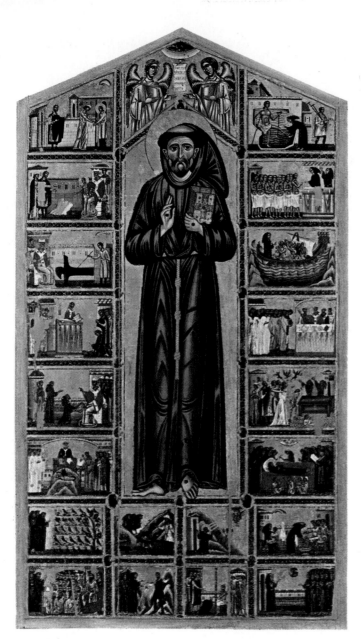

two-coloured inlays whose geometric rhythms, even when in the Byzantine tradition, show an intellectual desire for abstraction and spatial severity in the surface planes.

The immense cathedral at Pisa, undertaken by the architect Boschetto or Buschetus in 1063, is a crystalline pile, sharply chiselled along the extent of the transept, with the flat severity of its line given rhythm by the vibrant whiteness of the Carrara marble. At the base of the façade with its many projections, Rainaldus took up the rhythm of blind arcades. These also run along the sides and, above, they adopted the Lombard style of blind galleries, on four levels, playing on the chromatic contrast between the luminous, isolated columns and the background shadow. The interior is Early Christian in inspiration, but carried to a new degree of power. The nave has five aisles with double galleries, zebra work in the upper part, and an oval dome over the spacious intersection with the transept. The Pisa complex was to have repercussions not only in Pisa itself (S. Paolo at Ripa d'Arno) and at Lucca (façade of S. Martino) but also in the Romanesque buildings of Sardinia. The complex is completed by the campanile (the Leaning Tower), begun in 1173 by Bonanno, who cleverly adopted the motif of the tiered open loggias, and by the Romanesque part of the baptistry by Diotisalvi (begun in 1153), where the blind arcade of the base is surmounted by a loggia.

Tuscan Romanesque sculpture is worthy of consideration, especially that centred on Pisa, where it was not connected with the Paduan school. In 1159, Guglielmo created for Pisa cathedral a pulpit with strong reminiscences of Provençal sculpture. This pulpit was later moved

Tuscany

In Tuscany, Romanesque architecture had certain particular characteristics, with special forms in Florence and Pisa. The great Romanesque buildings at Lucca, Pistoia and Arezzo, on the other hand, were nearer to those already discussed. The interplay of thrust and weight was fined down into a space-balance equation which avoids any indication of the forces involved. An austere, original style evolved, recalling Early Christian forms and revealing, in its composure and harmonious proportions, an innate reserve of classicism. The typical feature was the shifting of focus to the marble decoration of the exterior, with

Above: *Bonaventura Berlinghieri, St Francis and scenes from his life (Bardi chapel, Sta Croce, Florence)*

Bonaventura Berlinghieri, detail from the Sermon to the Birds (Bardi chapel, Sta Croce, Florence)

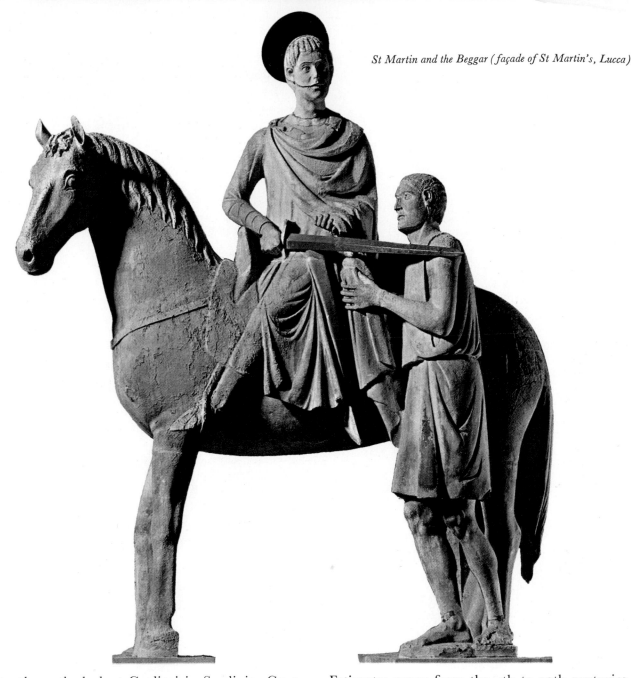

to the cathedral at Cagliari in Sardinia. Grua-monte and Biduino, who followed after him, left the best of their work in the architraves of Sant' Andrea at Pistoia and S. Salvatore at Lucca, respectively. But the most outstanding of them all was Bonanno Pisano who, in 1180, was responsible for the bronze west doors for Pisa cathedral, which were destroyed in the fire of 1595, and for the S. Ranieri door in the south transept, which has survived. The synthesis of style and fluent narrative scenes in the panels reveal their inspiration from Byzantine ivory work and are highly poetic.

In its present form the baptistry at Florence was consecrated in 1059, though remains of much earlier structures were incorporated, and ancient traditions were followed so closely that it is extremely difficult to date any part with accuracy.

Estimates range from the 4th to 12th centuries, except for the attica and vault, which are clearly the work of the 12th century. The building is octagonal, with three blind arches on the second storey of each façade, classical fenestration below and an architrave, divided into squares, above. Structure and decoration are, however, closely fused. Similar rhythms and similar conceptions occur in the façades of S. Miniato and the Badia at Fiesole. The basilica form is repeated in the interiors of S. Miniato and SS. Apostoli, with simple round-headed arches marking the bays of the naves. Here, too, there is close association between the structural elements and the decoration, and there are a number of sculptural pieces, like the magnificent pulpit in S. Miniato, as well as the parti-coloured pavement in the baptistry, and the great mosaic cycle in the vault.

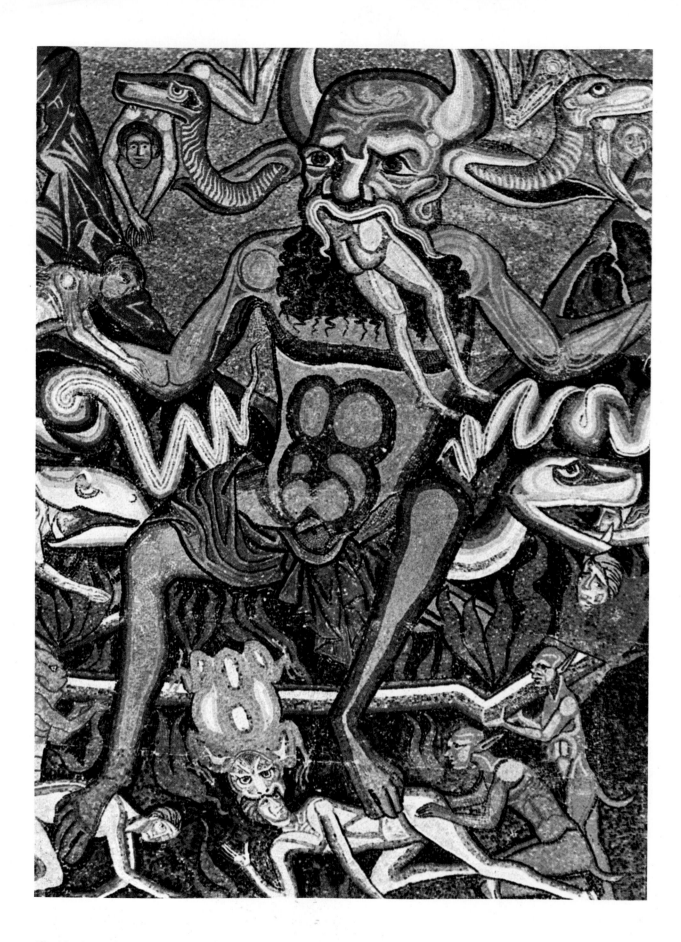

The Mouth of Hell, detail from the mosaic in the dome of the baptistry, Florence

In Venetian paintings of the Romanesque period, as in Sicilian painting at Cefalu, Palermo and Monreale, Byzantine influences were still very much in evidence, but in Tuscany there was a desire for a strong and independent Romanesque idiom to replace them. A new dramatic feeling was expressed in the painted crosses with figures of the saints, and scenes of the Passion on the wing panels flanking the Crucifix. The Cross in the cathedral at Sarzana dates from 1138; the one by Bonaventura Berlinghieri at Lucca, from about 1228; the great panel showing St Francis and scenes from his life in S. Francesco of pescia dates from 1235 and is also by the Luccan. The crucifixes by Giunta Pisano, dating from the first half of the 13th century, show a particularly dramatic expressionism, especially the one in Sta Maria degli Angeli at Assisi. The static Madonna in Majesty by Guido da Siena, in the Palazzo Pubblico at Siena, dates from 1221. The most important work to reveal the new approach, however, is the mosaic cycle in the vault of the baptistry in Florence. Alongside the Venetian and Roman mosaic workers stand the Florentines, and in particular the late 13th century Coppo di Marcovaldo, to whom is attributed the terrifying representation of Hell in the baptistry at Florence, and whose Crucifix in the Palazzo Comunale of San Gimignano has a dramatic power which foreshadows Cimabue.

Further to the south, the great cycle of frescoes in Sant' Angelo in Formis, commissioned

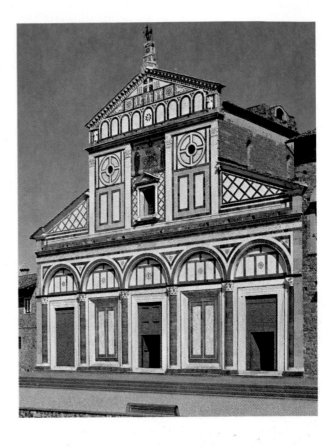

by Abbot Desiderio of Montecassino in the second half of the 11th century, is really Byzantine. In Rome, however, in the frescoes of the lower church of S. Clemente, and around Rome, in the church at Castel Sant' Elia near Nepi and in the

Above: *façade of S. Miniato, Florence*
Ground-plan and exterior of baptistry, Florence

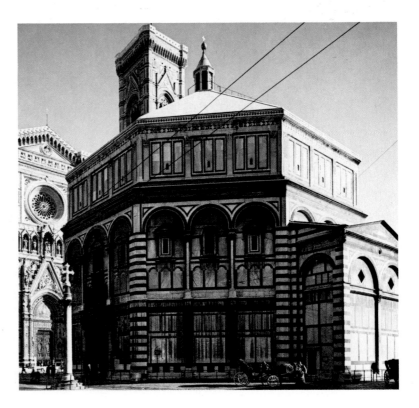

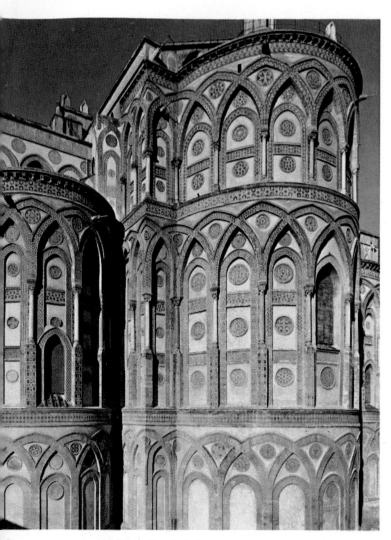

Apse of Monreale cathedral

crypt of the cathedral of Anagni (1225), there was evidence of powerful expressionistic tension. This opened the way for the Roman masters of the late 13th century: Jacopo Torriti, with the apsidal mosaic in Sta Maria Maggiore, and Filippo Rusuti, with the decoration of the façade.

It is pointless to seek for uniformity among Romanesque monuments south of Tuscany. The powerful cathedral of Assisi, the work of Giovanni da Gubbio dating from 1140, is largely still in Early Christian style but has Lombard overtones in the façade. The abbey of Sant' Antimo, begun in 1118, recalls foreign influence; it harks back even more than does Modena to French prototypes. At Civita Castellana, there is a classical air about the horizontal emphasis of the architrave on the portico, which dates from 1210. This work foreshadowed the success which the decorations of Cosmati marble cutters were to have and which is so clearly seen in Roman churches, especially in Sta Maria in Aracoeli. It is to this restrained inlay decoration that the fame of the fascinating cloisters of S. Giovanni on the Lateran and in S. Paolo, by the Vassalletti, is due.

Rome is full of characteristic Romanesque campaniles, like that of SS. Giovanni e Paolo, but two buildings dating from the beginning of the 12th century bear witness to the way in which Romanesque art there was intrinsically linked to the revival of Early Christian forms. These are Sta Maria in Trastevere, with the beautiful

Façade of the basilica of S. Nicola, Bari

Detail of the bronze door of Troia cathedral, Italy

apsidal mosaics of Christ and the Virgin Enthroned; and S. Clemente, with the brilliant mosaic of clusters of flowers on a gold ground.

More disparate external influences are noticeable in the Campagna. The original part of the cathedral of Caserta has horseshoe-shaped windows and overlapping arch decorations of Arab type. There is another singular example of Moorish style in the closely intertwined pointed arches of the cloister at Amalfi. Italian Romanesque elements and French-Gothic features combine in the double-capped pointed arches in the Benedictine abbey of S. Clemente at Casauria, from the second half of the 12th century. Sculpture was of a high order, with Byzantine influences in the ivory altar-frontals and classical inspiration in the ambo (pulpit) in the cathedral of Salerno. The bronze doors of the period include those of the cathedrals of Benevento and Ravello, the latter by Barisano of Trani (1179).

There is, on the other hand, manifest unity in the Romanesque art of Puglia. Here, however,

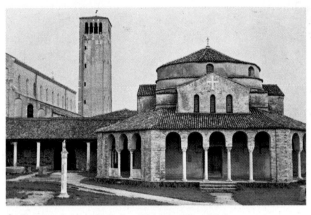

S. Fosca and the cathedral at Torcello, Venetia

it is Lombard Romanesque with local variations, and a few faint echoes of French work, which characterises the great cathedrals like S. Nicola at Bari, compac and turreted like a fortress; the more Lombardesque cathedral at Bitonto, the less refined cathedral at Ruvo, and the airy cathedral at Trani with its lofty apses. The remote

Doorway of cathedral at Ruvo di Puglia, Italy

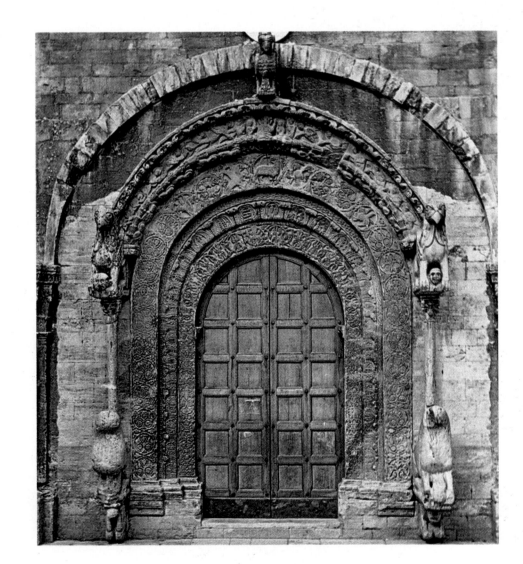

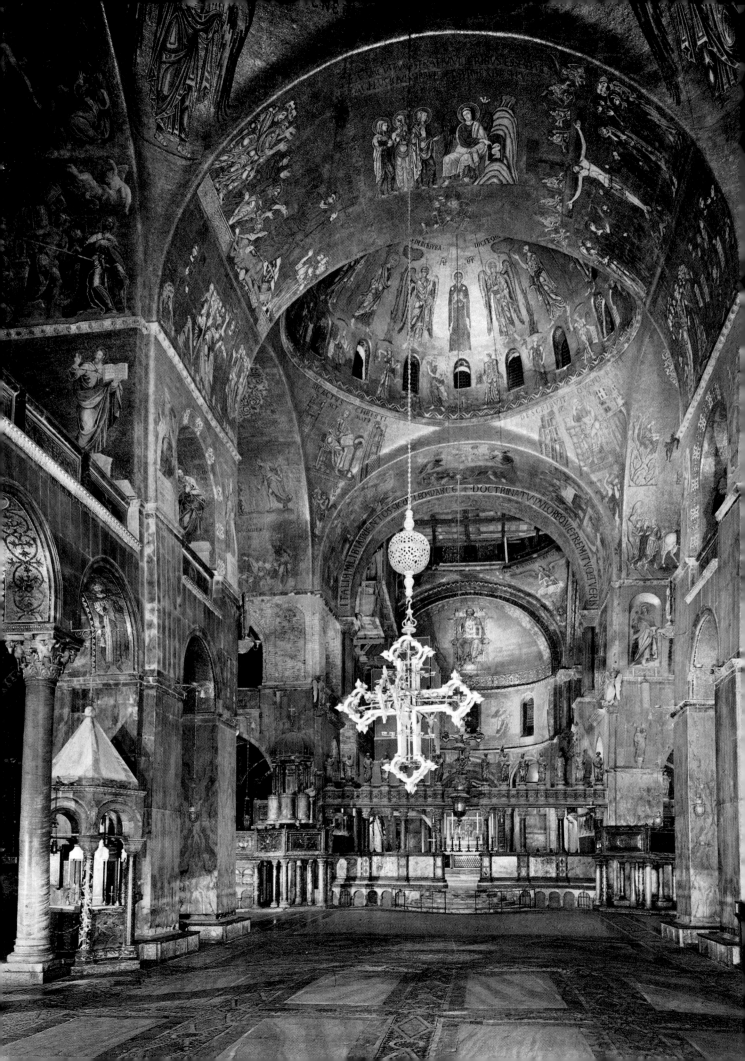

cathedral of Troia is no less important for its structural values. In Puglia, sculpture reflects the very essence of the Romanesque style. This is also seen in independent works, such as the vigorous sculpture of the episcopal chair at Bari (*c.* 1100); the door jambs of the cathedral of Trani and Barisano's bronze door there; and the more clearly cast bronze door, dating from 1119 in the cathedral of Troia, the work of Oderisi da Benevento.

Last, but certainly not least among the centres of Italian Romanesque art, comes Sicily. The arrival of the Normans, in the second half of the 12th century, gave rise to that Normano-Moorish architecture which was so singularly successful in combining the love of tall, taut, square masses, brought by the new rulers from Normandy and England (and found, in its pure state, in the cathedral at Cefalù), with the enchanting Arabic decoration of intersecting arches. This combination is demonstrated in the apsidal part of Palermo cathedral which, unfortunately, has subsequently been altered, and more especially in the cathedral at Monreale. Norman eclecticism absorbed Arab, Byzantine and Venetian influences in its splendid painting decorations, and this is evident in that precious gem, the Palatine chapel at Palermo, and in the great mosaic cycles of Cefalu and Monreale. The contributions made here by the Campagnan school and French sculpture should not be underestimated. The most characteristic works are the capitals at Cefalu; the complex of capitals in the magnificent cloister of Monreale, the telamons (male figures supporting a pillar) of the tomb of Roger II in Palermo cathedral and, above all, the remarkable marble candelabrum for the Paschal candle in the Palatine chapel – though this has classical overtones, reminiscent of the art of the Campagna.

Architecture derived from the Cistercian reforms also reached Italy, though relatively late. In particular this meant a simplification of the plan, abandoning apsidal development and introducing typical Burgundian elements. In the north, we owe to this Cistercian element the Milanese abbey of Chiaravalle, begun in 1172, with its high lantern tower which recalls St Sernin at Toulouse. In central Italy, the abbeys of Fossanova and Casamari which recall their French inspiration at Fontenay, have ogival arches and anticipate Gothic structures.

Considered as a whole, and leaving aside any of its isolated and secondary manifestations, Italian Romanesque pictorial art lacks uniformity. In northern Italy, it was drawn towards the imposing cycle of mosaics of Byzantine derivation which influenced both architecture and sculpture, and which give an incomparable brilliance to St Mark's in Venice. The point of arrival in St Mark's, where Venetian takes over from Byzantine, is in the narthex – in the mosaic on the first dome representing the Creation (*c.* 1230). A rigid Byzantinism coupled with tendencies that are already Venetian are found in the expressionism of the great mosaic depicting the Last Judgment in Torcello cathedral. In the frescoes of the crypt of the cathedral at Aquileia, dating from about 1200, on the contrary, the Deutero-Byzantine styles already seen in the Balkans are echoed with strong expressive tension.

Interior of the basilica of St Mark, Venice

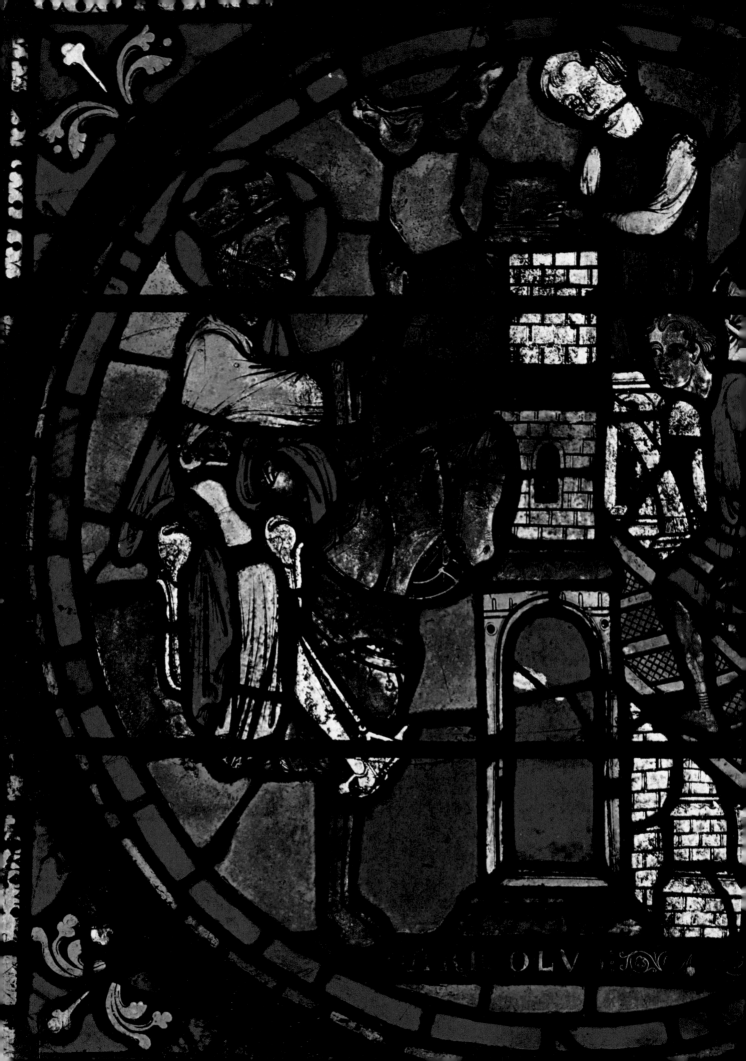

GOTHIC EUROPE

Romanesque art and architecture dawned in Europe as the renewal of culture after a period of artistic darkness. It had a popular stamp, was monastic in origin, and resolved its architectural problems with the static balance of mass and the mystic intimacy of spaces. Gothic architecture, on the other hand, was dynamic in all its manifestations and reflected a desire for freedom and complete, powerful unanimity. In this respect it was in perfect unison with history, with the social turmoil of the times and with the new developing cultures.

Towards the middle of the 12th century, when

Charlemagne gives order for the building of St James'. Early 13th-century, stained glass (Chartres cathedral)

Jean Fouquet, 'The Building of the Temple', MS Fr. 247 (Bibliothèque Nationale, Paris)

297

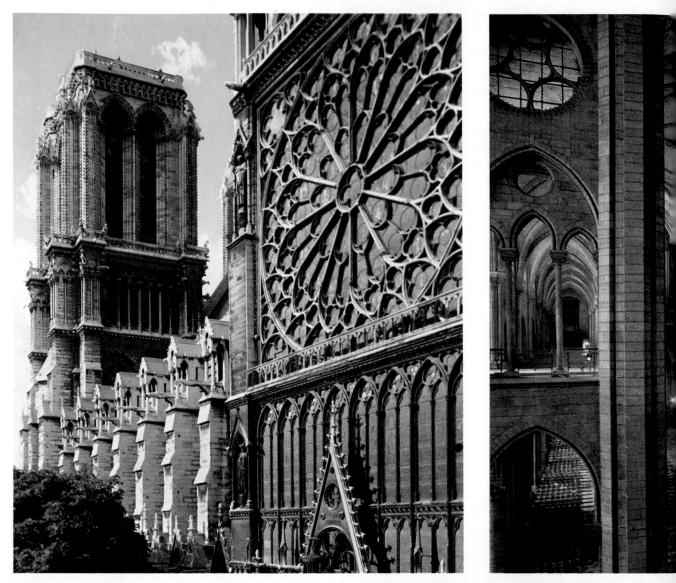

Exterior, interior and rose-window, Notre-Dame, Paris

the foundations of the first Gothic cathedrals were being laid, the situation in Europe was profoundly changed. The Middle Ages, with all the roughness, uncouthness and violence which they entailed, were coming to an end. New forces were in action, influencing a wide area and pervading and altering the social framework. Europe was dominated by crises in the two major medieval institutions, the Church and the Empire, which were both exhausted from their long struggle for leadership. In Italy the cities participated in the struggle, asserting their desire for organisation at urban level, which led to municipal independence. The stagnant state of both the economy and society typical of the feudal world was replaced by the revival of exchange and trade, to which the sea-faring republics of the Mediterranean and the Baltic

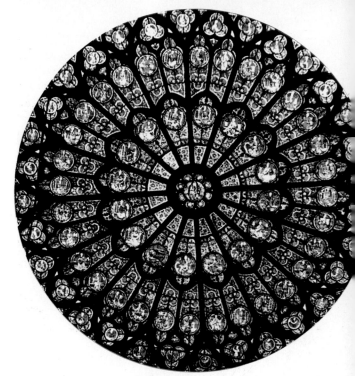

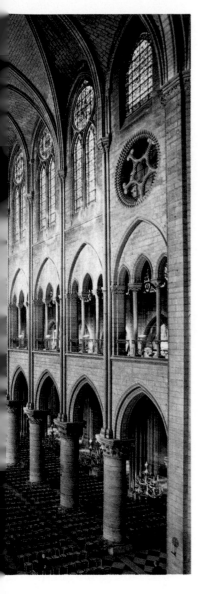

Plan of Notre-Dame, Paris

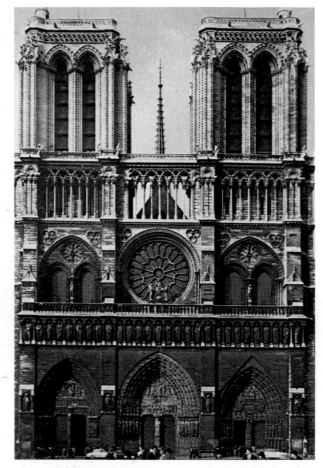

Façade of Notre-Dame, Paris

Apse of Notre-Dame, Paris

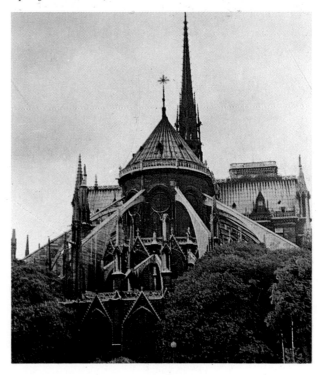

made important contributions. Based on the principle of free labour and free trade, and organised into powerful craft guilds, the cities became the centre of activity, as well as of the economy. 'The city makes free men' – so runs a medieval saying. It was to the cities that men came, not only to work but to free themselves from the complex of subjection, restraint and hard labour that prevailed under the feudal system. A new social class, the *bourgeoisie*, or middle class, came to power, rapidly growing in wealth as a result of trade and exchange. Behind them was the commonalty, consisting of artisans, shopkeepers and labourers. The cities became a force in opposition to the declining world of feudalism in its country castles. The community institution of the city folk, who were a living embodiment of the new and active

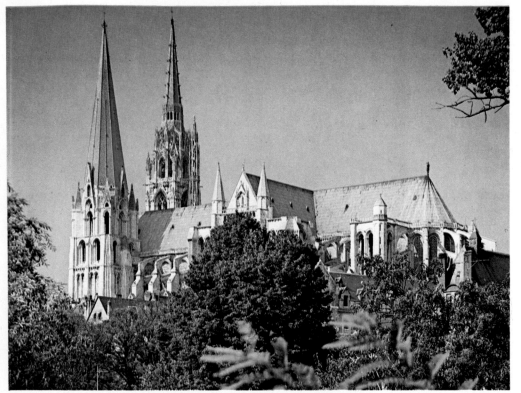
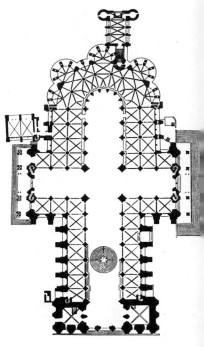

View and plan of Chartres cathedral

community spirit, constituted a political force capable of eroding the privileges and the arrogance of the feudal aristocracy. In western Europe, and especially in France and England, there emerged what were to become the most unified monarchic states of Europe. From then on, these states were founded on independent national development. In the German sphere, the policy of Empire failed in its objective of establishing control over Italy—less through the resistance of the Church than of the Italian city-states. But it gained a foothold in Europe in the Danube basin, especially under the family of Habsburg.

The 12th, 13th and 14th centuries were periods of crisis for European culture, too. The fundamentals of this culture remained religious and theological, but the thinking of the time was brought up to date under the influence of scientific advances and the investigation of nature, along with translations of works from Greek and Arabic. The philosophic work of St Thomas Aquinas (1225–74) attempted a synthesis between the orthodox principles of faith and the knowledge of the time. At the beginning of the 14th century, the *Divine Comedy* of Dante Alighieri (1265–1321), though rigorously dominated by the concept of a transcendental God and redolent with ideas carried over from the Middle Ages, was rich in new values regarding man, nature and society. A culture

which had remained closed within the abbeys and convents, and which was the privilege of those in high places, was widened and deepened by the foundation of the universities of Paris, Oxford and Padua, very soon followed by others. In addition, a lay culture began to emerge, with individual national languages and both popular and erudite aspects.

The chronological limits of Gothic architecture may be fixed respectively as 1137, the year in which Abbot Suger began the Gothic reconstruction of the great cathedral at St Denis, on the outskirts of Paris, and 1430, when the cloister of Norwich cathedral in England was finished. Where, however, there was no other style to compete with or supplant it, as there was in Italy, Gothic persisted for a long time, sometimes for the whole of the 15th century, very often even into the 16th. The ultimate phase was somewhat hazy and uncertain, even problematical, which led to great variety in the artistic panorama of the different countries.

The three centuries from the early 12th to the early 15th were a period of architectural experiment conducted, to an even greater extent than in the Romanesque period, with a full awareness of the problems of construction. Each country, and therefore each builder and each building, contributed its own peculiar and specific solution. This fact remains true even if one ignores regional characteristics and the in-

dividual preferences of the various monastic orders. Yet in spite of differences of taste and ornamentation, different techniques and different materials, and the variety of ways in which links were retained with the previous Romanesque style, the vast majority of Gothic buildings show substantial uniformity. In fact they demonstrate a number of different ways of solving the same constructive problem, or, more precisely, of variants in a dynamic sense, in the method of compensation and spread of thrust – a problem which had been resolved in Romanesque only in a static sense.

The sphere of influence of Gothic architecture

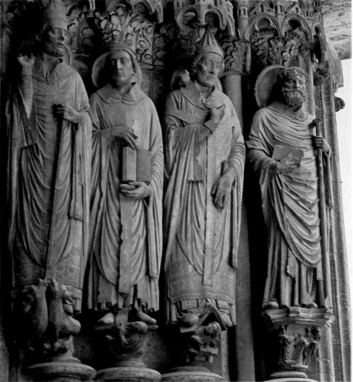

Detail of the sculptures on the south portal of Chartres cathedral

West front ('Portail Royal') of Chartres cathedral

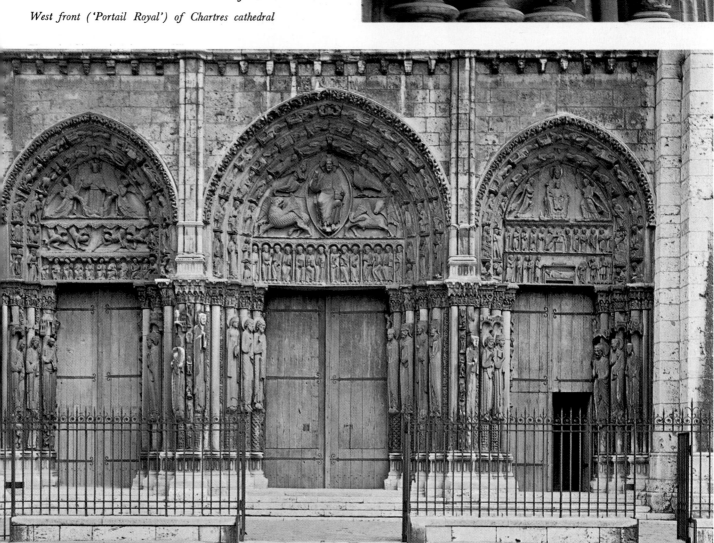

301

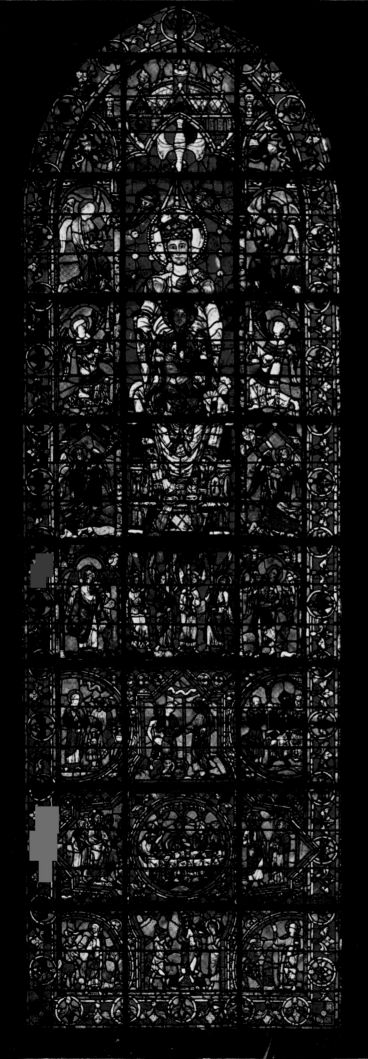

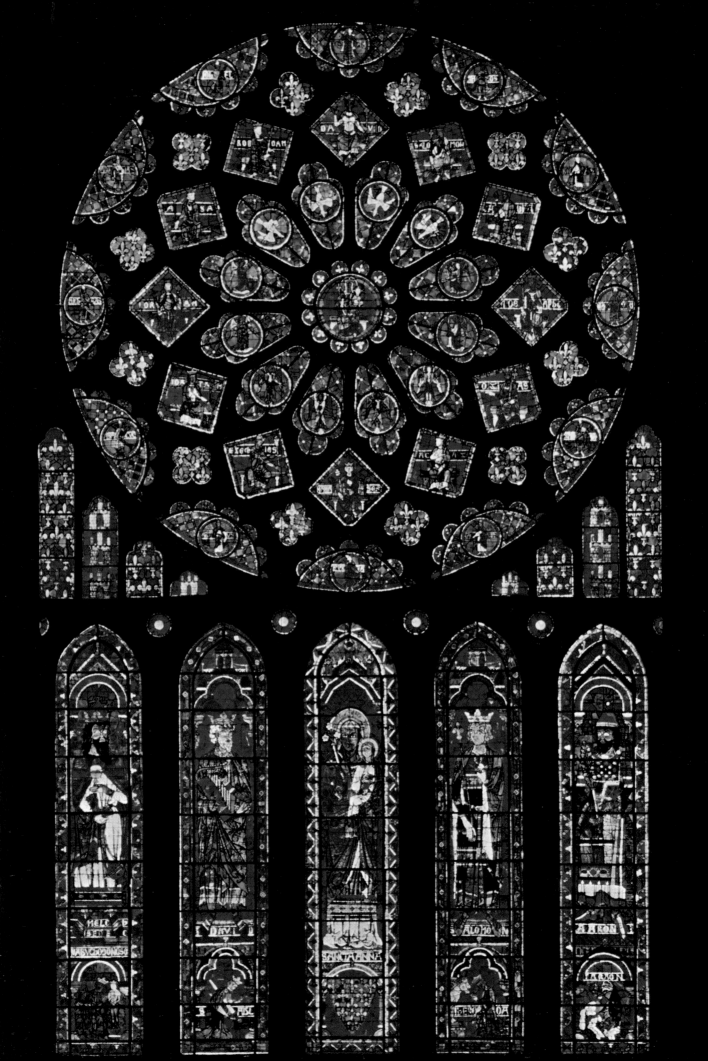

was even wider and deeper than that of Romanesque. It covered France, the Low Countries, England, Scandinavia, the German territories, Czechoslovakia, Poland, Roumania, the Iberian Peninsula, Switzerland and, with reservations, Italy. Although its most typical example was

Ivory statue of the Virgin and Child from the collegiate church of Villeneuve-lès-Avignon, France

probably the cathedral, Gothic architecture had a wider range of application: abbeys, chapels and baptistries, city halls, guild halls, houses and private mansions, hospitals, markets, castles, fortresses and city walls. Moreover, organically planned town complexes, like those at Carcassone and Aigues-Mortes in France, have survived. Everywhere stylistic models derived from Gothic architecture, and the taste for linearism, pointed arches and somewhat angular styles, spread into the realm of decoration (in stone, marble and wood). At the same time they pervaded the minor arts, beginning with goldwork, both sacred and secular, and going on to furniture and fittings.

The Gothic cathedral

However, the cathedral was the pivot on which the whole of Gothic architecture turned. Huge and majestic, towering high above the roof-tops, it was almost like an offering which the whole city community – participating in, or consenting to, its construction – raised towards God. It was a hymn, an invocation of grace made by the whole population. But it was also an affirmation, in monumental form, of the population's strength and faith. For this reason, the cathedral represented both the stabilisation and the heart of the city. With the constructional problems of the cathedral came the solutions which were the essence of Gothic architecture.

In common with Romanesque architecture, Gothic had as a basic principle homogeneity of structure, in that even the roofing had to be an integral part of the building. However, Gothic architecture substituted an essentially dynamic solution for the static solutions of Romanesque. This was foreseen in the ogival arch – a basic element of Gothic architecture – since in the Romanesque round-headed arch the weight was distributed equally, whereas in the ogival arch it tended to gravitate more rapidly towards the base. The Gothic cross-vault, intersected by ogival arches, facilitated the spread of the weight onto the bases of the arches and onto the ground, via the supporting pillars. This altered the whole static situation of construction: instead of the natural, even distribution of mass according to laws of gravity so typical of Romanesque, in Gothic architecture the differentiated concentration of weight in each calculated articulation had to be offset by the structural elements that spread it (arches, ribs and pillars). Thus the coherent body of the Gothic edifice became a rational and organic skeleton. To prevent this skeleton from disintegrating through the effects of stress, other dynamic, external elements of counter-thrust and support had to be introduced: buttresses to correspond to each of the rectangular bays and flying buttresses which were designed to carry the extra height of the nave.

Opposite page, left: *View of the interior of Reims cathedral.* Above, right: *View of the interior of Amiens cathedral.* Below, right: *Statue of the Saviour, known as 'Le Beau Dieu', in the doorway of Amiens cathedral*

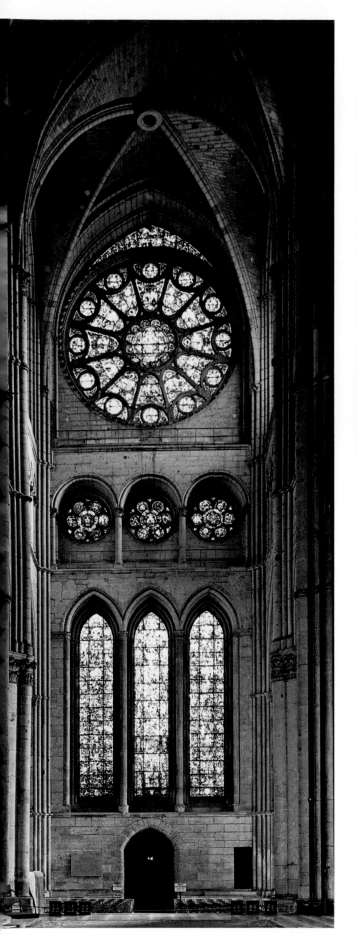

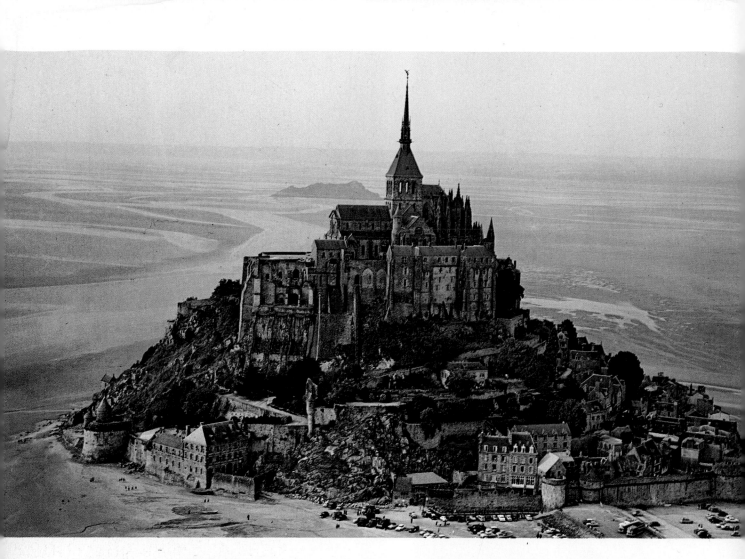

Such a combination of dynamic and fundamental structural solutions allowed Gothic architecture to exploit two other constructional features. One was the realisation of the vertical upthrust of the extremely high naves, which gave the Gothic style its characteristic ascending rhythms. The second was the possibility of using light materials and extremely thin walls in the spaces between the elements carrying and concentrating the weight and resistances. It was not long before architects realised that only these basic structural elements were essential, and that the intervening wall spaces were structurally superfluous and could be virtually eliminated, giving way to large window areas.

That, briefly, is the solution represented by the substantially uniform aspect of Gothic cathedrals. The rest of Gothic architecture is important and characteristic, but functionally of secondary importance. All the same, it was by no means negligible, and was responsible for such features as linear elements echoing the ascending rhythms; sculptural decoration which, on façades and lateral walls and especially in the apertures of the great ogival portals, accentuated the

vertical emphasis of the building; the prominence given to campaniles, towers and spires; the wealth of pinnacles, spires, niches and indentations which decorated the walls and terminated the buttresses and flying buttresses.

Dynamic elements such as these also changed the spatial sense of the Gothic cathedral. From the outside it looked like a tall ship propped up in a dry-dock – a volumetric mass with an upward development. Inside, the circumscribed space so characteristic of Romanesque was replaced by a sense of limitless space, which the stained-glass windows often turned into a mystical combination of space and light; and because of the skeleton of the pillars and ribs, the vault also gave the same soaring impression.

France

First in point of time came the cathedrals of northern France – of the Ile-de-France – where Gothic had its beginnings. In 1137, Abbot Suger, minister and counsellor to Louis VI and Louis VII, and at one point Regent, began the reconstruction of the basilica of St Denis (later

306

much altered) with a deep rational understanding of the new problems. Noyon, Laon and Soissons soon followed, and some of the features of these places (such as galleries and sexpartite vaults) paved the way for the building of Notre-Dame (1163–1250) on the historic Ile de la Cité, in Paris. This cathedral is unified and compact in that the transept does not extend on either side beyond the limit of the lateral aisles and ambulatory. The calm façade is flanked by two square towers, and the apse presents a mass of pinnacles and flying buttresses which support the tall, slender body of the choir. The new architecture spread, and the even more impressive cathedrals of the 13th century were in preparation: the powerful outlines of Meaux; Bourges, with the airy lightness of its high nave and flying buttresses; Senlis, where the façade is dominated by the rose window and doorways; and Sens, at the gateway to Burgundy.

The cathedral at Chartres was built between 1195 and 1290 on the site of its Romanesque

Virgin and Child, silver-gilt and enamel (Louvre, Paris)

Opposite page: *Aerial view of Mont Saint-Michel, France*

Façade of Strasbourg cathedral

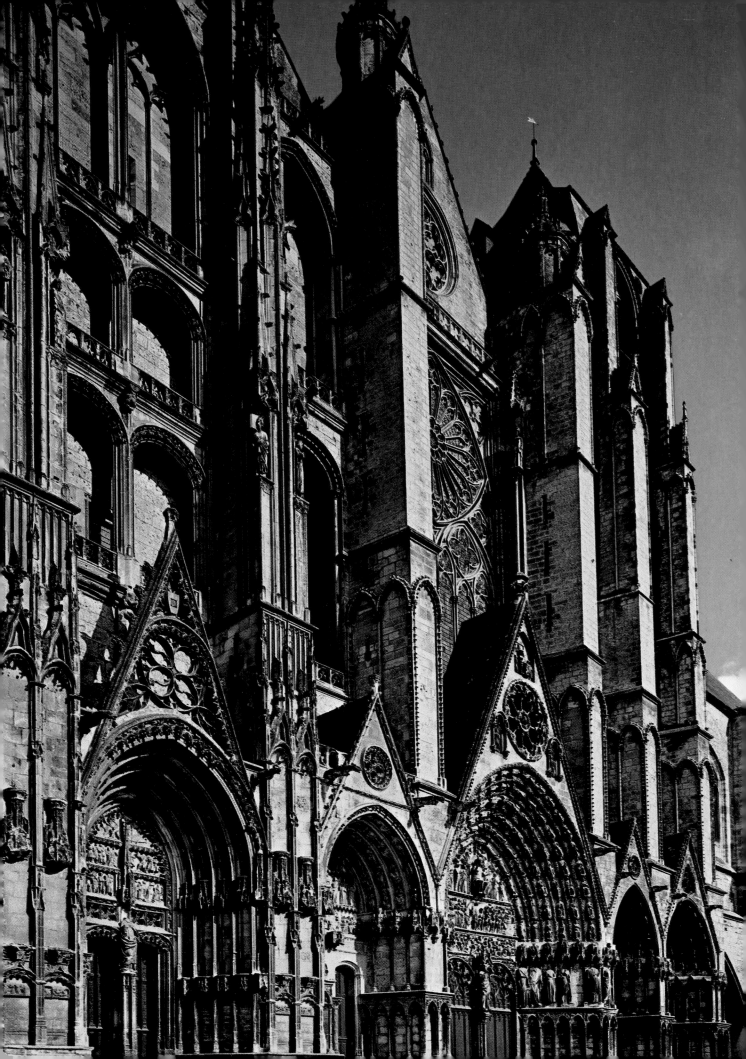

Façade of Bourges cathedral

Interior of Bourges cathedral

Limoges enamel reliquary (Victoria and Albert Museum, London)

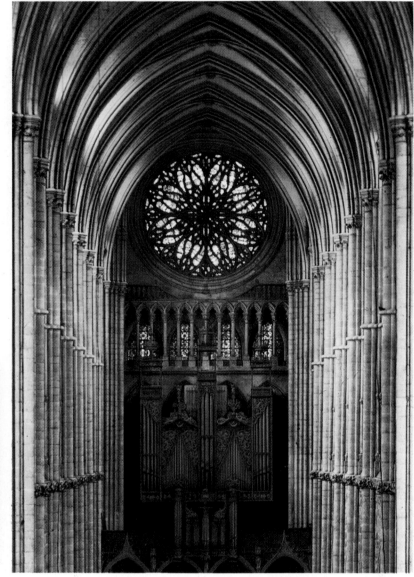

predecessor. This cathedral was limited by its severity of plan, with a clearly defined transept and choir, and a double ambulatory and chapels; the vertical rhythm of its interior is bathed in a mystical light from the splendid stained-glass windows. The deeply embrasured lateral porches are very beautiful and are decorated with important cycles of sculpture and carvings. The succession of buttresses and flying buttresses, and the two strong towers on either side of the façade with its magnificent rose window are also of great beauty.

The cathedral at Reims, begun in 1211 on the site of its predecessor, was well worthy of the honour of being the setting for the coronations of the kings of France. The development of the presbytery and choir is imposing, and there is an urgency about the vertical lines of the interior. Two strong, squat towers flank the façade with

its superb sculpture and its three deeply embrasured doorways with pointed arches. The imposing cathedral at Amiens dates from 1220. It is on a more complicated plan than Reims, though here, too, the ascending rhythms of the interior are compact and the three deeply embrasured doorways of the façade make a ponderous combination.

Rouen cathedral has some splendid sculpture and stained glass, with a clearly rhythmic nave and a light, luminous choir. The façade is highly ornate and the steeply pointed arch over the central doorway bisects the rose window. The lateral towers are somewhat truncated by comparison with the sharp, prominent *flèche* (spire) at the crossing of the transept. The Gothic style is even more marked in the leaping verticality of the 13th-century church of St Ouen (also in Rouen). Even in a brief survey one

cannot ignore Beauvais, with its daring apsidal buttresses and flying buttresses. Of no less interest are Bayeux and Coutances, in Normandy; Clermont-Ferrand, in central France; Bayonne, near the Pyrenees; Dijon in Burgundy and Albi in Provence. An extremely individual Gothic construction, built upon its island rock, is the soaring complex of the Mont St Michel, which is reminiscent of the temple-mountains of the East. Constructed between 1203 and 1228, it has all the characteristics of a medieval town. It is built on three terraces and, apart from the church, includes abbey buildings, a cloister, a knights' hall and a hospice, all of which rise one on top of the other.

Examples of civic architecture are also important. In Paris, the only Gothic remains of the ancient and much-altered Palais Royal in the Cité, apart from the Sainte-Chapelle, are some vaulted rooms and the massive towers of the Conciergerie, now part of the Palais de Justice. The foundations of the original Charles V palace of the Louvre have recently been brought to light. The Château de Vincennes with its compact central keep, surrounded by a bastion, dates from the 14th century. The Château d'Angers, in western France, is earlier – perhaps dating from the first half of the 13th century – and has a curious outer wall with alternating bands of black slate, granite and sandstone. In the Midi, the papal palace at Avignon, dating from the second half of the 14th century and designed to house the popes during their long exile from Rome, is a vast, richly articulated and moving complex.

In France, sculpture gave admirable assistance to the development of Gothic architecture. It was like an exuberant blossoming that enriched the dryness and schematic effect that could easily have resulted from such a rigorous architectural base. Above all it decorated the great, deep doorways with figures of saints and apostles flanking the entrance, with scenes of the Last Judgment and biblical scenes on the tympani and flights of angels over the embrasure of the pointed archivolt. This development followed a scheme seen in a simplified form in Notre-Dame in Paris, developed in the north and south portals of Chartres, and attaining impressive monumental power at Amiens and subtle fascination at Reims. Alongside new themes depicting Christ, the Virgin, the prophets and patron saints, Gothic sculpture continued the Romanesque exploration of the subject of the Last Judgment. We find it on the tympani at Paris, Amiens, Rouen and Reims. The best example, however, is in the central portal at Bourges (c. 1280), especially in the lower part where an elongated angel weighs the souls and separates the blessed from the damned, who are swept away into fearful torments. Naturalism and freedom were now becoming established in a dynamic narrative where space was fully employed. Statues appeared on projections of the façade, on little niches and shrines, on buttresses, and on the tops of spires and pinnacles.

On the other hand, such sculpture assumed an independence of its own in relation to architecture, and was in fact less subordinate to it than in Romanesque. Above all, the subject matter

changed: it became serene yet vivacious, un-assailed by the monstrous and the terrifying, and more securely human. French Gothic sculpture founded its own values and its own fascination on its search for naturalism. It also gave back proportion and spontaneity which – taking advantage of the linearistic stylisation and sinuous curves of Gothic – softened the clothes and draperies. We may follow the path it took from the *Porte de la Vierge* (Virgin Portal) and the statue of the Madonna in Notre-Dame, to the group in the Visitation and to certain figures of the apostles at Chartres. We see it triumph at Reims in the figures of the Virtues, in the classic fullness of the group of the Visitation, and in the famous Angel, who brought back into art that open, roguish smile. Later, at Strasbourg, between France and Germany, these tendencies appeared in the refined elegance of the figures of the Church and the Synagogue, of the Wise and

311

Cloister of Salisbury cathedral

Opposite page: *St Peter, detail from the Westminster Retable. Westminster Abbey, London*

Plan of Salisbury cathedral

Foolish Virgins and the subtle sophisticated charm of the statues of the Virtues.

Pictorial art found a new impulse in the splendid and colourful stained-glass windows which played such a great part in creating the mystical atmosphere of Gothic interiors. The stained-glass windows of Notre-Dame are known universally, as are the fascinating windows at Chartres and those of the Sainte-Chapelle in Paris. Miniaturist art was more important than wall-painting or painting on panels. It became extremely sophisticated and refined, as in the Belleville Breviary (*c.* 1325) and the History of St Louis (*c.* 1380) at the Bibliothèque Nationale in Paris. A rather interesting documentation of Gothic design, its modules and the ornamental stylisation of art and architecture is the Notebook of Villard de Honnecourt (*c.* 1235), a travelling architect who was interested in any experience he came across on his way and was attentive and scrupulous in noting down everything that caught his fancy.

The development of the whole field of minor

arts at this time was remarkable, and as far as goldwork was concerned, Limoges enamels reached the height of their development.

England

From France, the Gothic creative impulse passed to England. English Romanesque experience, especially in early experimentation with cross vaulting, facilitated the passage into Gothic, which was introduced in about 1175 by the Frenchman William of Sens in his reconstruction of Canterbury cathedral. In the 12th and 13th centuries, a number of cathedrals followed in quick succession: Lincoln, where the magnificently fenestrated Angel choir is a typical example of the constructional capabilities of the English; Peterborough, with its façade dominated by three huge arches; Wells, structurally homogeneous and with its characteristic internal X-shaped scissor-arches. The uninhibited articulation of mass in these cathedrals is very effective, with sensitive, ascending linear rhythms, as well as an increased number of ribs in the cross vault. In this respect, the cathedral at Salisbury (1220–1320) is typical in the picturesque articulation of its mass and its spire-crowned lantern tower (404 feet high) and its calm, vigorous stylistic development, especially on the façade.

Westminster abbey is of similar importance, especially in the central part, the presbytery, which has distinctly pointed arches and which from earliest times was the setting for the coronation of the kings of England. The splendid chapter house at Lincoln (c. 1235) with its umbrella vault radiating from a central pillar, reveals the English taste for high rhythmic ribbed vaulting with an extremely complicated line-force structure. These characteristics are also recognisable in the Lady chapel and chapter house in Wells cathedral. The vaults of the 14th century were marked by this tendency to insist on the play of the ribs which divided, criss-crossed and multiplied between the cross vaults. Vaults of this kind are to be seen in

313

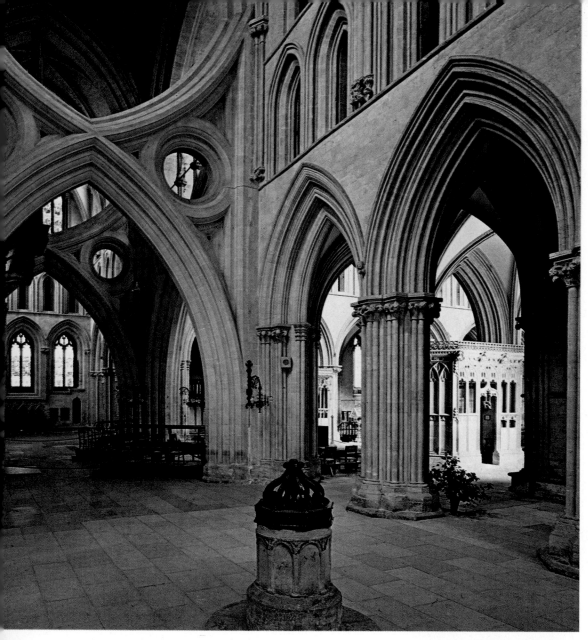

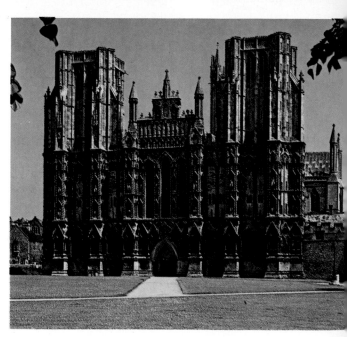

Interior and Lady chapel vault of Wells cathedral

Façade of Wells cathedral

rhythmic clusters of ribs at Exeter and Lichfield; with complex springing at Gloucester, or at Ely, with its daring, octagonal wooden lantern tower. This 'ornate' or 'decorated' style passed finally into the Perpendicular style opening the way to Flamboyant Gothic. The ribs became flatter, reduced to a linear rhythm, which was sinuous, broken or angular and became simply a definitive ornamentation for the springing. The most characteristic example is in the cloister at Gloucester, where the ribs of the vault spread out into fan vaulting.

Perhaps because it was overwhelmed by the way in which decorative developments had turned into complicated ornamentation, sculpture was of secondary importance. The Judgment Porch of Lincoln cathedral (second half

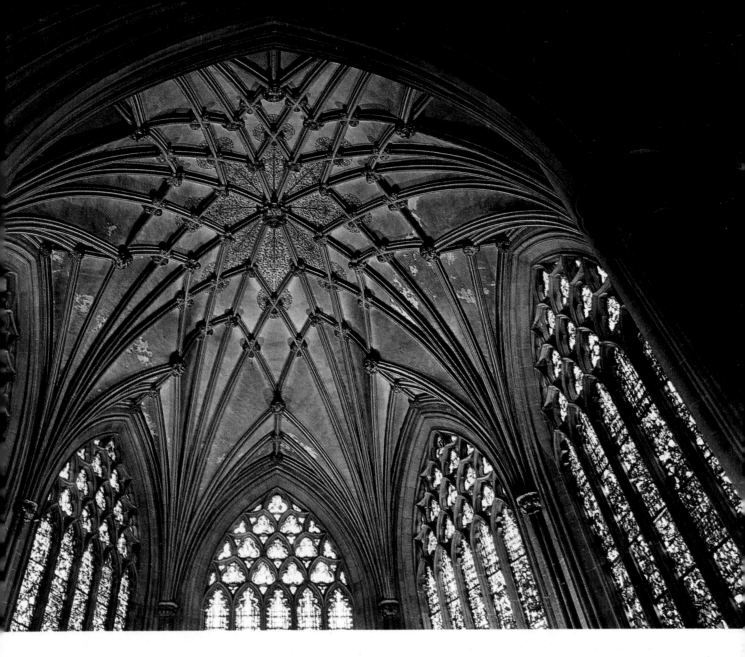

of the 13th century) is poor in sculpture by comparison with similar French works. The individual characterisation of tombs, however, was lively, as can be seen in the tomb of King John in Worcester cathedral.

Except for the fragments at Westminster, all witness to painting is lost, and it was to miniaturist work that pictorial art turned. After initial setbacks, miniaturist art reached a high level in the Gothic period, with exquisite graphic elegance and soft colouring. One noteworthy example is the 14th-century Psalter of Robert de Lisle in the British Museum in London.

Germany

The spread of Gothic from France to Germany was late, beginning only in the 13th century, but it put down firm roots. Romanesque traditions were very strong in Germany, and the passage from one to the other was slower and more circumspect, as the simple clarity of structure of Bamberg and Limburg cathedrals shows. Not infrequently Gothic was used to complete and decorate Romanesque constructions, which sometimes show signs of foreign influence. The magnificent cathedral at Strasbourg (then on German soil) is completely subject, both in architecture and sculpture, to French Gothic style. Cologne cathedral, the most colossal and imposing of German Gothic constructions, derived its choir and ambulatory with radiating chapels from Amiens. The first stone was laid in 1248 but, after the erection of the choir and the west front, the work remained uncompleted for centuries, being finished, to the original design, only in the 19th century. The spread of the Cistercian Order brought with it types of

315

building and influences from Burgundy (visible at Ebrach and Walkenried). The German development of Gothic was, however, both zealous and imaginative, uniting audacity with solidity. Alongside the developments of a Gothic style that was both taut and exuberant – as in the vault of the church at Oppenheim in the Rhineland, or the choir of Aachen cathedral, dating from 1335 – there were the characteristic high towers with pierced spires, as at Freiburg, Ulm and Vienna. Another German peculiarity, perhaps inspired by the Cistercians, is seen in the Hallenkirchen, vast hall-like churches developed centrally and horizontally, in which the aisles and nave are the same height. The most coherent and delightful examples of this style are the Elisabethkirche at Magdeburg, erected in the 13th century to house the remains of Elisabeth of Hungary, and the 14th-century Wiesenkirche at Soest. In the northern plains, from Holland to Pomerania, brick churches were built, plainer and more restrained, in which the decoration was adapted to the materials. The cathedral at Lübeck (end of the 13th century) is the most significant prototype. More traditional forms of great brilliance, spatial power and rich articulation are revealed in the Lorenzkirche at Nuremberg, the cathedrals of Halberstadt and Magdeburg, the three-apsed cathedral at Ratisbon and the vigorous cathedral of St Stephen in Vienna.

It was in this guise that a region of German Gothic was consolidated, with developments that lasted well into the 15th century. Its influences, along with those of France and

Opposite page: *Detail of the statue of Queen Uta, Naumburg cathedral*

Below, left: *Exterior of Ulm cathedral*

The Horseman of Bamberg cathedral

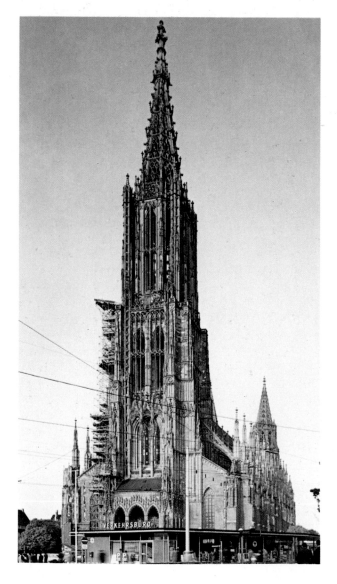

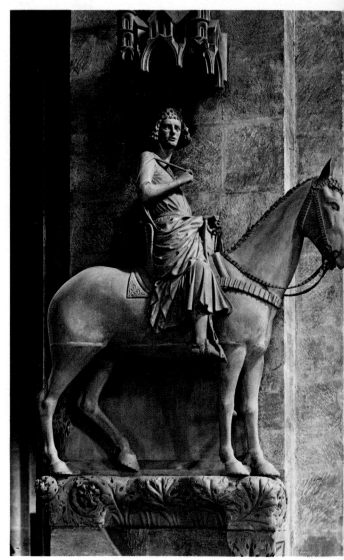

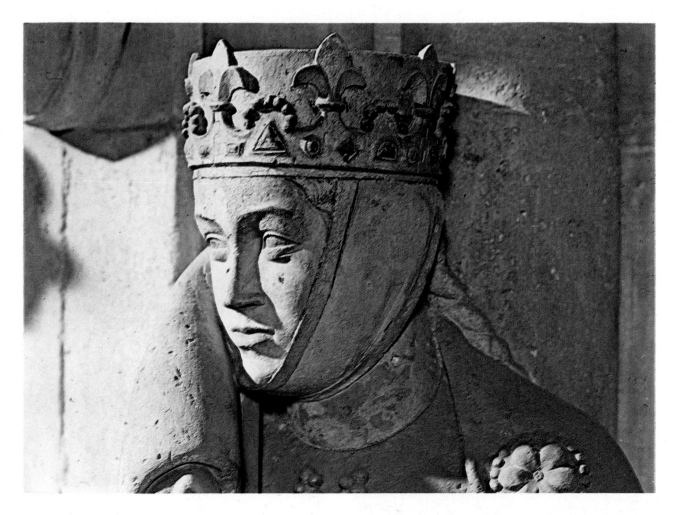

England, were felt throughout the surrounding countries: from Switzerland (the noticeably French-influenced cathedrals of Geneva and Lausanne, and the German-inspired Fraumünster in Zurich) to Scandinavia (Roskilde in Denmark, Upsala in Sweden and the English-styled one in Trondheim in Norway). The diffusion towards the East, though considerable, was more varied and more indistinct. Prague, which had become a lively cultural centre, saw the erection, in 1344, of its airy cathedral, designed by a French architect, Matthaias of Arras. In Poland, the Order of Teutonic Knights brought some innovations and left behind some notable monuments, such as Cracow cathedral.

Civic architecture was also noteworthy: castles, where the living quarters with their sumptous apartments were of prime importance; towers in city walls, and watch towers on bridges (like the exceptionally beautiful complex in the Old City of Prague, built in 1367 by Peter Parler), city halls, as at Aachen, Münster and Lübeck, hospitals (Lübeck), warehouses (Mainz) and town houses in stone (Oberstolzhaus in Cologne, Greifenhaus in Breslau).

A lively impulse was felt in German Gothic sculpture, although French influence was certainly very strong. At Strasbourg, for example (in the sculpture and statues on the doorways, and on the Angel Pier), echoes of Chartres and Reims, in the introduction of a refined naturalism, are so strong that even when the work was carried out by German craftsmen one is faced with the problem of whether it ought not rather to be regarded as being French. At Freiberg, in Saxony, the Gold Door (1240) suggests French work at Laon combined with a classical breadth of composition. On the other hand, in the Last Judgment on the Prince's Door (1237) at Bamberg (as in the Foolish Virgins of the portal at Madgeburg) the expressive naturalism degenerates and becomes forced. Also in the cathedral at Bamberg, the statue of the medieval horseman has sculptural vigour, strong characterisation and emerges clearly from the mass, and there are expressionistic overtones in the statues of the prophets Jonah and Hosea and the slender statue of St Elisabeth.

German Gothic sculpture reached its height in the output of the anonymous master who first worked at Amiens, Noyon and Metz and later

The towers of the Lorentzkirche, Nuremberg

Interior of the Lorentzkirche, Nuremberg

produced sculptures for the cathedral at Mainz (from which comes the flowing group of St Martin and the beggar, now at Bassenheim) and, in the middle of the 13th century, the five statue groups of the donors in the choir of the cathedral of Naumberg. The chubby, smiling bewimpled Regelinda and the enchanting statue of Uta, who lifts the collar of her cloak in a delightfully feminine gesture, are also among his masterpieces.

The way was being paved for expressionistic characterisation. We catch a glimpse of it as early as the middle of the 13th century in the tomb of Siegfried von Eppstein in Mainz cathedral and in the strong relief of the panels, showing scenes of the Passion on the rood screen of the cathedral at Naumburg. It is fully evident in the wrinkled face of the statue on the tomb of Bishop von Roth in Augsburg cathedral (1303)

and in the sinuous curves of that of Friedrich von Hohenlohe (*c.* 1380) at Bamberg. There are numerous statues of the Madonna, some with artistic finesse, some vigorously popular in style; they are done in stone and in wood, which is sometimes polychrome. There are sinuous stylised draperies and impassioned crucifixes, sometimes tautly expressionist (Sta Maria im Kapitol, Cologne). In the 14th century, Bohemian sculpture had a truly linear lyricism (Madonna of Krumlov) while Peter Prater, at Prague, was influenced by local paintings when he created realistic characterisation on the royal tombs in the cathedral and in the portrait-busts in its triforium.

Painting is more interesting for its independent pictures on panels than for examples of wall-painting or stained glass. The search for an expressive language has the inexperience but

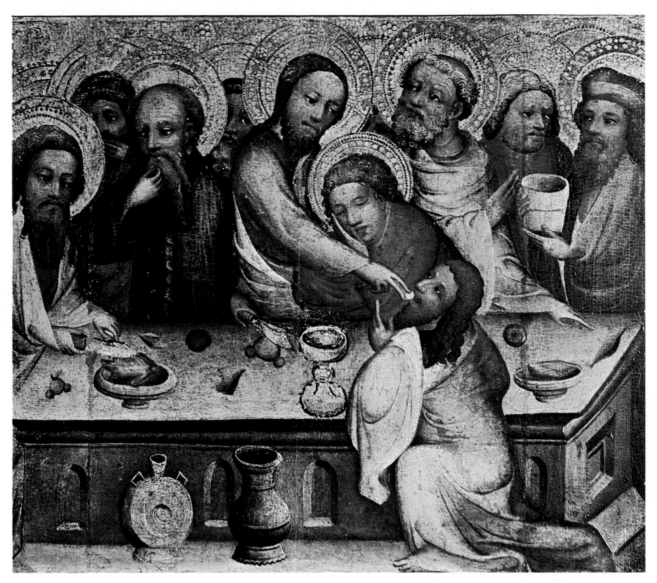

Scene from the life of Christ, 14th-century German school (Musée des Arts Décoratifs, Paris)

popular vigour of primitivism, often rich in original ideas and free from preconceived notions. It was only after 1300 that individual masters and stylistic streams began to be defined.

The Low Countries

In the Low Countries, which constitute an area apart, the woollen-cloth industry of Flanders led to the early development of a prosperous and enterprising middle class. Gothic art, preceded by Cistercian influences, penetrated easily from France. In Belgium the Romanesque complex of the grandiose cathedral of Tournai gained new vertical elements in the transept and choir, while St Martin arose at Ypres and St Bavon at Ghent. The French type of twin-towered façade is to be found, with even greater emphasis on upward movement, in Ste Gudule in Brussels and in

Antwerp cathedral, which is of considerable size and has an imposing and lofty apse. The development of civic architecture was characteristic, however. The city halls were a symbol of the free community institutions and were often dominated by extremely high *beffrois* (belfries), as at Tournai, Bruges and Ghent, though the latter has subsequently undergone major alterations. The mercantile buildings are interesting, as for example the *halles* (covered markets) at Ypres, which were largely rebuilt after World War I.

In other arts, apart from a few exceptions (for example, the 14th-century fresco of The Last Supper in the abbey of Byloke at Ghent, or the funerary statues of the dukes of Louvain) there was a migration of Flemish artists to the court of Burgundy which gave rise to Franco-Flemish art, especially in the important and developing field of miniatures.

In the minor arts, the Flemish town of Arras was the birthplace of tapestry manufacture in the 14th century. However, little survives from this early period (Tournai cathedral, Padua Museum), though it is probable that the great tapestry of the Apocalypse, designed by the Parisian Nicolas Bataille, and now in Angers Museum, was made with the close co-operation of the workshops at Arras.

Spain

Spain was by now fully engaged in the great enterprise of reconquest of its territories from the Moslems. Nevertheless it played a lively part in the growth of Gothic, in those areas where the *mudejar* style did not still persist, by effecting a compromise with the Moorish style. France was the main source of inspiration, sometimes through direct regional contacts (Salamanca deriving from Romanesque Périgord prototypes; Ávila from those of the choir at Vézelay). From

an earlier French tradition, but with typical exuberance, was drawn the inspiration for the most important Spanish Gothic buildings: the great cathedral at Toledo (begun in 1225); León cathedral (1225) and, particularly, the cathedral at Burgos. The latter was begun in 1220 and completed only in the 16th century after John of Cologne, in the 15th century, had built the towers with their pierced spires. There is also a light, Gothic architecture with much dentillation and piercing in the 14th-century cloisters of Pamplona and Vich.

Sculpture had rather more originality. The portals at Burgos with, respectively, the Judgment of the World and Christ in Glory, follow prototypes from the Ile-de-France, but the rhythm is freer and there is a strongly realistic approach. A little later, at the end of the 13th century, these tendencies are accompanied in the portals of León, by a new narrative freedom and by aristocratic elegant dress. Still later, Spanish Gothic, which tended to persist into the 15th

General view of castle and cathedral at Prague

Left: *Interior of the Prague cathedral*

Opposite page: *South door (the Sarmental portal) of Burgos cathedral*

century, became encrusted with an exuberance of ornamental detail, especially in the retables (altarpieces) made of marble, wood or alabaster. The sculpture of Catalonia (Tarragona, Lérida) is more massy and less refined.

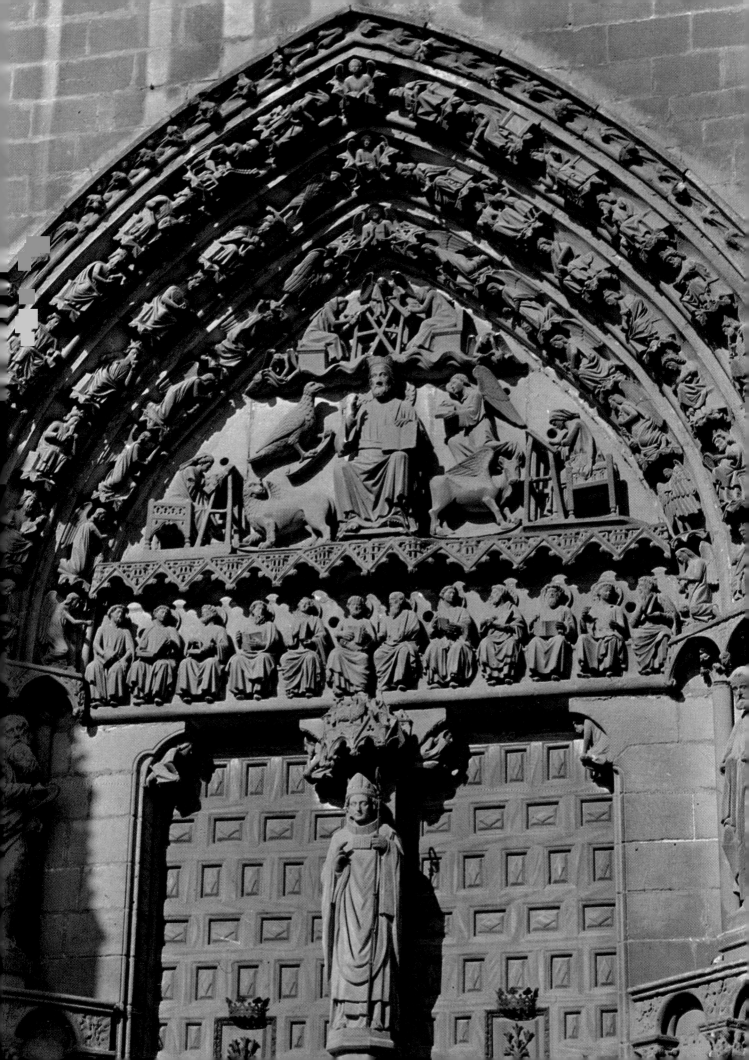

The tradition of painting in Spain did not decline. It was kept up by known and unknown artists, in frescoes and in panel-painting, with a vigorous and popular expressionism enriched by Gothic linearism. This painting, both in pictures and in miniatures, passed from sacred to profane and chivalrous themes. At Pamplona, Juan Olivier painted some rhythmic frescoes with freely distorted shapes. An almost Italian grace marked the popular simplicity of the works of Jaime and Pedro Serra. However, the artist who stands head and shoulders above the rest – also

in Catalonia – is Ferrer Bassà, who, in the frescoes in the monastery of Pedralbes (1345) carried over, into a modulated and dream-like fineness of line, influences derived from Giottesque and Sienese Italian painting, whose sphere of influence was widening in Europe.

Italy

Italian Gothic cannot be regarded in the same way as the Gothic of other areas. For chronological reasons it is later and of shorter duration.

Exterior (left), plan (above) and entrance gate (below) of Castel del Monte, Italy

accepted as an objective description – may be attributable to the Renaissance Italians, but it had a pejorative and condemnatory connotation (wrongly attributing to the Goths or the Germans a responsibility which was not theirs). However, Gothic in Italy was no ephemeral and superficial foreign fashion, nor was there a kind of Italian

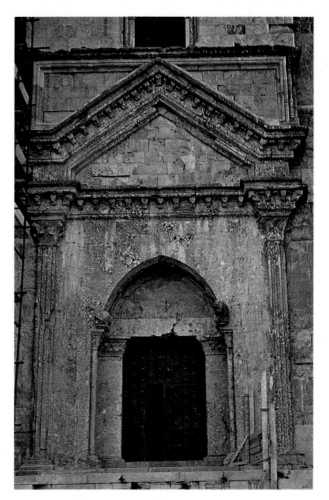

It appeared only quite late in the 13th century. The Renaissance intervened to compete with it after the second decade of the 15th century, and almost completely supplanted it by about the middle of the same century, whereas elsewhere this period remained truly Gothic.

All the same, artistic, aesthetic and stylistic reasons made Italy a special case. A contributory factor was that this period was a time of feverish revival, particularly with the economic and social growth of cities. The derivation of the term 'Gothic' – which was eventually universally

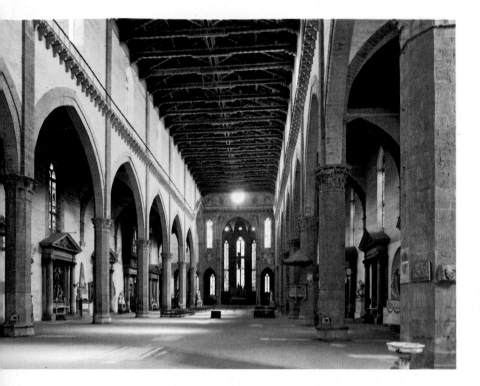

incompatibility with Gothic values. The attainments of Italian Gothic are too lofty and too original, and were the source of too much effective influence, for such a thesis to be tenable. It is true, though, that Italy did not repeat, nor passively adopt, the usual forms of foreign Gothic. But it wanted, and was able, to turn them and adapt them to its own peculiar views, inspired by the principles of order, balance and clarity that had characterised its classic experience. All the Gothic building techniques were known and applied in Italy, but with different significance and different results. The principle of dynamic tension, of resolved forces, which found realisation in the ogival arch and the cross vault, were subordinated to the demands of volume, mass and stasis ('stoppage') which acted as a rein on any daring or excess. The principle of ascending thrust, of extended vertical line, was offset against a desire for spatial development, balanced expansion and a coherent and unified outlook. Finally, the even more essential Gothic principle of the sensitive, taut, leaping, line, while it was certainly not repudiated in Italy was, however, interpreted in a great variety of ways. At first sight some of these even seem to be antithetical in the emphasis given to volume, plastic force of mass and the conspicuous use of light and shade.

The specialities as well as the fascination of the solutions can be seen with such impressive clarity that the figure of the artist emerges from anonymity and allows his personality to speak

with the universal voice of humanity, outside of any formulae.

One could say that Italian Gothic began with the basilica of S. Francesco at Assisi, which was begun in 1228, scarcely two years after the death

Above, left: Interior of Sta Croce, Florence

Above, right: Giotto's campanile, Florence. Opposite page: *Detail of Giotto's campanile, Florence*

Andrea Pisano, inset carving from Giotto's campanile

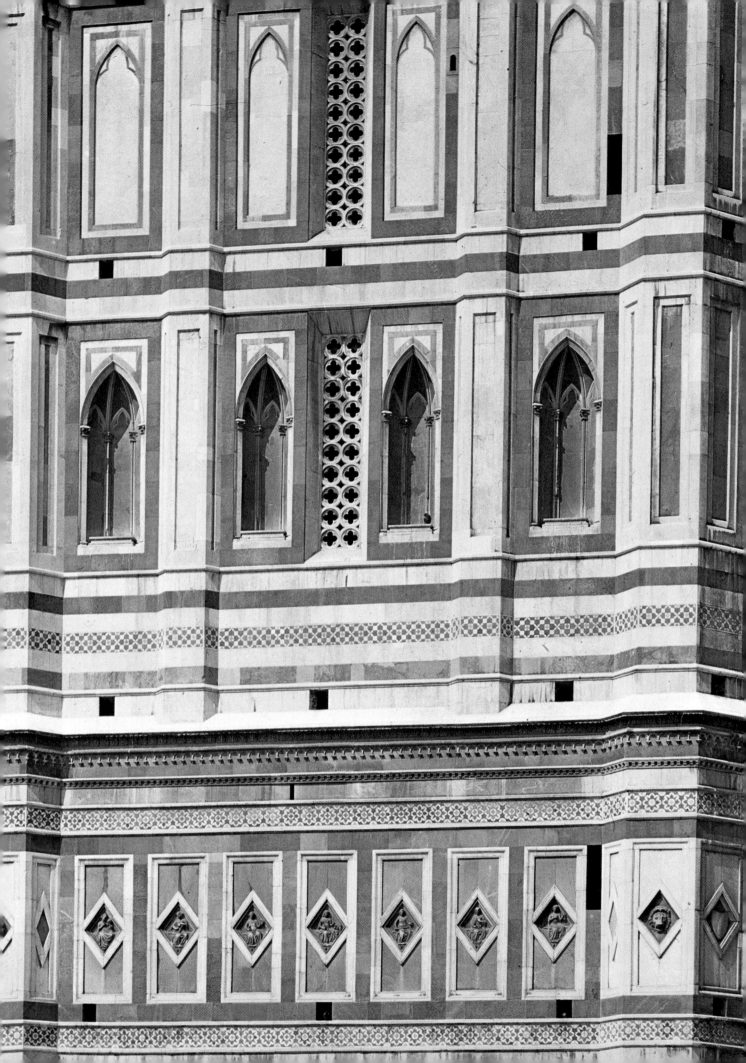

of that great and popular saint. The unevenness of the site was exploited and two churches erected one above the other. The lower church is not very high, almost like a crypt, with enormous ogival arches rising from plinths rather than from pillars; the upper church is simple and luminous, with a single T-shaped nave, having four bays, in which the crossing of the ogival arches broadens rather than rises upward. Even the exterior, with its stocky Lombardesque campanile, the undecorated façade with its pointed gable and the turreted buttresses, has a Romanesque flavour. The cathedral at Siena is almost contemporary with S. Francesco. Gothic characteristics are moderated and spaced on the later façade, with round-headed doorways within angular cusps. They are somewhat attenuated in the interior in the ample, round-headed arcade and in the decoration of horizontal light and dark strips which arrest the upward movement of the pillars. The Palazzo Pubblico (1228–1342) in Siena is the focal point of the concave slope of the piazza; it is highly picturesque with its red brick and the forward movement of the two wings, punctuated by the ogival, triple-paned mullion windows beneath the tall, slender Mangia Tower with its white corbels. This is a lofty example of the civic architecture that was so important in Italy, and other outstanding examples of it may be seen at Pistoia, Perugia, Gubbio, and Orvieto.

The cathedral at Orvieto was begun in 1290 by Fra Bevignate, and later sculptural reliefs were added to the façade by the Sienese Lorenzo Maitani in the 14th century. The cathedral has echoes of Siena, but the vertical line of the clusters of pillars and the lateral spire-topped towers are more Gothic in emphasis.

Although Pisa has its serene Gothic camposanto or cemetery, and the precious 'casket' of the tiny Sta Maria della Spina, dating from the 14th century, Florence was the great Italian Gothic centre. The Dominican Sta Maria Novella (1246–1310), built on a simple T-plan, exhibits Tuscan style in the height of the lateral aisles and the fullness of its ogival arches, with a sense of space that lessens any ascending movement. This effect appeared again, fifty years later, in the Franciscan Sta Croce. However, the major Gothic undertaking in Florence remains the cathedral, Sta Maria del Fiore, begun in 1294 on a plan by Arnolfo di Cambio, and continued after his death by Francesco Taleni. It is to Arnolfo that we owe the grafting of the nave to an ample trilobate choir with radial chapels. The nave is light and spacious, with the upward movement of the ogival arches held in check by the recurrent horizontal line of the galleries; the choir was completed in the 15th century with a cupola by Brunelleschi. In 1334, Giotto added a solid, well-defined campanile with restrained vertical movement. While the palace of the Bargello (begun in 1255) is a square mass of stone still in medieval style, the Palazzo Vecchio, begun in 1299 and by tradition assigned to Arnolfo, is a compact block with simple embossments. These are only slightly relieved by the marble mullions, and are given movement by the

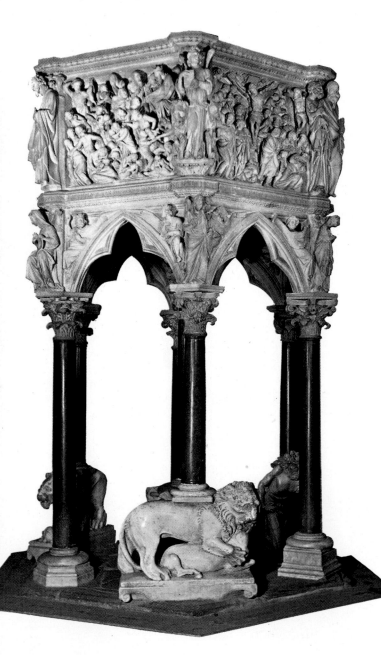

Giovanni Pisano, pulpit (S. Andrea, Pistoia)

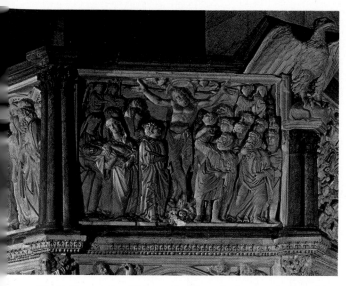

Nicolò Pisano, Crucifixion, relief from the baptistry pulpit, Pisa

Mangia Tower of the Palazzo Pubblico, Siena
Below: *Detail of mullion windows, Palazzo Vecchio, Florence*

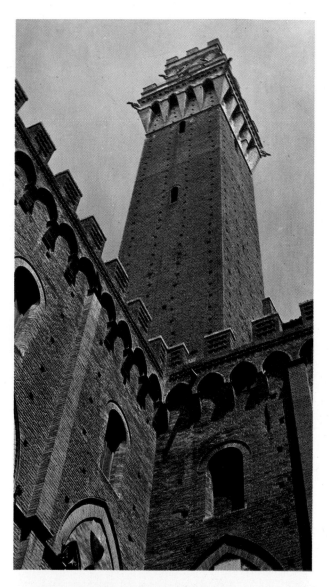

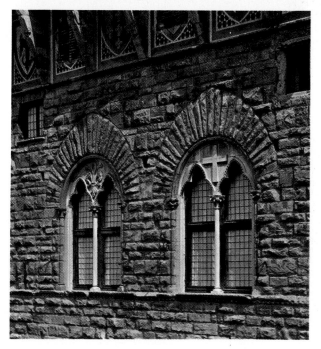

jutting crown of corbels, which recur, asymmetrically, in the tower.

The Palazzo Pubblico of Piacenza, which was begun in 1281, and where the red brick is linked to a stone base, is a splendid fusion of energy and elasticity. At Milan, the isolated octagonal campanile of S. Gottardo, marked at the corner edges by extremely long columns and with the airy, jutting, open-sided double gallery, and the Loggia degli Orsii, which Matteo Visconti built in 1316, were the major Gothic buildings before the cathedral was begun.

At Verona, the Castelvecchio of the Della Scala family and the reconstructed battlemented bridge over the Adige, bear witness to the passing of the community world into that of the noble families. In Venetia, much hesitation and compromise hampered what might have been the grandeur of S. Antonio at Padua, while the Frari church and the church of S. Zanipolo at Venice, dating from the 14th century, have a grand and spacious purity.

Sculpture, which was fully independent of architecture, was moving to a climax, marked in 1260 by the hexagonal and isolated carved pulpit in the baptistry at Pisa by Nicolò Pisano. His breadth of manner and sculptural force place him above all schools and all artistic streams. He was aware of Romanesque sculptural precedents – particularly notable in Pisa – and it is very probable that he knew about French sculpture, yet the fount of his inspiration

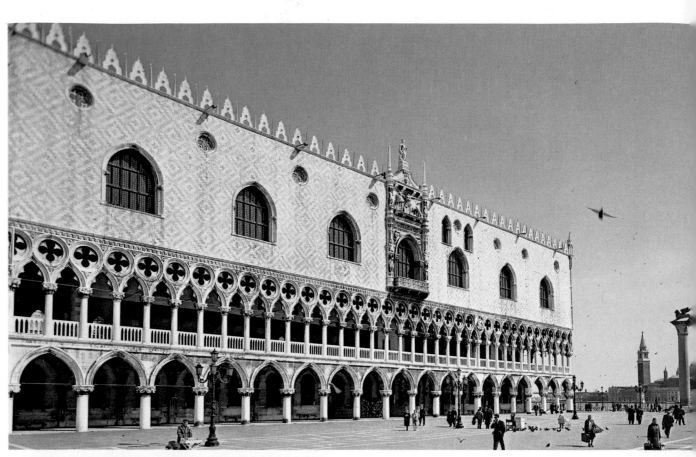

Exterior of the Doges' palace, Venice

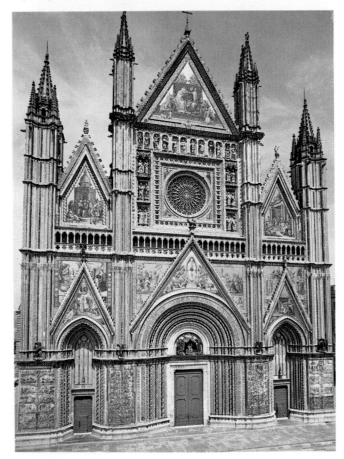

Façade of Orvieto cathedral

was classicism. His Apulian origin and, possibly, an apprenticeship in the Campagna, together form the fundamental imprint of his artistic vision. The powerful squareness of his shapes, his full, calm sense of volume and his spatial balance are marks of the superimposition of liberal naturalism onto a classical sense of order. The pulpit for the cathedral at Siena, which he executed between 1265 and 1269 with his son Giovanni and assistants, marks a change towards a more Gothic style. The dynamism is accentuated by the crowding and intersecting of the volumes and by their fluidity. The Fontana Maggiore in the piazza at Perugia, dating from 1278, is the last work of Nicolò in collaboration with his son.

The collaborators of Nicolò developed his art in a more determinedly Gothic sense. The Tuscan Arnolfo di Cambio, whom we have already mentioned as an architect, had a more classical and volumetric restraint. This first became apparent in the sepulchre of S. Dominico at Bologna; we find him later at Rome, in the service of Charles d'Anjou, whose compact statue is in the Capitol. We may admire his tomb of Cardinal de Braye in S. Domenico at Orvieto, with the two deacons pulling aside the veils on

the funeral alcove and with a fully classic statue of the Madonna. Still at Rome, he created in 1285 and 1293 the Gothic ciboria (altar canopies) in S. Paolo fuori le Mura and Sta Cecilia in Trastevere with their remarkable form and sculptural vigour. Nicola's son, Giovanni Pisano, had a style which was more markedly Gothic, and was culturally more aware of the linearism of French sculpture. Apart from his collaborations with his father, we find him in 1284 as the master-craftsman responsible for the lower part of the façade of Siena cathedral. The statues of the prophets, biblical characters and sibyls on the façade, which are fully independent of the architectural divisions, are one of the high points of Italian Gothic in their incisiveness of line and striking dramatic sense. Between 1298 and 1301, Giovanni created the pulpit of S. Andrea at Pistoia, along the lines of the one at Siena. Here, however, one finds an overwhelming dramatic quality, broken and tormented lines, extreme tension and a violent contrast between mass and void, relief and hollow. The Madonna of Prato cathedral (1317) with the sinuous folds of the garments, expresses, in human terms, the mute dialogue between the

Virgin and the creature she holds in her arms.

The art of Giovanni Pisano inspired two other notable sculptors. One was Camaino who worked at Pisa, Florence and, from 1324, at Naples, where in the church of Sta Maria Donna Regina he left the best example of his work in the tomb of Queen Mary of Hungary. The other was the Pisan, Giovanni di Balduccio, who brought Tuscan Gothic sculpture to Milan with the tomb of St Peter Martyr in S. Eustorgio.

At the death of Arnolfo di Cambio, Andrea Pisano was sent for from Pontedera. Andrea was the major sculptor of the 14th century, and the one most open to international culture. His style not only had great naturalism but had also a sinuous and flowing, almost melodic, line. In 1330, he created the first set of bronze doors of the baptistry in Florence, and, after the death of Giotto in 1337, not only continued the construction of the campanile which had been left incomplete, but also created, in what was certainly the spirit of Giotto, the extremely beautiful insets of the Arts and Crafts that decorate it. The sculpture of this period outside Tuscany – in Milan, Bologna and Verona – was heavier and less noble in content.

Lorenzo Maitani, God creates the animals (from the façade of Orvieto cathedral)

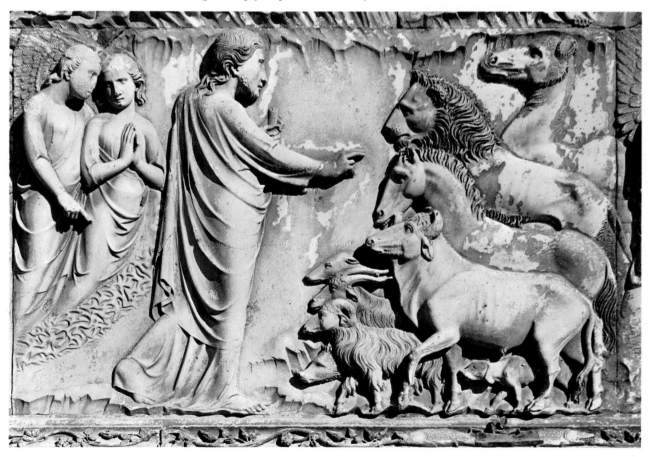

THE BIRTH OF ITALIAN PAINTING

Painting in Italy was dominated by three masters of widely different tendencies.

In Florence, there was Cimabue (*c.* 1240–1302?), who was sensitive to both Byzantine Neo-Hellenism and to the Romanesque expressionist vein of the mosaics of the baptistry in Florence. A profound pathos, due in part to the incisiveness of the contours, imbues his *Crucifix* in S. Domenico at Arezzo, and in the later one in the museum of Sta Croce in Florence (damaged in the flood of 1966). His *Madonna in Majesty* in the Uffizi, Florence, dates from 1285. The overall impression is still static, space is treated in an

Opposite page: Cimabue, detail of his 'Crucifix' (S. Domenico, Arezzo)

Below: Cimabue, 'Madonna Enthroned with Angels' (Louvre, Paris)

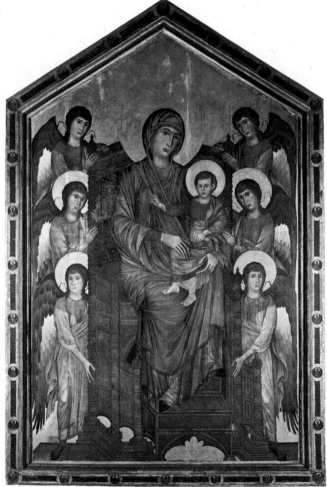

abstract way and the filigree illumination is Byzantine. Here, however, it is possible to detect the start of a new approach, a gradual appearance of volume, a sharp individualising of the contours. The most important surviving work by Cimabue is found in the frescoes in the choir of the upper church at Assisi, painted in about 1288, now sadly deteriorated yet still alive with dramatic tension. The fresco in the lower church, of the *Madonna Enthroned,* surrounded by angels and including the mystical figure of St Francis reveals spatial composition and a carved effect.

The second master was the Roman, Cavallini, whose approach was even more that of a sculptor. The third, the Sienese Duccio di Buoninsegna was already establishing the difference between the preciously colouristic line of Siena and the volumetric sense of form of Florence that was to be the fundamental dialectic contrast in Italian 14th-century painting. This shows up very well in his *Maestà,* now in the Museo dell'Opera in Siena, which was triumphantly carried to the altar of Siena cathedral with popular acclaim in 1311. Preciousness of colour and sinuosity of line, late Byzantine styles and the elegance of French Gothic miniatures are all to be found in this work. On the front is the *Madonna in Majesty* with three files of adoring saints superimposed one above the other with little sense of perspective; on the back are scenes from the life of Christ depicted with a strong feeling for illustration.

However, the one person who truly represented the turning point of painting was Giotto (1267?–1337). Possibly a pupil of Cimabue at Florence, he made his first journey to Rome in 1280, later going to Assisi, and brought about the meeting between Cimabue and the painters of Rome, among whom was Cavallini. His first great enterprise, twenty-eight frescoes of the *Legend of St Francis* on the walls of the nave of the upper church at Assisi, dates from 1298. The story is told tersely, with no anecdotal distractions. The frescoes all unfold in a new human dimension, marked with moral seriousness and caught at the most dramatic moment of the action. All the usual stylistic formulas are turned towards a new feeling for volume in the shapes,

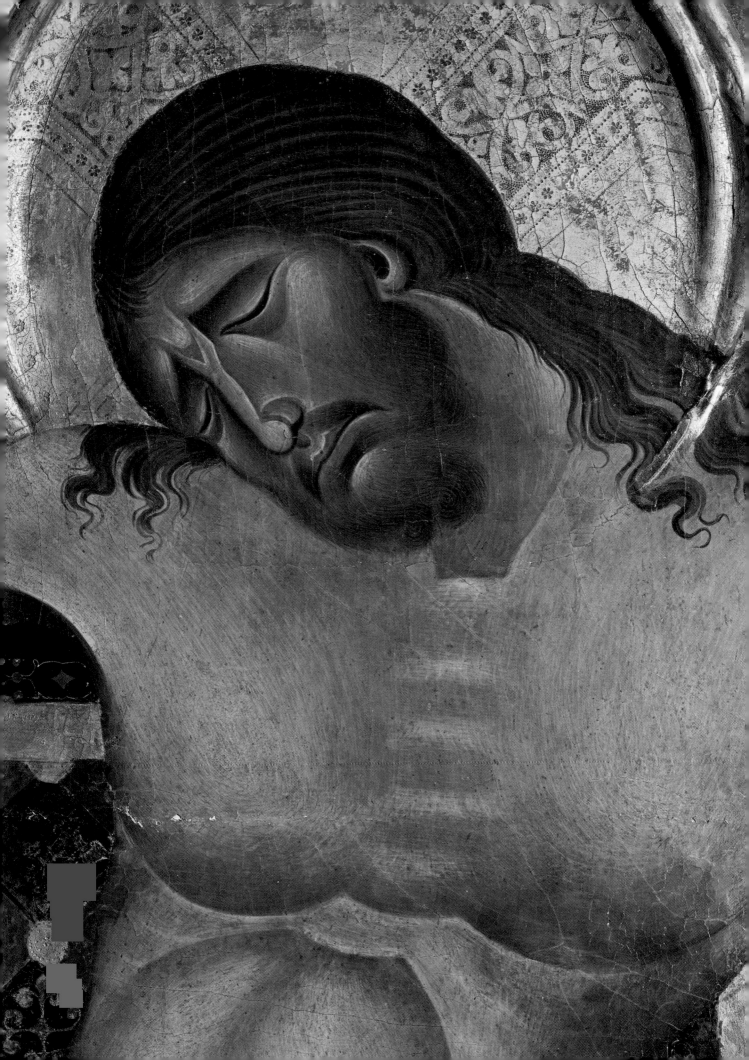

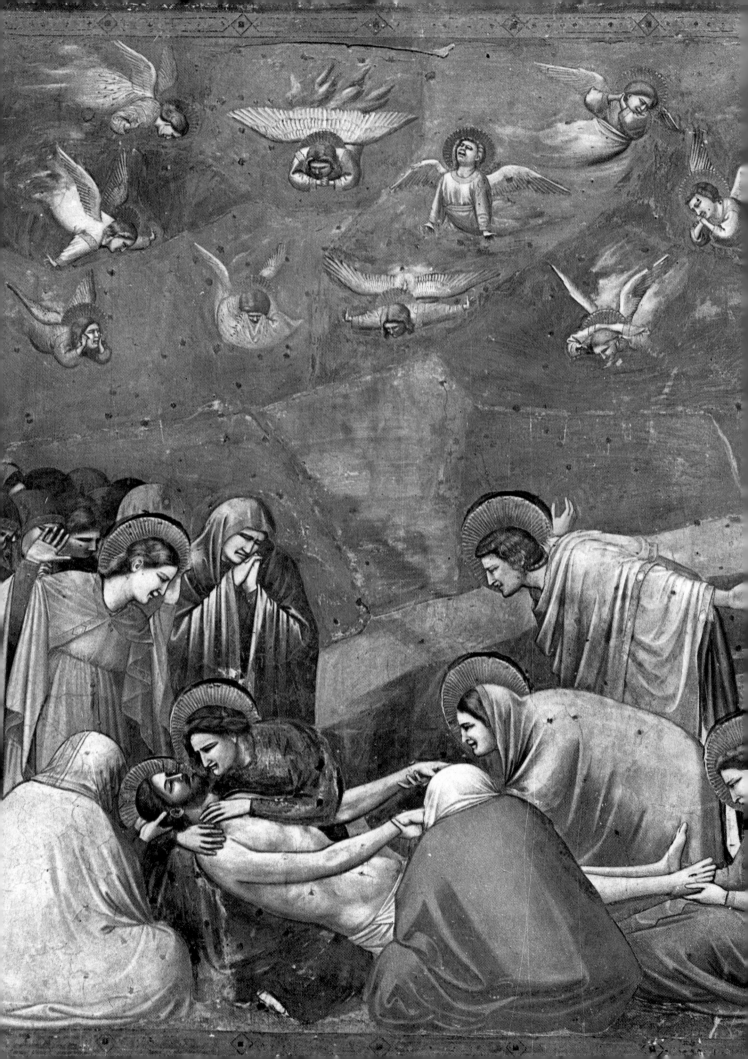

Left: *Giotto, the 'Deposition from the Cross' (Scrovegni chapel, Padua)*

Giotto, detail of architecture from the 'Life of St Francis' (S. Francesco, Assisi)

Giotto, detail of the 'Annunciation to St Anne' (Scrovegni chapel, Padua)

333

334

almost statuesque in their solidity. It is this same sense of compact and enclosed volume, which determines the spatial effects – in a far from naturalistic way. These, indeed, are the values which visibly marked Giotto's new approach to painting and which can be found in concentrated form in his *Madonna* at the Uffizi. Giotto's fame was really consolidated when, in about 1305, he was called to Padua to paint the frescoes in the chapel which Enrico degli Scrovegni had had erected. The narrative cycle includes scenes from the lives of Joachim and Anna and from the life of Christ, the Annunciation and the Last Judgement. His greater maturity can now be easily seen. There is more naturalistic freedom; the use of colour is more varied and harmonious; the spatial sense more profound and the volume more solid. More than anything else, however, these frescoes represent the unconditional realisation of a fusion between a limpid, forceful and extremely popular language and a language which was exceptionally concerned with figuration.

It is easy to understand the enormous repercussions caused by the rational and realistic pictorial language of Giotto. Florentine painting of the 14th century was completely overwhelmed by his disciples and imitators, and his influence,

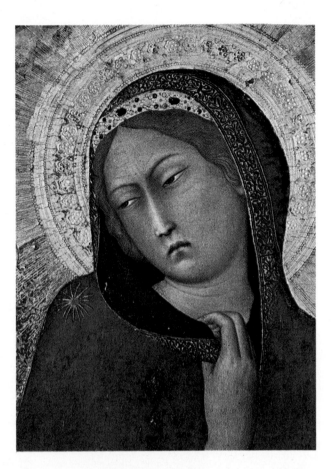

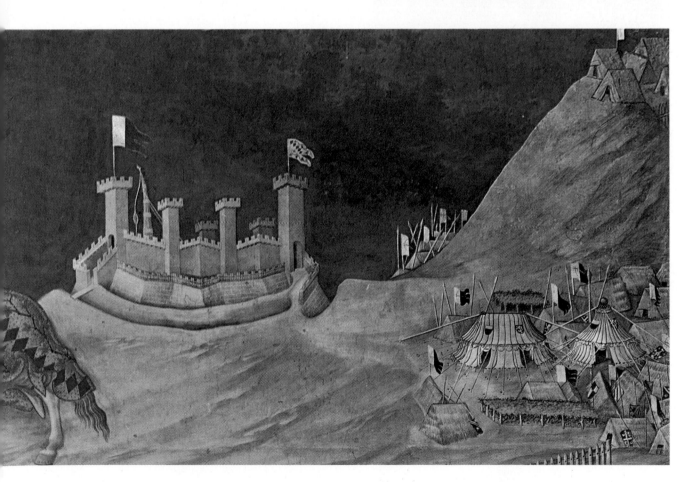

sometimes mingled with other derivations, sometimes combined with local interpretations, spread to Pisa, Padua, Milan and Bologna.

Younger than Giotto by some twenty years, Simone Martini (1284–1344) followed the tradition of Duccio in encouraging the spread of a more punctiliously Gothic style. Sophisticated and aristocratic, it relied on beautiful, flat enamelled colours and the sensitivity of flowing arabesques in flexible contours. Bearing witness to this enchanting antithesis of musical line and exquisite stylisation are the *Maestà*, painted in 1315 in the Palazzo Pubblico at Siena opposite the *condottiere*, Guidoriccio da Fogliano, shown riding alone across an unreal landscape; of the frescoes in late chivalric style in the chapel of S. Martino in the lower church of S. Francesco at Assisi; and, above all, the *Annunciation*, 1333 (Uffizi, Florence), with its background of gold.

It was Duccio who inspired Pietro Lorenzetti

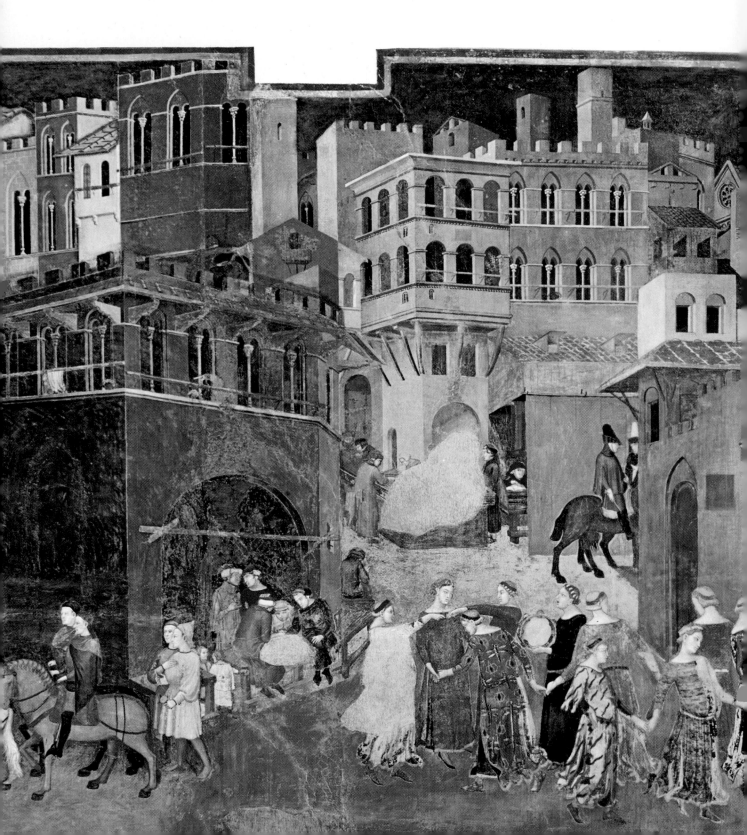

(active 1320–45), but the latter's dramatic vision was steeped in the taut expressionism of Giovanni Pisano and he was also very much aware of the influence of Giotto. The frescoes of the *Passion*, especially the *Deposition*, in the lower church of S. Francesco show how these influences inspired Pietro to great things. The extent to which the frescoes are imbued with an intimate linearism is revealed in the one of the *Madonna with St Francis and St John*. A calmer and more liberal imagination is evident in the work of Pietro's brother Ambrogio (active 1319–47), as may be seen in his frescoes (1337–39) of *Good Government* in the Palazzo Pubblico at Siena. The homage which the representatives of the Republic are paying to the Virtues is still founded upon medieval schemes, but the frescoes describing the effects of good government in town and country are alive with narrative naturalism and municipal and civic pride.

Ambrogio Lorenzetti, 'Good Government in the City' (Palazzo Pubblico, Siena)

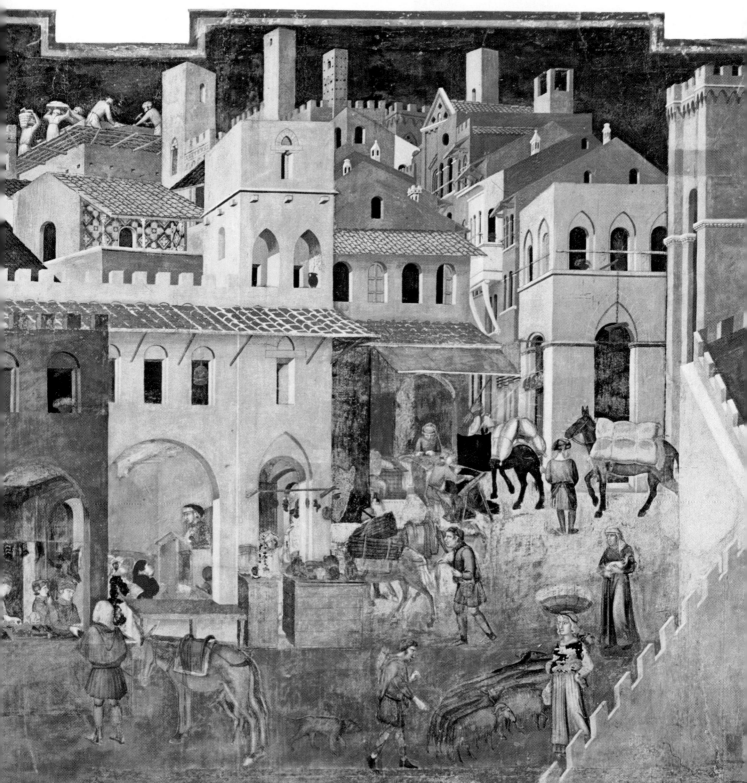

INTERNATIONAL GOTHIC

From the middle of the 14th century there was a shifting focus of style. Once essentially constructive in purpose, Gothic became simply an ornamental requirement. At times it was no more than an extraneous element, incidental and superimposed. Structures were not always coherent and related in purpose, nor did they always correspond to the stresses at play, but instead proliferated and blossomed into filigree and perforation. Stylistic features that originated with such essentials as the ogival arch or ribbed vaults and piers tended to be reduced to merely picturesque forms and designs, so that they became more profuse, elaborate and involved. Linear traceries were either isolated or grouped, straight or curved, vertical or supple, fragmented or intertwined. At the same time the already crowded formal repertoire became saturated with festooned friezes, pendants, tiers of arches, dentils and perforations, lobed arches, curves and counter-curves intersecting volutes, projections and recesses elaborately sculpted in the fabric.

Architecture and Flamboyant Gothic

The distinction between what is usually known as Florid Gothic (characterised by a vigorous outburst of plant decoration) and the overlapping of purely decorative elements is not always clearly definable. Neither is it easy to describe in detail the subsequent step which made the transition, with almost baroque violence, to Flamboyant Gothic – a style which, in its impetus, seemed to derive inspiration from the sinuous twisting and winding of a mounting flame.

Examples of this stylistic evolution can be found in all areas where Gothic architecture flourished. If one recalls the English taste for the complicated Decorated and Perpendicular styles, it is easy to understand how that country came to play a major role, particularly as Gothic survived longest there. The late 14th century naves of Winchester and Canterbury cathedrals with their urgent vertical rhythms and intricately ribbed vaults, were a prelude to the exuberant fan vaults and pendants in Henry VII's chapel (1503) in Westminster Abbey, which round off the impressive display of English Gothic. Other notable examples are the Divinity School at Oxford (1479) and the famous King's College chapel at Cambridge (1466–1508). In France this form of Gothic was developed in civil rather than ecclesiastical architecture, though the church of St Maclou at Rouen and the façade of St Wulfran at Abbeville, both dating from the first half of the 15th century, should be mentioned. A magnificent example is the palace built by Jacques Coeur, Charles VII's treasurer, during the middle of the 15th century at Bourges. The law courts in Rouen, built by Louis XII in 1499 after his Italian exploits, provide an extreme example of Flamboyant Gothic. The Low Countries were fervent contributors, with such notable examples as the town hall in Brussels, with its lofty belfry dating from the first half of the 15th century, and, a little later, the flamboyant verticalism of Louvain's town hall built by Matthew of Layens. In Germany the slow spread

Master of Biberach, 'Group of Mourning Women', wood (Staatlichen Museen, Berlin)

Opposite page: *Page from the Rohan Book of Hours (Bibliothèque Nationale, Paris)*

daim qui dort senefie thuarist qui dorm
en la crois cue qui p̃ sti lore du coste
dadaim senefie sainte eglise qui p̃ st lores du
coste thuarist leo dnilles lestre seruent t dui
see trligions

MAY· d· xxxi lo· xiiii·
Et la lune xxx·
n· b· S philipe· S iaqued·

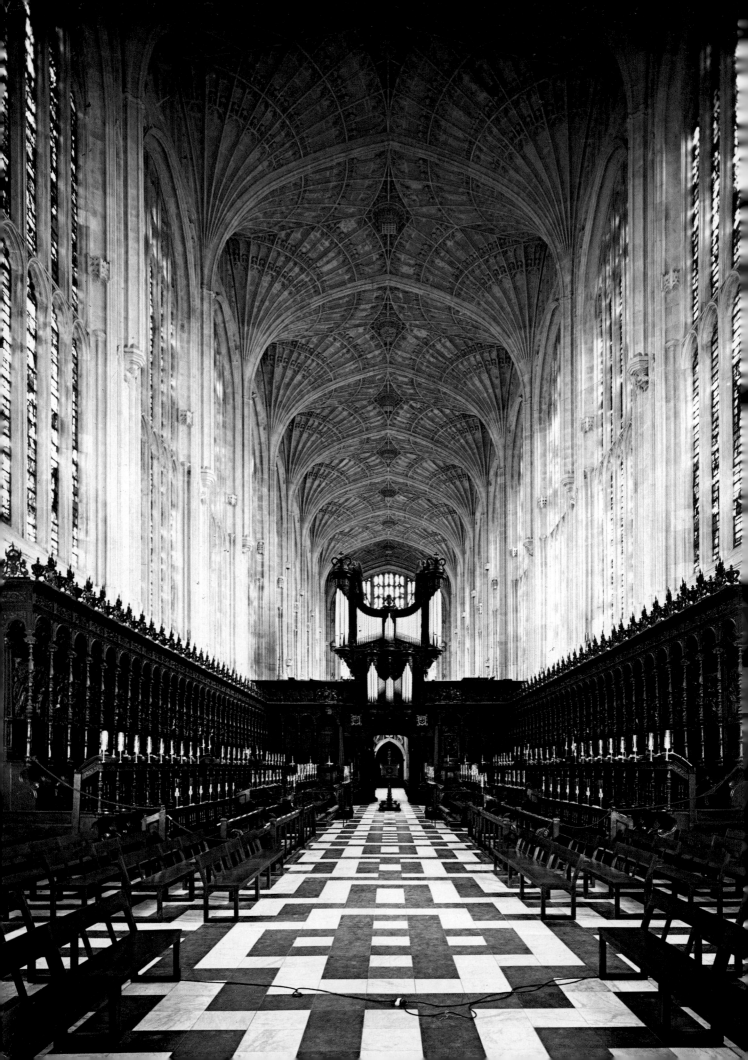

of Gothic makes it more difficult to recognise the subsequent development of late Gothic, of which, however, several remarkable examples survive. They include the choir of Freiburg cathedral (re-echoing the spatial concepts applied by Parler in Prague), the Franciscan church (1408) at Salzburg and that of St Ulrich and St Afra at Augsburg. The new stylistic developments even spread into the Iberian peninsula: the 15th-by the incongruous 17th-century façade – was structure of Seville cathedral and, in Portugal, the abbey of Batalha, are just a few of many examples of the way Gothic here lapsed into almost baroque excess.

In Italy, Florid, or Flamboyant, Gothic has left its more important works at Milan and Venice. In 1386 the century-long construction of the huge pile of Milan cathedral – later defaced by the incongruous 17th-century façade – was begun by a horde of Italian, German and French craftsmen. The interior, with its nave and double aisles and remarkable transepts, is impressive in its harmony, and it introduced some singular innovations like drums (decorated with tabernacles filled with statues) over the capitals of the slender pillars. On the outside a luxuriant wilderness of spires, pinnacles, niches and an

Interior of King's College chapel, Cambridge

The interior of Milan cathedral

The apse of Milan cathedral

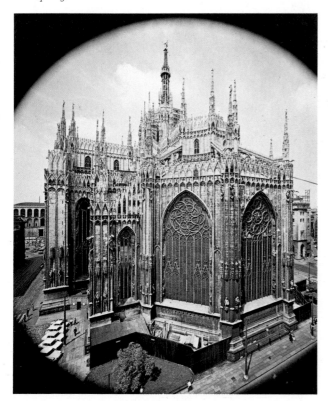

army of statues grew up around the tall spire. The structural values were submerged, repetitively and insistently, by a confused luxuriant marble vegetation, whose effect is purely decorative and intended more to impress than to suggest emotional values. Also designed to impress, and to be consciously picturesque, but in quite a different manner, is the Doges' palace in Venice, set against the iridescent background of the lagoon. The graceful Florid Gothic balcony on the southern façade, fronting onto the Bacino, was built between 1348 and 1400 and is the work of the Dalle Masegne brothers, whereas the continuation of the Piazzetta side in about 1424 is the work of Tuscan craftsmen. The paradoxical reversal of mass by which the heavy, compact part (although lightened by the delicate pink and white inlaid motif of the walls) overhangs the deep void of the galleries on the first and ground

floors, is governed by a desire for the picturesque rather than by rules of structure. The link between the Doges' palace and the chromatic mass of St Mark's is achieved by the polychrome Porta della Carta, the work of Giovanni and Bartolomeo Bon between 1438 and 1443. This would be the most typical example of Flamboyant Gothic were it not for the charming, almost ethereal architecture of the jewel-like Ca' d'Oro on the Grand Canal, begun sometime after 1421 and completed about twenty years later.

Sculpture

Gothic sculpture presents a less well-defined and more intricate panorama. On the one hand, in its decorative function it was often closely connected with architectural developments; on the other, it was bound up not only with the

Pillar in the choir of the church of the Jacobins, Toulouse

The Limburg Brothers, 'April', miniature from the 'Très Riches Heures du Duc de Berry' (Chantilly, Musée Condé)

goldsmith's art but with the impressive development of the minor arts in all their branches. One of the widespread, if not general, tendencies of the Florid Gothic style of sculpture was towards preciousness and elegant mannerism. In particular it emphasised sinuosity of line, softness of drapery with a multiplicity of folds and swags. Examples of the style include the Madonnas of Nino Pisano in Tuscany, the pure sweetness of the Bohemian school, the nervous linearism of the Franco-Flemish school which sprang up around the Burgundian court, and the mannered *Schöne Madonnen* or 'Beautiful Madonnas' in many German churches. A virtually opposing trend, which usually appeared in secular subjects – particularly funeral sculpture – was the compelling desire for naturalism – a movement which anticipated realism. Works quite remote from one another confirm this trend, which heralded a new artistic climate founded on realism. Examples are the Beauneveu statue of Charles V in the basilica of St Denis near Paris, the bronze effigy of the Black Prince (1376) in Canterbury cathedral, the effigy of the 'Reading Page' in Sigüenza cathedral in Spain (1406), the figures which adorn Jacques Coeur's palace at Bourges, and above all, near Dijon, the powerful creations of expressionistic realism moulded by the Franco-Flemish Klaus Sluter in the Charterhouse of Champmol at the end of the 14th century.

Painting

However, the art which best expressed the changing style of late Gothic was painting. So well did this interpret a subtle nostalgia pervading not only in noble circles but also in those bound to the concrete mercantile interests of a rising middle class, that the period has aptly been described as 'the autumn of the Middle Ages'. In this sense there existed singular affinities between artists of different countries that extended beyond personal contacts and precise influences. These painters were lifted out of the historic reality that surrounded them into a dreamlike, enchanted world of elegant aristocracy. It was the re-creation of an already vanished world of chivalry that took on romantic overtones, the myth of courtliness devoted to elegant clothes or affected, exquisite gestures.

Opposite page: *Pisanello, the 'Annunciation', detail (S. Fermo, Verona)*

Pisanello, bronze medals (Civic Museum, Brescia, Italy)

Below: *Giovanni di Paolo, 'St John in the Desert' (Ryenson Collection, Chicago Art Institute)*

Technical skill supported these inclinations with a love for the minute and for calligraphy, for the detailed rhythmic arabesque, for vivid, dazzling colour used for its own sake rather than to interpret volumes. International Gothic is the term used to define such similarities, yet if it serves to underline trends common to all the different national schools, this term also tends to overlook the former international character of the entire Gothic civilisation.

The exponents and centres of International Gothic which flourished in the last quarter of the 14th and the first quarter of the 15th centuries, were many and varied. In France the chief centre was the Burgundian court at Dijon and Bourges, then also under the influence of Franco-Flemish trends. Less prominent was Paris, although 14th-century anticipations of the movement are to be seen there in Jean Pucelle's production of miniatures. Outstanding examples of International Gothic are Jean de Baumetz's graphic *Pietà* in the Louvre; the delightful wings of an altarpiece, formerly in the Charterhouse of Champmol and now in the Dijon Museum, in

which Melchior Broederlam combined the *Presentation in the Temple* and the *Flight into Egypt*; the Duc de Berry's exquisite Psalter, illuminated by the painter and sculptor André Beauneveu de Valenciennes; the calligraphy and delicately shaded miniatures which Jacquemart de Hesdin, in the first decade of the 15th century, used for the *Très Belles Heures*, now in the Royal Library of Brussels (also for Jean de Berry).

All these works indicate the path that was to lead to the fascinating masterpiece executed somewhere around 1416 by the two Limbourg brothers of Nijmegen. This was the *Très Riches Heures du Duc de Berry*, now in the Condé Museum at Chantilly. In this work noble courtly scenes alternate with those representing humble peasant tasks, the whole being picked out in enamelled colours against a landscape background of the most famous castles in France. The juxtaposition of aristocratic themes with an incipient realism is remarkable.

In the south of France the papal court at Avignon was the centre of a different order, marked by the influence of the Sienese Simone Martini, who settled there for the last years of his life (1339–44) and who made a present to his beloved Petrarch of the illuminated works of Virgil, now at the Ambrosian Library in Milan. The frescoes in the Wardrobe Tower of the papal palace, depicting scenes of hunting and fishing painted by Italians, constitute a page of great freshness. Central Europe was still a most vital centre, with the mystic, terse painting of the Master of Třeboň (Prague Museum) and an intensive production of miniatures.

Spanish painting was also very prolific at this moment. Luis Borassà at Barcelona introduced International Gothic, mixing echoes of Siena and native strains. This culminated in the first decades of the 15th century with the chivalrous myth and sinuous composition of Bernardo Bartorell's picture *St George Slaying the Dragon* (Chicago Art Institute).

There were painting cycles of undoubtedly courtly inspiration in northern Italy. The frescoes in the castle of Angera, dating from the first half of the 15th century, anticipate this taste, which later appeared in the castle of Manta near Saluzzo, with what almost amounts to a gallery of fashionable models. Around 1407 an unknown master delightfully depicted the events of each month in the Eagle's Tower of the castle of Buonconsiglio at Trent, mingling Lombard and northern influences.

Milan was an important centre for International Gothic. It was already far ahead in breaking new ground, for Giotto's influence had been developed, as shown by the frescoes of Viboldone, Lentate and Mocchirolo (now in the Brera Gallery). Giovannino de' Grassi revealed his elegant taste and a fairy-like unreality in the miniatures in the Visconti 'Little Office' (National Library, Florence) and even more so in his sketchbook in the Bergamo Library. Franco and Filipolo de Veris, the talented authors of *The Judgment*, a fresco in Sta Maria dei Ghirli at Campione, showed themselves to be fine illuminators in the *Theatrum Sanitatis* or 'Theatre of Health' (Casanatense Library, Rome) and the *Tacuinum Sanitatis*, or 'Notebook of Health' (National Library, Vienna). The *Nuptials of St Catherine* (Picture Gallery, Siena) and the *Nuptials of the Virgin* (Metropolitan Museum, New York) by Michelino da Besozzo show remarkable northern influences. The frescoes in the Palazzo Borromeo in Milan of scenes from games in fancy dress are also attributed to him. The Zavattaris prolonged this aristocratic taste right up to 1444 in a chapel in Monza cathedral by depicting the deeds of Queen Theodelinda in contemporary dress.

Verona was another important centre of International Gothic painting. As early as the 15th century, Stefano da Zevio revealed himself as one of the most enchanting exponents of the style with his unreal, celestial *Madonna in the Rose-garden* and *Madonna with the Quail* (both at the Castelvecchio Museum) and in the fresco of the angels at S. Fermo in Verona. Antonio Pisano, called Pisanello (1395–1455), was more cultured, less provincial and already showed a shrewd anticipation of realism in his drawings (nearly all in the Louvre, Paris). But in frescoes such as the *Legend of St George* in Sta Anastasia or in the nocturnal scene of the *Legend of St Eustachius* (National Gallery, London) he introduced fable and chivalry.

In central Italy, more even than at Florence, where Lorenzo Monaco carried on the Sienese tradition with decorative flourishes, it was Gentile da Fabriano (*c.* 1360–1428), in the Umbrian Marches, who continued to enchant. Perhaps extended stays in Venice and Lombardy gave him the International Gothic inspiration which richly enhances his *Adoration of the Magi* (1423, Uffizi, Florence) with its golden light, beautifully coloured costumes and flowing lines. In this way the Gothic period, rather than coming to an abrupt end, gradually faded out.

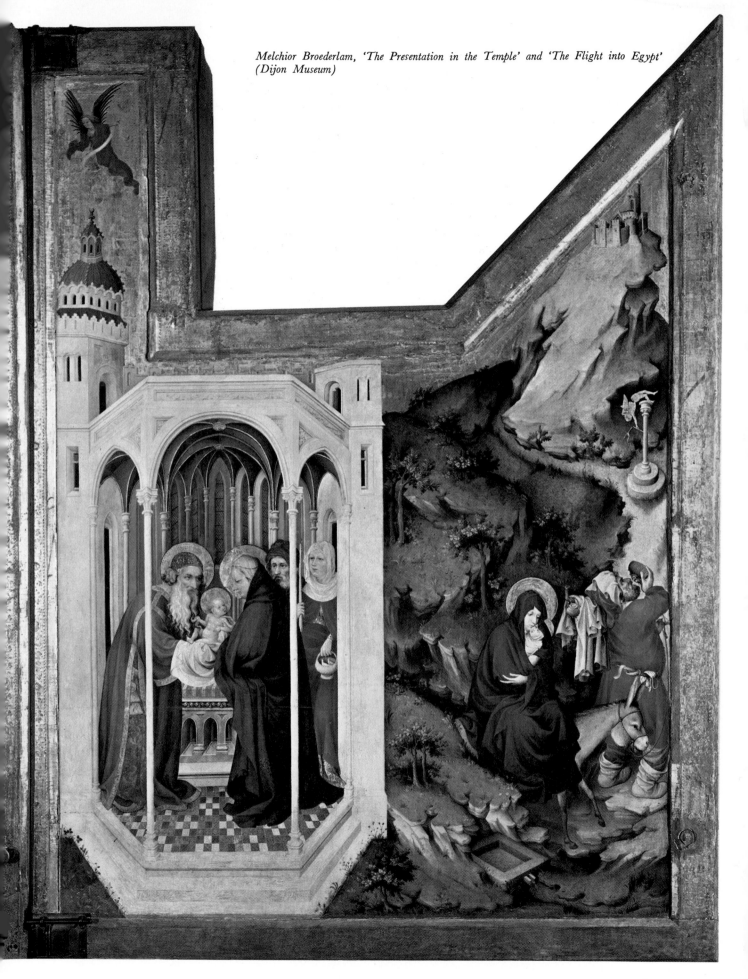

Melchior Broederlam, 'The Presentation in the Temple' and 'The Flight into Egypt'
(Dijon Museum)

THE RENAISSANCE IN ITALY:
15TH CENTURY

15th-century Italy was the birthplace of the society that eventually found its counterpart in the whole of modern Europe. Strategically placed along the trade routes to the East in the central Mediterranean and with a flourishing communal life – both rural and urban – the cities of northern and central Italy were the first to produce a type of man who had nothing in common with feudal civilisation: the middle-class man. His trading, manufacturing, financial and commercial undertakings, his acceptance of risk and even of adventure, his political scheming, his power, his riches – but also his refined tastes and his culture – together constituted a total break with the con-

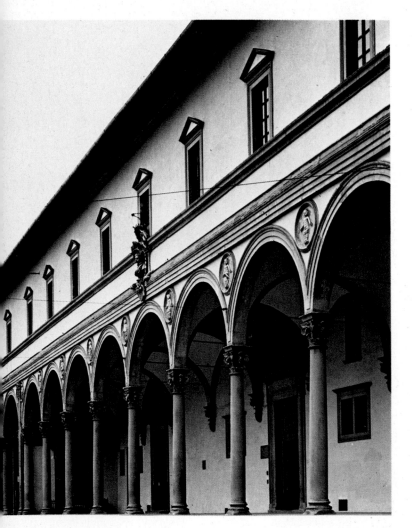

stricting net which had formed and contained medieval man. Whether bankers or popes, soldiers of fortune or statesmen, the protagonists of the Italian Renaissance dared not only aspire to power, but conquer it and boast about it.

Of course this process did not happen in a day, but began gradually in the core of the rich and active Italian society of the latter part of the Middle Ages. Naturally connections with the recent past still existed, and were expressed both in the resumption of the most vital stream of native tradition and, in the new age, in the continual revival in calm and alert minds of doubts that had only recently been assuaged and of anxieties that had only apparently been dispelled. The harking back to the remote past of Rome and Greece mushroomed to such an extent that it transformed the classical world into a myth which men sought to revive, but which could not be revived without smothering both the mass of experience Italy had acquired through centuries of Christianity and the original and dynamic advance of the new society.

Thus there arose a complex cultural problem interwoven with new points of departure and evocations of the ancient world. Old needs were felt with a new spirit, while the eruption of human activity into various fields of action and knowledge enriched and co-ordinated the components of culture. Everything overlapped: neo-platonic aestheticism with Aristotelian naturalism; the re-interpretation of the Christian faith with the unspent demands of religious rigorism; the development of mathematics with the discovery of new countries; magic skills for dominating

Filippo Brunelleschi, the dome of Sta Maria del Fiore (Florence)
Filippo Brunelleschi, the Foundling Hospital (Florence)

348

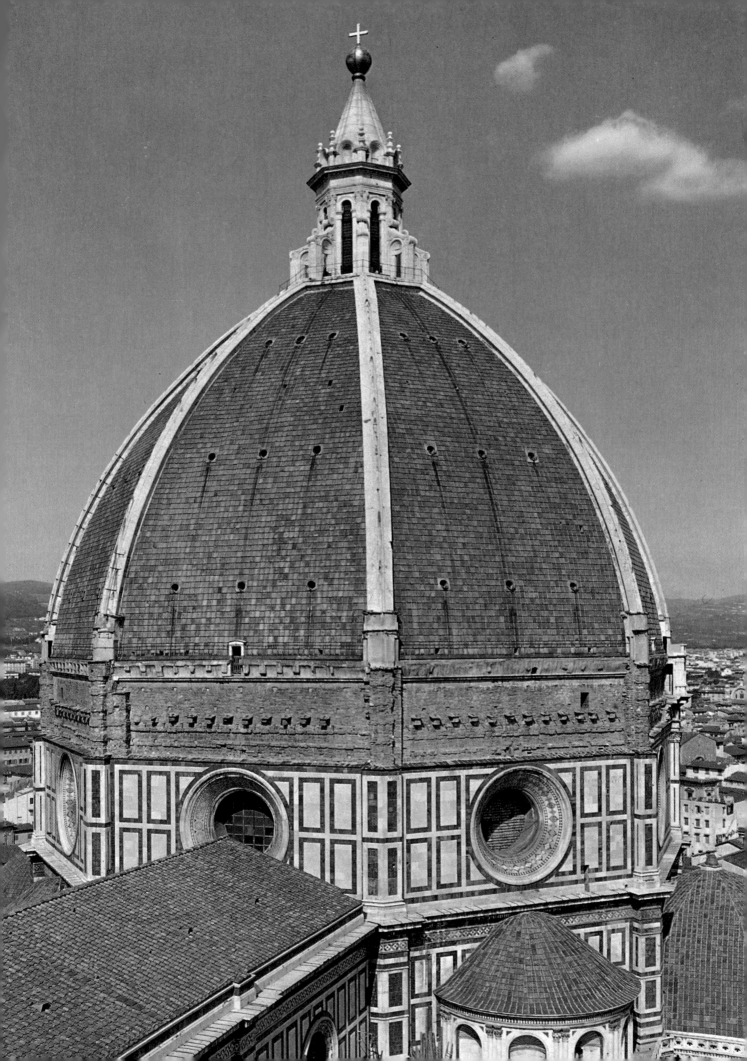

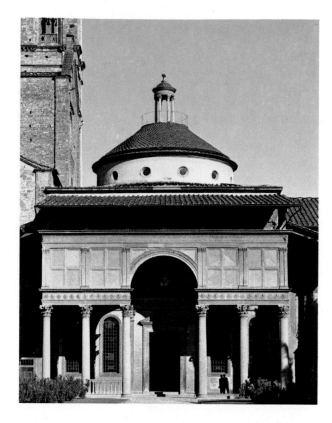

Filippo Brunelleschi, the Pazzi chapel, exterior and lateral section (Florence)

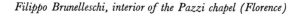

nature, with great works to make her truly subservient to man; aesthetic artistic problems with the birth of a technique of politics conceived as an art. All this made up the prolific and diverse context of the cultural renaissance, matrix of modern Western culture.

Underlying all this was the great richness of Italy at that time, the first country to enter the ascending spiral of modern society.

However, it was not in Italy that modern society attained its maturity nor there that the modern state, an indispensable complement to growth and consolidation of the new economic ventures and even of the new culture, was born. Amid the splendour of her courts and the array of balanced, clever men and brilliant political skills, 15th-century Italy revealed her incapacity to achieve the federal unity that alone could have endowed her with a structure adapted to the new society. The discovery of America in 1492, the displacement of the trade routes in the direction of the Atlantic, and the influx of new riches to European countries already constituted as national states, made the deficiencies of 15th-century Italy even graver and more definitive. And at the beginning of the 16th century Italy thus became a prey for the new emergent powers in Europe – a prey splendid but easy to take, a stake, justly coveted, in the great duel between France and Spain and between France and the Habsburg Empire.

Overrun by mercenary armies, arena of the first battles in the bloody history of modern Europe, despoiled of her accumulated gains and her works of art (the disastrous sack of Rome took place in 1527), deprived of her sources of income, Italy found herself rapidly impoverished. Already, by the middle of the 16th century, while the whole of Europe continued to be inspired by her culture and her civilisation, Italy herself was a country no longer worth conquering – a country which could be abandoned to the greedy and reactionary exploitation of decadent Spain. Over and above this political and economic collapse, the serenely confident onset of the Renaissance had reached a critical point, confirmed in the 16th century by the rupture in religious unity and by the Protestant Reformation, the new determinant of Europe's cultural development. No less serious was the spiritual sterility caused by the successive reactions of the Church and the suffocating atmosphere of the Counter Reformation.

So it was that modern society and culture, though born in Italy, were unable to pursue their proper development there. However, the arts continued to function at their peak in Italy. The Renaissance, while nourished by intellectual and rationalistic influences, was a great and original movement that renewed everything. For this very reason, it was not an impossible resuscitation of ancient art that emerged but the conquest of new forms and of a new style.

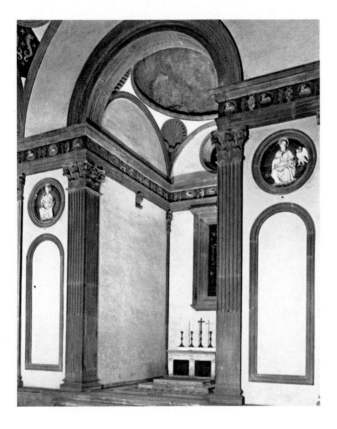

The Renaissance in Florence: architecture

Filippo Brunelleschi (1377–1446) inaugurated the Italian Renaissance in Florence. His architectural language, although following a continuous development from the Old Sacristy of S. Lorenzo to its culmination in the Sto Spirito, was born complete and absolute – an explicit liberation from the still recent Gothic experience – and was characterised by its use of pillars as the regulators of thrust and counter-thrust. It was an obvious refutation of the plastic ideals with which Leon Battista Alberti had experimented and which were to characterise 16th-century architecture.

Brunelleschi's mark of originality lies above all in the way he made the internal spatial void so real. Enlivening factors were the dimension of light, austere building technique and decorative additions. On the outside the clear parallelepipedic volumes, freed from the polychrome effects so dear to preceding Florentine architects, were plunged into the enfolding space. Apparently born spontaneously, Brunelleschi's works expressed an intimate balance translated into a spiritual order composed of reason and poetry. His classicism was never nostalgic for the experiences of the past, nor was it simply the application of rules and formulas: it was the measure of the new man, born of a culture, ethic and religion which had been renewed by literary and philosophical Florentine humanism. His classicism was overwhelmed by transcendental impacts: it was the love of scientific research which inspired him to experiment with perspective linear vision, destined to remain basic to the figurative arts right up to the end of the following century.

In an architectural sense his cultural history was completely Florentine. It sprang from the prismatic concept of the baptistry of S. Giovanni and the basilicas of S. Miniato and of the Holy Apostles, showing that same inclination towards the abstract which once had linked Florentine Romanesque with Byzantium. Brunelleschi's creative programme was fashioned by his experiences as a sculptor – right from the time of his participation in the competition in 1401 for the second set of bronze doors of the baptistry (as testified by the panel depicting the *Sacrifice of Isaac* in the Bargello Museum at Florence) to the realisation of the Crucifix in Sta Maria Novella, where he was competing with Donatello.

His scientific attitude was wholly expressed in the construction of two small perspective tablets demonstrating rules for the exact concept of perspective for a building. His influence on the Florentine artistic climate was immense inasmuch as he imposed the adoption, in painting as well as in sculpture, of the new concept of spatial unity according to the canons of linear perspective. A few examples among many are Donatello's bronze panels on the altar of the Santo in Padua and Masaccio's fresco of the Trinity in Sta Maria Novella in Florence in which the illusion of three-dimensional space is achieved.

When, between 1418 and 1428, Brunelleschi built the Old Sacristy in S. Lorenzo he took the square as a module and the cube as a spatial reference. Internal surfaces, defined by pilasters and architraves, culminated in the umbrella vault which Brunelleschi called 'crested', emphasising its linear connections. In 1421 he embarked on the project for the Foundling Hospital, of which there now remains only the gracious, vibrant loggia of slender columns. Rising stem-like above the flight of steps, these are interrupted twice – first by the delicate curving arches and then by the positioning of the austere architrave. As time slowly progressed, from 1418 onwards, S. Lorenzo began to take shape. Light and colour are equally stressed in the co-ordinated space; immense harmonised dimensions, flights of perspective and proportioned structures make this noble Florentine basilica the classic example of an architectural work responding to a renewed religious sentiment which, being of the human order, aspires to the divine order.

The period of Brunelleschi's most intense activity was between 1430 and 1440 when he was simultaneously employed in completing the dome of Sta Maria del Fiore (the cathedral at Florence), building the Pazzi chapel and drawing up the plans for the Sto Spirito church and the Palazzo Pitti. The Gothic style was Brunelleschi's starting point for the cathedral, but he avoided giving a purely vertical elevation to the dome, creating instead a huge, calm area dominating the mass below. The supple upward surge of the ribs is intended to contain the structure rather than elevate it, and culminates in the splendid lantern with its rounded, dignified arches. In the Pazzi chapel the interior recalls the parallelepipedic volumes of the Old Sacristy, and the exterior the connection between arch and architrave as resolved in the façade of the Romanesque cathedral at Civita Castellana. Sto Spirito took up the remainder of Brunelleschi's life. Here the rectangular plan was re-introduced and developed to great perspective effect with a double aisle in the transept. The ceiling plane blocks the light but a new and unexpected feature is the introduction of continuous niches along the walls to create a dynamic surface which encloses the space alternately in light and shade.

After Brunelleschi, Florentine architecture opened up paths to endless solutions, but all were pervaded by his spiritual and geometrical values.

Leon Battista Alberti (born Genoa 1404; died Rome 1472) was a pure product of humanist culture, both Florentine and Roman, as demonstrated by his temperament, his studies and the circles in which he moved (he was secretary of the Pontifical Chancellery). His genius has always been regarded as being in opposition to that of Filippo Brunelleschi.

In Alberti's output one can see his evolution from the adoption of classic formulas (coupled with the persistence of features that were still Gothic) to a handling of mass which, in its approach to proportion and form, recalled the architecture of Imperial Rome. If, in general, Rome was always the inspiration behind the concept of monumentality in all Alberti's work, he was placed firmly in the mainstream of 15th-century Florentine architecture by his flexibility in accepting Brunelleschi's premises and, in buildings he restored, Brunelleschi's profound respect for the past.

When Alberti began the task of facing the Tempio Malatestiano in Rimini in 1450, Brunelleschi had been dead for four years. In his treatment of the façade Alberti, now more than forty-five years old, showed a nostalgia for Roman triumphal arches (inspired by the one in Rimini itself). The arcading along the side of the building recalls the pillars and arches of the aqueduct of Flavius. Previously he had lived in Padua, Bologna, Rome and Ferrara, but only occasionally in Florence. It is not surprising, therefore, that at Rimini he showed no evidence of Tuscan influences. However, when Alberti came to build the Palazzo Rucellai in Florence he had no hesitation in adopting the style of entablature already used by Brunelleschi on the Palazzo Pitti. Here he showed the theoretical and rational nature of his personality in the inclusion of vertical pilasters which help to emphasise the mullioned windows with their heightened arches. Similarly with the Loggia and the Rucellai chapel, Alberti showed himself to be far from indifferent to the Florentine tradition, just as he upheld it in the insertion of the portal and the completion of the upper part of the façade of Sta Maria Novella. There, playing with decorative effects, he added linking features which in no way change the whole and are faithful to Gothic tradition.

S. Andrea at Mantua (completed in 1470 by Luca Fancelli after Alberti's death) is quite outside the Florentine Brunelleschi tradition, both in its use of adjacent cubes (three in the longitudinal nave, two in the transept) and for the huge barrel vaults above the architraves. In this creation by Alberti, the light – partly deflected by Juvara's dome – unifies the volumes in complete antithesis to Brunelleschi's concept, of light in harmonious but distinct areas.

On the Florentine scene Michelozzo (1396–1472) was a follower of Brunelleschi and collaborated with the master. His masterpieces belong to the central period of his activity. In the monastery of S. Marco (1437–52) the library is

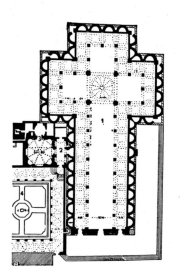

Filippo Brunelleschi, plan of Sto Spirito (Florence)

Opposite page: *the interior*

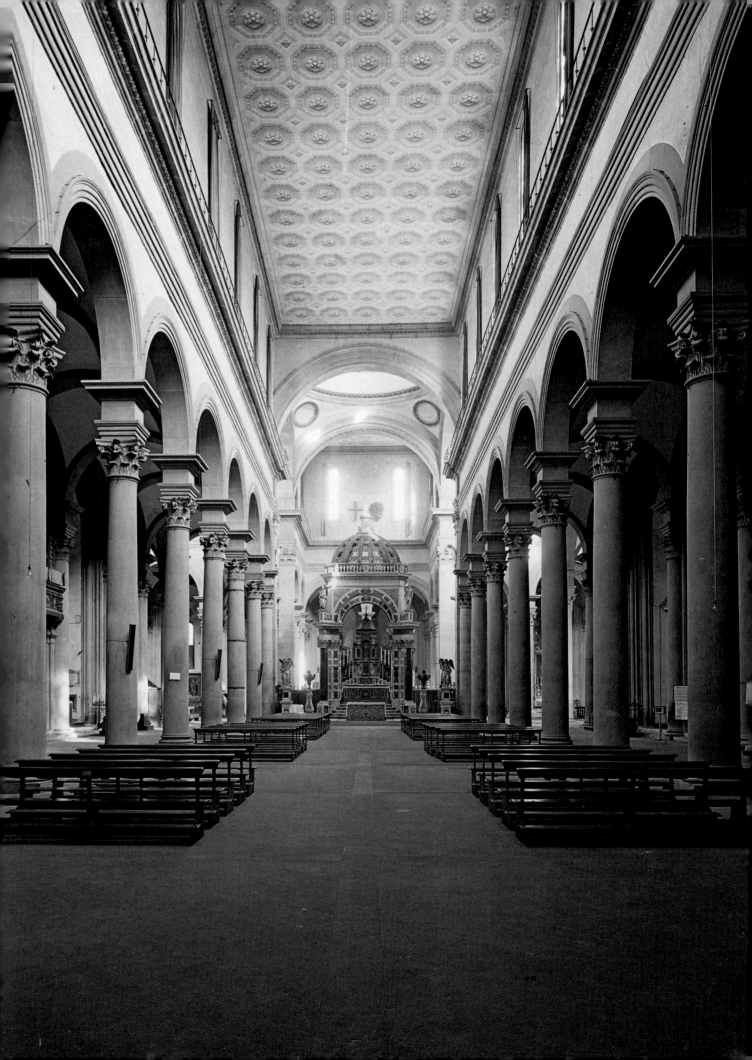

probably the most characteristic example of his work. It is extremely simple, but of considerable ingenuity in the way the rhythm of the columns is connected by delicate arches and the gentle curve of the vaults resting on corbels. The Palazzo Medici in the Via Larga, begun in 1444, echoes Brunelleschi's Palazzo Pitti with its horizontal blocks of rusticated masonry on the ground floor. By diminishing the rustication on the second storey and omitting it altogether on the third, however, Alberti allowed the light spreading from the top to dominate until it is suddenly cut off by the deep cornice with its prominent girders. The villa at Cafaggiolo, a Medici retreat, dates from 1451 and is turreted in the medieval manner although the extensions of the wall surfaces, with their clear-cut edges, are unadorned.

An anxiety to reconcile the Brunelleschi manner with that of Alberti dominated the work of Bernardo Rossellino (1409–64), who was employed by Pope Pius II (Aeneas Silvius Piccolomini) in the rebuilding of Pienza. (This was one of the first experiments in rational town planning). The Palazzo Venezia at Rome, which is attributed to Bernardo, is of stark purity and is significant also for the transfer of Florentine ideas to the home of the papacy.

In the meantime, the rich Florentine middle classes were competing with each other in the building of their palaces, amongst which are Benedetto da Majano's Palazzo Strozzi and Giuliano da Majano's Palazzo dei Pazzi. Among the churches, S. Salvatore al Monte, so dear to Michelangelo, is the work of Simone del Pollaiuolo and already anticipates the 16th century, while the square masses of the church of Sta Maria delle Carceri at Prato, by Giuliano da Sangallo, bring the 15th century to its close.

Sculpture in Florence

The first official act concerning 15th-century Italian sculpture was the announcement of the competition for the second set of bronze doors for

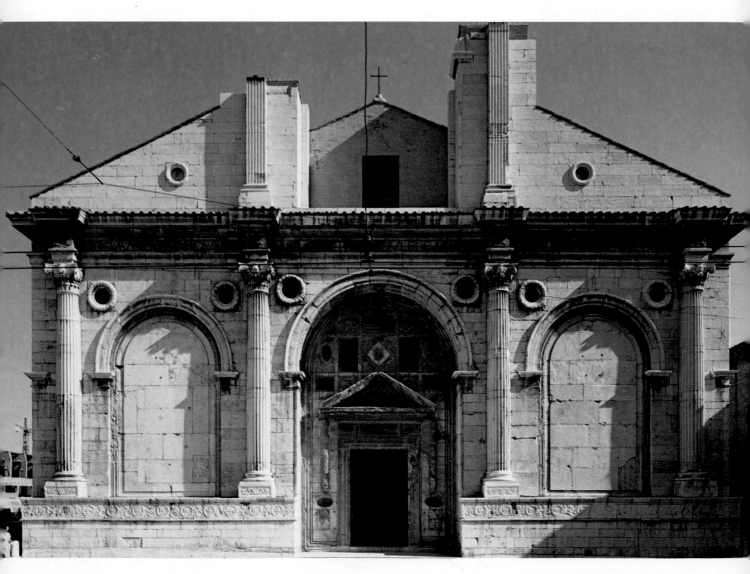

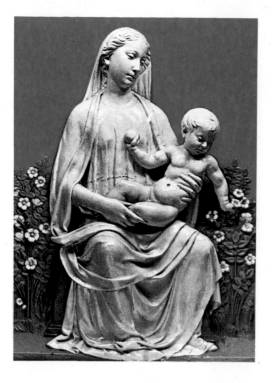

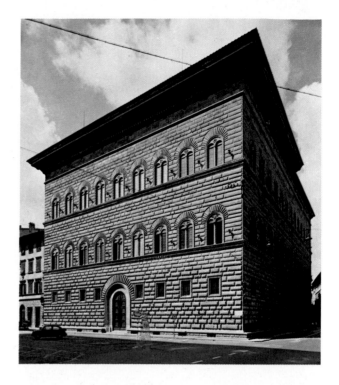

the baptistry at Florence in 1401. Brunelleschi, Jacopo della Quercia (1371–1438) and Lorenzo Ghiberti (1378–1455) participated: the latter was the winner because his style was closest to that of Andrea Pisano's first set of doors, and his taste for Florid Gothic pleased the conservative Florentines. Ghiberti immediately set to work, and between 1403 and 1407 employed the young Donatello in his workshop as a panel polisher.

Meanwhile Jacopo della Quercia, defeated in the contest, started the tomb of Ilaria del Carretto in Lucca cathedral and finished it in 1406. In this fascinating work there are obvious Gothic rhythms in the drapery, but the nobly thoughtful countenance ushers in Renaissance naturalism. Still at Lucca between 1413 and 1422, Jacopo sculpted the altarpiece for the Trenta chapel in S. Frediano. This bridged the most dramatic moment of contrast between Gothic undertones and a desire for innovation. From this point Jacopo definitely emerged as an innovator in his figures for the Fonte Gaia, or 'gay' fountain, formerly in the Piazza Palio in Siena, and now in the Palazzo Pubblico (the present fountain in the Palio is a copy). Among these figures *Wisdom*, because of its serene composition and thoughtful expression, constitutes the link with the sculptural cycle on the doorway of the church of S. Petronio at Bologna, executed between 1427 and 1437. Here a feeling of space, powerful sculpted relief, coherence between the natural background and

Benedetto da Majano, Palazzo Strozzi (Florence)

Above, left: *Luca della Robbia, 'Madonna of the Rose Garden' (Bargello Museum, Florence)*

Below: *Leone Battista Alberti, Palazzo Rucellai (Florence)*

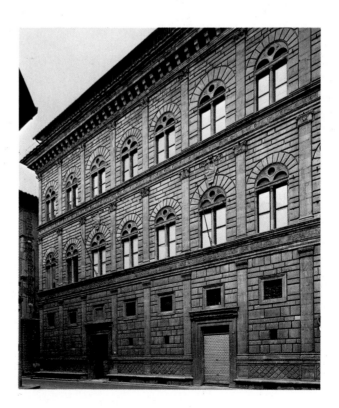

Opposite page: *Leone Battista Alberti, the 'Tempio Malatestiano' (Rimini)*

355

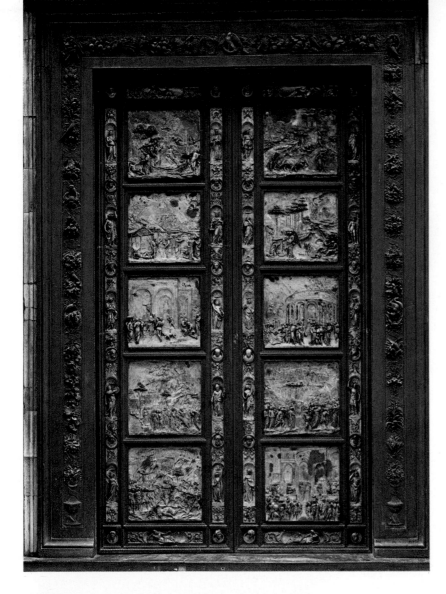

Lorenzo Ghiberti, the 'Gate of Paradise'
(Baptistry, Florence)

Opposite page: Lorenzo Ghiberti, the
'Sacrifice of Isaac', detail from the 'Gate
of Paradise' (Baptistry, Florence)

Below: Jacopo della Quercia, the
'Banishment from the Garden of Eden'
(S. Petronio, Bologna)

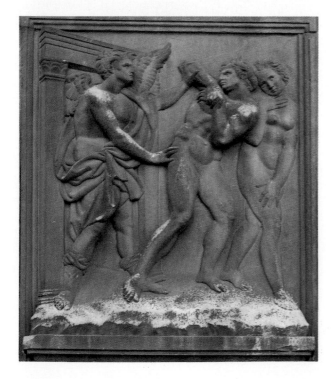

the human drama, the vigorous stance of the figures, the anatomic strength and the bold drapery, created a language which, sixty years later, Michelangelo revived.

When Jacopo della Quercia, Donatello and Ghiberti met in Siena to work on the reliefs for the font in the baptistry they undoubtedly had discussions about perspective. The effect of these talks on Ghiberti can be seen in his reliefs for the third pair of doors of the baptistry in Florence. In the previous pair of doors he had worked within a Gothic, quatrefoil frame, the figures projecting from a flat background which was consequently, the most distant point of the composition. Here a plain rectangular framework is employed, and the eye is carried into the distance by the perspective scheme and the wealth of detail in the background. Michelangelo was to call these gilded doors the 'Gates of Paradise'.

While Ghiberti was initiating this completely new experience, the thrilling, passionate creativity of Donatello (1386–1466) burst forth. In 1425

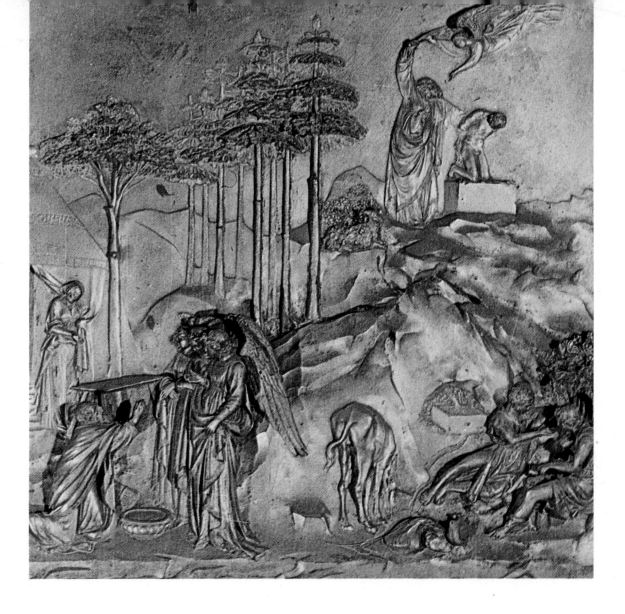

Donatello was almost forty and his personality was fully developed. When the statues of Jeremiah and Habakkuk emerged from his workshop to be placed in the niches of Giotto's campanile, ordinary living reality created by men of flesh and passions suddenly acquired the right to enter the domain of art. Jeremiah, notable because of his baldness, well deserved the name of *Zuccone* (bald-head) which the people gave him. But the dialogue between art and the public at last reached beyond the closed circles of the court and nobility. The prophets are clothed in heavy wool, shadows thicken in the folds and the gestures are alive. It is already a far cry from the youthful St George (1416), destined for a niche in Orsanmichele and now at the Bargello Museum – a nervous, anxious interpretation in linear Gothic style, the slender head executed according to canons of idealised beauty, the body enclosed in the space between the slanting shield, with its cross, and the cloak that falls over the shoulders.

Donatello's stay in Rome between 1432 and 1433 contributed to the creation of the bronze David, also at the Bargello Museum. The expanded chest is the most obviously realistic touch. The general outlines of the face are still Gothic, but there is a mature content in the inclined head, which has a noble Renaissance quality. The work is not classic, in the sense of a return to the ancient world, but a superb expression of the Florentine humanism that expressed itself spontaneously in the field of literature at the same time. Similarly, the dancing cherubs on the pulpit in the Prato and those on the singers' gallery of Florence cathedral (Opera del Duomo Museum) could have been born out of Donatello's recollection of classical decorative sculpture. Instead what has been captured is the vitality of children playing in the squares of Florence, whirling round faster and faster, as their mothers call them from the windows up above. Through Donatello, Florence gave its greatest gift to Renaissance naturalism.

Donatello used an even more complex idiom at Padua when, between 1447 and 1450, he com-

357

pleted the statues and reliefs for the altar of the Santo and began the equestrian statue of Gattamelata. Here the inspiration came from Rome, from the surviving equestrian statue of Marcus Aurelius; but while this was essentially an individual portrait, the Gattamelata who rides across the space looking towards the Santo church, impassioned and alert, is a symbol of the human concept of the Renaissance. Here is a man conscious of his human destiny, immersed in the light and shadows of his earthly day. The heroic tone is not an evocation of the classical style but a personification of individuality. By the time Donatello returned to Florence, the first half of the century had passed and a new culture was spreading. Ambitions and intellectual refinements were becoming more pronounced, grace and elegance prevailed – not without reversions to late

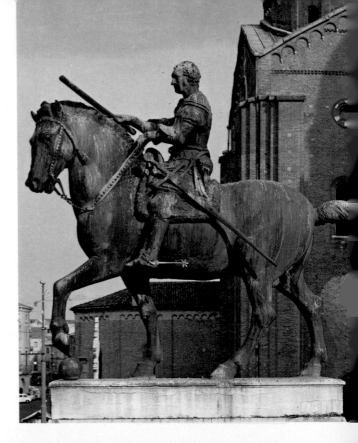

Donatello, equestrian statue of Gattamelata (Padua)

Donatello, the 'Descent from the Cross' (pulpit in S. Lorenzo, Florence)

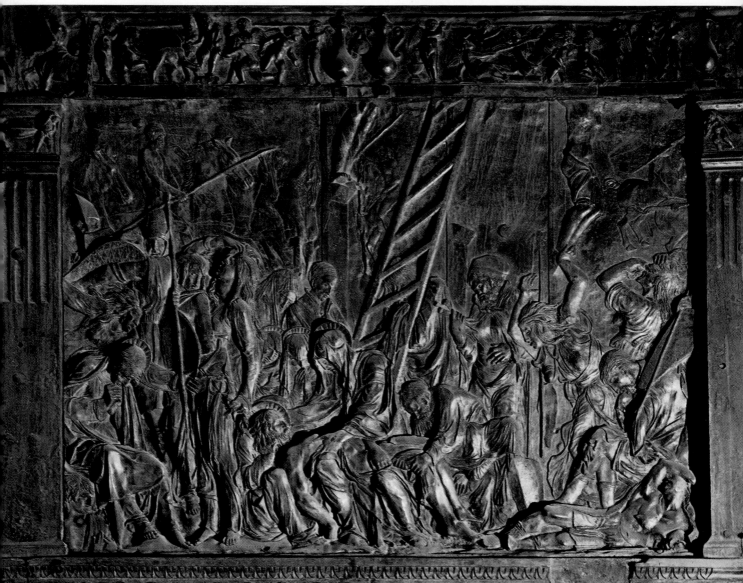

Gothic. Donatello himself was in fact thrown off balance to the point of producing such works as the statue of St Mary Magdalene in the baptistry at Florence – a dreary protest of unsuccessful expressionism.

Bernardo Rossellino (1409–64), Agostino di Duccio (1418–81), Desiderio da Settignano (1428–64) and Mino da Fiesole (1430–84) held the field far beyond the confines of Florence, their places being taken in the final quarter of the century by Antonio del Pollaiuolo and Andrea del Verrocchio. Architecture, sometimes recalling Brunelleschi, at others Alberti, combined with sculpture in the creation of tombs, as in that of Leonardo Bruni by Bernado Rossellino in Sta Croce in Florence, in which the calm space between the lower panels and the pilasters is circumscribed by the heavy Albertine arch. The cherubs bearing the coat of arms and the Virgin in the tondo are Donatellesque; the figure of the famous humanist is relaxed as if he were merely sleeping, as in the tomb of the Beata Villana in Sta Maria Novella, and as in Desiderio da Settignano's tomb of Carlo Marsuppini in the Church of Sta Croce.

Luca della Robbia (1400–82) came into prominence with such examples of architectural tondi as in the Old Sacristy, the Pazzi chapel and the Foundling Hospital, which round off Brunelleschi's buildings in Florence. His power as a sculptor is revealed above all in the singers' gallery (now in the Opera del Duomo Museum), which was originally placed in Sta Maria del Fiore opposite the one by Donatello. Della Robbia's tondi and lunettes in glazed terracotta of groups such as the Virgin with Child or scenes from the Passion are bright and fresh in their translucent blues, whites and greens, and are universally popular.

Antonio del Pollaiuolo (1432–98) and Andrea del Verrocchio (1435–88) ended the century and expressed it in all its maturity. With Pollaiuolo, the calm spatial concept of the early 15th century gave way to the definition of space in outbursts of active, vital mass, as in the small group of *Hercules and Antaeus* in the Bargello

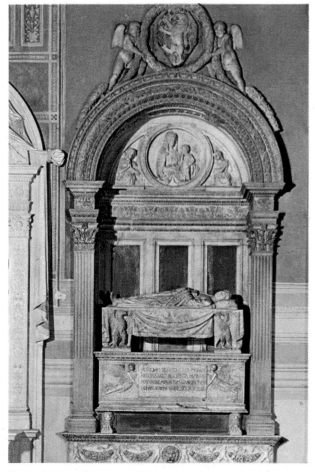

Bernardo Rossellino, tomb of Leonardo Bruni (Sta Croce, Florence)

Right: *Donatello, St George (Bargello Museum, Florence)*

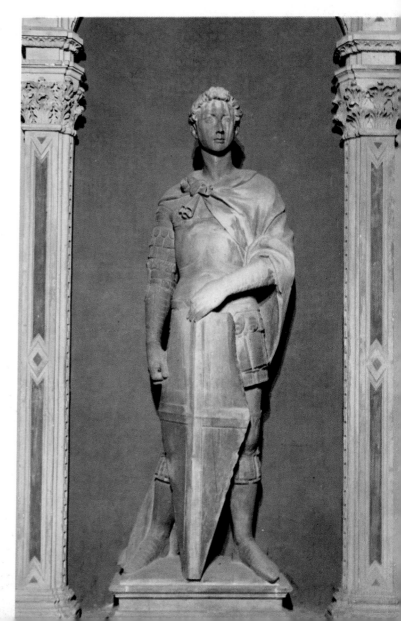

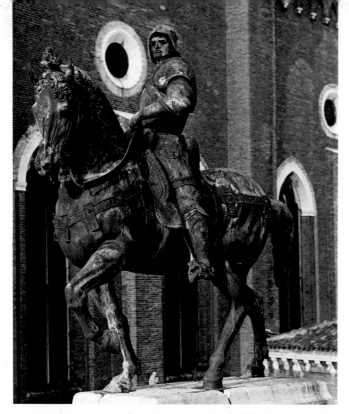

Andrea del Verrocchio, equestrian statue of Bartolommeo Colleoni (Venice)

Museum. Verrocchio is the most complete personality in the last great page of the Tuscan Renaissance. His experiences as a goldsmith explained his natural tendency to decoration, as can be seen in the austere tomb of Cosimo de' Medici in S. Lorenzo; in this the porphyry sarcophagus contrasts with the diamond pattern of the bronze, and the dignified arch lends itself to the gracefully intertwining floral motifs which stand out from amphoras in relief. Verrocchio's predilection for the chisel is evident in his decorative armour and equestrian trappings on the Colleoni statue in Venice, where the mane and the tail of the fine horse provide an opportunity for ornamentation. But it is in the rendering of the figure that he showed his firm grasp of form, his considerable powers of psychological observation and his taut use of light and shadow, which justifies the view that he anticipated Leonardo's values. His *David* at the Bargello Museum, in the style of Pollaiuolo, has an exuberant linearism, and the outlines and proportions of the figure are directly dictated by its interior vitality. Also at the Bargello Museum is the *Woman with the Nosegay*, a work which anticipates the *Mona Lisa* of Leonardo da Vinci.

Painting in Florence

In Florence the passing from late imitators of Giotto to direct realism was so sudden and so revolutionary that one can pinpoint it to 1424, when Masaccio (1401–28) emerged for the first time as a collaborator of the still gothically-inclined Masolino in the *Madonna with Child and St Anne* in the Uffizi. In this work, between the crown of angels with their buoyant, linear quality and limpid colour – still very much Masolino's style, the central group is carefully placed by Masaccio according to rigorous laws of perspective, and the large, balanced mass is composed of real beings displaying a vital, intellectually active humanity. Such an apparently unexpected eruption of realism into Florentine painting is less surprising when one remembers that Donatello's statues of Jeremiah and Habakkuk also date from 1424 and have a similar feeling of living, thinking humanity. At the end of the first quarter of the 15th century it was thanks to Donatello and Masaccio that humanity, dignity, physical force and emotions gained full rights as values of the figurative arts, breaking down barriers of tradition and culture.

Masaccio's polyptych, dated 1426 and com-

Desiderio da Settignano, the 'St John as a Boy' (Bargello Museum, Florence)

missioned by the Pisan church of the Carmine but now dispersed, proves the enduring depth of his work. In the moving *Crucifixion* (Capodimonte Museum, Naples) Christ, viewed from below, His head hunched between His shoulders, His legs splayed out, expresses a heavy human sorrow; on either side of the cross the Virgin and St John are drawn together by the figure of the prostrate Magdalene, whose arms are raised in the great wings of her vivid red cloak. The golden background isolates the sculptural reality of the figures and projects them into the foreground, showing that there is no connection with the golden backgrounds typical of International Gothic style.

The spatial setting of the fresco of the *Trinity* in Sta Maria Novella is more rational and more harmonious with Brunelleschi's contemporary architecture (he was then employed on the construction of the Barbadori chapel), and this fresco fully reveals the new stylistic achievements. Christ, modelled in light, is the focus of the space

Andrea del Verrocchio, David (Bargello Museum, Florence)

which is defined by the illusionistic architectural perspective. The Virgin, St John and God the Father emphasise the relative magnitudes: in front of them the worshippers, whose profiles are picked out against the grey pilasters, are deliberately excluded from the privileged circle. Masaccio's spatial and volumetric language was in full spate, and reached its fullest expression in the frescoes in the Brancacci chapel in Sta Maria del Carmine at Florence. Execution of this work was preceded by meetings at Pisa in 1426 with Donatello and Michelozzo to discuss plans for the Brancacci tomb (now in S. Angelo a Nilo at Naples). The enterprise had been started by the dilatory Masolino, who arranged the story in panels; but it was left to Masaccio alone to create one of the most noble works of the Italian Renaissance. The contrast between the linear grace of Masolino's *Adam and Eve* and the bursting, dramatic quality of Masaccio's *Banishment from the Garden of Eden* reveals the change of vision.

Of the episodes painted by Masaccio, the *Tribute Money* towers above them all. Christ orders Peter to catch the fish in which the coin will be found to pay the tax collector. His gesture to the apostle defines the space in the central group. His moral grandeur reveals His certainty in the miracle, and transfigures the circle of men who are shown as individuals through ordinary human gestures. In its immensity the surrounding nature seems to draw the bonds between men even closer. This is the first real Renaissance landscape and, overtaking with one bound all the fabled 'Gardens of Eden' so popular in International Gothic, placed the Tuscan painters in the van of an experience of reality with no return.

If Masaccio's language of painting sprang from the same root as that of Donatello, Beato or Fra Angelico (1387–1455) echoed Ghiberti's experience and, like Ghiberti, reflected in his development the critical transition from International Gothic to the Renaissance. On the one hand – particularly in his early period – he attempted increasingly elaborate linearism and greater delicacy in the enamelled colours of miniaturist origin; on the other, bodies assumed solidity and plasticity beneath the silvered drapery, and he went from golden backgrounds to landscapes of vague perspective, such as that in the *Descent from the Cross* (Museum of S. Marco, Florence). Here, as in the devotional paintings for the cells of his brother monks, the prevailing light is abstract and silvery, becoming more thrillingly accentuated at the top of the sky and around the outlines of figures. After his experiences in Florence and Orvieto, Fra Angelico went to Rome to paint the cycle of frescoes in the Vatican

Masaccio, an architectural detail from 'St Peter Giving Alms' (Brancacci chapel, church of the Carmine, Florence)

Opposite page: Masaccio, the 'Crucifixion' (Capodimonte Museum, Naples)

Masaccio, the 'Banishment from the Garden of Eden' (Brancacci chapel, Church of the Carmine, Florence)

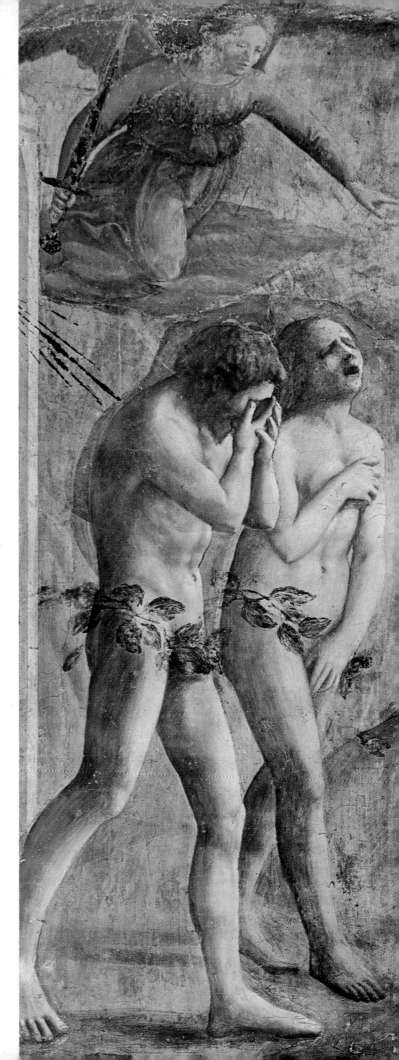

chapel of Niccolo V (1452–55). Here Brunelleschi's spatial discoveries (which Ghiberti had already experimented with in his 'Gates of Paradise') constitute the backcloth against which figures imbued with Masaccio's realism move, like those in the scene of the *Almsgiving of St Lawrence*. So, too, the moment of full commitment to the rational, realistic and perspective vision of the Renaissance arrived for Fra Angelico.

The personality of Paolo Uccello (1397–1475) was the most complex among the first generation of Florentine painters, for he combined two very different characteristics: a curious abandon to the fantastic which attained dream-like metaphysical enchantment, and a profound urge to seek perspective by reducing reality, in a severe visual pyramid, to geometric forms bathed in a cold, abstract light. One cannot say that the first of these manifestations was simply a youthful flowering encouraged by his encounters with Gentile da Fabriano and Pisanello on Venetian soil, since one of his fascinating late works (*c.* 1468) – the *Hunt* (Ashmolean Museum, Oxford) – is perhaps his masterpiece in this manner. However, his research into perspective was fraught with difficulties. His progress at one stage shows a somewhat exaggerated idea of volumes, as in his episodes *Noah's Ark* and the *Drunkenness of Noah*, painted in the Chiostro Verde (Green Cloister) of Sta Maria Novella; in these an astral greenish-silver light magically bathes synthesised forms studied from every angle. It culminates in the famous battle

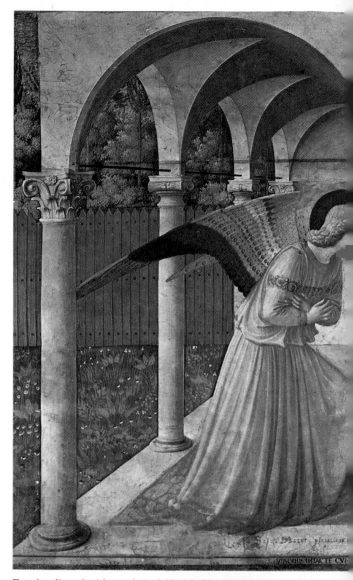

Michelozzo, library in St Mark's monastery, interior (Florence) *Fra Angelico, the 'Annunciation' (St Mark's monastery, Florence)*

scenes executed for the Medicis in 1456 and now at Florence (Uffizi), Paris (Louvre), and London (National Gallery). The unnaturally coloured horses and horsemen of these scenes are plunged into a nocturnal, sublunar atmosphere in a space created by the diagonal lances. Foreshortened, they move or lie like surrealistic automatons.

Paolo Uccello stands on his own, despite his long working life. Andrea del Castagno (1423–57) who is frequently bracketed with him partly for chronological reasons, immobilised his figures and sacrificed realistic inspiration and human anecdote in order to emphasise the heroic character, as in the cycle in the Sant' Apollonia Museum in Florence. The possibility should not be dismissed that Andrea del Castagno may have picked up such characteristics as the craggy, stony landscapes and harsh linearism during his stay in Venice (as illustrated in the figures of St Jerome

and the Holy Women in the *Trinity* in SS Annunziata in Florence). His most famous work is the fresco in Sta Maria del Fiore with the equestrian figure of Nicolò da Tolentino, painted in 1456, twenty years after Paolo Uccello had also painted there the one of Sir John Hawkwood (Giovanni Acuto). Comparison of the two emphasises the diverse essence of these artists: whereas there is a rigorous unity between Uccello's horse and rider, Castagno's graceful *condottiere* is reduced to little more than an artist's figure of wavering, uneven outline. Among the group of Tuscan masters of the early Renaissance, Filippo Lippi (1406–69) was less original but introduced a more relaxed and popular touch with his pleasantly composed Madonnas in the Uffizi in Florence. Yet he achieved a more successful expression in later works after the first half of the century. His decorative fresco in Prato cathedral of the *Life of*

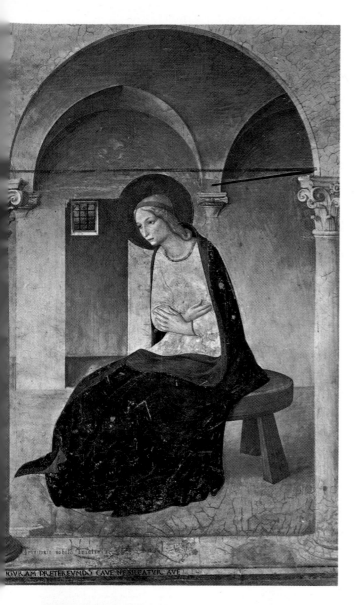

St John the Baptist is a particularly good example, with the famous figure of Salome in her floating dress, which foreshadowed Botticelli's linearism, though in a more realistic manner.

Domenico Veneziano (1406–61), emerging from Venetian late Gothic, remained alone in his approach to colour and the way he blended it with light. The altarpiece known as *Sta Lucia dei Magnoli* (Uffizi, Florence) is his most famous work, justifying the recent critical view that he should be credited as Piero della Francesca's master. It remained for the latter to carry Renaissance painting to its highest level.

Piero della Francesca (1416–92) was a great solitary figure in the history of Italian painting, and was fundamentally outside the Florentine artistic atmosphere, with its realistic vision. This was due as much to his absolutist formal language as to his concept of the human and the divine as a vibrant, intimate harmony attaining sublimity in individualisation. It also resulted from the spatial precision with which he set up a natural or architectural environment adapted to the nature of his figures. In other words his painting was outlined and controlled to contain gestures that were symbolic rather than real, and forms and volumes that were essentially geometric rather than descriptive and personalising.

Briefly the cultural components of Piero della Francesca's painting can be indicated as follows: the problem of light and colour which had interested Domenico Veneziano; Alberti's interpretation of classicism as the source of laws and proportions for the expression of beauty, and Piero's own admiration for the diffused naturalistic lighting of the Flemish painters. These basic elements of Piero della Francesca's poetic genius are synthesised in the youthful *Baptism* (National Gallery, London), in which Christ, St John and the angels are strong compact forms, modelled in the light of the encircling space. A not dissimilar concept of the spatial relationship of figures dominates the *Flagellation* (Palazzo Ducale, Urbino), which was executed round about 1445 and is a testing ground for an even more sublime organisation of the relationship between action and setting. The picture is divided into two fields. On the left is the flagellation scene, which recedes into the background, and is contained within a cube defined by the floor, ceiling and walls. Here a clear, abstract light eliminates any sense of reality and emphasises actions which are symbolic rather than natural; in it the detached figures are alive and yet preserve a kind of restrained

Fra Angelico, detail from the 'Descent from the Cross' (Museum of St Mark's, Florence)

365

P. Uccello, portrait of Sir John Hawkwood (Giovanni l'Acuto), fresco (Florence cathedral)

Domenico Veneziano, the 'Annunciation' (Fitzwilliam Museum, Cambridge)

immobility. In the square on the right three people stand out in solitary isolation against an open background.

Between 1452 and 1459 Piero stayed in Arezzo to decorate the presbytery in S. Francesco with the cycle of the *Story of the True Cross*. The complex legend is told in panels and, in his mature awareness, Piero achieved his greatest creative experience. The immense variety of environment, activity and emotion is impregnated with Piero's silent humanity, which magnifies his point of departure without giving way to heroics or becoming merely superficial. He expressed the intimate harmony of the world as an absolute, and it is very difficult to cite any one example from such different episodes as the *Death of Adam*, the *Battle of Massenzio*, the *Dream of Constantine*, or the *Queen of Sheba Received by Solomon* since, to a great extent, the same needs arise in each. The most striking features are the closely sustained relationship between figures and space, the taut synthesis of forms within strong outlines, the white morning light, the minimal, essential gestures, and the desire for a pictorial rather than illusionary composition. Piero della Francesca's pictorial output is vast. There is the remarkable *Resurrection* in the Palazzo Communale of his native Borgo San Sepolcro, contemporary with the portraits of Battista Sforza and Federigo da Montefeltro, with their delicate background landscapes (Uffizi, Florence), or the *Sacra Conversazione* dating from 1475 (Brera, Milan). In the latter the Virgin and Child achieve in an architectural setting a

Paolo Uccello, the 'Battle of San Romano' (Uffizi, Florence)

monumental quality within the circle of adoring angels and saints. Piero della Francesca provoked great repercussions, and not just in Italy, or within the limits of his own century, for the problems he created were subsequently taken up in different ways by Botticelli and Fouquet, Van der Goes and Raphael.

In the second half of the 15th century – in Florence – coinciding with the climax of Lorenzo the Magnificent's (1449–92) authoritarian and contradictory policies – both painting and sculpture assumed positions entirely opposite to those of the first half of the century.

Sandro Botticelli (1445–1510) was a pupil of Filippo Lippi but soon attached himself to Verrocchio and Pollaiuolo. His life followed the ascending parabola of Lorenzo the Magnificent's pagan hedonism and the culture of his circle, as in for example the poetry of Poliziano. It became involved, too, in the conflict over the intransigent religious attitude taken by Gerolamo Savonarola, under whose spell Botticelli fell, and which affected the last period of his activity.

Botticelli's first masterpieces date from 1470 and are youthful, spirited works, but nevertheless show a carefully considered seriousness. The *Return of Judith* (Uffizi, Florence) shows that he had already perfected his familiar, slight female form: supple and linear, light of step, evenly distributed in weight, with flowing, rhythmically draped veils and golden curls falling in heavy locks. The background landscape recedes so that the static mass of the tree on the right dominates and emphasises the action of the two women bearing their bleeding burden.

Botticelli came under the Medici protection immediately after 1470, as is proved by the appearance of members of the household in the *Adoration of the Magi* in the Uffizi. This work already shows that sublime sense of composition which reached its zenith in the tondo of the *Magnificat*, in which the wreathed gestures around the Virgin and Child culminate in the jewelled crown held above the blonde head of the Madonna.

The balance of composition for the allegory of *Spring* (c. 1478) is more complex and more

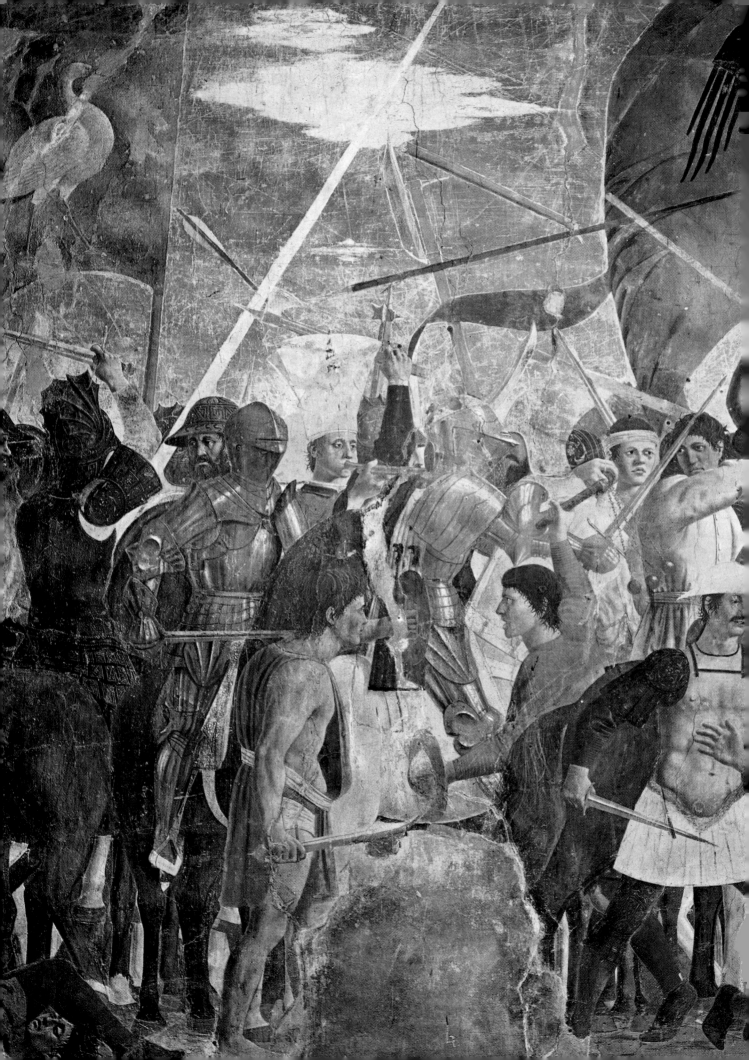

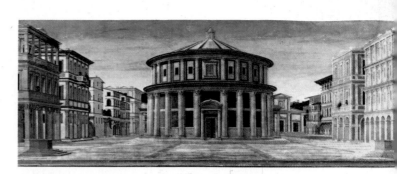

Piero della Francesca, 'An Ideal City' (National Gallery of the Marches, Urbino)

carefully thought out. It is a pagan, timeless moment of light captured in a clearing amongst the trees – silhouetted against a silken sky – with fruits hanging like opaque lanterns. The central female figure is placed asymmetrically and, as the focus of the narrative, has her hand raised as if directing proceedings. From the right another female form advances, gently pushed by Zephyr; on the left the veiled group of Graces link hands in the dance. Their feet hardly touch the ground and their serious tilted faces are entirely appropriate to the somewhat airless atmosphere. The *Birth of Venus* (Uffizi) is a later work, perhaps

Piero della Francesca, detail from the 'Defeat of Khusru' (S. Francesco, Arezzo)

Piero della Francesca, portrait of Federico da Montefeltro (Uffizi, Florence)

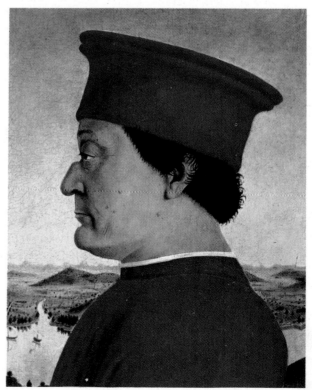

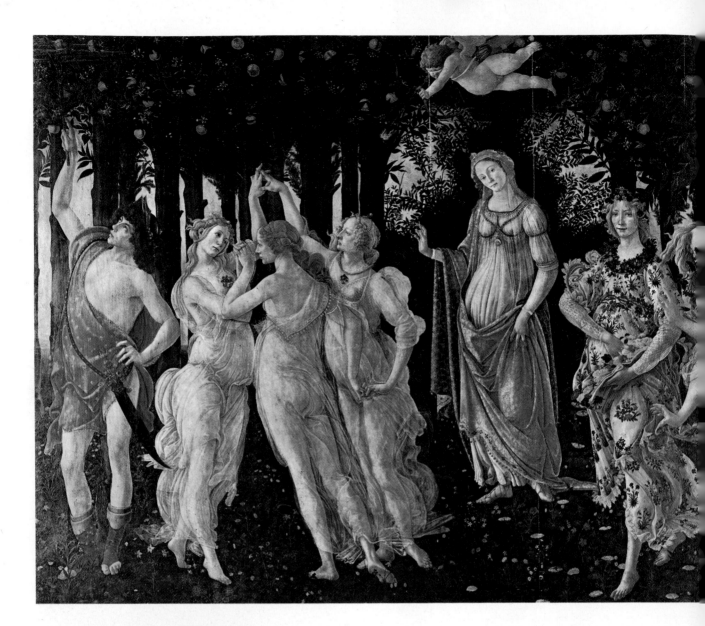

dating from 1485, and shows intellectual enquiry
carried almost to the point of exaggeration. The
light of the sea and sky is unnatural; it is a
background for two idealised arcs consisting
respectively of the wind gods on the left and, on
the right, the open swelling cloak offered to the
naked goddess, poised on the rim of a shell, by a
girl in a beautiful dress. Venus, painted in a gentle
curve of arms and legs, is aware with dreamy
melancholy that she must finally change from a
mythical to a human being. Abstract colours and
unreal lights make the *Birth of Venus* a masterpiece
totally opposed to the whole Florentine tradition
of the early 15th century, which explains why the
work remained unrecognised until the nostalgic
reminiscences of the romantic pre-Raphaelites.

There followed the saddest years for Botticelli;
Lorenzo the Magnificent died in 1492 and
Savonarola was put to death in 1498. The harmo-

Sandro Botticelli, 'Spring' (Uffizi, Florence)

Opposite page, below: *Filippino Lippi,'Madonna with Child' (Corsini Gallery, Rome)*

Andrea del Castagno, Cumaean Sibyl (Sant'Apollonia, Florence)

Domenico Ghirlandaio, 'The Birth of John the Baptist' (Sta Maria Novella, Florence)

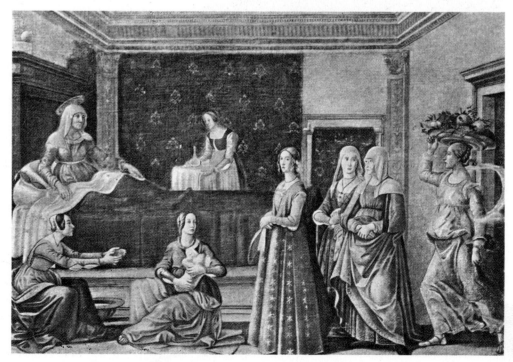

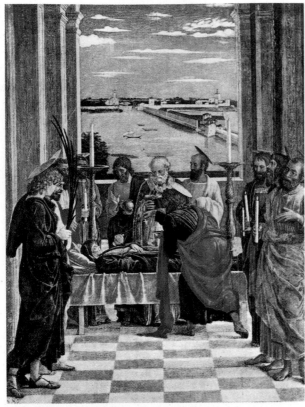

Andrea Mantegna, the 'Death of the Virgin' (Prado, Madrid)

Cosimo Tura, 'St Dominic in Prayer' (Uffizi, Florence)

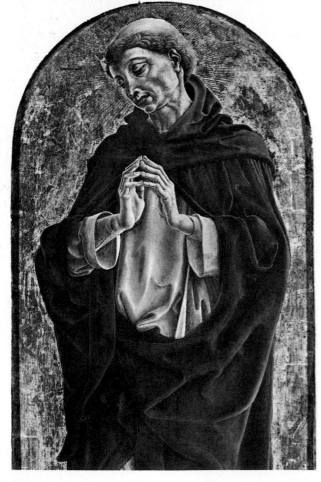

nious linearism of his forms disintegrated into the turmoil that was lacerating his spirit. He produced works like the *Pietà* (Poldi Pezzoli Museum, Milan), in which the drama is expressed by fragmented, convulsive lines and masses, and the *Calumny* (Uffizi), in which heavy allegory is submerged in an uneasy surrealist atmosphere.

Next Ghirlandaio (1449–94) came into the limelight at Florence. He somewhat irreverently introduced people from the Medici circle into the stories of the saints and the Virgin that he painted in the apse of Sta Maria Novella. He was careful in his reproduction of fashionable dress, petty in his attention to detail, but full of ingenuity and pleasing in his use of colour.

Painting in the rest of Italy

In the 15th century northern Italy witnessed the flowering of four great schools of painting at Padua, Milan, Ferrara and Venice.

Padua, where humanism seemed to find its most direct expression, was the centre of chief cultural interest. Here, before anywhere else, Tuscan contributions united to revolutionise traditions and developments; here the ancient classicism seemed utterly to enthrall local masters like Squarcione, and it was from here that an extremely severe style developed, of which Andrea Mantegna (1431–1506) was the chief exponent. The main features of his style, which was rich in humanistic and archaeological traditions, hinge on the inspiration of Donatello's works in Padua and the Venetian experiences of Paolo Uccello. Mantegna's creative cycle began with the frescoes in the church of the Eremitani in Padua (badly damaged during World War II), in which a new spatial perspective setting gives a monumental aspect to architectural forms, landscapes and figures, often by foreshortening or viewing from beneath. In the S. Zeno altarpiece (1459) in Verona, the abstract spatial concept and deliberate monumentality does not jar with his tendency to transform Donatellesque inspirations – like the cherubs on the back of the Virgin's chair – into a decorative feature. The predella, now separated from the centre panel, was particularly significant – for example the *Crucifixion* in the Louvre. Here the space, which is reminiscent of Piero della Francesca in its dimensions, is broken up by huge, rugged blocks of lava deposit. The coldness and the dramatic intensity of the crucifixion scene itself is mercilessly emphasised by the cold light bathing the sharply defined forms, the acid colours and harsh arrangement of the robes.

Mantegna's greatest example of pure, rich painting remains the decoration of the Bridal

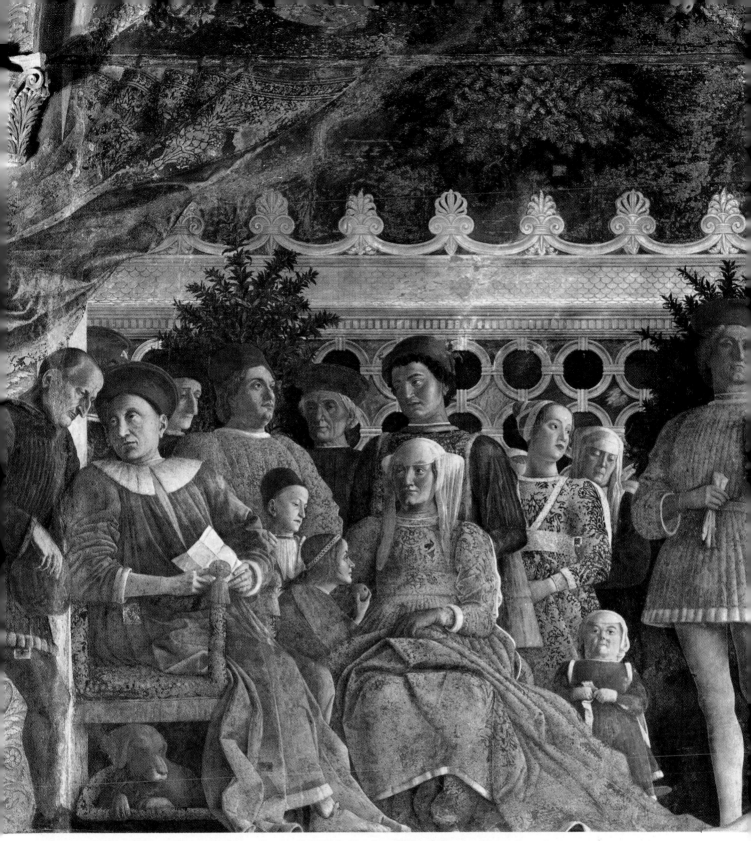

Andrea Mantegna, 'The Family of Lodovico Gonzaga' (Bridal Chamber, Palazzo Ducale, Mantua)

Chamber in the Palazzo Ducale at Mantua (*c.* 1474) where, already saturated by the courtly spirit of the Renaissance, he depicted episodes in the life of his patrons. The setting is dignified and unique because of the vague, indeterminate light, whether in open or restricted spaces. Mantegna needed to increase the size of the room so he simulated an open, cloud-flecked sky above a circular balustrade thrown into perspective relief.

Mantegna's new style of painting aroused

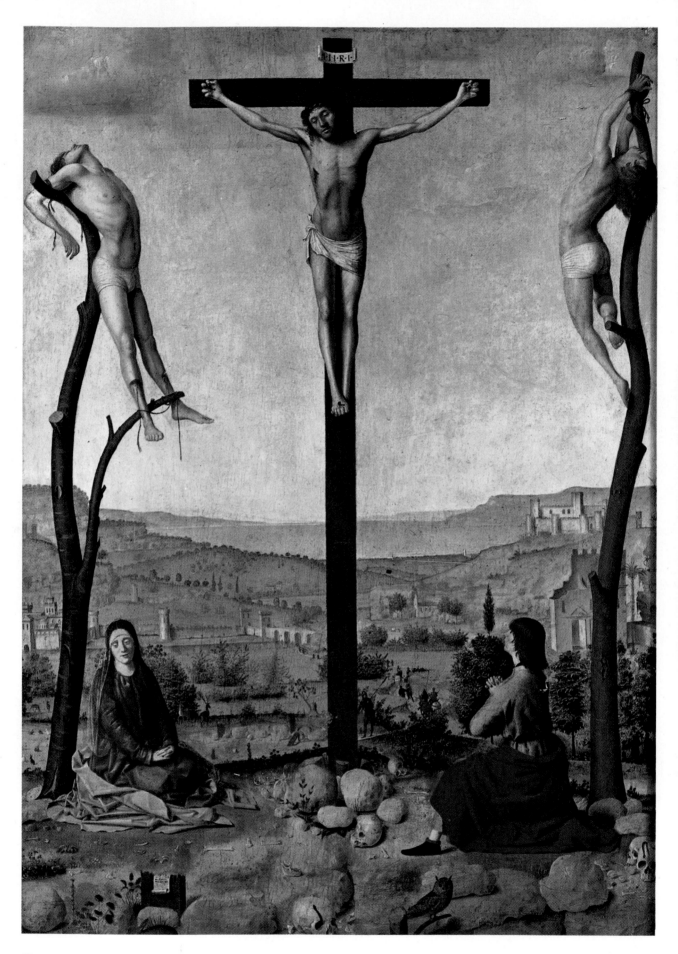

widespread admiration in neighbouring circles. At Ferrara, Cosimo Tura, Francesco Cossa and Ercole de' Roberti founded the Ferrara school with its tense dramatic expressiveness and its reflected influences from the North, the Low Countries and Piero della Francesca. In Lombardy Vincenzo Foppa (1428–1515) took up and restated Mantegna's legacy, even if at times his style of painting betrays provincial crudities, particularly in youthful works like his *Crucifixion* (Carrara Gallery, Bergamo). Foppa's language appears to greater advantage, however, in the cycle of frescoes in the Portinari chapel in S. Eustorgio in Milan, where he organised space with geometrical precision with the figures standing in foreshortened perspective and painted in clear colours not unlike those of the late Gothic-Lombard tradition.

With Antonello da Messina (1430–79) Italian painting again reached a high point in form and culture. Antonello came from the extreme south, brought up in that interesting Neapolitan atmosphere that surrounded the school of Colantonio where Flemish and Catalan elements converged, as much for political reasons as anything else. Antonello revealed – even when still very young – a strong personality capable of assimilating acquired values. Only slightly bound to local traditions, he expressed remarkable originality. His style is a closely reasoned synthesis heightened in places by a light technique that reveals Flemish precision and by plastic relief that is monumental, like that of Mantegna. The realistic note, at times heavily emphasised as in the *Portrait of a Man* in the Cefalù Museum, could be of Catalan origin. However, any suggestion of derivation is cancelled out by the immediate,

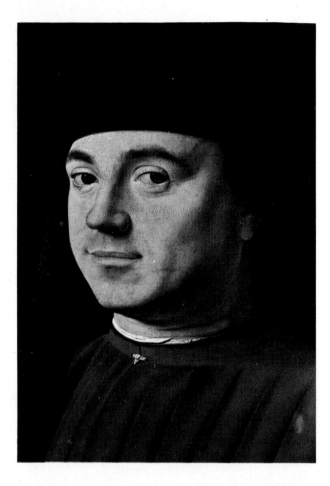

vigorous strength and the sensitive use of colour, which are the dominant features in the work of this exceptional and solitary personality.

In studying the evolution of Antonello's painting it seems possible to identify closer contact with Piero della Francesca before 1460 and a warmer and more relaxed colour emphasis after his Venetian visits – particularly after encounters

Above: *Antonello da Messina, 'Portrait of a Man' (Uffizi, Florence)*

Opposite page: *Antonello da Messina, the 'Crucifixion' (Musée des Beaux Arts, Antwerp)*

Gentile Bellini, detail from the 'Sermon of St Mark at Alexandria' (Uffizi, Florence)

375

with Giovanni Bellini. One of Antonello's most important works, if only for the influence which it had in turn on Venetian painting, is the polyptych, (*c.* 1475), once in S. Cassiano in Venice but now split up and only partially reassembled in the Kunsthistorisches Museum, Vienna. These were the years in which Bellini created *The Coronation of the Virgin* in S. Francesco in Pesaro, in which the figures vibrate in a kind of warm atmosphere. All in all, it is a work not far removed from Antonello's viewpoint. The question of the relationship between environment and the figured form is perhaps more obvious in the superb *St Sebastian* (Gemäldegalerie, Dresden), which was also a product of Antonello's Venetian period. The saint tied to the tree is the focal point of the space. The body is portrayed with smooth outlines and simple anatomical rendering. Some of the details

Vittore Carpaccio: detail from the 'Dream of St Ursula' (Accademia, Venice)

Vittorio Carpaccio, 'St George and the Dragon' (Scuola di S. Giorgio degli Schiavoni, Venice)

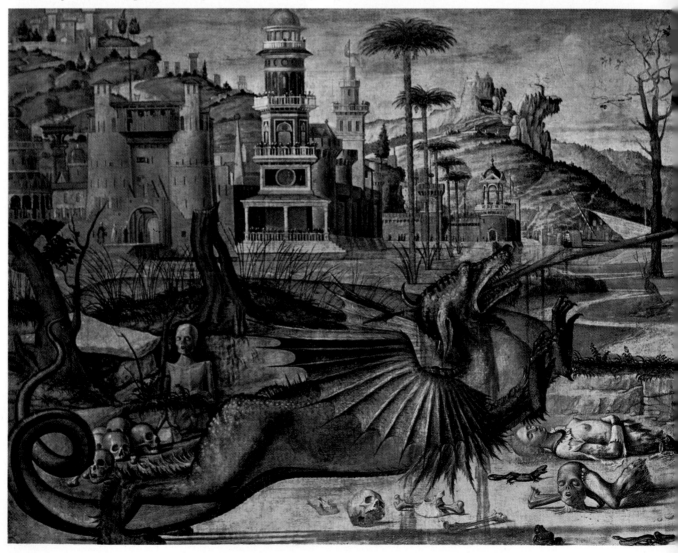

in the picture remind one of the Venetian School. The fallen section of column supports the perspective and at the same time symbolises the desire for pure geometric content. Colour – warm, solid and very mellow – is a magic contribution in Antonello's work, and sometimes he uses chiaroscuro or a thin wash to bring out the essence of figures rather than attempt to reproduce reality. The best known example is that of *Our Lady of the Annunciation* in Palermo Museum, painted by Antonello after he had returned to his native Sicily in 1476, never to leave it again. The oval face is outlined by the blue cloak but the hand (almost an anticipation of Leonardo da Vinci's *Virgin of the Rocks*) hesitantly extends into the light to resolve the space by itself.

Venice

15th-century Venetian painting started in Murano and was somewhat behind the other schools in central Italy. Giovanni Bellini (1430–1516) was the only outstanding painter capable of giving a story magical and metaphysical overtones. He had an innovator's ambition, and his work contrasted with the anecdotal, narrative and descriptive style of his brother Gentile (1429–1507) and the fantastic spirit of Carpaccio (1486?–1525). He established himself in Venice and produced a vast output. His unpredictable personality suddenly expressed a thirst for the naturalism of the Venetian Renaissance, the definite exclusion of any hint of gothicism, and detachment from the provincial conservatism that later carried Venetian painting to the mature splendour of Giorgione and Titian.

Giovanni Bellini, a product of the school of his father, Jacob, was at first immersed in the conventionalism of International Gothic. Shortly after his twentieth year however, he suddenly came face to face with the art of Mantegna, since they were now brothers-in-law. His paintings of

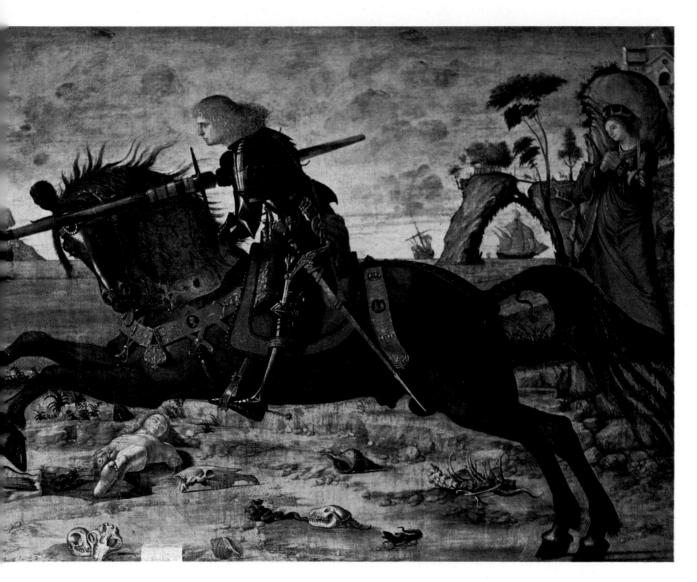

the Madonna and Child prior to 1470 have much in common with the plastic ideals of Mantegna, in that the composition is heightened by *trompe l'oeil*, as, for example, in the windowsill in the painting of the *Madonna* in the Sforza castle, Milan. Here, too, the colours are sharp, and the acid yellow lemon held out by the Virgin to the Child and the opaque filamented halo have no luminosity. The same strict plan can be seen in the *Pietà* (Brera, Milan), where the action is carried into the foreground right up to the edge of the balustrade on which Christ's heavy, inert fist lies.

The sorrowful leavetaking is communicated by the powerful line running from the entwined hands of the Mother and Son up to their contorted, touching faces. The landscape is subservient to the action and the light has a dramatic function in relieving the harsh monumentality of the forms.

With Giovanni Bellini, sky, hills and mountains, trees and water and the events of country life became the environment within which men lived out their lives. With him Venetian naturalism was born. Human figures found their natural proportion and dimension in the landscape, providing a

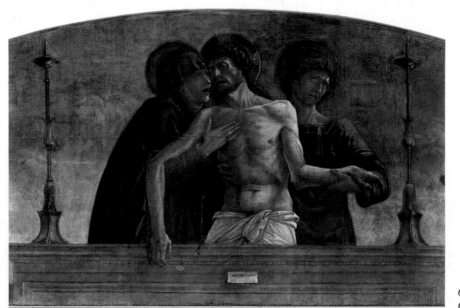

Giovanni Bellini, the 'Descent from the Cross' (Doges' palace, Venice)

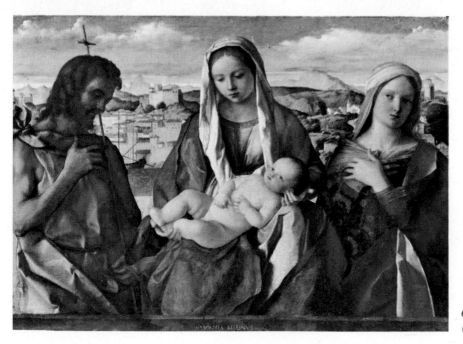

Giovanni Bellini, 'Madonna and Saints' (Accademia, Venice)

kind of chorus to the main figures with their natural gestures and serene expressions. The story became a completely natural moment in time, bathed in a light that enlivened the colours with tonal values, as in the various paintings on the Madonna and Child theme, or the *Sacre Conversazioni*, and the symbolic themes. This was the period of the *Coronation of the Virgin* in S. Francesco in Pesaro, of the *Madonna and Child* (Brera, Milan), of the superb *Transfiguration* (Capodimonte Museum, Naples), of the sublime altarpiece from S. Giobbe (Accademia, Venice), and of the metaphysical *Allegorical Scene* (Uffizi, Florence). The *Sacra Conversazione* in S. Zaccaria (1505) in Venice reveals contacts with Giorgione and Leonardo, and paves the way for Titian.

Architecture

Outside Tuscany architecture had distinctive regional characteristics which must be discussed, and will be treated province by province.

The Marches saw the completion of the most beautiful work of Luciano Laurana (*c.* 1420-1479): the Palazzo Ducale at Urbino. Despite successive additions, this palace expresses a strict, abstract concept of volume that is in harmony with the space and light concept adopted by Piero della Francesca in his painting. In this creation it it also possible to see the influences of Alberti and Brunelleschi converging. Alberti's influence is more evident in the arched frontal niches between the little towers, which are nostalgically medieval; Brunelleschi's values are particularly obvious in the splendid galleried courtyard, which is broken up into distinct planes, and also in the rhythm of the architrave with its dedicatory inscription. The flat pilasters are given more emphasis through the contrast with the brick walls.

Umbria welcomed the work of the Sienese Francesco di Giorgio (1439–1501); in theory akin to the spirit of Alberti, he also experimented with military defences, and was in this respect a precursor of Leonardo. He is generally remem-

Giovanni Bellini, 'Allegorical Scene' (Uffizi, Florence)

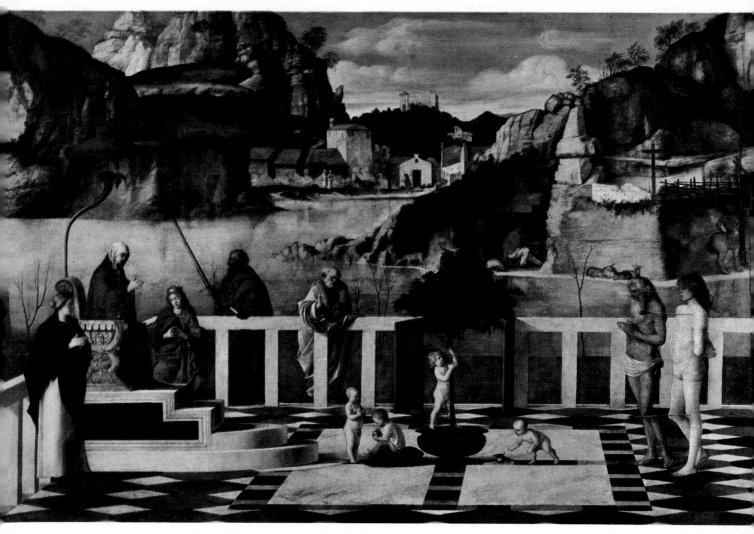

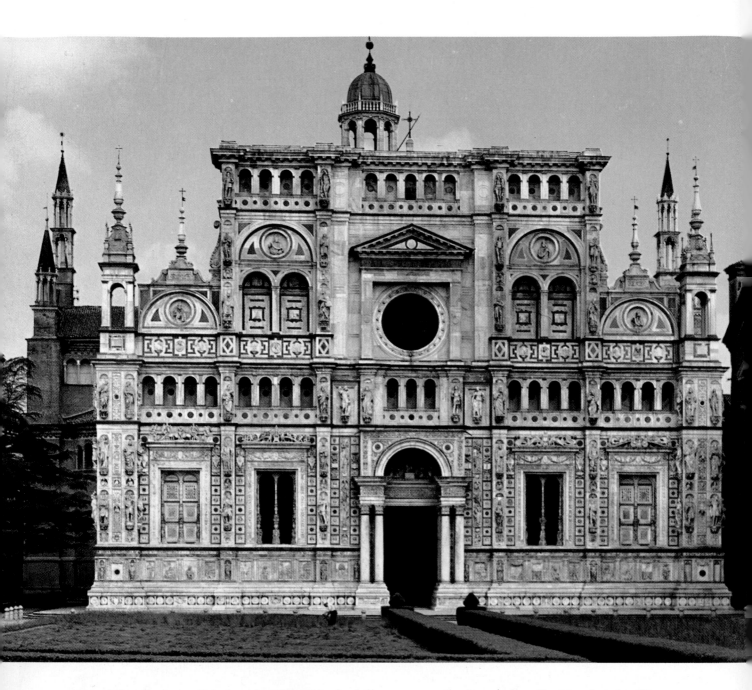

bered for the beautiful church of Sta Maria delle Grazie at Cortona.

Renaissance architecture is rare in Rome, and the architecture of southern Italy did not follow the new fashion. Syracuse and Palermo combined late Gothic and Norman elements with Catalonian influences, which resulted in a style of compromise. 15th-century architecture in Lombardy was completely different from that in Tuscany. Even when an artist like Michelozzo went to Milan to build the Portinari chapel in S. Eustorgio, his style lost the scrupulous clarity of Florentine work and assumed the heavy decorative features so dear to the provincial taste of the region. Antonio Averulino, called Filarete (1400–69), was a Florentine but was influenced by the Lombardian taste for decoration. Received at the Sforza court, he produced an ambitious project for building 'Sforzinda', an ideal city which was to be a satellite of Milan. The hospital was the only building actually finished, and it has been made ponderous by Guiniforte Solari's collaboration. But the three adjoining squares are inspired and functional, the two external ones being bisected by lobbies on a cruciform plan with open loggias. The actual appearance of the building, which was badly damaged in the war, shows how limited the adaptation was in that the ground floor arches have been bricked-in and Gothic windows inserted. Brickwork motifs were admired in Lombardy because of the vivid relief they provided to the grey Lombardian sky.

One of the causes for the meagre originality of Lombardian architecture before the time of Donato Bramante, who arrived in Milan in 1480, was the slow reconstruction of Milan cathedral, and the fact that it was being built in the middle of the 15th century in the Flamboyant Gothic style. The cupola provided by Giovanni Antonio Amadeo (1447–1522) is not a harmonious inclusion. A more definite measure of Amadeo's architectural personality exists in the Charterhouse of Pavia and the Colleoni chapel in Bergamo. The Charterhouse, which was originally conceived and slowly developed in Gothic style, is, with Amadeo's façade, an exercise in decoration and the use of precious metals (later it was transformed completely into 15th-century style by B. Briosco). Taken individually, the sections are admirable for the ingenuity, skill and elegance they display, but the total effect is an obvious example of the Lombard architect's *horror vacui*. Similarly the façade of the Colleoni chapel by Amadeo – built on the site of Sta Maria Maggiore in Bergamo – is ostentatious, with its elaborate windows, great open loggia and polychromaticism, which recalls Bergamo's political dependence on the Venetian republic. It is in sharp contrast to the spirit of Bramante, who by then had started work in Milan with the zeal of a true reformer.

Bologna did not show any particular originality either, and the Palazzo Bevilacqua and the Palazzo Fava did not break any new ground when they introduced brickwork.

Ferrara, on the other hand, was the centre of the most complete urban experiment of the 15th century. Biagio Rossetti (1474–1519), with the 'Herculean addition' (of Hercules I, Duke of Ferrara), mapped out a functional city with intersecting roads marked at the crossing points by palaces. One of these is the Palazzo dei Diamanti, which is entirely embossed with pyramidical, or diamond-shaped, chiselled stone.

Venetian architecture is more interesting, even if mainly in the Florid Gothic style. Sta Maria dei Miracoli is the most beautiful of 15th-century Venetian polychromatic churches. Surrounded by canals, it is small, intimate and harmonious, and the decoration on the lateral walls is restful in contrast with its more brilliant façade. But as Pietro Lombardo (1435–1515), author of this elegant example, left the 15th century, so too did Venetian architecture.

Biagio Rossetti, Palazzo dei Diamanti (Ferrara)

Luciano Laurana, courtyard in the Palazzo Ducale, Urbino

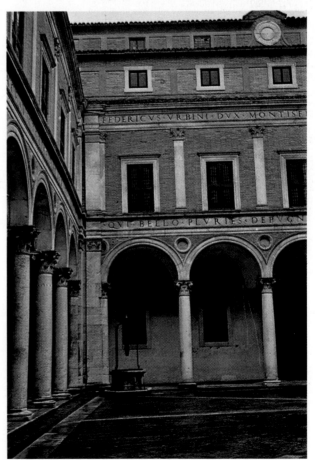

Opposite page: *Giovanni-Antonio Amadeo, façade of the Charterhouse of Pavia*

381

16TH-CENTURY ITALY

Within the span of the Renaissance, architecture, above all, indicates the profound spiritual difference between the 15th and 16th centuries. This difference is evident in attitudes to history, philosophy and literature, as well as in the field of artistic production and the theory of art. It is particularly true of Donato Bramante (1444–1514) and Michelangelo Buonarroti (1475–1564). Although they used contrasting languages, both progressed beyond Brunelleschi's vision of co-ordinated space circumscribed by surface areas. They preferred solemn monumental effects, with huge masses, imposing dimensions, and central forms with domes. Space was unified, abstract and understood in an ideal sense as being symbolic of the universe. However, although they had a common spiritual outlook, which was itself the expression of a far wider religious-philosophical trend, they were sharply separated by their language. Bramante, who was committed to the proportions and forms of classicism, and aspired to a balanced whole, adopted a classical

Michelangelo, Medici chapel, interior seen from above (S. Lorenzo, Florence)

Leonardo da Vinci, Vitruvian Man

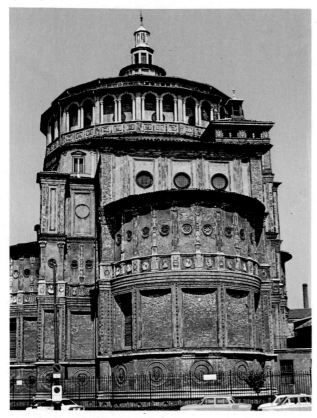

Donato Bramante, apse of Sta Maria delle Grazie, Milan

position, whereas Michelangelo, who conceived form with a sense of drama and added a dynamic enthusiasm to the plastic expression of masses, adopted an anti-classical position. All Italian architecture in the 16th century derived and developed from these two sources.

Bramante

Bramante, who came from Urbino, made his first appearance in Lombardy, chiefly in Milan, between 1480 and 1497. He began by facing the Pre-Romanesque chapel of S. Satiro in Renaissance style; he continued by building Sta Maria near S. Satiro and its octagonal baptistry,

Opposite page: *Donato Bramante, Tempietto di S. Pietro in Montorio, Rome*
Donato Bramante, projected plan for St Peter's, Rome

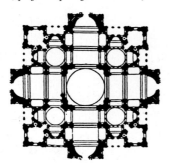

followed by the presbytery of S. Ambrogio. Finally he designed the gallery of Sta Maria delle Grazie (dating from 1492), the first major example of space architecture, heralding the monumental buildings of the 16th century. Its form is severely geometric, based essentially on the cube, which absorbs the semicircular apses and is crowned by an octagonal cupola with a gallery.

With Bramante's removal to Rome new originality was revealed in his character, not so much in the cloister of Sta Maria della Pace, nor in the Palazzo della Cancelleria (which is attributed to him by some scholars) but in the Tempietto of S. Pietro in Montorio, his first work designed to a central plan. Here the Doric columns create effects of light and shade between the base with its flight of steps and the architrave, which is in the form of a balustrade. Above both this and the lofty drum, which is hollowed out by niches, the delicate cupola is crowned by a central cylindrical mass, which acts as a solid pivot for the dynamic exterior. It was a huge stride from this work to drawing up the projects and plans for restoring St Peter's (1506) where Bramante adopted monumental dimensions reminiscent of the Pantheon. He envisaged the huge church, the symbol of the heart of Christianity, as a centrally planned structure in the shape of a Greek cross. It was to be crowned by five domes and enclosed by relatively light masses. The whole – had Bramante's plan been realised – would have been a structure on four vast pillars linked by huge barrel vaults in the Imperial Roman tradition.

16th-century Italian painting had three great centres: Florence, Rome and Venice. The greatest achievements of these three traditions (hinging on Leonardo, Raphael, Michelangelo, Giorgione and Titian) had in common the fact that they all surpassed 15th-century achievements. It was in fact a period of creative maturity which was no longer concerned with representing reality in its relation to either space, nature or the human body. A new spirit of enquiry into the universal values both of man and of the world was abroad. The period of the High Italian Renaissance painting was in reality very brief. Giorgione, Leonardo and Raphael all died between 1510 and 1520, and only Michelangelo and Titian lived beyond the first half of the century.

Leonardo da Vinci

Leonardo (1452–1519) was a native of Vinci in Tuscany and came to Florence when he was fifteen years old. one of his first works, the *Annunciation* (Uffizi, Florence), shows traces of

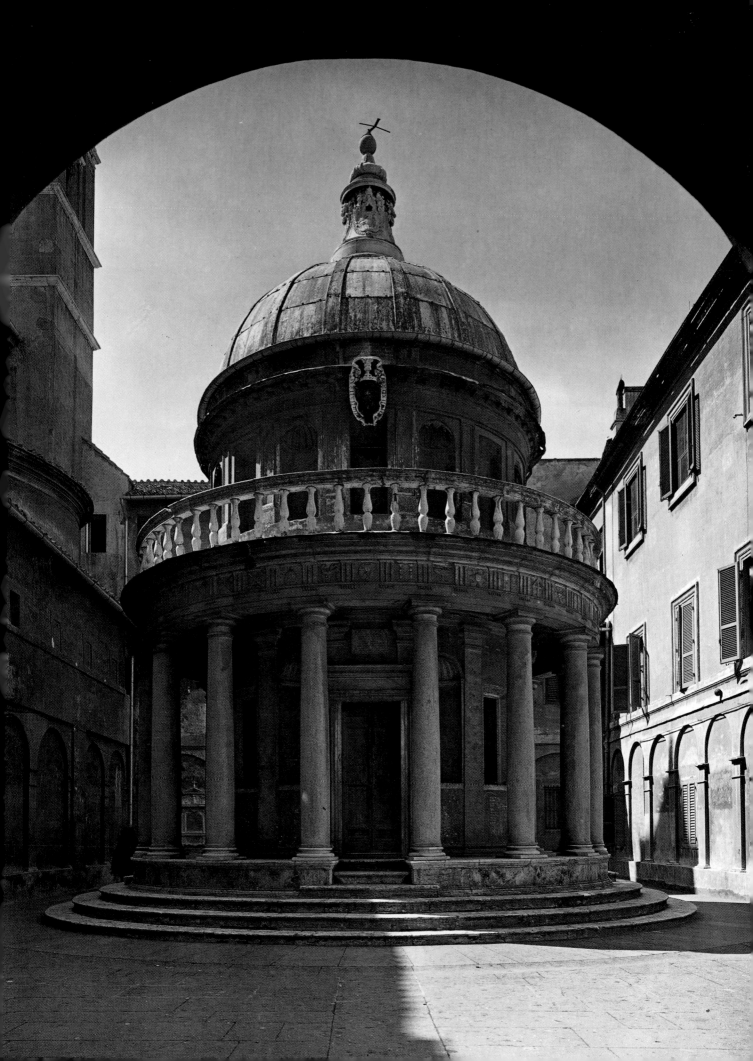

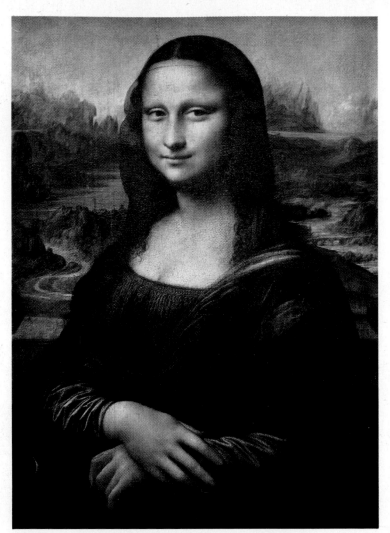

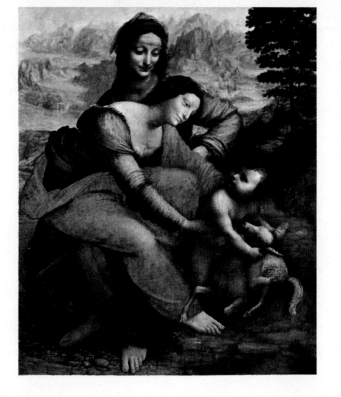

Verroccio's ebullient dynamism, and in fact Leonardo was a pupil in his workshop until he became an independent master in 1478. He made some concession to his master's penchant for decoration and showed that he was not unaware of Flemish precision, as revealed to Florentines by the presence of Hugo van der Goes' triptych, now in the Uffizi but then in S. Egidio. Shortly afterwards his angel in the left foreground landscape of Verrocchio's *Baptism* (Uffizi, Florence) shows that he had broken with his early starting point; the delicately shaded profile and the ruffled, flowing hair appeared for the first time. The portrait of *Ginevra Benci* (National Gallery, Washington) which is possibly contemporary, is, on the other hand, reminiscent of Piero della Francesca's essentialism – an important element in Leonardo's stylistic formation.

The high-water mark of Leonardo's painting is revealed in the unfinished panel of the *Adoration of the Magi* (Uffizi, Florence), for which his initial preparation consisted of numerous studies in draughtsmanship, poetic, aesthetic and

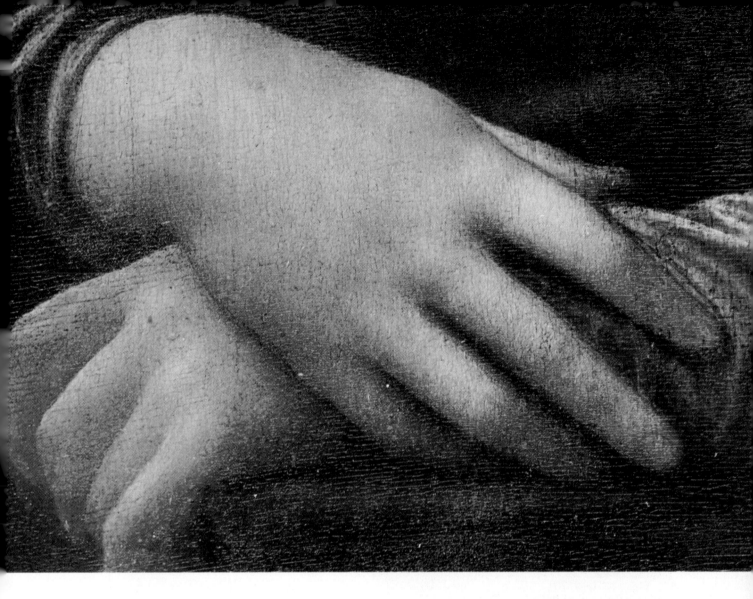

critical theorising and direct enquiry into the nature of the real world. This moving work is almost monochrome. Shapes emerge as shadowy apparitions from the enveloping darkness, give definition to the seemingly endless space, and are organised into groups. The kneeling Magi and bystanders leaning forward – who are shielding themselves from the light emanating from the Virgin and Child – occupy the base line of an imaginary pyramid, the vertex of which is the Madonna. The empty space surrounding her renders the human divine. The indistinct outlines of faces and drapery reflect spiritual awe better than a more delicate chiaroscuro effect might have done.

In 1483 at the Sforza court in Milan Leonardo began his *Virgin of the Rocks* (Louvre, Paris) finding new answers to his problem of softening outlines in the light. Between 1495 and 1497 he painted the *Last Supper* in the refectory of Sta Maria della Grazie in Milan; a dialogue between the divine and the human, a religious moment transformed into universality.

Leonardo da Vinci, 'Adoration of the Magi', detail (Uffizi, Florence)

The *Last Supper* is presented in a 15th-century perspective setting, enlivened by the free flow of light, and contrasting with the right wall of the supper room, which is lit as if by the direct light of the monastery refectory. Christ's gesture conveys a sense of serene poise, contained within an imaginary equilateral triangle. On each side the apostles either lean forward or back and express

Leonardo da Vinci, drawing of a mortar (Biblioteca Ambrosiana, Milan) .

a variety of individual human emotions. The figures are grouped by gesture and colour as the impact of Christ's incredible announcement makes itself felt. The *Mona Lisa* (Louvre) with its range of delicately shaded colours, suspended in a greenish magic underworld atmosphere, gives the transience of matter an eternal value as enduring as the cosmic order.

Raphael

Raphael (1483–1520), a native of Urbino, was the most strict upholder of classicism and pleasing creator of figurative and spatial forms – according to Renaissance rules – in Italian 16th-century painting. His creative impulse was formed by the environment of Urbino, particularly by Laurano's architecture in the Palazzo Ducale and Piero della Francesca's poeticism. In this respect he acquired a more valid spatial absolute than could be learnt from Perugino, to whom Raphael looked in his Umbrian period which lasted until 1504. Like Leonardo and Michelangelo, in his youthful works Raphael showed that he had assimilated enduring values. The blending of figures and space, harmonious gestures and balanced masses were all fundamentally achieved in the *Three Graces* (Condé Museum, Chantilly), the *Dream of the Knight* (National Gallery, London), and the *Conestabile della Staffa Madonna* (Hermitage, Leningrad) and their complete expression is to be seen in the *Marriage of the Virgin* (Brera, Milan), but with an additional 16th-century spaciousness. In this work – as opposed to Perugino's *Christ Giving the Keys of the Church to St Peter* (Sistine chapel, Rome) – the axis of the little Bramantesque temple coincides with the imaginary pivot of a spatial pyramid that links the distant horizontal line with the marriage scene in the foreground. His youthful figures have delicately curving lines, and the faces show little psychological variety, thus emphasising his desire to understand man as the perpetual expression of a complete, unified harmony contained rather than diffuse.

In Florence Raphael became aware of Leonardo and his use of *sfumato* which he applied, in an adapted form, in the *Madonna del Granduca* (Palazzo Pitti, Florence). Here the circular gesture of the Virgin which carries over from the left hand to the right and continues in the development of the cloak up to the veil, together with certain important internal oval movements, anticipate the more expansive settings in an open landscape of groups of the Virgin with the Infant Jesus and St John in the *Madonna del Cardellino* (Uffizi, Florence), the

Leonardo da Vinci, silver point drawing of a condottiere *(British Museum, London)*

Madonna in the Meadow (Kunsthistorisches Museum, Vienna) and the *Belle Jardinière* (Louvre, Paris). The pyramid plan is undoubtedly inspired by Leonardo, as in the occasional trace of *sfumato*, but Raphael's great originality lies in the interplay between sinuous outlines and elliptical movements, which stamp his beautifully conceived composition.

In Rome, where he remained from 1508 until

Leonardo da Vinci, sketch of a screw-shaped rotor (Bibliothèque de l'Institut de France, Paris)

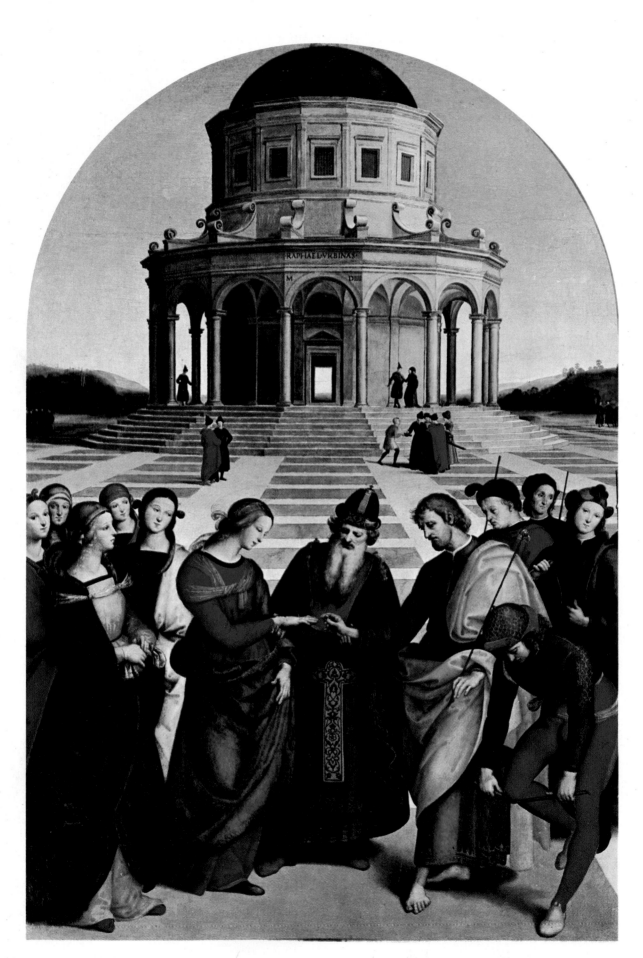

Perugino, the 'Baptism of Christ' (Kunsthistorisches Museum, Vienna)

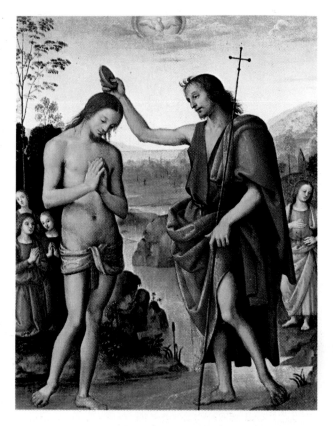

his death in 1520, Raphael painted the great frescoes in the Vatican, of which the subject matter alone indicates the vast classical culture of the Roman 16th century. Raphael's contact with Michelangelo (then busy decorating the Sistine chapel), although somewhat disturbing for him on account of Michelangelo's anti-classicism, gave him a 16th-century feeling fof space and figures. Also, the architectonic forms Bramante was then employing in St Peter's suggested new dimensions and relationships to him. Episodes like the *School of Athens*, the *Mass of Bolsena*, and the *Expulsion of Heliodorus from the Temple* are proof of this. In the *Disputa*, or *Disputation about the Holy Sacrament*, and *Parnassus*, however, space is conceived with a different spherical development. Within the space of the *School of Athens* great thinkers of classical antiquity are placed in grouped relief against the geometrically arranged buildings in an abstract light. In the *Disputa*, where heaven and earth are arranged as if viewed on the internal surface of a sphere, parallel rhythms accentuate the ideal vertical axis running from the isolated Host on the altar to God the Father. In the pictures of Raphael's Roman period the colour is heightened by Venetian influences, as for instance in such masterpieces as the *Sistine Madonna* (Gemaldegalerie, Dresden) or the portrait of Leo X (Uffizi, Florence).

When Raphael died, humanity lost the creator

Raphael, 'Portrait of Baldassarre Castiglione' (Louvre, Paris)

Opposite page: *Raphael, the 'Marriage of the Virgin' (Brera, Milan)*

Right: *Raphael, the 'Holy Family of the Canigiani', detail of the landscape (Alte Pinakothek, Munich)*

of pictorial forms who came closest to producing the ideal of perfection, and who made art seem the fount of serenity.

Michelangelo

The dominant aspect of Michelangelo's personality was expressed in sculpture. Tuscan by birth, he was linked by temperament and by his formal discipline to the neighbouring Florentine tradition, particularly in his youthful works. The *Virgin of the Stairs*, the *Battle of the Centaurs* and also his *Bacchus* (Bargello, Florence) – all works preceding 1500 – while displaying remarkable originality of expression, show the influence of Donatello and Masaccio. However, the *Pietà* (St Peter's, Rome), though still inspired by Florentine traditions, shows a culture ranging from the school of Ferrara to German-Flemish influences. The statue of *David* (Accademia, Florence) dates from 1504 and was commissioned by the officials of the Florentine republic. It is the symbol of youth, passionate strength and classic virtue. The balanced nude makes no concession to details, and the harsh intimacy of the face foreshadows the great solitude of the biblical characters in the Sistine chapel.

By now Florence and Rome were fighting over Michelangelo, and at this point began the exhausting experience of the tomb of Julius II, which occupied him from 1505 to 1545 but was never completed and was beset by dramas, illusions and delusions. Michelangelo wanted to embody symbolically not only his own passionately disturbing torment of soul, but also the discords which assailed and overwhelmed his age and environment. He wanted to wrest an expression of universal suffering from sculptural forms. Consequently, from being secondary, ornamental figures, the slaves become manifestations of Michelangelo's spirit, the acme of his dynamic effort to loosen and liberate. At the same time they are like symbols of a soul longing to free itself from the fetters of the body, and of a form ready to emerge from the indeterminate matter imprisoning it. The statue of Moses came later (1515–16), and is today in the church of S. Pietro in Vincoli. It is a dramatic representation of human might in the act of freeing itself to become a cosmic power.

These were Michelangelo's most impassioned years, the best moment for the manifestation of his creative genius and his soul. From 1525 he worked on the Medici tombs in S. Lorenzo, in

Raphael: the 'Mass of Bolsena', detail of the Swiss Guards (Vatican Gallery, Rome)

Michelangelo, the 'Battle of the Centaurs' (Casa Buonarroti, Florence)

Florence, where he determined the architectonic space with a well-defined purpose: to give significance to the life and death of man the hero. The main characters are shown as soldiers, alive, and yet beyond earthly time. One of them is

Michelangelo, the 'Pietà' (St Peter's, Rome)

Opposite page: Michelangelo, tomb of Lorenzo de' Medici (Medici chapel, S. Lorenzo, Florence)

Following pages: Michelangelo, detail of the ceiling (Sistine chapel, Rome)

about to spring to action, the other is sunk in profound meditation. Beneath them the two sarcophagi with their curved covers support four reclining nude figures, symbols of the times of day, immense in their solitude and thought. The face and gesture of the hand show that *Dawn* is awakening. The body, polished and smoothed to the point of shining radiance, is a symbol of youth and expectation without hope of fulfilment. *Dusk*, symbol of another moment in human life and time, is huge in repose and still trembling from exertion, but the face is bitter on account of the useless day that has been endured. *Day* and *Night* are on the other sarcophagus. In *Day* the fixed gaze controls the release of great force, the limbs are dilated to symbolise power about to burst out. *Night* is relaxed and finished in form. The hair is modelled in the shape of a crown above the silent, peaceful, timeless face and the head leans heavily on one arm. This last statue symbolises death as a serene haven, and is both Christian and pagan.

After so much tense drama and such an extensive enquiry into the reasons for existence, Michelangelo turned to architecture and then again to painting. Only much later (in fact these were the last works of his life) three *Pietàs* show him once more to be a sculptor of torment, anguish and dissolution.

Michelangelo's painting career overlapped with his sculptural activities, and his chief work is the ceiling of the Sistine chapel in the Vatican. Its pulsating, dramatic sense shows man's frailty when confronted by the power of God, his desire for redemption in the terror of biblical events and the breadth of time in prehistory when he revealed hopes of the sibyls and the prophets were given to man. The great work was accomplished in the four years from 1508 to 1512, after his youthful painting of the *Holy Family* – the Doni tondo – (Uffizi).

Trompe l'oeil architecture on the Sistine ceiling divides the complex subject matter into two basic types. The nine great panels on the wide central axis which leads from the entrance towards the altar tell the story of the creation of the world and of man and of his first misfortunes; the space lacks setting or natural light, figures are huge and ponderous in their gestures, whereas

the flanking monumental figures of the prophets and the sibyls symbolise, with their expressive faces and gestures, the power of prophecy.

By the time Michelangelo returned to the Sistine to paint the *Last Judgment* on the altar wall (between 1536 and 1541) the Counter Reformation had upset the equilibrium of the preceding age by questioning the nature of the Almighty. The vast area is shot through by dramatic lights and dark shadows; the powerful Christ the Judge, appearing in a vortex, dominates the scene, separating the damned from the elect. The human forms are deformed by passion; gestures indicate desperate pleas and bodily contortions already hint at the Baroque. The whole work denotes a retreat from the Renaissance, confidence in man and the universe.

Michelangelo began his architectural activities

Above: *Michelangelo, staircase in the vestibule of the Biblioteca Laurenziana (S. Lorenzo, Florence)*

Michelangelo, 'Slave', statue for the tomb of Julius II (Louvre, Paris)

late in life. By the time he drew up his plans for the New Sacristy of S. Lorenzo in Florence – designed to contain the Medici tombs – he was already forty-five with a sculptor's career behind him, numbering such works as *David, Moses* and the *Slaves*; also a painting career that had produced works of the order of those in the Sistine chapel. Turning his attention to this new creative field – in which he continued until his death – Michelangelo followed principles in the Brunelleschi tradition, but added a vertical impulse to the internal space and a noble abstract lighting suitable to the funeral sculptures intended to be housed there. The niches, pediments and tablets on the walls are not only antithetic both to Brunelleschi's static, continuous surfaces and to Bramante's harmonious, buoyant ones, but they also express a vigorous force attempting to present plastic and carefully controlled solutions. The coffered dome contains the hollow space, and by its cold insistence sets off the difference in colour between the white marble and the grey sandstone of the middle and lower areas.

Still in Florence, Michelangelo began his most powerful and original architectural work, the Biblioteca Laurenziana, in 1523. Here an atmosphere of austerity prevails, perfectly in keeping with the need for study and meditation. The vestibule, which is not very large, has pairs of columns which break up the surface of the walls, but have no functional significance. Consoles, pediments, tablets and pilasters suggest a plastic statement which is even more emphatic than in the Medici chapel. Michelangelo's assistance in completing St Peter's (work had been suspended after Bramante's death and the additions by Raphael and Peruzzi) dates from 1546, when he was already seventy-one. The basilica underwent a great transformation in the plastic rendering of masses and enlarged pillars which emphasise its strength. On the exterior, both on the sides and on the apse, the dynamic tension increases towards the summit and the mighty dome.

Rome – the place where the Church took up the challenge of the northern Protestant revolution with a religious movement of its own – was the scene of a massive building programme. One architect, Jacopo Barozzi, known as Vignola (1507–73) created a new basilica form for the church (which found its most ardent supporters among the Jesuits) in the Gesù in Rome, where the single nave flows into the domed transept and exalts in a sumptuous and spectacular manner the new pronouncements on the Faith.

Michelangelo, Rondanini Pietà (Castello Sforzesco, Milan)

Jacopo Sansovino, façade of St Mark's library, Venice

Sansovino

Jacopo Tatti, known as Sansovino (1486–1570), was in a certain sense bound to Bramante's tradition by his acceptance of classical forms and his ordered sense of composition. He arrived in Venice in 1527 after a long stay in Rome. It was here that Sansovino, already a sculptor, grasped the importance of chiaroscuro and decoration, not only in his architecture but also in his sculpture on the façades of buildings. The façade of the Biblioteca Marciano has two arcades corresponding to the two floors of the library, the lower one open and the upper one closed, surmounted by a balustrade decorated with statues. With remarkable imagination and genius Sansovino brought together and unified austere volumes and brilliant decoration. The nearby Loggetta at the foot of the campanile, also by

Small pail of transparent glass with polychrome enamel decoration (Glass Museum, Murano)

Sansovino, is no less interesting for the sculptural effects, which repeat briefly, and in a more vivid language, motifs which reappear in other works like the churches of S. Fantin or S. Francesco della Vigna, as well as the Palazzo Zecca and the Palazzo Corner. However, this last has been rendered more clumsy by successive additions.

What remains of the great architectural production of the 16th century – taking into account Michelangelo's influence, which projects further into time – can, in a certain sense, be unified under the heading of Mannerism, even though there were many aspects of this trend that reached high points at Verona with Sanmicheli, at Vicenza with Palladio, at Florence with Vasari and at Rome with Vignola. All worked from theoretical premises following, in particular, codified rules derived from architectural treatises, amongst which the most influential was the one published by Serlio in 1537. Consequently the high noon of the great architectural renaissance was short. Mannerism arrived before the first half of the century was complete, and then cultural and intellectual standpoints, together with a desire for synthesis and effect, prevailed in the crisis precipitated by Michelangelo.

Palladio

Andrea Palladio of Vicenza (1508–80) was the greatest among them, as much for his new language (although Mannerist in accent) as for

Andrea Palladio, proscenium of the Teatro Olimpico, Vicenza

Andrea Palladio, the Rotonda, Vicenza

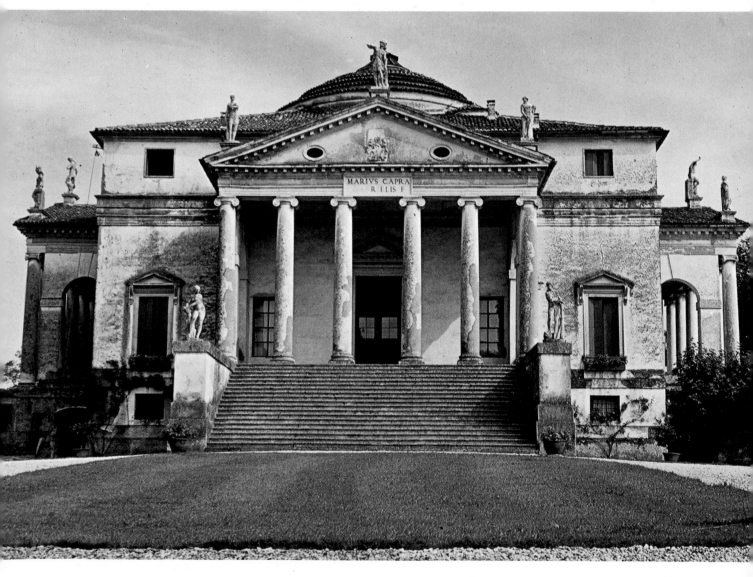

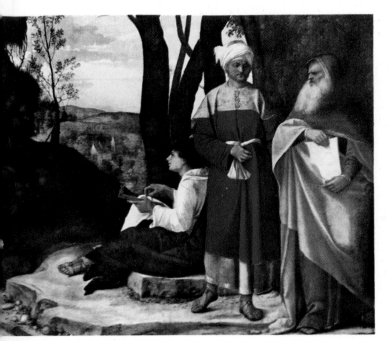

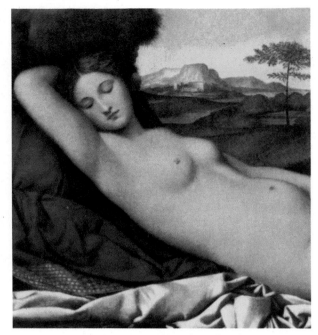

Giorgione, the 'Three Philosophers' (Kunsthistorisches Museum, Vienna)

Giorgione, 'Venus', detail (Gemäldegalerie, Dresden). Opposite page: Giorgione, the 'Tempest' (Accademia, Venice)

his sensitive urbanism in the invention of the so-called Venetian villa and for the depth of his classical education and the wide dissemination of his style.

An early work is the Vicenza 'basilica' (Palazzo della Ragione), whose exterior is richly decorated and yet stately. His villas are full of sunlight and brilliantly conceived. There is the famous Malcontenta near Mira with its classical colonnade on the ground floor, more intimate second floor, and open wings. The Rotondo near Vicenza is more austere with its central plan and four façades. Then there is the more simple façade of Villa Barbaro at Masèr, with its great colonnaded wings. Palladio's villas were built directly in relation to their intended function and setting, sometimes in the full light of the flat countryside and sometimes in the leafy shade of trees. Palladio's most notable achievements are at Vicenza, in the proportions of the façade of the Palazzo Valmarana, the alternating volumes and spaces of the Palazzo Chiericati or of the elegant Teatro Olimpico with its permanent backcloth and splendidly rich effects of perspective and colour.

Michele Sanmicheli (1484–1554) was active before Palladio in the Veneto and, apart from imposing city gates, is specially noted for his palaces around Verona. An example of his work is the Palazzo Bevilacqua, with its heavy façade centred on the upper storey. It is unified by great columns, but the different sizes of windows and the uneven spacing of the columns render the intervening spaces discordant. By comparison

with Sansovino's contemporary work, the façade of the Palazzo Grimani in Venice is oppressive.

Giorgione

In the development of Venetian art it was for Giorgione (born at Castelfranco in the Veneto in 1477, died in 1510), to break with the 15th century. Giovanni Bellini's early tonal discoveries and Carpaccio's vein of fantasy and anecdote give only slight hints of Giorgione's production. From Giorgione's painting the essence of Venetian classicism emanates, and he imposed it on a pictorial poetry which also took account of contemporary Paduan culture. His spirit – and in this respect he was not unlike Leonardo – was keen and sincere in his enquiry into man and nature, and affirmed the essential virtues of meditation. In the early years of the 16th century Giorgione's works aroused sentiments in the Venetians which were so much in harmony with their expectations and taste that, amazingly enough, his art – which should have seemed 'modern' – happily took over the positions of Giovanni Bellini and Antonello.

An even more surprising fact is that in his later works Giovanni Bellini drew inspiration from a painter who had once been, indirectly, a pupil. The strong personality of the young Titian was also in turn influenced by Giorgione. Both during and after his lifetime, despite the very limited number of his finished works, Giorgione inspired such a large amount of imitation that he can safely be regarded as the founder of an entire style. The more important characteristics of

402

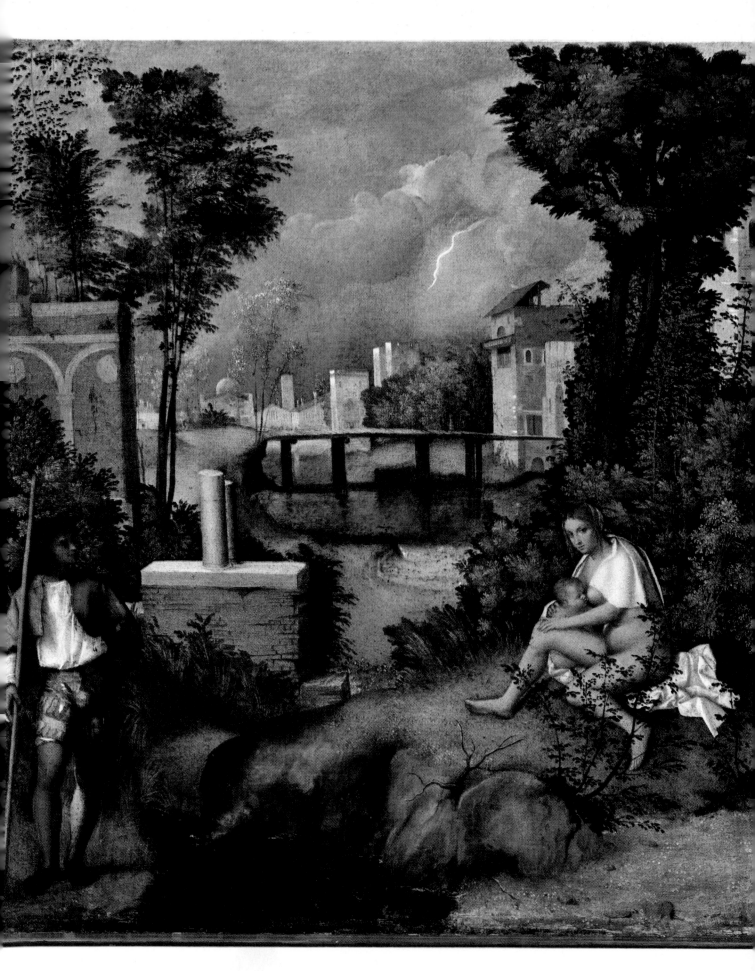

his art consist of restraint in draughtsmanship in order to heighten colour, which is suffused by a glowing light – achieved with a fluid brush stroke and the use of coloured glazes. The spiritual aspect of Giorgione's works, which is where he appears most forcibly as the precursor of modern feelings, is achieved through his ability to make an emotional fact of the painted reality, and his capacity to individuate in man his interior world.

In Giorgione's altarpiece of the *Virgin with S.S. Francis and Liberale* in the church at Castelfranco in the Veneto, where the throne interrupts the background Venetian landscape, Antonello's plastic interests and Bellini's tonality prevail. By this time Giorgione had already produced the panels of the *Trial of Moses* and the *Judgment of*

Solomon (Uffizi) – which derive from Umbrian-Ferrarese culture – not to mention the *Nativity* (National Gallery, Washington). However, it is the *Three Philosophers* (Kunsthistorisches Museum, Vienna) that expresses the full maturity of Giorgione's art. Whether the three characters symbolise three moments of philosophic thought, or whether they portray three stages in the life of man, or are simply the three Magi, bearers of wisdom, they convey an impression of profound solitude and deep concentration. There is a continuity between the men and the landscape which creates a kind of harmony. The strong colours of the drapery and the different faces are bathed in an all-pervading light which makes the colours vibrate.

The *Tempest* (Accademia, Venice) shows the fury of nature unleashed on the world. The sky is full of lightning-pierced clouds, the distant houses glimmer in the violent light, and the dark green leaves of the trees are shaken by the wind. In the foreground, quite indifferent to this display of nature's force, are a mother feeding her child, with a beautiful protective gesture, and a motionless shepherd. Splendid portraits, like the *Portrait of a Man* (Staatliche Museen, Berlin), and the *Young Man Wearing a Fur* (Alte Pinakothek, Munich), are light of colour and careless of touch, and the *Boy with Flute* – vaguely reminiscent of Leonardo in colour and shading – are only a few links in a superb chain. In it can be included works of difficult attribution such as the *Concert Champêtre* (Louvre, Paris), the *Concert* (Palazzo Pitti, Florence) and the *Sleeping Venus* (Gemäldegalerie, Dresden). They have also been attributed to Titian, but in any event are expressive of the moment when Giorgione's great legacy passed on to Titian.

Titian

Giorgione's brief season of youthful lyricism was followed by the lengthy, prolific and varied career of Titian (1490–1576). He was a painter by instinct and created exuberant forms with rich colour, becoming a model not only for the development of more than a century of Venetian painting but also for the work of Rubens and Velásquez. Giorgione saw in nature a poetic and passionate stimulus to seek out truth. Titian saw it in a classical form as the need to turn reality into a pleasing blend of life and sensory perception, best exemplified in nature by the warm beauty of female nudes, such as the dancing Ariadne in the *Bacchanal* (Prado, Madrid), *Sacred and Profane Love* (Borghese Gallery, Rome) and the *Venus of Urbino* (Uffizi, Florence).

Titian, Pesaro Madonna (Frari church, Venice)

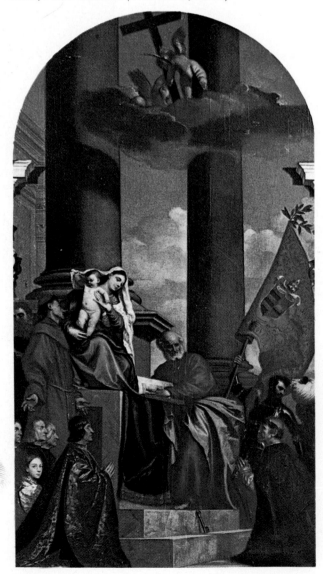

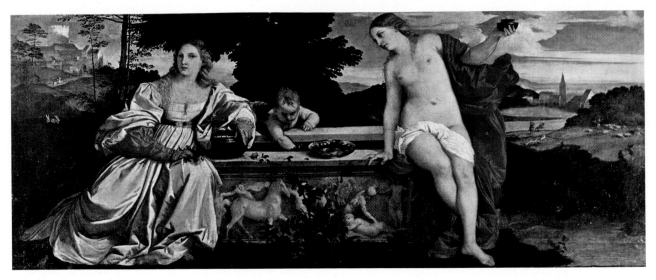

Titian, 'Sacred and Profane Love' (Borghese Gallery, Rome)

Titian, 'Sacred and Profane Love', landscape detail (Borghese Gallery, Rome)

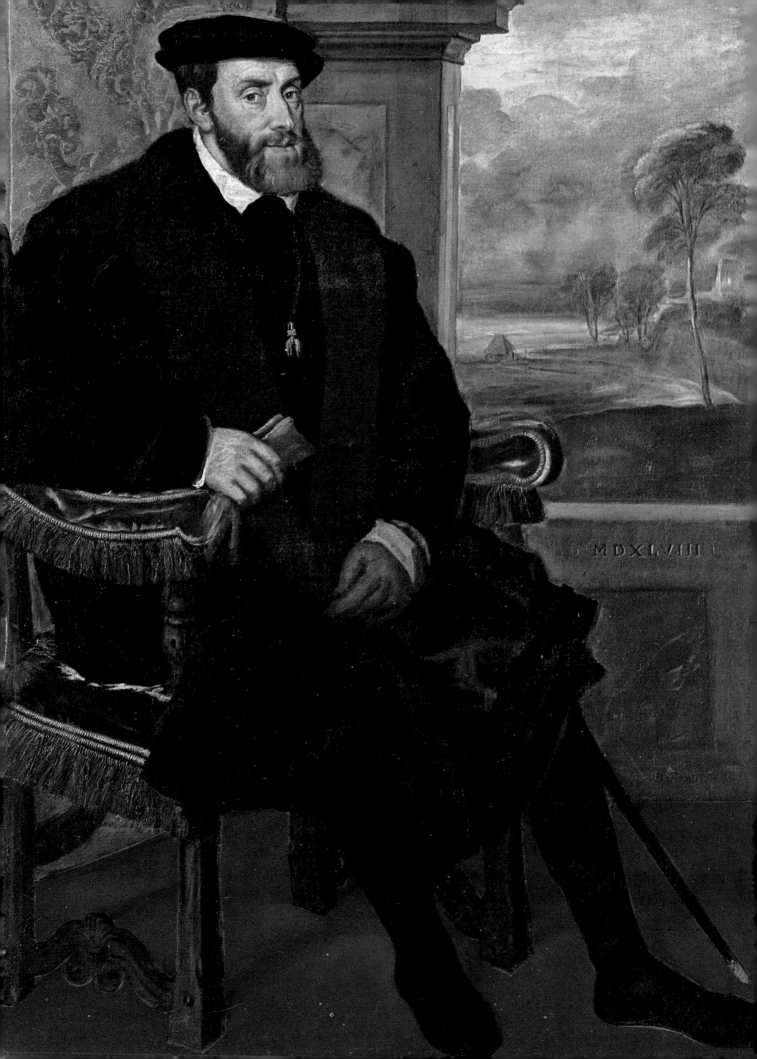

Titian chose for his simulated landscape distant, radiant horizons, delicate, green hills and densely foliaged trees, modified by a calm light – such as appear in the *Concert Champêtre* (Louvre, Paris) which is attributed to Giorgione by some scholars. While within Giorgione's ambit, and right up to 1516–18, he executed several beautiful portraits. In the *Man with the Glove* (Louvre, Paris) the pose is dignified – particularly in the hands in the foreground – and the contrasts of light and shadow throw the face into romantic relief, caught in the moment of withdrawing into melancholic solitude. In 1515, still fascinated by Giorgione, Titian painted *Sacred and Profane Love*. The composition is problematic, but the gestures are balanced, and the glowing nude contrasts with the rich silken dress of the other woman. The whole work is bathed in a sunset glow. The *Flora* (Uffizi, Florence) of the same year, displays her ample,

serene beauty in the change of colour from the golden, flowing hair to the pale pink dress. Titian came into contact with Michelangelo's creative world but was not thrown off balance by it, as is evident in the *Assumption* (Sta Maria dei Frari, Venice). The setting is a dual circular dynamic of coloured masses – the angels in heaven, the apostles on earth – and the Virgin's ascent towards God is proud and confident.

The Pesaro Madonna, also in the Frari (dated after 1519), marks the high spot of Titian's sense of composition. The painting is divided by horizontal planes formed by the steps and the seat of the throne, and austere columns dominate the space, both in depth and height. Titian thrusts his narrative onto a bold, diagonal plane marked by the group of the Virgin and Child at the top, and the standard bearer with the faithful at the bottom. At the central

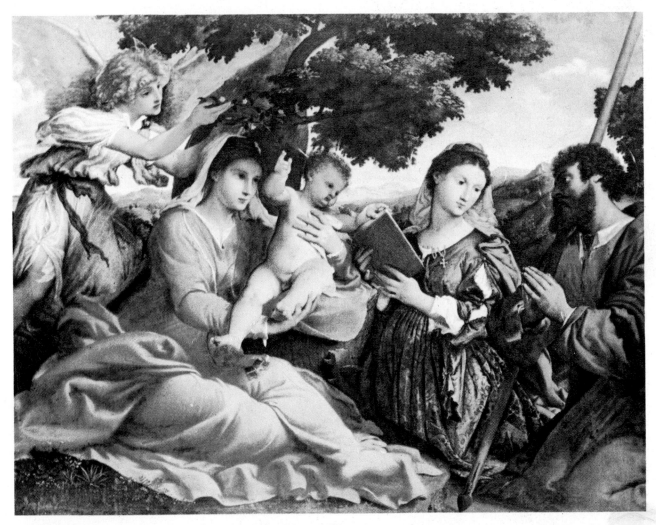

Lorenzo Lotto, 'Sacra Conversazione' (Kunsthistorisches Museum, Vienna)

Opposite page: *Titian, portrait of Charles V (Alte Pinakothek, Munich)*

focal point is the old man with his book, while the Pesaro family are placed in the foreground, the bright face of the little girl turned towards the onlooker. In the secular works painted towards the middle of the century, particularly in the female nudes – *Venus and the Flautist* (Kunsthistoriches Museum, Vienna), the *Danaë* (Prado, Madrid) – one is aware of a freer hand, a more spacious arrangement and a more subtle technique. The brushwork is ragged and uneven, creating an almost impressionist effect suited to a restless but experienced sensuality. The portraits, such as *Pope Paul III with His Nephews* (Capodimonte Museum, Naples) or the portrait of *Ariosto* (Prado, Madrid) are dominated by more immediate dynamic expressions

and formal poses. The occasional shaft of light also prefigures a Mannerist note.

Titian's portrait of *Charles V* (Prado, Madrid) is more dramatic. The subject is bowed by the burden of his inner conflict in which the sky participates, fading after a flaring sunset. The religious themes which Titian had always enjoyed, beginning with his early Madonnas – serenely beautiful mothers in an open landscape – are taken up again with new dramatic force in the Pietàs, both in the Louvre and in the Prado. The *Pietà* in the Venice Accademia, with its signature and propitiatory dedication, added after he had contracted the plague, sets the seal on the generous span of his life and work. Here the landscape has disappeared, the background is

Jacopo Robusti called Tintoretto, 'Adoration of the Shepherds' (Scuola di S. Rocco, Venice)

Opposite page: *Tintoretto, the 'Finding of the Body of St Mark' (Brera, Milan)*

Below, left: *Jacopo Bassano, 'St John the Baptist' (Museo Civico, Bassano)*

Below, right: *Jacopo Bassano, 'Rest on the Flight into Egypt' (Accademia, Venice)*

enclosed by the large gold-lit niche and the scene is set on a continuous diagonal plane emphasised by Joseph of Arimathea's genuflection, the ample gesture of the Virgin and the upraised hand of St Mary Magdalene. In the centre, Christ, bathed in light, still emits His radiant divine beauty.

Lorenzo Lotto (1480–1556), although a member of the Venetian circle and in his early days inspired by the contrast between Bellini and Giorgione, was a solitary. His complex personality inclined in one way towards a naturalistic representation of the world and the beauty of man as in the *Mystical Marriage of St Catherine* (Carrara Gallery, Bergamo), but in another sense he tried to reconcile Raphael's handling of space

with the Flemish taste for precision, as in the altarpiece of the Virgin and Saints in Vienna. An excellent portrait painter, Lotto was particularly successful in his *Young Man in His Study* (Accademia, Venice) where he translated Giorgione's intimacy into realistic effect, but it is in the *Old Nobleman* (Brera, Milan) that he gave the full measure of his skill, with its Northern overtones. There are traces of Lombardian radiance and more immediate evidence of spiritual unease than in Giorgione.

Meanwhile, Venetian painting continued its great, uninterrupted development. Wealth, the fruit of unparalleled economic success, continually demanded new contributions from art. Sometimes it was a matter of decorating the walls and

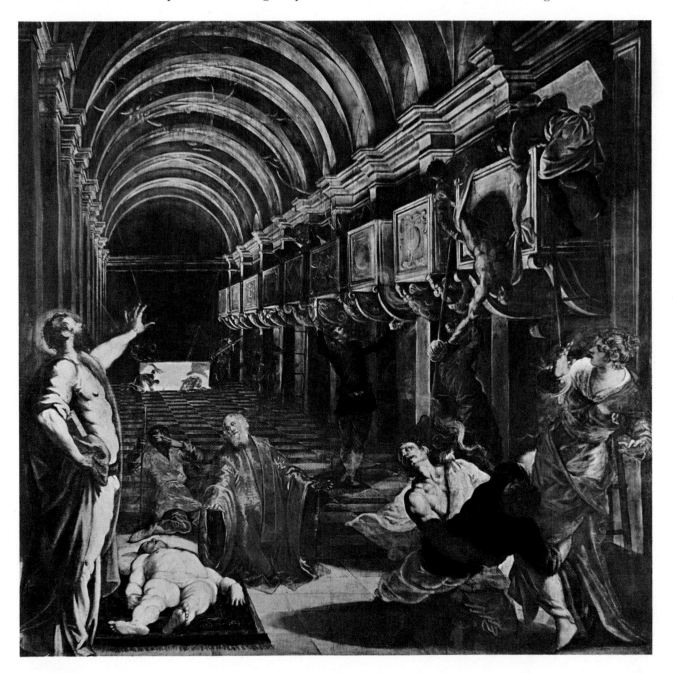

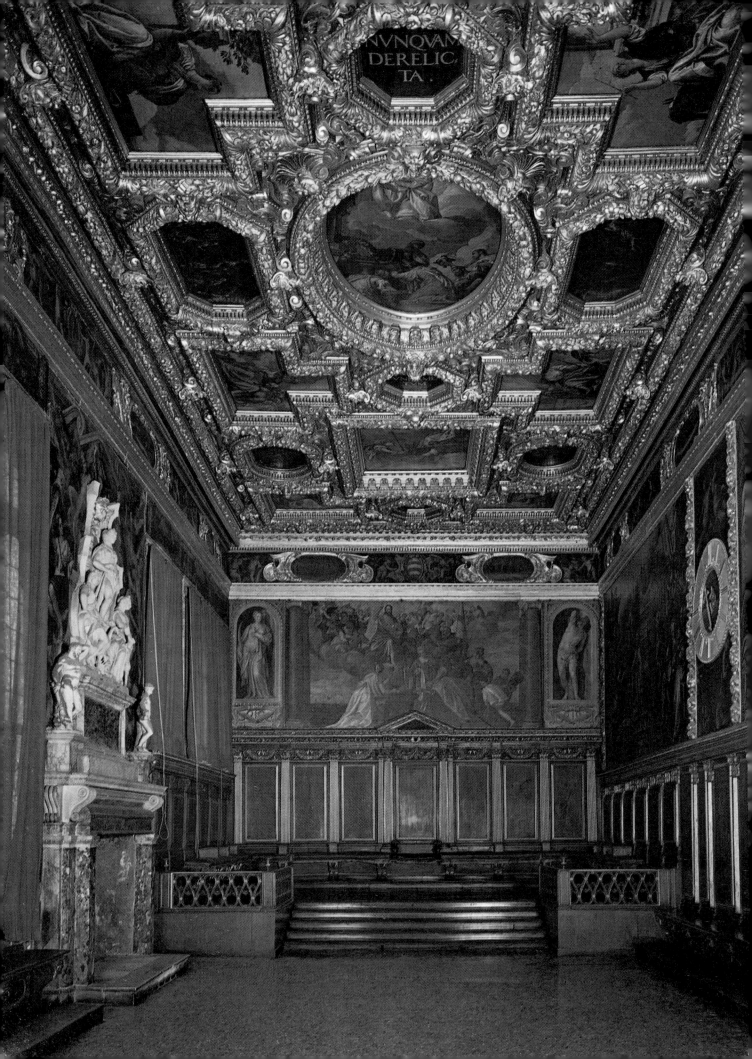

P. Veronese, 'Dialectic' (ceiling of the Sala del Collegio, Doges' palace, Venice)

ceilings of the Doges' Palace, at other times of renewing the pictorial patrimony of churches, ranging from altarpieces to frescoes of new dimensions, of which the Scuola di S. Rocco is a typical example. Tintoretto and Veronese were first among the artists who fulfilled these demands. In the second half of the century Titian achieved late maturity and Tintoretto (1518–94), at the age of thirty, began his long career of painting, destined to take up the legacy of Venetian 16th century classicism and to carry it forward into an anti-classical Mannerist standpoint. In fact he overrode the sensual naturalism of colour and used light to emphasise and distort. He took composition to the limits of scenic effect in the way he both arranged space and organised figures in a contrasting, violent dynamic of masses.

Tintoretto

The *Finding of the Body of St Mark* (Brera, Milan) is an example of Tintoretto's technical and spiritual revival of art. In this picture the boldly lit nocturnal scene and the dramatic row of sepulchres from which the corpses are being dragged by torchlight form a background to the two contrasting masses in the foreground. On the left is the monumental ghost of St Mark, reminiscent, in a certain sense, of Michelangelo, and on the right, a group of three twisted figures. In this group the beautiful woman stands out because of the mellow, golden tones of her drapery shot through by shafts of light.

Tintoretto had reached full maturity when,

between 1564 and 1587, he painted the forty-eight pictures for the Scuola di S. Rocco. The vast work, even if erratically pursued through the years, maintained basic fundamental values. It also demonstrated a new spatial concept, stated either by foreshortening from below, as in the episode of the *Crib*, or by ascending, oblique development – as in *Christ Before Pilate* or spirally as in *Calvary* or the *Crucifixion*. The open

Jewel belonging to the Palatine Electress (Silver Museum, Florence)

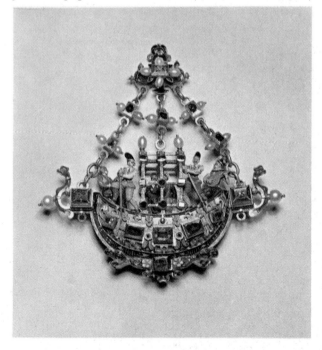

411

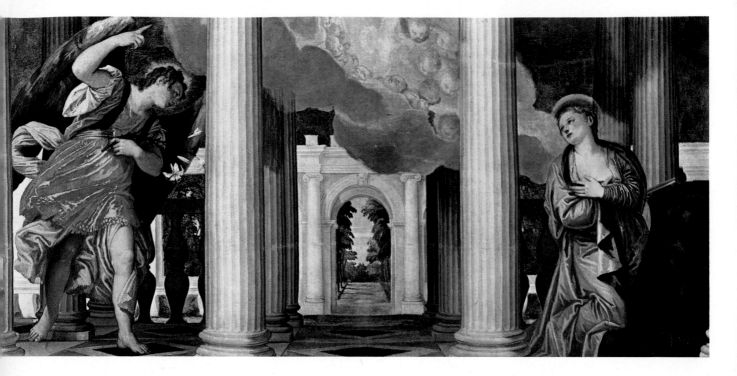

landscape, as in the *Flight into Egypt,* has a luxuriant kind of grandeur pierced with darting lights which highlight the trees as if in a fireworks display. In pictures with a sacred theme such as the *Descent From the Cross* (Brera, Milan), the dramatic unity is tense and concentrated. His works on a profane or mythological subject, as in the Sala dell'Anticollegio in the Doges' Palace, reveal female nudes quite unrivalled for their rhythmic composition, warm, glowing skin tones and serene beauty. *Susanna and the Elders* (Kunsthistorisches Museum, Vienna) which in one sense is clever, elegant and refined, shows a natural setting to be the most suitable for its particular kind of sensual enchantment.

Veronese

Paolo Veronese (1528–88) provided a complete contrast to Tintoretto's dramatic imagination, dynamic excitement, free (and occasionally uncontrolled) composition, and unreal light. Instead, Veronese introduced a more classical feeling of relaxed, peaceful serenity and brilliant, vibrant colours. Venice wanted him to celebrate her power and stage her splendours as magnificently as possible; her justice, charity and power were to be symbolised by resplendent female figures. This Veronese did, turning the Venetian landscape into a silken stage-set or a tapestry woven with silver thread, with radiant-skinned women, naked, or dressed in magnificent silk damask robes profusely scattered with pearls. The *Feast in the House of Levi* (Accademia,

Venice), The *Feast in the House of Simon* (Brera, Milan), and the *Marriage at Cana* (Louvre, Paris) show banquets attended by numerous guests who are grouped beneath classical loggias with stairs and terraces. A sumptuous secularism abounds in all his works, together with an attention to detail which reproduces the rich Venetian way of life. Colour is always precious and diaphanous, frequently silky or pearly, and the contrasts of light are spacious and vibrant. With Veronese, classicism assumes the atmosphere of an enduring myth, a fairy tale painted in sumptuous colours.

The most carefully executed Venetian cycles in the Doges' palace and the church of S. Sebastiano in Venice are but great moments in the vast production of a master who introduced Venice to the Mannerist movement. When Veronese decorated Villa Masèr (a result of the development of Venetian villas inspired by the work of Palladio) he staged a major display of foreshortening, *trompe l'oeil,* brilliant colour and realistic observations of the countryside which set the trend for all great decoration in Italy from the end of the 16th century to the beginning of the 17th century.

However, as the paintings of Tintoretto and Veronese gave way to their imitators, the political greatness of Venice also declined. It is true she was still able to live splendidly on her inheritance, but she could no longer develop her scope. In the Veneto Jacopo da Ponte, called Bassano from his place of origin, was the most important of an entire family of painters. He favoured the proportions, the wide colour spectrum and lighting

effects so dear to Mannerism, but at the same time allowed the vitality of anecdote to prevail – often in a simple, peasant vein blended with some exterior element. The squares, streets, palaces and houses of the Veneto, traditionally colourful and picturesque, all appear in this happy painting.

Paolo Veronese, the 'Annunciation' (Uffizi, Florence)

Venetian glass cup (Glass Museum, Murano)

Paolo Veronese, 'Feast in the House of Levi', detail (Accademia, Venice)

EUROPEAN ART IN THE 15TH AND 16TH CENTURIES

While 15th-century Italy was completing the first phase of the Renaissance, the Flemish school of painting experienced its greatest creative moment, which itself was of the order of a renaissance and lasted from Jan van Eyck (*c.* 1390–1441) to Hieronymus Bosch (*c.* 1450–1516). The 16th century, on the other hand, apart from Bosch and Bruegel, was not so original – perhaps because of its lingering imitation of the 15th century, or perhaps because of the great enthusiasm reserved for Italian influences which here, as in the whole of Europe, assumed the dimensions of a general and characteristic movement.

Flemish architecture was less important during these two centuries. The Flamboyant Gothic style arrived relatively late, so that there was little inclination to adapt to the forms and structures of the Italian Renaissance, except to include classical decorative features in basically Gothic conceptions. As a consequence Flemish architecture of the period shows compromise

Jan van Eyck, 'St Barbara' (Musée des Beaux Arts, Antwerp)

Burgundian school, funeral monument of Philippe Pot (Louvre, Paris)

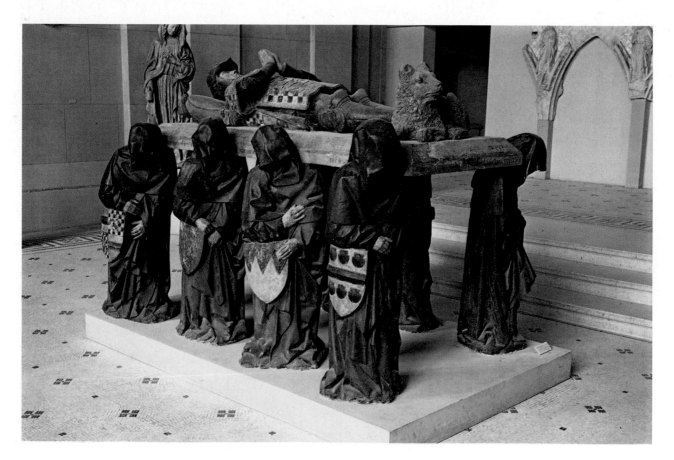

Jan van Eyck, 'Portrait of a Young Man' (National Gallery, London)

solutions, good examples of which are the law courts in Malines (Mechelen), the Prince Bishops' palace in Liège, and the Hôtel Plantin in Antwerp, all begun towards the middle of the century. The Maison du Saumon ('House of the Salmon') at Malines and the town hall at Arnhem are both tied to local tradition. The architect-sculptor Cornelis de Vriendt, called Floris, was the most significant personality of the period. The façade of his town hall in Antwerp (1561) was inspired by similar façades on Florentine Renaissance palaces, but with a pronounced horizontal emphasis and a raised central turreted section. Holland, in any case poor in stone, did not experiment with new forms and reproduced the somewhat ponderous style of Brabant in the 'Old Church' in Amsterdam and in the cathedral at The Hague, making some concession to classical decoration, particularly after the translation of Serlio's treatise was made available in 1539.

In sculpture the influence of Klaus Sluter (active *c.* 1380–died 1406), a Flemish sculptor who worked in Burgundy, spread into Holland, characterised by a preference for monumental, fluent forms, amply draped, romantically expressive, and taken from an architectural context. However, at the court of Margaret of Austria, regent of the Netherlands in the early 16th century, a taste for classical decoration developed. This is still visible on the magnificent great chimney pieces and on small brass objects (where much attention has been given to detail) such as candlesticks, which formed part of household furnishings.

The birth of realism in Flemish painting

By the second half of the 14th century, Franco-Flemish painting, as a result of the experiments of the Bohemian and Sienese schools, began to take an interest in naturalism. But it was only in the 15th century, through the work of Jan van Eyck, that a new style of deliberate, realistic painting emerged, interested in man as such, in his relationship to his environment and in the beauty of the universe. The situation, although comparable to that of the Italian Renaissance, differed from it in that it was not supported by the cultural influence of Florentine humanism, and was therefore less inclined to theorising in philosophical or moral terms. However, this was compensated for by the middle-class love of possessions and the precise tangible evidence of everyday objects, presented without any flight of fancy in faithful clarity.

The method of simulating space in painting was especially different: the Florentines confined it to rigid rules of linear perspective, whereas Van Eyck saw it as freely diffused light, changing distant colours – an atmosphere within which to place an ordered vision of reality, dominated by solemn, motionless figures painted in jewel-like colours. Such features of Jan van Eyck's style are evident in the central panel – the *Adoration of the Lamb* – of the altarpiece finished in 1432 for the cathedral of St Bavon in Ghent, and clearly distinguishable from his brother Hubert, to whom we owe the three heavier, more ostentatious panels depicting God the Father, the Virgin and St John. In the lower panels, Jan van Eyck introduced open, limpid landscapes, distinctly visible right to the far horizon. In the top portion, with the groups of singing angels and the angels forming a crown above the head of St Cecilia at the organ, Jan came into line with his brother's pictures, but in his two nudes of Adam and Eve there is exquisitely modest naturalistic attention to detail in the faces.

The signed portrait by Jan van Eyck of Giovanni Arnolfino and his wife (National Gallery, London) is dated 1434. Here space, as in the old miniaturist tradition, is reflected by

Jan van Eyck, the 'Madonna with Chancellor Rolin' (Louvre, Paris)

417

the mirror on the far wall and becomes a prismatic box modified by the contrasts of light and shade which touch the couple and render them silent and motionless. His psychological observation was extremely subtle and is even more evident in the *Madonna with Chancellor Rolin* (Louvre, Paris), painted at about the same time. In this picture two spaces are brought together. First there is the bright interior spanned by columns, with brilliant tiles on the floor and the solid figures of the red-cloaked Virgin and the solemn chancellor. Secondly there is the open space that recedes into the far distance with varying tones of greens and blues. Portraits like that of the dour Cardinal Albergati (Kunsthistorisches Museum, Vienna) or the *Man in the Red Turban* (National Gallery, London), or the one of his wife Margaret (Bruges Museum), dated 1439, where the face is offset by the light headpiece which falls in great folds over the red bodice – all these are masterpieces whose spiritual terms of reference throw out a magic bridge from the Flemish 15th century to the Dutch 17th century.

In contrast to Jan van Eyck's style, which was not essentially sculptural, the output of Robert Campin was clearly influenced by sculpture. The works grouped under the name of the Master of

Rogier van der Weyden, the 'Annunciation' (Louvre, Paris)

Rogier van der Weyden, the 'Annunciation', detail (Louvre, Paris)

Flémalle are attributed to Campin and, despite the uncertainty of this attribution, he was certainly the master of Rogier van der Weyden from 1427. It is to Campin that we owe the frontal positioning of figures expanded to their full spatial limits and heavy with drapery, as in the Salting *Madonna* (National Gallery, London). He was closely connected with the realistic sculptural tradition and was possibly a painter of wooden statues also, which would explain a certain note of popular piety in his paintings.

It was from these different approaches – Van Eyck's idealism, Campin's realism – that the strong, eclectic personality of Rogier van der Weyden (active from 1427–died 1464) emerged. A goldsmith by family tradition he always preferred a buoyant linearism in his figures, with drapery modelled in a somewhat metallic manner. Won over by Van Eyck's interest in landscape, Rogier van der Weyden also introduced it into his work, but tended to reduce the open background in order to stress the enclosed foreground space into which he projected the figures. This is the case with the *Miraflores* altarpiece (Staatliche Museen, Berlin). Sometimes the background is entirely sacrificed in favour of a golden-painted expanse intended to emphasise the plasticity of the figures and their dramatic gestures which determine the composition, as in the *Descent from the Cross* (Prado, Madrid). The balance of the composition pivots on the figure of St Mary Magdalene on the right, and there is a hint of Mannerism in the carefully grouped figures and the spectacular, iridescent colours.

His early period ended with this work, and Van der Weyden once more incorporated spacious landscape settings in the triptych of the *Crucifixion* (Kunsthistorisches Museum, Vienna), where again there is a hint of Mannerism in the gesture of the Virgin embracing the cross. The subject matter of the *Adoration of the Magi* permitted Van der Weyden to introduce superb clothes and secular notes such as the youngest king's salutation. *St Luke Painting the Virgin* (Boston Museum of Fine Arts) is particularly

419

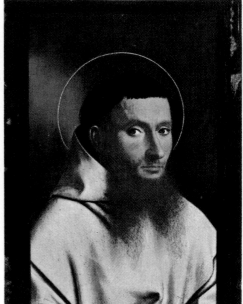

Above, left: *Joachim Patinir, 'Charon Crossing the Styx'*
(Prado, Madrid)

Above, right: *Petrus Christus, 'Portrait of a Carthusian'*
(Metropolitan Museum, New York)

Opposite page: *Hans Memling, 'Portrait of a Man'*
(Uffizi, Florence)

Klaus Sluter, 'Christ' from the Charterhouse of Champmol
(Musée Lapidaire, Dijon)

well known for the free landscape extending beyond the loggia – an idea derived from Van Eyck. The *Annunciation* (Louvre, Paris) is painted in a tone of serene intimacy, and his ability as a portrait painter is attested by the *Portrait of a Young Woman* (National Gallery, Washington) with her white veils contrasting with her black dress. Arriving in Italy in 1450, Van der Weyden exercised a remarkable influence on certain local painters, particularly at Ferrara.

Petrus Christus (*c.* 1400–72?) had a sculptural quality very similar to that of Van der Weyden. At the height of his maturity, a portrait such as that of Sir Edward Grymstone (National Gallery, London), with its sharply modelled face, almost takes on a metaphysical aspect. The realistic narrative of *St Eligius in his Workshop* (Lehmann Collection, New York) is less significant, but he achieves great nobility in the beautiful *Portrait of a Young Girl* (Staatliche Museen, Berlin) in which there is evidence of Italian influence. The plastic synthesis is vaguely reminiscent of Piero della Francesca, and the gold-tinged blacks and blond skin tones recall Venetian painting.

Flemish painting ended its first renaissance with Hans Memling, Rhenish by birth, but active in Bruges right up to his death in 1494, and Gerard David, Dutch by birth, but who also lived in Bruges until his death in 1523. Memling, who was rather arbitrarily placed by 19th-century critics above other Flemish masters, kept his early production within the confines set by the school of Cologne and Stefan Lochner's ideals of grace. Once at Bruges, he studied Van der Weyden with particular care, and yet always

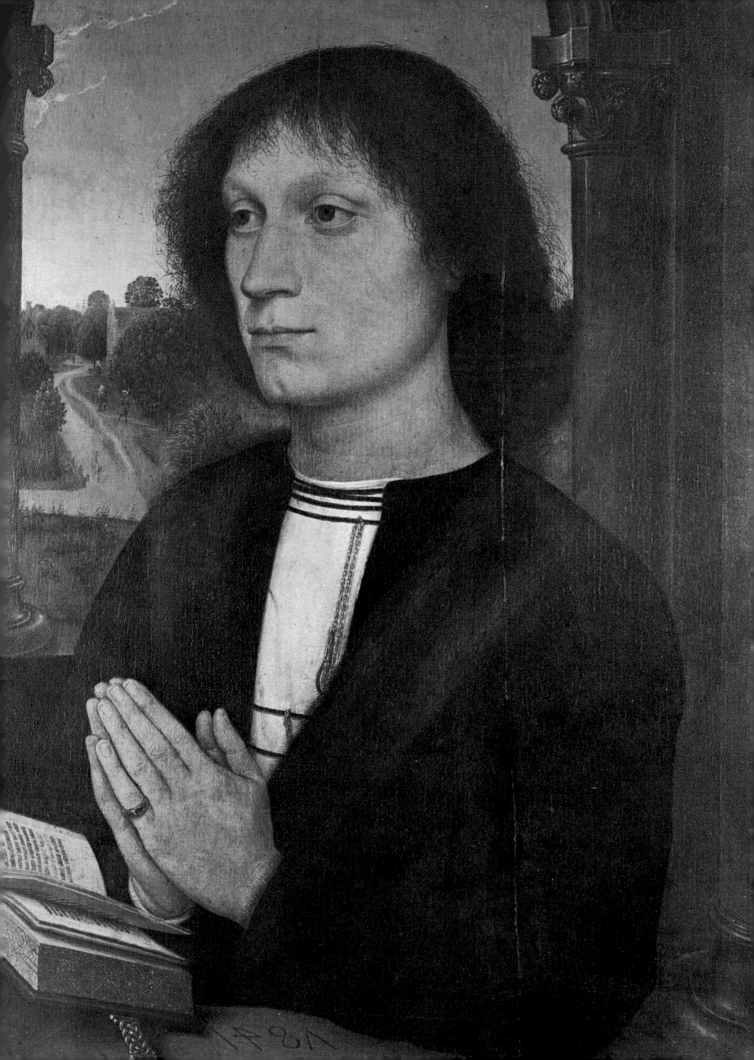

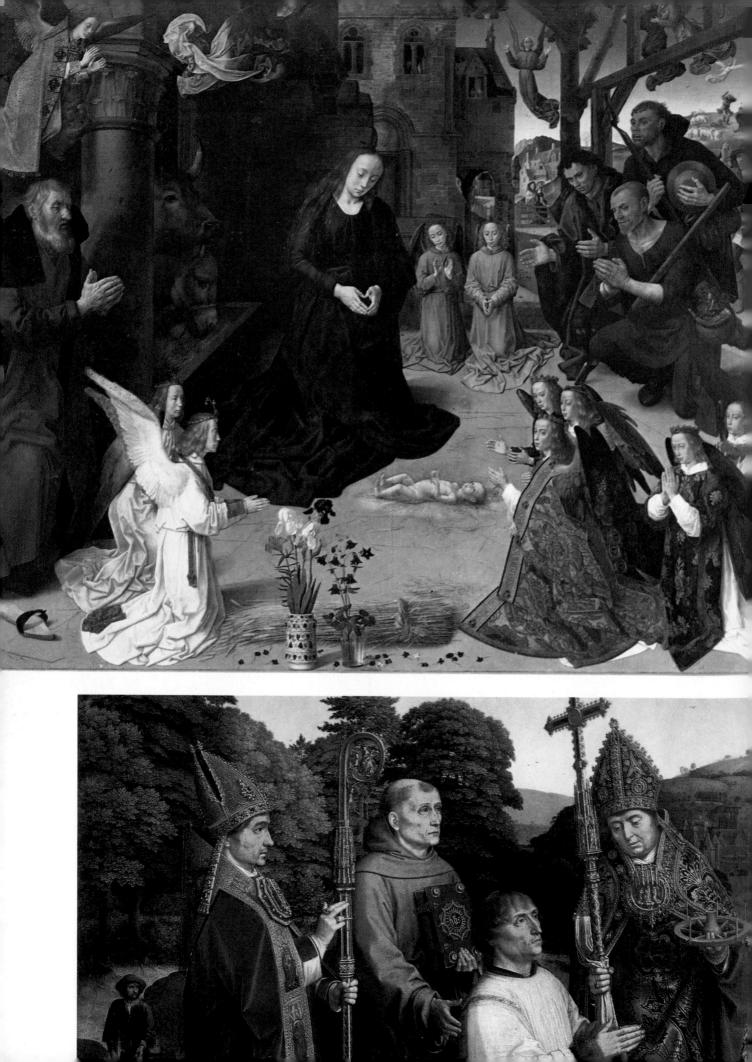

preferred his own quiet, ordered world, which is sometimes reminiscent of Perugino. The intimacy of his portraits is nonetheless suggestive, and a good example is the portrait of the *Young Man in the Black Berretto* (Accademia, Venice). Although working after 1520, Gerard David remained even more within these limits.

Dirck Bouts (*c.* 1415–75), who was active in Louvain held an eclectic position at the turning point between Van Eyck and Van der Weyden. Sometimes the sense of composition stiffened in him as in the *Entombment* (National Gallery, London); sometimes he made an ambitious enquiry into perspective as in *The Last Supper* (St Pierre, Louvain).

Hugo van der Goes (died 1482) was active in Ghent from 1467. His buoyant linearism reminds one of Antonio Pollaiuolo's work. In his *Original Sin* (Kunsthistorisches Museum, Vienna) he endowed the softly outlined nudes, touched by the cold light of the enchanted landscape, with an expression of ingenuousness which is poetic. Van der Goes attained full maturity in the *Adoration of the Shepherds* (Berlin Museum) with his broad sense of space, his psychological penetration of character, brilliant study of costume and balanced, classic composition. The *Portinari* altarpiece (Uffizi, Florence), painted between 1475 and 1476, shows spatial development, accentuated by the receding diagonal of the central group with the Virgin, and the worshipping angels and shepherds. The realism of this work exercised a great influence on Florentine painting of this period. The pictures on the side panels are also remarkable.

When Italian influence had already begun to make itself felt in Flanders, Hieronymous Bosch (1450?–1516), haunted by an almost medieval sense of terror, broke onto the scene as a painter of pictures, panels, stained-glass windows and backcloths for mystery plays. The subject matter of his work shows his interest in alchemy, allegory and Flemish proverbs. Infernal dramas and celestial delights, persistent realism and almost obscene transfigurations, cabalistic enigmas and metaphysical concepts are his themes, sometimes leading to a world of metamorphosis worthy of a Kafka fantasy, as in the triptych of the *Garden of Delights* (Prado, Madrid). His technique is refined and subtle; his colour almost Venetian, and intellectually he anticipates Mannerism. It is difficult to single out examples from such a large and varied output. Sometimes man is bereft of dignity, betraying his essential folly, as in the little picture of the *Conjuror* (Saint-Germain-en-Laye Museum); or he reveals quarrelsome greed, as in the *Hay Wain* (Prado,

Opposite page, above: *Hugo van der Goes, the 'Adoration of the Shepherds', central panel of the Portinari altarpiece (Uffizi, Florence).* Here above: *Detail from the 'Adoration of the Shepherds'* Opposite page, below: *Gerard David, 'Canon Bernardino de Salviatis and Three Saints', detail (National Gallery, London)*

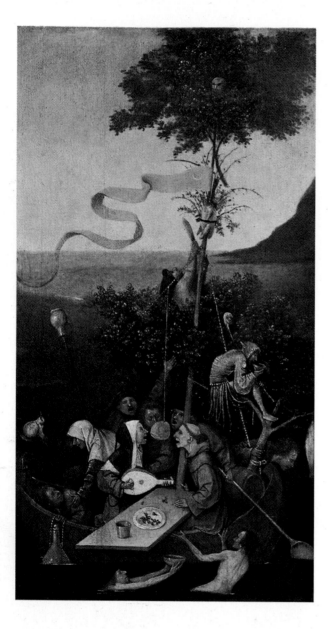

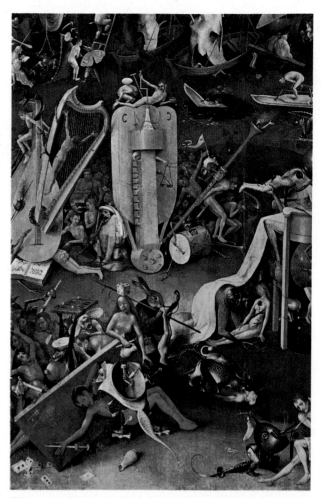

Hieronymus Bosch, detail of the right-hand panel of the triptych, the 'Garden of Delights' (Prado, Madrid)

Left: *Hieronymus Bosch, the 'Ship of Fools' (Louvre, Paris)*

Opposite page: *Hieronymus Bosch, detail of the central panel of the triptych, the 'Garden of Delights' (Prado, Madrid)*

Madrid); at times he expresses man's sad earthly lot, as in the pictures of the *Prodigal Son* in the Prado and in the Boymans Museum, Rotterdam. In the *Temptation of St Anthony* (Lisbon Museum), sin disturbs and convulses the saint, who finds it hard to flee from the beautiful women and the monstrous creatures around him. For the elect, Paradise becomes a distant sky at the end of a long tunnel as in the *Ascent into Heaven* (Doges' palace, Venice). Bosch considers this to be an unreasonable world teeming with monstrous metamorphoses; space is threatening but measureless. Reality becomes a diabolical surrealism.

Pieter Bruegel (1528–69) emerged at a time when Flemish painting had become deeply moved by the spirit and forms of 16th-century Renaissance classicism. The humanity he depicted consists of pleasure-loving creatures, as in

the *Land of Cockaigne* (Alte Pinakothek, Munich); the *Cripples* (Louvre, Paris) and the *Blind Men* (Capodimonte Museum, Naples). *Dulle Griet* or *Greta the Mad Girl* (Van den Bergh Museum, Antwerp) passes by, dragging the objects of her madness, but sometimes the whole world becomes mad as in the *Carnival Battle* (Kunsthistorisches Museum, Vienna). One step further is the *Triumph of Death* (Prado, Madrid), which indicates another kind of folly – war and its terrible horrors. But at other times this acid, popular northern moralist relaxes in the contemplation of human foolishness. Friends sit crowded around the bridal couple greedily enjoying a rustic banquet as in the *Peasant Wedding* (Kunsthistorisches Museum, Vienna) or indulge in crude open-air dances *Peasant Dance* (Kunsthistorisches Museum, Vienna) or else reap the *Harvest* (Metropolitan Museum, New

424

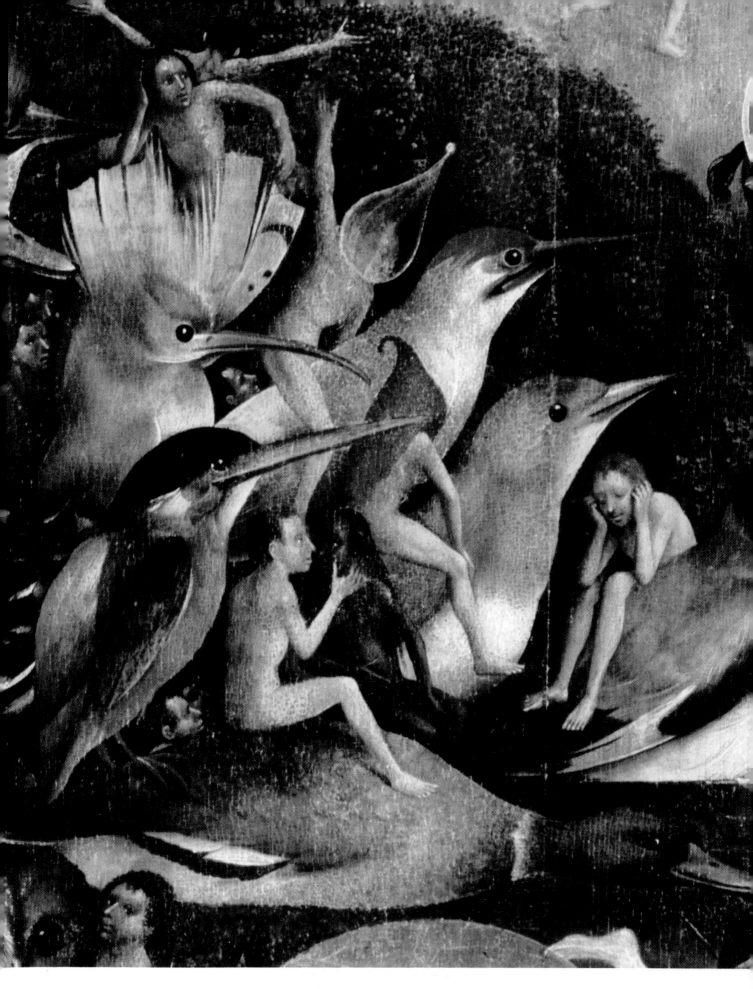

Pieter Bruegel the Elder, the 'Parable of the Blind Men'
(Capodimonte Museum, Naples)

Pieter Bruegel, detail from 'Harbour with Ships' (Doria
Pamphili Gallery, Rome)

York) against a vast, open landscape. When the
Hunters in the Snow (Kunsthistorisches Museum,
Vienna) return to their village in the evening, a
beautiful landscape greets them, scattered with
cold, green, icy lakes, and embroidered with tiny
figures skating. The dark groups of trees break
up the space, while in the foreground the men
and dogs drag weary steps.

French painting in the 15th century and early 16th century

France at the beginning of the 16th century
had not achieved political unity, and had several
regional artistic schools which, to a great extent,
coincided with the local feudal domains of
Paris, Bourges, Dijon, Avignon, Aix and Tours.
However, religious architecture in the pre-
dominant Flamboyant Gothic style was begin-
ning to minimise earlier regional distinctions and
bring about a compromise by introducing
decorative motifs already Italian in emphasis.
Civil buildings, too, were modified, changing

Pieter Bruegel, the 'Harvest' (Metropolitan Museum, New York)

Pieter Bruegel, 'Old Peasant Woman' (Alte Pinakothek, Munich)

from turreted fortresses to more luxurious palaces, as with the Louvre of Charles V in Paris and the Hôtel Bourgtheroulde in Rouen. There are also Italianate influences in the town halls of Compiègne and Noyon. When the policies of Louis XI restored political unity to the country in the second half of the century, the court spent long periods in the Loire valley, and architects were summoned to transform the castles there into places where life could be relaxed and enjoyable. At Chambord, Blois, Amboise and Chaumont there lived a noble, lively society, which in the full 16th-century spirit encouraged meetings between artists, scholars and thinkers from different countries who were responsible for the renewal of the French cultural renaissance.

At the end of the first half of the 15th century (somewhat later than Italy and Flanders) Provence, where there was a long tradition of artistic culture, especially in view of Avignon's importance as the seat of the papacy, became the centre of cultural exchanges between the Flemish and the Italians. A new naturalism was expressed

Left: *French school, the 'Pietà of Avignon' (Louvre, Paris)*

Opposite page: *French School, Tapestry with winged deer (Musée des Antiquités, Rouen)*

in paintings of warm, religious feeling. In the anonymous *Annunciation* (1445) in Aix-en-Provence, the kneeling angel is clothed in drapery of the Van der Weyden manner. Then there is the *Coronation of the Virgin* in Villeneuve-lès-Avignon (*c.* 1452–54) with dramatically sculpted forms, by Enguerrand Charonton. This was a precursor of the anonymous *Pietà of Avignon* (Louvre, Paris) – the greatest expression of Provençal painting. Here, against a gold background, the group is entirely constructed around the body of Christ; St John and St Mary Magdalene converge on the pyramid of the Virgin in her blue mantle. St John's cloak is a muddy grey, St Mary Magdalene's crisply draped in metallic pleats, threaded through with yellow and deep grey shadows. On the left is the donor, robed in a white of Van Eyckian intensity.

Jean Fouquet (*c.* 1420–81?) was the most

outstanding French painter of the 15th century. He was an amalgam of the lofty moral and religious sentiments in Provençal painting, the subtle outlook of Parisian miniaturists and the direct influences of the Italian Renaissance, in which he immersed himself by journeys in Tuscany, Rome and Naples between 1445 and 1448. His *Madonna*, one half of the Melun diptych (Antwerp Museum) is placed high on the throne, her austere, crowned head almost sculpted in the light. This is the exaltation of pure form, a synthesis of content and gesture using the precious colours of the miniaturist tradition. The other half of the Diptych of Melun (Staatliche Museen, Berlin), with the vivid portrait of Etienne Chevalier being presented by St Stephen to the Virgin and Child, handles space in the abstract manner of Piero della Francesca. It introduces the portrait of

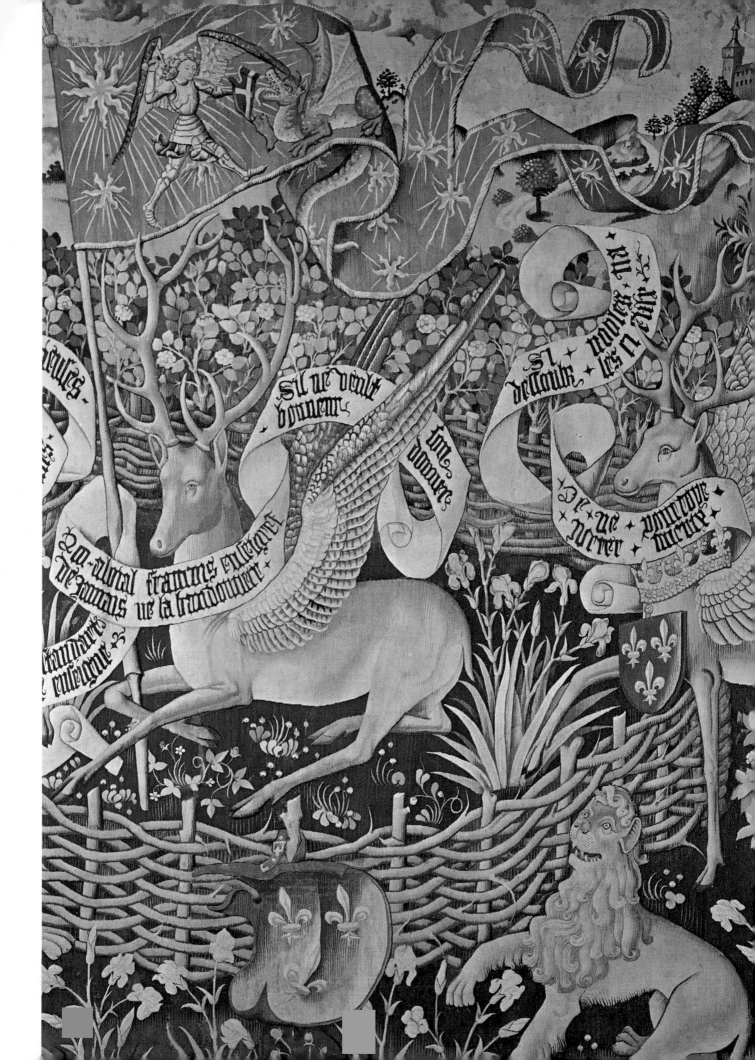

Charles VII, King of France (Louvre, Paris), where the space is confined between the drawn curtains showing the expanse of heavy, dark red coat, above which appears the head itself. Also in the Louvre is the imposing portrait of Juvenal des Ursins, against a florid gold background. These works reveal Italian influence, and the style was continued in France (though not always with the same degree of quality) by the Master of Moulins, working in the duchy of Bourbon up to the end of the century. In his portraits, the spacious setting against a decorative background or an open landscape, the vivid faces and the Flemish attention to materials, create an atmosphere of harmony and an ideal of quiet ecstasy, reminiscent of Perugino or Memling. Notable among his portraits is that of Cardinal Charles of Bourbon (Alte Pinakothek, Munich) and the one of the youthful Margaret of Austria (Lehmann Collection, New York). Simon Marmion, from

the evidence of his *Our Lady of Sorrows* (Strasbourg Museum), made no progress and was somewhat devoid of originality.

Although 16th-century France and particularly the school of Fontainebleau made a great contribution to Mannerism, the thread of realism remained unbroken, even if somewhat intellectualised, as in the case of the works of two great portrait painters, Jean (died 1540/1) and his son François (died 1572) Clouet. Jean conveyed penetrating psychological insight and fascinating intuition; François was a more subtle interpreter of taste, introducing the noble pose, as in the portrait of *Charles IX* (Kunsthistorisches Museum, Vienna). In addition to their paintings, the Clouet brothers made splendid small pencilled portraits which suggest even more immediately the atmosphere for which they were created. Corneille de Lyon (active *c.* 1533–74) worked in a similar style, and was so

Master of Moulins, the 'Magdalene with the Donor Somzée' (Louvre, Paris)

Jean Clouet, portrait, presumed to be of the Dauphin (Musée des Beaux Arts, Antwerp)

successful that he inspired a band of imitators apparently ignorant of Mannerist canons.

German painting in the 15th century

15th-century Germany, deprived of political unity, made highly original progress in architecture, sculpture and painting, thus anticipating later developments. Architecture as has already been said, was mainly Flamboyant Gothic in style, although one should not forget the hall church, where the nave and aisles are of the same height, which was a significant German innovation. An even more independent situation is noticeable in the sculpture of this period, for, while Flanders and France emphasised and repeated Sluter's naturalism, Germany, although not entirely impervious to this trend, introduced dynamic, unexpected poses, angular drapery and dramatic intensity which foreshadowed the

tendency to expressionism always present thereafter in German art. Nicholas of Leyden at Strasbourg, Hans Multscher at Ulm, Tilman Riemenschneider at Würzburg, Veit Stoss at Nuremberg, and Michael Pacher in the Tyrol – all working in the late 15th and early 16th centuries – produced a variety of styles along these lines, influenced by their different milieus and cultures. An original note in the German sculpture of this period was the way it underlined popular characteristics, markedly anti-classical by comparison with Italian art. At the same time, however, the international trend was continued, particularly in the graceful, delicate Madonnas. Two examples illustrate the contrasting extremes in German 15th-century sculpture: the altarpiece by Veit Stoss in St Mary's, Cracow, and the *Virgin with Child* by Pacher in the church of the Franciscans in Salzburg.

However, the greatest artistic experience of

this period in Germany was provided by painting. While accepting the most significant European innovations, indeed making them central to their theory, painters sought – again by a new, spontaneous impulse – to represent reality by means of expressionist emphasis. In the 14th century, both the school of Cologne and the school of Prague had experimented with Byzantine and Italian influences deriving from Giotto, Siena and Venice. Reality had also tempered the courtly Franco-Flemish influence with a popular, middle-class touch deriving from the Bohemian school. But at the start of the 15th century Germany took up quite a new position. The turning point in Westphalia was marked by Conrad von Soest and, at Tiefenbronn in Baden, by Lukas Moser in his polyptych of St Mary

Right: *Léonard Limosin, enamel backgammon board (Louvre, Paris)*
Below: *Chambord, east façade*

Magdalene dated 1431. Here the Swabian painter introduced the fresh, lakeland landscape into the left-hand picture and a new sense of spaciousness in the lunette depicting the Washing of the Feet, thus breaking with every Gothic canon. The sometimes excessively intense expression on the faces was already there and became a permanent feature in other works by the master. He anticipated the harsh, almost grotesque characterisations of Hans Multscher, a painter and sculptor at Ulm in the first half of the century. To Pietro Longhi, an 18th-century Venetial painter his work suggested 'super-truthfulness' and 'anarchic realism'.

Cologne, where the Master of the Veronica spent the first decade of the 15th century, witnessed, between 1435 and 1450, the flowering of the art of Stefan Lochner (1410?–51). Lochner's complex personality, formed probably by direct contacts with Flanders and influenced by Fra Angelico's painting, endowed him with a vivid sense of composition, translated at times into graceful rhythms and precious colouring. The delicious *Madonna of the Rose Garden* (Wallraf-Richartz Museum, Cologne) has a golden background and a crown of angels around the full blue mantle of the Madonna. In the case of Lochner delicate forms and sweet expressiveness were the dominant notes, whereas the work of Konrad Witz (1390–1447) at Basle was diametrically different. He painted his figures in a vigorous sculptural manner and handled space compactly and geometrically. Even in youthful works such as the *Sacra Conversazione* (Capodimonte Museum, Naples), his debt to Van Eyck and Petrus Christus is evident, but at the same time there are signs of the characteristics that found their finest expression in his greatest work, the Basle altarpiece, now dispersed between Dijon, Berlin and Basle. In all there are sixteen panels, each containing biblical or saintly figures relating to moments of allegorical significance in the Old and New Testaments. Some panels, such as *St Bartholomew*, the *Synagogue*, *Sabothai* and *Benaiah*, show the figures conceived in simplified planes; the drapery is harsh, and the movement rigid. By contrast, the landscape is unexpectedly expansive and alive in the *Miraculous Draught of Fishes* (Museum of Art and History, Geneva).

At the end of the 15th century, Martin Schongauer (1440–91) of Colmar was the first great German engraver. He introduced Germany to a technique requiring skill and a cultured background which gained great favour and became an important way of spreading knowledge of Italian 15th century art and encouraging an Italianate outlook in painting. The German 15th century ended in this search for an original, expressive language: intense and taut as well as graceful. With these values firmly instilled, it opened the way in the following century to more wide-ranging cultural and artistic acquisitions.

German painting in the 16th century

While Renaissance art was developing in Italy, Germany, between the 15th and 16th centuries, appeared backward and steeped in myth, outdated social customs and medieval ideologies. Yet there were signs of disturbance; outbursts of rural discontent and religious revolt occurred against the corrupt practices and conciliatory scepticism diffused throughout the entire Christian world by the opulent Renaissance papacy.

Modern Germany was born with the Protestant Reformation, which soon extended beyond the German sphere of influence. The Reformation, in part a result of the Renaissance revival of the value of man and his individual conscience, reaffirmed the priority of mystical and transcendental needs by emphasising the moral and religious aspect of human choice. It also destroyed the cultural unity of Europe.

In Germany, the Reformation defined and consolidated both national characteristics and culture (for example, priority was given to musical interests rather than to the figurative arts). However, this formative process was accompanied by an inner tension which has left its mark on German culture right up to the present day.

Germany held an eminent but, in a certain sense, isolated position among the different European artistic developments of the 16th century. Artistic experience in Italy, France, Flanders and Spain ultimately showed that the earlier authentic, absolute values of the Renaissance were wearing thin, to be infiltrated by intellectual tendencies which are usually designated as classical and Mannerist. 16th-century Germany, on the other hand, witnessed an artistic revival stemming from spontaneous forces that had their roots in realist, popular tradition. It was alien to classical idealisations; indeed, if anything, it inclined towards the demands of expressionism. It was the moment of impact for the German Renaissance as, deeply concerned, it rebelled against the splendours of Rome and adopted strong reservations about the 16th-century Italian classical idealisation of man. Religious and civil architecture continued to employ extreme Gothic style, and sculpture

Master of St Veronica,
'Madonna of the Vetch'
(Wallraf-Richartz
Museum, Cologne)

continued to reflect popular, pious sentiment. The elaborate, pretentious sculpture of Tilman Riemenschneider (active 1460–1531), who worked at Würzburg, has little appeal.

It fell to Albrecht Dürer (1471–1528), as the greatest German artist, to express the spirit of contemporary Germany. Draughtsman, wood-engraver, painter and essayist, he was another Leonardo in his versatile output and intellectual inquisitiveness. When only fifteen – after a preliminary education from his goldsmith father in draughtsmanship and the use of the burin at the school of Wolgemuth in Nuremberg – he learnt about Flemish painting. Soon afterwards he realised, at Colmar, through studying Schongauer's wood-engravings, the importance of forms of nature as elements of universal values. His journey to Italy in 1494 introduced him to the Italian Renaissance, particularly through the Venetian painting of Mantegna and Giovanni Bellini, whose handling of space and colour inspired him. At Bologna, Luca Pacioli's study of the proportions of the human body fascinated him, and the problem occupied him for a long time.

An examination of the three extant self-portraits helps to trace his spiritual evolution.

Master of Frankfurt, St Anna Selbdritt (Palatine Museum, Heidelberg)

Carved moneychanger's table, 15th century (Musée des Arts Decoratifs, Paris)

The first, dating from 1493 (Louvre, Paris), has details studied with an almost calligraphic precision. The second, dating from 1498 (Prado, Madrid), reveals him steeped in Italian Renaissance idealisation, but with a more heroic bearing, and deep in thoughtful melancholy. The third, dating from 1500 and generally known as *Ecce Homo* (Alte Pinakothek, Munich), shows the essence of humanity transfused with a religious significance. He was both attracted by and dissatisfied with Italian humanism, and participated in the great historic, religious experience his country was undergoing at that time. His output is very varied: his handling of space in the *Nativity* altarpiece (Alte Pinakothek, Munich) and the *Adoration of the Magi* (Uffizi, Florence), dated respectively 1503 and 1504, indicates Mantegna's influence. Luca Pacioli's theoretical approach to anatomy is evident in *Adam* (Prado, Madrid), while an Italian sense of composition

pervades his *Holy Trinity* (Kunsthistorisches Museum, Vienna), but it is marred by over simplification. The wood-engravings which he published in fifteen parts from the beginning of 1498 indicate his technical skill and ability to equate physical anguish with the conflict between faith and reason inherent in the Protestant movement. The *Knight, Death and the Devil*, one of the *Apocalypse* series, attempts to show the human synthesis between resignation and revolt. Huge and richly coloured, the *Four Apostles* (Alte Pinakothek, Munich) express the unflinching Reformation spirit of concerted dialogue and the dignity of man.

All the other German artists, right up to the end of the 16th century, were as convinced as Dürer that art should express the important drama of the age. Albrecht Altdorfer (*c.* 1480–1538) was a lyrical anti-classicist who showed a certain archaism in his harsh linear definition,

but was completely original in his flights of imagination, incandescent skies and traces of light in landscapes and figures. The *Battle of Arbela* (Alte Pinakothek, Munich) and the *Resurrection of Christ* (Kunsthistorisches Museum, Vienna) are two exceptional examples of his work. Lukas Cranach (1472–1553) looked to Altdorfer and, in a certain sense, derived as an artist from him, particularly in that part of his painting which, for dramatic intensity, dynamism of form and expressionist overtones, reveals him as a link between late Gothic and Baroque. The Christ is his *Crucifixion* (Alte Pinakothek, Munich) is just such an example. He is proportioned on a gigantic scale, moved by the desire to rebel against His fate – the fluttering loincloth is a vivid orange, the lowering, lightning-rent sky is black.

In another sense Lukas Cranach was a Mannerist who inclined to intellectual, so-

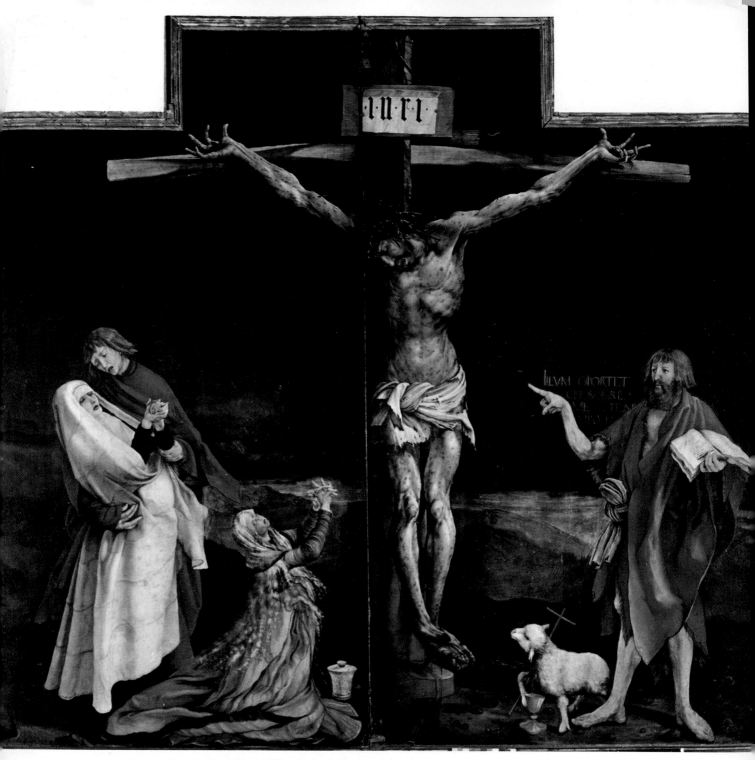

Matthias Grünewald, the 'Crucifixion' (Unterlinden Museum, Colmar)

phisticated grace. The Venuses (Fernau Collection, Munich, Alte Pinakothek, Munich and the Gemäldegalerie, Dresden) are masterpieces in this style. Vibrating outlines are clearly defined against a uniform background, and the balanced gestures of the figures are surmounted by faces fully aware of their naked beauty. Cranach, as a friend of Luther, painted his portrait, and the one in the Uffizi brings out the sitter's character with immediate impact. His other portraits have a kind of inner ecstasy, like *Judith* (Kunsthistorisches Museum, Vienna), with its splendid, dazzling whites, reds and yellows against a black background.

High drama, violence and mysticism abound in the works of Matthias Grünewald (1455–1528) whose emphasised, contrasting gamuts of colour, rugged sculptural shapes and exaggerated scenic effects prefigured the Baroque. Christ in the *Crucifixion* (Colmar Museum) becomes a

monumental figure bathed in light. His blood is a vivid red, His hands and feet claw the air in a spasm and the crown of thorns gleams like metal. St Mary Magdalene, in a dramatic diagonal pose, weeps with her mouth wide open and her hands knotted together. The white, yellow and black figure of the Virgin stands out against the red cloak of St John and the livid background. Deeply mystic, Grünewald, who came from Alsace and the Middle Rhine, defied Renaissance, humanist values with an anguished cry of passionate belief. Another Alsatian, Hans Baldung Grien (1485–1545), accentuated these sentiments with a note of thoughtful sadness in his monumental rendering of forms. This is particularly true of his male portraits, as for instance the one in the National Gallery, London.

Hans Holbein the Younger (1498–1543) was born in the Italianised atmosphere of Augsburg, and from there went to Basle, where he achieved a synthesis of Italian and Flemish influences in his large and impressive portraits which exemplify German painting at its peak. *Erasmus of Rotterdam* (Louvre, Paris), the elegant *Amerbach* (Kunstmuseum, Basle) and the *Ambassadors* (National Gallery, London) are but a few of his more notable portraits.

Spanish 15th-century art

In 15th-century Spain, Seville, with its impressive cathedral, was the major centre for architecture, and in the following century inspired the cathedrals at Segovia and Salamanca. Sculpture was mainly centred on Burgos, where Flamboyant Gothic combined with Moorish art in one of the many versions of the *mudejar* style. The tombs and chapels of the Isabella period in Toledo and Granada are rich and sumptuous, and the need for wood carving, altars, liturgical furnishings, choirs, thrones and grilles brought in French, Burgundian and German artists, consequently creating a somewhat eclectic style. Gil de Siloe, German by upbringing, created a trend in the last twenty years of the 15th century, veering in style between the sumptuous and the Mannerist, which became very popular.

As far as painting was concerned Spain looked to Flanders. From Jacomart (Jaime Baço), in Naples between 1440 and 1450, to Jaime Huguet, her painters were copyists or transposers of the Flemish style. Bartolommé Bermejo (active 1474–95) reached a high standard through his direct enthusiastic contact with the Neapolitan school, where he experienced the sculptural

Matthias Grünewald, the 'Crucifixion', detail (Unterlinden Museum, Colmar)

Albrecht Altdorfer, 'Landscape on the Danube' (Alte Pinakothek, Munich)

quality of the work of Antonello and Piero della Francesca. His handling of figures and landscape in the *Pietà* in the cathedral of Barcelona make this a work of major importance. Pedro Berruguete (1450?–1504), who worked in Italy in the Palazzo Ducale at Urbino and met Piero della Francesca there, introduced Spain to Italian painting.

Above: *Hans Holbein, portrait of the Merchant
Gisze of Danzig (Staatliche Museen, Berlin)*

Below: *Hans Holbein, portrait of Anne of Cleves
(Louvre, Paris)*

Opposite page, Left: *Lucas Cranach, portrait of Martin Luther
(Uffizi, Florence)*

Right: *Lucas Cranach, detail from 'Venus and Cupid'
(Borghese Gallery, Rome)*

Below: *Conche shellcup, German work 16th century
(Victoria and Albert Museum)*

MANNERISM IN EUROPE

As early as the second and third decades of the 16th century the Italian Renaissance, particularly in certain paintings, showed signs of turbulence and unrest. At times painters such as Raphael, Correggio and, to a certain extent, Titian rejected its values. In fact an artistic movement which came to be called Mannerism was about to appear. It was an individual and personal mode of expression, pre-eminently intellectual, which no longer derived from other well-known masters or from the consolidated Renaissance pattern. This style not only gained the support of artists aware of the crisis in Renaissance values, but it also appealed to the taste, habits and cultural viewpoint of a particular social class throughout Europe. From a historical point of view it is well known that all this coincided with a moment of great moral uneasiness in Italy, a country then passing through the crisis of the Reformation without knowing how to set up opposing autonomous values.

The causes of this artistic experience were varied, but the effects similar: the rejection of

Opposite page: *Giambologna, 'Mercury' (Bargello Museum, Florence)*

Michele Mazzafirri, vase with a figure of Hercules (Museo degli Argenti, Florence)

Attributed to Giulio Taverna, rock-crystal vase with enamelled mounts (Louvre, Paris)

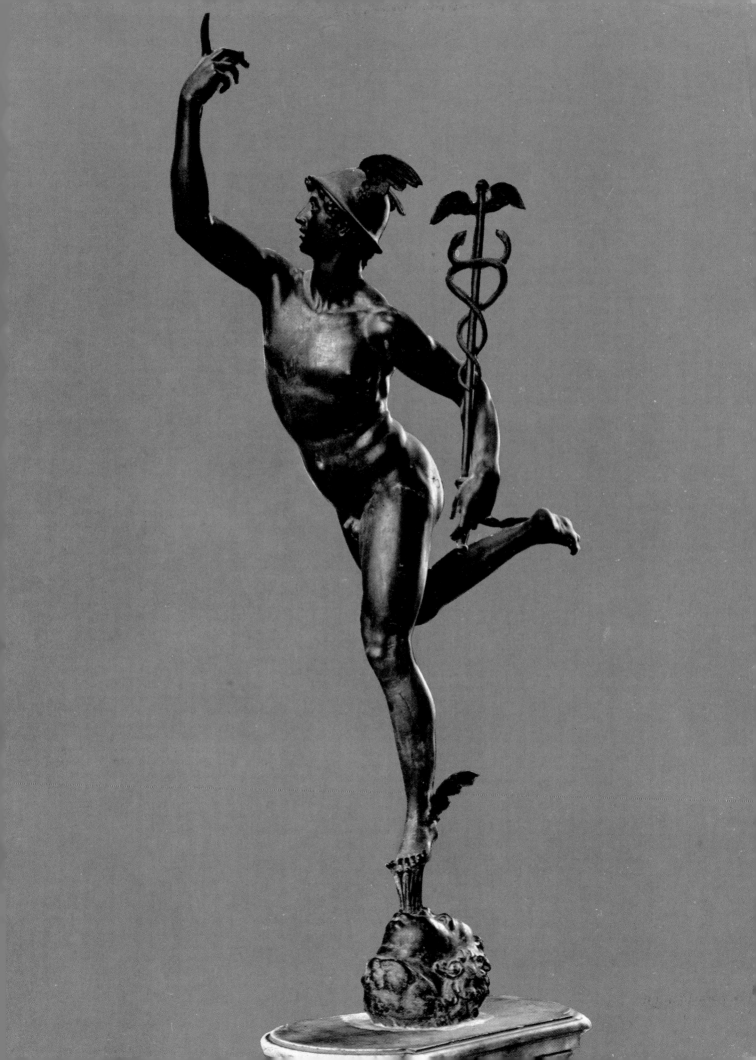

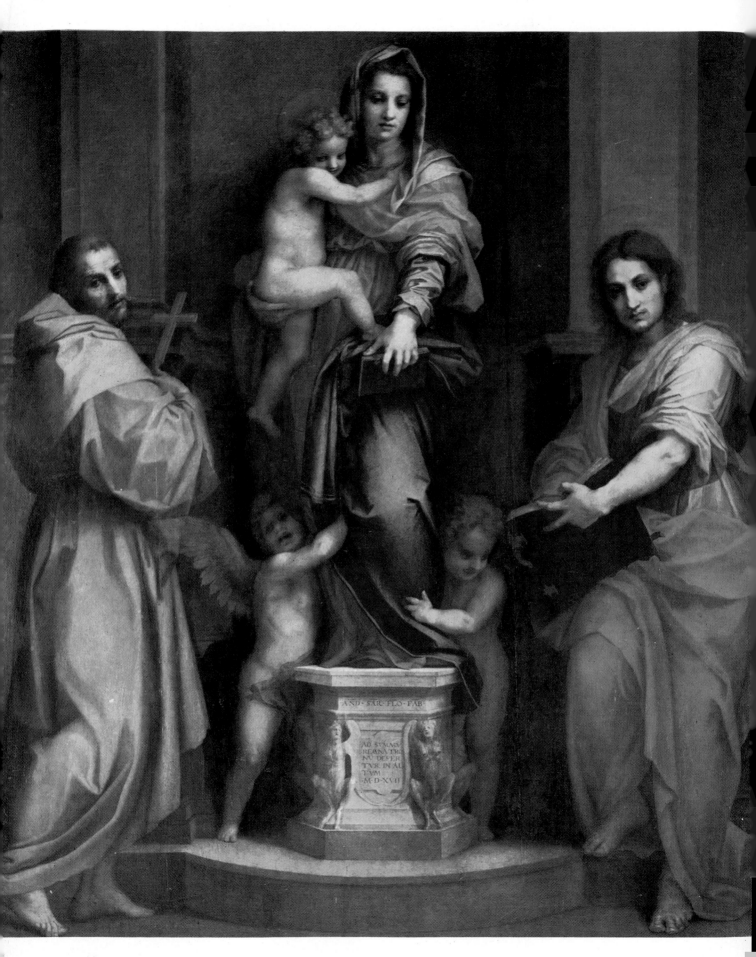

AND·SAR·FLO·FAB

AD·SVMMV
REGNA·TRA
NV·DEFER
TVR·IN·AL
TVM
M·D·XVII

444

the classic ideal in the portrayal of the human figure, and of poetic values in imaginary settings. In Florence, Mannerism, first hinted at in the works of Andrea del Sarto, is found in the works of Pontormo, Rosso, Beccafumi and Bronzino. Engaged on paintings and frescoes, both religious and secular, these men disclosed an ideal of beauty dignified and expansive in its gestures and unusual in its expression. They favoured abstract spaces in rhythmic compositions, figures delineated with a more conscious, fragmented outline, artificial lighting and a gamut of new colours, some iridescent, some metallic. In Jacopo Pontormo's *Descent from the Cross* (Sta Felicità, Florence) the colour is pale and watery, but in his *Visitation,* at Carmignano, there is a closely reasoned development of rhythmic, ample forms rendered sonorous by pink, green and orange. The *Portrait of a Young Boy* (Lucca Museum) emphasises the toss of the small head above the clear red robe, while the *Lady with a Dog* (Staedel Institute, Frankfurt) wears a bright red dress with deep green sleeves and looks out with laughing eyes. Rosso Fiorentino (1495–1540) exaggerated forms and tensions in his

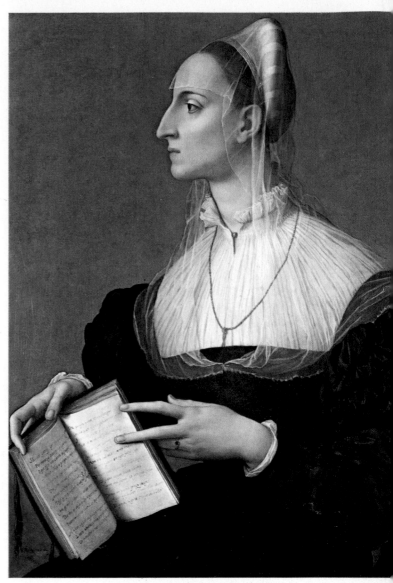

Angelo Bronzino, portrait of Laura Battiferri (Palazzo Pitti, Florence)

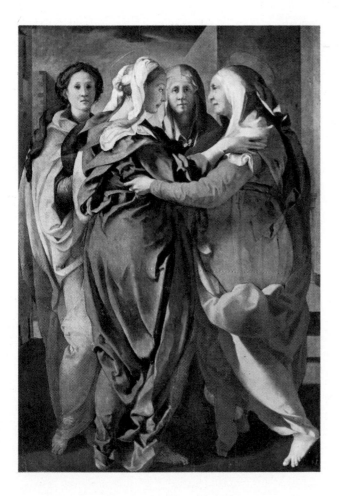

Jacopo Pontormo, the 'Visitation' (Carmignano, Pieve, Italy)

Opposite page: Andrea del Sarto, the 'Madonna of the Harpies' (Uffizi, Florence)

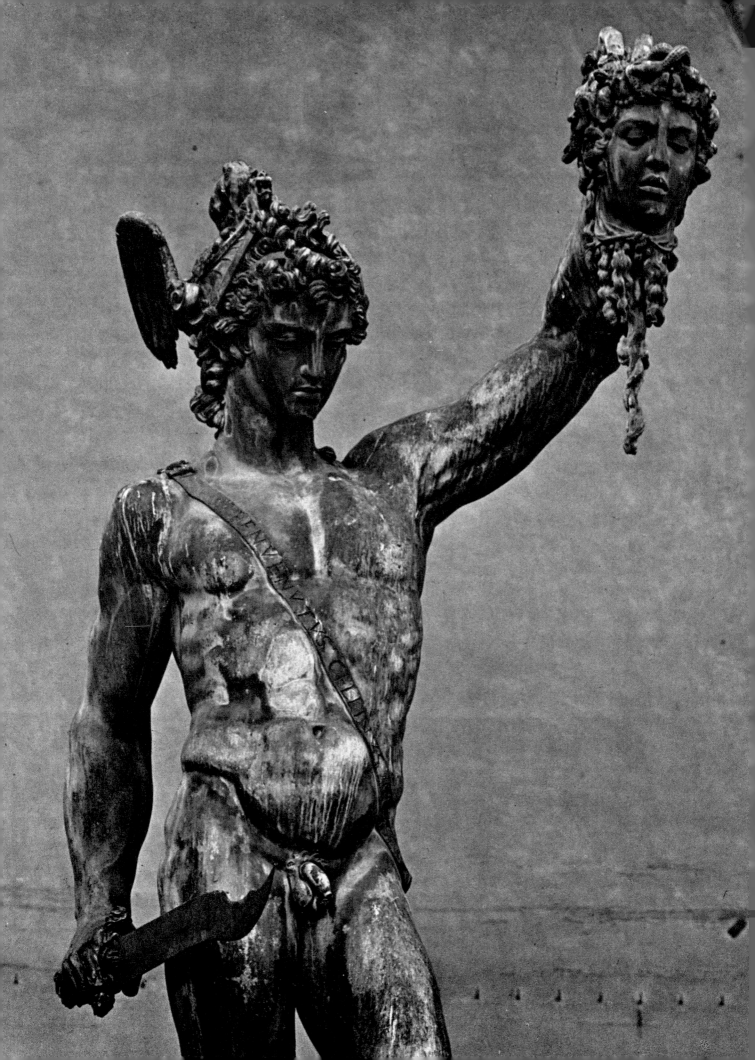

Descent from the Cross at Volterra and created an atmosphere of vibrant, abstract light, throwing into greater relief the crisply cut drapery of the clothes of the holy women.

In Florence, Angelo Bronzino (1503–72), a specialist in portrait painting, transformed Raphael's calm settings into an almost explosive intimacy, paying great attention to hands by the use of vivid yet cold tones, as in his portraits of members of the Panciatichi family (Uffizi, Florence). Parma, because of Correggio, played an important part in Mannerism, and Francesco Parmigianino (1503–40) developed it even further. He was the most provocative exponent of sinuous rhythms and figures elongated almost to the point of deformity, as in the *Madonna with the Long Neck* (Uffizi, Florence). In this picture the traits are emphasised by the juxtaposition of forms and abstract volumes as if to suggest further complex, mannered comparisons. The female figures symbolising virtue on the triumphal arch of Sta Maria della Steccata at Parma can be regarded as excellent examples of Italian Mannerism.

The remarkable goldsmith, Benvenuto Cellini (1500–71), was also a sculptor, and his statue of Perseus in Florence virtually constitutes a Mannerist challenge with its exceptional sculptural and dynamic qualities. Giambologna (1529–1608), also, but a little more slowly, incorporated Mannerist ideals into his richly elegant sculptures.

Opposite page: *Benvenuto Cellini, 'Perseus' (Loggia dei Lanzi, Florence)*

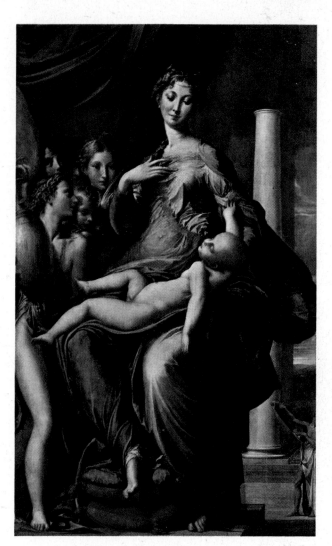

Francesco Parmigianino, the 'Madonna with the Long Neck' (Uffizi, Florence)

Right: *Antonio Correggio, the 'Coronation of the Virgin' (Pinacoteca, Parma)*

447

Benvenuto Cellini, salt-cellar (Hofmuseum, Vienna)

Opposite page, left: *Germain Pilon, the Three Graces*
(Louvre, Paris)

Opposite page, right: *Jean Goujon, 'Nymphe de la Seine'*
(Louvre, Paris)

French tapestry dating from the second half of the 16th century: wool, silk and silver (Musée des Arts Decoratifs, Paris)

Mannerism in France: the school of Fontainebleau

However, the full impact of Mannerism occurred in France, where it became an expressive medium for the Italian style and revived the splendours of the court and the great families. Fontainebleau, Paris and Anet were the principal centres of Mannerism in France. François I was obsessed with the Italian Renaissance, which caused him to summon numerous Italian painters – among them Rosso, Primaticcio, Dell'Abbate – and sculptors like Cellini and Giambologna to France. A certain Italianate taste had already appeared in the châteaux of the Loire through restorations, additions or new constructions during the 16th century. In Paris, the seat of the monarchy, the joint work of the architect, Pierre Lescot (died 1578), and the sculptor, Jean Goujon (active 1540-62), on the side of the Louvre along the Seine, created a rich succession of jutting architraves and alternating light and shade in a rhythmic horizontal progression. Beneath the semicircular pediments are elegant sculptures of symbolic figures. Also in Paris, the Hôtel Carnavalet was the work of the same men, but is more unified and complete, combining a

Gallery of François I with stuccos by Rosso Fiorentino and Francesco Primaticcio, Fontainebleau

Léonard Limosin, miniature of François II (Louvre, Paris)

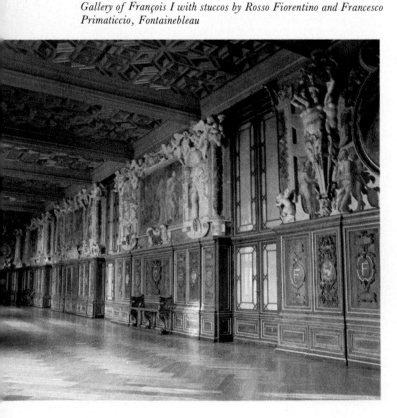

*Perseus and the Naiads, tapestry
(private collection, Paris)*

*Antoine Caron, the 'Massacre of the Triumvirs'
(Beauvais Museum)*

classical exterior with a serene, finely decorated interior. The sculpture of the period was excellent. Goujon was explicitly Mannerist by inclination. He produced predominantly slender, gently rhythmic female forms carefully posed either nude, veiled, or elegantly draped. Goujon's oeuvre includes the reliefs for the Fontaine des Innocents, the caryatids in the music gallery at the Louvre after a design by Lescot, and possibly the *Diana and the Stag* from the Château of Anet (Louvre, Paris). The Three Graces by Germain Pilon (*c.* 1535–90) are another example of French Mannerist sculpture.

The noblest achievement of Mannerism, how-

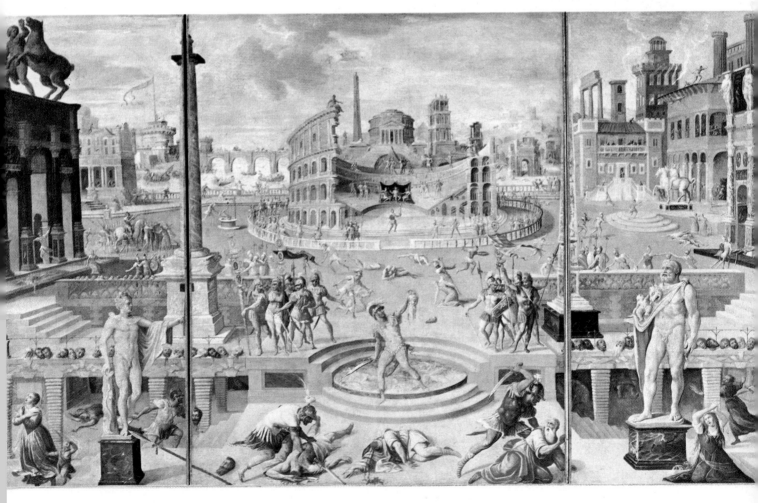

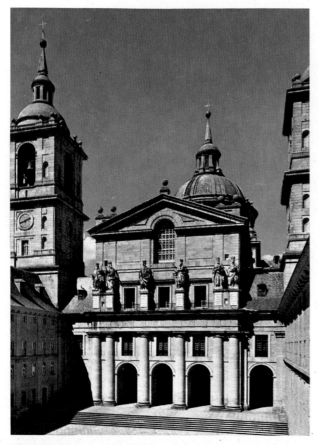

Abbey church of S. Lorenzo, Escorial, Madrid

General view of the Escorial, Madrid

ever, is at Fontainebleau in the decoration of the magnificent, complex palace, begun in 1528 by François I. Initially it was the work of the Italian, Rosso Fiorentino, who was summoned there in 1530. Francesco Primaticcio (*c.* 1504–70) joined him two years later and created that supple, beautiful, slender feminine type so delightful to the eye in the stuccos of the former bedroom of the Duchess of Etampes. By this time it is possible to talk of a school of Fontainebleau which, with its influx of artists and decorators from different places, mingled Italian, French and Flemish influences. To begin with it produced allegorical decorative frescoes; later its members branched out into individual paintings either with a mythological subject or showing courtiers transformed into mythical figures. They produced delightful nudes, as in *Eve Before Pandora* (Louvre, Paris), painted in 1548 by Jean Cousin (1490–1560); in the *Triumph of Flora* (Feilchenfeld Collection, Zurich), by the so-called Master of Flora, and perhaps derived from an exemplar by Nicolo dell'Abbate (*c.* 1512–71), whose style is echoed in the splendid nude in the Arcadian landscape; in the tall, lithe *Diana the Huntress* (Louvre, Paris) as she strides towards the wood, perhaps by the Florentine Luca Penni, but certainly deriving from Primaticcio; and in the many studies of ladies at their toilet (for example the one in the Dijon Museum). All these are works combining great freshness with sophistication, and they are by no means inferior to more ample compositions like *Diana Bathing* (Rouen Museum), where a Venetian landscape is evoked, thus blending Flemish experience with Italian

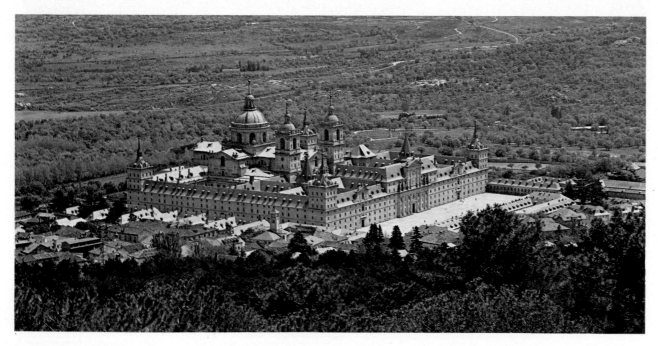

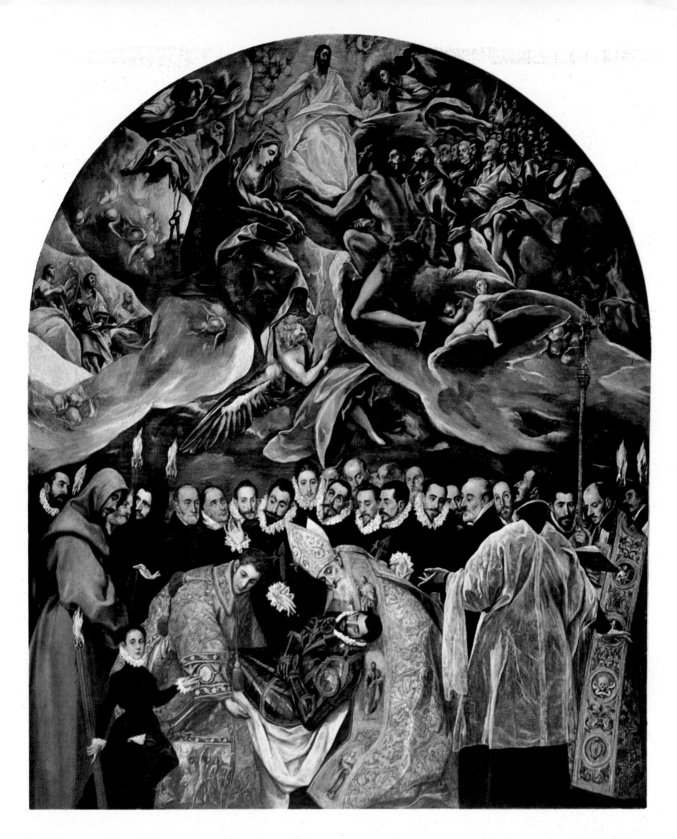

classicism. The school of Fontainebleau was widely disseminated through the châteaux of the Loire (for instance, Chenonceaux) and also in the Château of Anet, given by Henri II to the beautiful Diane de Poitiers – a frequent model for gallant portraits, where she is presented in unveiled grace.

French Mannerism was less ephemeral and therefore more overwhelming than Italian Mannerism, and went further. The complex compositions of Antoine Caron (1520–1600) link up with Poussin, who once more revived classicism.

El Greco, the 'Burial of Count Orgaz' (S. Tomé, Toledo)

Mannerism in Spain

16th-century Spain was the country of Charles V (who reigned from 1516 to 1556) and of Philip II, who reigned until 1598. It was the age of conflict between Protestantism and Catholicism, when Spain considered herself the leader of Christendom and the Counter Reformation was triumphant. It was the moment of wealth and power, but above all – particularly in so far as it concerned artistic development – it was the time when the court was at its most magnificent, the aristocracy strong and prelates great. It is not surprising, therefore, that architects were called upon to create buildings which for size, appearance and magnificence had never before been attempted on such a scale. It also explains why decoration, with echoes of Gothic and Moorish styles, predominated, at times covering the entire building, as for instance on the monastery of St Mark at Léon, or, with a freer linear development, as on the college of S. Idelfonso at Alcalà.

Conversely, the palace of Charles V at Granada, built by Pedro Machuca after 1526, is severely classical and Italian in inspiration. The external features recall Michelangelo, and the interior circular courtyard is vaguely reminiscent of Vignola. This incredibly ornate trend became even more marked in Castile, where technically it so resembled the goldsmith's craft as to be dubbed the plateresque style. There are notable examples in Salamanca, particularly on the façade of the university. Andalusia, on the other hand, perhaps because of the serene, undulating landscape, was the centre of a purist architectural experiment initiated by Diego de Siloe (c. 1495–1563), who built the much more calm Granada cathedral, from which derive those in Malaga, Baeza and Jaén. The Habsburg Dynasty, in the person of Charles V, had already attempted a classical revival, but then found a despotic sovereign in Philip II. He commissioned Juan de Herrera (1530–97) to continue the Escorial in a cold, austere style befitting the inflexible spirit of the Counter Reformation. The Escorial, a palace-convent, has a single horizontal order with meagre conventual windows. Its structural complex is developed on a square, gridiron plan consisting of the basilica, with its imposing forecourt, occupying the central position, and the university, library and museum adjacent.

Sculpture actively followed the development of taste, and the trends of the Counter Reformation. Altars and altarpieces achieved a blend of the popular and the mystical which is surprising in its ornamental exuberance. Francisco Becerra (died 1605) has provided many examples that are still extant. Alonso Berruguete (1486–1561) outdid all by his Mannerist affectations, while the group of Italians, led by Pietro Torrigiano (1472–1528), expressed an occasional Italianate nostalgia. Only Pompeo and Leone Leoni enjoyed the full favour of Philip II, who commissioned them to make fifteen statues for the *capilla mayor* or major chapel in the Escorial, five for the tomb of Charles V and five for his own.

Portugal, both in architecture and sculpture, followed the lead of Spain, but drew a sharper line between the late Gothic style, as in the cloister of Belem monastery in Lisbon, and a fully classical style, as in the convent of Christ at Tomar.

Spanish painting, thrown into confusion by El Greco's exceptional personality, generally reflected developments in west central Europe. There were those like Juan de Juanes (1523–79), who were inspired by Raphael and repeated his early themes; others took up the Florentine Mannerist position – not entirely free from Flemish influence in the use of colour – which Antonio Moro introduced to Spain. Luis de Morales (1509–86) enjoyed great favour for his sentimental intimacy, which inspired Quentin Massys, while Juan Pantoja de la Cruz (1551–1608) was a Mannerist portrait painter who paid great attention to detail in costume.

Toledo was the centre for the art of the Cretan Domenikos Theotokopoulos, called El Greco (1541–1614). After initial Byzantine influence in Crete and a Venetian education from Tintoretto, El Greco left Italy to return to Counter-Reformation Spain. He found the atmosphere most congenial to his religious ardour and extremism of spirit. He dissolved the heaviness and solidity of forms, accentuated vertical rhythms, extracted pulsating expression from gestures, and experimented with strident, unusual colours. The *Assumption* (Chicago Art Institute) was his first work executed at Toledo in 1577, and already revealed his mature dramatic expression and ability to create an artificial setting and abstract drapery. But his genius was completely revealed in the *Disrobing of Christ on Mount Calvary* (1579, Toledo cathedral), with its penetrating psychological observation, the strong red of Christ's robe and the modern individualisation of the female figures. Expressionism and surrealism combined, perhaps to their fullest measure, in the *Agony in the Garden* (National Gallery, London). Vortices

El Greco, portrait of a knight (Prado, Madrid)

454

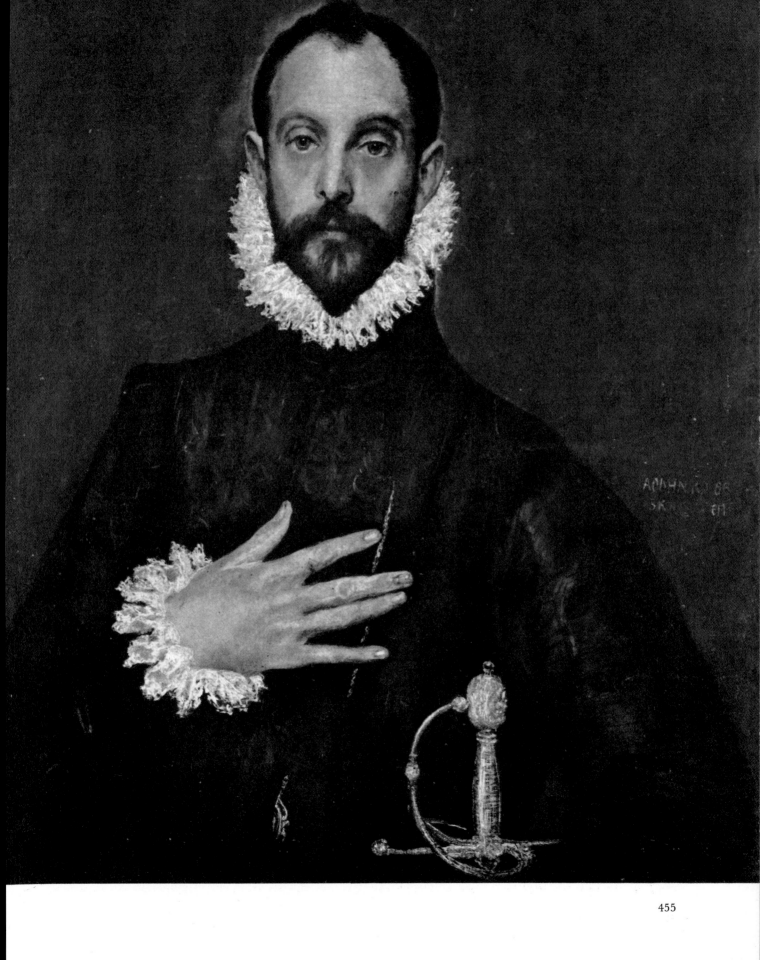

455

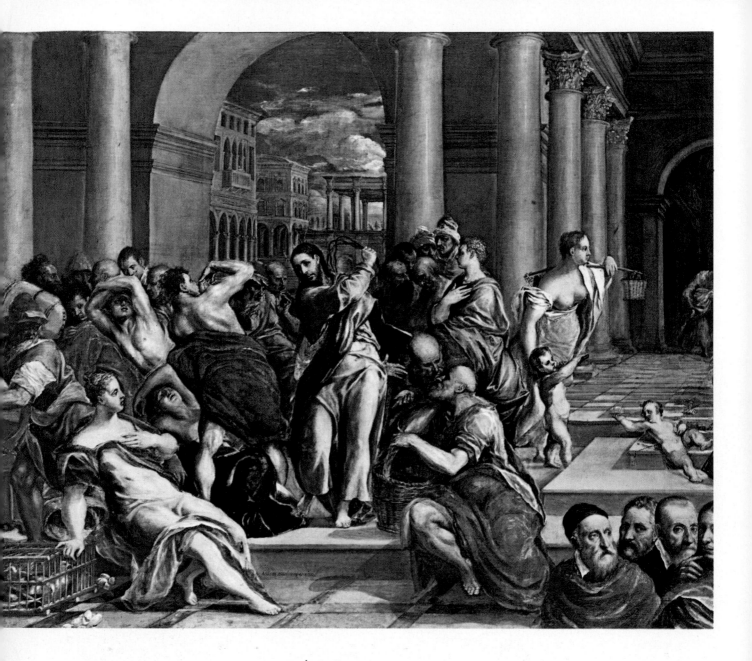

El Greco, 'Christ Driving the Traders from the Temple'
(Institute of Fine Arts, Minneapolis)

of astral light, and a frozen landscape in green and blue drawn upwards like wings of ice, isolate the distraught, skeletal figure of Christ in His cloak. The *Burial of Count Orgaz* (1586–88), in S. Tomé at Toledo, must, however, have been more acceptable to the Spanish society of the period, where belief was carried to the point of ecstasy and splendour to the point of pomp. Works by El Greco proliferated with prodigious rapidity. The last years of the century signalled the development from *St Martin and the Beggar* (National Gallery, Washington) to the *Purification of the Temple* (National Gallery, London). The year 1600 opened with the most novel portrait that the age could have conceived, that of *Cardinal Fernando de Guevara* (Metropolitan Museum, New York). the 'Grand

Inquisitor' has unlimited power, the position of the hands, the withdrawn face, the purplish-red cloak and the surplice fluttering like wind-blown sails, are signs of the strength that only the Counter Reformation could summon up. El Greco created for himself a language of painting that marked the final passage from Mannerism to Baroque.

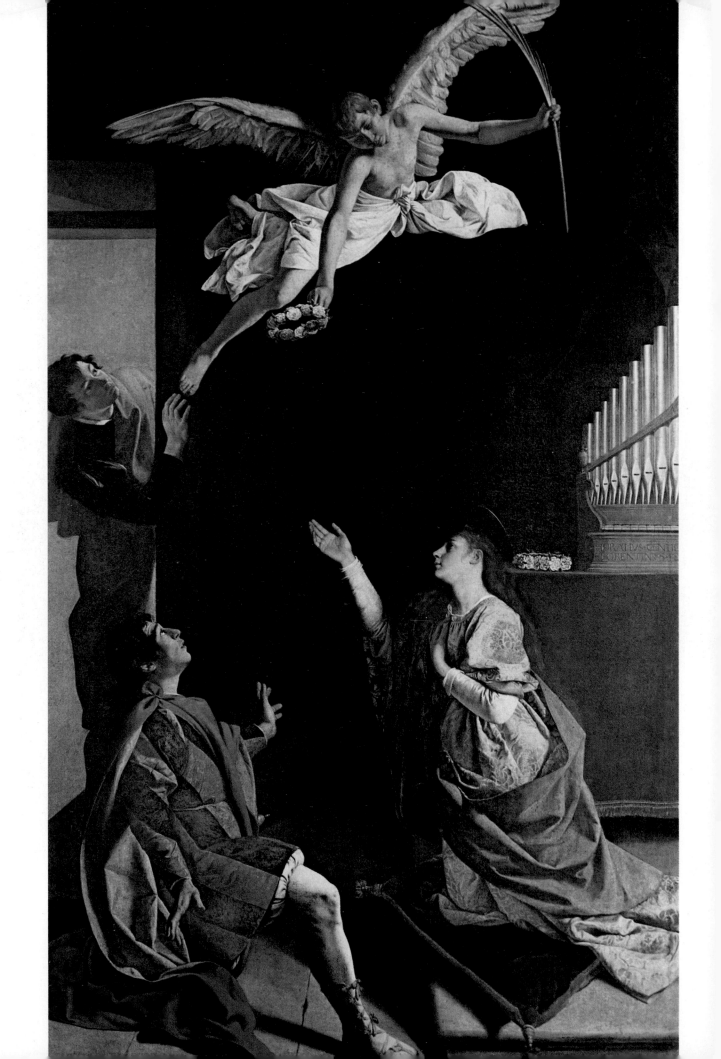

17TH- AND 18TH-CENTURY ITALIAN ART

Painting in the 17th century

In Italy, during the 17th and 18th centuries, Baroque and Rococo art were triumphant. After the excessive intellectualism, elaborate compositions, artificial poses and exterior elegance of Mannerism, and the exhausted patterns of the widespread Italianism of the late 16th century, Baroque art offered delighted exuberance, dynamic boldness, and surprising spectacular effects. The ideal Renaissance values of proportion, balance and decorum were repudiated, and Bernini, Borromini, Rubens and Rembrandt – in spite of the profound differences between them – became interpreters of the new values of movement, impetuosity, strength, contrasts of form and structure, light and colour. Painting, often used as an integral part of interior decoration schemes, overflowed onto walls and ceilings, and in the 18th century the Italian Tiepolo and the German Domenikus Zimmermann showed what heights of freedom and lightness could be attained by the vivacity and fervour of Rococo.

These tendencies prevailed throughout Europe, except for Protestant Holland, which kept itself apart, being involved in a special evolution of its own. Spain, moving away from realism, found a passionate, free and anti-Renaissance attitude in Velásquez. England remained detached, within its own classical architectural limits, but 18th-century English portrait and landscape painting of the period have an emotive sensibility which sometimes foreshadows Romanticism. In Italy, Caravaggio's great achievements in realism and those of the Carracci Academy in Bologna were followed, in Rome, by the fervour of the new Baroque monuments and important frescoes and painted ceilings. In Venice, however, in the calmer climate of the 18th century, a serene and resplendent style of painting reappeared.

Throughout Europe the lines of demarcation between architecture, sculpture and painting became less definite, and the fantastic forms attempted in the major arts also enlivened and inspired the minor arts. The Venetian Brustolon

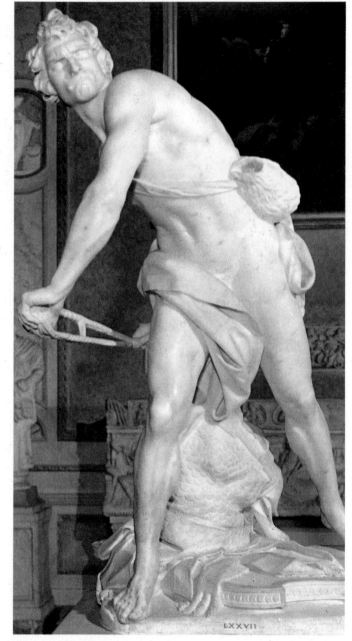

Gian Lorenzo Bernini, 'David' (Borghese Gallery, Rome)

Opposite page: *Orazio Gentileschi, 'SS. Valerian, Tiburtius, and Cecilia' (Brera, Milan)*

PAGE 457: *Vittore Ghislandi (Fra Galgario), 'Portrait of a Gentleman' (Brera, Milan)*

459

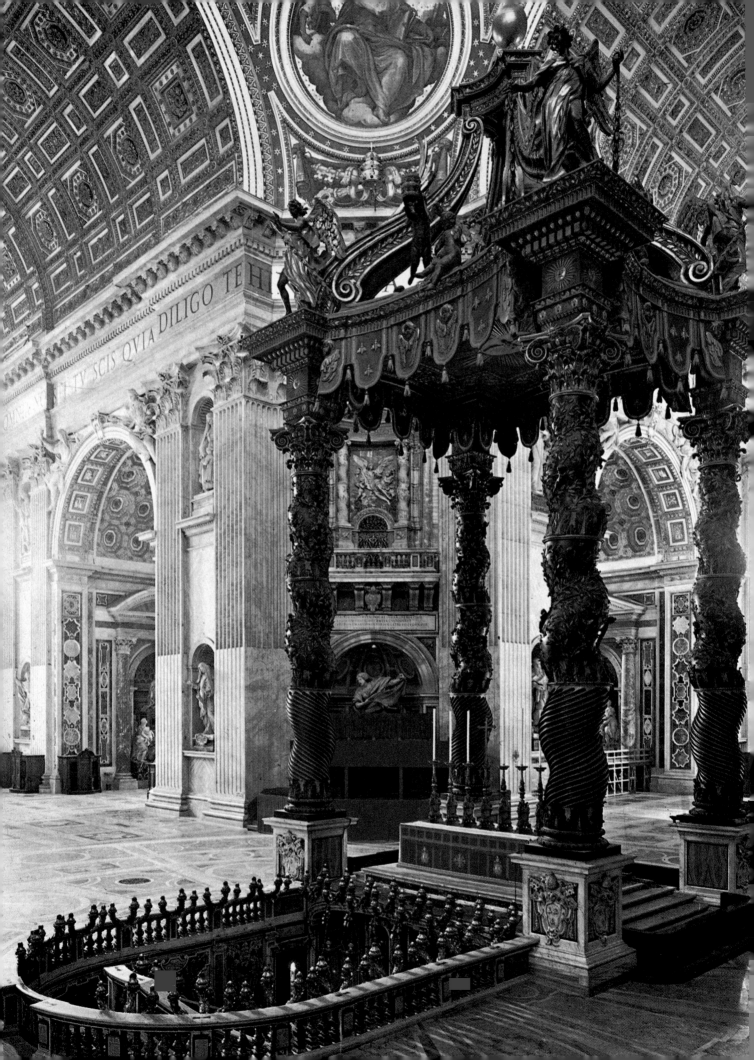

was actually described as a maker of Baroque furniture. In England, however, Adam prepared the way for the Neo-classical taste.

In the sumptuousness of its religious painting, the Catholic Church was one of the most important promoters of Baroque art. Another was the court society of the great absolute monarchies; Austria, Germany and Russia followed the lead of the French court at Versailles, the pattern and pinnacle of regal life.

The last decades of the 16th century and the first of the 17th century in Italy were enlivened by the Caravaggio-Carracci confrontation. The positions assumed by these artists were in some respects directly opposed to Baroque and the Counter Reformation. Caravaggio (1573–1610), with his aggressively humble and dramatic realism, avoided all signs of external pomp that might be assimilable to the Church of Rome or the court of France. The Carracci (Lodovico 1555–1619; Agostino 1557–1602; Annibale 1560–1609) fostered a sense of proportion and attempted to reconcile ideas of beauty and nature that were by no means explicitly opposed to those of the 16th century and Mannerism. Even so, they cannot properly be understood without studying their Baroque aspects. In the first place, the previous insistence on harmony, serenity and calm was replaced by impetuosity, contrast, evidence of sentimental values, abandon and spiritual alarm. It is no accident that this style of painting coincides with the times of St Theresa of Ávila and St Ignatius Loyola. Light and shade, violently opposed to each other, predominate in the works of Caravaggio, whereas intimate landscapes and warmly dramatic subjects are the most obvious features of the best works of Annibale Carracci (typical is his *Flight into Egypt*, Doria Pamphili Gallery, Rome). With Caravaggio, as with the Carracci and the Bolognese masters of their school, there is a compelling attraction in the anecdotal content of their works, as, for example,

in Gentileschi's *Holy Family* (Kunsthistorisches Museum, Vienna) or in Guercino's *Aurora* (Casino Ludovisi, Rome).

Caravaggio

Caravaggio was born in Lombardy, and his early work clearly shows the influence of the traditions of Brescia and Bergamo. But when he arrived in Rome, perhaps in 1593, and entered the conventional society of his teacher the Cavalier d'Arpino, the expression of natural truth – which was always a concern in Lombardy – was transformed by a poetic sense. This can be seen

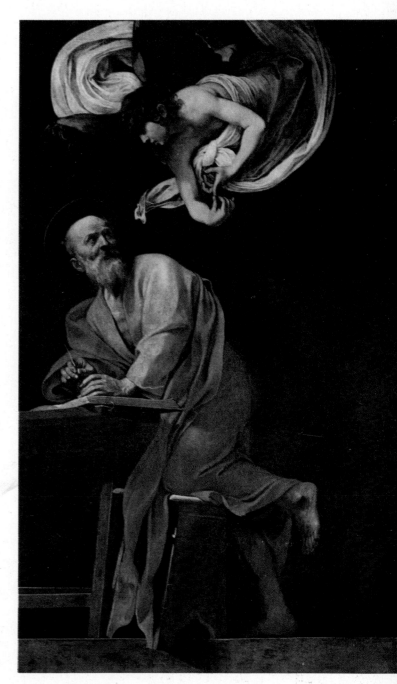

Gian Lorenzo Bernini, baldacchino of St Peter's, Rome

Right: *Caravaggio, 'St Matthew and the Angel' (Contarelli Chapel, S. Luigi dei Francesi, Rome)*

461

from the first group of paintings of his Roman period: the *Boy with the Basket of Fruit*, the *Boy with Fruit* or *Bacchino Malato* (both in the Borghese Gallery, Rome), and the *Boy Bitten by a Lizard* and the *Basket of Fruit* (Ambrosian Gallery, Milan). Already in these paintings, though more completely in the *Young Bacchus* (Uffizi, Florence) every detail of the story reveals the extraordinary strength of the composition. In the *Bacchus* reality is expressed with particular sensitivity in the exact rendering of the colours, accentuated by the severity of the surrounding outlines, which carefully pick out the central form from the grey background. Among other no less important pictures, are the *St Mary Magdalene* in which the gesture of the hands folded in the saint's lap has a touching intimacy, and the *Rest during the Flight into Egypt* (both in the Doria Pamphili Gallery, Rome). Here the family group is portrayed in the open countryside; the picture is rich in associations with Venetian painting, but has novelty in its free expression of affections – as in the relationship between Joseph and the angel, and the way the

Christ Child lies easily in Mary's arms. From this moment Caravaggio's work made a final break with the 16th century, and contemporary criticism was quite accurate when it saw in his naturalism and treatment of light the exact antithesis of Michelangelo's heroic vision.

In 1600 the paintings for the church of S. Luigi dei Francesi in Rome were finished. Here light breaks in to give dramatic unfamiliarity to the incidents from the life of St Matthew, treated in human terms. In the *Calling of St Matthew* a beam of light emphasises Christ's gesture and falls across the faces of the men in the dimly lit room. A certain nostalgia for the beautiful nudes of Mannerist painting diminishes the feeling of innovation in the *Martyrdom of St Matthew*. The *Conversion of St Paul* and the *Crucifixion of St Peter*, in Sta Maria del Popolo, painted for the narrow Cerasi chapel there, illustrate the sudden effect of foreshortening and diagonal composition with Baroque boldness. In the *Conversion of St Paul*, the figure of the saint lying outspread on the large cloak is particularly eloquent, with his arms

Caravaggio, 'Youthful Bacchus' (Uffizi, Florence)

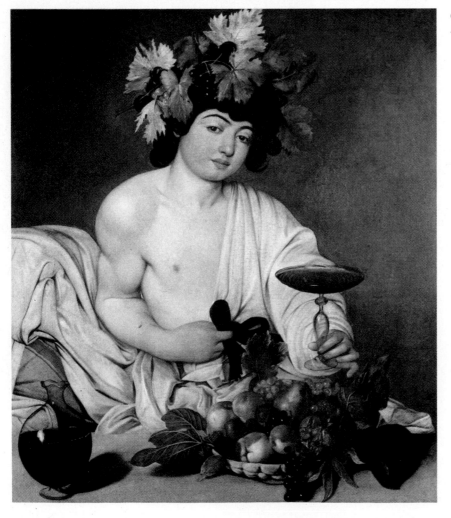

raised in front of the amazed and doubtful groom and the solid mass of the horse. The composition of the *Crucifixion of St Peter* follows the shape dictated by the cross itself, and stresses the dynamic lines with a crude realism. The Counter Reformation and Baroque had nothing to add to this way of feeling, and if Caravaggio's works were destined to be rejected by the Church – which was scandalised by such popularly crude and outspoken language – this was because Rome was aiming more at the external splendour already in demand in the Spanish Empire, and less at the humane austerities of the Counter Reformation. Other works by Caravaggio followed in succession. The *Madonna of the Pilgrims* (S. Agostino, Rome), the *Madonna, Child and St Anne* (Borghese Gallery, Rome), the astonishing *Death of the Virgin* (Louvre, Paris), bought by Rubens for the Duke of Mantua, all deserve careful attention. Then came Caravaggio's Naples period, which produced the *Seven Works of Mercy* (church of Pio Monte della Misericordia). He was obliged to seek refuge from

Caravaggio, 'Medusa' (Uffizi, Florence)

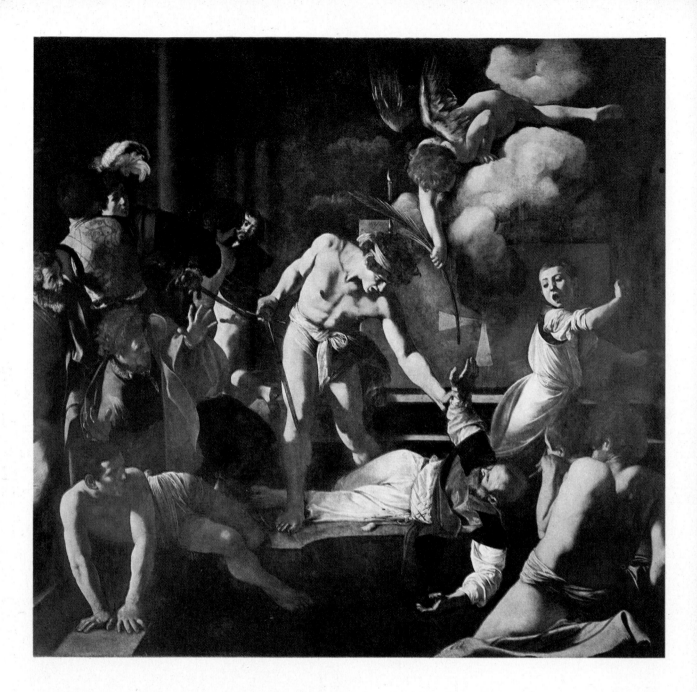

the consequences of his tumultuous life in Malta, where he painted the *Beheading of St John the Baptist* for the church of S. Giovanni, as well as the extraordinary portrait of the Grand Master of the Order of Malta, Alof de Wignacourt (Louvre, Paris). After this came his visit to Sicily, with the *Burial of St Lucy* in Syracuse and the *Adoration of the Shepherds* in Messina, followed by his wretched and dramatic death at the age of thirty-seven.

Caravaggio's followers form the large group of *Caravaggisti*, with their varied origins and aims: the subtle Orazio Gentileschi, the fervent Venetian Saraceni, the lyrical Cavallino at Naples. Outside Italy there was Rubens' Italianate work, the Dutch painters Terbrugghen and Gerard Dou,

Caravaggio, 'Martyrdom of St Matthew' (S. Luigi dei Francesi, Rome) Opposite page: *detail*

the Frenchmen Valentin and La Tour, the Spaniard Ribera and the German Elsheimer.

The Carracci

Meanwhile the Carracci were equally important in their influence on the development of Italian Baroque painting. They were responsible for founding in Bologna and Rome the school which was known first as the *Accademia del Naturale* and later as the *Accademia degli Incamminati*, and which at one time conformed to the ideals of the Baroque

464

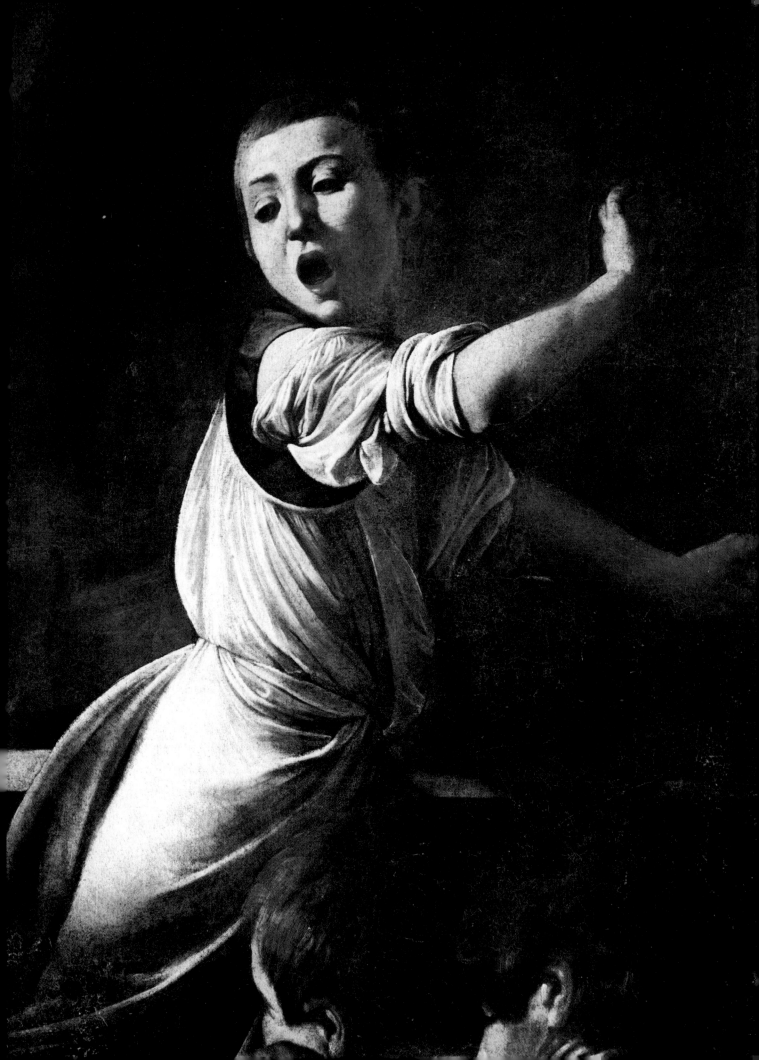

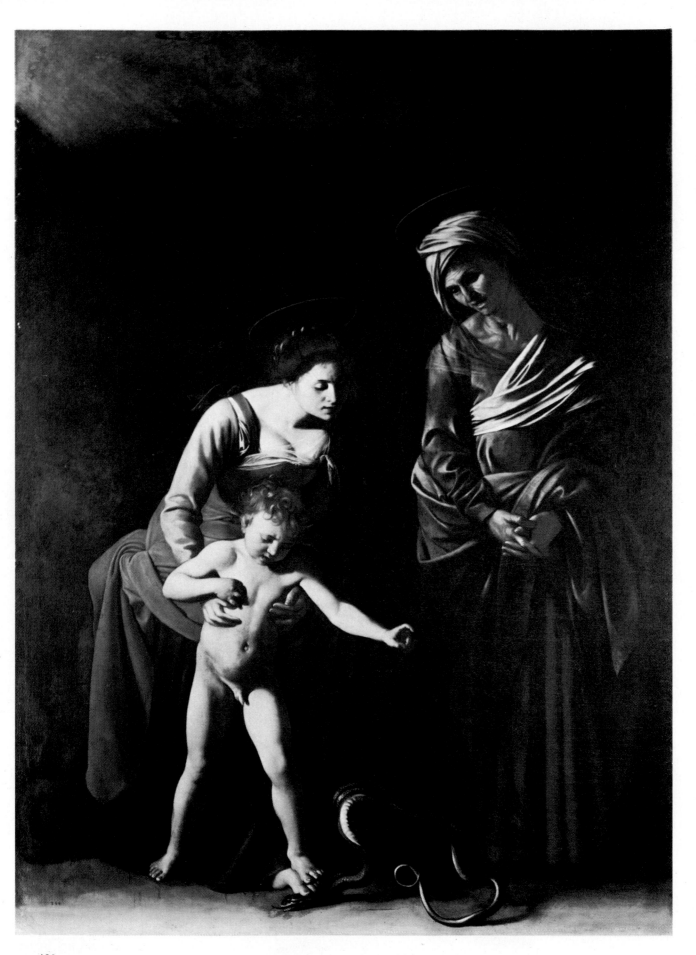

466

and the Counter Reformation. If unlike Caravaggio, they hardly exerted revolutionary influences, it must also be remembered that the charge of eclecticism in this school – which was the verdict of old-fashioned criticism – can no longer be accepted. The Carracci went beyond mere virtuosity to express lively, intimate sentiments, inspired by a genuine, fresh religious faith. Lodovico Carracci certainly did not forget Correggio's Venetian naturalism and sensuality, but he gave these qualities the dramatic force and action which marked the dividing line between Baroque and Mannerist painting. Of the three Carracci, Lodovico remained specially close to the spirit of the Counter Reformation. His seriousness, his ever-apparent carefulness, and his emphatic style are all evident in the *Madonna of the Scalzi*, in the *Martyrdom of St Ursula* (both in the Pinacoteca, Bologna), and in the *Christ and the Canaanite Woman* (Brera, Milan).

Annibale Carracci first appeared in Rome in 1604, when he started the decoration of the gallery of the Palazzo Farnese, the first important chapter in the history of Baroque painting. Narrative and imagination are the keynotes of his mood, and his poetic feeling has been compared with that of Tasso's *Aminta*, because of his spontaneous passion for nature. With him, too, the spectacular becomes pastoral. Agostino Carracci, nearest to him in age, was no more than an interpreter: the creator of the grand style of the Palazzo Farnese was Annibale. Allegorical subjects, such as the war between divine love and earthly love, were simply an excuse for Annibale for imbuing everything with the vigour of nature. Ariadne, Bacchus, and Mercury are real creatures, warm and passionate, surrounded by bands of putti who run about on earth and fly in the heavens to symbolise the perpetuity of human life. Of Annibale's paintings, it is sufficient to mention the charming *Flight into Egypt* (Doria Pamphili Gallery Rome), in which the sacred story takes on human interest in the way the Virgin turns back towards St Joseph, while the buildings in the background, bathed in the light of the setting sun, give way to lush green fields and trees.

The influence of the Carracci was enormous, even more widespread than that of Caravaggio, and it was in Emilia above all that the trend continued. Bartolomeo Schedoni renewed the interest in composition, stressing the imitative gestures of the main figures. Guido Reni (1575–1642) presented a much wider variety of interest and output. He was a great portraitist, as in the superb portrait of his mother (Pinacoteca, Bologna), but he preferred more ambitious themes. In *Hippomenes and Atalanta* (Capodimonte Museum, Naples) Baroque painting perfected the X-shape diagonal composition in the glow of a magic light. After painting what was probably too many devotional subjects during the course of his life, Guido Reni, in his late period, discovered a new mastery, and softened his outlines with delicate touches of light. Domenico Zampieri (1581–1641), known as Domenichino, was a great and captivating landscapist, but he introduced a more scholastic note to his altarpieces. Another pupil of Lodovico Carracci, Francesco Barbieri – known as Guercino – also painted complicated sacred compositions, but showed himself to be a master of decorative work in his *Aurora* on the ceiling of the Casino Ludovisi in Rome. In the art of Emilia in the 17th century the Bibiena family – Ferdinando, Francesco and, in the 18th century, Carlo – stands in a class of its own. Scene painters, masters of architectural *trompe l'oeil*, and inventors of stage machinery, they served the Farnese family at Parma and Piacenza in preparing revels and spectacles.

Annibale Carracci, 'Quo Vadis, Domine' (National Gallery, London)

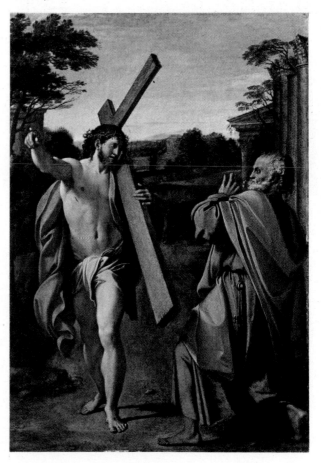

Caravaggio, 'Madonna, Child, and St Anne' (Borghese Gallery, Rome)

Baroque architecture

More than any other art at this time, architecture deserves the name of Baroque – if the term can be freed from all negative associations and assigned a positive artistic and historical meaning, for it has a vital place between the Renaissance and Neo-classicism, and was in clear contrast to both these experiences.

Roman Baroque architecture was directly related to the historic moment of enthusiasm in the Roman Catholic Church's counter-offensive against Protestantism. With its monumental forms, it exalted the power and authority of the papacy, and was emphatic and theatrical in all its manifestations. It was not surprising, therefore, that many centres of Catholic Europe accepted Baroque art from its Roman birthplace, and carried on its spirit and its forms. Gian Lorenzo Bernini (1598–1680) and Francesco Castelli (1599–1667), known as Borromini, were the two most important – though contradictory – exponents of Roman Baroque architecture. Popular amusement has added to the number of anecdotes told of the dramatic clashes between these two characters, who were alternately honoured and humiliated by popes and patrons alike. The stylistic contrast can be understood from the fact that Bernini's architecture represents, within the Baroque development, a stricter continuity of 16th-century and ancient classicism. However, what was absolutely new was the softening of outlines – typical of this is the ellipse instead of the circle as a base – with free application of

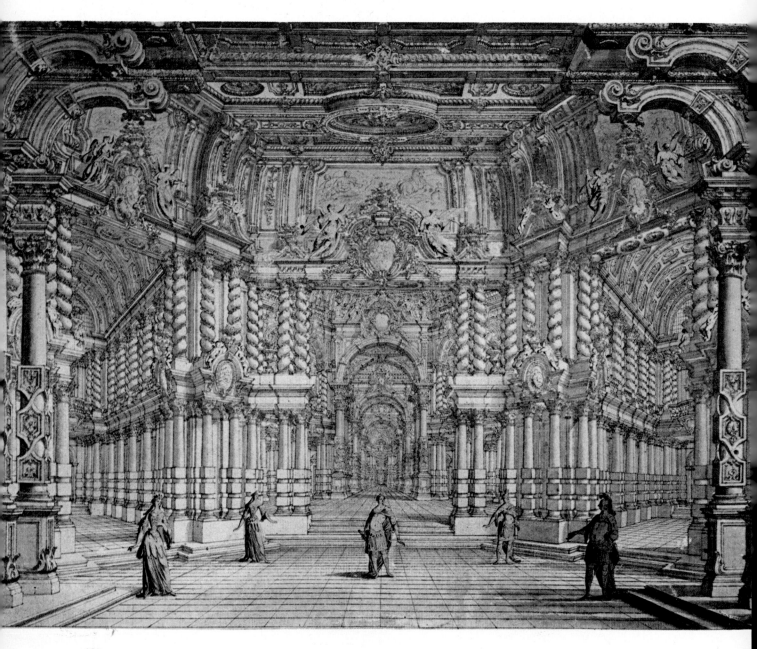

patterns and orders, accentuated contrasts of light and shade and, above all, the bold immersion of the architectural form in an 'infinite' rather than a 'finite' space. Borromini's art, on the other hand, produced revolutionary shapes, visualising spatial developments that had never before been attempted, as well as vertical extensions full of yearning for the transcendental, characteristic of the Counter Reformation. His imaginative ground-plans, his gently curving walls, his dynamic ribs and structures are all proof of this.

Bernini

The main stages of Bernini's architectural output date from 1657 to 1680. The year 1657 saw the beginning of work on the colonnade of St Peter's, surrounding the piazza with a four-fold row of columns, arranged in an ellipse. Open towards the Tiber, and linked to the trapezoid space in front of the cathedral, it marks the invention of the formula which led to all the architectural *trompe l'oeil* and scenographic design of the 17th and 18th centuries. The vigour of Bernini's colonnade offsets the cold and mannered effect of Maderno's façade to the church itself, changed from a central to a longitudinal plan, thus sacrificing the original designs of Bramante and Michelangelo. If, as seems likely, when Bernini sketched the plan, he referred to the relationship between the head and the arms – meaning the dome and the colonnade – then his theory represents an entirely modern conception. In three successive churches – S. Tomaso at Castelgandolfo, Sta Maria dell'Assunzione at Ariccia, and S. Andrea al Quirinale, Rome – the transition from a cruciform plan to a circular and finally an elliptical one reveals a passionate search for a new treatment of space, as a result of which Rome became the rightful mother of Baroque form. On the front of S. Andrea, finished in 1658, the unexpected projecting porch plays a functional

role and relieves the severe façade contained between strong pillars and terminating in a heavy tympanum. The interior, with its unbroken ellipse, calm, strong architrave and rhythmic columns and pilasters, shows the contribution made by classicism to Bernini's Baroque. The baldacchino of St Peter's with its twisting columns, is a dynamic challenge to what were probably Michelangelo's intentions for this space. Like the bronze *Cathedra* in the apse, the baldacchino is a work that links the art of Bernini the architect with that of Bernini the sculptor.

In sculpture, too, Bernini's development was inspired by classical art, with special attention to Hellenistic examples. His youthful works, executed between 1614 and 1618, foreshadow the genius that led to the creation, in 1619, of the dynamic and passionate *David* (Borghese Gallery, Rome). With the advent of Bernini, Mannerism in sculpture was definitely superseded, just as his earliest architectural works had broken Mannerist forms and patterns. The *Apollo and Daphne* group of 1621 (Borghese Gallery, Rome), shows unsurpassed technical skill in the play of light on the smooth flesh, contrasting with the roughness of the laurel branches sprouting from Daphne's hands and hair. With the *Ecstasy of St Teresa*, in Sta Maria della Vittoria in Rome (a work which

dates from 1646), Bernini achieved spectacular effects. True to the taste of the time, sensuality appears. The angel, smiling seductively, is like a conquering Eros; St Teresa swoons in ecstasy, hands and feet trembling, head turned to one side, in a river of drapery. The marble, which has the softness and warmth of wax, vibrates with light from the golden sunbeams above and represents an instant of human reality, which attracts the greedy curiosity of the spectators in flamboyant costumes, who look on from their niches in the side walls of the chapel. Examples such as these alternate with the great funeral statues of popes, like the monument to Urban VIII, in St Peter's, with its outstretched hand and imperious face, and the solemn drapery of the papal cloak. The statue of St Longinus, with an oratorical gesture, looks out from a niche in St Peter's, and the human warmth of Lodovico Albertoni visibly seems to grow calm in death in S. Francesco a Ripa. Bernini's portraits are swift and intuitive: the bust of Scipione Borghese (Borghese Gallery, Rome), is lively almost to the point of vulgarity; that of Francesco d'Este (Estense Museum, Modena), is bursting with movement.

On the borderline between architecture and sculpture, because they represent a spatial answer to the problem of their surroundings, Bernini

created several great Roman fountains: *La Barcaccia* ('Leaking Boat') in 1626 in the Piazza di Spagna; the Triton in 1640 in the Piazza Barberini, but, above all, in 1647, the Four Rivers in the Piazza Navona. The Nile, the Ganges, the Danube and the Plate, masculine figures of great vitality, are set around the base of an obelisk which displays, with rich effects of light and shade, natural species of flora from the various countries. The spectacular element is obvious: Bernini's naturalism is permeated with unbridled fantasy.

Apart from Bernini, Roman Baroque sculpture was largely a matter of derivation. Algardi's forceful statue of Innocent X (Palazzo dei Conservatori) is in Bernini's manner, and he vied with Bernini, the portraitist, with his lively bust of Donna Olimpia (Doria Pamphili Gallery, Rome). Venice and Milan saw the Baroque age come and go without having made any significant contributions to the style. At best they employed legions of lesser artists, who merely produced imitations of the work of more inspired colleagues.

Borromini

The main stages of Borromini's output in Rome – considering only his most important works – were between 1634 and 1667. In 1634 work

Gian Lorenzo Bernini, 'Apollo and Daphne' (Borghese Gallery, Rome)

Gian Lorenzo Bernini, colonnade of the Piazza of St Peter's, Rome

471

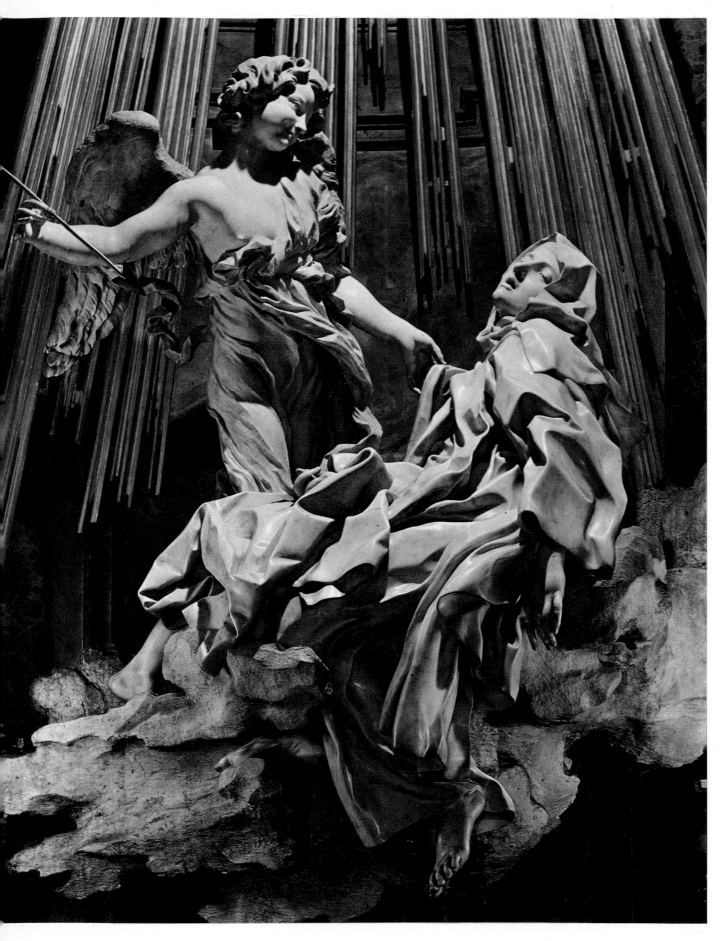

started on the monastery and cloister of S. Carlino
alle Quattro Fontane; between 1637 and 1650 he
worked on the Oratory of St Philip Neri; from
1642 to 1650 on S. Ivo della Sapienza; from then
till his death he worked on S. Agnese in the
Piazza Navona and on the façade of S. Carlino.
Bernini's calm and unbroken ellipse was replaced
by Borromini in S. Carlino with a restless, curved
ground-plan, which extends its dynamism to the
walls, the broken cornice and the brightly lit
dome. In the cloister, the interplay of light and
shade is nevertheless conducive to meditation. On
the façade of the Oratory, in strict accordance
with the active spirit of the Congregation of St
Philip Neri, the surface is divided into two great
planes which swell sinuously, protruding and
receding, as though moved by internal spasms.
The entablature and window-cornices experiment
with effects which were to serve as patterns for
much of 18th-century Europe.

S. Ivo della Sapienza, framed by Della Porta's
lively 16th-century courtyard, is Borromini's
masterpiece. Its concave façade gives way to
the convex four-lobed drum which rises on
the elaborate pattern of a six-pointed star. Above
the drum towers the tall lantern, its pillars appar-
ently pushed up by the rampant Baroque arches

Gian Lorenzo Bernini, 'Ecstasy of St Theresa'
(Sta Maria della Vittoria, Rome)

Gian Lorenzo Bernini, detail of the horse from the
'Fountain of the Four Rivers', Rome

Gian Lorenzo Bernini, bust of Cardinal Scipione Borghese
(Borghese Gallery, Rome)

that wind their way over the roof of the drum. The top of the lantern represents the Papal tiara, reduced to architectural terms, together with the insignia of the Barberini. The interior, lit by hidden windows, consists of a single space which extends unbroken right up to the immense segments of the roof, which come together at the base of the lantern, with tall evenly spaced windows in between them. Other works are the Collegio di Propaganda Fide, with its noble chapel; the renovation of S. Giovanni in Laterano, with the effects of light and shade in the subsidiary aisles; Sant'Agnese in the Piazzo Navona, and S. Andrea delle Fratte, with the culmination of his articulated vertical structures. All of these are, both in general lay-out and in individual details, examples of the astounding imagination that led eventually to the dramatic achievement of the façade of S. Carlino alle Quattro Fontane, which foreshadowed the developments of the boldest 18th-century Baroque architecture.

Apart from Bernini and Borromini, an important and varied school of architecture flourished in Rome. Pietro Berrettini da Cortona, more celebrated as a fresco-painter, displayed sculptural sensibility and a feeling for light effects in his designs for the churches of S. Luca and Sta Maria della Pace. Carlo Rainaldi (1611–90), after working out problems of articulation in the Baroque interior of Sta Maria in Campitelli, modelled the exterior of the tribune of Sta Maria Maggiore. He also collaborated with Carlo Fontana (1634–1714) in planning the Piazza del Popolo, in the form of a wheel radiating from the central Egyptian obelisk. Alessandro Algardi offered some resistance to the Baroque tide when he built the façade of S. Ignazio with its two linked orders, a logical corollary to the axially planned interior, with the light pouring in through its great dome, the whole conception closely corresponding to the ideals of the Council of Trent.

Pietro da Cortona (1596–1669) brought Italian decorative painting to its highest point, and was one of the most distinct exponents of Baroque aims. Compared with him, the contribution made by the Carracci in the Palazzo Farnese seems modest. With the spacious ceiling of the Palazzo Barberini, representing the *Glory of the Barberini*, the painting becomes so full of movement that it turns into a swirling wave of arabesques. The composition breaks all rules; the forms become fluid, the sparkling colours and brilliant light eliminate all sense of weight and matter as they plunge everything into a celestial infinity.

The Jesuits were quick to realise how much such overwhelming painting could contribute to intensifying faith. Andrea Pozzo (1642–1709), in

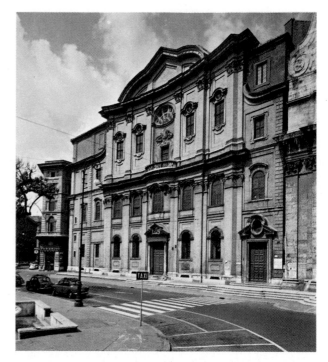

F. Borromini, Oratory of the Congregation of St Philip Neri, Rome

F. Borromini, interior of the dome of S. Ivo alla Sapienza, Rome

Pietro da Cortona, Sta Maria della Pace, Rome

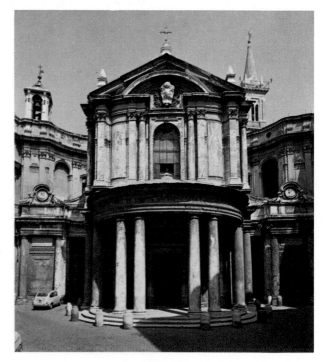

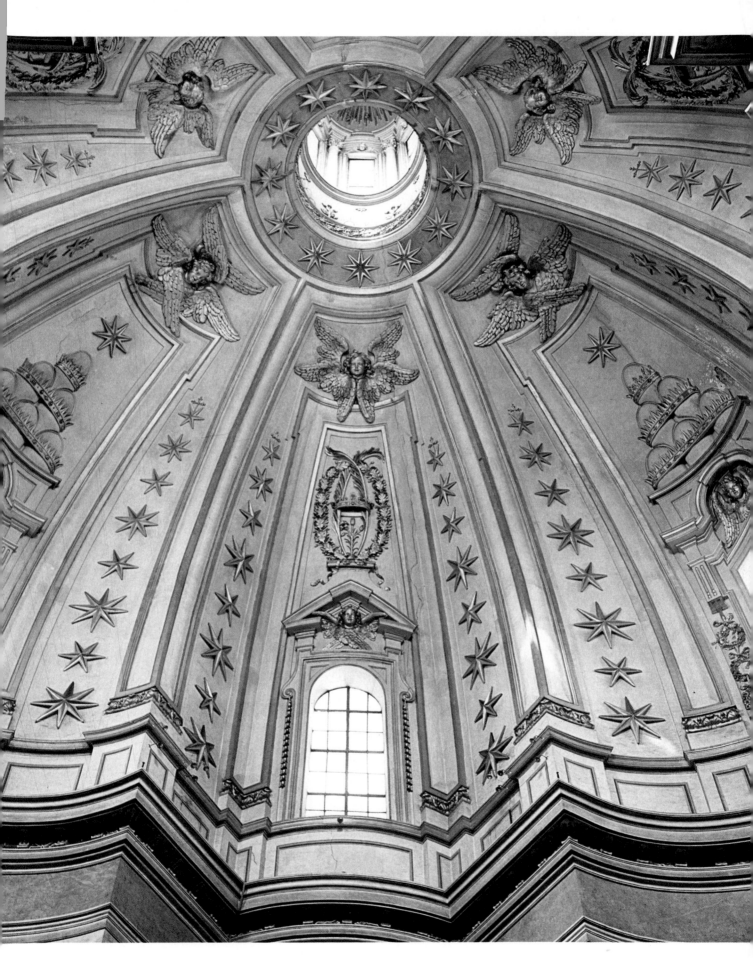

the *Glory of S. Ignazio* (S. Ignazio, Rome), created new dimensions of artificial architectural perspective, showing the saint of the Counter Reformation ascending to heaven in a whirlwind. Baciccia (1639–1709), on the ceiling of the Gesu, also made his composition burst out from its spatial confines.

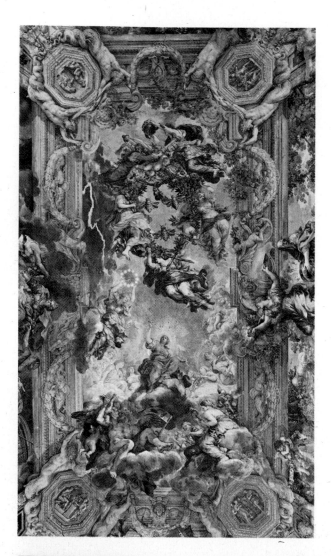

Pietro da Cortona, 'Glory of the Barberini' (Palazzo Barberini, Rome)

Andrea Pozzo, 'Glory of St Ignatius' (S. Ignazio, Rome)

Pietro da Cortona, Putto with dog, detail (Palazzo Pitti, Florence)

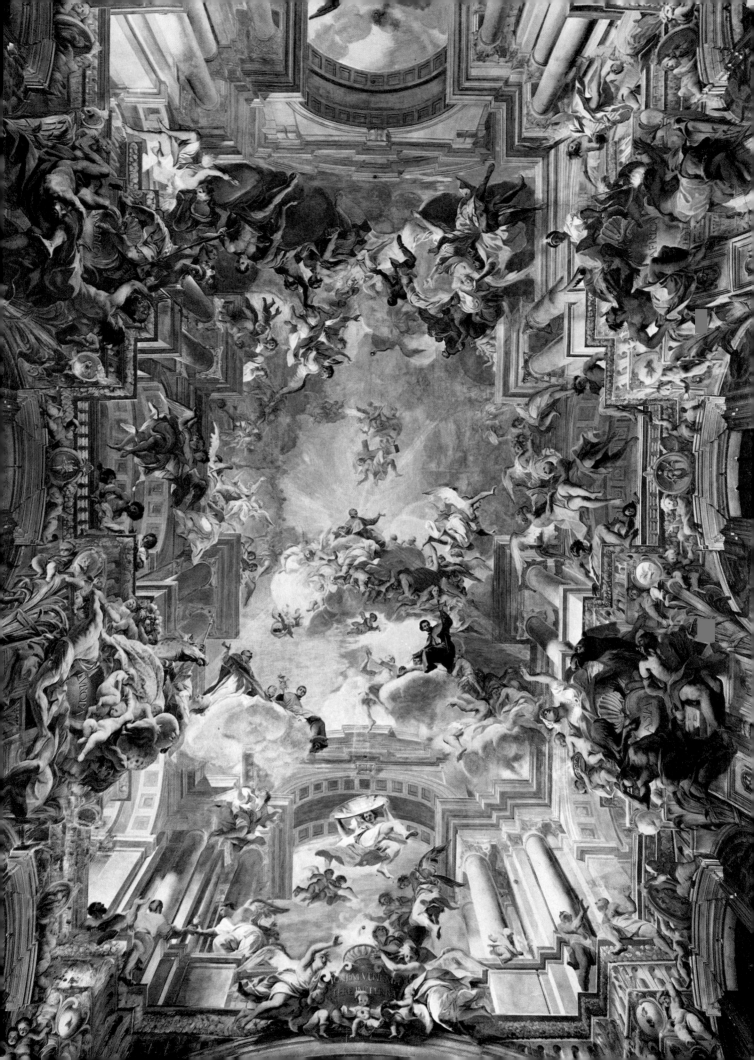

Architecture outside Rome

In northern Italy, Genoa – partly because of the presence of Rubens and the young Van Dyck – was at one time the home of a school of portrait and decorative painting rich in inspiration and ideas. Painting in Naples was of a high standard, particularly in the work of Mattia Preti and Luca Giordano.

Architecture in the manner of Borromini was still widely accepted in Italy in the 17th century, especially at Turin, through the Theatine Guarino Guarini (1624–83). Under Vittozzi the city had undertaken enterprising town planning experiments with the lay-out of its streets like a chessboard. It also had the picturesque church and monastery on the Monte dei Cappuccini, overlooking the Po. Under Carlo da Castellamonte the spacious Piazza S. Carlo took shape. Turin was also open to fresh influences from beyond the Alps, as in the castle which the Dowager Duchess Maria Cristina had built in the style of a French

Façade of Sta Croce, Lecce

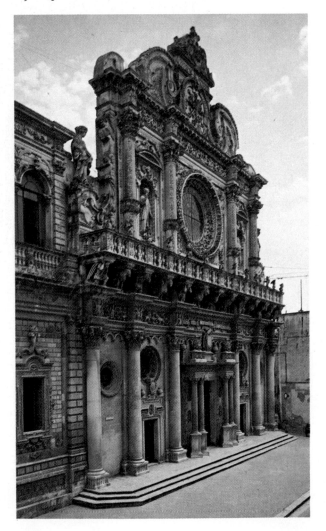

château. Nevertheless, towards the middle of the century, the architectural language of Turin was substantially classical, in spite of its freedom and imagination.

Guarini, who was both philosopher and mathematician, represented a standpoint that was complicated, but decidedly new. His architecture was based on the premises of Borromini, but it was also permeated with explicitly Gothic tendencies and included Spanish, Portuguese and Bohemian influences as well. The chapel of the Holy Shroud dates from 1668, and is undoubtedly derived from Borromini's Sant' Ivo della Sapienza. Externally the dome emphasises the novelty of functional growth by means of converging segments, and indicates the use of abstract mathematical calculations transmuted to extravagant rhythms. Inside, the contrast of light and shadow has an ethereal effect, especially when approached from the steps of the cathedral. The interior of S. Lorenzo, built between 1663 and 1687, is entirely Baroque in conception, with a square ground-plan broken up with triumphal convex arches. The interior of the dome is an unsurpassed example of continuity between Gothic and Baroque conceptions. It stretches over the eight adjoining arches as though carved out of one piece of stone, lit from above. The spaces are accentuated by the essential rhythms derived from mathematically calculated dimensions. The fine brick façade of the Palazzo Carignano, not unlike that of S. Carlino alle Quattro Fontane, draws its effect from its alternating concave and convex curves, flanked by the projecting wings, and from the curious insertion of the loggetta.

Genoa is interesting in a different way in its 17th-century architecture. It has several monumental palaces, designed for effect, with their terraced storeys, along the natural contour of the hills. The court and staircase of Bartolomeo Bianco's university and Lurago's Palazzo Doria Tursi, with balconies and statues alternating right up to the hanging garden at the top, are two more notable examples.

Florence contributed little to the Baroque age, pledged as she was to complete the heavy and ambitious chapel of the Medici princes. But the Baroque architecture at Lecce (south-east Italy) is important and original, representing the unusual meeting ground of the late Spanish Plateresque style with the ornamental splendour of local tradition. The church of Sta Croce is particularly famous for its exuberant ornamentation. In Sicily, the solid town planning of the Quattro Canti at Palermo must be mentioned, as well as Vaccerini's integrated planning at Catania; but the island lagged behind the times with 17th-

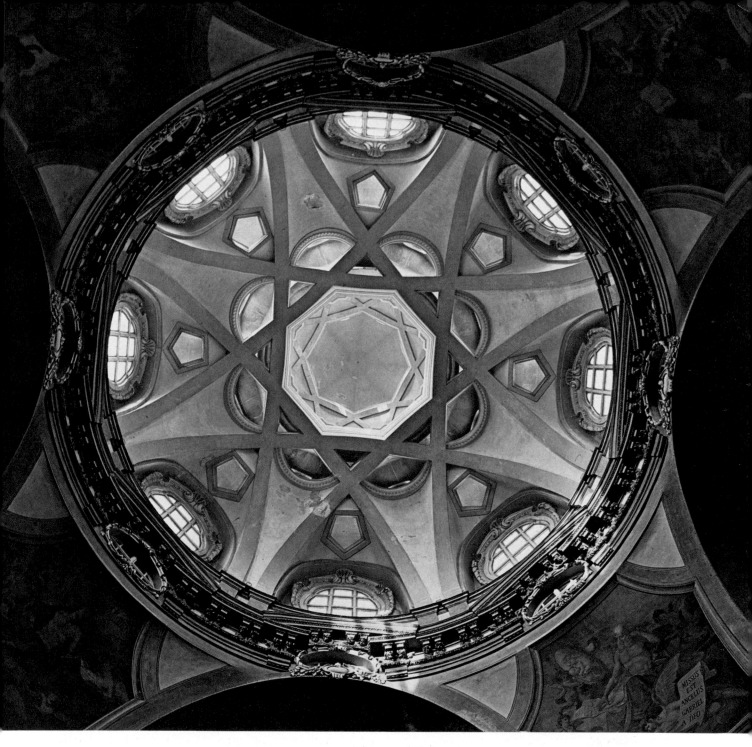

Guarino Guarini, dome and plan of S. Lorenzo, Turin

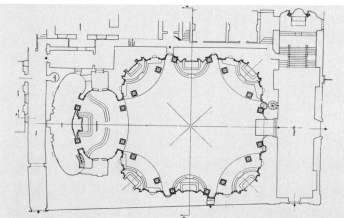

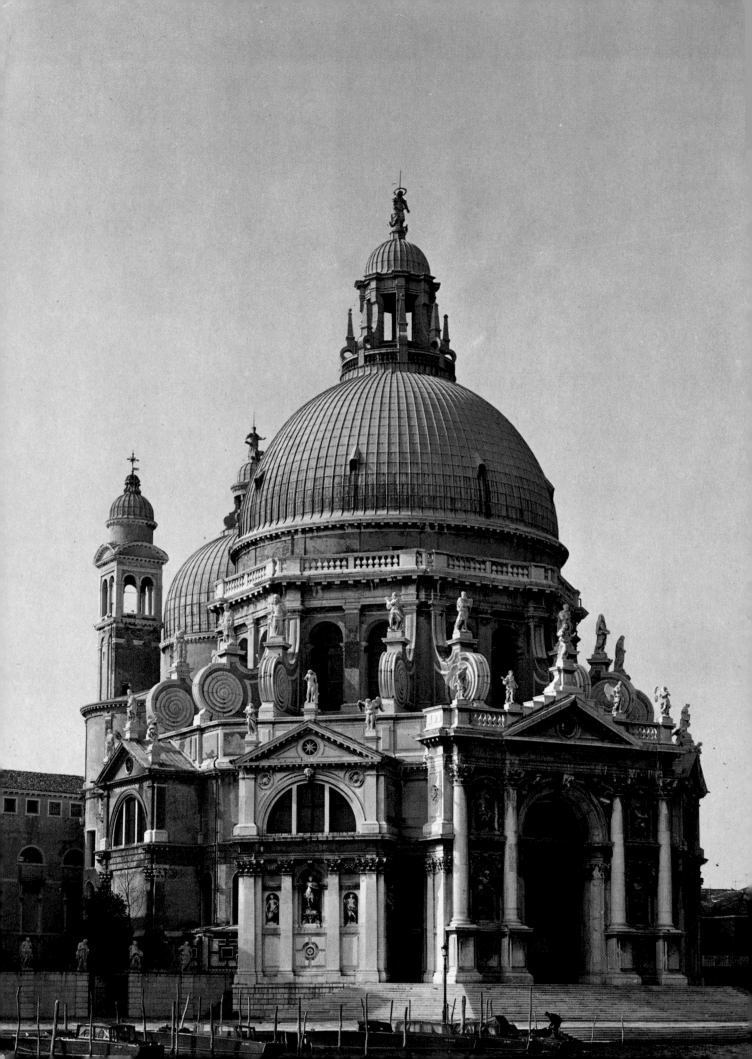

century Mannerist designs in which decoration does not conceal exhaustion and repetitiveness. Cosimo Fanzago, known for the Charterhouse of S. Martino, worked in Naples in a similar style. Milan was belatedly conservative, especially in its academic spirit: Lorenzo Binago's church of S. Alessandro is in some ways exceptional in its faint nostalgia for Borromini, while Francesco Maria Ricchini's Palazzo Brera is one of the coldest and most classical of Jesuit buildings.

The other Italian centre with definite Baroque features – particularly in the work of Baldassare Longhena (1598–1682) – is Venice. The Venetian pictorial tradition and the whole earlier development of its architecture would seem to be at variance with the powerful marble mass of Sta Maria della Salute, built on one of the key-points of the Bacino. In particular, the triumphal pediments, marking the external limits of the octagonal body of the church, still permeated with Palladian immobility, are apparently rigid and static features. And yet, as a whole, Sta Maria della Salute is, in the Baroque sense, outstandingly dynamic; this is due to the expressive strength of the great scrolls, which link the octagonal body with the drum and the dome. The water of the lagoon makes the light glimmer on the rusticated stone of the lower parts of the Ca' Rezzonico and the Ca' Pesaro, also the work of Longhena. Other Venetian buildings of the period, however, like the heavy façade of S. Moisè, express a decorative taste which is commonplace and heavy. Even in Venice this inferior style had its day.

Venetian painting

Venice, which in the 17th century made comparatively little contribution to Italian painting, suddenly came back to life in the 18th century. Her contribution lay mainly in two directions: in the splendid decoration of walls and ceilings which reached its zenith with Giambattista Tiepolo; and in the new school of landscape painting and views which had its finest expression in the works of Canaletto and Francesco Guardi. As in France and the German countries, the new taste called for a new choice of subjects. G. B. Piazzetta (1683–1754) painted such subjects as *Idyll on the Sea-Shore* (Wallraf-Richartz Museum, Cologne) and the *Fortune Teller* (Accademia, Venice). P. Longhi (1702–85) produced interiors with vivid *genre* scenes (the *Dentist*, the *Dancing Lesson*, the *Concert*), while Tiepolo himself (1696–1770) was decidedly romantic in *Rinaldo and Armida* (Alte Pinakothek, Munich) or the idyllic *Telemachus and Mentor* (Rijksmuseum, Amsterdam). His great decorative frescoes – the series in the Palazzo

Baldassare Longhena, Ca' Rezzonico, Venice

Opposite page: *Baldassare Longhena, Sta Maria della Salute, Venice*

Andrea Brustolon, a moor, statue in ebony (Ca' Rezzonico, Venice)

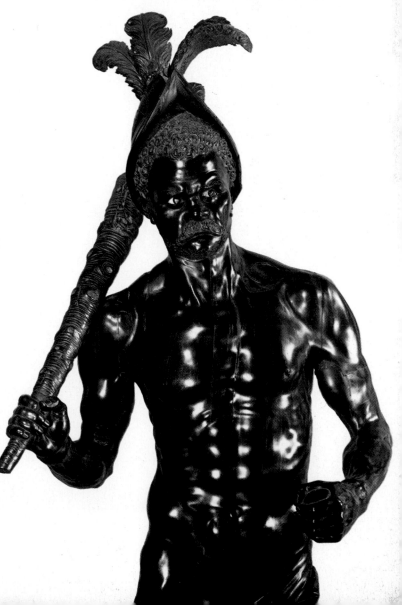

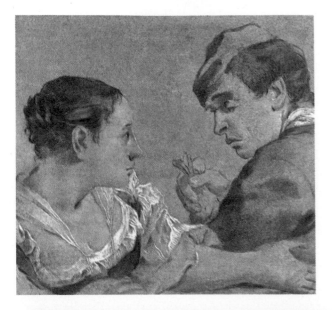

Labia at Venice, the ceilings of the Palazzi Archinto (now destroyed), Casati Dugna and Clerici in Milan, the ceiling of the Würzburg Residenz, the frescoes in the Colleoni chapel at Bergamo and in the Scalzi chapel at Venice – are the most mature and perhaps the most fascinating achievements of Italian Baroque painting. But Tiepolo disregarded the stereotyped forms and familiar cadences of Baroque. Softness and sumptuous colour make some of his paintings unforgettable, as in the profane splendour of *Venus Accepting the Gifts of Neptune* (Doge's palace), or the touching *Adoration of the Magi* (Alte Pinakothek, Munich). Art criticism has suggested comparing him with Guarini and Juvara – that is to say placing him in the forefront of all that is frank, inventive and impetuous in Baroque.

Towards the middle of the 18th century,

Above: *Giovanni Battista Piazzetta, 'Two Youths' (Accademia, Venice)*

Giovanni Battista Piazzetta, 'Idyll on the Sea Shore' (Wallraf-Richartz Museum, Cologne)

Giambattista Tiepolo, sketch for The 'Santa Casa of Loreto' (Accademia, Venice)

484

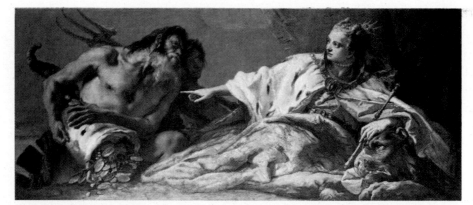

Giambattista Tiepolo, 'Neptune offering Venice the Gifts of the Ocean' (Doges' palace, Venice)
Opposite page: *detail*

Giambattista Tiepolo, 'Ulysses Welcomed to the Island of Ogygia by Calypso' (Villa Valmarana, Vicenza)

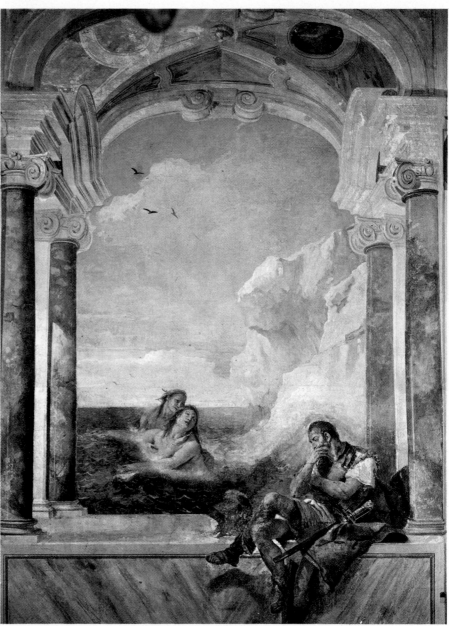

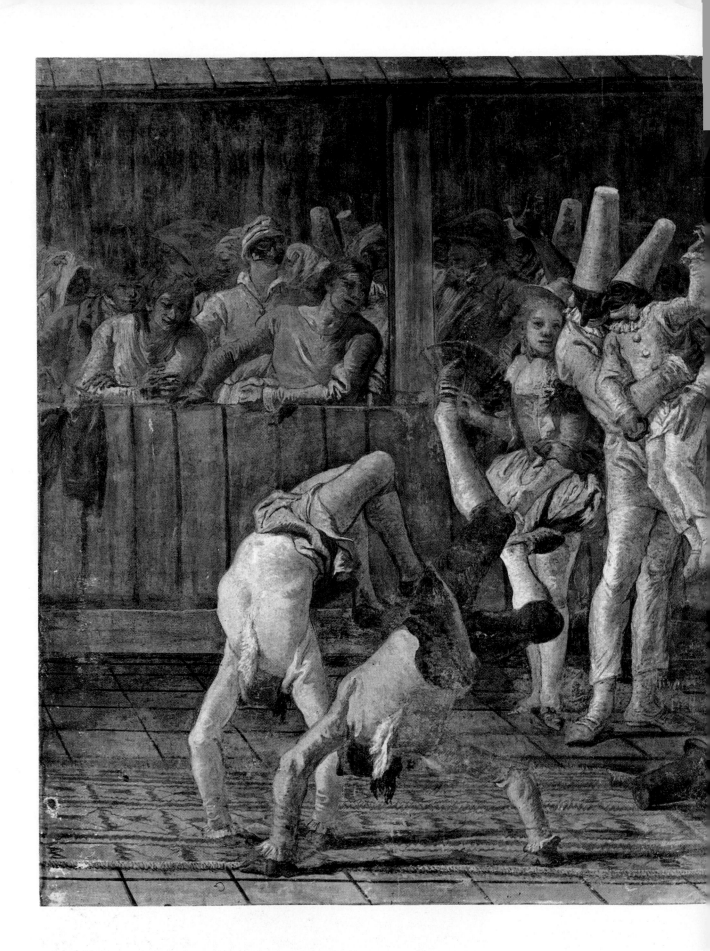

Giambattista Tiepolo, 'Pulcinelli and Acrobats' (Ca' Rezzonico, Venice)

Venice saw the birth of a new school of landscape painting. With Canaletto, this kept within the limits of exact and almost photographic representation. Brilliant at perspective, always somewhat scenographic, he was nevertheless successful in catching impressions of the Grand Canal in tones that are solid, abstract and cold. Softer, more sensitive to atmospheric values, more ready to look for the rhythms in a sketch, was Bellotto. Francesco Zais translated the pastoral themes of 18th-century France into a popular and more acceptable language, while Francesco Zuccarelli was more Arcadian. All remained far enough removed from the magic of Francesco Guardi (1712–93), who discovered how to simulate reality with darting touches of light. In his paintings (which are sometimes very small) imbued with the green of the lagoon; in his views of the canals, the squares, or the Piazza S. Marco, matter is dominated by light, which outlines the shapes, softens the contours, and accentuates the splashes of colour. Guardi caught with infinite skill the magic of the passing moment.

Allied to Guardi was the Ligurian painter, Alessandro Magnasco (1677–1749). But Magnasco lacked Guardi's sense of display, and was tormented in his choice of subjects. His draughtsmanship is at once uncertain and vigorous, and his slashing brush-strokes range from the reverie of *Figures on a Terrace at Albaro* (Palazzo Bianco, Genoa) to night scenes.

Lombardy was taken up with its 'realist' painters, its Cerutis and Ghislandis, while Naples, in the 18th century, drew from Solimena increasingly vast and theatrical paintings, flaming and vibrant colours, to make grand dramatic effects

Above: *Giovanni Antonio Canal ('Canaletto'), 'London: The Thames and City seen from Richmond House', detail (Goodwood Collection, Chichester)*

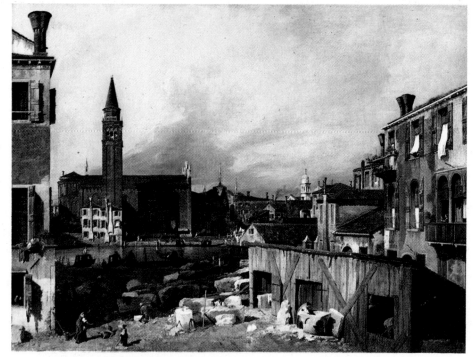

Giovanni Antonio Canal ('Canaletto'), 'The Grand Canal: The Stonemason's Yard' (National Gallery, London)

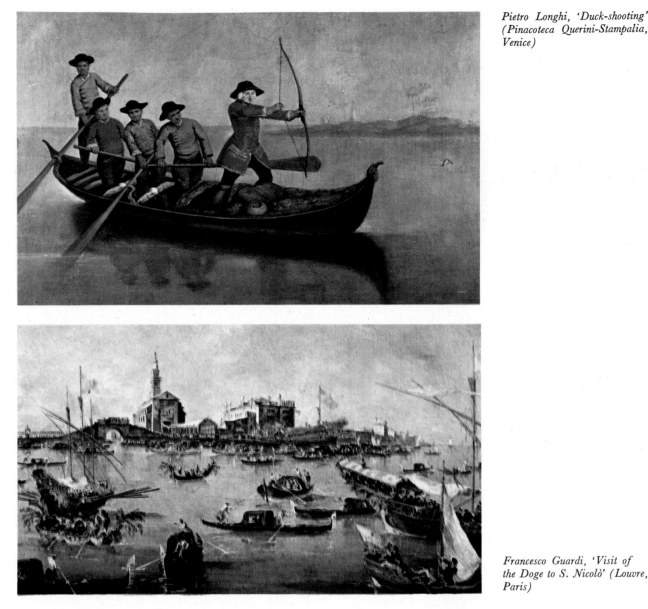

at the loudest moment of the Baroque crescendo.

18th-century architecture was dominated by the art of urban design. In this field Rome led the way, because of the nature of her site. Two examples in particular stand out for their spectacular and picturesque effect. The first, the work of A. Specchi and F. de Sanctis in 1721, is the flight of steps – the Spanish Steps – leading to Sta Trinita dei Monti; the second is the Fontana di Trevi, the work of Nicola Salvi and others, in 1733. In the context of a humbler urbanism, not swamped by the greater works with which Rome put on a new face, is the piazzetta facing S. Ignazio. Its small sloping palaces, used for Jesuit offices, are arranged like a setting for one of Goldoni's comedies. It is a typically 18th-century arrangement, rich in taste and fantasy.

In addition to Guarini, Piedmont had a great architect in Filippo Juvara (1678–1736), who built the basilica of Superga on the hills near Turin and the hunting palace of Stupinigi, with its great wings reaching into the park. The axis of the polygonal central body of the villa points in one direction towards the country, and in the other down the central avenue of approach, bordered by the stables and harmoniously designed farm buildings.

In southern Italy the great palace of Caserta, deep in its park, is altogether Rococo in style, with fountains and pools picturesquely reflecting mythological and Arcadian statues. The Boboli gardens at Florence and the Farnese gardens at Caparola express taste and refinement, again within the limitations of urbanism.

Architectural forms in themselves during the 18th century vary according to the different

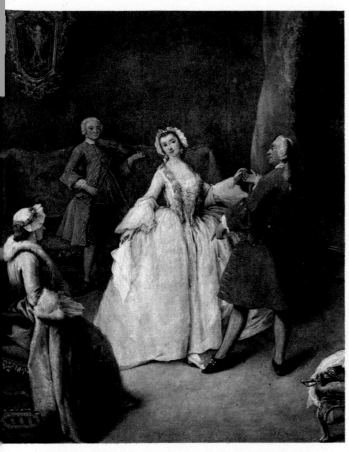

Pietro Longhi, 'The Dancing Master' (Accademia, Venice)

Pietro Longhi, the 'Visit', detail (Aldo Crespi Collection, Milan)

Italian centres where they occur. Rome combined 16th-century moderation with Baroque contrasts of light and shade, and consequently has such impressive works as Alessandro Galilei's façade of S. Giovanni in Laterano (St John Lateran) or Ferdinando Fuga's façade of Sta Maria Maggiore. The year 1732 is the date of one of the noblest civil buildings, the Palazzo della Consulta, in whose courtyard Fuga allowed himself a series of diagonal planes rising inside the central body. Turin and several other smaller Piedmontese centres were given some fine architecture during the 18th century. Juvara was responsible for some of the finest works, and in the basilica of

Villa Pisani at Stra, Venice

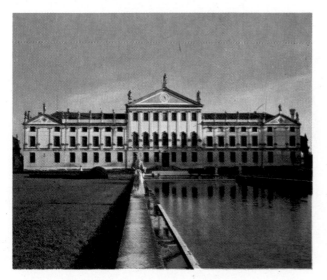

Villa Pisani at Stra, interior with frescoes by Tiepolo

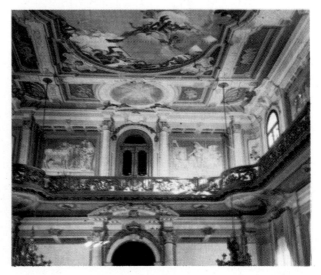

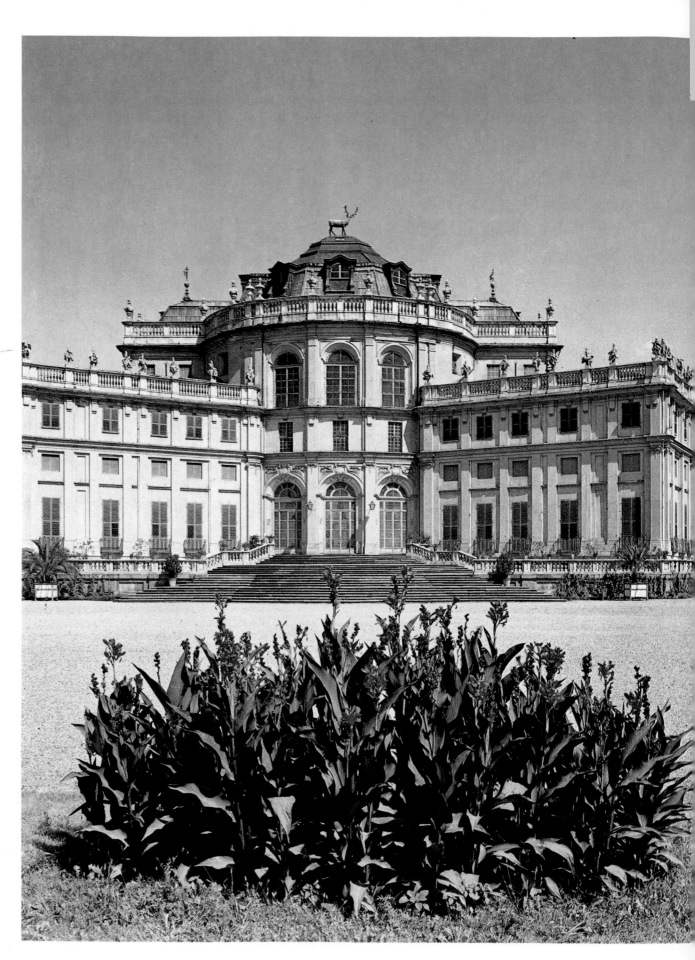

Luigi Vanvitelli, Palace of Caserta

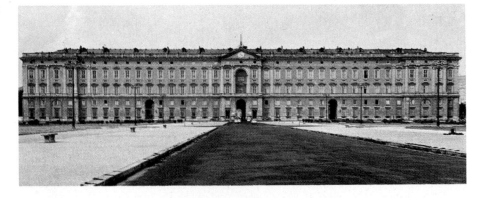

Superga combined the classical portico with the curving line of the main building. This has affinities with the Roman Pantheon, except that in the upper part the drum and cupola are developed on a strong vertical thrust. The Palazzo Madama at Turin, whose design was partly affected by these buildings, is not very interesting from the front, but offers a superb example of Rococo in the winding curves of its main staircase, decorated with thread-like patterns in luminous white plaster. The 'scissor' staircase in the royal palace has originality and exquisite Rococo elegance, and is also of interest for its structural audacity. When Juvara went to Madrid to collaborate on the royal palace there, Benedetto Alfieri carried on the work in Turin with style and elegance, particularly in the royal theatre (now destroyed).

At Milan, the Palazzi Litta, Clerici and Archinto, decorated by Tiepolo, and at Merate the Villa Belgioioso show the extent of Rococo influence. At Naples, Luigi Vanvitelli (1700–1773) worked for the Bourbons on the royal palace of Caserta. Its amply proportioned front is about 600 feet long, and follows the example of Versailles in its columned porch and rows of windows. The interior is sumptuous with its fanciful perspectives, though the entrance hall is somewhat cold.

Nicola Salvi, Trevi fountain, Rome

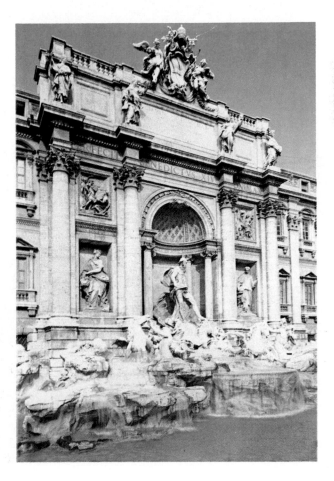

Filippo Juvara, façade of the Castle of Stupinigi, Turin

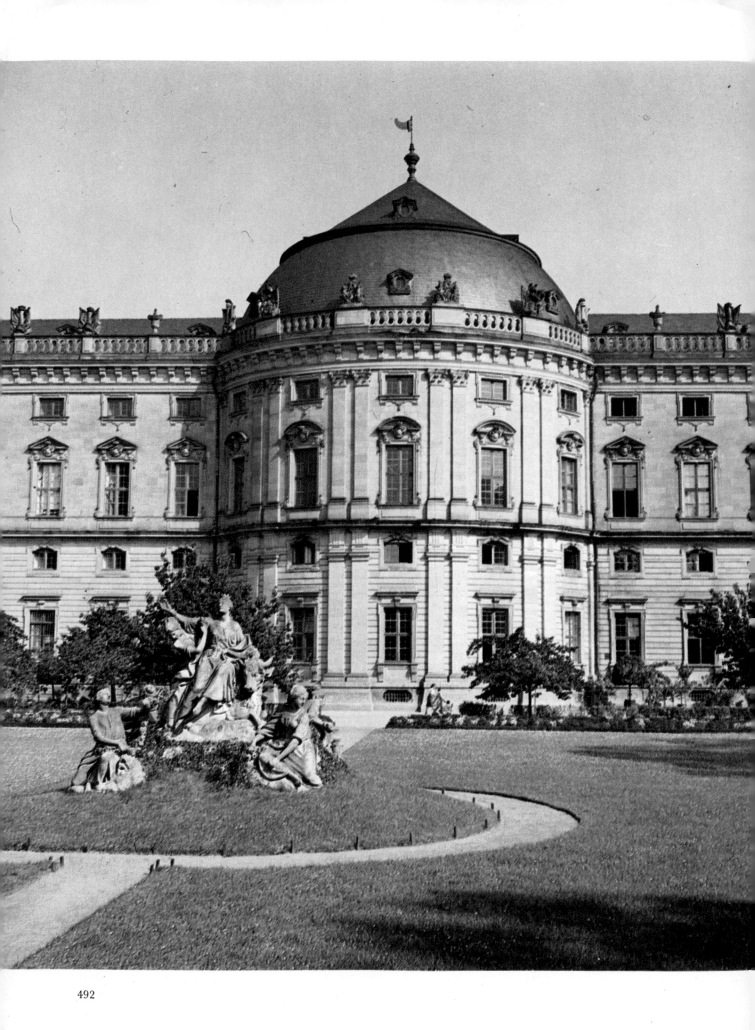

17TH- AND 18TH-CENTURY GERMAN ART

The Baroque style influenced architecture over a vast area of Europe, including German-speaking Switzerland, Austria, Bavaria, Bohemia and Moravia, with outposts in Poland, Budapest and Leningrad. Spain and Portugal, the Low Countries, England, Protestant Germany and – most significantly – France, either remained untouched by this influence or adapted it to their own traditions and national tastes. Throughout the 17th century a unifying architectural trend, which came originally from Rome, can be seen wherever the Jesuits and the policies of the Counter Reformation gained a foothold. Basing their ideas on the churches of S. Ignazio and Il Gesù in Rome, the Jesuits favoured spacious churches built on a rectangular ground plan, with light entering through a dome, and with sumptuous decoration and richly decorated altarpieces. This Baroque influence penetrated the German countries slowly, and did not reach its height until the beginning of the 18th century. By that time Italy was already open to Rococo influence, particularly developed in France.

German scholars use the term *Frühbarock* (early Baroque) to describe works dating from 1620 to 1680. During this period the more northern districts, for the most part, followed Mannerist Flemish patterns, while the Catholic countries in the south employed Italian architects. Between 1612 and 1645 Solari built the cathedral at Salzburg; between 1667 and 1670 Zuccalli, architect to the Bavarian court, restored St Cajetan at Munich. German architects generally built churches with triple naves, as can be seen from P. Francke's cathedral at Wolfenbüttel, dating from the first decade of the 17th century. All these buildings, as well as others at Vienna and Innsbruck, have in common their decoration, which generally takes the form of heavy, static white plaster covering an architectural framework that is wearily Mannerist.

The complete arrival of Baroque in German countries dates from the moment when curved ground-plans were introduced. With this development, walls were made to undulate, and concave planes to converge onto ceilings, while new spatial dimensions were sought. The first example of this concept of architectural form is the church of St Lawrence at Jablonné (Deutsch-Gabel), in

Balthasar Neumann, the Residenz at Würzburg, façade facing park (below) *and south wing* (opposite page)

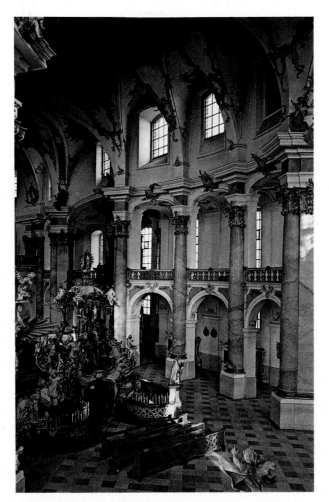

Bohemia (1699). It is the work of Lucas von Hildebrandt (1668–1745), who based his ground plan on a central circle enclosed on four sides by ovals, with a result not unlike the designs of Guarini. In Franconia, at the end of the 17th century, the church of the Trinity of Kappel was built by Dientzenhofer on a ground plan of three intersecting circles. There, too, Balthasar Neumann (1687–1753) started from similar premises when he designed his church of the Vierzehnheiligen. The centrally planned church with an oval nave seems to expand outwards. This effect is heightened by the illusionistic effects in the apse, while outside the high façade curves between its two towers. The façade of the abbey of Neresheim, also by Neumann, has close links with Borromini.

Between 1719 and 1739 Neumann was responsible for the creation of one of the most splendid German princely homes: the episcopal palace or Residenz at Würzburg. Here the main U-shaped façade, with its horizontal stress and restful proportions on the first floor, is less important than the garden façade, which has a protruding central bay and gallery, curving towards the Italian-style park. The interior is particularly sumptuous. The ceiling above the fantastic staircase was painted by Tiepolo. Highly scenographic in the transition from the single flight to the slow rise of the double stairs, it is

Balthasar Neumann, Church of Vierzehnheiligen, interior, Staffelstein

Jacob Prandtauer, abbey of Melk, on the Danube

Dominikus Zimmermann, interior of the church at Wies

18th-century German spinning wheel (Residenz Museum, Munich)

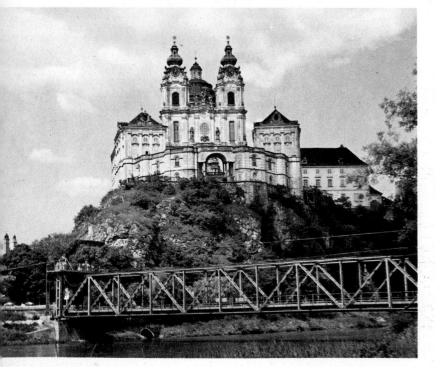

494

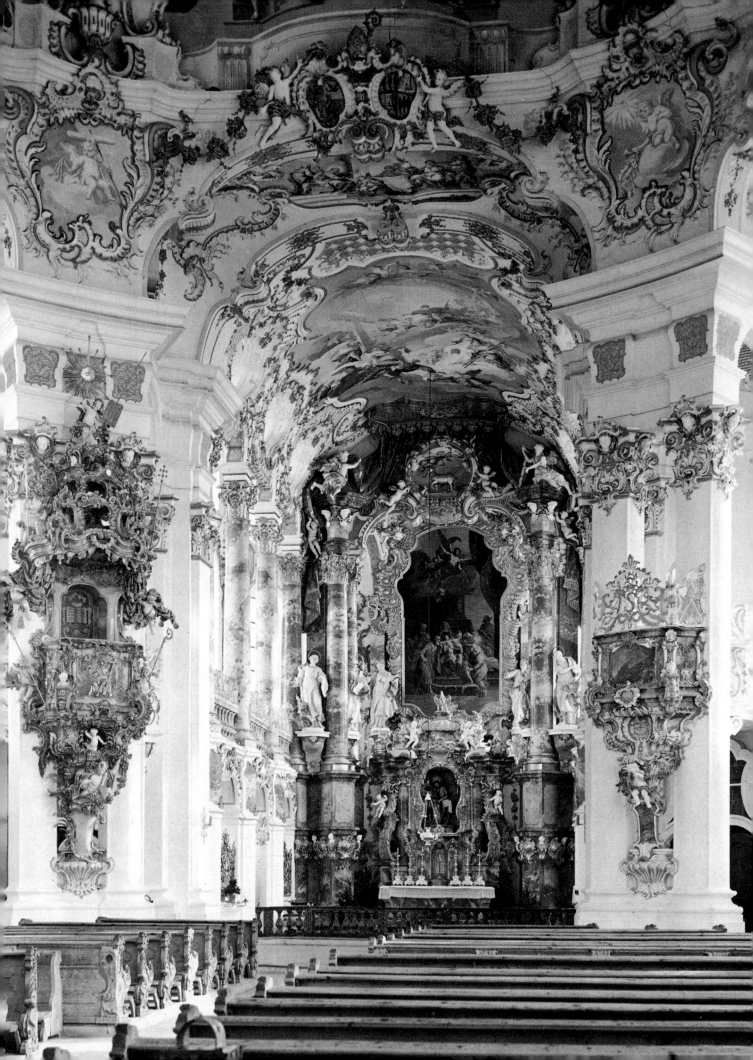

exceptionally rich in decoration although –
unlike the Kaisersaal with its denticulated ceiling
– a certain rigidity keeps it distinct from
Rococo. Even richer, and not without a certain
amount of excess, is the episcopal chapel. The
architectural plan is divided into segments con-

*François Cuvilliés, the 'Festsaal' in the Sünching Castle near
Ratisbon*

*Agostino Barelli, central section of Nymphenburg Palace,
Munich, façade facing the park*

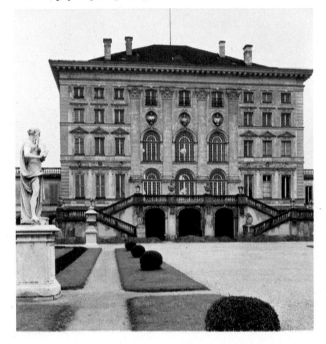

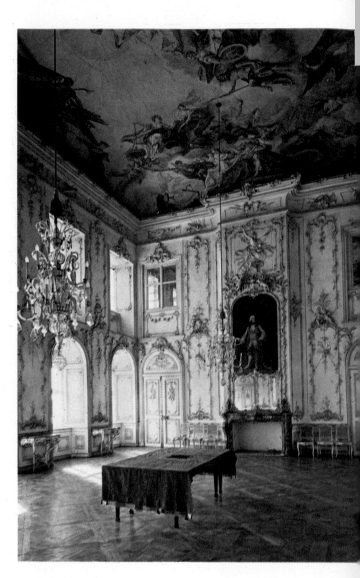

verging on a central oval in the manner of
Tiepolo. It is one of the mose notable examples
of continuity of architectual form and Baroque
decoration with its proliferation of white plaster,
gilded festoons, denticulated mirrors and precious
materials in many colours.

The churches belonging to the great religious
orders are no less sumptuous. Outstanding ex-
amples are the abbey at Rott am Inn, where a
wealth of plaster rises from festooned panels,
painted with frescoes by Günther, one of the
great Rococo decorators; the grandiose and
dominating Melk abbey in Austria; and the
abbey of Zwiefalten in Swabia, built in the mid
18th century by Fischer, in which Spiegler's
ornamental frescoes seem to hurl themselves from
the vaulted ceiling, caught up in the swirls of
plaster and in the scrolls over the pilasters with
their twin pillars. In the open chapels on the
abbey's side walls, the altarpieces are arranged
on the axial side so as to be visible to an

observer crossing the vast nave. This idea reached
Prague, where from 1703 to 1711 the church of
St Nicholas, Malá Strana, was rebuilt, the square
piers being placed diagonally to increase the
feeling of movement inside the building. In
Switzerland this arrangement can be seen at St
Gall, in the restoration of the abbey, with its rest-
less façade in the style of Borromini. St Gall
has a most impressive library, its ceiling resplen-
dent with decorative frescoes.

Munich, the centre of an aristocratic society,
copied French models when building its palatial
homes. In the castle of Schleissheim on the
façade facing the park, Effner achieved an ex-
tremely restful effect. J. B. Zimmermann (1680–
1758), a great and talented artist in plaster,
introduced a new fashion with his decorations
at Amalienburg, in the garden of the Nymphen-
burg, and in the Residenz at Munich; in
invention, freshness and fantasy, these come very
near to French Rococo. The interiors of these

Johann Baptist Zimmermann,
fresco in the Nymphenburg palace,
Munich

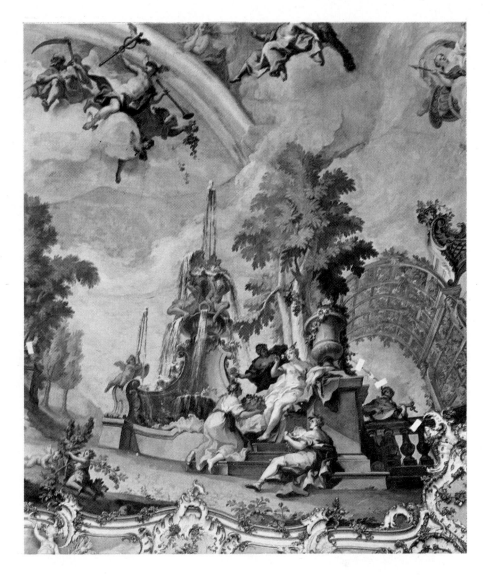

Joseph Effner, castle of Schleissheim

buildings, in which long galleries alternate with open rooms and loggias, amply and brightly lit, mark the highest peak of wall decoration: fluted pilasters alternate with festooned cornices, intertwined branches with stylised scrolls and fanciful flourishes, carved corbels with sumptuous pier-glasses. Superimposed decoration reaches the ceiling in the lightest of friezes, assimilating itself there in endless patterns of bas-relief. Yet there is never any question, as in France, of transforming the basic architectural structure, and for this reason there remains a distinction between the dynamism of superimposed decoration and the static quality of the wall surfaces. For this reason also these designs are not recognised as explicitly and completely Rococo in character, since in France Rococo was understood to involve filling up the spaces in the curves of walls with decoration. However, this did not prevent the design of very fine buildings which stand as brilliant examples of external architecture – like the pavilion at Amalienburg, the work of Cuvilliés (1695–1768).

During this period Prussia, under Frederick the Great, looked exclusively towards France. G. W. von Knobelsdorff (1699–1753), the court architect, combined Palladian severity and various Rococo features in his designs. The palace of Sans-Souci at Potsdam best illustrates this trend, although it does not achieve the nobility, the genius and the unity of the Zwinger at Dresden, a pavilion for court festivities by M. D. Pöppelmann (1662–1736).

Germany is rich in late 18th-century castles. These include the castle of Brühl, near Bonn and Ludwigsburg in Württemberg. None are truly

Johann August Nahl, the Library at Sans-Souci, Potsdam

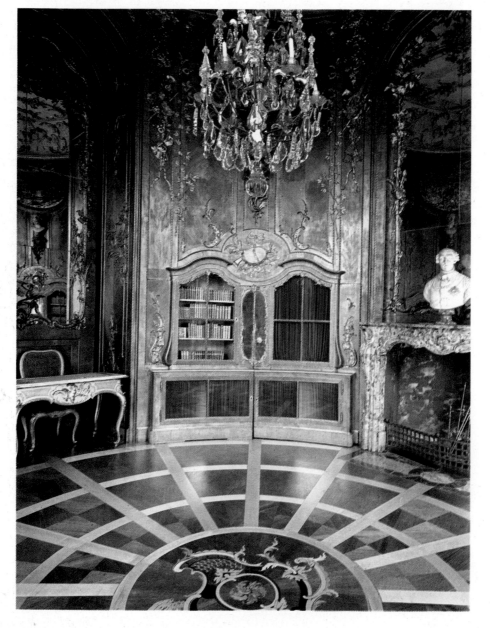

Opposite page: Hoppenhaupt senior, the Music Room at Sans-Souci, Potsdam

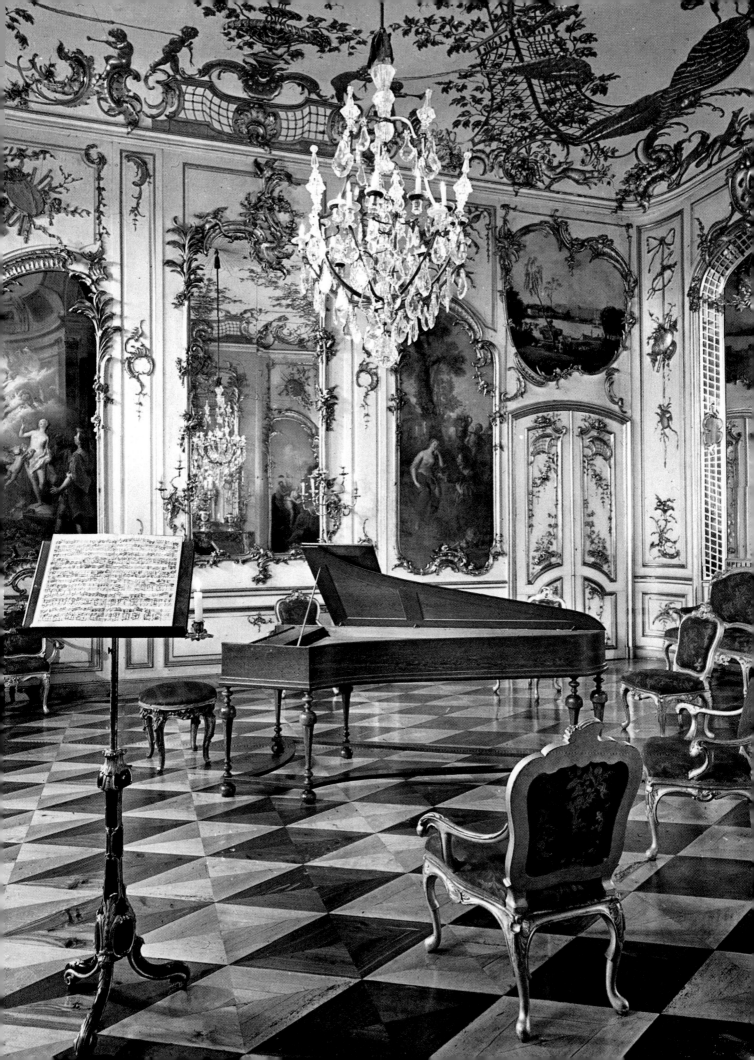

Rococo since they usually avoid intimacy and coherence, reduced proportions, and closed and organic forms. The importance generally given to impressive entrances, theatrical stairways, and illusionistic effects suggests that these features should be seen as the final evolution of the Baroque, with its characteristic flamboyant decoration, which becomes increasingly free and exuberant. The staircase in Hildebrandt's castle at Pommersfelden gives some idea of this splendour.

The 18th century is one of the best periods of

18th-century German goblet (Residenz Museum, Munich)

Johann Bernhard Fischer von Erlach, Schönbrunn Palace

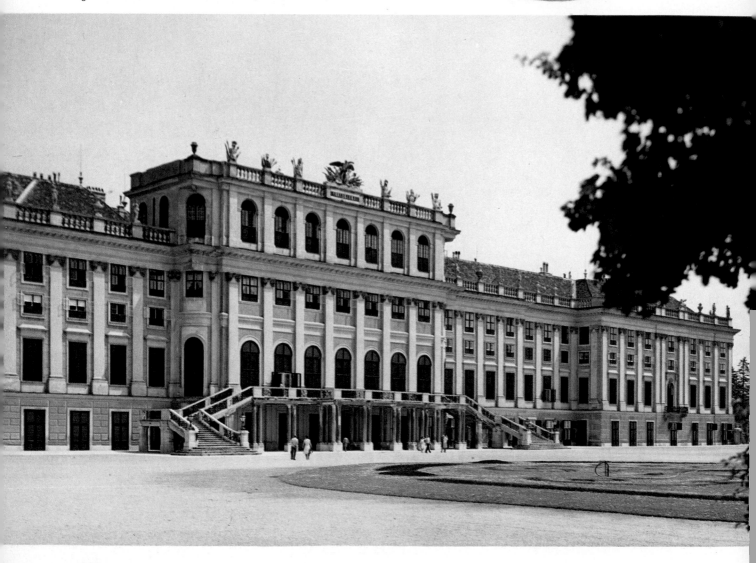

Austrian architecture. J. B. Fischer von Erlach (1656–1723) and L. von Hildebrandt (1668–1745) were the two great architects who made Vienna glorious, playing down Italian influences in favour of a greater freedom of expression. The Imperial palace of Schönbrunn is Fischer von Erlach's best-known work. The main façade, with the vertical rhythm of its pilasters and the restful arrangement of the first floor zone, was begun in 1694 for Leopold I. The interior decoration, however, completed during the reign of Maria Theresa, yields to grace and fantasy in its decorations and furniture. Among Fischer's most fascinating work, reflecting contemporary Viennese culture and customs, is the splendid National Library. Its exterior is compact and measured, with a sensitivity of design conspicuous in its silver-grey colour scheme. Inside, filled with warm lights, it is severe and yet fantastic in the profusion of free Baroque modelling. Fischer von Erlach's ecclesiastical architecture reached its peak in the church of the Trinity at Salzburg, which is based on a broken oval ground plan with converging chapels. In the impressive Karlskirche at Vienna, the dome and the pillared portico betray a nostalgia for Italian classicism, and there is strength in the Baroque feeling of the oval axis, which leads onto four chapels, and in the perspective illusion of the apse beyond. Hildebrandt stressed theatrical effects, both in the palace he built for Prince Eugene and in the horizontal stress of the design of the Upper Belvedere.

Baroque churches are also to be found outside the German countries. The churches of St Anne at Buda-Vezeváros and the Carmelites at Györ, Hungary, are built to a pattern similar to the Peterskirche in Vienna. Certain Baroque palaces in Prague are also worthy of notice, like the Waldstein and the Michna palaces. 17th-century Russia, still bound to churches with spires and domes, added nothing to the Baroque achievement except that the cathedral of Kiev vaguely recalls the work of Bernini. But in the 18th century the enthusiasm with which Peter the Great sought to introduce into his country western ideas manifested itself in the creation of a new city – St Petersburg on the Neva. This opened the gates to Baroque influence. Now known as Leningrad, the city is today a busy port, but the impressive layout of its open spaces retain their original beauty. Among the Italians who were invited to work there, the architect Rastrelli (1700–71) played a leading part, being responsible for the great Winter Palace, the palace of Tsarskoe-Selo, and several palaces for the nobility.

Johann Bernhard Fischer von Erlach, detail of ceremonial room, Schönbrunn

Detail of a fountain in the Schönbrunn gardens

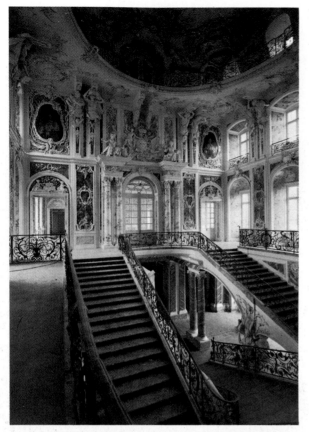

Balthasar Neumann, the staircase of Brühl Castle, Rhineland

Matthäus Daniel Pöppelmann, the 'Crown's Gate' in the Zwinger at Dresden

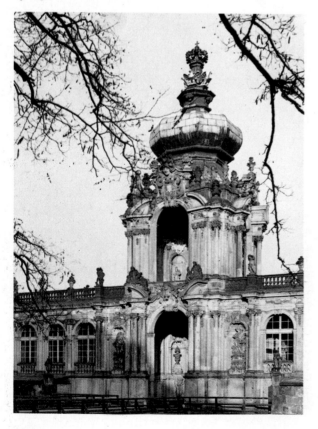

Sculpture

Sculpture in German countries was mainly decorative in function. During the 17th century it was heavy and ornate, but in the 18th century became lighter and finer due to French influence. In the 17th century German sculpture was dominated by monumental statuary, seen especially in the work of G. Petel, who was a follower of Rubens, and in that of M. Rauchmüller, who was influenced by Italian artists, including Bernini. Rauchmüller's *Apollo and Daphne* (Kunsthistorisches Museum, Vienna) derives from one on the same theme by Bernini. Only the 18th century can boast an original artist, Andreas Schlüter, who accepted the essential values of Italian Baroque sculpture and enlivened his own work with traditional German expressionist feeling. Schlüter worked in Berlin for Frederick III, and his statue of the monarch is today at Königsberg. His monument to Frederick William is in the Charlottenburg at Berlin. In Bavaria, B. Permoser worked in the Italian manner; and so, in Austria, did Donner, an ardent and elegant sculptor.

In Munich during the 18th century Ignaz Günther, an affected but graceful monumental artist, was much favoured. His figures of angels in the German National Museum at Nuremberg are famous. The Asam brothers, who were educated in Rome, have left a remarkable example of flamboyant decoration in the interior of the church of St John Nepomuk in Munich. Finally, A. F. Dietz, at the height of the 18th century, worked at Würzburg and Bamberg.

Painting

17th-century Germany had no distinct school of painting, and the German countries looked to Venice, expecially where decoration was concerned. H. Rottenhammer was one of the more notable painters of the day, and the work of J. Liss shows a progression from the style of Caravaggio to that of Piazzetta and Tiepolo. Elsheimer, in his luminous and idealised landscapes, recalls the Carracci, while H. Schönfeld followed the Neapolitan school of Cavallino. In the 18th century, the decorators whose activities coincided with the construction of the great Baroque churches became important. At their head was J. B. Zimmerman, already seen at work in the Nymphenburg palace at Munich. D. Gran and R. Troger were the greatest Viennese fresco painters, while Maulbertsch painted frescoes and panels full of contrasting light and shade.

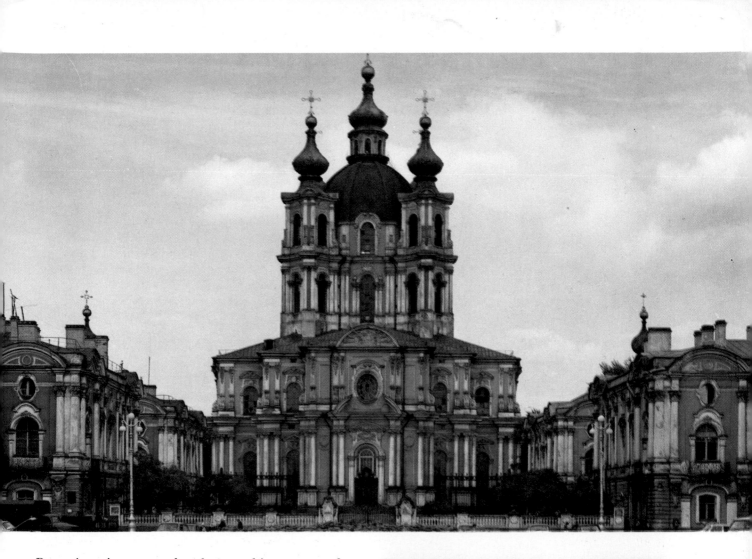

Portrait painters emulated the achievements of Italian and French artists, combining likeness with characteristics of pose and sumptuous costume.

In addition to sculpture and painting, the masters of porcelain at Meissen and Nymphenburg produced outstanding work. They were in fact rivals for supremacy in this field, especially with their statuettes of masked figures in elaborate costume and their chinoiseries.

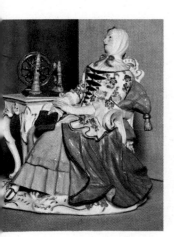

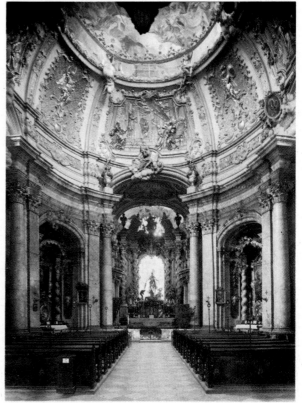

Above: Bartolomeo Francesco Rastrelli, monastery of Smolnij, Leningrad

Left: 18th-century Meissen porcelain. Lady with spinning wheel, from a model by Kaendler, taken from 'Les amusements de la vie privée' by Chardin (Victoria and Albert Museum, London)

Right: Interior of the abbey church at Weltenburg

17TH-CENTURY FLEMISH ART

Rubens

In Flanders, bulwark of the Counter Reformation in northern Europe, painting during the 17th century was Catholic and Baroque, and Peter Paul Rubens (1577–1640) was its greatest exponent. For Rubens, painting was a synthesis of all past achievements in the art – both in the restricted sense of the interpretation of reality and in the formal sense of free composition, a bright palette and brilliant brushwork.

Coming from the studios of Adam van Noort and Vaenius (Otto van Veen), Rubens was

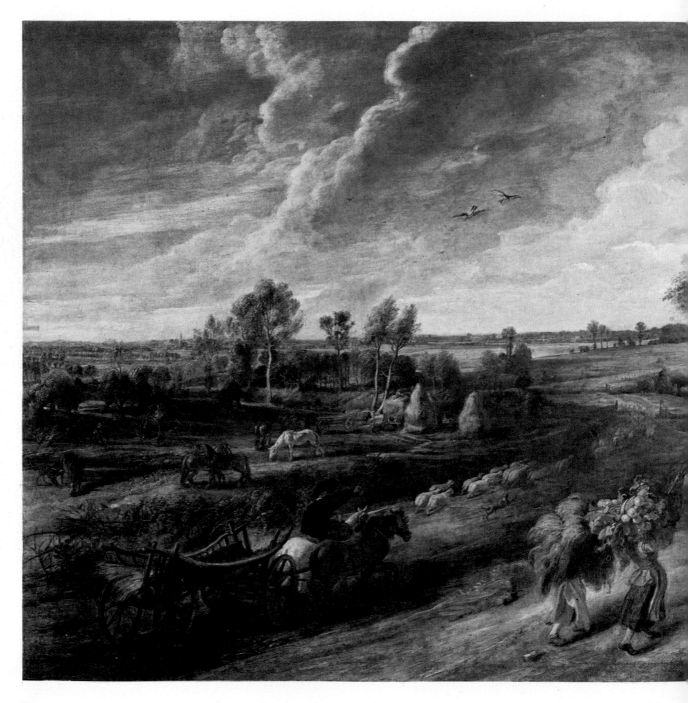

attracted to the Jesuits and reflected the spirit of their teaching. He observed the rules of composition of the Carracci and Domenichino, and echoed the religious sentimentalism of Frederico Barocci, whom he had studied during his stay in Italy from 1600–08. These influences can be seen in works like the *Annunciation* (Kunsthistorisches Museum, Vienna), with the sumptuous expanse of red cloth in the background, the fine pose of the Virgin in the act of withdrawal, and the theatrical lighting which illuminates the faces and hands. On his return to Antwerp, Rubens' first masterpieces – the *Raising of the Cross* and the *Descent from the Cross*, painted for the cathedral – proclaim his great debt to Italy in his monumentality in the manner of Caravaggio, his Venetian use of colour and his Correggio-like curiosity. But they also show a strictly Flemish continuity in their love of their subject matter, still-life and landscape – which is mainly introduced as a background.

Around Rubens there grew up a famous school of painting, which made Antwerp the rival of Rome. A large group of artists collaborated with the master in executing his great cycles of painting. There were also specialists, called upon

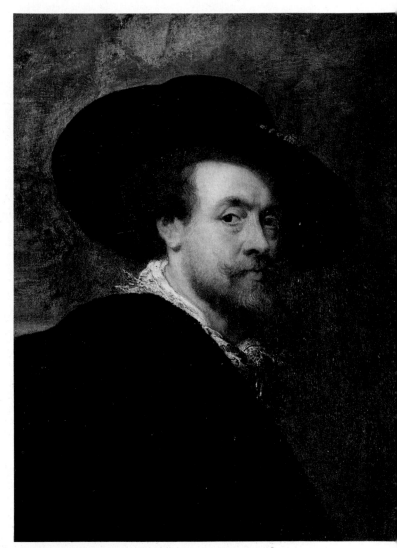

Peter Paul Rubens, 'Self-portrait' (Uffizi, Florence)

Peter Paul Rubens, 'Peasants Returning from Work' (Palazzo Pitti, Florence)

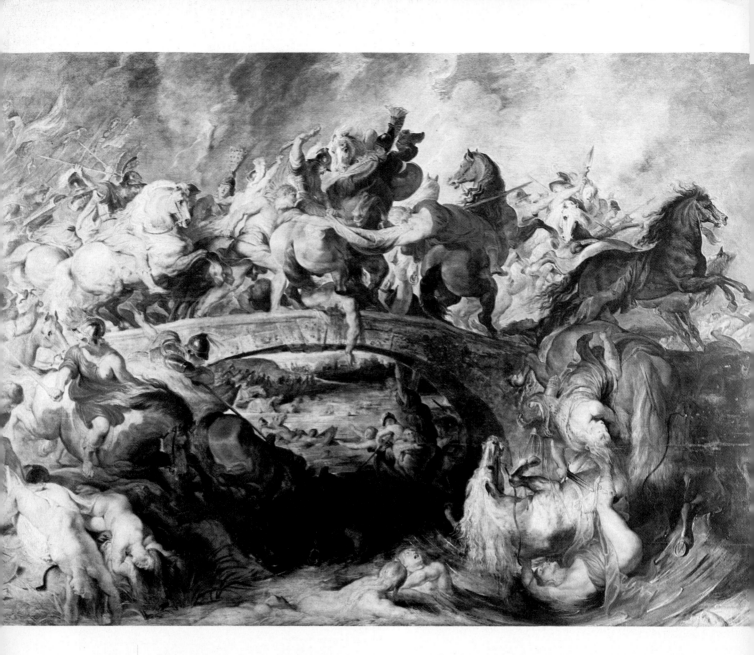

to work on particular parts of Rubens' canvases. The master reserved for himself the creation of the monumental compositions, which cross the pictures in diagonal thrusts, revealing his mastery of pictorial space. Landscape backgrounds, architectural *trompe l'oeil,* draperies fluttering against open skies all accompany his presentation of contemporary history – as in the twenty-two canvases illustrating the life of Marie de'Medici, originally painted for the Luxembourg palace, and now in the Louvre. This series of paintings was received with such enthusiasm that the painter came to be considered the most influential factor in bringing to an end the strife between Spain and England: diplomacy interrupted Rubens' painting career on more than one occasion. Already he had painted splendid portraits, amongst them himself with his wife, Isabella Brant (Alte Pinakothek, Munich), in

which the romantic element is seen in the gesture of the hands touching each other and the couple's natural isolation. It also occurs in the psychological insight on the pale faces, revealing the innermost soul, against the splendour of the dark red garments.

Mythology had already played a large part in the Marie de'Medici cycle – the three Graces, for example, in the episode of the queen's education – and this dominated much of Rubens' painting. Mythology inspired the kind of energy animating his forms, including his splendidly tender nudes, soft and trembling in the light. The *Rape of the Daughters of Leucippus* (Alte Pinakothek, Munich) shows the horses of the ravishers bursting out from the background in an X-shaped composition. They bear down on the naked women, valiantly attempting to escape, transformed in a cascade of sensual vitality and

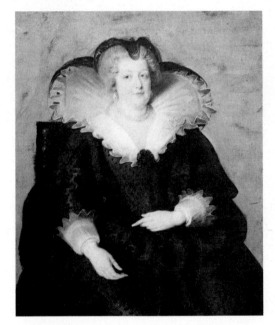

illuminated by the red and yellow of the
fluttering draperies. For Rubens, myths were
always opportunities for drama. This is seen in
the *Defeat of Sennacherib*, and the *Battle of the
Amazons* (both in the Alte Pinakothek, Munich)
which shows, in the impact of the opposing
forces on the bridge, women and riders dis-
solving in the elliptical light.

In 1630 Rubens married his second wife, the
young and beautiful Helena Fourment. He
retired with her to live in the country, and lost
himself in natural surroundings which are
superbly reflected in several paintings. In 1637
he painted the double portrait of his wife and son
(Alte Pinakothek, Munich), in which his palette
ranges from tenderest blues to gentle and exciting
greens. Landscapes are transformed into rural
subjects such as his *Landscape with Peasants
Returning from the Fields* (Palazzo Pitti, Florence),

*Rubens and Helena Fourment Walking in Their
Garden* (Alte Pinakothek, Munich) and the
Garden of Love (Prado, Madrid). Here the brilliant
colours anticipate much of 18th-century French
painting. The highest point of chromatic intensity
and intimacy, expressed in a generous and free
composition, is however, the portrait of his wife
known as the *Chapeau de Paille* (National Gallery,
London). This work, extraordinarily modern in
feeling, shows Rubens overcoming the restrictions
imposed by his situation within Baroque art, and
finding the true accents of universal greatness.

The art of Rubens appealed to the whole of
Europe: in Italy, especially at Genoa and
Mantua, with the religious and secular works he
left there; in London, with his imported easel-
paintings and the great paintings commissioned
by Charles I for the ceiling of the banqueting
hall in Whitehall; in Spain, with the series of

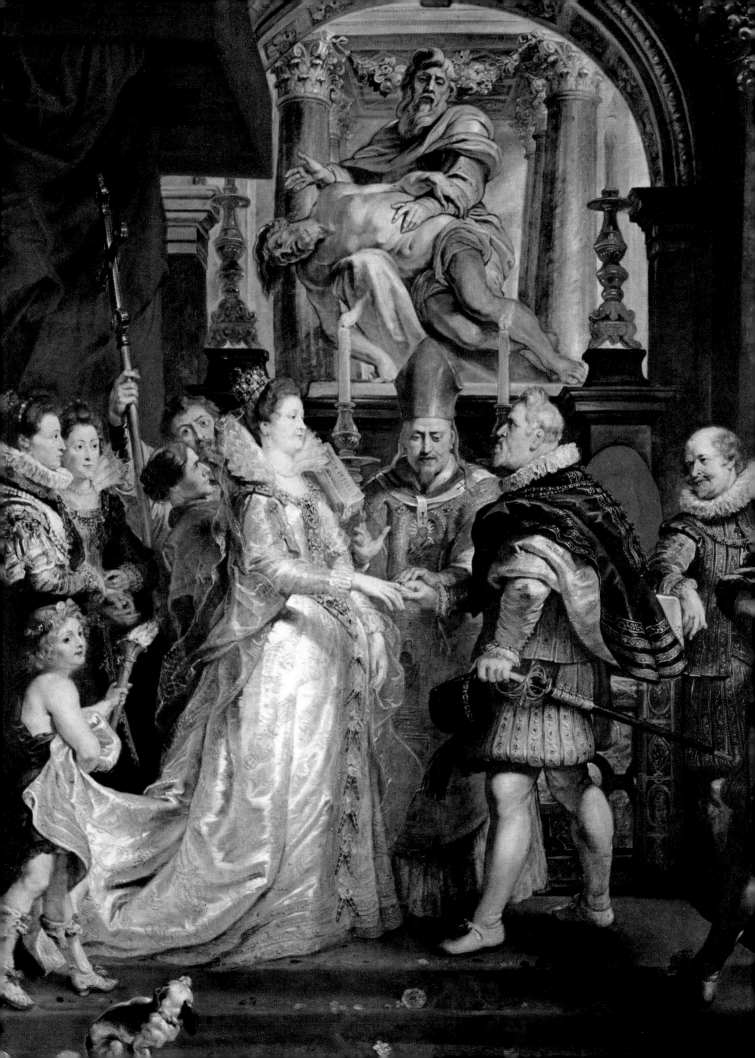

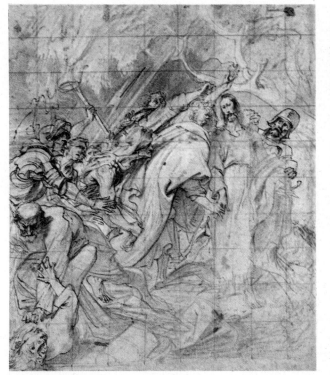 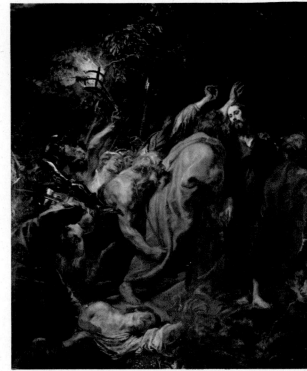

Above, left: *Anthony van Dyck, sketch for the 'Judas' Kiss' (Kunsthalle, Hamburg)*

Above, right: *Anthony van Dyck, the 'Judas' Kiss' (Prado, Madrid)*

Peter Paul Rubens, the 'Marriage of Marie de' Medici to Henri IV of France' (Louvre, Paris)

hunting subjects in the Torre de la Parada. Everywhere his solemn eloquence, lofty expression and dynamic compositions were pleasing and attractive. His warm hedonism pervaded a great part of both sacred and profane art. His tapestries were highly prized, and set the taste in the palaces of Europe.

Van Dyck

Two contrasting personalities derived from Rubens: Van Dyck and Jordaens. Anthony Van Dyck (1599–1641), an assistant in Rubens' studio, was born 20 years after the master but died soon after him. At the age of 20 he sojourned in London at the court of Charles I. In 1621 he was at Genoa, then in Rome, Florence, Venice and Turin. His favourite Italian painters were Titian and Correggio, and his *Rest on the Flight to Egypt* (Alte Pinakothek, Munich), shows the influence of Titian. However, the beauty of the naked child and the rosy tones of the faces recall Rubens. His *Pietà* (Alte Pinakothek, Munich), with the heavy body of Christ and the light on the faces of the holy women against the background of the sepulchre at night, expresses deep religious feeling. His preference for portrait painting derived from the finest Flemish traditions and found its outlet in England, especially after 1630, when Charles I appointed him court painter. Even in his Genoese period, however, he had shown his capabilities with life-sized full-

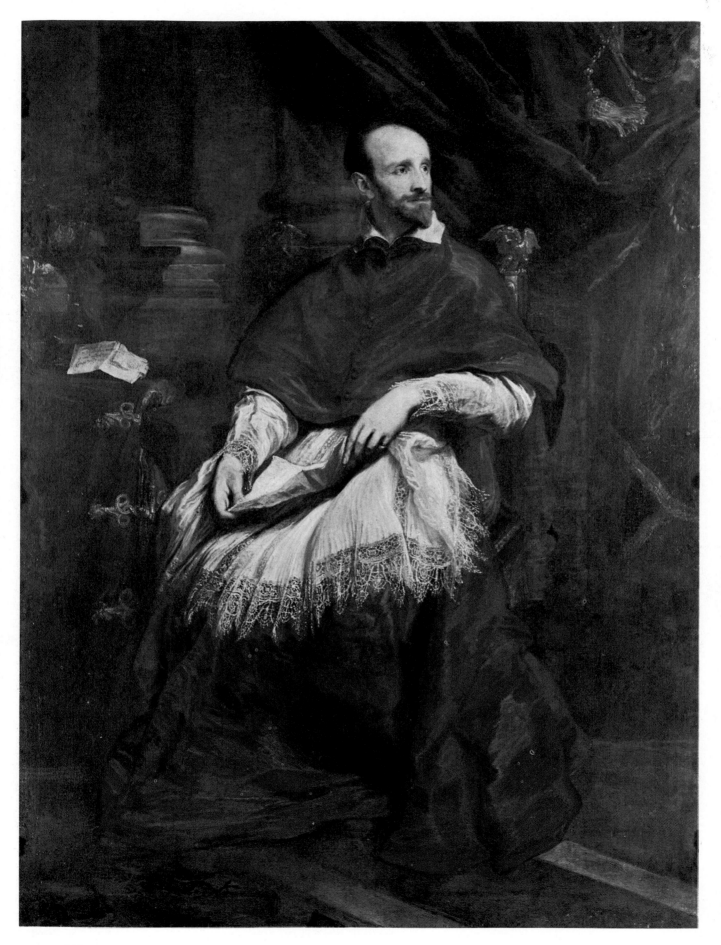

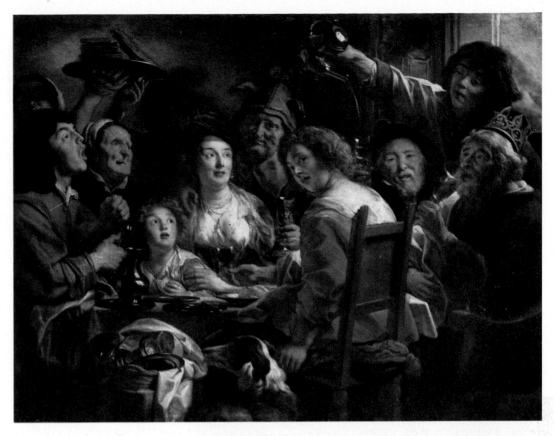

Jacob Jordaens, 'The King of the Banquet Drinks' (Louvre, Paris)

Opposite page: Anthony van Dyck, portrait of Cardinal Bentivoglio (Palazzo Pitti, Florence)

Below: Jacob Jordaens, 'Double Portrait' (Museum of Fine Arts, Boston)

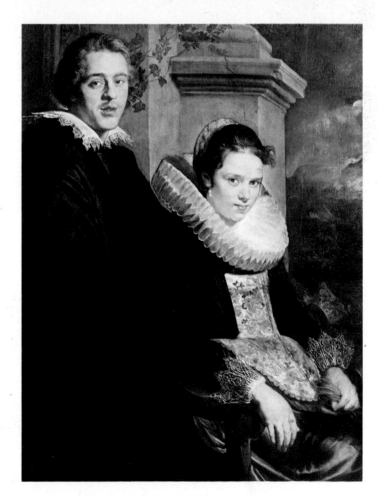

length portraits, immobile in the dignified self-control of their pose, but facially alive. His equestrian portrait of Giulio Brignole, that of his wife Paolina (Palazzo Rosso, Genoa) and the even finer portrait of the Marchesa Grimaldi are great conceptions. The latter moves in a splendid setting, her negro servant holding aloft a red parasol. The lady has paused in her slow walk, concerned for her velvet dress, which emphasises her charmingly thoughtful face and the position of her hands. These were the years of the delightful children's portraits, such as those in the National Gallery, London and the Sabauda, Turin. The silken splendour of the children's bright clothes, the dog's fur, the carpet, the flowers and even the landscape in the background accent the shy faces, as if intimidated by the ordeal of posing.

Van Dyck's greatest portraits were painted in London; these were not only for the royal family, but for a large number of nobles and officials, who wanted to see themselves transfigured by Van Dyck's rules of elegance, distinction and detachment. The royal character of Charles I is glorified in Van Dyck's portrait of him in the Louvre, Paris, which is moving in its happy combination of theory and spontaneous factors. Van Dyck has caught the king's personality in his manner of walking, in the placing of his arm on his hip and in the sudden turn of the head with

its broad-brimmed black hat. He uses the silky magic of the distant sunset, the trees standing out against the light, the warm coppice and the horse with its golden mane, to light up the silvery blue and reddish brown of the monarch's hunting dress with a brush loaded with light and translucency. This and other great portraits by Van Dyck eventually inspired the English 18th-century school of portrait painters.

Jordaens

Jacob Jordaens (1593–1678) closest of all Flemish painters to Caravaggio, is sometimes heavy in a way similar to that of the Italian Bassano family. He was attracted by popular and violent epic subjects, and in this respect he was

David Teniers, 'Fête champêtre' (Louvre, Paris)

Houses in the Grand'Place, Brussels

in sympathy with Dutch realism. His pictures are sometimes enlivened by the contact of reality with mythology, or by the intrusion of allegory, which leads to spontaneity in the presentation of the narrative. His palette is warm and even brighter than that of Rubens (because of his love of contrasts), and his subjects always stand out from their background, which is usually the darkness of night. But the prevailing foreshortening is detrimental to his figures, and concentration becomes accentuated on faces and the gestures of hands. A psychological enquiry into his work reveals the difference between Caravaggio's dramatic subjects and Jordaens' interest in outward appearances. The *Painter's Family* (Prado,

Madrid), one of his best-known works, is an artistic unity, expressed with extrovert splendour.

Another important artistic current in 17th-century Flanders was developed by painters who specialised in small works, showing ordinary, everyday events, intended as decorations for the home. Jan 'Velvet' Brueghel (1568–1625) established his world on a microscopic scale, where the landscape nevertheless recalls the touch of Rubens as in the *Earthly Paradise* (Louvre, Paris). David Teniers (1610–90), influenced by Dutch painting, tended to be somewhat heavy in his *genre* scenes, but with comic overtones, and at other times his tone is almost French and intellectual as in the *Fête Champêtre* (Louvre,

512

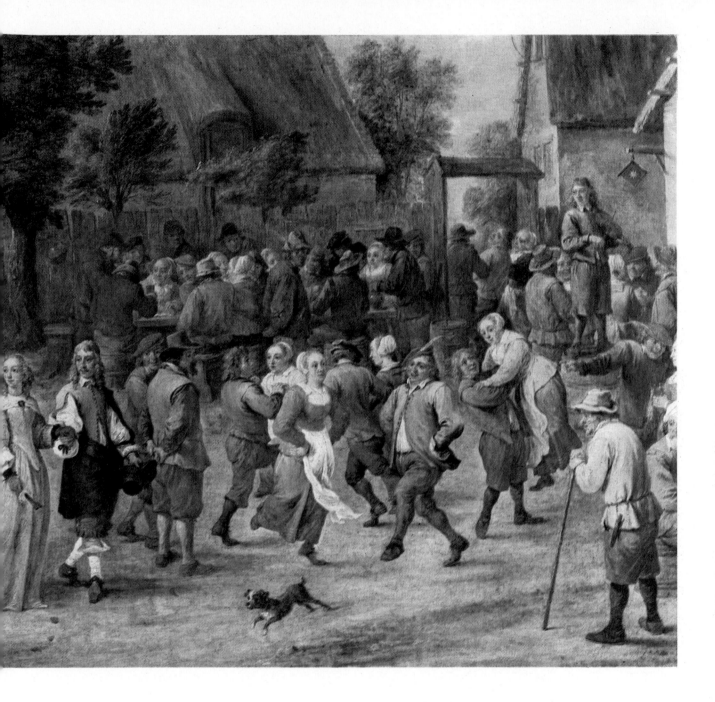

Paris). His work is particularly associated with a return to the spirit of Bosch, with the sarcasm of his description of witchcraft, for example, while for art historians of today his painting of the gallery of the Archduke Leopold at Brussels (Prado, Madrid) is a remarkable insight into the contents of a contemporary connoisseur's collection of masterpieces.

To Frans Snyders (1579–1657) fell the task of reviving the taste for still-life painting which – once the minute representation of reality had been abandoned – was Baroque in its forms and rich colour. Even so, it was still Rubens who was the instigator and inspirer of the fashion.

Flanders has little fine Baroque architecture of the 17th and 18th centuries. Antwerp, however, adopted curved ground plans and fantastic ornate designs such as those of the church of the Jesuits. The church of Our Lady of Hanswyck is more original in its rectangular plan, which takes on movement in the central section with its ambulatory, and in the articulation of the pediment of the façade. William de Bruyn was responsible for the houses in the Grande Place at Brussels, where French influence can be detected, especially in the design of the roofs. Flemish sculpture of the period was unoriginal and – apart from F. Duquesnoy, who left Flanders for Italy – expressed nostalgia for 16th-century Italy and the work of Rubens.

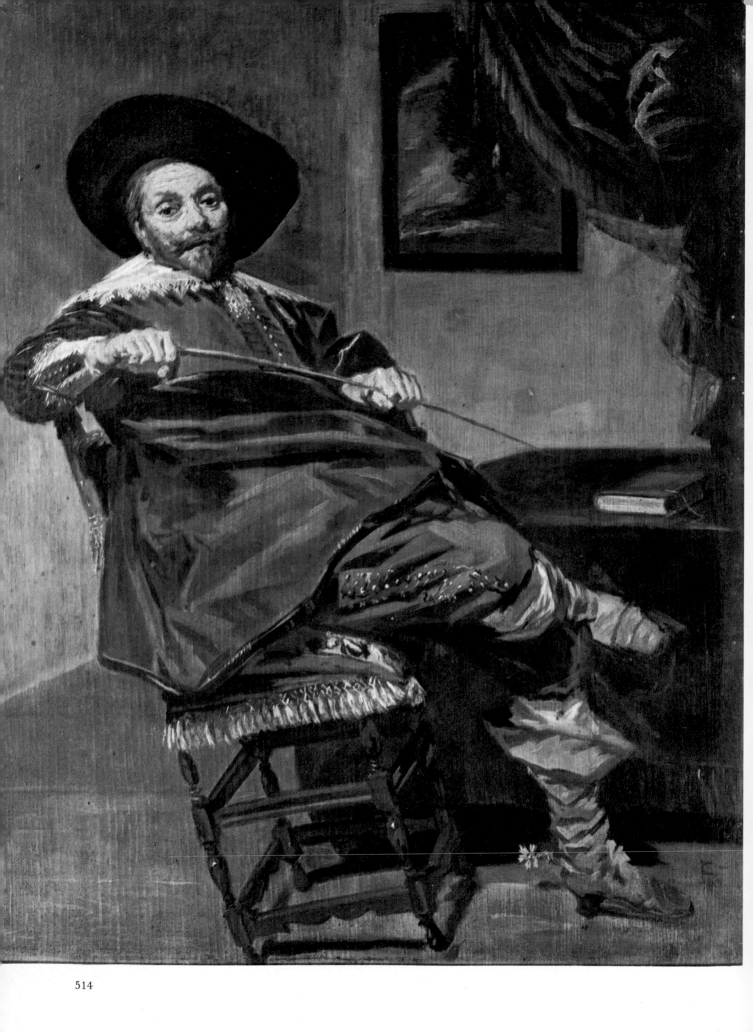

17TH-CENTURY DUTCH PAINTING

17th-century Dutch painting began with works in the manner of Caravaggio, especially in Utrecht, where they were introduced by Dutch painters who had worked in Rome during the first two decades of the century. There were several artists in this group, and some of them, such as Hendrick Terbrugghen (1588–1629), Gerrit van Honthorst (1590–1656) and Dirk van Baburen (c. 1590–1624) were outstanding. In Italy, Terbrugghen had already been very close to Manfredi and the romantic Gentileschi, and he brought with him to Holland the interior scenes so dear to Caravaggio in his early manner. Characteristic of Terbrugghen's style is the play of light from one side, while retaining individual intensity and colour, as in his *Flute-Player* (Gemäldegalerie, Kassel), which picks out the large black hat and the red cloak so strongly from the brightly lit background.

Frans Hals

Frans Hals (1580–1666) worked almost continuously at Haarlem and dominated the first period of 17th-century Dutch painting with his individual and group portraits. For psycho-logical understanding and for revolutionary technical originality, his painting – which is modern in comparison with the Flemish tradition – seems almost contemporary in the vigour of its line, its poses and its vibrant interpretation of reality. The figures in his pictures are living people, drawn with obvious accuracy, with brush strokes so powerful that they seem to be impromptu. Hals. is always concerned with essentials. In the group portraits, the colour – warm reds, lively yellows and vibrant blues – flows into the draperies, the cloaks and flags that spread over the canvas. In painting technique, his violent and thick brushwork anticipates the Impressionists; his black is black without any suggestion of grey, especially in the later period, when he loved to contrast it with white. The scene painter's vision is missing in Frans Hals. His figures are drawn from life; they are spontaneous, and vivacious because they are alive and at ease. His perspective, too, does not attempt special effects, because he prefers unified bright backgrounds. The pictures he painted before 1630 are mainly short half lengths, indicating his origin in Utrecht, and give early warning of his future mastery.

Frans Hals, the Women Governors of the St Elizabeth Almshouse (Frans Hals Museum, Haarlem)

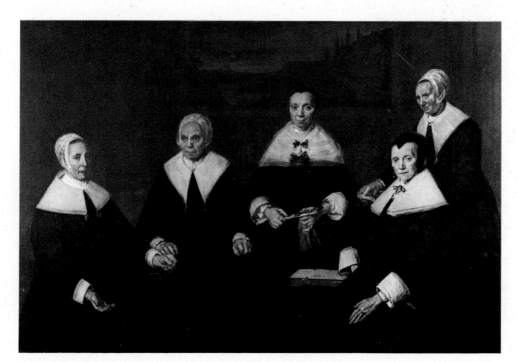

Frans Hals, portrait of W. van Heythusen (Museum of Ancient Art, Brussels)

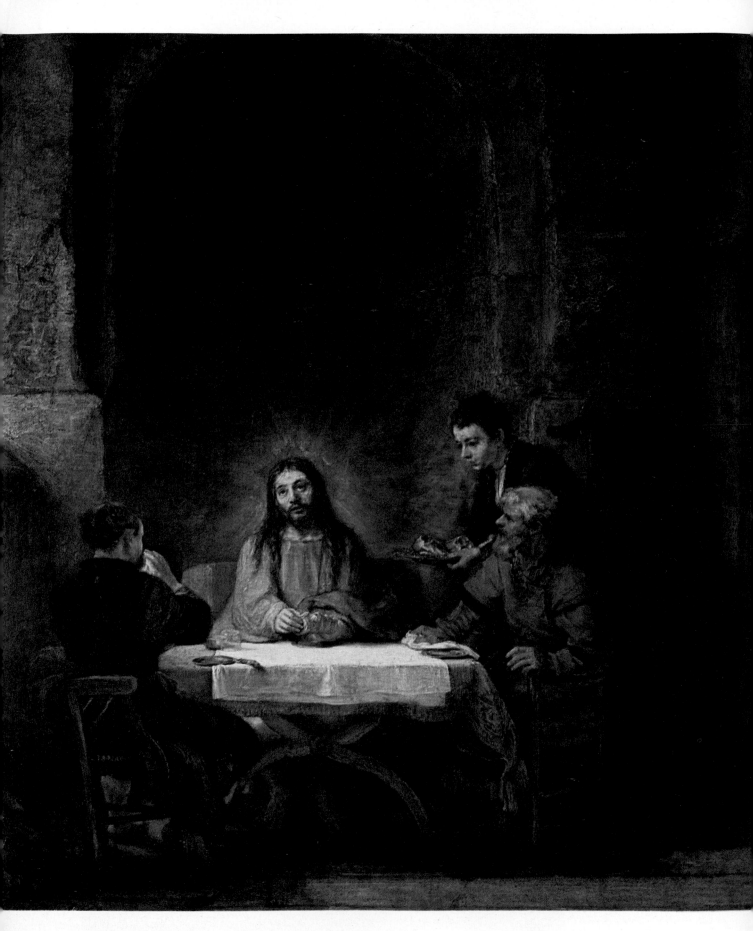

Rembrandt van Rijn, 'Christ at Emmaus' (Louvre, Paris)

Between 1623 and 1624 Hals painted the great group portrait of *The Officers of the Guild of St Adrian* (Haarlem Museum), with its stirring frontal presentation of some fourteen people in rich costumes and with attitudes alternately arrogant and conversational. In the background are the spears and banners, in the centre foreground a cascade of blue in the cuffs and sash of the man in the large feathered hat. For the *Banquet of the Officers of the Guild of St George* and for the *Banquet of the Officers of the Guild of St Adrian* (both in the Haarlem Museum), the backgrounds are more stirring – in the wide spread of the green material in the first picture, with the lively red and white diagonal banner seen against it; and, in the second painting, with the open window beyond which green countryside appears. In these works the composition is more varied, with calculated spaces between the closely related individuals, who are vividly picked out against the various surrounding greys. Hals' portraits of single subjects bring out the whole value of faces, which are full of life. Typical are the *Man Pouring out Beer* (Boymans Museum, Rotterdam), delicately detached from the green velvety background, and the *Merry Drinker* (Rijksmuseum, Amsterdam), with the subject's broad white collar seen against a green and gold background. The series of fine works comes to an end with the group portrait of the *Women Governors of the Haarlem Almshouse* (Hals Museum, Haarlem). The group of women is composed of figures that are isolated both by the insistent light on their wide, white collars and by the hardness of their hands, which seem to be incapable of any affectionate contact. A suggestion of caricature has touched their faces, a technique which Goya later used when painting the King and Queen of Spain. The bills are paid, the account books are closed, the ladies have taken up fine attitudes, and are images of their authority. In all this the ageing Frans Hals, himself an inmate of the home, saw harshness, loneliness and misery even greater than that of the people whom they were ostensibly helping.

Rembrandt

Rembrandt van Rijn (1606–69) was the most profound portraitist of Protestant humanism. Born in Leyden, he was a pupil in 1623 of Pieter Lastman in Amsterdam. His youthful work came to an end in 1640, and his mature work never deteriorated. 600 paintings and 1700 drawings and etchings are the total of his output, which has preserved for posterity the bright smile of his wife, Saskia, and the portraits of his mistress, Hendrijke, and his adored son, Titus. The portraits and self-portraits, the scenes from the Bible and from everyday life, the broad landscapes and the meditative studies are the products of an endless enquiry into every aspect of man and his existence.

Rembrandt's painting has no connection with Baroque rules and principles. It is an established fact that his forms are most mobile in his early work, that his figures become fewer in his last period. It is known that he was very widely informed, though in fact he gives positive indications of having absorbed only characteristics of Venetian 16th-century painting. Caravaggio's three-dimensional vision was important to him, and led him to his idea of contrasting light and shade. But Rembrandt is above all a personality on his own, with his essential qualities complete from the very

Rembrandt van Rijn, the 'Slaughtered Ox' (Louvre, Paris)

beginning. Opposed to the Baroque mood, Rembrandt's painting does not demand involvement, but uplifts and increases the observer's understanding until he is lost in the artist's universality. While other 17th-century Dutch artists painted man's outward appearance, with his thoughts laid open and self-evident, Rembrandt was concerned with the depths of man's soul, looking for his grandeur and his misery in dramatic encounters of light and shade. Sacred and profane stories from the past are illustrated and brought up to date; contemporary events are steeped in the infinite past. All the so-called *genres* of Dutch painting were known to him: his *Slaughtered Ox* (Louvre, Paris) is a challenge to transfigure stark reality, the most unpoetic of subjects. His landscapes, with their inimitable greens and blues, in the brilliance of the low-lying land and the stippled water, capture all the neat beauty of Holland; it is this reality which is the subject of Van Ruysdael's and Hobbema's work, and which finds its perfect expression in Rembrandt's graphic works.

His religious subjects – like the dramatic *Christ at Emmaus* (Louvre, Paris) – owe their charm to the simplicity of the surroundings, the spontaneity of the gestures, and the intimacy of the dialogue between the figures, which are rather small in relation to the space. His nudes – like *Bathsheba* (Louvre, Paris) – are intimate, restful delicately caressed by the light.

Rembrandt's technique follows no precedent, but is entirely linked to problems of light and shade – coloured shadow, and light that is warm with colour. The light brings out the painter's forms, and the shadows subdue them, almost annihilate them, in a mastery of technique that moved people to speak of 'alchemy' and 'magic'. The colour is applied sometimes thickly and heavily, and sometimes lightly, as if in veils, transparent and iridescent, which seem shot through with gold dust. Rembrandt's pictures need a great deal of wall-space, careful lighting and solitude.

His youthful pictures are new in conception, even compared with those of Frans Hals. His

Rembrandt van Rijn, the 'Anatomy Lesson of Dr Tulp' (Mauritshuis, The Hague)

Rembrandt van Rijn, 'Self-portrait as St Paul', 1661 (Rijksmuseum, Amsterdam)

Anatomy Lesson of Dr Tulp (Mauritshuis, The Hague), painted in 1632, is composed in the form of a triangle with a high apex. The gestures and expressions are alive in their concentration on the dissected corpse. This is another portrait of a group – the *Guild of Surgeons* – whose representatives are not shown in magnificently calm attitudes, but in action, intent and anxious. The decade between 1632 and 1642 is that of the fine portrait of Saskia (Gemäldegalerie, Dresden); the *Descent from the Cross* (Alte Pinakothek, Munich), and the dramatic *Storm on the Sea of Galilee* (Gardner Museum, Boston).

Rembrandt's best-known painting, *Captain Banning Cocq's Company* (better known as the

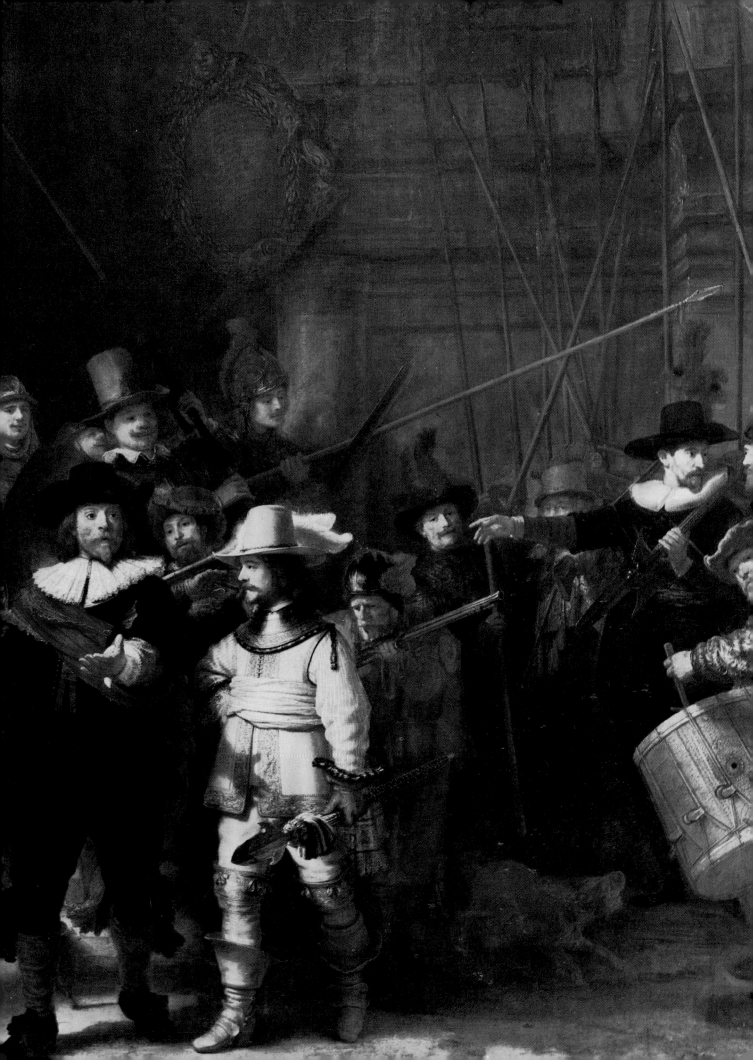

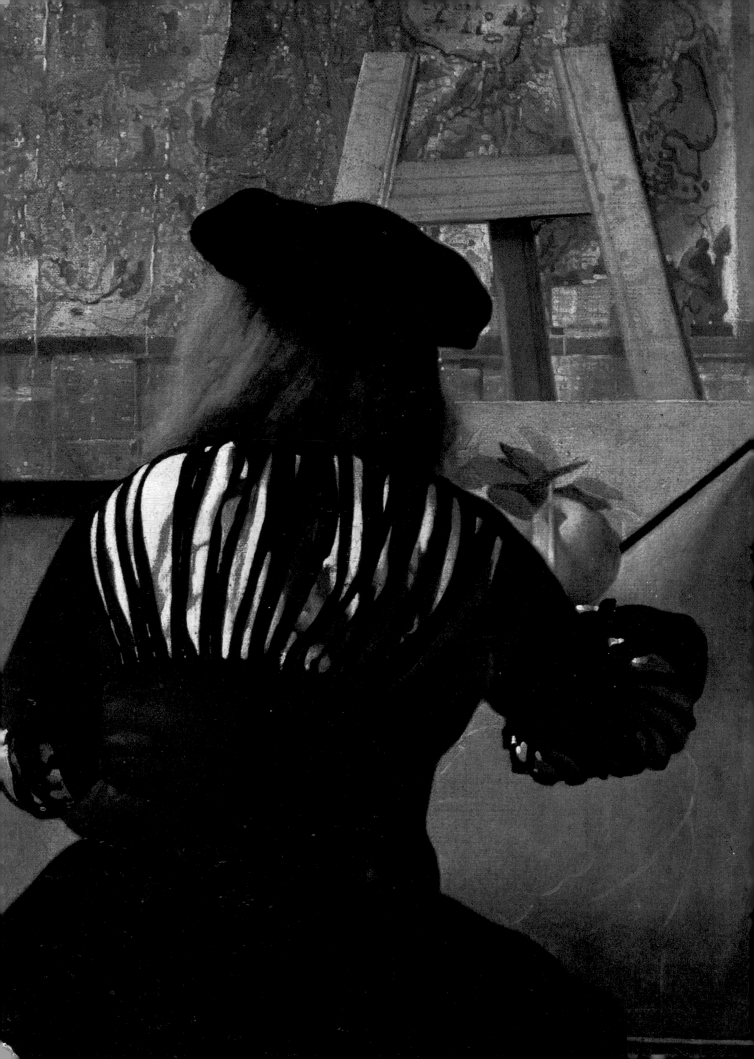

Night Watch) (Rijksmuseum, Amsterdam), dates from 1642. The work belongs to the category, revived by Frans Hals, of group portraits, but here the composition achieves an amplitude, strength and unity never before attempted – by virtue of the number of characters involved, their distribution on the canvas, the liveliness of the way they are portrayed, and the introduction of individual details. The captain, in black suit and hat, with a red sash, has just ordered his lieutenant, W. van Ruytenburgh, to give the men their marching orders. The yellows and blues of the figure of the young man at the captain's side light up the scene and accent the surface of the drum on the right and, on the left, the gown of the girl who runs in among the armed men. Banners and spears emerge from the background, and there is a silver gleam of helmets. Plumed hats, sashes and collars place the action in time and space gradually, from the dark background to the modulated light in the centre foreground. Interest in the individual portraits is played down in order to stress the dialogue between the central figures, and the moment of transition between waiting and action. Between 1642 and 1655 Rembrandt was at his highest powers of understanding, his greatest sensibility. If the *Night Watch* still links Rembrandt with his country's traditions, a new fullness of freedom, an even more complete mastery of form, a disregard for detail, a warmth of tone and more harmonious light are the means by which he eventually achieved intimate masterpieces, moving in their drama or their serenity. These include such works as *David and Saul* and the *Jewish Bride* (in the Mauritshuis at The Hague and the Rijksmuseum at Amsterdam) with their splendid reds touched with gold, and their luminous faces. For Rembrandt, man's true beauty is within.

Vermeer and genre painting

Johann Vermeer van Delft (1632–75), a generation younger than Rembrandt, was a great painter who was also isolated, but in a different way. A master of harmony and balance, Vermeer's painting has a poetic quality comparable with that of Raphael or Piero della Francesca. Vermeer had no masters and no pupils; his work stands alone, a detached moment of quiet tranquility in the history of European art. The realistic premise, the descriptions of everyday things, are unequalled – as in the *Woman at the Window* (Metropolitan Museum, New York), *Girl with a Red Hat* (National Gal-

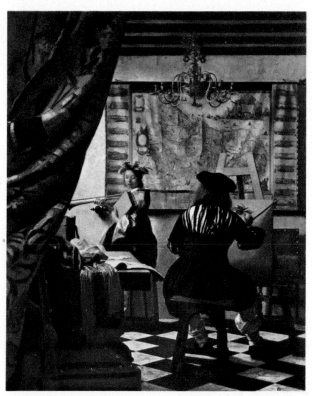

Jan Vermeer, the 'Studio' (Kunsthistorisches Museum, Vienna)

Opposite page: *detail*

Jan Vermeer, the 'Girl with a Turban'
(Mauritshuis, The Hague)

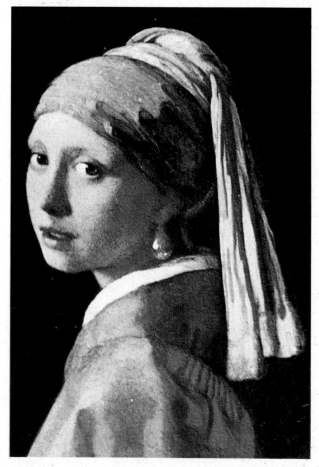

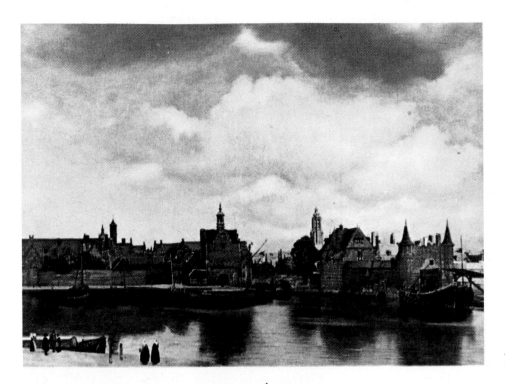

lery, Washington), the *Love Letter* (Rijksmuseum, Amsterdam), and the *Allegory of the Art of Painting (The Studio)* (Kunsthistorisches Museum, Vienna). Vermeer's assimilation of form and matter, of space and light are altogether modern in the *Girl with a Turban* and the *View of Delft* (Mauritshuis, The Hague). His composition, handling of perspective and treatment of light, which models his forms and emphasises their intimacy, all diminish the importance of much other Dutch painting. Only Pieter de Hooch (1629–84) shows Vermeer's influence, especially in the intimacy of his interior scenes.

In its brief career, which lasted less than a century and was essentially bound by three generations, Dutch painting included a great number of masters. Often these enjoyed greater fame and fortune than did Holland's three great national geniuses: Frans Hals died in an old people's home, Rembrandt was beset during his last years by failure and financial ruin, and Vermeer had endless economic hardships and disappointments to contend with. Carel Fabritius (1622–54), Gabriel Metsu (1629–67), Gerard Terborch (1617–81), Jan Steen (1626–79) and Gerrit Dou (1613–75) were diligent artists, sometimes gifted colourists, who loved to tackle *genre* painting, always centred on the picturesque or characteristic anecdote.

Another aspect of the art of the times is landscape painting, which delights in capturing the changing light and cloud effects on the flat countryside. With a compulsion to portray their native land and the splendour of the sea which surrounds it, the landscape painters – virtually uneducated – created enchanting vistas. Salomon and Jacob van Ruysdael (1628/9–82) and Meindert Hobbema (1638–1709) painted the flat horizons, while Peter Saenredam (1597–1665) – to mention only one name – studied the clear architectural forms of the lonely churches, plunging them in abstract light as though torn out of reality.

The Dutch landscape painters

In a certain sense Dutch 17th-century painting was all representational portrait painting – of man, of the landscape, of objects. So Rembrandt, with his deep religious feeling, remained isolated, and Vermeer stood out as an exceptional, dazzling figure of poetic expression. But even these two took everyday reality as their starting point: they transformed it, but did not betray it. Dutch art has been called bourgeois. It is true that in a country without a court or an aristocracy given to ostentation, clients tended to be prosperous burghers – individually or in their professional and corporative associations. The love of concrete reality, of tangible things, of the familiar scene, is ingrained in the character of the Dutch people, who, confident of their

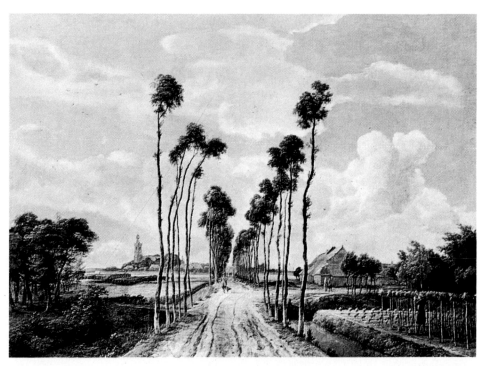

Meindert Hobbema, 'The Avenue'
(National Gallery, London)

Jacob van Ruisdael, 'Landscape' (National Gallery, London)

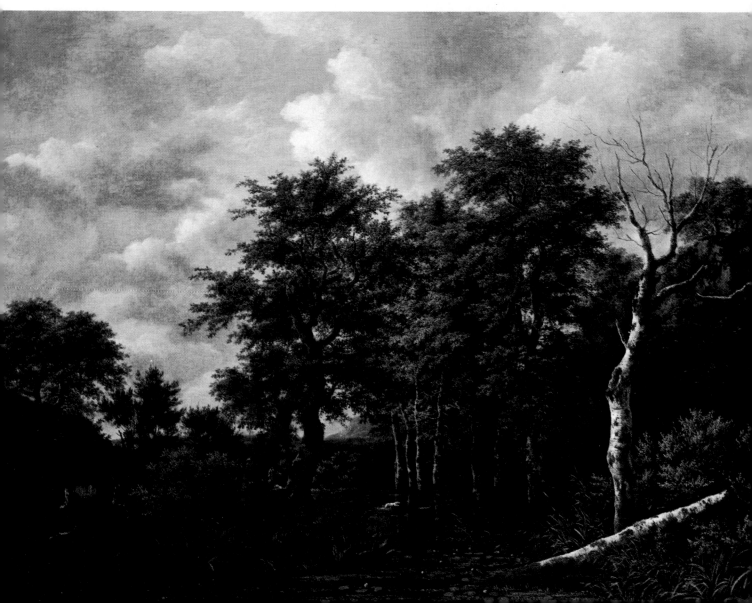

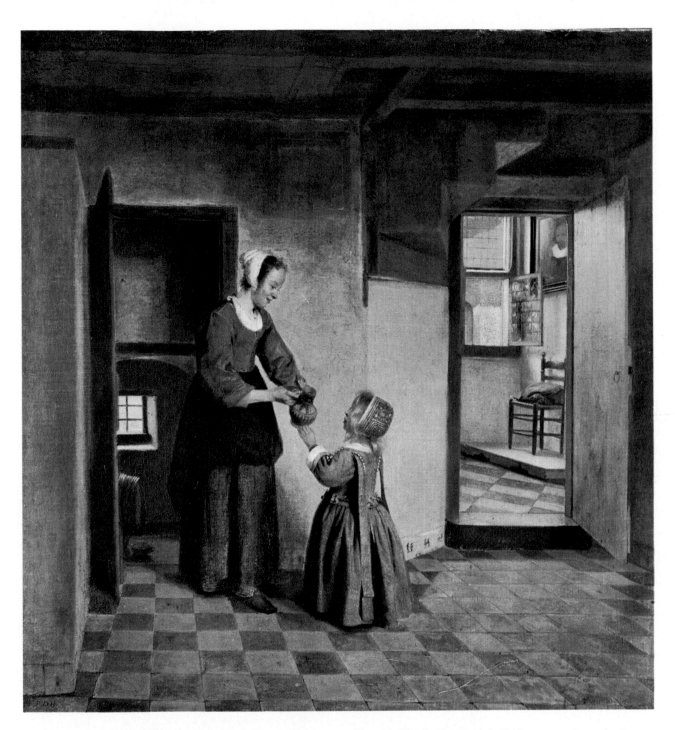

Pieter de Hooch, the 'Larder' (Rijksmuseum, Amsterdam)

well-tested faith, have renounced the wish to represent transcendental subjects. Consequently pictures were generally small, and hung rather low down so that they could be easily scrutinised with the help of a magnifying-glass.

Dutch 17th-century painting taught a deep observation of reality, which is the eternal measure of comparison in pictorial art. Landscape, too, had a down-to-earth concrete quality, and had to be discovered and investigated. *Genre* painting was very popular – especially still-life, which is astonishing in its ability to reproduce nature exactly. But the subtle play of reflections, of transparent tones, of material illusion – of which W. Heda and P. Claesz were masters – is only the same love of precise, tangible reality, and so, in a very different field, are the paintings of animals by Potter, or Steen's convivial scenes of everyday life. In this respect, Dutch painting was linked with its earliest Flemish origins. It derived from Van Eyck, and even the important influence of Caravaggio and his school did not change its basic standpoint.

526

Willem Heda, 'Still-life'
(Louvre, Paris)

Below: *Pieter Jansz*
Saenredam, 'Interior of the
St-Odolphuskerk at
Assendelft' (Rijksmuseum,
Amsterdam)

Only towards the end of the 17th century did Dutch painting turn its attention elsewhere – and then superficially – to the styles of the French Régence and Louis XIV, and to the refined and elegant innovations of English portrait and landscape painting.

Holland, already firmly established in its Protestantism, had no problems where religious architecture was concerned. Her civic buildings were severe and heavy, as in the royal palace at Amsterdam, in the town hall at Delft, with its substantially classical rhythm or – in a more provincial idiom, particularly in its use of brick – in the Old Meat Market, at Haarlem.

SPANISH ART:
THE GOLDEN CENTURY

The 17th century was Spain's golden age in art and literature, even though, politically, the country had sadly declined from the position of power it had achieved under Charles V, with his dream of universal Catholic dominion and his colonial expansion beyond the Atlantic. Economically, too, Spain lost its influence after the reign of Philip II – Charles V's successor – through maladministration of the wealth it acquired from America and through its persecution of the Jews and the *Moriscos*. The Spain of Gongora, Cervantes, and Lope de Vega was cultivated, full of imagination and drama. Ribera, Zurbarán, Velásquez and Murillo were the children of this Spain, interpreting its deepest feelings and ultimately preparing the way for Francisco Goya. Before them, Spanish painting

Opposite page: *Jusepe de Ribera, the 'Old Money-Lender' (Prado, Madrid)*

Spanish jug in silver-gilt, with engravings and enamels (Victoria and Albert Museum, London)

was Mannerist in mood and of a high quality – particularly through the presence of El Greco – up to the year 1614. Italian artists in Spain were the authoritative mouthpieces of the academies of Bologna and Rome, and the influence of Caravaggio – perhaps through direct imports of the master's paintings, certainly also by contact with Stanzioni and Battistello – was felt in subtle ways. No city could boast finer collections of Italian and Flemish paintings than 17th-century Madrid. The court was dull, but it surrounded itself with artists, and when Velásquez was only twenty-four he was appointed its official painter. Rubens lived for a while in Madrid, and Van Dyck also went there.

Ribera and Zurbarán

Jusepe de Ribera (1590–1652), known as Spagnoletto, combined the best aspects of Emilian painting and the school of Caravaggio with Spanish three-dimensional realism. His dramatic qualities, as in the *Martyrdom of St Bartholomew* (Prado, Madrid); his expressionism, as in *Drunken Silenus* (Capodimonte Museum, Naples), have a mellow softness reminiscent of Guido Reni (*St Mary Magdalene,* Prado, Madrid). In this sense Ribera responded to the widespread need for mysticism, which, in a different way, led to the spiritual consistency of Francisco Zurbarán (1598–1664). Zurbarán dispensed with natural backgrounds, since for him his figures and objects emerged from the blackness and obscurity – as his master, Pacheco, had intended and as Caravaggio had suggested. But Zurbarán stands apart from Caravaggio as a painter of reality, in his explicit refusal to represent detail, in his skill in capturing essential qualities which, in his paintings, are always sculptural and three-dimensional, always real, but simplified, as if the power of the spirit held them intimately and closely in its grasp. The monumental *Death of St Bonaventura* (Louvre, Paris) focuses the dominant light on the white of the cope, the clear triangle of the mitre and the solid splash of pure red of the Cardinal's hat. With Zurbarán, pictorial reality, anchored to

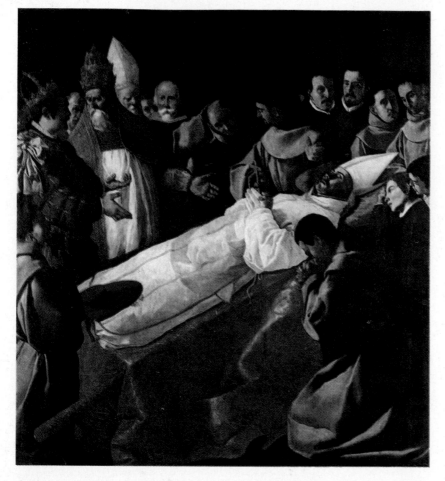

all the realism of Flemish and Spanish painting, tends to metaphysical composition with the help of light, which clarifies and exalts. Some of Zurbarán's isolated pictures, with well-spaced forms and prominently strong colours, transfigure and compress matter and form. His *Monks* (Cadiz Museum) are brilliantly white, like great statues of snow in the moonlight; his splendid women are dressed like queens, in stiff pleated damasks – yellow, blue, and sea-green – to add seductiveness to the image of *St Inez, St Ursula and St Dorothy* (also at Cadiz).

Velásquez

Diego Velásquez (1599–1660) was not influenced by Zurbarán, though he too, like Zurbarán and Alonso Cano, was trained by Pacheco. Velásquez married Pacheco's daughter, who appears with his own self-portrait and his

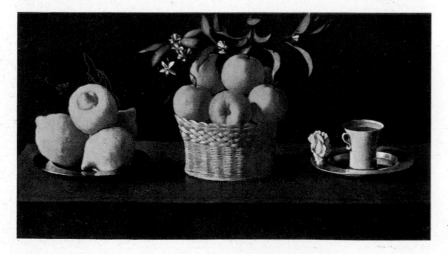

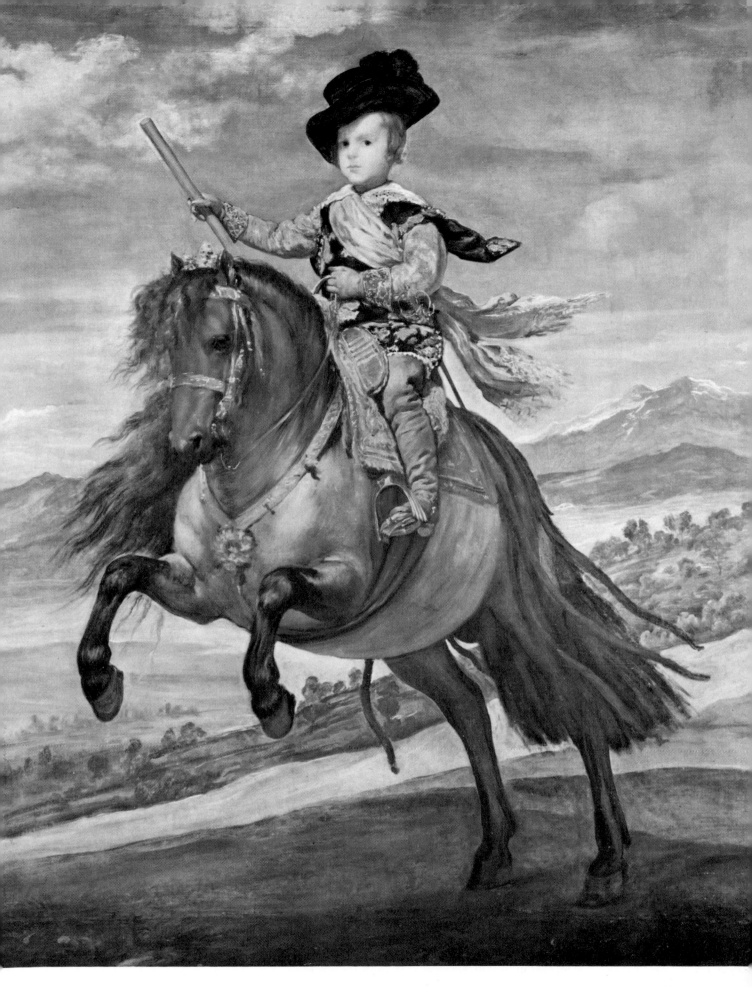

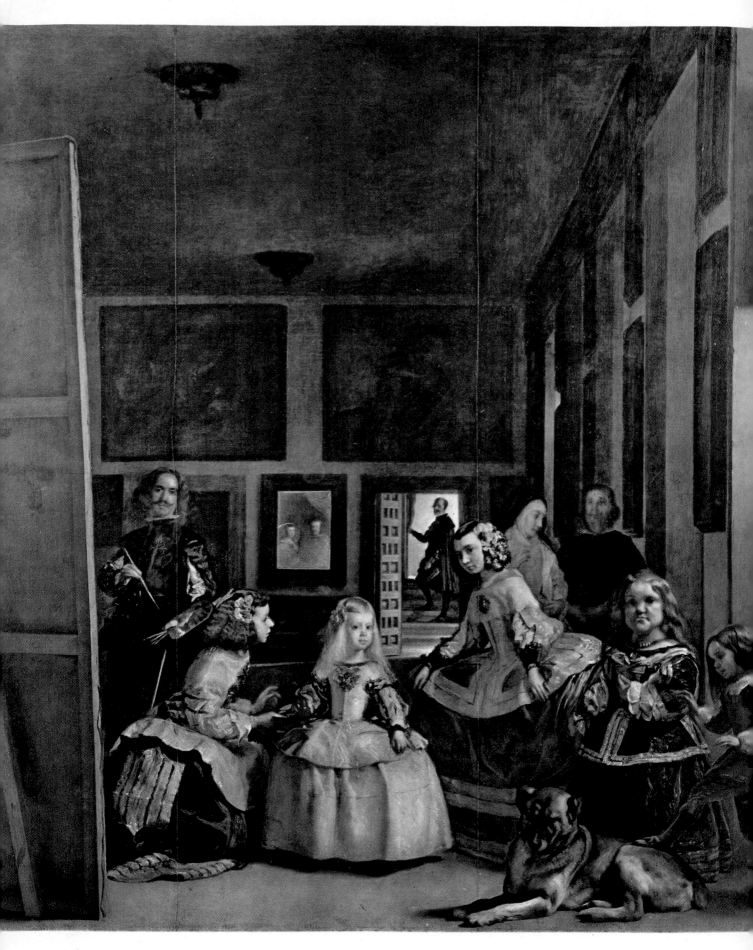

master in an *Adoration of the Magi* (Prado, Madrid) which is already all Velásquez. Pacheco had shown him how to make his painting true, sharp and spontaneous with strong brush strokes and heavy colours. In 1619 Velásquez painted *Christ in the House of Martha and Mary* (National Gallery, London), in which the narrative is allotted a small space, beyond the door, leaving room in the foreground for the four silver fish, two eggs and a head of garlic. In 1620 he painted the *Water-Carrier* (Apsley House, London), which is dominated by the smoothness of the porous earthenware pitchers, glistening with the water oozing through them. The idea of thirst in the dialogue between the old man and the boys draws attention to the mellow gold of the water-carrier's cloak and the icy water which beads the glass. In 1624, under the patronage of Duke Olivares, Velásquez entered the court of Philip IV, where he painted eighty-three portraits of the royal family and sixty of courtiers and jesters. His equestrian portraits of Olivares, Philip IV, and the Infante Balthasar Carlos (all at the Prado, Madrid), have something of the vigour of Rubens in their diagonal sweeps across the canvas. The *Surrender of Breda* (Prado, Madrid) is closely packed and yet spacious, with spears and ensigns to suggest space, while the clothes are vivid with almost impressionist brush strokes.

Velásquez twice visited Italy, finding inspiration especially in Rome and Venice. During his second trip (1649–51) he produced the delightful little landscape of the *Villa Medici* at Rome (Prado, Madrid), painted from recollection in Venice and suggesting a foretaste of Corot's Roman painting. The *Rokeby Venus* (National Gallery, London) was also probably painted in Italy, although the long muscular back of the splendid nude is very different from any Venetian Venus. There followed some of his greatest and most notable paintings. They include *Las Meninas* ('The Maids of Honour'; Prado, Madrid), effectively conceived in space, with elaborate treatment of the adult figures – the artist in the act of painting, yet looking at the observer, and the King and Queen reflected in a looking-glass – to pinpoint the splendid diffidence of the blonde little Infanta Margarita.

Murillo

Bartolomé Esteban Murillo (1617–82) was born in Seville. He was especially esteemed by 19th-century critics for his paintings of religious

Diego Velásquez, Las Meninas (Prado, Madrid)
Diego Velásquez, self-portrait, detail from Las Meninas

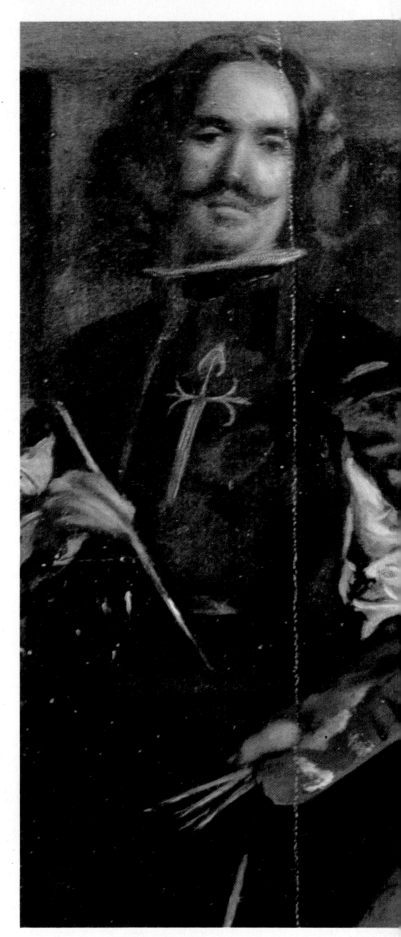

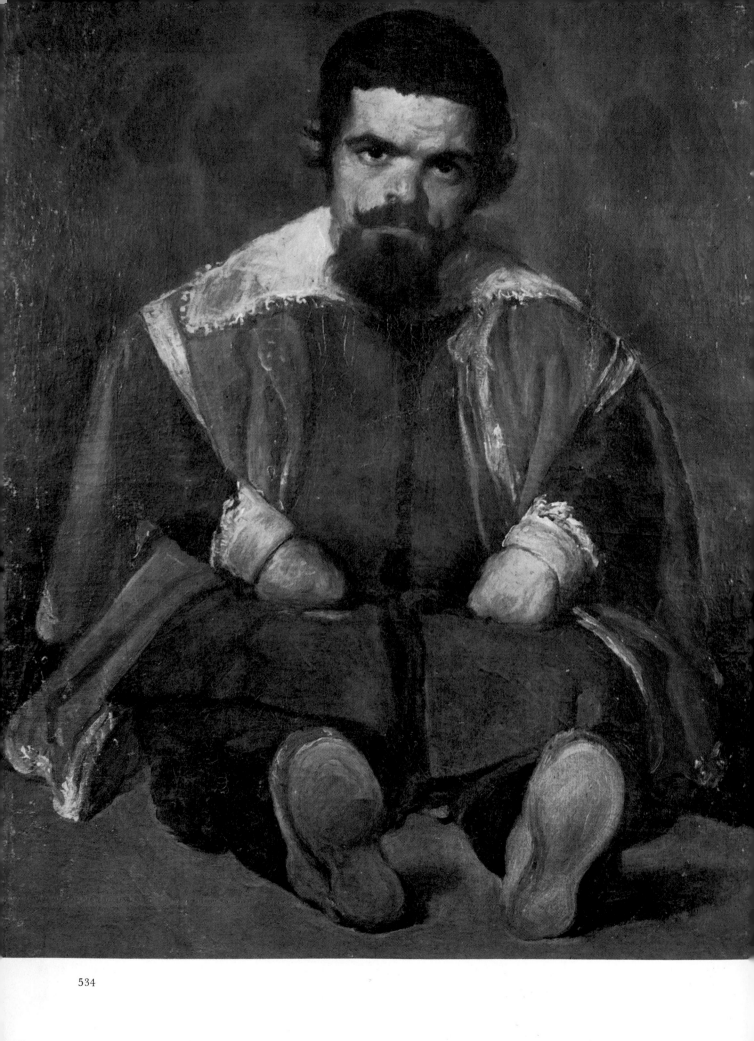

534

subjects, such as the *Virgin Appearing to St Ildefonsus* (Prado, Madrid), and above all for his representations of the Immaculate Conception, which earned him the title of the 'Spanish Raphael'. He was, however, more successful – in his vigorous realism – in subjects from real life, such as the *Little Beggar* (Louvre, Paris) or *Boys Eating Fruit* (Alte Pinakothek, Munich); these pictures show his bright but soft colour, carefully varied, and not uninfluenced by Rubens' palette. The conversational tone of his works and a certain concentration of outward appearances separate him from the great masters, Zurbarán and Velásquez, and signal the approaching decline of Spanish painting from that point until Goya burst upon the scene.

Architecture

The development of Baroque in the architecture of the German countries during the 17th and 18th centuries can be studied by comparing ground-plans, elevations and three-dimensional treatment of volume; but where Spanish architecture of the same period is concerned, other factors must be examined. The tradition of Jesuit architecture in Spain, firmly based on rectangular designs, can be traced from Rome, but the innovations introduced by Bernini and Borromini in their treatment of internal space were almost unknown in Spain, and only façades and apses show some slight curvature which is Baroque in inspiration.

17th-century Spain expressed itself in decoration, display and magnificence, and paid great attention to doorways, pediments of façades, and altars – features which most lend themselves to such elaboration. Love of precious materials played its part, hence the spectacular perspective effects seen alongside rare stones, fine wood, and mirrors and glass, with a certain trace of Moorish influence. The 16th-century Escorial, by Juan de Herrera, continued to be the main example to follow. From the school of Herrera came Francisco de Herrera the Younger, who built the Pilar church at Saragossa, with its tall bell-towers and cupola in the Italian style. During the reign of Philip IV (1621–65) two architects, Francisco Bautista, designer of S. Isidro el Real at Madrid and St Juan Bautista at Toledo, and Juan Gómez de Mora, who built the Jesuit Clerecía at Salamanca, were entirely Mannerist. S. Isidro at Madrid has a façade with columns and pilasters between two angular bell-towers; the other churches are even more extreme.

The 18th century was a happier moment for

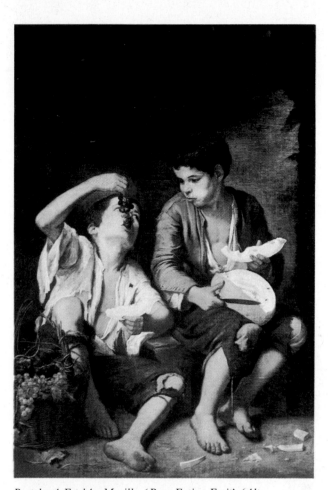

Bartolomé Esteban Murillo, 'Boys Eating Fruit' (Alte Pinakothek, Munich)

Opposite page: *Diego Velásquez, the 'Jester of Don Sebastiano de Morra' (Prado, Madrid)*

Spain in the realm of architecture, even though one of the greatest buildings, the royal palace at Madrid, lacks originality because of its emulation of Versailles. The small buildings are more original – for example, Juan de Villanueva's *casitas* (or villas) for the royal family, and the Prado, which anticipates Neo-classicism; the same architect's Escorial, Ventura Rodríguez' Liria palace at Madrid, and – more intimate and original – A. G. Velásquez' 'Labourer's House' at Aranjuez. Rodríguez achieved a certain sense of Baroque in the dome of the chapel of the royal palace, which is vaguely inspired by Borromini.

The whole of 18th-century Spanish architecture developed within the framework of Churriguerism, the achievement of the Churriguera family of architects (José Benito, Joaquín, Alberto, Gerolamo and Nicola). Working together in a series of buildings, they gave rise to a style and taste which aimed at submerging or softening architectural form and structure, in order to emphasise decorative and spectacular features. The precedents for this are to be found

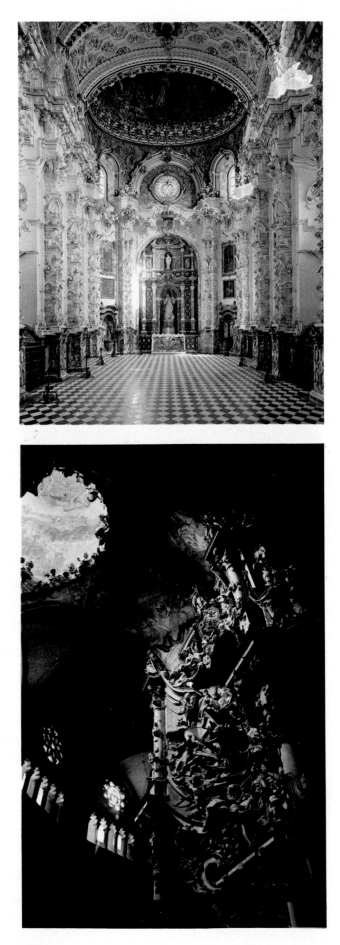

in late Gothic, in Moorish art, and in the closer Spanish Plateresque style. José, the founder of the family, worked at Salamanca and Madrid. At Salamanca he set to work with Alberto on building the palaces of the Plaza Mayor, creating calm, unbroken surfaces enlivened by unexpected decorations on doors and pediments. When Garcia de Quiñones joined in the work with his design for the municipal palace, the façade became even more elaborate and, in the spaces between the fluted columns, attention was directed to decoration around the windows, on the architrave and on the pediment. As for altar design, José Churriguera is famous for those of S. Esteban at Salamanca. In Madrid the chapel of S. Tomás and the Goyeneche palace (now Accademia de S. Fernando) are by him. He was deeply interested in urbanism, and was responsible for planning a whole city, Nuevo Batzán, where he in fact completed the church and one palace.

One of the most original features of Spanish architecture at this time was the concentration of interest around the doors, in contrast with their plain, and even undecorated, surface of the doors themselves. The façade of the university of Valladolid was the first of such designs, with its columns rising rhythmically as far as the balustrade, between which there is a wealth of elaborate decoration. Pedro de Ribera always showed great respect for broad surfaces; he worked on the hospice of S. Fernando at Madrid, where the spectacular doorway is surrounded with rich, flowing decoration. Heavier and more elaborate is the niche decoration which de Ribera used in the church of S. Cayetano at Madrid. The most famous Baroque doorway is that of the palace of the Marquis of Dos Aguas at Valencia. In the solid, unbroken cube of the palace, enlivened by its angular towers, the doorway is paradoxically overloaded with decoration. A hint of the style of Michelangelo or Mannerism in the figures is cancelled out by the ornamentation, which unrolls in rivulets, twisting and swirling in scrolls. Somewhat similar is the palace of S. Telmo at Seville, which may be the work of Leonardo de Figueroa. The façade of the cathedral of Valencia, by Conrad Rudolf, is exceptional in its vaguely Baroque flavour.

One of the bolder designs, on the border-line between architecture and sculpture, is the famous Transparente of Toledo cathedral, built in 1734 by Narciso Tomé, in an attempt to display the Blessed Sacrament so that it could be seen from both the nave and the choir.

17th-century Portuguese architecture did not differ much from that of Spain. Even here,

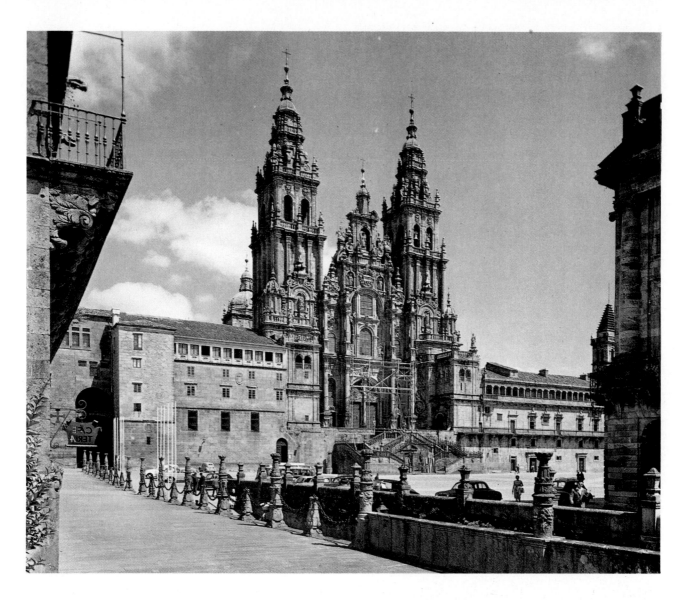

The cathedral of Santiago de Compostela

decoration had the upper hand and was characterised by the use of coloured ceramics to enliven the unbroken surfaces. As an example of spectacular design, the Bom Jesus shrine, near Braga, must be mentioned; its façade is crowned with two bell-towers which recall Borromini, and it foreshadows the famous cascade of stairs. Rich and brilliant, with perspective effects and sumptuous decoration, it is the work of Cruz Amarante. The most active family of Portuguese architects was the Tinoco family: Pedro Nunes Tinoco was responsible for the sacristy of Santa Cruz at Coimbra, and João Tinoco built the seminary of Santarém. Two huge altars, that of the church of the Gesù at Aveiro and that of the Incarnation at Lisbon, belong to the Churriguero style, which reached Portugal from Spain.

Opposite page, above: *Granada, the sacristy of the Charterhouse*

Opposite page, below: *Narciso Tomé, the 'Transparente', Toledo cathedral*

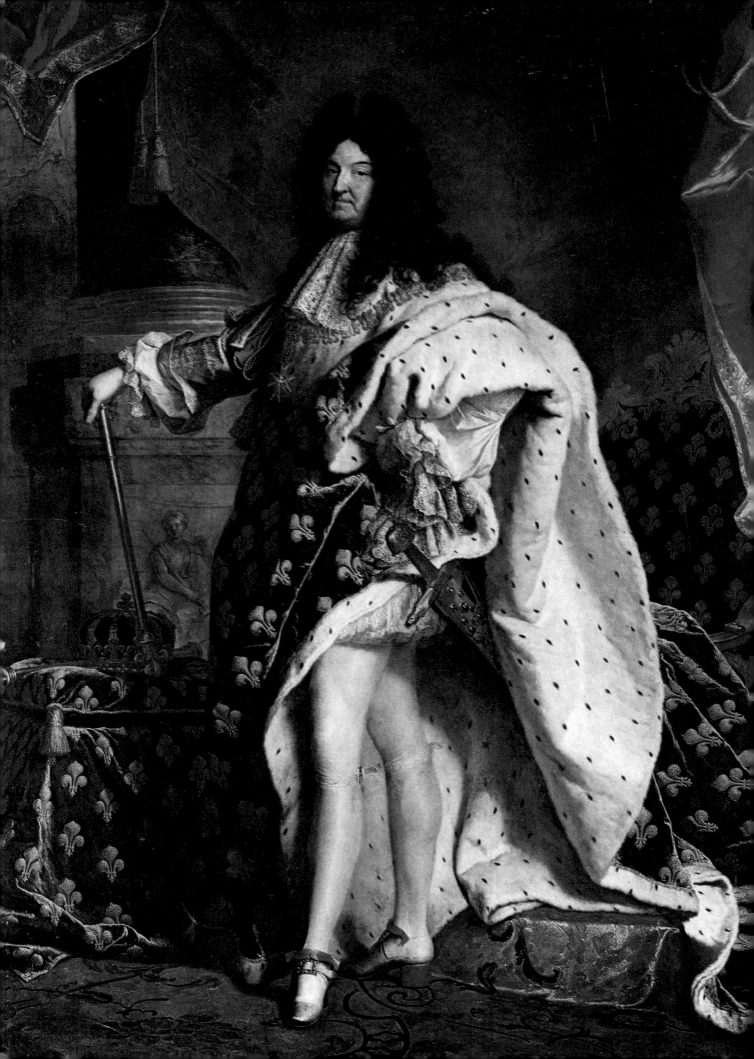

FRENCH ART IN THE 17TH AND 18TH CENTURIES

The 17th century, the *Grand Siècle*, or great century, of French history and culture brought artistic independence for France, directly reflecting its historical situation and the power of its ruling class. French architecture, which had affinities with Italian Renaissance architecture, played down the forces and vigour of Baroque, and avoided Spain's ostentatious decoration and England's cold moderation. Instead, the development of French architecture was towards dignified forms and volumes, proportion and order, and sensitive planning of buildings and their environment.

Paris and Versailles formed the hub of French 17th- and 18th-century architecture. The Academy of Painting and Sculpture was founded in Paris in 1648, and in 1662 the Gobelins factory started active production. In 1671 the Academy of Architecture was founded, and the French Academy in Rome, revered as the training ground for artists, had been founded in 1666.

In Paris great steps were being taken in the realm of town planning. The city already had the Pont Neuf, dating from the time of Henri IV, and the adjacent triangular Place Dauphine (1607) with tradesmen's shops, for the first time,

occupying the ground floors of noble houses. Between 1605 and 1612, Turgot was laying out the square Place Royale (today the Place des Vosges). With Louis XIV, town planning in Paris became magnificent. Jules Hardouin Mansart (1646–1708) built the Place Vendôme, which today retains its original harmony and the golden tone of its stones. Mansart was also responsible for the Place des Victoires (the present statue of Louis XIV is not the original), which was the first of the circular *places* of Paris. Louis XV was fond of large open spaces and vistas in perspective, and at his instigation Jacques-Ange Gabriel opened out the Place de la Concorde, which joins the Tuileries to the Champs Elysées.

When Louis XIV abandoned the Louvre as a residence and seat of government, the palace was by no means neglected. It was in fact renovated, and Lescot's quadrangular courtyard completed, while Claude Perrault's great colonnade was added on the façade opposite St Germain l'Auxerrois. The façade might have been different had Bernini's design been accepted when he was in Paris in 1665, but rivalry between several artists led to its rejection. The

Hyacinthe Rigaud, 'Portrait of King Louis XIV' (Louvre, Paris)

The Trianon de Marbre, or Grand Trianon, at Versailles

539

dome of the Hôtel des Invalides, designed by Mansart and completed in 1735, gives an equally good picture of classicism. Designed in horizontal planes, and enlivened by a pillared porch, it has a low drum in the style of Michelangelo, with protruding buttresses. The dome itself has a vertical emphasis, and terminates in a spire above the lantern. Seen from the Seine, it gives elevation to the long, stately façade built from Bruant's plans between 1671 and 1676. The whole construction is huge, and severe.

The church of the Sorbonne, designed by Lemercier, is in the form of a Greek cross, and François Mansart's churches of Ste Marie de la Visitation (now the Temple St Marie) and Val-de-Grâce are built on restrainedly curved plans. Also in Paris, the church of St Gervais has a restful and noble façade.

Versailles, however, was the newest, greatest and most interesting planning achievement, and

Victor Hugo's house, Place des Vosges, Paris

Claude Perrault, colonnade of the Louvre, Paris

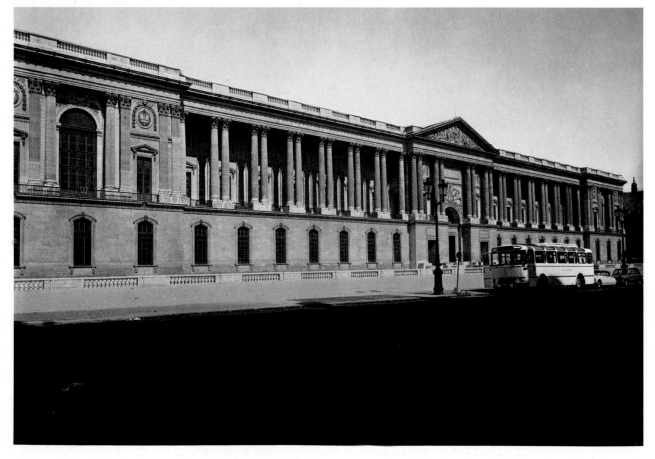

became a pattern for the whole of Europe during the 17th, 18th, and even part of the 19th century. In its entirety it is a vast, U-shaped building with wings, with its base turned towards the park. It fell to Louis le Vau (1612–70) to build the central part of the palace (incorporating the original Louis XIII building), and later it was enlarged by the addition of wings, which accentuate its horizontal development. The huge work, which was executed by an army of specialists and workmen, was directed by Jules Hardouin Mansart, who was responsible for the realisation of the dignified Cour Royale and the elegant buildings of the Grand Trianon and the Orangery. Between 1661 and 1665 the park, the laying out of which was entrusted to Le Nôtre, acquired its spectacular appearance with its vistas, its formal areas, its fountains, Italian gardens and its immense avenues, so that it constituted a kind of new art of natural archi-

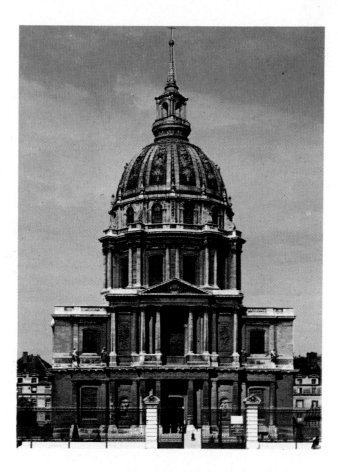

Jules-Hardouin Mansart, façade of St-Louis-des-Invalides, Paris

Louis Le Vau, Château of Vaux-le-Vicomte

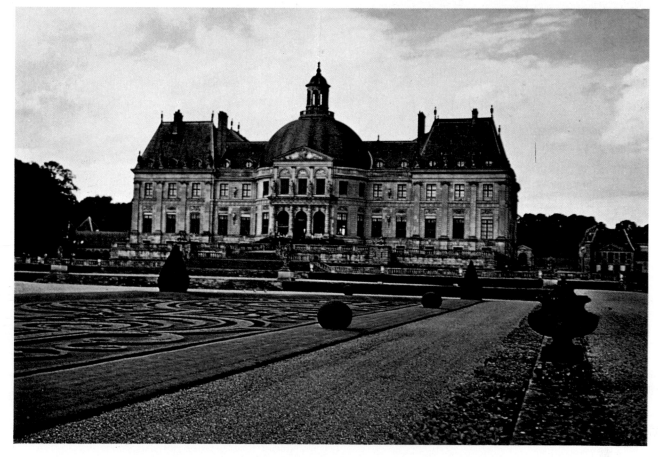

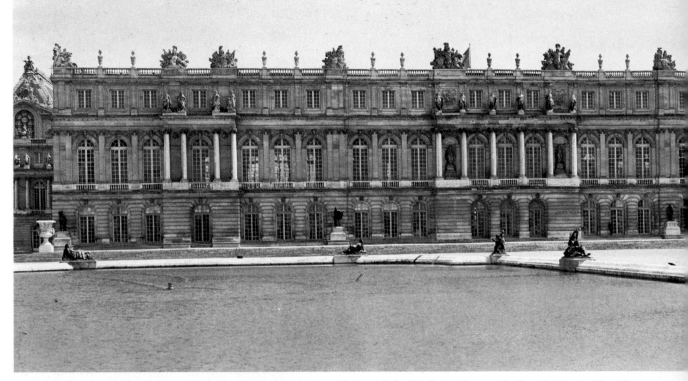

Louis Le Vau and Jules Hardouin Mansart, façade facing the garden, Versailles

Below: *Jules Hardouin Mansart, the Cour de Marbre, Versailles*

tecture. The palace, completed in 1708, was designed so that attention was concentrated on its first floor, both on the front façade and on the splendid façade facing the park. The interior, rich with marble, glorifies the monarch's power with almost theatrical magnificence, consistent with the theory that lay behind it. Galleries, some as much as eighty yards long, lined with windows and mirrors – like the famous Galerie des Glaces – and with frescoes on the ceilings, sparkle with gilding on architraves and capitals. The stately rooms open off each other – the corner rooms are particularly sumptuous – with carved doors and overmantels, elegantly framed windows, splendid furniture side by side with priceless tapestries, pictures in ornate frames, splendid examples of the cabinetmaker's art, bronze and silver, all combining to give an incomparable impression. Everything contributes to the splendour and dignity of the building, once the home of the French court. There is a restful classicism in the design of the chapel (by J. H. Mansart and Robert de Cotte) with its softly curving apse. In the park the monumental mood is less evident in the Grand Trianon, built – again by Mansart – between 1687 and 1688. Here

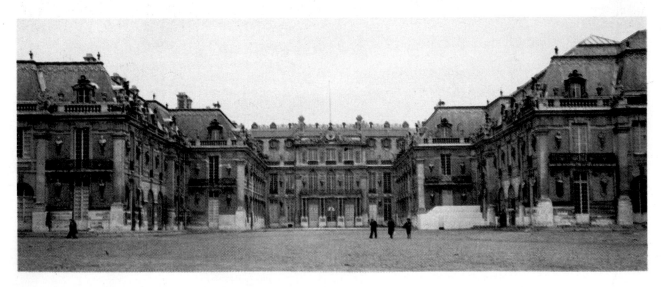

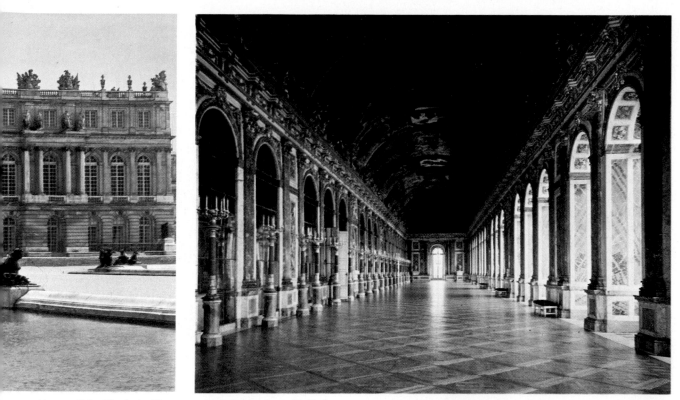

Above: *Jules Hardouin Mansart and Charles Le Brun, Hall of Mirrors, Versailles*

the prevailing mood is that of relaxation from wearisome pomp and ceremony. Several of the royal palaces of Europe are the descendants of Versailles: Caserta in Italy, Buen Retiro and the royal palace in Madrid, Schönbrunn in Vienna, and the royal palaces of Germany and Russia. The French châteaux built in the years immediately before this period – Coulommiers for Catherine Gonzaga, the Luxembourg for Marie de' Medici, even François Mansart's Maisons-Laffitte – all seem modest in comparison with the exceptional grandeur of Versailles.

Sculpture

17th-century French sculpture was considerably less important than the architecture of the same period, bound as it was to the Mannerist tradition and the rules laid down by the French Academy. After the important work of Simon Guillain and Michel Anguier, Pierre Puget (1622–94) heralded the arrival in France of Baroque sculpture – derived from Bernini and Pietro da Cortona – as well as the rejection of classical forms. The *Andromeda* group of 1684 (Louvre, Paris) would never have been created if it

Decorated door in the Salon de l'Abondance, Versailles

543

had not been for Bernini's *Apollo and Daphne*. The French work, however, is marred by a certain amount of exaggeration, and the forms are weighed down by the emphasis on muscular movement. Still more emphatic in his attempt to increase the dynamism of his composition was Pierre Legros, also famous for his work on the altar of S. Ignazio in the church of the Gesù at Rome. The plans for Versailles called on sculptors to adorn the gardens with statues on secular themes. Girardon was one of the most highly regarded of these sculptors, and his group *Apollo with Nymphs* for the Grotto of Thetis is deservedly famous. His skill in rendering smoothly polished surfaces has never been surpassed, and his *Bain des Nymphes* at Versailles recaptures the sensibility of the Fontainebleau tradition. Coysevox (1640–1720) was a more complex personality. His bust of the Grand Condé, his self-portrait, and the head of Robert de Cotte are already full of realism, with slight bourgeois overtones.

Painting

While 17th-century Italian painting made a dramatic break with the Mannerist position, the same cannot be said of French painting at this time, which in certain aspects showed a continuing intellectual nostalgia and refinement which came from Fontainebleau. However, these tendencies were reconciled with Roman decorativism in the manner of the Carracci, and with Venetian and Bolognese naturalism, valued by several French painters who had stayed in Rome in order to come into contact with classicism.

The violence of the break between the early 17th century and the 16th century in French painting can be seen in the works inspired or influenced by Caravaggio, the Flemish school and Roman classicism. Valentin, Le Clerc and Simon Vouet were the chief artists at this moment of transition. Valentin, in pictures like *Musicians and Soldiers* (Musée des Beaux Arts, Strasbourg), was already decidedly a realist painter, who had taken over the romantic tones of the school of Caravaggio from the Italian, Bartolomeo Manfredi. Simon Vouet was classical in the Bolognese sense, or else – as in his *Allegory of Wealth* (Louvre, Paris) – he showed the influence of Venetian painting. Immediately after this, the Le Nain brothers (Louis, Antoine and Mathieu) – who were long considered minor

Pierre Puget, 'Alexander Victorious' (Louvre, Paris)

Louis Le Nain, the 'Forge' (Louvre, Paris)

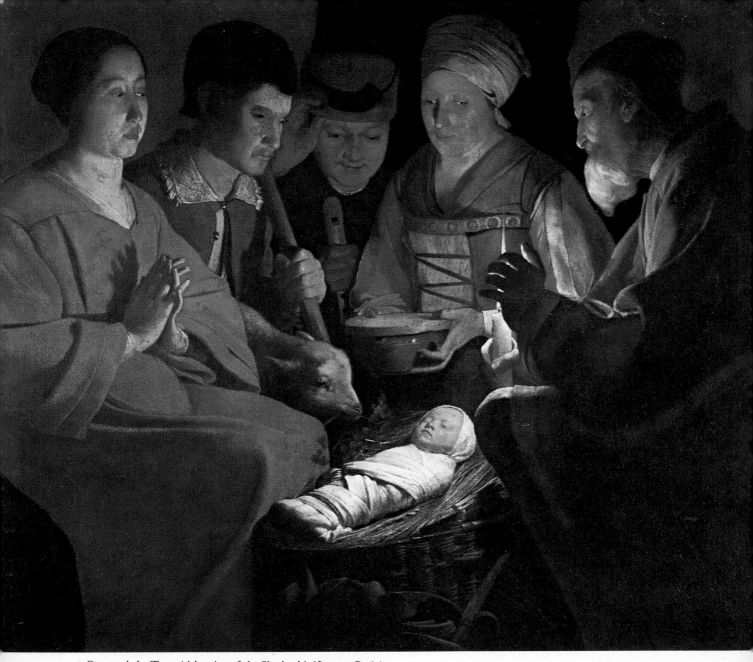

Georges de la Tour, 'Adoration of the Shepherds' (Louvre, Paris)

artists and only recently classed with Millet and Courbet – influenced French painting in a realist direction by their insistence on definite subject matter. Their *Peasants Dining*, the *Wagon*, and the *Forge*, all in the Louvre, show moral qualities, simplicity in figure representation, spiritual serenity and, in particular, an interest in humble people.

Georges de la Tour (1593–1652) derived from the school of Caravaggio, but remained in a class of his own. The solid monumentality of his forms, moulded by delicate effects of light in geometrical and three-dimensional composition, helped him express the divine element in man, and the predominant note in his work is mysticism. His *Virgin and Child* (Musée des Beaux-Arts, Reims), his *Magdalene* (Louvre,

Paris) and his *Lamentation on the Death of St Sebastian* (Staatliche Museen, Berlin), are devotional works with great fascination. The light of the candle, shaded by a hand, in the first picture; the lamp on the table which assists the Magdalene's meditation; the torch which throws an intense and theatrical light on the group of devout women alongside St Sebastian – all these are touches which transform the stories into dramatic action. The simplification of planes of perspective and the solid geometry of the forms already suggests intimations of cubism, but the strength of the colour (which betrays Flemish influence), the warm light, the nocturnal settings and – above all – the forthright anecdote, belong to the wider territory of the Counter Reformation. The stillness of gestures and atti-

tudes is decidedly non-Baroque, but the stress on the spectacular, which involves the onlooker in the drama, is a dominant note in the painting of this period.

Sébastien Bourdon and Richard Tassel were each inclined, in different ways, to naturalist painting, were working in France at the same time, and both showed the influence of Caravaggio in their handling of light, but within the context of Flemish tradition. Simon Vouet (1590–1649), although he valued the work of Caravaggio, which he had encountered during his stay in Italy, painted brightly and freshly, in the style of Fetti and Liss. These qualities, which were well suited to the decoration of ceilings and walls, acted as a point of departure for Lebrun, Le Sueur and Pierre Mignard. With Vouet, the influence of Caravaggio in France completed its course, reviving the taste for monumental forms with a feeling for naturalism.

Nicolas Poussin

Nicolas Poussin (1594–1665) was the greatest exponent of French 17th-century classicism. His ideal was harmony within the dimensions of separate forms and in strictness of composition. 'Painting is only ideas of living forms', he said, and with him reality became form with three-dimensional effects and harmonious colours. The rules which Alberti first drew up, and which Raphael followed, were the basis of Poussin's personal thought. His individuality would not have developed in this direction had it not been for his long stay in Rome, where he arrived in 1624. Until 1630, Poussin was busy studying and making contact with cultivated and intellectually stimulating society. His great pictures of this period reveal Baroque influence. Immediately afterwards he turned to easel-painting, in which he attempted compositions partly inspired by engravings of Raphael and Giulio Romano. There are obvious perspective experiments and *trompe l'oeil* effects, as in *Venus Arming Aeneas* (Musée des Beaux Arts, Rouen) or in the series of *Sacraments* (National Gallery of Scotland), which was begun in 1636. During a brief stay in Paris (1640–42) Poussin produced altarpieces, decorative schemes, book illustrations and designs for bindings. However, his official position as court painter inhibited his genius, and the deaths of Richelieu and Louis XIII decided him to return to Rome. There he had his finest hour in the variety of studies which brought him psychological insight reflected in works such as the *Judgment of Solomon*, or in spatial studies as in the *Adulteress* (Louvre, Paris), even though to our

Jacques Callot, stage set for a play, drawing

contemporary taste the gestures may be excessive and the pose heavy. He is more original in paintings like the *Bacchanal* (National Gallery, London), where the finest aspects of the Fontainebleau tradition are enlivened by colours influenced by Titian. The landscape in which his mythological or Arcadian scenes take place has a new fascination, a poetry all its own. His setting is never natural. He provides a contemplation of nature with dramatic overtones in the

Baugin, 'Still-life' (Louvre, Paris)

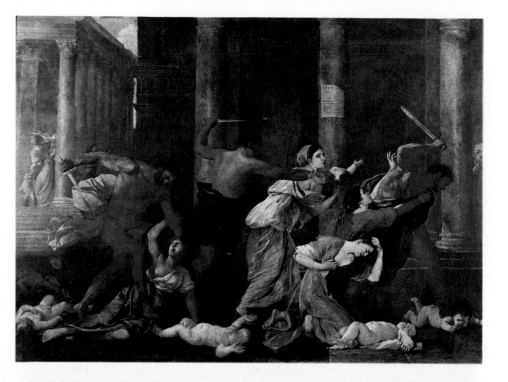

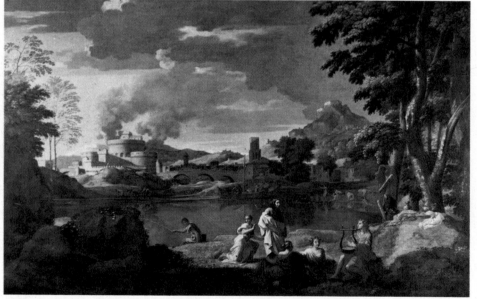

Burial of Phocion and a sumptuous study in light in *Orpheus and Eurydice,* painted in 1659 and now in the Louvre. Certain fragments, like the romantic background to *Ruth and Boaz* (Louvre), already anticipate the handling of landscape in its own right. Other works, in their figurative narrative, anticipate the *rêveries* of the 18th century. The relationship between man and the world, or between man and architectural space, is the dominant thought in Poussin, and he remained the greatest exponent of the French 17th century. In the 18th century his output won him great popularity; David and Ingres took him as their master, and even Cézanne studied him as a point of reference and contrast in his search for his own individualistic creative identity.

Charles Le Brun

Charles Le Brun (1619–90) set the tone, with his vast output and his authority, for the whole of the second half of the 17th century. He represents the most complete expression of French art and taste in the time of Louis XIV. Eclectic in his development through his acceptance of the

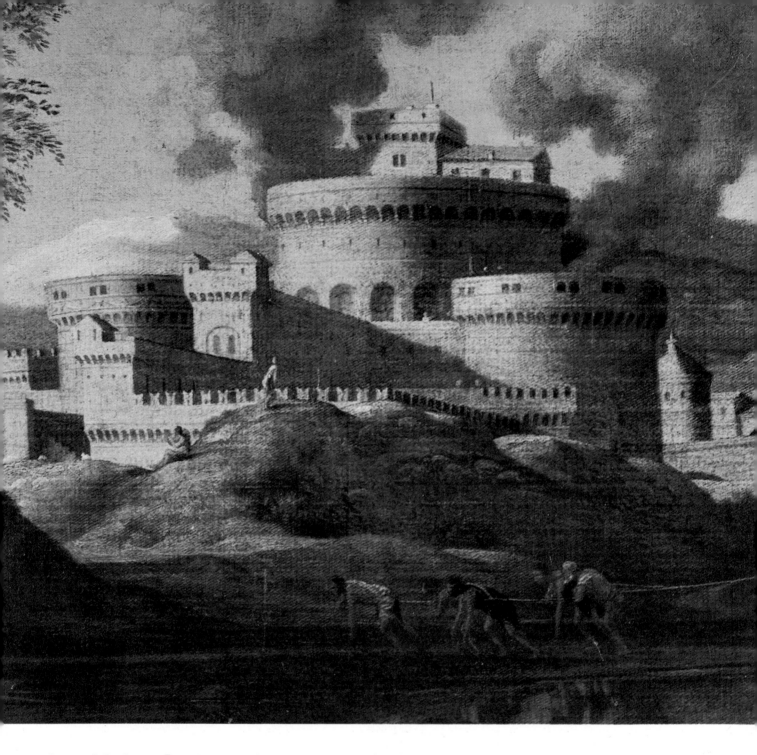

values of Rubens, Poussin, the Carracci and
Pietro da Cortona, his work is Baroque insofar
as he took obvious pleasure in his subject
matter, aimed at spectacular representation, was
a great decorator and fresco painter, and missed
no opportunity for introducing ornamentation.
In his sacred painting, Le Brun either approached
the standpoint of Caravaggio, though with a
heavy sculptural emphasis, as in the *Pietà* in the
Louvre, or else he showed affinities with the
Carracci, as in the *Risen Christ* (Musée des
Beaux Arts, Lyons), in which he showed his debt
to Louis XIV by including him, at prayer, in the

picture. His most successful easel-paintings are his
portraits, and his grandiose equestrian portrait of
the Chancellor Séguier (painted in 1661 and now
in the Louvre) is a good example. The work has
a restful atmosphere, with thick, silver-grey tones
which deaden the blues and golds. Already by
1653 Le Brun had ventured on large decorative
schemes, as in the frescoes for the gallery of the
Hôtel Lambert, or the Château of Vaux-le-
Vicomte, where he combined stucco with fresco —
a feature he had seen in the work of Pietro da
Cortona in Rome. It was not till 1660, however,
with *Alexander, Conqueror of Darius*, that he gave

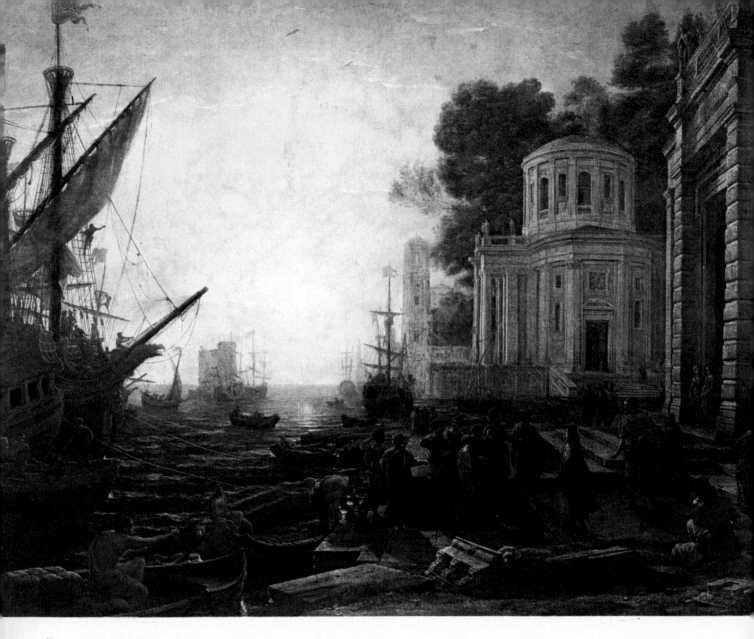

proof of his ability to illustrate great historical events, which is what Louis XIV asked him to do, celebrating his deeds and his power. His Babylonian scenes are well suited to a combination of the intellectual refinement of the old French school, warm colours derived from Flemish painting, and the classical dignity encouraged by the Academies. In 1662 Le Brun became the King's chief painter, and director of the furniture manufactory at the Gobelins. His influence here was immense, and determined the main direction of the Louis XIV style.

The decoration of the state rooms at Versailles, with the choice of marble for the walls, mirrors for the galleries, plaster and carving for doors and overmantels, is all Le Brun's work, together with a vast series of frescoes on the ceilings, painted by a band of pupils under his direction. Work on the *Grands Appartements* at Versailles lasted from 1671 to 1681. From 1679 to 1684

Le Brun was at work on the Galerie des Glaces, which set a pattern for most of the courts of Europe. Here, as in other rooms, the frescoes have elaborate frames, decorated in relief, which link the fresco with the whole scheme, and at the same time isolate and emphasise it. Mythology mingles with the heroic deeds of Louis XIV: in the battles, goddesses such as Venus and Diana – not unlike the Fontainebleau nudes – appear naturally and spontaneously in the narrative. The magnificence of the ensemble never lacks decorum since, like the monarch's passage through the state rooms during festivities, it is always conducted with strict ceremony. Allegory, which at this time was extremely popular in French literature, had the ability to transform, without Baroque bombast or rhetoric. Here also, France was in a certain sense on the fringe of Baroque. The king's deeds were also described in the tapestries, which

550

covered the walls with scenes where the facts could be pointed to, and where there was room to notice the imaginative touch, the interesting episode, the particular detail. When Le Brun's star waned, between 1680 and 1690, Mignard succeeded him, and continually expanded the array of tributes to the Sun King's splendour. Amid so much pomp and splendour, the figure of Philippe de Champaigne (1602–74), an intransigent Jansenist, morally bound to the standpoint of Port Royal, stands apart. His vivid portrait of Cardinal Richelieu (Louvre, Paris), with its ample composition and awakened psychology, marks points of contrast with Flemish painting, always remembered in France.

Claude Lorrain

Claude Gellée, known as Claude Le Lorrain (1600–82), was formed, no less than Poussin, by his encounter with Rome. But he allowed himself to accept his natural surroundings more freely, along with the strong southern light and the thick green vegetation which inspired his *Acis and Galatea* (Gemäldegalerie, Dresden), *Dancing Figures* (Doria Pamphili Gallery, Rome), and the *Expulsion of Hagar* (Alte Pinakothek, Munich). With Claude, Europe witnessed the full maturity of the landscape painting tradition of Elsheimer and Paul Bril, and Italy saw the extension and strengthening of the vision of nature that the

Above: *Claude Lorrain, 'Entrance to the Port of Genoa' (Louvre, Paris)*

Opposite page: *Claude Lorrain, 'Cleopatra at Tarsus' (Louvre, Paris)*

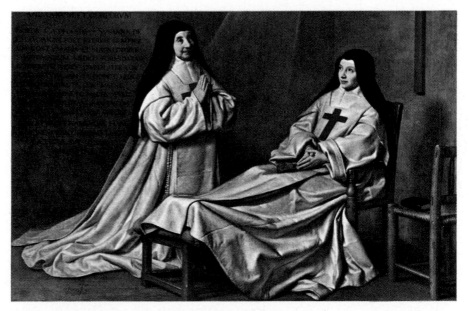

Philippe de Champaigne, 'Two Nuns' (Louvre, Paris)

Carracci handed on to Domenichino and Albani. Compared with Poussin, who gave the 17th century a landscape of meditation, Claude created a landscape of dream, freedom and thought, and in so doing anticipated the English 19th century.

The death of Louis XIV in 1715 coincided with the arrival of the Rococo style. The term describes not only architecture, but every aspect of decoration, and came to be known in France as the *Régence* (regency) style. The word Rococo stresses the analogy between the new artistic taste and the exuberant and irregular decoration known as *travail de rocaille*. Correspondingly, the term *Régence* indicates the favourite style of society in Paris and Versailles in the period of transition from Louis XIV to Louis XV, which aimed at turning formality into comfort and severity into light-hearted frivolity. A negative opinion of this art and taste was soon formulated by the Academicians, who were already opposed to the design of the Trianon and of the Dauphin's apartments at Versailles.

It was particularly between 1715 and 1730 that Rococo took its chief steps forward – that is to say, during the regency of Philippe d'Orléans, connoisseur and collector of works of art, and patron of artists such as the architect Oppenordt, the decorator Vassé, the 'gallant' painters Watteau and Pater, and the cabinetmaker Cressent. From the architectural point of view, the most important innovation was the feeling for internal space, which set out to make the most of an individual and imaginative way of life, rich in taste and wit, and far removed from the rigours of court society. A calm exterior – such as that which J. Courtant chose for the Hôtel Matignon in Paris – gives no hint of the charm of the small, bright interior, with its low ceilings framed in light wood and its freshly coloured tapestries illustrating scenes of gallantry. Round about 1730, Pineau designed the exquisite entrance hall of the Hôtel Matignon before going on to the Hôtel de Rouille. From 1732 to 1736 Boffrand worked on the Hôtel Soubise, and gave it a profusion of light cornices, shining silks, corner mirrors and elegantly curved furniture.

By the middle of the century the 'Pompadour style', named after Louis XIV's famous mistress,

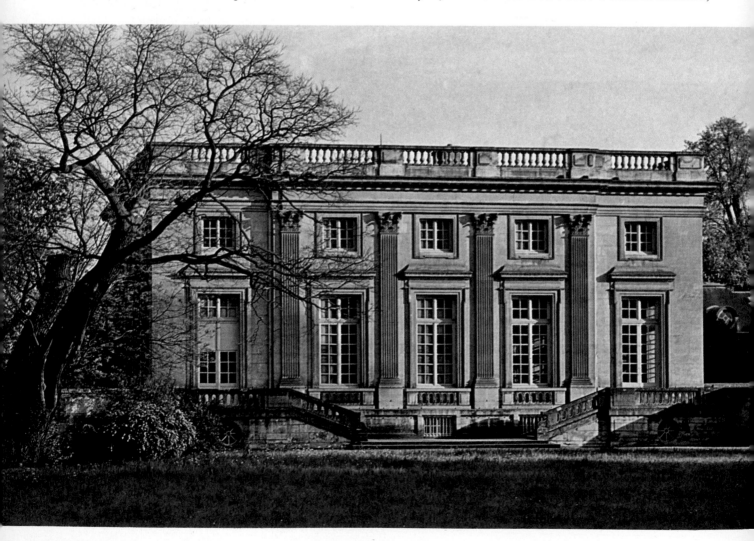

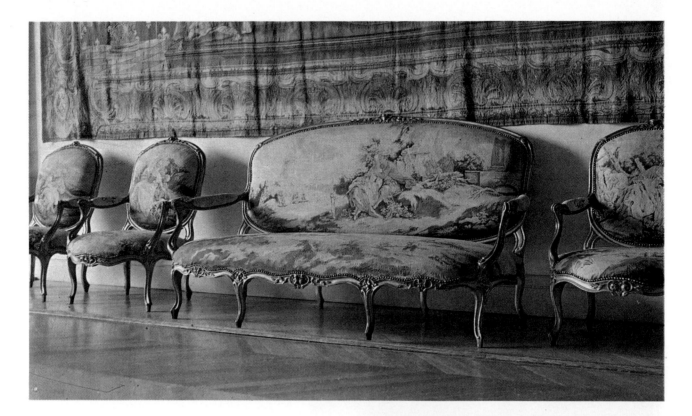

Furniture upholstered in Beauvais tapestry, from a design by Boucher (Louvre, Paris)

Opposite page: *Jacques-Ange Gabriel, the 'Petit Trianon', Versailles*

Right: *André-Charles Boulle, 18th-century cabinet in ebony (Louvre, Paris)*

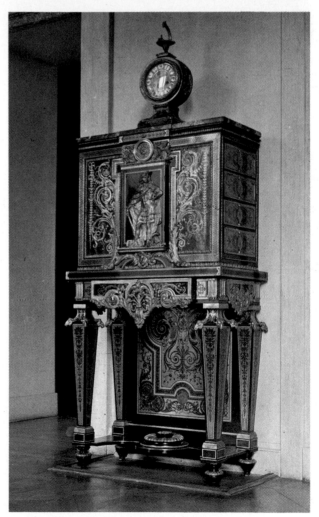

Mme de Pompadour, had already appeared as a variation on the Rococo theme. Curves and counter-curves enlivened the walls and rhythmical decorations; assymetry asserted itself; curvilinearism covered everything, adding the finishing touch to wall-panels, fireplaces, mirrors, furniture and porcelain and even to upholstery fabrics, carvings and dress materials. The villas built for Mme de Pompadour indicate a style that fluctuated slightly as it developed. The Château of Champs-en-Brie dates from 1746, and was followed closely by the *petit château* of La Celle. The *ermitages* of Versailles and Fontainebleau, of Compiègne and Bellevue, provided solitude with intimacy and refinement. The final phase of Rococo was dominated by Jacques Ange Gabriel (1698–1782). His finest work is the Petit Trianon at Versailles which, particularly in its naturalistic setting, suggests English country house architecture. The Ecole Militaire at Paris is more severe, because of its function. R. Mique introduced the round temples known as *temples d'amour*, which eventually led to Neo-classicism. Interiors in the Louis XVI style – for example

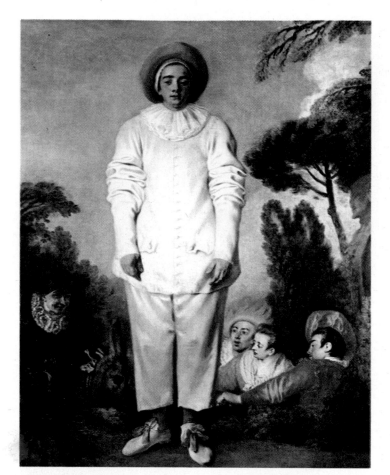

Marie Antoinette's salon at Versailles, by Mique – have walls with white panelling and gold borders, large frames with medallions round the pier-glasses, armchairs upholstered in tapestry or petit-point, sofas on straight and slender legs, and elegant wall-brackets.

For architecture, the death of Louis XIV meant the end of spectacular effects and a preference for intimate Rococo surroundings. In painting, too, cycles of frescoes were discarded to make room for tapestries, which added intimacy to conversation and discretion to silences. Portraits like the one painted by Rigaud in 1701 for Louis XIV were no longer popular; a favourite portrait painter was now Nicolas de Largillière, with his figures in spontaneous poses, his conversational atmosphere, and his clothes, wigs and painted faces. Nattier, who painted the daughters of Louis XV, created miracles of lightness and frivolity with a palette refreshed by silvers and pastel tints. Pictures were small, and were hung between doors or beside windows, where mirrors were no longer to be seen. Sometimes pictures had a special room to themselves, the *cabinet* of painting, where the connoisseurs met to enjoy together the new forms and the ever-increasing frivolity of the subject matter. Watteau, Boucher

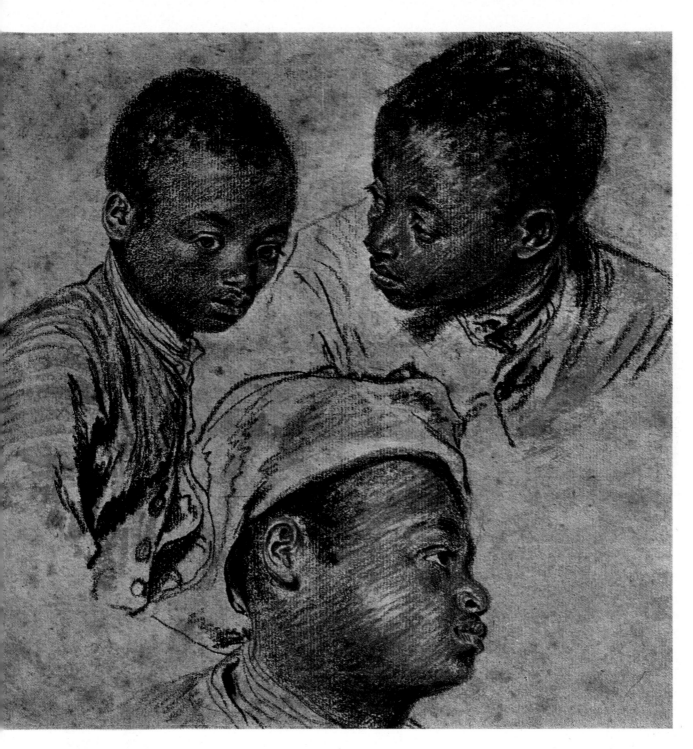

and Fragonard were the greatest innovators in form and theme.

Antoine Watteau

Antoine Watteau (1684–1721) burst upon the scene with paintings that appealed to the heart – works that were captivating by the charm of their setting, the softness of the composition, and the light and colour of his palette, which underlined the hints to be found in gestures and expressions. When the Italian Comedy, which had been banned by Louis XIV, reappeared in 1716, Watteau made the first rapid and elegant sketches of them with his *Mezzetin* (Metropolitan Museum, New York), and *Pierrot and Columbine* (Nantes Museum) and *Gilles* (Louvre, Paris). Free and lively touches combined with a veiled melancholy, anticipating the mood of those *fêtes galantes* in which Watteau remained unsurpassable. His paintings no longer had a definite subject. The wood with its deep shadows and the softly lit lakes are stage sets and mirrors for the happy couples in their loving silence, in amorous

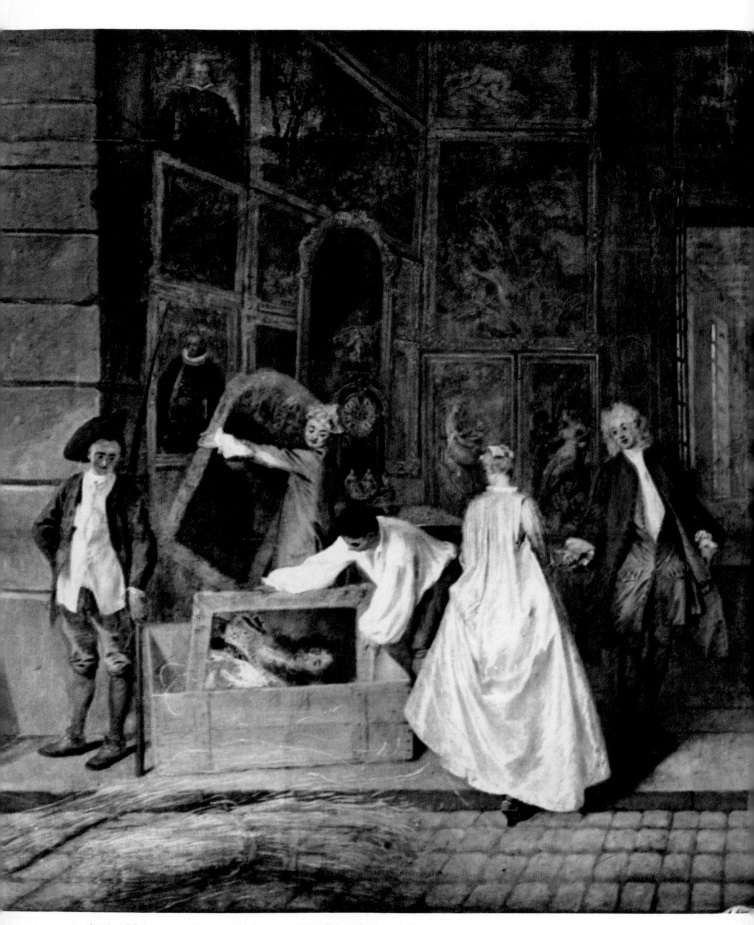

Antoine Watteau, 'At the Sign of Gersaint' (Staatliche Museen, Berlin)

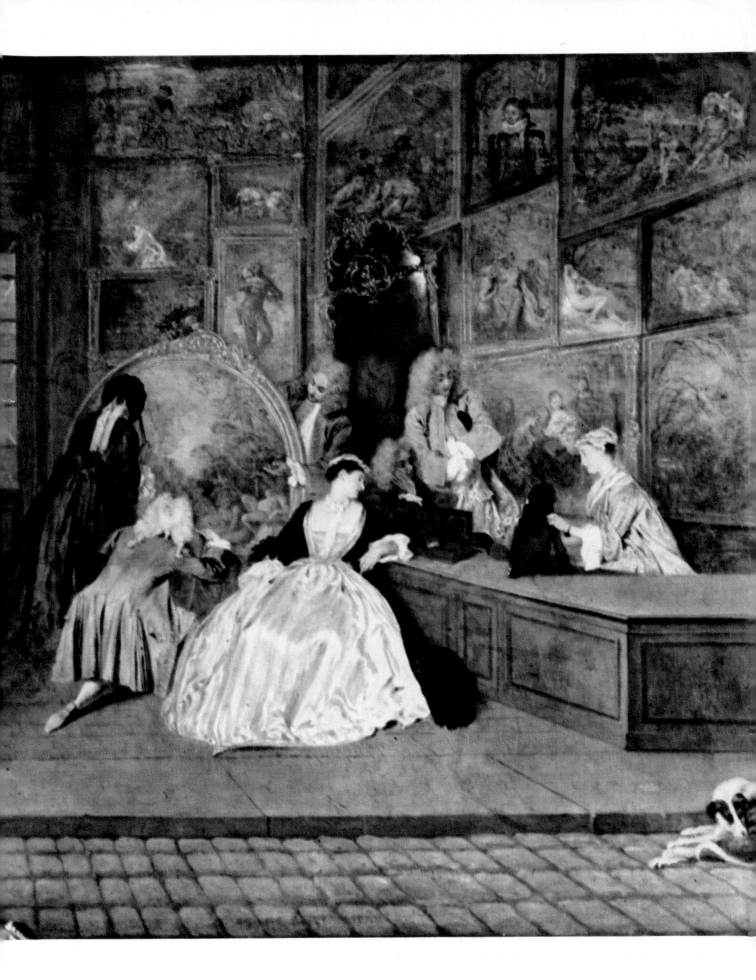

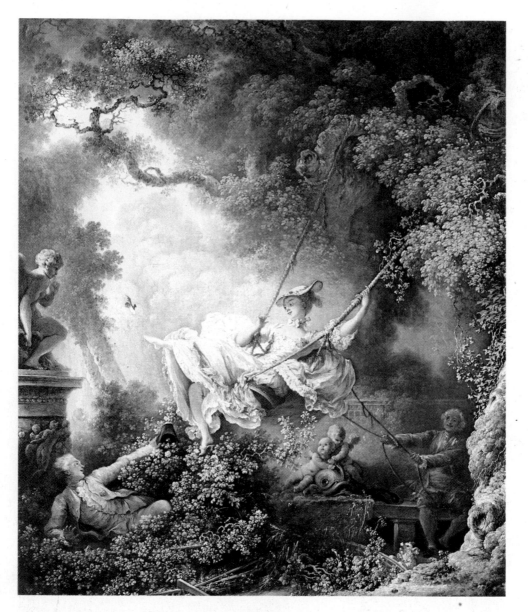

Jean-Honoré Fragonard, the 'Swing' (Wallace Collection, London)

Opposite page, above: Hubert Robert, 'Bridge with Washerwomen' (Palazzo Barberini, Rome)

play, and in intimate conversation. The *Conversation Out-of-doors* (Gemäldegalerie, Dresden) and the *Embarkation for Cythera* (Louvre, Paris) depict moments of sentimental magic in the warmth of the atmosphere and the spontaneous elegance of the gestures. *At the Sign of Gersaint*, in the Berlin Museum, strikes a note of inimitable taste and wit in its testimony to the love of art and to conscious feminine grace.

It could be said that painting now aimed at being agreeable, at suggesting the pleasures of life. J. B. Pater (1695–1736) and N. Lancret (1690–1743), who followed Watteau, are sometimes more discursive, more decorative even, with some insistence on *genre* or more obvious realism.

Jean-Honoré Fragonard (1762–1806) revived the lyrical impulse, partly because of his more complex artistic education, which included the influence of Tiepolo and Rubens, but also because

he had a care-free spirit which made light of his subject matter; his work coincided with the last years of the French monarchy. Landscape – especially the Roman landscape, which he himself had known – is the theme of his settings with their swift brush strokes, and their airy touches of colour and light. The *Bathers* (Louvre, Paris), recall Correggio, though they dissolve in an all-enveloping light, which makes their provocative forms almost ingenuous. In the *Game of Blind Man's Buff* (National Gallery, Washington) the game turns into a dance, the fun turns into sunlight, while the couples turn to the wood for escape and solitude.

François Boucher (1703–70), in his *Venuses*, his *Dianas*, and his *Bathers* has the secret of sensitive and luminous skin texture, but his backgrounds, with their draperies and 'natural' stage settings, are artificial.

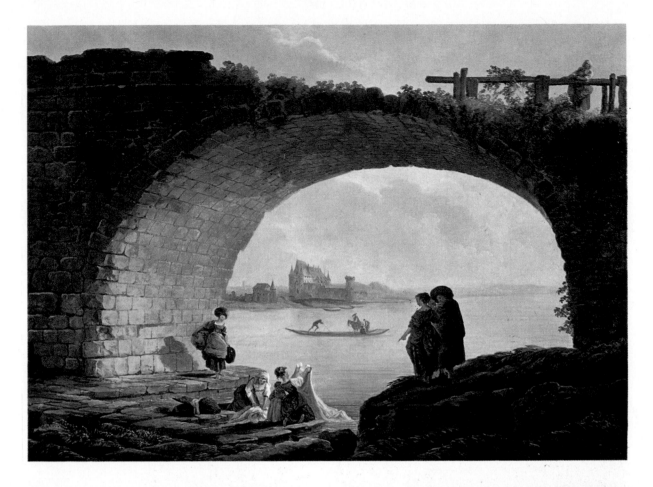

Nicolas Lancret, 'The Game of Pied-de-Boeuf' (New Palace, Berlin)

François Boucher, 'Madame de Pompadour' (Wallace Collection, London)

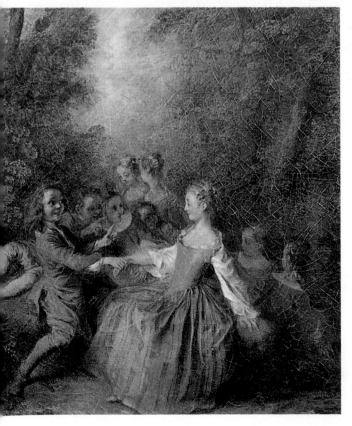

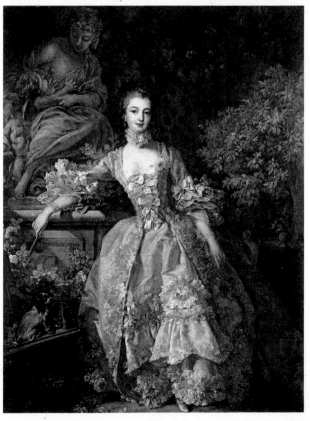

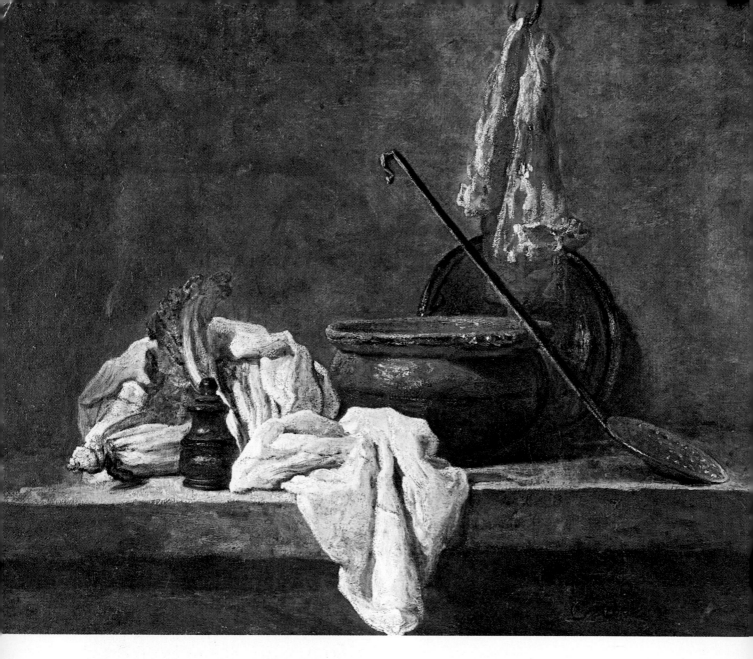

Jean Baptiste Siméon Chardin (1699–1779), in temperament, education and taste directly opposed to Watteau, Boucher and Fragonard, must be mentioned as a spokesman for the French Bourgeoisie on the eve of the Revolution, and is an important painter who is always interesting. He has already been compared to La Tour, and consequently occupies an exceptional position in the Rococo period. Scenes in the home, children's games and still-life – *Pipe and Vase* (Louvre, Paris), is very fine – have the freshness of immediacy and spontaneity, even if they are imbued with a severity which anticipates Cézanne's thoughtful and thrilling seriousness. Already in 1763 Diderot, looking at Chardin's still-lifes, spoke of 'a kind of magic' which still fascinates anyone who looks at these timeless masterpieces without thinking of past influences and the context of his own times.

Coysevox, moving into the 18th century, led on to Nicolas and Guillaume Coustou. The latter was responsible for the groups of dashing horses – the *Chevaux de Marly* – now at the bottom of the Champs Elysées. Lamoyne (1665–1755), in his great portrait busts, attempted to express shades of feeling and passion. J. B. Pigalle, on the other hand, is famous for his paintings of children. Falconet (1716–91), greatly esteemed by Louis XV, provided the most complete record of contemporary court society. His affinity with the painter Boucher is evident; his chisel created graceful, warm and luminous female nudes, who already – anticipating Neo-classicism – had mythological characteristics. With J. A. Houdon (1741–1828) the 18th century came to an end, at the meeting point of fresh Rococo inventions and sensitive realism.

Compared with important decorative develop-

Etienne-Maurice Falconet, 'Bather', marble (Louvre, Paris)

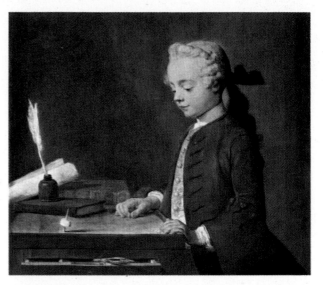

Jean-Baptiste Chardin, 'Boy with the Top' (Louvre, Paris).
Below: *detail*

Opposite page: *Jean-Baptiste Chardin, 'Still-life' (Amiens Museum)*

ments, porcelain represents a minor aspect of 18th-century French sculpture. Yet even celebrated artists made designs and models for the new Sèvres factory, which was famous for its *bleu roi*. In the form of souvenirs, the small groups illustrate *genre* scenes, describing scenes of gallantry, jokes and children's games in a fresh medium and in luminous colours, or contributed to the exotic craze for chinoiserie. Tapestries also continued into the 18th century, with exotic or gallant themes, as well as those of mythology and history. The great royal factory of the Gobelins was founded in 1662, and its direction was entrusted to Le Brun. This actively encouraged the French tapestry industry, its output was extensively used for furniture, and the best-known artists supplied drawings for it.

ENGLISH ART IN THE 17TH AND 18TH CENTURIES

Architecture

England, having laid the foundations of her sea and island power in the reign of Queen Elizabeth I, remained – partly for reasons of temperament – largely alien to Baroque art and architecture. Delayed Mannerist features and Gothic survivals were largely eliminated in 17th-century architecture by the taste for Italian art, dominated by the influence of Palladio. This was an obstacle to the attractions of Baroque, and led to an unbroken continuity, with few differences between 17th and 18th centuries. In the second half of the 18th century it also led to the Neo-classical movement, which affected England more than any other country.

The Italian style, like Palladianism, was a direct outcome of travels and visits to Italy, and was introduced at the beginning of the 17th century by Inigo Jones (1573–1651), architect and designer of theatrical costumes and sets. The two-storeyed Queen's House at Greenwich, built as a country house for Queen Anne, wife of James I, makes no secret of its derivation from the Palazzo Chiericati at Vicenza, with small changes occasioned by the re-siting of the loggia at the centre. The banqueting hall in Whitehall, London, also by Jones, is a sober, solid double cube, with columns and classical windows. There is a more definitely Palladian flavour in the architecture of Sir Christopher Wren (1632–1723), who prepared plans for the rebuilding of the City of London after the Great Fire of 1666, and designed a great many monuments for it. The most famous is the splendid St Paul's cathedral, originally planned in the form of a Greek cross, which has echoes of Borromini in the placing of the towers flanking the façade. There is a feeling of Michelangelo's influence in the ground-plan and the great dome, with its colonnade encircling the drum; but the porch,

Christopher Wren, St Paul's cathedral, London

with its fluted columns and triangular tympanum, belongs to the Palladian manner. Other Wren churches, like St Stephen Walbrook, follow the Counter Reformation scheme of the Gesù in Rome. Wren's work at Cambridge, like that at Hampton Court, shows how successfully he adapted the Italian style to English taste: the library in Neville's Court, Trinity College, and the chapel at Pembroke College show Wren's personal stature as a designer.

The work of those who followed in the style of Wren extended into the 18th century. Sir John Vanbrugh, architect of Castle Howard and Blenheim Palace, and Nicholas Hawksmoor were the most influential architects. They did not abandon the Palladian style, however, and the Senate House at Cambridge, by James Gibbs, and John Wood senior's Prior Park at Bath show this trend in its maturity. It was only a short step to the brilliant Neo-classicism which Robert Adam foreshadowed in Derby House, London. John Wood junior was responsible for sensitive town planning, and created a middle-class residential district in an unbroken curving semicircle in the Royal Crescent, Bath. Meanwhile the introduction of squares was a characteristic English contribution to town planning. These open spaces, with a garden in the middle,

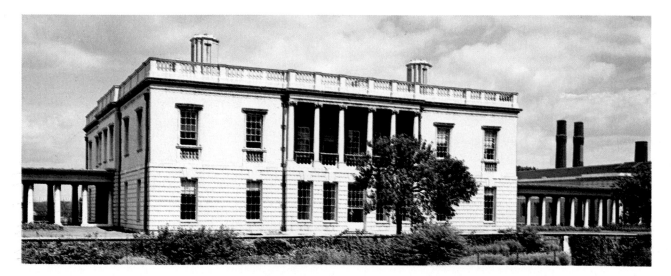

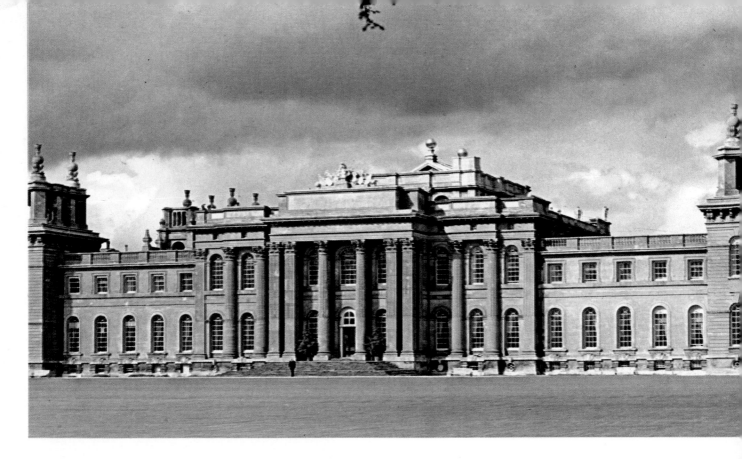

are surrounded by streets giving access to the private houses facing them. While parks and gardens in the English style were on the increase, with a pre-Romantic love of nature, special attention was also given to country houses that fulfilled the British desire for privacy. A fine example of these, built during the second half of the 17th century, is Eltham Lodge in Kent, the work of the architect Hugh May.

While sculpture was unimportant in England in the 17th century, painting was stimulated in the direction of aristocratic taste and sensitive colour by the visits to England of Rubens and Van Dyck. The portrait and the miniature were especially popular, and the latter, in which Thomas Flatman and John Hoskins excelled, reached international fame with the work of Samuel Cooper. But foreign influence – especially Dutch – prevailed, and the greatest English portrait painter, Sir Peter Lely, who carried on the traditions of Van Dyck, was originally a Dutchman.

Painting

Only with the 18th century did a short-lived, fascinating school of English painting emerge from the mediocre artists and those who imitated

Above: *John Vanbrugh, south façade of Blenheim Palace*

Opposite page, above: *Christopher Wren, south and east façades of Hampton Court, Middlesex*

Opposite page, below: *Inigo Jones, the Queen's House, Greenwich*

Inigo Jones and John Webb, a 'double-cube' room, Wilton

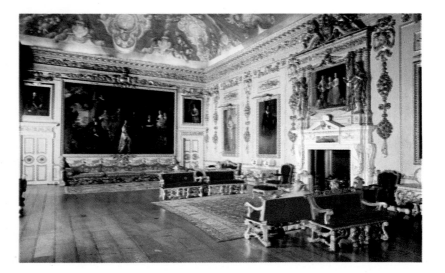

foreign models. It began with William Hogarth (1697–1764), who, in his scenes of social satire – like the famous *Marriage à la Mode* (National Gallery, London) – evolved a native British humour in open social comment without sacrificing his gifts of incisive draughtsmanship and fresh and harmonious colour. But Hogarth was no mere painter of *genre* scenes or anecdotes of manners; in acuteness of observation and moral judgment he was rather the painter of social history, a critic of English society in his day, seen as it really was. Hogarth appears at his liveliest and greatest when, freed from this task of caustic description and good-natured moralising, he paints impromptu portraits, as in the finely analysed picture of the *Artist's Servants* (Tate Gallery, London) or the spontaneous sketch of the *Shrimp Girl* (National Gallery, London).

During the second half of the century, the refined and aristocratic trend of English painting triumphed, to the extent of creating the Royal Academy, with Sir Joshua Reynolds (1723–92) as its first President. Full of admiration for the masters of the past, Reynolds was not deterred by his visit to Italy from the artistic gifts of softness, absorption, and finesse with which he immortalised the 18th-century English aristocracy. He painted admirable portraits of children – the *Age of Innocence* (Tate Gallery, London) and *Master Hare* (Louvre, Paris), as well as gentlemen and soldiers *Lord Coussmaker* (Metropolitan Museum, New York) and *Lord Heathfield* (National Gallery, London). From the luminous grace of the *Misses Waldegrave* (Edinburgh), he passed to frivolous mondanity in *Mrs Carnac* (Wallace Collection, London) or *Mrs Scott* (Waddesdon Manor) in formal dress. Thomas Gainsborough (1727–88) was less classical, more freely fanciful, more gallant but more lyrical, more influenced by atmospheric surroundings and landscape. If *Sarah Siddons* (National Gallery, London) or *Mrs Graham* (National Gallery of Scotland, Edinburgh) are fine ladies posing in their rustling silks, the aristocratic *Mr and Mrs Andrews* (National Gallery, London) have their portraits painted in the midst of an English summer, in their lightly coloured clothes deep in the countryside. This aristocratic style was carried on and, through Neo-classicism, continued into the 19th century by Sir Thomas Lawrence, George Romney and, with an added touch of realism, the Scot, Henry Raeburn.

The other deep and important stream of English art was landscape painting. Richard

William Hogarth, a scene from the Beggars' Opera (Tate Gallery, London)

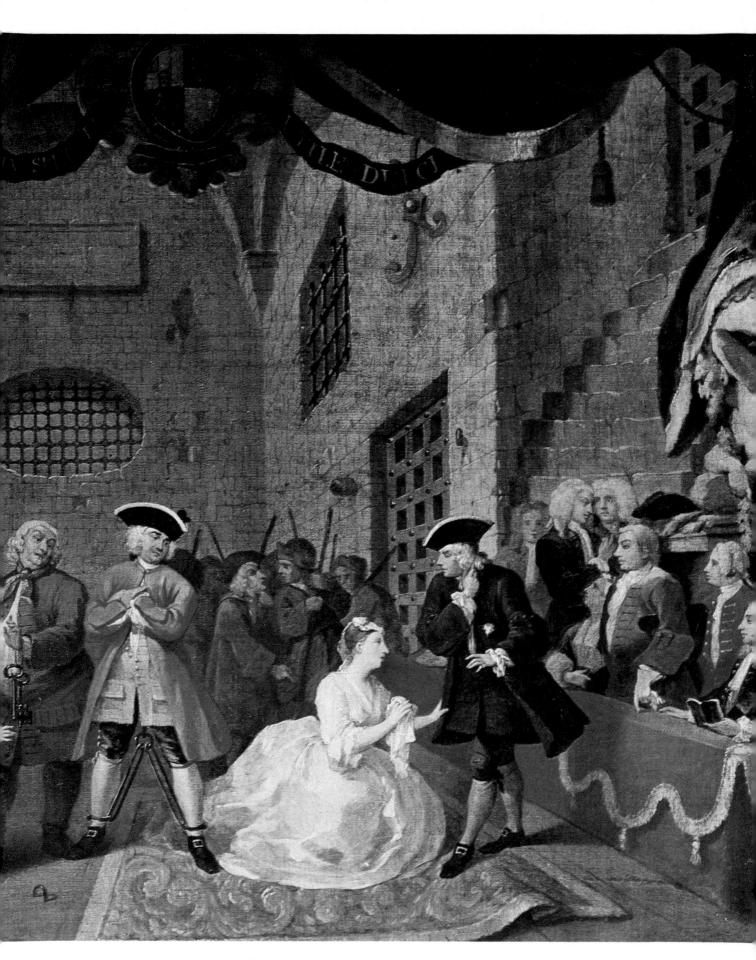

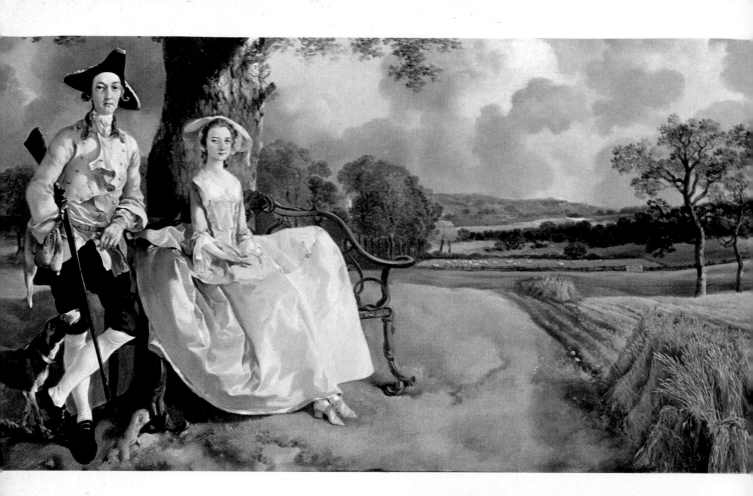

Above: *Thomas Gainsborough, Mr and Mrs Andrews*
(National Gallery, London)

Wilson (1714–82) still followed – though with
great freedom of inspiration – the rules which
he learned from Claude and Poussin in Rome.
But during the second half of the century,
thanks to water-colour technique, English land-
scape painting sought lyrical identification with
nature to such an extent that it almost became
a state of mind, and was an immediate foretaste
of Romanticism. John Robert Cozens gave an
important stimulus to the water-colour, en-
livening it with delicate blues and softened
shades of green. He was described by Constable,
who was himself much admired for his studies
of cloud effects, as 'a painter who succeeds in
turning everything into poetry'.

English sculpture in the 18th century was of
little importance. The production of ceramics
was, however, noteworthy, with the porcelain of
Chelsea, Bow and Worcester, while Wedgwood
ware cultivated the Neo-classical taste.
Repoussé silverware of the period was fine and
elegant. Furniture was also refined and directed
towards elegance of line. The Adam brothers
gave it a classical stamp.

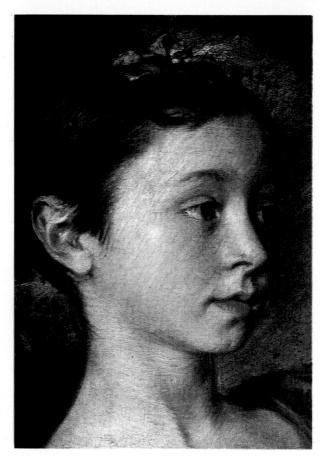

568

Opposite page, below: *Thomas Gainsborough, the 'Painter's Daughters', detail (Victoria and Albert Museum, London)*

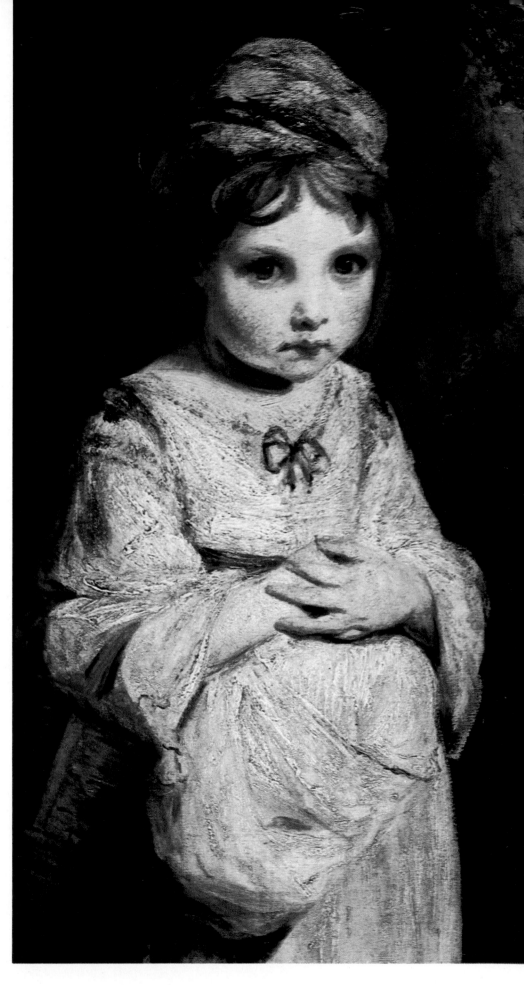

Joshua Reynolds, 'Child with Cherries' (Wallace Collection, London)

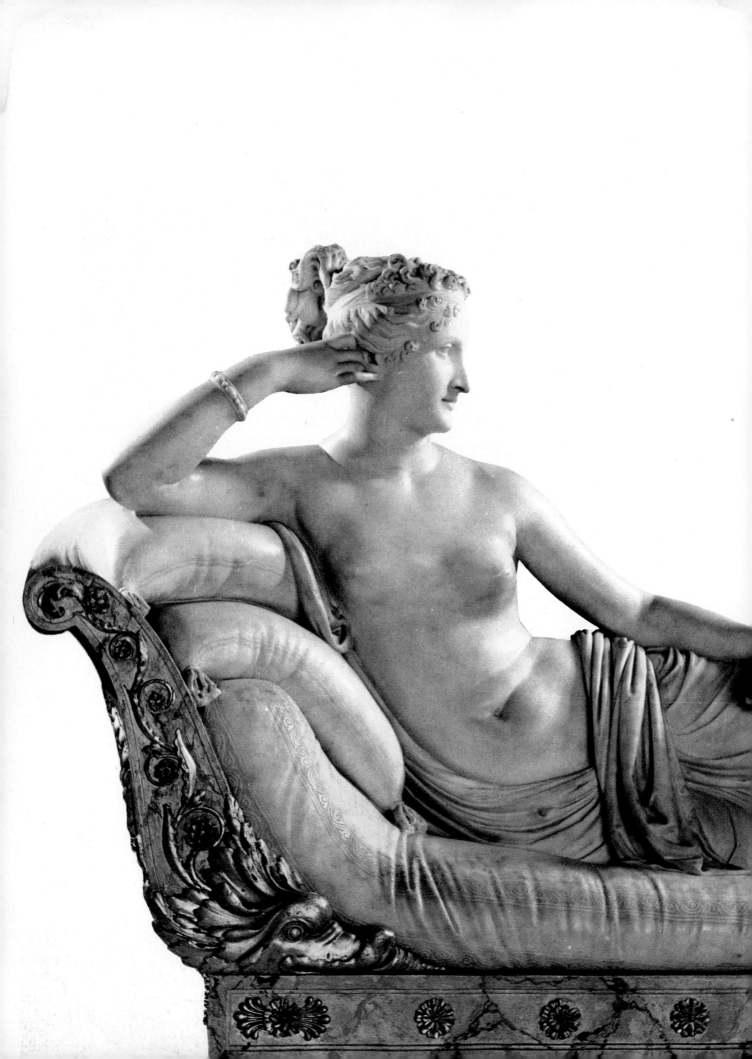

NEO-CLASSICISM

Towards the middle of the 18th century, a reaction away from both Baroque and Rococo began to make itself felt. It finally triumphed in the last twenty years of the 18th century and the first five years of the 19th, as the Neo-classical style. The phenomenon was not an exclusively artistic one. It also concerned aesthetics – the acceptance as a model of an ideal of beauty not to be found in nature, a mental elaboration of perfection. It concerned taste – hence the importance assigned to decoration, furniture, and even the changing fashions of clothes. It also concerned knowledge – the interest and enthusiasm aroused by archaeology, with its discoveries of the Greek, Roman, Etruscan and Egyptian worlds. It was also a phenomenon which, in the new directions it gave to thought, assumed international, cosmopolitan dimensions. It affected the whole of Europe, from Rome to London and Copenhagen, from Madrid to what is now Leningrad. It reacted from the exuberance and extravagance of Baroque and the ornamentation of Rococo, replacing them with the strength,

Antonio Canova, Pauline Borghese (Borghese Gallery, Rome)

purity and balance of ideal classicism. It was, however, an idea which could not be a slavish imitation of re-emerging classical antiquity; it could not be attained directly, nor by making use of the Italian Renaissance. In fact, while

Adam family, ceramic vase (Victoria and Albert Museum, London)

Bedroom of the Empress Josephine, Malmaison, Paris

Jacques-Germain Soufflot, dome of Pantheon, Paris

taking antiquity as its model, Neo-classicism had to re-work it on new principles of rationality, proportion, moderation, symmetry, order and clarity. It is true that such creative upheavals were later crystallised in the scholastic rules of Academies, becoming a conservative restraint during much of the 19th century, but this does not mean that Neo-classicism was symptomatic of weariness and passive imitation.

It is impossible to examine here the deeper factors, not all of them artistic, beneath the vast Neo-classical movement: its affinity with the call for clear human reasoning, which started with 18th-century enlightenment and the French Encyclopedists; the formation of a cosmopolitan and secular school of thought, preaching tolerance and understanding, and henceforth remote from the fervours of the Counter Reformation; the reaction against the aristocracy, its ostentation and its capriciousness, which helped to develop a new bourgeoisie, coming of age with the already active Industrial Revolution, and in 1789 flowing into the great destructive movement of the French Revolution; the myth of antique virtù, fostered at first by civic and republican values, and later, under Napoleon's triumphant leadership, transformed (even to the point of rhetoric and bombast) into the cult of the hero.

After the middle of the 18th century, Rome became the cradle of Neo-classicism. Antiquarianism and archaeology – the latter reinforced by the excavations at Pompeii and Herculaneum – brought antiquity back into the limelight. An artist of genius, the Venetian Piranesi, through his engravings, revived interest in Roman monuments and ruins, and on the Aventine anticipated the new architectural trend with the villa and church of the Knights of Malta. The German Winckelmann settled in Rome from Dresden, and progressed from the love of classical antiquity to theoretical criticism of the ideal of Neo-classicism. In this he was partnered by the decidedly anti-Baroque architect, Milizia, and by the theorisings of the German painter Mengs. Architects, painters and sculptors from every part of the world came to Rome to find fresh inspiration.

Architecture

Neo-classical architecture most readily embodied the new ideals and new structural patterns of simplicity and clarity, still making use of the classical orders as well as a pseudo-antique form of decoration. From time to time it fluctuated between nostalgia for the severity, grandeur, and monumentality of the Romans,

John Nash, Carlton House Terrace, London

Thomas Walter, the Capitol, Washington

and the grace, elegance and purity of Greek art.

In Italy, Neo-classical architecture is comparatively rare. In Rome we find the picturesque ensemble of the Piazza del Popolo, with the uphill approach to the Pincio and Valadier's *Casina*; at Naples, between 1816 and 1820, the arrangement of the Piazza del Plebiscito with S. Francesco da Paola in the centre; at Turin, an echo of the Roman Pantheon in the *Gran Madre di Dio*. And

Carl Gotthard Langhans, Brandenburg Gate, Berlin

it would be rarer still but for the vital contribution of Milan, first under Maria Theresa, and later under Napoleonic rule. For Maria Theresa, Giuseppe Piermarini designed the austere theatre of La Scala, the royal palace, the Belgioioso palace and the royal villa at Monza; for Napoleonic Milan, Luigi Cagnola – who later built the great villa of La Rotonda at Inverigo – designed the classical *Arco della Pace*. Meanwhile, the plan to surround the Castello Sforzesco with a circular forum remained unrealised, except for the construction of Canonica's Arena.

In England, Robert Adam, with memories of Rome and Pompeii, built a pure Ionic portico for Osterley Park in 1761, and John Nash, the greatest English Neo-classical architect, was clearly inspired by classical models in his designs for the buildings round Regent's Park in London. In France, after his visit to Rome, Soufflot was inspired by the new aesthetic ideas to build the

Pantheon in the form of a Greek cross, with pillared porch, triangular tympanum and monumental dome. But it was clearly Napoleon who did most to further Neo-classicism, in both town planning and architecture. Examples are the triumphal arch by Percier and Fontaine at the Carrousel, Chagrin's splendidly monumental one at the Etoile (not completed until 1836), the Madeleine, derived from the Roman *Maison Carrée* at Nîmes and conceived as a 'Temple of Glory', and the Corinthian columns around the Bourse. The Brandenburg Gate, Berlin, designed by Langhans and erected in 1788–91, was a forerunner of the Neo-classical movement, of which the leading exponent in the 19th century was Karl Friedrich Schinkel (1781–1841). The style spread, leaving important monuments in Poland, (the Primate's palace and the Lazienki palace in Warsaw) and in smaller centres; it reached St Petersburg to leave its mark on the

Giuseppe Piermarini, La Scala, interior, Milan

Giuseppe Piermarini, La Scala, exterior, Milan

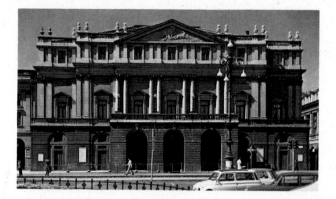

Below, left: *Giuseppe Piermarini, Palazzo Belgioioso, Milan*

Below, right: *Giovanni Battista Piranesi, the 'Prison', etching*

monumental Grand Duke's palace, built by the Italian C. Rossi, as well as on the church of St Isaac, and the Ionic colonnade which divides the interior of the Tauride palace, built by the Russian, Starov.

Sculpture

The aesthetic of Neo-classicism resulted in a purity of sculptural forms, and an estrangement from the passions of the human nude. In fact, a great many artists turned to sculpture. But this attention to severity and impassibility gave rise to the coldness, restraint and academicism which greatly mars so much of their work. Only three sculptors deserve mention here. One is the Englishman John Flaxman (1755–1826), who in his bas-reliefs sought for an Attic grace which disappeared in large statuary. The second, saturated with Roman art, was the Danish

Albert Thorwaldsen (1770–1844), colder and more reflective than his rival, Canova, as can be seen in *Mars and Eros* (Copenhagen Museum) or in the tomb of Pius VII, in St Peter's. The third and most famous, the Venetian Antonio Canova (1757–1822) was at the centre of artistic life in Rome. Some of his most complicated works, like the funeral monuments of Clement XIII and XIV in St Peter's, or the classical statue of Napoleon, with its emphatic note of homage, in the courtyard of the Brera in Milan may be noted here. But his most impressive qualities are to be found in the lively grace of his *Hebe* (Pinacoteca, Forlí), the sculptural sensitivity of his *Venus* (Palazzo Pitti, Florence), or the feminine charm of Pauline Borghese as a classical goddess (Borghese Gallery, Rome).

Painting

Neo-classical painting was inhibited by the aesthetic ideals of the movement, which were essentially sculptural and formalist. The German

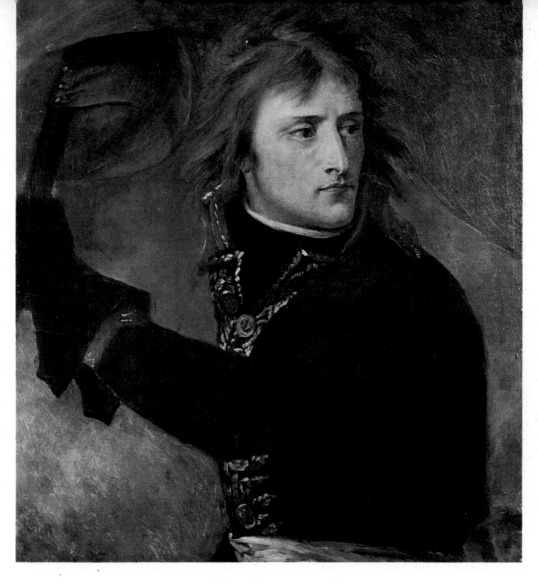

Antoine-Jean Gros,
'Bonaparte Crossing
the Bridge at Arcole'
(Louvre, Paris)

Opposite page,
above: Jacques-Louis
David, the 'Rape of the
Sabines' (Louvre, Paris)

Opposite page,
below: Jacques-Louis
David, 'The Death
of Marat' (Musée
Royal des Beaux Arts,
Brussels)

painter Mengs was more important for spreading the new artistic creed than for his own art, as can be seen from his cold *Parnassus* in the villa Albani at Rome. A man who greatly admired Mengs' ideals was the American, Benjamin West (1738–1820) who settled in London in 1763. He made a great impact by imposing a classical composition upon figures in contemporary dress – a fashion which was widely imitated in both England and France. In Italy, Andrea Appiani, from Milan, painted some good portraits, when he was not overcome by mythology or floundering in rhetoric celebrating the glory of Napoleon. In Germany Angelica Kauffmann maintained sensibility; all the rest were mediocre. Neo-classical painting was rescued, however, by the stimulus given it by Jacques Louis David (1748–1825), even though his many followers were in fact preparing the way for Romanticism. Within the Neo-classical framework, David had great resources of rare, pictorial energy, as can be seen in the delicate portraits of the Sériziats (Louvre, Paris), painted in the 18th-century manner, or in the forward-looking realism of *La Maraichère*, in the Lyons Museum. There is a moral overtone in the *Oath of the Horatii*, in *Marcus Brutus* and the *Rape of the Sabines*, (Louvre, Paris), which in republican times finds expression in David's respect for the fallen hero in his *Marat Assassinated* (Musée Royale des Beaux Arts, Brussels). It was this note of exaltation of antique and heroic virtue that saved him from mere rhetorical adulations of Napoleon.

Neo-classicism, above all in France, was nevertheless harnessed by the Napoleonic cult, and risked becoming simply an adulatory style. In the field of decoration and furniture it gave rise to the Empire style, with its restrained, and sometimes exquisite, elegance of forms and rhythms. But even in this more hazardous aspect, Neo-classicism opened new roads, and within the school of David, Antoine Jean Gros his pupil, was already anticipating the vigour, the involvement and passion of Romanticism.

ROMANTICISM AND REALISM

At the beginning of the 19th century, reaction to Neo-classicism, and sometimes Neo-classicism itself, gave birth to what eventually became Romanticism – the most important artistic movement of the first half of the century. Even before its emergence in the figurative arts, Romanticism took shape in literature, the theatre, music, and in a general transformation of taste and thought. Throughout its history, Romanticism marked a complete break with the ideas of the past. It represented vindication of the individual and his changeable personality, of sensitivity, emotion and inner values. Against abstract principles were set the fluctuating reality of life, the infinite rhythm of nature and the dramatic course of history. Against the cold rule of reason was set the power of feeling, passions and imagination: against the unwavering absolute, the anxiety of the doctrine of subjectivism. It was a perpetual appeal to the self, which set itself up against everyone and everything, as a more genuine alternative to them. Together with all this, the very concepts of art changed, too. The idea of free creation, based on subjective values, came to the fore. Whereas Neo-classicism,

Francisco de Goya, the 'Executions of 3rd May, 1808' (Prado, Madrid)

Francisco de Goya, the 'Sunshade' (Prado, Madrid)

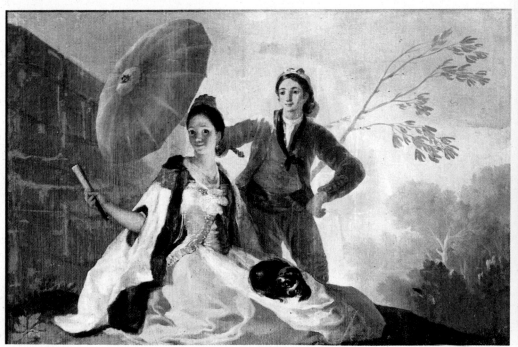

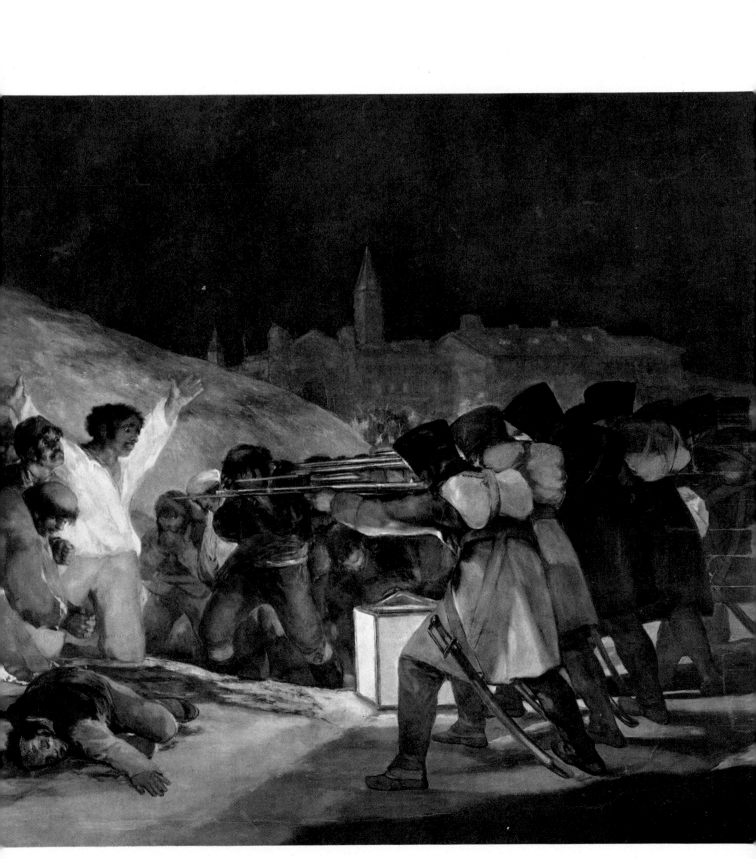

Francisco de Goya, the 'Execution', tempera

peaceful, comfortable life. This was the source of the inequalities and uneasiness which entered into, and formed part of, this same Romantic repertoire. Whereas the Classicist felt himself the master of reality (even when it was merely the product of his own insensitivity and invention), reality seemed to torment and browbeat the Romantic. The elation of individualism became isolation; emotional tension soared to the ultimate. Consciousness of carrying subjective beauty within one's being can lead to aestheticism and forced attitudes; the exasperation of passion can become an incentive to adventure, to restless wandering, to the disorderliness of a bohemian

Francisco de Goya, 'Village Bullfight'
(Academy of S. Fernando, Madrid)

Francisco de Goya, the 'Family of Charles
IV' (Prado, Madrid)

based on imitation of the ancients and the inspiration of an evolved ideal beauty, claimed that noble form and sublime content have more value than individual expression, Romanticism refuted this, firmly opposing it with its own subjectivism and the sometimes ostentatious pursuit of feeling. In fact it saw in Neo-classicism an artificial detachment, a lack of ability to adapt to the reality of imagination, an elaboration of fictitious and artificial museum-type beauty.

But progress in the new direction was neither simple nor peaceful. The many values put forward by Romanticism rejected all external pressure, restraint or moderation. But at the same time they were in conflict with the artistic dullness of the rising bourgeois society which was greedy, selfish and pretentious, placing before everything its own material interests and its own desire for a

life. Hence the attitude, occurring frequently in many Romantic writers and artists, of considering oneself at one and the same time a victim, an exile and a rebel. Hence the inclination to flee from reality into dreams, imagination, or nostalgia for an idealised unreal mythical past – especially for the Middle Ages. Even some of the more eccentric aspects of Romanticism – a taste for the mysterious, the appalling, the sinister or the bloodthirsty – seem to be yet another aspect of escape from unpleasant, uncontrollable realities.

Dramatic and sentimental subjects, inspired by literature, history, or descriptive anecdote, were the most frequent Romantic themes. In content their aim was frequently the achievement of emotional rather than artistic value. Consequently, in reviewing Romantic art it is necessary to reject the many examples of the pathetic,

sugary, theatrical or simply banal, for the great works of Romanticism will be found elsewhere: either in compositions rich in originality, imagination and impetus, or else in that landscape painting which is now understood to be the reflection of an attitude of mind.

Goya

Spain made a unique but exceptional contribution in the painting of Francisco Goya (1746–1828). From his native land he inherited an extraordinary artistic verve that could be mystical, tragic or satirical. His beginnings were in the 18th century, in opposition to the cold Neo-classic plasticism that Mengs was advocating from Madrid. Great freshness of colour and skilful freedom of composition inspired the *Sunshade*

(Prado, Madrid), *Youth and Old Age* (Lille Museum) and the frescoes of 1798 in the dome of S. Antonio de la Florida in Madrid. But a restless fervour and an amazing power of characterisation already enlivened Goya's early portraits – from the flame pink of the little *Manuel Osorio de Zuñiga* (Metropolitan Museum, New York), painted in 1788, to the *maja*-like insolence of black lace and pink skin in the portrait of Doña Isabel Cobos de Porcel (National Gallery, London); from the portrait of the *Family of Charles IV* (Prado, Madrid), whose ridiculous inanity Goya denounced, although he was a court painter, to the portrait of the Marquisa de la Solana (Louvre, Paris), a symphony of subtle greys on which red ribbon blazes, or to the portrait of the young Señora Sabasa García (National Gallery, Washington),

581

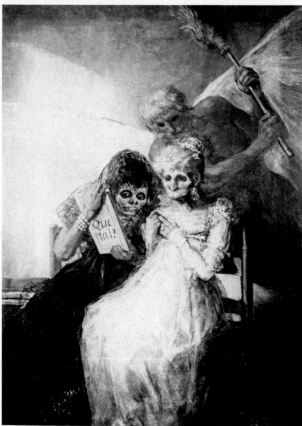

in her gold and black shawl. The pulsing life in the youthful *majos* and *majas* led him to a sensual search, in luxurious colour, for the comparison between the *Maja desnuda* and the *Maja vestida* (Prado, Madrid), and progressed, by about 1810, to *Majas on a Balcony* (Metropolitan Museum, New York), from which Manet subsequently drew inspiration.

The French Revolution inspired Goya with a liberal outlook, which rendered him ever more intolerant of the reactionary and backward climate of his own country. From this period (1793) came the hasty, summary, biting engravings of the *Caprichos*, denouncing the superstition, bigotry, baseness and corruption of Spain. This denunciation is symbolised in the etching *Fantastic Vision (The sleep of reason produces monsters)*, in which the sleeping writer is surrounded by a cloud of terrifying bats and vampires. Moreover, this was the world that was to be transformed expressionalistically, in a mixture of enthusiasm and coarseness, into the distorted figures, between dazzling whites and violent blacks, in the *Pilgrimage (Fiesta) of S. Isidro* (Prado, Madrid).

When the Napoleonic invasion of Spain took place, Goya reacted violently, and with appalling realism denounced the *Disasters of War*. The suppression of a revolt of the people in 1808 gave him the inspiration for the *Executions of the 3rd of May* (Prado, Madrid), a violent treatment of a contemporary theme. Goya, however, experienced for himself the most significant moments when, in 1819, before his exile in Bordeaux, he shut himself up, deaf and ailing, in a house on the outskirts of Madrid which the local people called 'Number 5, the deaf man's house'. The paintings which decorated it (now in the Prado) indicate frightening nightmares, obsessions of panic and bloody visions. Among them are *Saturn Devouring His Son*, the devilish *Witches' Sabbath*, and the appearance in the sky, above a terrified crowd, of the spectre of a Colossus.

England

The major English Romantic artist was William Blake (1757–1827), whose work was unknown except to the cognoscenti during his life-time, but the significance of which has been increasingly recognised by later generations. He was a painter, illustrator and poet, obsessed by Milton, Dante and the Bible, an admirer of Michelangelo, who

Above: *Francisco de Goya, 'Doña Rita de Barrenechea, Marquesa de la Solana y Condesa del Carpio' (Louvre, Paris).* Left: *Francisco de Goya, 'The Old Women' (Musée des Beaux Arts, Lille).* Opposite page: *Francisco de Goya, 'Funeral of the Sardine' (Academy of S. Fernando, Madrid)*

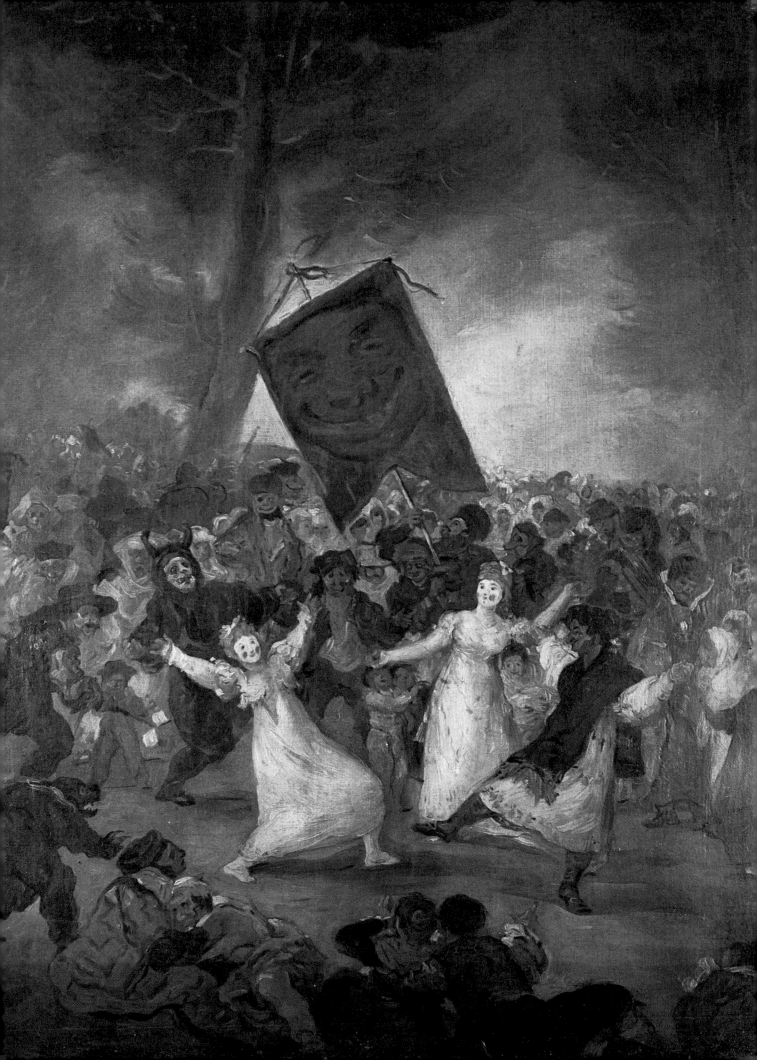

*John Constable, 'Stonehenge',
watercolour (Victoria and
Albert Museum, London)*

with a peculiar use of tempera, created mystical paintings which were visionary and symbolistic, beyond the bounds of reality: 'I do not notice that which I see with my mortal eyes'.

His older friend and contemporary the Swiss Heinrich Füssli or Fuseli (1741–1825) arrived in London in 1764. A fanatical admirer of Michelangelo and Shakespeare, he introduced in his careful style subtle allusions to the erotic or to the world of nightmares. In his *Obsession* (Goethe Museum, Frankfurt), for example, there appears to a young girl, restlessly tossing in her

sleep, the nightmare figure of a gigantic and devilish horse's head. A meeting with Blake was decisive for Samuel Palmer (1805–81) and during the time he lived in the Valley of Shoreham, Kent, his work is very much in the vein of the older man.

Possibly the major English contribution however, was in landscape painting. This had moreover, deep 18th-century roots in the romanticising taste of the English for nature untamed, for the seashore, for natural parks, as already revealed by Gainsborough. In the second

*John Sell Cotman, 'Beach with
Boats' (Tate Gallery, London)*

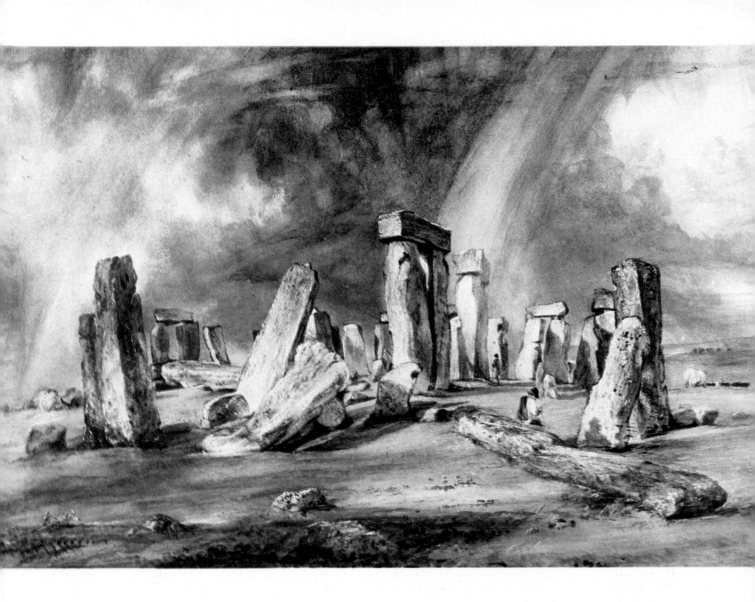

half of the 18th century there had spread to landscape painting, especially in the work of Girtin and Cozens, the application of the technique of water-colour, evocative – fluid, receptive to changing tones and to atmospheric effects. One particular group of artists, among them John Crome (1768–1821) and John Sell Cotman (1782–1842), gave birth to a pre-Romantic landscape of great subtlety and freedom. Richard Parkes Bonington (1802–28) who worked in France, painted water-colours of marine subjects. Their light palette and free handling were much admired by Delacroix.

However, there are two great English landscapists that stand out above all the rest. One is John Constable (1776–1837) who was, for the French Romantic painters, the great revelation at the Paris Salon of 1824. If he appears pre-occupied with his finished technique in his more famous works – such as the *Hay Wain*, or the *Cornfield* (National Gallery, London) – Constable reveals in more spontaneous works, as in his

studies and sketches, a very high sensitivity. Naturalistic and lyrically rhythmic, this sensitivity changes in its liveliness of tone, in the subtlety of its relations, in the transparent luminosity of

Henry Fuseli, 'Lady Macbeth' (Tate Gallery, London)

Joseph Mallard William Turner, the 'Temeraire Being Towed into Dock' (National Gallery, London)

skies, with a fine play of broad draughtsmanship, energetic brush strokes and a fluid touch. *Wivenhoe Park* (National Gallery, Washington), *Weymouth Bay* (National Gallery, London), *Salisbury Cathedral* (National Gallery, London) are works of revolutionary freshness.

The other great English landscapist is Joseph Mallord Turner (1775–1851). When he succeeds in freeing himself from a certain academicism or from nostalgia for the 'heroic' landscape of 18th-century derivation, then (especially in the works in the Tate Gallery in London) the great, fervid Turner is revealed. Here is a painter who melts every concrete aspect of reality into an atmospheric envelopment of lights and glowing colours, into a tissue of intertwined brush strokes which, lacking concrete relationships, seems at times to be an anticipation of contem-

porary, non-figurative painting. Certain storms at sea, certain blizzards, certain mist effects, with light piercing through, or with intense shadows, constitute his most evocative work. A curious forerunner of modernity can be observed in *Rain, Steam and Speed* (National Gallery, London), depicting an illuminated train travelling across a bridge between curtains of rain and mist.

Another, later, development of English Romanticism was the pre-Raphaelite movement, encouraged by the aesthetic theories of Ruskin, who set the purity of the 15th-century Italians against the frivolity of 18th-century art and against the banal decadence of the then contemporary art.

The movement established itself in 1848, almost as a mystic brotherhood, on a co-operative foundation instituted by John Everett Millais

John Everett Millais, the 'Carpenter's Shop'
(Tate Gallery, London)

Dante Gabriel Rossetti,
'Beata Beatrix' (Tate
Gallery, London)

(1829–96), Ford Madox Brown (1821–93), William Holman Hunt (1827–1910), Thomas Woolner (1823–92) and the Italian by origin Dante Gabriel Rossetti (1828–82) who was also a poet. His dreaming *Beata Beatrix* (Tate Gallery, London) is one of the most characteristic works produced by the movement. Into this movement came latterly Edward Burne-Jones (1833–98), a pupil of Rossetti's, with eurhythmic cadences and fascinating linearity, as in the *Golden Staircase* and *King Cophetua and the Beggar Maid* (Tate Gallery, London).

Pre-Raphaelitism disseminated that impulse, idealistic and mystic in its implications, towards a return to the purity and simplicity of the primitives, which recurred in Romanticism and which was seen in the German Nazarenes in Rome and the 'purists' of Tuscany and Rome.

Against the artistic sterility of these groups English Pre-Raphaelitism placed a more explicit desire to swim against the stream. It sought to be 'non-contemporary' (rejecting all conventionalism), to search romantically for a poetic evasion in a lost world of unreal and languid beauty, a world of the mythical chivalry of other times, of a mysticism which can redeem the everyday. It was a subtle and fascinating aesthetic.

France

France made an essential and highly significant contribution to Romanticism. Symptoms of it had been visible at the very heart of the Neoclassicist school, and as in the energetic drive and descriptive power of the Napoleonic battles of Gros, the sensual and luminous melancholy of

Prud'hon, and the decadent *sensiblerie* of Gérard.

A foretaste of Romanticism occurred at the Salon of 1819 when Théodore Géricault (1791–1824) exhibited his *Raft of the Medusa* (Louvre, Paris). The painting was inspired by the true episode of a shipwreck, but what exalts it to the plane of genius is the expressive power of passions, the contrast between the fragile human cargo of the raft, breaking up, and the raging elements, the huddled, confused mass of the living and the dead, and the brightly coloured sea and sky. However, the complete and controversial launching of Romanticism did not take place until the 1824 Salon, when Eugène Delacroix (1798–1863), who had already shown his tragic vein with *Dante's Boat*, exhibited, in memory of the struggle of the Greeks against Turkish oppression, the livid, desolate *Massacre of Chios* (Louvre, Paris). Cultured, refined, critically alert, Delacroix possessed great ability as a colourist – a quality pervading all his work. 'Colour dreams, sings and speaks: it is the music of a picture', he stated and, knowing his own power, he added, 'Give me even mud, and I can make of it the brightest female flesh'. With powerful harmonies

Théodore Géricault, 'Horse Races in Rome' (Louvre, Paris)

and clever contrasts of colour he developed his open, evocative, dynamic forms. A symphony of colour is produced by the bloody, incendiary fury of the *Death of Sardanapalus* (Louvre); amid the greys, browns and blacks of the combatants and the fallen, the tricolour flag is raised in the light of morning in *Liberty Leading the People* (Louvre), an evocation of the 1830 revolution which united the workers and the bourgeoisie; in a quiet pattern of intimate, filtered light sit the *Algerian Women* (Louvre), picturesquely dressed, in careless idleness. Delacroix's journey to Algeria and Morocco in 1832 not only suggested to him the exotic orientalism which became fashionable in Romanticism, but also taught him the secrets of vivid luminosity in heightened colour. This enthusiasm for intensity was expressed in the *Parade before the Sultan of Morocco* (Bührle Collection, Zürich) and in the *Jewish Wedding in Morocco* (Louvre), and was followed by pictures of game traps, wild animal hunts and horses fighting or galloping on the seashore. An

echo of this is found in the *Entrance of the Crusaders into Constantinople* (Louvre) of 1840, or in *Jacob Wrestling with the Angel*, a mural in St Sulpice.

Since a great part of Delacroix's activity developed, at least in the arbitrary opinion of the public and certainly in Delacroix's own mind, into a kind of perennial duel with Jean Auguste Dominique Ingres (1780–1867), it is impossible to dissociate these two artists. Certainly Ingres, who had spent a long time in Rome, dominated by Raphael, was considered the leader of the classicising school, opposed to Romanticism, and paying homage to academicism in the pseudo-classicism of the *Apotheosis of Homer* or in the orthodox nude of the *Source* (both in the Louvre). Undoubtedly Ingres, on the artistic plane, represents by his lucid, 'honest' drawing the antithesis of the flaming, leaping colour of Delacroix. Yet it is easy to see Romantic cadences in Ingres: they are occasionally visible in the chaste delicacy, even intense colour, of the luminous *Grande Baigneuse* (Louvre); in the red

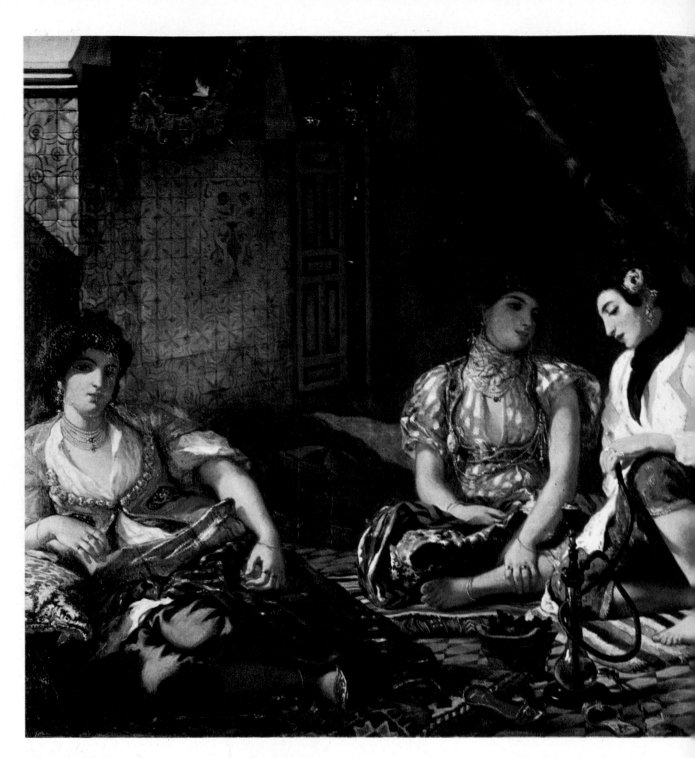

velvet in the portrait of the beautiful Mme de Sennones (Nantes Museum); or in the sinuous line of the long nude back of the *Odalisque* (Louvre); in the violent expressive distortions, which are certainly not classical, in *Jupiter and Thetis* (Aix Museum); in the *Odalisque with Slave* (Fogg Museum, Boston), or in the intertwining nudes in the *Turkish Bath* (Louvre).

Another vital aspect of French Romanticism was landscape painting. This came to the fore when, on the initiative of Théodore Rousseau (1812–67) a group of artists – among them

Diaz, a fiery colourist, the more subdued Dupré and Troyan, later a painter of animals – abandoned Paris, forgot academic precepts and set out to rediscover the authenticity of nature. They settled in the little village of Barbizon on the edge of the forest of Fontainebleau. Strongly anticipating Realism, to which the Barbizon school (as it came to be known) attached itself, these landscape artists steeped themselves in the solemn, austere poetry of the earth and the forest.

Camille Corot (1796–1875), the greatest, most lyrical, most fascinating French landscapist, was

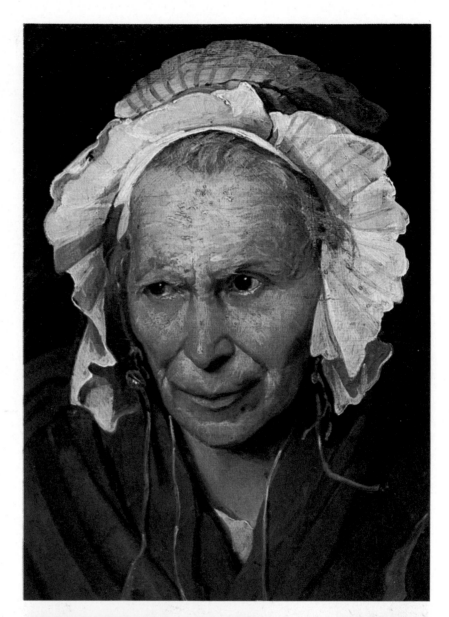

Eugène Delacroix, 'Algerian Women' (Louvre, Paris)

Above, right: *Théodore Géricault, one of the 'Portraits of the Insane' painted in the clinic of Dr Georget (Musée de Lion)*

Eugène Delacroix, 'Liberty at the Barricades' (Louvre, Paris)

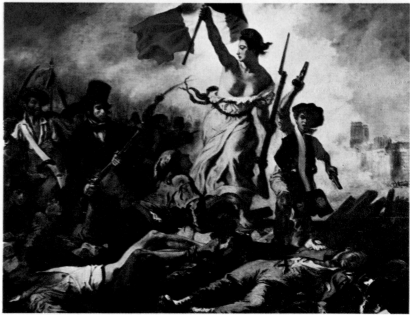

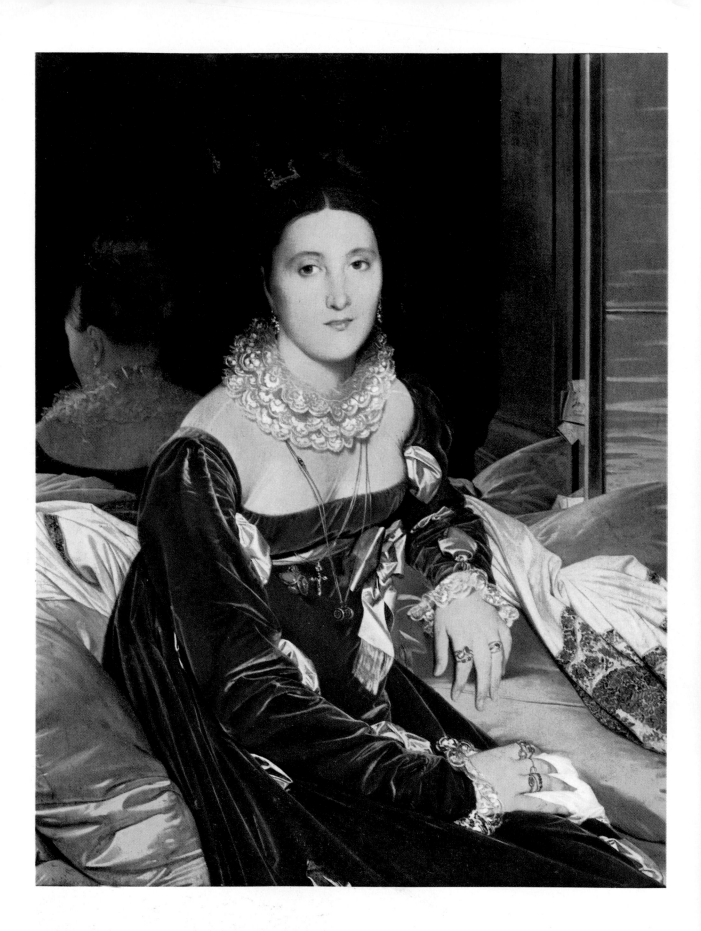

Jean-Auguste-Dominique Ingres, 'Madame de Senonnes'
(Musée des Beaux Arts, Nantos)

Jean-Auguste-Dominique Ingres, 'Raphael's House in Rome' (Louvre, Paris)

Jean-Auguste-Dominique Ingres, 'Portrait of Louis-François Bertin' (Louvre, Paris)

Jean-Auguste-Dominique Ingres, 'La Grande Baigneuse de Valpinçon' (Louvre, Paris)

in frequent contact with the Barbizon school. He also spent long periods in Italy where, closely associated with academic teaching, he learned the clearly pronounced tonal effects and luminous impressions of a landscape steeped in light. Along with several Roman vistas, the sketch of the *Bridge at Narni* (Louvre) gives ample evidence of this process. From the youthful *Chartres Cathedral*, through the *Bridge at Nantes* and *Ville d'Avray*,

a series of landscapes developed which culminated in the *Douai Belfry* of 1871 (also in the Louvre), in which the treatment of the light amply demonstrates Corot's identification with the new Impressionist outlook.

France made the most significant contribution to sculpture, which had been predominant in the Neo-classical period, and which – probably for this reason – was overshadowed by Romanticism. François Rude (1784–1855) found a fiery impetus in the heroic stance of the statue of Marshal Ney and the *Marseillaise*, a high-relief on the Arc de Triomphe in Paris. David d'Angers (1788–1856) engraved medallions of some of the most important people of his day, and Antoine Barye (1796–1875) gave a bursting energy to his wild beasts and his groups of men and animals engaged in combat.

The picture of Romantic art in Germany is much more complex. The first reaction against Neo-classicism was found in that curious 'confraternity' of Germans the so-called Nazarenes, who assembled in Rome in the monastery of S. Isidoro, around Friedrich Overbeck (1789–

Camille Corot, 'Remembrance of Mortefontaine' (Louvre, Paris)

Opposite page, above: *Camille Corot, the 'Fountain of the Villa Medici' (Froidevaux Collection, Paris)*

Opposite page, below: *Camille Corot, 'Self-portrait with Palette' (Uffizi, Florence)*

1869). To this group belonged, among others, the landscapist Joseph Anton Koch (1768–1839), Julius Schnorr von Carolsfeld (1795–1872), and Peter Cornelius (1783–1867).

The aspirations of these painters towards an ingenuous and 'pure' form of primitivism, repudiating the complexity of the later Re-

594

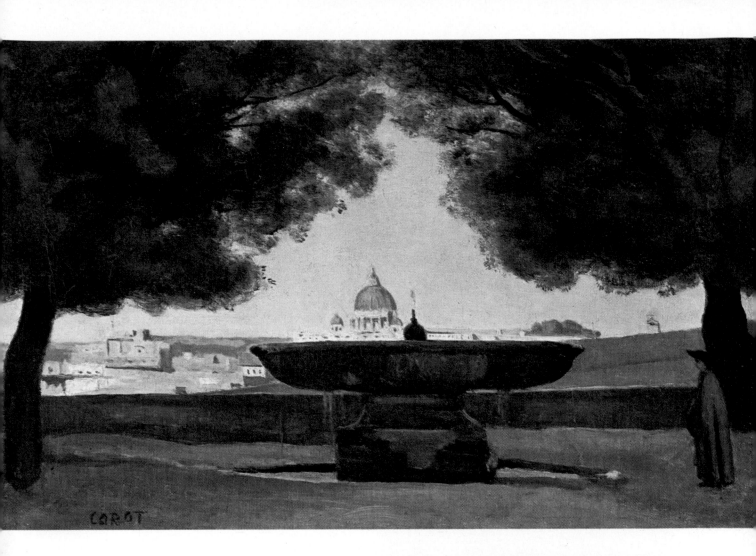

CAROT

naissance, did not produce very substantial results. The movement came to an end with the bitter frescoes of the *Adventures of Joseph in Egypt*, executed for the consul-general Bartholdy (Staatliche Museen, Berlin), or the complicated murals illustrating stanzas from Dante, Tasso and Ariosto in the casino of the Villa Massimo in Rome, only to re-echo subsequently in the laborious historical painting of Cornelius or the constrained *Triumph of Religion in the Arts* (Städel Institute, Frankfurt) by Overbeck, in which culture takes the place of art.

Another German group of painters of the greatest importance had its beginnings in the peculiar 'romantic' Neo-classicism of the Dane Asmus Jakob Carstens (1752–98), and in the work of the Norwegian Cristian Dahl (1788–1859), who developed his style in Copenhagen but later settled in Dresden. Noted for their pantheistic abandon, figure painting and rather childish portraits, these painters included Otto Runge (1777–1810) and for landscape, Caspar David Friedrich (1774–1840). The latter's works include *Chalk Cliffs of the Island of Rügen* (Rhein-

hold Collection, Winterthur), *Men Looking at the Moon* (Gemäldegalerie, Dresden), and the *Shipwreck of 'Hope'* (Kunsthalle, Hamburg).

Moritz von Schwind (1804–1871) left his native Vienna to settle in Berlin. There, continuing the Austrian taste established by Grillparzer in poetry and Schubert in music, he was a fresh and vigorous interpreter of fables and romantic anecdotes, as in the *Farewell at Dawn*.

Sculpture in Germany, on the other hand, was scant, with the exception of the pure grace, born of earlier Neo-classicists, which Gottfried Schadow (1764–1850) occasionally achieved.

In Italy, where Neo-classicism left an overpowering legacy in the academies, the lack of political unity gave rise to regional schools of art bound up in provincialism. In Milan, the most outstanding figure of Romantic painting was the Venetian Francesco Hayez (1791–1882). His reputation, however, stems only in a lesser sense from his historical paintings or those with historical-dramatic themes – no matter how typical of Romanticism may be his *Kiss* or his *Our Lady of Sorrows* in the Brera. More important are certain fine portraits of his such as the one of

Juva-Branca (Gallery of Modern Art, Milan). There was a solitary attempt by the Lombard, Giovanni Carnevali, known as Il Piccio (1806–73), to re-introduce a fluid type of brushwork with traditional treatment of light. Tuscan purism yielded no appreciable results. In Romantic painting, the work of Antonio Fontanesi (1818–82) of Turin, either through the influence of the Swiss landscape painters Diday and Calame, or through his contact with the Barbizon school and the English landscapists, was pervaded by a lyrical naturalistic sensitivity, and showed delicate effects of atmosphere and light in turbulent colour.

Realism

If Romanticism dominated the first half of the 19th century, Realism occupied its second half, and even penetrated beyond it. The change of direction, which revealed itself towards mid-century, was sudden and disconcerting for a public accustomed to the mild revelations of the Romantic period; and it was positively alarming for bourgeois taste hitherto satisfied by subjects which might be dramatic or sensational but

Carl Spitzweg, the 'Poor Poet' (Neue Pinakothek, Munich)

François Rude, 'La Marseillaise', high relief, Arc de Triomphe, Paris

597

which were still innocuous because they were far removed from the reality of daily life.

In fact, influences outside the field of art were leading to a realistic outlook. Scientific discovery and technical changes of the time induced people to take notice of facts and concrete experiment; science, in full development, sought to explain everything, without supernatural intervention or subjective judgment; the theories of evolution, which found in Darwin their great propounder, and subsequently positivist thought drew attention to the dispassionate objectivity of reality and to progress achieved by an inevitable succession of events. In the face of this, imagination, sentiment, passion and emotionalism – the very foundations of Romanticism – could only appear untrustworthy elements and evocative factors even arbitrary and suspect. Imagination, once stimulated by Romantic inspiration, was condemned as an obstacle to the objectivity now advocated, namely research into, and representation of, reality. Here, as in every move towards Realism, reality, the world without, nature – all were taken as models for inspiration. The aim of art became faithful portrayal of the real. 'We have to think only of presenting', proclaimed Flaubert, the author of *Madame Bovary*, later. And rejecting Romanticism, Courbet said further, in support,

'Painting is an essentially concrete art and can only consist of the presentation of things real and existing . . .'

This hypothesis of Realism was, however, extremely generalised; in fact it contained different purposes not easily reconcilable. One must distinguish between, on the one hand, that limited group of artists for whom Realism was a point of departure for a deeper creative commitment and for the assertion, even a controversial one, of new values; and on the other hand that endless mass of artists from many countries, most of whom have now fallen into oblivion, who appealed to Realism for self-justification. These artists persisted, in the old assumption of complete Realism, in reproducing the real with scrupulous fidelity at the very time when the camera permitted this to be done with far greater objectivity. So as not to deviate from the real they had recourse to devices, as in the case of Meissonnier who, in order to paint his oleograph of Napoleon's retreat from Russia, scattered cottonwool and flour around his studio and dropped imitation snow from above. Others confused 'pictorial' with 'picturesque', evoking scenes with characteristic costumes, backgrounds

Gustave Courbet, 'Funeral at Ornans' (Louvre, Paris)

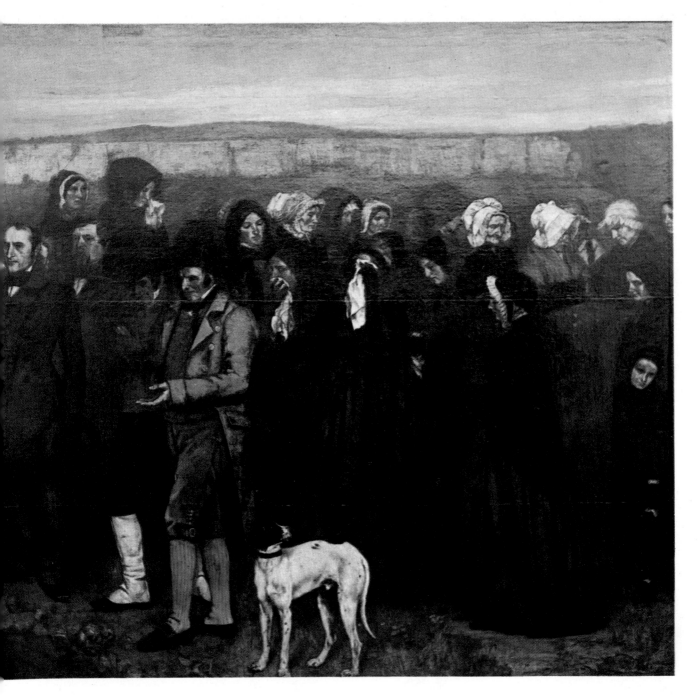

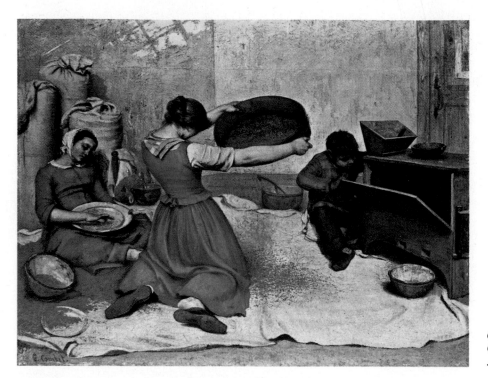

Gustave Courbet, 'Girls Winnowing Corn' (Musée des Beaux Arts, Nantes)

and places, or, like the literary realist, assembled bitter, squalid or miserable aspects of contemporary social life, in which only the outward appearance was described or illustrated. All this had little to do with art.

As regards the other aspect of Realism (the only one which is, in effect, artistically valid) a trio of three great Frenchmen comes to the fore: Courbet, Daumier and Millet. Their artistic involvement was not inspired by any theoretical manifesto but sprang directly from a determination to make the public aware of the issues at stake. It was no coincidence that this happened in 1848 – the year of revolutions. For Courbet, Daumier and Millet, the vital issues were authenticity and frankness, shown in scenes taken from everyday life. These concepts they advanced in opposition to the banal and insipid official painting which the conservative academies, schools of art and Salon juries prized, encouraged and rewarded. They were prepared to set contemporary reality – as harsh as it might be – against bourgeois taste which went into raptures over ugly, bad, paintings like the *Tepidarium* by Bouguereau, or the pretty nudes of Baudry or Cabanel. In short they put the truth, as experienced and suffered by the workers and proletariat, to a society that appeared to have forgotten it. In a gesture of rupture Courbet, at the official review of the 1855 Paris exhibition, set up his stall in the Place de l'Alma and exhibited his works under the sign Realism, revealing a quite different type of artist.

Courbet

Coming from the Franche-Comté, endowed with the solid virtues of a man of the soil, imbued by his friend Proud'hon with socialistic ideas, Gustave Courbet (1819–77), proclaimed that 'one must give art a popular content: for too long my contemporaries have been painting affectedly'. His break with the painting going on around him was complete, not only in subject but in technique: in savage vigour of brushwork, and in sober love of beautiful subjects, thickly laid bituminous colour, powerful chiaroscuro. The pictures produced by Courbet from 1848 to 1849 – *Funeral at Ornans* (Louvre, Paris), with its characterisation of country life and of his country companions on the bare landscape, the *Stone Breakers* (formerly in the Gemäldegalerie, Dresden, but destroyed in 1945), with the social protest of the old stone breaker and his boy assistant, tired out under the pitiless sun; the 'vulgar' interior of an inn in *After Dinner at Ornans* (Lille Museum) – present a new language. Whether he depicts live figures or still-life, soulful nudes or mountain scenes, the captured light of forest or undergrowth, or the marine expanses of water to which the Impressionists later turned, his generous, vital style always comes to the fore, like a lesson in energy and honesty. Precisely for this reason Courbet succeeded, in 1855, in presenting his vast *Artist's Studio* (Louvre) as a realistic allegory of a new type, almost a symbolic synthesis of the society of the day. In this picture

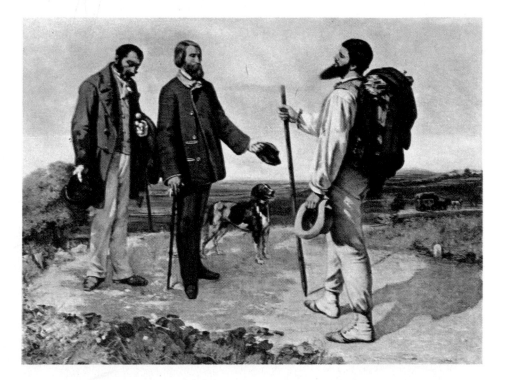

*Gustave Courbet, the 'Encounter'
or 'Bonjour, Monsieur Courbet'
(Musée Fabre, Montpellier)*

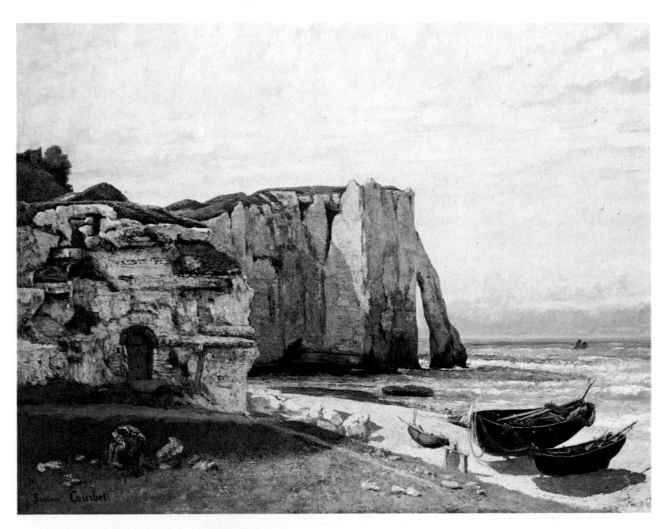

Gustave Courbet, the 'Cliffs of Etretat' (Louvre, Paris)

601

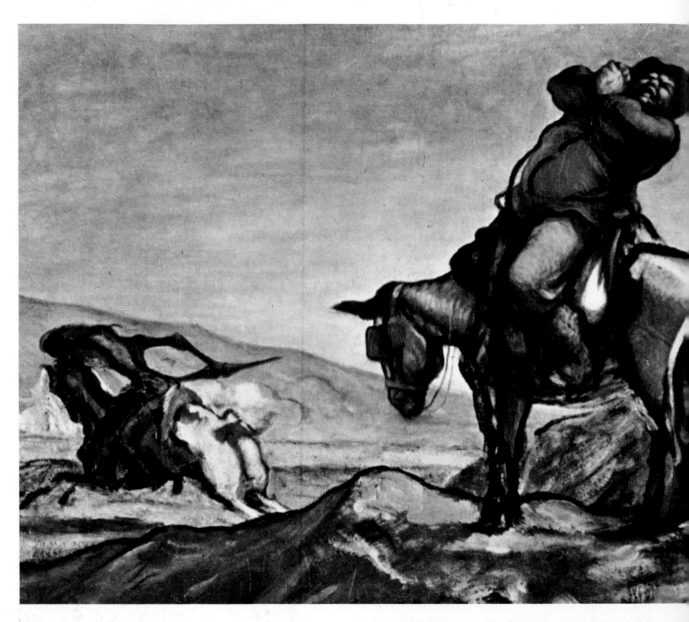

the most varied types of humanity – from the workman and the highlander to the sexton, from the huntsman to the moneylender, from the poor people to intellectuals and critics – such as Champfleury or, in the corner, Baudelaire immersed in his reading, from the beautiful lady in a luxurious shawl accompanied by her husband to the young couple kissing – all these contribute to the crowd, in the dimmed light of the studio, surrounding Courbet who, watched by his nude model, is intent on painting.

Daumier and Millet

While Courbet's life ended with imprisonment (he was accused of having organised the demolition of the column in the Place Vendôme during the revolutionary Paris Commune) and exile in Switzerland, Honoré Daumier (1808–79) ex-

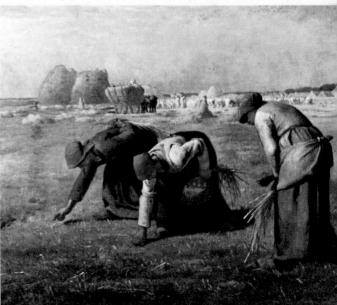

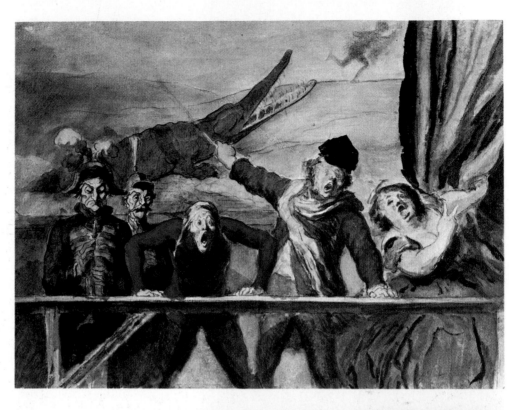

Honoré Daumier, 'Circus
Parade' (Louvre, Paris)

Opposite page, above:
*Honoré Daumier, 'Don
Quixote and Sancho Panza'
(Tate Gallery, London)*

Opposite page, below:
*François Millet, the
'Gleaners' (Louvre, Paris)*

Below, right: *Honoré
Daumier, caricature
of Victor Hugo, from the
'Charivari'*

perienced imprisonment at the very beginning of
his career as a political caricaturist. He was
locked up when, in *La Caricature*, he drew King
Louis Philippe as a pear (in France a 'pear' is
someone who is easily taken in). Political
caricature – in engravings, etchings, and especially
lithographs – always incisive, sometimes of
extreme tension or dramatic power comprised
the greater part of Daumier's creative work. It
was matched in his sculpture, which with
expressionist and distorting plasticity depicted
the political figures of his day, and sketched the
aggressive figure of *Ratapoil*, the despicable agent
provocateur of Napoléon III. This mordant
satire, with a note of human pathos, also
characterised the rich, varied graphic work in
which Daumier attacked the world of judges,
lawyers and accused – that alarming pomp which
calls itself 'justice'. Here he worked in frenzied
knots of lines or violent contrasts of black and
white, and with acute psychological insight. The
same kind of satire appeared, too, in the plebeian
humour with which he captured the common
people of Paris in their daily life, with its
suffering, its vices, its pleasures.

For Daumier painting was a rarer part of his
output, and was generally on a much more
elevated plane. Even so, there was no lack of the
accents of human suffering – as in the pathetic
picture, against the light, of the weary *Washer-
woman* (Louvre), nor of revolutionary influence –
as in the powerful and proletarian *Revolt* (Philips

Wilhelm Leibl, 'Women in Church' (Kunsthalle, Hamburg)

Adolf Menzel, the 'Balcony Room', detail (National Gallery, Berlin)

Memorial Gallery, Washington). But in his painting, together with excellent insistence on anecdote, we find great strength in the violent colour relief and the expressionist distortion. This is visible in the various versions of the *Print Connoisseur*, in scenes from the theatre and in the *Chess Players*, and culminates with astonishing foresight in the phantom-like and almost hallucinatory *Don Quixote* series.

If Daumier took his inspiration from the working classes of the city, François Millet (1814–75) – abandoning Paris for the Barbizon school and settling there – invested the image of the peasant and his relentless toil with a quiet, almost religious solemnity. However much he may appear conventional in his famous *Angelus* or in the humble *Gleaners*, both in the Louvre, he justifies himself, apart from fresh landscapes, by other paintings with a great sense of colour and composition, such as *Harvest* (Louvre) and the *Washerwoman*, or with a most effective intimacy, as in *Peasant Woman Feeding Her Baby* (Louvre). A feeling of the grand manner is also to be found in the picture, the *Sower* (Boston Museum).

Under Realistic influence the same *genre*-painting took on wider horizons. This was demonstrated in France by Constantin Guys (1805–92) not only by his perspicacity in capturing, with taste, aspects of wordly life under the Second Empire, or the seductiveness of the Paris *midinettes*, but by the flowing, mellow and evocative character of his work. These qualities impelled Baudelaire to recognise in Guys the illustrator of 'modern life' reflected as in a mirror.

Realism in other European countries

This surge of Realism extended to some degree into all European countries (although it was weaker in England because of Pre-Raphaelite influence and its stylisation). Its significance was, however, less than in France. In Germany, where Courbet was much admired, he influenced Wilhelm Leibl (1844–1900), who restrained solid colouristic vigour by his strict, confining surroundings as in the *Women in Church* (Kunsthalle, Hamburg) and the *Peasants of Dachau* (Staatliche Museen, Berlin). Independent of any school, Adolf Menzel (1815–1905), almost ahead of his time, painted the *Balcony Room* (Staatliche Museen, Berlin) and then subsequently paid tribute to the rising power of industrial Germany in his realistic *Foundry* (Berlin), painted in 1875.

In Belgium the Realist stream was robust, especially in the vigorous sculpture of Constantin Meunier, who also painted workmen and miners, and in Holland, where Josef Israel painted grey,

Winslow Homer, 'Stag Hunt' (National Gallery, Washington)

melancholy works, full of pathos. In Russia Realism took on the scope of proletarian rebellion, in keeping moreover with the new movements in literature and music. A typical representative of this was Ilya Répin, whose exhausted *Volga Boatmen* won him world fame. In the United States Realism succeeded the ingenuous primitivism of the so-called 'Hudson romantics'; there George Innes was an outstanding painter of landscapes and Winslow Homer of scenes of maritime life.

Realism also asserted itself, without great difficulty, in Italy, but remained attached in outlook to the various provincial schools. There was a Lombard school of Realism, concerned with atmospheric effects, with Giulio Carcano and Mosè Giuseppe Bianchi, while Vincenzo Vela and Giuseppe Grandi gave new Realist stress to sculpture. In Venice, the work of Giacomo Favretto, although always confined to animated anecdote, vibrated with colour, while Guglielmo Ciardi gave a new inspiration to traditional views. There was a school of landscapist Realism in Piedmont, influenced to lyricism by Fontanesi. In Rome the vigorous landscapes of Nino Costa were somewhat reminiscent of the Barbizon school. Neapolitan Realism, when not dominated by the animal painting of

Palizzi, achieved new accents in the colour – pathetic and grev – of Gioacchino Toma, or in that, more bold and lavish, of Michele Cammarano. The most lively experience of Italian Realism, meriting truly European importance if its protagonists had not confined it within the limits of provincial experience, was that of the Tuscan 'Pointillists'. Rebelling against the stifling Florentine academicism and inspired by the epic spirit of Garibaldi, they set out between 1856 and 1861 to depict the truth with the synthetic and abridged technique of clear Pointillist articulation, reflecting tonal effects, with light values and precise colour relations. Abbati, Borrani, Sernesi, D'Ancona, Cabianca and Cecioni (who subsequently dedicated himself mainly to sculpture, however) practised, in an intuitive lyricism, this clearly pronounced syntactic colour and light. Of greater weight, for clear critical understanding and for the culture acquired by the artist in his travels to France and England, was the fine and very sensitive painting of Telemaco Signorini (1835–1901). More independent and laborious was the work of a strong painter, Silvestro Lega (1826–95), including the *Visit* (Gallery of Modern Art, Rome) and, with a colourist synthesis that Cézanne would have admired, the *Strawstacks at Gabro* (Ricci-Oddi Gallery,

605

Giovanni Fattori, 'Cavalryman' (Gallery of Modern Art, Milan)

Telemaco Signorini, the 'Shrine of Riomaggiore' (Marzotto Collection, Valdagno)

Opposite page: *Silvestro Lega, 'Adolescent' (private collection, Milan)*

Piacenza). Alone and unassuming, Giovanni Fattori (1825–1908), from Leghorn, contributed the serious and lonely poetry of the Maremma district of Tuscany, either in paintings of massive structure, like the *Red Cart* (Brera, Milan), or in his many valuable and translucent little paintings starting with the *Terrace of the Baths at Palmieri* (Gallery of Modern Art, Florence), in which Pointillist painting, clearly articulated, achieves strong picturesque effects.

Realistic concessions are to found, moreover, in the 'returning wave' of Romanticism which flowed through the second half of the century. To this belonged, in Germany, Böcklin, famous for his mournful *Isle of the Dead* (Art Museum, Basle), the nostalgic Feuerbach and the prolific,

morbid Von Marées. In Italy this late Romanticism brought with it the colourism of Tranquillo Cremona and the delicate luminosity of Daniele Ranzoni both from Lombardy.

IMPRESSIONISM

Realism brought innovations in the subject matter and meaning of painting, but not in technique. In this respect it even marked a retrospective step through its limitations in imitating reality; its submission to traditional conventions (especially in regard to perspective and local colour of individual objects); its insistence on the plastic treatment of forms.

Edouard Manet

The transition to a substantially new type of painting, to a painting which in its intrinsic coherence deserves to be called 'modern', was made by Edouard Manet (1832–83), and hence the liking for him shown by Baudelaire, Mallarmé and Zola. 'To belong to one's own times and depict what one sees . . .', he used to say, and this did not remain an abstract intention. Cultured, refined, with excellent social contacts, and coming from a bourgeois town family, Manet was a paradoxical case. Works like *Déjeuner sur l'herbe* and *Olympia* shocked bourgeois taste much more than certain Realist works with a more explicit social message. In the Café Guerbois, he stimulated noncomformist discussions on art which influenced a whole generation of artists and taught people to look at contemporary reality with an unprejudiced eye and grasp it with freshness and rapidity. Nevertheless Manet had neither the intentions nor the spirit of a revolutionary. No one loved the old masters more than Manet – the great Venetians and Velásquez, Frans Hals and Goya – whom he copied at the Louvre or studied on his travels. Secretly he valued praise, recognition and the glory of 'being accepted at the Louvre' – an honour which some critics idiotically attempted to deny him, even after his death.

In 1863, at the Salon des Refusés – established by Napoleon III for those turned down by the official Salon – *Déjeuner sur l'herbe* was exhibited (Jeu de Paume, Paris). The work is not intentionally naturalistic; the theme is inspired by Raphael, and the wooded background is derived from Venetian landscapes. What shocked the public was the intrusion of a nude young woman between the two men in conversation, wearing

Jean Baptiste Carpeaux, the 'Dance' (Opéra de Paris)

Opposite page: *Edouard Manet, the 'Fifer' (Jeu de Paume, Paris)*

contemporary dress. What amazed the connoisseurs was the clear luminous palette, and the juxtaposition of frankly disconnected colours. In 1865 the shock was repeated with *Olympia*. Scandal over the 'insolent vulgarity' of the adolescent courtesan, naked on a silken couch, to whom the Moorish serving woman is offering a bunch of brilliantly coloured flowers, was hypocrisy in the face of the literature and customs of the period. Moreover it was not Realism, being quite obviously derived from the Venus' of Titian and the *majas* of Goya. But there was something else that was not acceptable: the elimination of chiaroscuro of solid objects, of dense shadows; the juxtaposition and contrasting of light colours; the frank, speedy brushwork; the effect of flattening shapes; the magical colour composition of light on light and dark on dark. This was repeated in the *Fifer* (Jeu de Paume, Paris) where the figure is strongly thrown into relief against a space suggested but not described. The *Execution of Maximilian of Austria in Mexico*

609

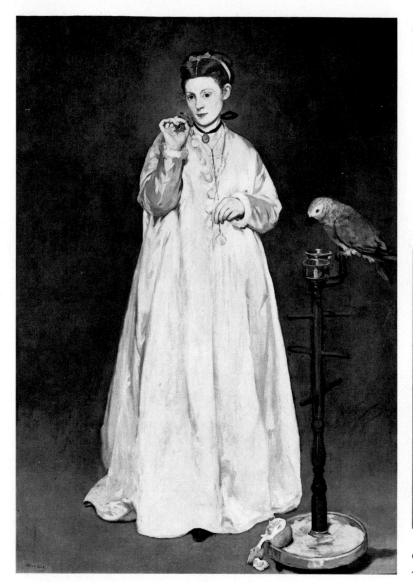

Edouard Manet, 'Woman with Parrot'
(Metropolitan Museum, New York).
Below: detail

Opposite page: Edouard Manet, 'Le Déjeuner
sur l'Herbe' (Jeu de Paume, Paris)

(Mannheim Museum) saw this frank and rapid technique applied to a contemporary event but one which, in contrast to Goya's famous precedent, was looked at by the artist with detachment, almost indifference.

After 1870, Manet was attracted to the Impressionists – represented very effectively by the fine *Monet Painting in the Studio-boat* (Neue Pinakothek, Munich) – whom he admired, although with some reserve. The solitary *Rowers at Argenteuil* (Tournai Museum), or *Boating* (Metropolitan Museum, New York), with their unusual definition and abbreviations on the blue of the waves, are an incursion into the milieu beloved by Claude Monet and the Impressionists, but they remain Manet himself. Similarly the exquisite colour variations of the interior depicted in *La Servante de Bocks* (National Gallery, London) recall Degas' thematic material, but remain within the range of Manet's style. The

same thing occurs in his peaceful farewell to art, the *Bar at the Folies-Bergère* (Courtauld Institute, London), with the blonde barmaid surrounded by a wonderful still-life, the mirror behind her reflecting the movements of the crowd in the foyer. Also far removed from Impressionism is Manet's delicate portrait painting: from the somewhat Spanish browns and blacks in the portrait of Zola (Jeu de Paume, Paris) to the quick, evocative study of Mallarmé smoking a cigar, and the soft pastels in which Manet paid homage to feminine beauty.

One of the most important disciples of Manet's realism was the American Thomas Eakins (1844–1916) who came to Paris in 1866. Four years later he returned to the U.S. where he sparked off a revolution in the methods of teaching painting by insisting on a thorough knowledge of anatomy. His *Gross Clinic*, showing a surgeon operating, caused an uproar.

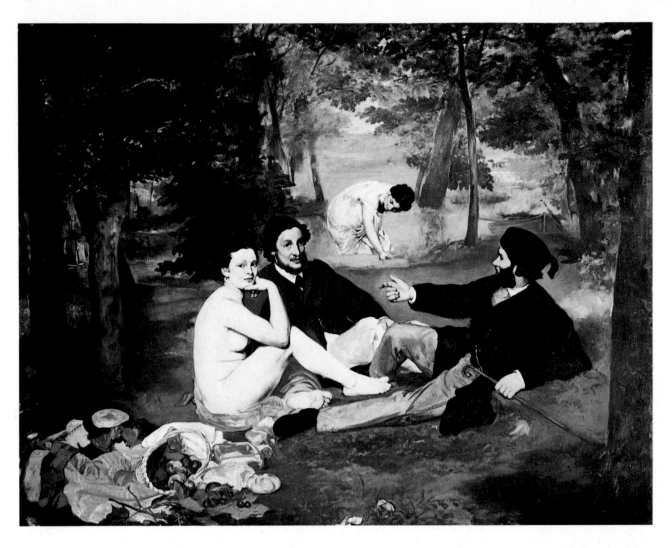

More circumscribed was the position of James Abbott McNeill Whistler (1834–1903), American by birth, Parisian by education, English in his output. A friend of Manet and the Impressionists, an enthusiast for Japanese prints, he brought to Victorian England a taste for the new painting. But, more superficial than Manet, Whistler insisted on the elegant, on beautiful composition, on the exquisite musicality of the image.

The profile of Impressionism

Impressionism, in its short career, was the most lively experience of the 19th century, perhaps even the most revolutionary. The Impressionists established, above all, that reality, seen outside the distorting convention of the studio, breaks down into 'impressions', into optical phenomena, into a vibrant display of splashes of colour and light. Tangible, material reality becomes a volatile metamorphosis of coloured pictures. The aim is to portray the perpetual transience, the endless rebirth, through light

effects, of the infinite universe of pictures which make up the world of vision. The first step taken by the Impressionists was to put 'sensation' in the place of knowledge; changing appearance in place of the material concreteness of objects; fugitive, relative vision in place of lasting reality. Based on the immediate, the fresh and the spontaneous, the 'impressionist eye' demands rapid painting of reality, in full light, fluid and indeterminate. It demands that the work should be an evocative 'impression' and not a carefully finished description. A light palette; breakdown of the compact integrity of forms into pulsating, luminous patches of colour captured with minute touches and dynamic movement; the affirmation that shadows contain colour – these are the coherent results.

The ultimate victory of Impressionism, redeeming the lack of true tonal values and consequent 'atrophy' of our eyes, lay in its discovery of the value of light. Light is colour, life and movement; it is the reason why what we see appears and changes. The series which Monet undertook comprised an experimental

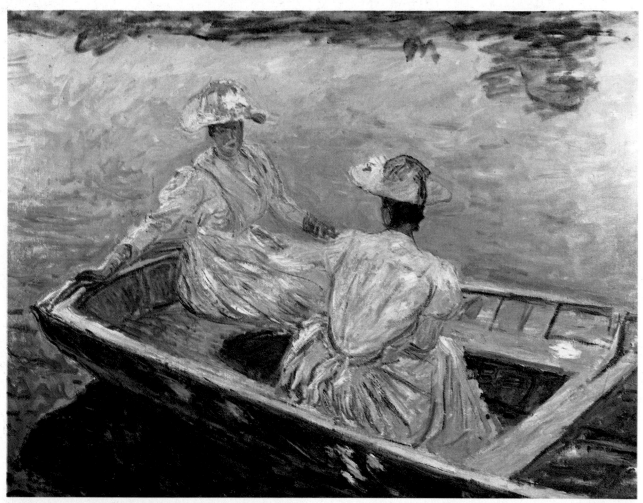

Claude Monet, the 'Blue Boat' (Thyssen-Bornemisza Collection, Lugano)

demonstration of how light, when the point of view (and hence the 'motive') is unchanged, contributes, with its endless variations, to make identical things appear different: the same haystack or the same cathedral façade gives rise to vastly differing pictures. The material object loses its definition, becoming light modulation.

This was the revolution for which the public and critics alike could not forgive Impressionism, when, in 1874, its first exhibition was held at the studio of the photographer, Nadar. The innovations of Impressionism were disconcerting: disintegration of tones and colours in a storm of brush strokes; the juxtaposition of unfused splashes of colour; contrasting colours which, by the optical law of complementary colours, accentuate each other – all this seemed an unbelievable hodgepodge. This reaction was completely ignorant of what, to the contemporary mind, constitutes the indestructible fascination of Impressionist

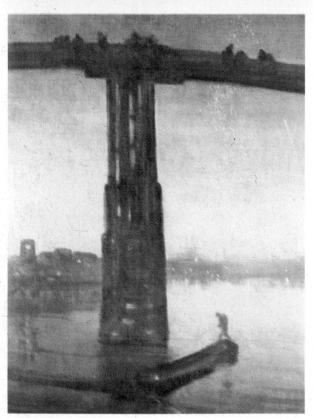

James Abbott McNeill Whistler, 'Nocturne in Blue and Gold' (Tate Gallery, London)

Claude Monet, 'Rouen Cathedral' (Jeu de Paume, Paris)

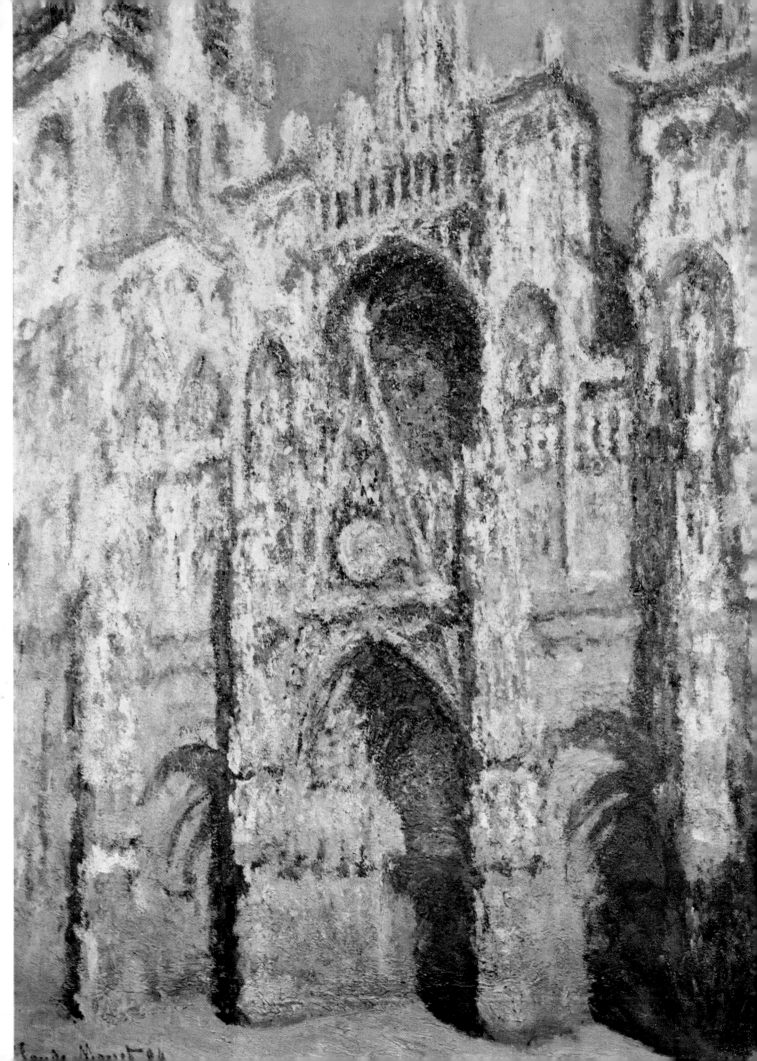

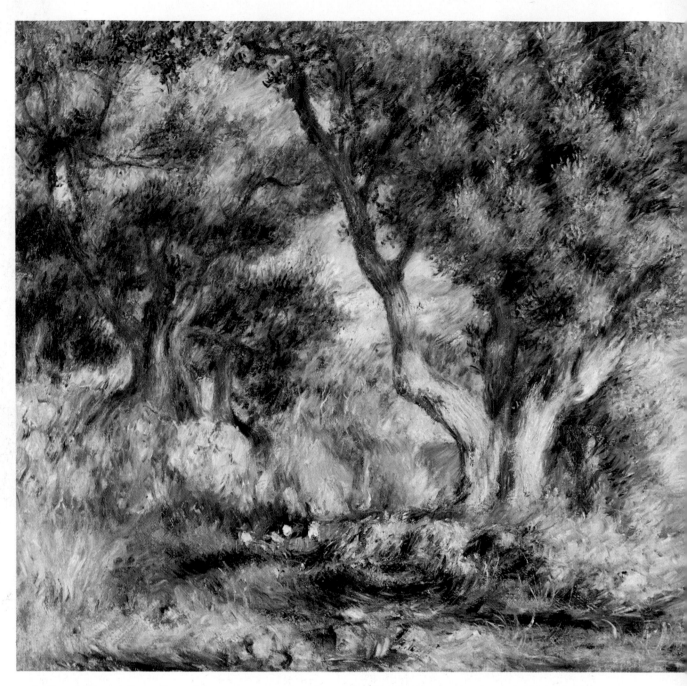

painting: the quality of reaching an exceptional peak of naturalistic happiness, of joy in living, of unspoilt tranquillity.

The period of preparation, spent in forming firm ties and in assiduous research, lasted for almost ten years. It was a period of exchange of experience between two groups: one which had formed at the Académie Suisse with Pissarro, Cézanne and Guillaumin, and another, also dating from 1862, which formed at Gleyre's studio with Monet, Bazille, Sisley and Renoir. To the latter Monet brought a taste for the sunny, lively seascapes to which, on the shores of France between Honfleur and his native Le Havre, he had been inspired by Boudin (1824–98) with his almost Impressionist painting of silvery skies, and the more troubled Dutchman Jongkind (1819–91). Corot, and the masters of the Barbizon school, even Courbet, urged painting in the open air, and the use of a light palette. Discussions at the Café Guerbois spurred the Impressionists on. With the *Femmes au Jardin* (Jeu de Paume, Paris) Monet in 1866, painted in full sunlight. But full light came only in 1869 when Monet vied with Renoir in presenting the aquatic reflections and splashes of sunlight at La Grenouillère on the Seine (Metropolitan Museum, New York; National Museum, Stockholm; Pushkin Museum, Moscow).

The war of 1870–71 dispersed the group and

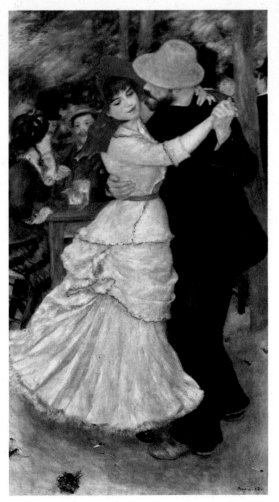

Auguste Renoir, 'Landscape near Menton'
(Museum of Fine Arts, Boston)

Auguste Renoir, 'Mademoiselle Grimprel with a
Blue Ribbon' (Private collection, Paris)

Auguste Renoir, 'Le Bal à Bougival'
(Museum of Fine Arts, Boston)

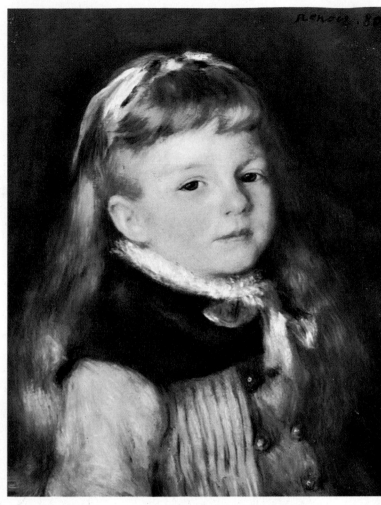

brought the death in action of Bazille, so promising and so generous towards his companions, who were in a perpetual state of poverty. When the group re-formed (Monet and Pissarro had gone to England, where they admired the work of Constable and Turner), the golden period of Impressionism began, and lasted some fifteen years. It was as a result of the 1874 exhibition that, amongst general derision, a malicious critic seized the opportunity from a title of a painting by Monet to create the name 'Impressionism'.

The existence of the group did not stifle the individual personalities. The chief position, by virtue of his vision and determination, was held by Claude Monet (1840–1926), with his many landscapes of Argenteuil, or the movement of the crowd in the light of the Parisian boulevards, or the effects of sun and the smoke of the engines in the Gare St Lazare. Of a similar outlook was Pierre Auguste Renoir (1841–1919), who painted his two masterpieces consisting of the *Moulin de la Galette*, a hymn to happy youth at a local Sunday dance, and the *Swing*, with the flaking light filtering through the trees (both in the Jeu de Paume, Paris). Nevertheless Renoir had,

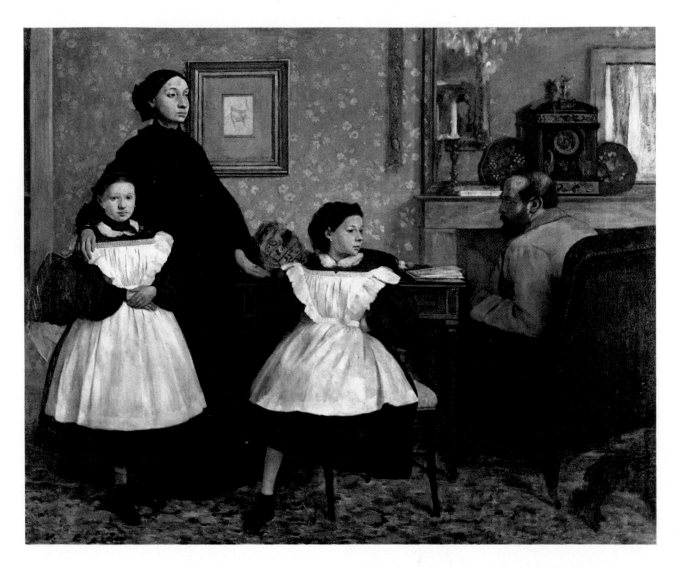

perhaps, a greater propensity for figure painting, as shown by his *Girl Reading* (Jeu de Paume), full of lively reflections, or the *Opera Box* (Courtauld Institute, London), with its lavish colour. An older member of the group, Camille Pissarro (1830–1903) transformed into the new language of light the solid country landscapes of Pontoise and Auvers (*Red Roofs*, Jeu de Paume, Paris; *Ermitage à Pontoise*, Kunstmuseum, Basle), while Alfred Sisley (1839–99) painted extrmely delicate, flowing landscapes, as in his landscapes and snow effects at Louveciennes.

Somewhat close to these, but of a different class and background, with his difficult, lone temperament, was Edgar Degas (1834–1917). Different from the others in his creative manner, pursued even throughout his posed and descriptive portraits, such as the *Belelli Family* (Jeu de Paume, Paris), he retained a feeling for Realism, of which the couple in *L'Absinthe* (Jeu de Paume) is his masterpiece. Degas, even when he used pastel, worked on a solid foundation of excellent draughtsmanship, quick and abbreviated, but

respecting integrity: and that is the difference where other Impressionists are concerned. His Impressionism is found in his turning to the image in movement and in his magical capacity for seizing the moment at the height of its dynamic development and the expressive gesture. To embody the leap of a ballerina, as in *L'Etoile* or in *Fin d'arabesque* (Jeu de Paume, Paris), the movement of a circus acrobat like *Miss Lola* (National Gallery, London), hanging upside down suspended on a rope, or the gesture of the singer as in *Café-concert des Ambassadeurs* (Lyons Museum) and the *Singer with Glove* (Jeu de Paume, Paris), was his perpetual aim. Degas' originality lies in his compositions and certain angles which anticipate cinema technique and break with traditional effects of perspective by means of new spatial intuition.

When hostility towards it was dying down, Impressionism entered a crisis, between 1883 and 1885. Although without definite disavowal of its aims each one of the protagonists went his own way. Renoir, influenced by the paintings of

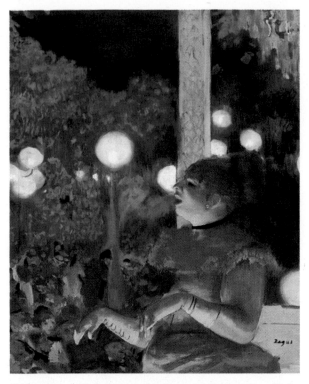

Edgar Degas, 'Café-concert' (Havemeyer Collection, New York)

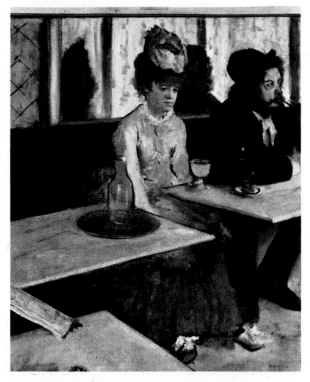

Edgar Degas, 'Absinthe' (Jeu de Paume, Paris)

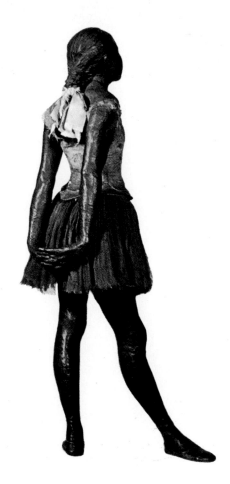

Left: *Edgar Degas, 'Dancer', bronze (Jeu de Paume, Paris)*

Opposite page: *Edgar Degas, the 'Bellelli Family' (Jeu de Paume, Paris)*

Pompeii and by Raphael, expressed a nostalgia for sculptural and figurative qualities which sensuously echo in the luminous grace of the supple nudes of his *Baigneuses,* and the chromatic escalation of his last period. Pissarro went over to the Neo-Impressionist camp, although later he painted his magnificent views of Paris seen from above, with their changing lights. Degas continued with his realistic pictures, also with refined pastels of female nudes in the intimacy of their toilet. Monet pushed his visual Impressionism to extremes. There now followed the 'series' (haystacks, poplars, the façade of Rouen cathedral); then disintegration into a powdery, colouristic *flou* (soft focus) as in the *Houses of Parliament, London* (Jeu de Paume, Paris) or certain views of Venice; and finally, in the peaceful country scenes of Giverny, the almost abstract exaltation of fragmented colours in the reflections of the *Water-lily Pond* (Orangerie, Paris). Sisley, however, remained faithful to the initial intentions of Impressionism.

Although it caused quarrels and strife, Impres-

Medardo Rosso, bust of Yvette Guilbert (National Gallery of Modern Art, Rome)

Auguste Rodin, the 'Burghers of Calais' (J. H. Hirshhorn Collection, Greenwich, Conn.)

Camille Pissarro, 'Boulevard Montmartre, Evening' (Fritz Nathan Collection, Zurich)

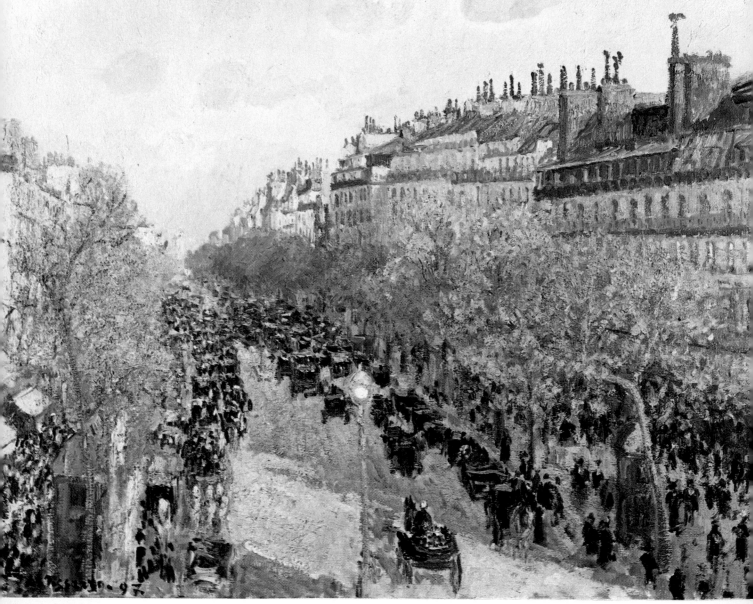

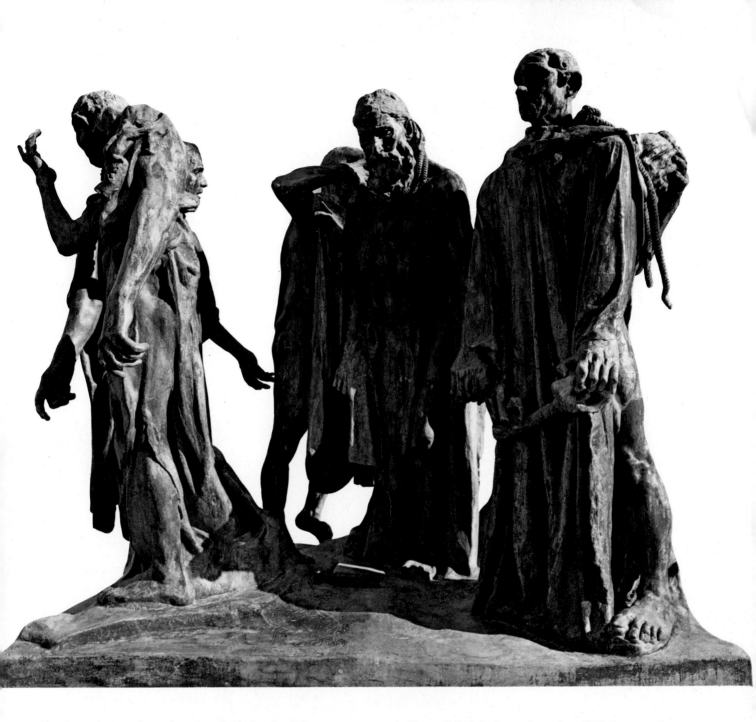

sionism won the day and gained followers throughout the artistic world. Generally, however, only the technical form was embraced, and this, separated from the inimitable Impressionist spirit, became stylised, tired and stereotyped.

Impressionism was echoed, indirectly, in sculpture, at which Degas and Renoir made occasional attempts. From Impressionism there descended the freshness and whirling movement which animates the group of the *Dance*, created for the Paris Opéra, and that of *Flora*, both by Carpeaux (1827–75). More complex was the influence on the greatest 19th century sculptor, Auguste Rodin (1840–1917). His powerful plasticism is evocative of the effort, the tension, the monu-

mentality of Michelangelo: the *Thinker* or the *Burghers of Calais* demonstrate this. But later his forms became less stable, more fluid, moving in the light which animates them and breaks down their surfaces, as in the evocative statue of Balzac. A more obvious effect of Impressionism is the evocative sculpture, in wax and bronze, of the disregarded Medardo Rosso (1858–1928) working in Paris, Vienna and London before returning to Italy to settle in Milan. In his sculpture the image disappears in evanescence and becomes a soft plastic modulation emerging into the light.

The reactions against Impressionism

Despite its achievements, Impressionism as an aesthetic was in a very dangerous position, difficult both to maintain and to develop. Its interpretation was extremely one sided, and was bound to betray its weaknesses before long. On the one hand there was the risk, by making light a subject in its own right, of reducing everything to a purely visual and optical interpretation. On the other was the risk (which Monet confirmed) of dissolving forms into a luminous and colouristic evanescence, having no longer sinew or substance. As the world of luminous and coloured vibrations which Impressionism discovered tended to dissolve more and more into a nebulous illusion, reaction against the movement began to set in, and as these reactions hardened, they represented further conquests for art, and the last stages on the path to truly modern art.

Neo-Impressionism

The first of these reactions, known as Neo-Impressionism, was the work of the inner circle of Impressionism, so it is not surprising that a great Impressionist like Pissarro espoused it for a time. Theoretician and champion of Neo-Impressionism in a brief, active life was Georges Seurat (1859–91). He accused Impressionism of empiricism, of excessive approximation, and he attempted to impose on it a scientific discipline. Once the question of the decomposition of light was posed, it had to be resolved on a strictly scientific basis – in the same way that the opticians of the time were demonstrating the nature of light. Seurat elaborated the technique of Pointil-

Giovanni Segantini, 'At the Drinking Trough' (Kunstmuseum, Berne; bequest of G. Keller)

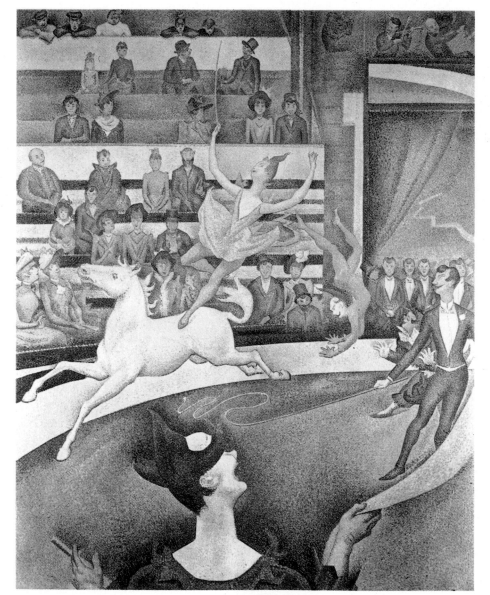

Opposite page, above: Vincent van Gogh, 'Interior of a Café in Arles' (Yale University Art Gallery, New Haven, Conn.; bequest of S. C. Clark)

Opposite page, below: Vincent van Gogh, 'Self-portrait with Mutilated Ear' (Courtauld Institute, London)

Georges Seurat, 'The Circus' (Jeu de Paume, Paris)

lism or Divisionism to obtain greater purity of colour and greater luminous vibration, abandoning a continuous colour surface and breaking it up into countless isolated dots of pure colour. Only in the eye, looking at it from the proper distance, is the fusion effected – the so-called 'optical mixture'. The dots are only minuscule touches of colour complementary to the colour which is intended, so that what appears to the eye as green is in fact a careful mixture of yellow and blue spots. Seurat did not confine himself to this technical revolution. His most famous works – *Sunday on the Island of La Grande Jatte* (Art Institute, Chicago), the *Bathers* (National Gallery, London), the *Circus* (Jeu de Paume, Paris) – are not only the practical application of it to subjects familiar to the Impressionists. They reveal a desire to return to some sort of formal composition. Forms and figures are subordinated to a rigid, geometrical

in Italy, through Previati, the Symbolist. The technique was adopted by the representational artist, Giovanni Segantini (1858–99), who left his native Trent to paint the changes of light in the mountains in the Swiss canton of Grisons.

framework to the point of taking on abstract shapes, like models in 'constructed' space.

When the 1886 exhibition opened, Neo-Impressionism represented a schism which made the crisis of Impressionism even more acute. Its followers were numerous not only in France, where the most significant was Paul Signac (1863–1935), but also in Belgium, where in the wake of Neo-Impressionism extremely advanced artistic groups were active. What most attracted and allured its supporters was nevertheless the technical formula of Pointillism, with its effect of enhancing colour. Sometimes, associating itself with Art Nouveau, Neo-Impressionism degenerated into the merely decorative, or extended into the beginnings of Futurism – as for example

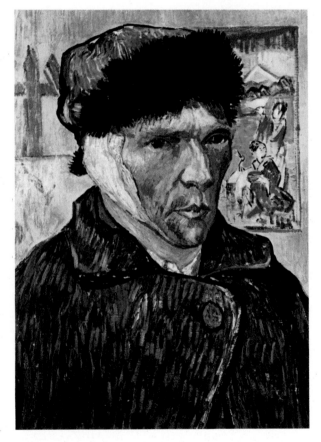

Van Gogh

Less rational was the second reaction to Impressionism, the art of the Dutchman Vincent van Gogh (1853–90). When, no longer young, he arrived in Paris in 1886, he had left behind him the mistaken sense of mystic-social vocation which had exhausted him at home and among the miners of the Borinage, and a type of painting

621

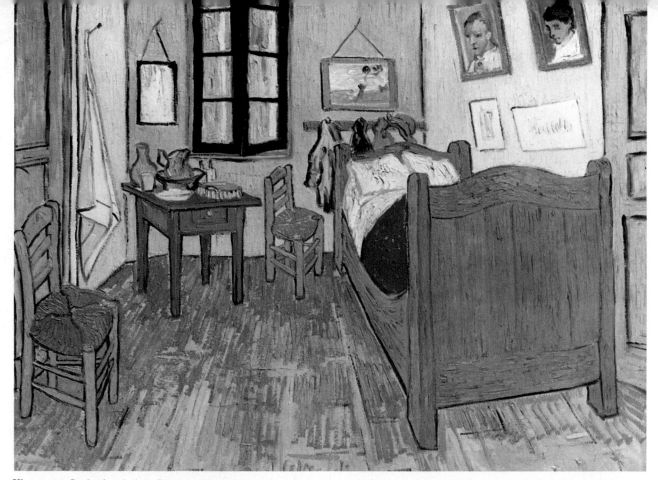

Vincent van Gogh, the 'Artist's Room at Arles' (Jeu de Paume, Paris) *Vincent van Gogh, 'Self-portrait' (private collection, Florence)*

of realist-popular inspiration that was serious and sombre in colouring. In Paris, tumultuous and easy-going, he was attracted neither by the city's artistic revelation nor by those discussions in which Gauguin and Toulouse-Lautrec (who were to become his friends) took part. The fluctuations between Impressionism and Neo-Impressionism taught him only to lighten the colour of his palette.

The urge toward an artistic vocation overtook him when, at the beginning of 1888 he moved, alone and in poverty, to Arles, where he came face to face with the sunbaked and violent south. There he was lured far beyond the limits of human capacity by that tense, obsessive, creative fury which, in little more than two years, burned out the most explosive pictorial experience of the 19th century. In the face of his absolute values, the dramatic incidents which pursued Van Gogh – the clash with Gauguin ending bloodily with self-mutilation of his ear; internment in the St Rémy lunatic asylum; return to the north through the hospitality offered in Auvers by Doctor Gachet, a friend of Pissarro and Cézanne; the single suicidal shot that cut him down in the middle of a cornfield – these were purely biographical episodes. They did not prevent the production of a succession of masterpieces. These

were peaceful during the Arles period – like the musical nocturne of the *Night Café* (Kröller-Müller Museum, Otterlo), the well-balanced composition of the *Pont de l'Anglois* (Wallraff-Richartz Museum, Cologne) and the humble primitivism of the *Artist's Room* (Jeu de Paume, Paris) or the incisive portraits of local people. Later, however, they became more disturbed during his stay in St Rémy as seen in the over-flowing gold of *Harvest* (Rijksmuseum, Amsterdam) or the sombre flame of the cypresses which rise to meet the brilliant stars of *Road with Cypresses* (Kröller-Müller Museum, Otterlo). Van Gogh had an almost baroque style in the Auvers period (which includes the portrait of Doctor Gachet in the Jeu de Paume, Paris), up to the time of the lugubrious *Cornfield with Crows* (Stedelijk Museum, Amsterdam).

Van Gogh's painting was subsequently opposed to Impressionism. It burdened itself with the will to express human drama and anguish; the colour sings, cries out, or explodes in interpreting feelings and passions. The brushwork, rather than spreading colour, carves into it the furrows of an agitated language soaked in human anguish. To the receptive contemplation and lyrical poetising of Impressionism, Van Gogh opposed another movement: Expressionism.

622

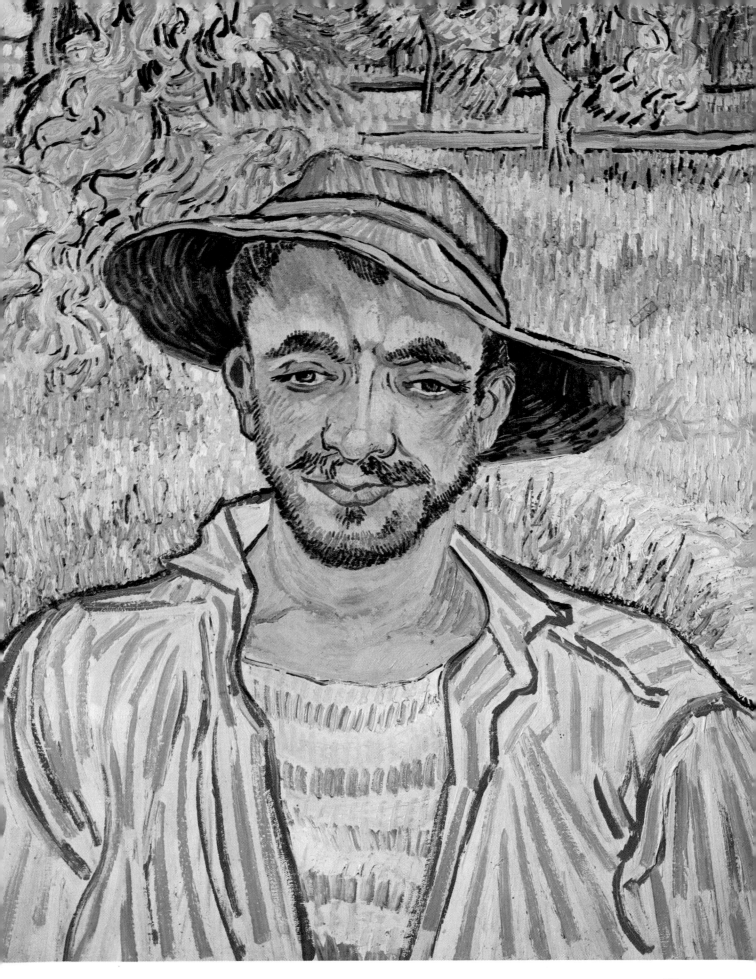

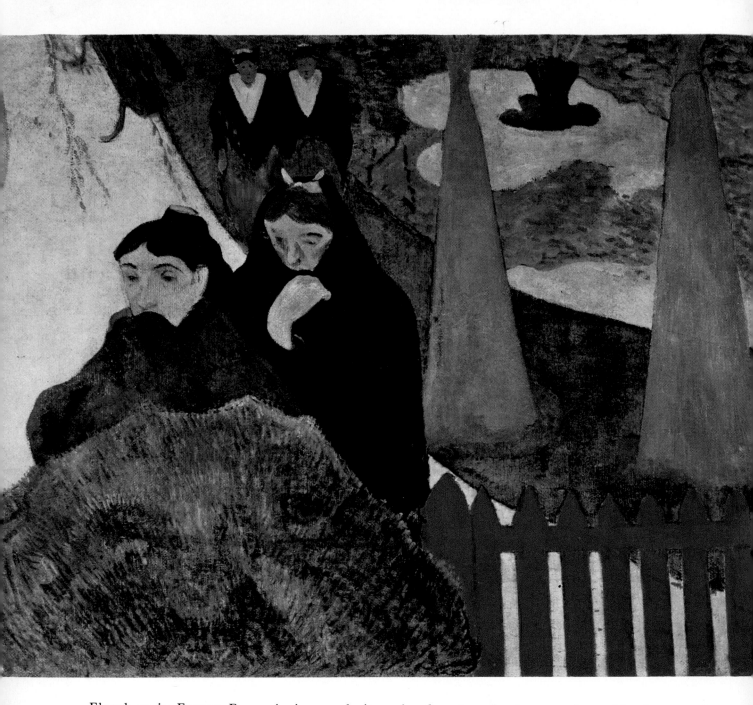

Elsewhere in Europe Expressionism made its appearance in Scandinavia. Where it was more influenced by the problem of inner anguish that had affected thinkers and writers from Kirkegaard to Strindberg and from Ibsen to Maeterlinck. It gave birth, in Belgium, to a spectral world of nightmares, with horrific masks and mocking skeletons, as in the work of James Ensor (1860–1949). In Norway, but ultimately influencing the rest of Scandinavia and Germany, there appeared the powerful painting of Edvard Munch (1863–1944), which found its culmination in the *Scream* (National Gallery, Oslo). In Germany an impetuous movement of painting began, with areas of solid colour and relentless

brushwork, as in the portraits and landscapes of Lovis Corinth (1858–1925).

Gauguin

The third reaction to Impressionism, personified by Paul Gauguin (1848–1903), was very different in character and effect. For him, too, it was a burning zeal for art which, in 1883, induced him to change from a 'Sunday painter' to an artist entirely absorbed in his problems, and willing to abandon his family, comfort and safe employment. Deep within him was a distrust of Western civilisation, and his bitter and often despairing search took him into a more primitive

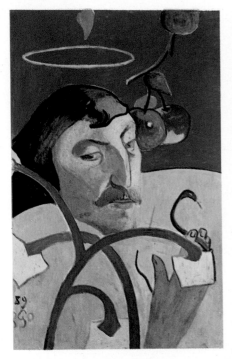

Paul Gauguin, 'Self-portrait'
(National Gallery of Art, Washington)

Opposite page: Paul Gauguin,
the 'Old Women at Arles'
(Art Institute, Chicago)

Paul Gauguin, 'Ia Orana Maria'
(Metropolitan Museum, New York)

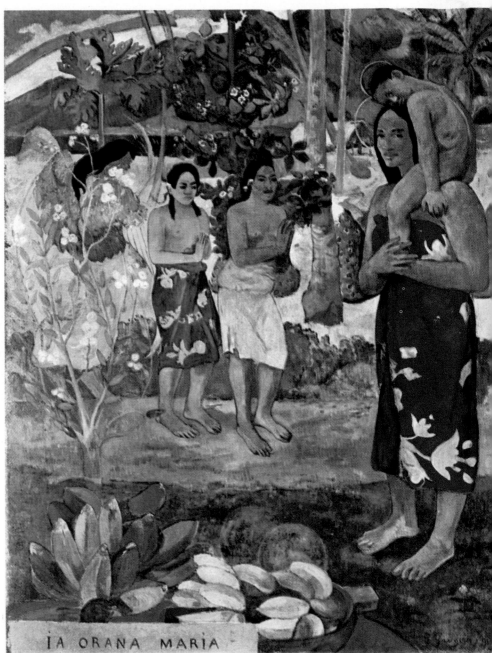

IA ORANA MARIA

and savage world of lost artistic values of candour, sincerity and authenticity. About 1885 he chose Brittany in order to practise – in landscapes, still-lifes and portraits – simple Impressionist painting. These were characterised by violent contrasts of pure colour, ever more arbitrary in the face of nature, because they were subjugated to the exigencies of the harmony of the composition. His meeting in Brittany with Emile Bernard – a young man of acute critical perception – persuaded Gauguin to break with naturalism. From then on he worked towards more synthetic and restricted forms, dominated by the demands of composition, and towards a *cloisonnisme* which encased them tightly within a frame. The group of artists who surrounded him in Pont-Aven ardently pursued this sort of research. Thus were born the works with a strong Breton flavour: *La Belle Angèle* (Jeu de Paume, Paris), the *Vision after the Sermon* (National Gallery, Edinburgh) and, above all, the famous *Yellow Christ* (Albright Gallery, Buffalo). The conviction that a painting should be not a collection of sensations but the purveyor of an idea, and that colour should be subordinated to this function, involved Gauguin, in about 1891, in the discussions of the Symbolists in Paris. But from these he derived little inspiration.

The hope of discovering, far away from civilisation, among savages, sincerity and the

power of the primitives lured him to a first visit to Tahiti in 1891. Later, in 1895, he left France altogether, first to go to Tahiti once more, but then to the remote Marquesas Islands. In this exotic world he did not find the spiritual values he had hoped for,·but in solitude he produced painting which, in its rich and somewhat arbitrary colour (as applied to natural objects), attained a new monumentality, a compact sculptural feeling, and an exceptional power of composition. From the rhythms that define the small fragments of colour in *Ta Matete* (The Market, Kunstmuseum, Basle), to the sculptural composition of *Tahitian Girls on the Beach* (Jeu de Paume, Paris); from the supple figures in the large symbolistic composition *Where do we come from? What are we? Where are we going?* (Boston Museum), to the fascination of the totem-like nightmare which pervades *Nevermore* (Tate Gallery, London); from the scattered wild horsemen on the pink fresco of the *Beach* (Folkwang Museum, Essen), the impressive static forms of the *Tahitians with Mango Flowers* (Metropolitan Museum, New York), and the *Girl with Flower* (Ny Carlsberg Glyptothek, Copenhagen), to *And the Gold of their Bodies* (Jeu de Paume, Paris), there is reintegration of form in the rhythm of a composition that stands alone in relation to real and natural elements.

Cézanne

The final reaction to Impressionism – but without doubt the most important by virtue of its deep re-assessment of the function of art, as well as for the repercussions it had on the artistic experiments of the 20th century – was that represented by the work of Paul Cézanne (1839–1906). A native of the south of France, and a childhood friend of the writer Zola, Cézanne obtained permission from his father, a provincial banker, to go to Paris in 1861 to study painting. At the Académie Suisse he became friendly with Pissarro and the future Impressionists, and with them took part in the art discussions at the Café Guerbois, although he most admired Delacroix and Courbet, and the old masters. For the rest, far removed from the experiments of his friends, his painting – maladroit, forced and lacking grace – was almost Baroque in flavour with the paint applied thickly with a palette knife. It was only in 1873 that Pissarro succeeded in luring him into the country, near Pontoise and Auvers, and persuaded him to lighten his palette and adopt the fluid manner and coloured shadow of the Impressionists. At their first show he exhibited the

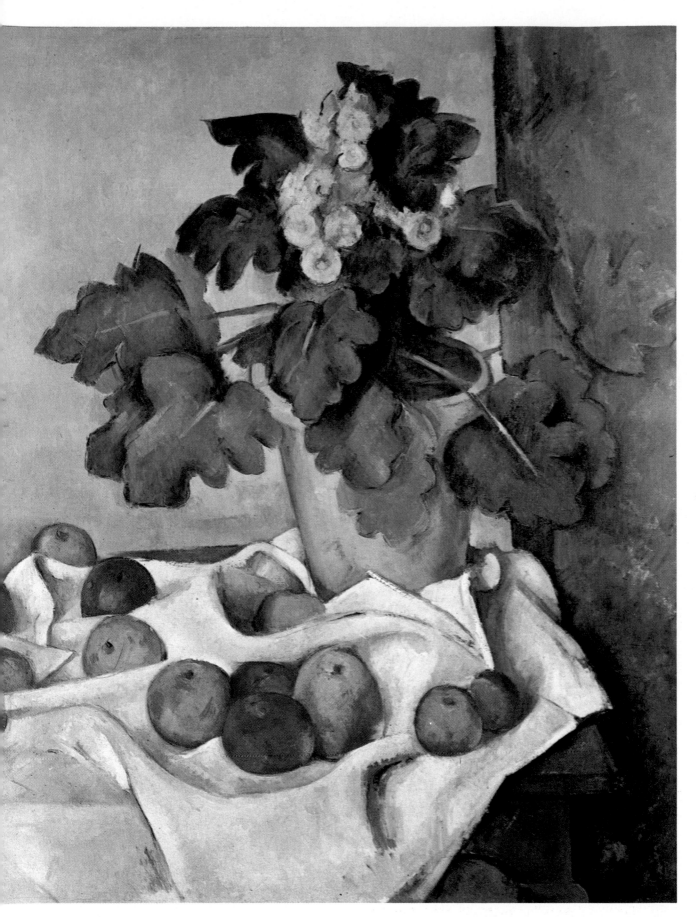

Paul Cézanne, 'Still-life' (Metropolitan Museum, New York)

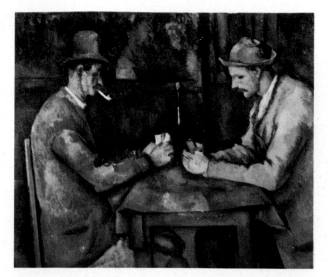

Paul Cézanne, the 'Card Players' (Jeu de Paume, Paris)

House of the Hanged Man (Jeu de Paume, Paris). But Cézanne's Impressionist period lasted only a short time. After the failure of the third exhibition he left the group in 1878 to return to Provence, at first to L'Estaque on the Gulf of Marseilles, then to his native Aix. With few exceptions, silence about his intense activity was maintained until the revelationary show of 1895 organised by Vollard, the art dealer. From then on Cézanne painted more for himself than for the public. In his eyes Impressionism presented two dangers that had to be overcome. The first was the dissolution of form in the enveloping vibration of light. Here it was a question of 'solidifying' Impressionism.

The second danger was that of confining one's optic function to a punctilious registration of visual sensations. This tendency ought to be resisted, bearing in mind that 'nature is not to be reproduced, but portrayed'. Painting was conceived of as construction by Cézanne. If colour and tone are the constituent elements, painting still has to have – and it is for the artist to provide it – a logical structure, solidity and coherence. Although he was the last great naturalist of the 19th century, Cézanne maintained that reality is one thing, painting another, so that 'painting does not mean copying the object, but producing coloured sensations'.

Cézanne felt that one cannot reduce oneself to a mere receptacle of visual impressions. It was necessary to find, not in the abstract but concretely, in advance of a specific 'motive', the indispensable moderation between the 'sensation' (the suggestive authenticity of the sensory data, whose freshness must be safeguarded), and the constructional order of the picture (the compositional requirement with its unity, its articulations, the subtle equilibrium of planes and volumes, spaces and atmosphere). Patient, contemplative, marked by the painter's preoccupation in achieving all this through the modulation of his colour, Cézanne's painting always reflects this problem and manages to find a new and specific solution to it: a solution rich in emotional content and calm grandeur. Predominant in it, of course, is landscape: from the seascapes of

Paul Cézanne, 'Bathers' (Private collection, Zurich)

Paul Cézanne, 'Self-portrait' (National Gallery, London)

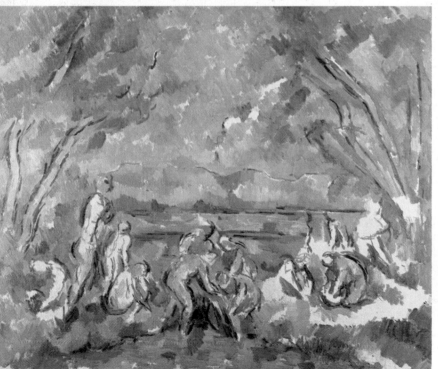

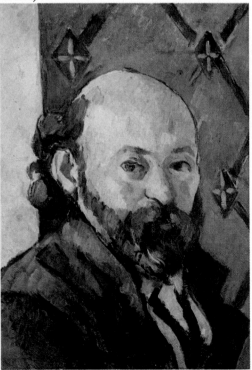

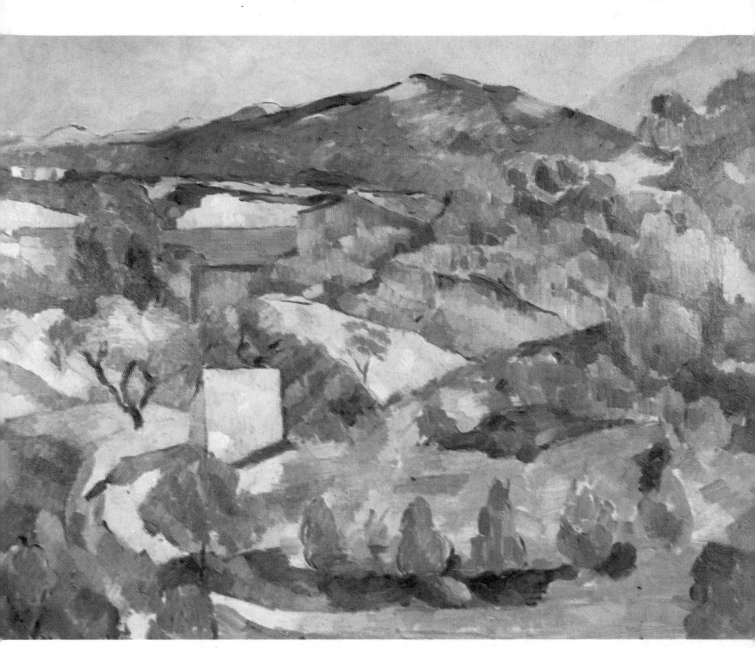

Paul Cézanne, the 'Montagne Ste-Victoire' (Courtauld Institute, London)

L'Estaque to the construction, in measured density of colour, of the well-known *Montagne de Ste Victoire*, and to that uncompleted and advanced *Cabanon de Jourdan* (Kunstmuseum, Basle) which influenced the Cubists. But identical problems of pictorial construction are presented by still-lifes, portraits and self-portraits and figure painting. A vase of flowers, a dish of fruit – simple objects arranged on a tablecloth – presented problems of form-structure, architectural construction of space, and colouristic and tonal relationships. His figure paintings are also pictorial constructions: from the monumentality of the squares of measured density in *Woman with a Coffee-pot* (Jeu de Paume, Paris) to the musical colour harmonies of the *Boy with a Red Waistcoat*

(Bührle Collection, Zurich); from the rustic thoughtfulness of the *Peasant with Pipe* (Kunstmuseum, Mannheim), to the absorbed seriousness of the *Card-players* (Jeu de Paume, Paris), where the vertical bottle on the rough table determines the perfect and psychological balance of the composition.

In this way Cézanne brought to a conclusion the creative problems of the whole century, defining the relation that can exist between exterior reality and the work of art. And at the same time he transmitted to the new century a lesson it absorbed well: that a work of art has its first and most complete *raison d'être* in the autonomous construction of the artist and his expressed 'mental operation'.

19TH-CENTURY ART AND ARCHITECTURE

Charles Percier and Pierre Fontaine, Rue de Rivoli, Paris

19th-century architecture and town planning, more than any other aspect of art, should have assimilated the new aesthetic developments. However, both lacked coherence and failed to take into account new requirements or new technical methods that were coming into use.

The effects of the Industrial Revolution had

Opposite page and below: *Gustave Eiffel, the Eiffel Tower, Paris*

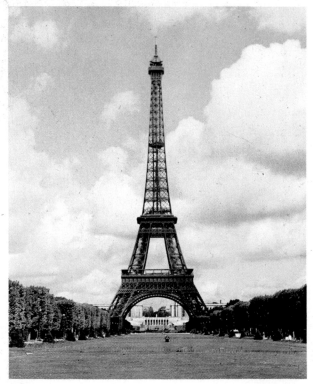

created a crisis in the traditional attitude to urbanism. From modest centres, and sometimes from nothing at all, new cities suddenly grew up around new industries or industrial centres. In other instances industry came to old towns, bringing an influx of masses of people, consisting largely of manual labourers. Such increases in population, the switching over to business and commerce, the decline of the traditional artisan classes and the appearance of new middle classes automatically entailed an enormous expansion – both physical and demographic – in 19th-century cities. Some of them, like London, Paris and, with a more relentless pace, some centres of the young United States of America (principally New York) changed into seemingly limitless agglomerations, destined to spread indefinitely.

No rational policy of town planning was introduced to try and bring some order into this exuberant but anarchical development. Everything was left to the apparently inevitable course of events. Private speculation reigned supreme, creating absurd congestion, terrifying hygienic conditions, and roads that were ridiculously inadequate for modern traffic – all with complete disregard for aesthetic considerations. This same private enterprise created dreary industrial suburbs where the working masses were crowded together in conditions of almost subhuman poverty. Even in blocks of apartments built for renting to the upper or lower middle-classes, little attention was paid to the quality of the building materials used, and concern was only for the greatest monetary yield.

The aesthetic appearance of towns deteriorated and, as far as possible, signs of proletarian poverty were concealed. The banal speculators' buildings dating from the 19th century in most of the large cities of western Europe lack monumental function and entirely disregard requirements of 'good' architecture. Their uninspired vulgarity marks a definite stylistic decline when compared with some examples from the beginning of the century, such as the elegant, unified appearance of the Rue de Rivoli in Paris, laid out by Percier and Fontaine at the wish of Napoléon I.

Even in specifically monumental architecture, which required careful thought and close consideration, the 19th century was unable to evolve

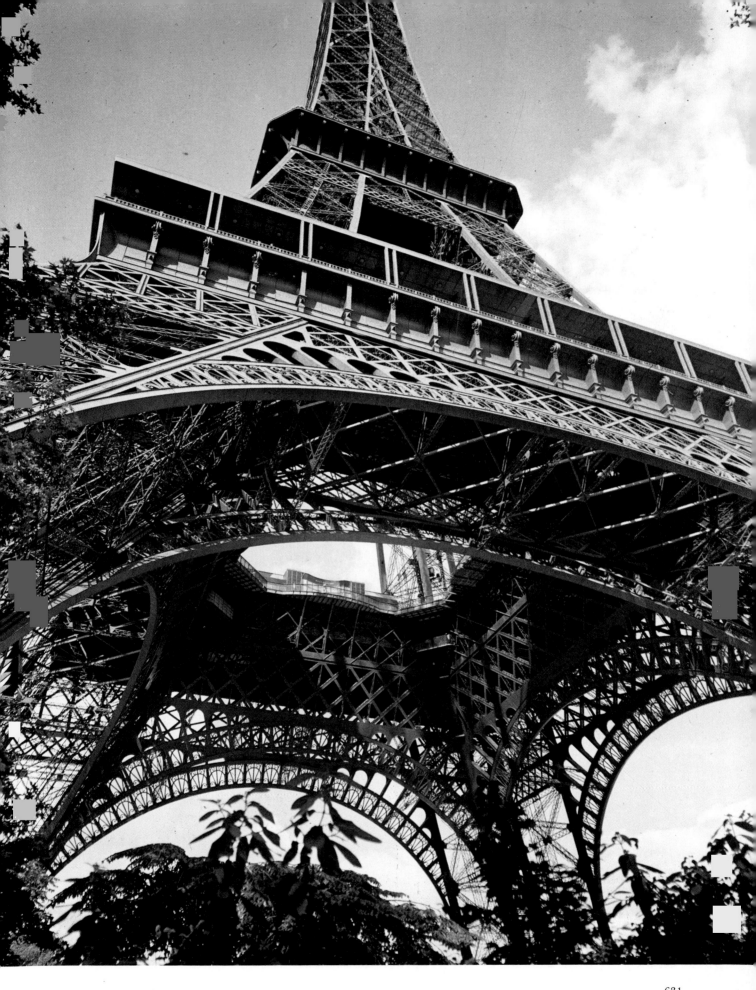

an architectural style of its own. Leaving aside certain belated Neo-classical productions, there was a choice between two opposed styles, to which the Romantic spirit tried to give the appearance of a revival, a revivification, and which persisted until after the second half of the century.

The first of these styles, the outcome of Neo-classical ideals, was the revival of classicism, or rather Greek Atticism. Germany was particularly fascinated by it. In Berlin, Von Schinkel (1781–1841) designed the palace of the Corps of Guards in the Doric style, complete with pediment, and added a long Ionic colonnade to the front of the Old Museum (1828); in Munich, Ludwig I of Bavaria had his favourite architect Leo von Klenze design a town square in which the Propylaea (1846) leads up to the Glyptotec (c. 1830), planned as an Ionic temple flanked by wings with niches. The most strange example was that of a temple – Walhalla – to the glory of the most illustrious Germans on top of a hill near Ratisbon,

of Parthenon-like form, also executed (1830–42) by Von Klenze. This classical trend had followers all over Europe (though not always so genuine), especially in England. John Soane (1752–1837) designed a series of somewhat pompous colonnades and façades on the Bank of England (1835), while William Wilkins (1778–1839) gave a classical flavour to the National Gallery and Robert Smirke chose Ionic colonnades and pediments for the British Museum (1823–47). Even the United States reflected the taste in the Capitol, Washington, completed in 1865.

The other revival was of the Gothic style, which in fact echoed the nostalgic Romantic interest in the Middle Ages, an interest inspired by the conviction that Gothic was the native aesthetic 'language' of the Teutonic peoples. The spread of the Gothic revival was perhaps even greater than that of the classical revival, and was impelled by various factors. In Germany it inspired the completion in 1824 of Cologne cathedral. Among

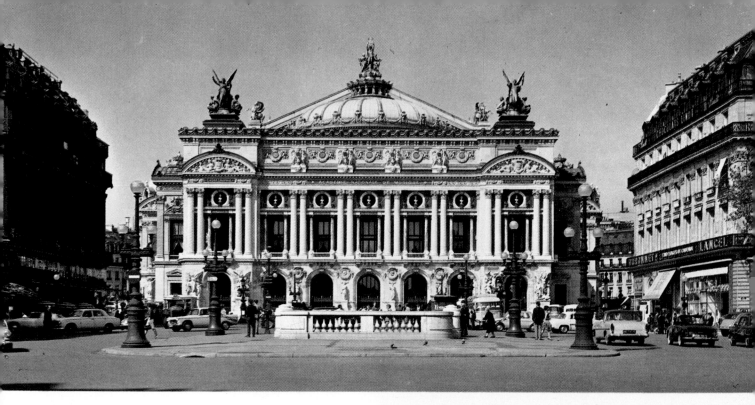

Charles Garnier, the Opéra, Paris. Right: *the staircase*

Opposite page: *Jean-François Chalgrin, the Arc de Triomphe, Paris*

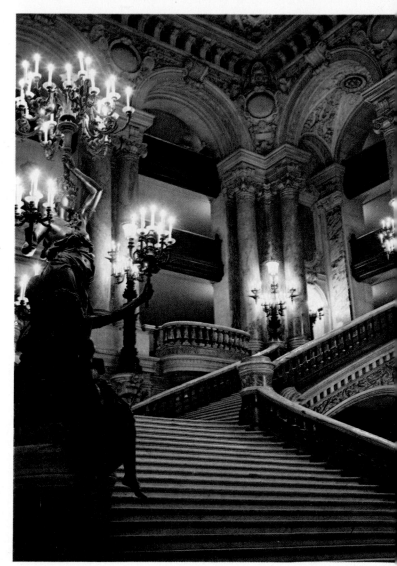

other examples should be cited the Nikolaikirche in Hamburg (1845–63), crowned with an exceptionally high spire and, in Vienna, the even later Votivkirche (1853–79) with its twin spires. In France the restorations undertaken by the architect Viollet le Duc (1814–79), on Notre Dame de Paris, Reims cathedral and the abbey of St Denis, generated an obsession for Gothic which encouraged him to romanticise while remodelling the castle of Pierrefonds and the citadel of Carcassonne, and which inspired such buildings as the church of Ste Clotilde in Paris (1846). The Gothic revival was even more deep seated in England where, following a host of Gothic-style churches, the rebuilding of the Houses of Parliament between 1840 and 1868, with the famous tower that houses Big Ben, took its inspiration from the English Perpendicular style, the designers being Charles Barry (1795–1860) and Augustus Pugin.

But even when this alternation between the classical and Gothic styles slowed down, 19th-

century architecture was still structurally and stylistically ostentatious, with unhappy compromises – often accentuated by the grandeur of its massive buildings or by the mechanical nature of its construction. Typical of these buildings is the enormous Palais de Justice in Brussels by Poelaert. Among the less intolerable compromises may be cited the Opéra in Paris, the work of Charles Garnier (1825–98), carried out between 1862 and 1875, and an excellent tribute, especially with its vast staircase, to the Second Empire. A few works by the German Gottfried Semper (1803–79), such as the Dresden museum and opéra house, and the Vienna Burgtheater (1888) are also worthy of note.

Among so much architectural poverty the

Alessandro Antonelli,
the Antonelli building, Turin

Opposite page, above:
Charles Barry and Augustus Welby
Northmore Pugin, the Houses of
Parliament and the Big Ben,
London

Opposite page, below:
Giuseppe Mengoni, the Victor
Emmanuel gallery at Milan
in an old print

exceptions are rare. One of the most important architects was the Piedmontese Alessandro Antonelli (1798–1888), who devised original structural solutions, technically well related, as in the dome of S. Gaudenzio at Novara or the Mole Antonelliana (1863) at Turin.

One of the saddest contradictions of the period was the refusal of 19th-century architecture to adopt the new techniques and new materials which were the fruits of the Industrial Revolution. Constructions in iron, which facilitated solidity and was admirably adapted to modern needs, were regarded simply as engineering, and therefore purely technical and practical, undeserving of artistic interest. Beyond the realm of official architectural considerations, but in fact much more lively and relevant, a new form was created in the iron bridges, such as the hog-backed Severn bridge in England, built as early as 1775, and the elegant Pont des Arts, in Paris, begun in 1802 but completed only after the middle of the century. Other examples are the suspension bridge built in 1852 over the Niagara Falls, the massive bridge over the firth of Forth in Scotland, and the single-arched bridge built in 1885 at Garabit (Cantal, France) by Eiffel. Nor was due consideration given – although even from an architectural point of view they deserved it – to iron constructions such as the barrel and umbrella vaults created by Henri Labrousse (1801–75) for the library of Ste Geneviève and the reading room of the Bibliothèque Nationale (National Library) in Paris. The combination of iron and glass, used in practical contexts such as large greenhouses and the roofs of railway stations, was not employed as often as it deserved. However, it was handled splendidly in the Crystal Palace, originally built in Hyde Park, London, by Joseph Paxton (1803–65) for the Great Exhibition of 1851, in the no less important Galeries des Machines of the Paris exhibitions of 1855, 1878 and 1889, and in the Vittorio Emanuele gallery in Milan, built in 1867 by Giuseppe Mengoni.

Architecture in iron was finally vindicated, however, in 1889 with the tower which the engineer Gustave Eiffel (1832–1923) erected for the Paris exhibition, proving that it is possible to build a very high tower, hollow but strong, static but supple.

Art at the end of the 19th century

The contradictory character of 19th-century artistic development was borne out by the painting that bridged the two centuries. There was a profound abyss between the advanced and

expansive attitudes already described (of great artistic importance, but regarded with diffidence and little comprehension) and the rest of the artistic scene (more favoured by the bourgeois public, but of heartbreaking mediocrity). As a consequence, the avant-garde break with a stagnant and insignificant art was all the more drastic. Realism and naturalism exhausted their possibilities and sought weary compromises in order to survive. Symbolism did not make contributions of any great relevance. Where it did

not fall flat in an effort to supply external inspiration in the later Romantic manner of Böcklin, Von Marées or, in France, the pseudo-monumentalism of Puvis de Chavannes, it lost itself in aestheticism.

Vuillard, with his intimate interiors, and Bonnard, with his restless range of colours, eventually detached themselves from the 'Nabis', a group of French artists who at one point recalled the preciousness of Symbolism and the (by then) outdated ideals of Gauguin. It was the pliable and musical lavishness of Bonnard's colour inspiration of *In the Box* which detached him from the aesthetic of the 'Nabis' and made him an ardent colourist. His many studies of nudes and women at their toilet are masterpieces of modulated harmonies and delicate lighting, but his fidelity to traditional viewpoints kept him apart from all modern movements.

In America, R. A. Blakelock (1847–1919) painted landscapes of the American West, whose sombre colourings reflect a melancholy mood.

A completely artificial and decadent style is seen in the complicated drawing, reminiscent of Java, of the Dutchman Jan Toorop, the satanic engravings and etchings of the Belgian Félicien Rops, and the tortuous drawing of the Englishman Aubrey Beardsley, who evolved from Pre-Raphaelitism to Art Nouveau. Enclosed in a literary, intellectual world was the work – Surrealist *ante litteram* – of the Frenchman Odilon Redon, who showed himself aware of the irrational suggestions of the subconscious.

Emile Gallé, decorated glass vase (J. Setton Collection)

The only great artist of the period usually referred to as *la belle époque* was Henri de Toulouse-Lautrec (1864–1901). His drawing, based on an exceptional visual memory and a surprising speed of execution, captures dynamic, fleeting gestures, but his aggresive, caustic style spares no one. His theme is still that of Degas: theatres, nightclubs, the circus, singers, ballerinas, prostitutes. But in his unconscious Expressionism his drawing becomes corrosive, his colour summary and

Edouard Vuillard, 'Roussel, ill' (Private collection, Paris)

Left: *Aubrey Beardsley, 'The Climax', one of the India-ink illustrations for Wilde's Salomé (published by 'The Bodley Head', 1894)*

Opposite page: *Hector Guimard, 'métro' station, Paris*

violent, the human content mordant, occasionally venomous. With almost sadistic pleasure he caricatured the features of friends or of intelligent artistes like Jane Avril, Marcelle Linder, or Yvette Guilbert, of the long black gloves, whom he admired all the same. Vivid and effective drawings and coloured lithographs followed each other, leaving a gallery of personalities of the period, and as in the case of Degas, there is often a new definition or angle of view.

After 1890 however, a new style made its appearance in the applied arts and interior decoration. It had various origins, according to individual countries or aesthetic demands; consequently it took the name of *Jugendstil* in the Germanic countries and Liberty style, after the London store or, *stile floreale* in Italy. The French term 'art nouveau' came from the name of the shop, the 'Maison de l'Art Nouveau' which opened in Paris in 1895. It has since been adopted in England and the United States. The phenomenon was contradictory, too, and yet interesting because it accepted the need for giving to a

world which boasted of being modern, a really original style corresponding to its way of life and its technical developments. Furthermore it aimed – at least in its more advanced streams, to react against the squalor and banality of industrial mass-production; thus in England it led to the Arts and Crafts movement inspired by the artist, writer and socialist William Morris. It also sought to encourage the rebirth of high quality modern output which, through its original forms, revived the taste for beautiful things – a very early anticipation of the problems that would generate contemporary interest in industrial design. It was appropriate, therefore, that the new style should develop mainly in the decorative arts, in the so-called applied arts: new types and shapes of furniture, ornaments in wrought iron, hangings, fabrics, gold and silverware, jewellery, ceramics and glass. Among many examples should be mentioned the glassware of the Frenchman Emile Gallé and that of the American Tiffany; the furniture of the Germans Endell and Riemerschmidt and that of the Frenchman

Pierre Bonnard, 'In the Theatre Box' (Bernheim Junior Collection, Paris)

Henri de Toulouse-Lautrec, 'Marcelle Linder' (John Hay Whitney Collection, New York)

Henri de Toulouse-Lautrec, 'La Modiste', Mlle Margouin (Henri de Toulouse-Lautrec Museum, Albi)

Henri de Toulouse-Lautrec, poster for Aristide Bruant's cabaret

Majorelle; and the architecture of the Scotsman, Charles Rennie Mackintosh (1868–1928).

However, Art Nouveau had several negative features that were in fact intrinsic characteristics. They included exuberance of ornament; love of the irregular, the asymmetric and the unusual; eurythmy taken to the extent of preciosity; sinuous, flexible ornament inspired by nature in its floral forms. In this way the artificiality of the style, the pursuit of the chic rather than the beautiful, and inadequate attention to the functional made it more a fashion of taste than of art.

Only two painters can be regarded as having given full expression to this passing taste. In Vienna, following the Secession – an anti-realist and symbolistic reaction among certain German artists that reflected a desire for renewal – Gustav Klimt (1862–1918) asserted himself with his rapid and synthetic drawing. His work developed into two-dimensional, Impressionist painting, almost mosaic in style, with tessellations of bright colours (*The Kiss*, Osterreichische Gallery, Vienna; *Judith*, Gallery of Modern Art, Venice). In Switzerland, Ferdinand Hodler (1853–1918) approached Expressionism in his mountain landscapes, but in his decorative work relied on an almost Gothic, circumscribed rhythmic line (The *Elected* and *Eurythmy*, Kuntsmuseum, Berne). Worthy of attention is the personal art of the

Gustav Klimt, 'Portrait of Madame Fritz Riedler' (National Gallery, Vienna)

Opposite page: Henri Rousseau (Le Douanier), the 'Gunners' (Guggenheim Museum, New York)

Ferdinand Hodler, 'Eurhythmy' (Kunstmuseum. Berne)

German Paula Modersohn-Becker (1876–1967), with its simplified forms and restrained palette.

To this *fin de siècle* painting belongs the work of certain artists who later moved on to quite different experiences, as in the Paris debut of Pablo Picasso and his Pink and Blue periods. Although 'discovered' later by the avant-garde and its critic and champion Apollinaire, Henri Rousseau (1844–1910) belongs to this period, but certainly not to the avant-garde school. He was the greatest representative of naive painting which, although maladroit and awkward, nevertheless reveals an authenticity of primitive and touching sincerity. Rousseau was self-taught, of humble origin, a lone and unknown amateur, somewhat in the style of the Montmartre Pointillists. His *Snake Charmer* (Jeu de Paume, Paris) has exotic fascination, and is a precursor of the Surrealist *Dream of the Gipsy Girl* (Museum of Modern Art, New York). Another exponent of Primitivism was the American, Grandma Moses (1860–1961) who took up painting late in life.

Unquestionably more important and more positive were the effects of Art Nouveau on architecture. Under the necessity of creating a modern style, it facilitated in Europe the search for a synthesis between a renewal of architectural ideas and new technical possibilities. About 1890 the United States was also preoccupied with this search, although in a more modest form, in the school of Chicago with Louis Sullivan (1856–1924) and William Le Baron Jenney (1832–1907). The result was the entirely new conception of the skyscraper, rejecting anything uselessly ornamental and adopting criteria of pure functionalism, with a metal frame and enormous window areas.

In Europe the most advanced countries were Belgium and Holland. In Belgium there was a marked contrast between, on the one hand, the restrained and well-defined functional style – foreign to normal construction plans – which the architect Henry van de Velde (1863–1957) established and, on the other hand, the inspired work of Victor Horta (1861–1947). With extensive use of iron, the latter brought entirely new ideas to housing projects in Brussels (housing block in the

641

Antonio Gaudí, two views of the church of the Sagrada Familia, Barcelona

Opposite page: Hendrik-Petrus Berlage, general view of the Stock Exchange, Amsterdam

642

Rue Turin; Hôtel Solvay), and in the Maison du Peuple he employed large areas of glass and an internal, visible iron roof. In Holland, Hendrik Berlage (1856–1934), with the Amsterdam Stock Exchange, created a new example of architecture, with metal supports exposed and given prominence in the interior. In Germany, Auguste Endell (1871–1925), in the abstract decorations of the Elvira house in Munich, created a magnificent example of Art Nouveau. In Vienna, again under the influence of Art Nouveau, several architects were making innovations: Otto Wagner (1841–1918), with his functional Savings Bank; Josef Olbrich (1867–1908), with the essential sobriety of his Secession buildings; and Joseph Hoffmann (1870–1956), whose masterpiece is the Maison Stoclet in Brussels. But it was in Barcelona that Art Nouveau gave itself free rein, with extraordinary fantasy, in the work of Antonio Gaudi (1852–1926), as seen in the tall spires of the as yet unfinished church of the Holy Family and in the lines of the Casa Milà and the Güell palace.

THE IMPACT OF AFRICAN ART

Towards 1906, when the more restless and active Parisian artists were seeking liberation not only from the influences of Egyptian and classical art, but above all from the Renaissance, and even from Impressionism, African art suddenly appeared, with its unusual masks and its statuettes with their broken rhythms. The shock was violent. Even today its effects are difficult to measure, and yet it is impossible to deny them.

Often, where great artistic movements turn established forms and plans upside down, it is easier to identify the convergence of deep motivations than to reveal precise influences. African art suggested directions that had already begun to form in the minds of a few artists.

Picasso, in spite of his famous quip, 'African art? I don't know it,' has admitted to being indebted for some sculptural elements, and certain

Ngaady Mwaash mask of wood and woven raffia, corals and beads (Musée Royal de l'Afrique, Tervuren)

644

masks, to the Ivory Coast. The concave faces of his *Demoiselles d'Avignon* can certainly be linked to the art of the Bakota and Fang Tribes. Derain also had an African period, as he later recognised. It is, however, more difficult, if not impossible, to find echoes of African art in the Fauves, in spite of their love of, and interest in, this art. Vlaminck was the owner of one of the first masks to reach western Europe from Gabon; a bronze copy of it is in the Museum of the Arts of Africa and Oceania in Paris. Later this same mask belonged to Derain.

Matisse had several African statuettes, and it would seem that some of his bronzes, rather than his painting, have experienced the effect of these, however remotely. Braque also came close to African art with his little sculptures, fishes and birds. But Fernand Léger made the first explicit reference in his drop curtain for the ballet the 'Creation of the World', on which he faithfully reproduced a Baoulé mask, among other extremely rhythmic elements.

On analysis, other artists have been shown to have made allusive references to, and even achieved a synthesis between, Western and African art. Obvious examples are the head by Brancusi, in dark red wood, and the bronze by Gonzales, *Le Cagoulard* (both in the Museum of Modern Art, Paris).

In actual fact, African objects had been known in Europe since the 16th century, but they had not, except in rare instances, aroused any reaction other than curiosity, which was never anything more than a passing fashion. However, after the important appearance in Europe of African art in the early years of the 20th century, and after the systematic research by ethnologists who at first did not seem to realise its aesthetic value, at last a wide panorama of different styles has eventually emerged. These can be called naturalistic, expressionist, abstract – although these terms can have only an approximate and arbitrary meaning, since African art rejects any possible subdivision into groups, tendencies or schools.

Today, a deeper knowledge, an increase in comparative study, and numerous investigations in a variety of directions, all bear witness to the importance of African sculpture in the world of art. As examples, we may note the Nok terracottas from Nigeria, bronzes from Ifé (constituting some of the most refined examples of bronze sculpture in the world), the austere dignity of the Dogon figures, the sensitivity of the Baoulé products from the Ivory Coast, and those of the Baluba from the central Congo.

Benin art, bronze head of a Queen Mother (British Museum, London)

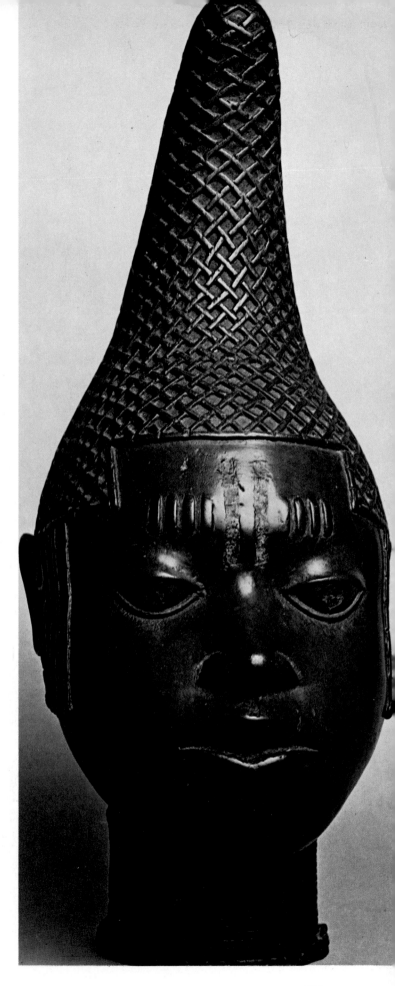

20TH-CENTURY AVANT-GARDE MOVEMENTS

Developments during the last thirty years of the 19th century brought about a complete transformation of perspective in the world of art, and things could never be the same again. Consequently it was the so-called avant-garde movements at the beginning of the 20th century which made the complete break, between 1905 and 1914, with all that had gone before. This break is at the base of 20th-century art, and endowed it with its characteristic anxiety, feeling of crisis, and interest in experiment.

Fauvism

The first avant-garde movement was Fauvism. Presented in Paris at the autumn Salon of 1905, it was regarded almost as an invasion of wild animals (hence the name from the French, *fauve*). Fauvism is a simplified style of painting, with no concern for volumes or for variety of colour, which is always pure and frequently violent in its juxtapositions.

Fauvism embraced various groups, whose composition varied considerably, but included some of the greatest French painters. In Le Havre, Georges Braque (1882–1963) and Raoul Dufy (1877–1953) painted seascapes of the Channel. In Paris, Albert Marquet (1875–1947) painted in a carefully modulated and delicate style, and the cultured and talented Henri Matisse (1869–1954) painted views of the city with intense zones of colour, adopting the tense Fauvist idiom. A good example of Matisse's work at this period is the *Portrait with the Green Streak* (Copenhagen Museum), in which the warm tones of the female face are simultaneously divided and united by the vertical streak of pure emerald. Georges Rouault (1871–1958), with the despairing Expressionism of his figures of lost people, was a painter apart. The most advanced position, however, was taken by two young men, almost self-taught, who worked in the suburb of Chatou on the banks of the Seine: Maurice Vlaminck (1876–1959) and André Derain (1880–1954). They treated colour with an explosive harshness.

Typical of Vlaminck is *Landscape with Red Trees* (Museum of Modern Art, Paris), and of Derain, views of London, such as *Westminster Bridge* (private collection, Paris), with their violent sunsets. Approaching them, in his adventurous artistic life, is the Dutchman Kees van Dongen.

However, the precarious homogeneity of the Fauves faded away in less than three years. Braque became one of the main pivots of Cubism; Dufy became a deft illustrator of modern life, with delicate outlines over washes of colour. Marquet poured himself out in delicate, lyrical landscapes, almost traditional in flavour; Derain restlessly sought his own way, while Vlaminck brought to his landscapes overtones of Expressionism. Only Matisse evolved the premises of Fauvism coherently in his lyrical, synthetic style.

Maurice de Vlaminck, the 'Bridge at Chatou' (Private collection, Soleure)

Opposite page: *Henri Matisse, 'Flowers and Pottery'* *(Thompson Collection, Pittsburgh)*

André Derain, the 'Houses of Parliament, London' (Thompson Collection, Pittsburgh)

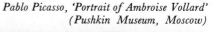

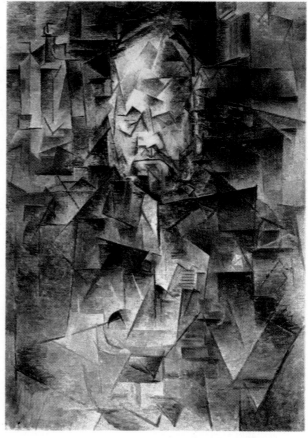

Examples include the dynamic rhythms of the *Dance* (Hermitage, Leningrad); the determination of space through uniformity of colour, as in *The Red Studio* (Museum of Modern Art, New York); the peaceful synthetic absolutes of *Goldfish* or the *Blue Window* (also in New York), producing art of balance, purity and serenity. Thus Matisse became one of the greatest and most fascinating masters of our century. His works are composed following orderly and clear ideals. For him the only artists are those who can order with method their own sensations. And so he reduces and simplifies forms in accordance with his demands for clarity. He groups the forms in a neat but sinuous and arabesque design, eschews illusions of volume, preferring two-dimensional painting, based on flat planes of colour, and searches for calm, chromatic harmony. In an age given over to restless and tormented searching, Matisse dreams of a reassuring and tranquil art, without worrysome or frightening subjects, which should be, as he put it, a cerebral tranquilliser for the man of today.

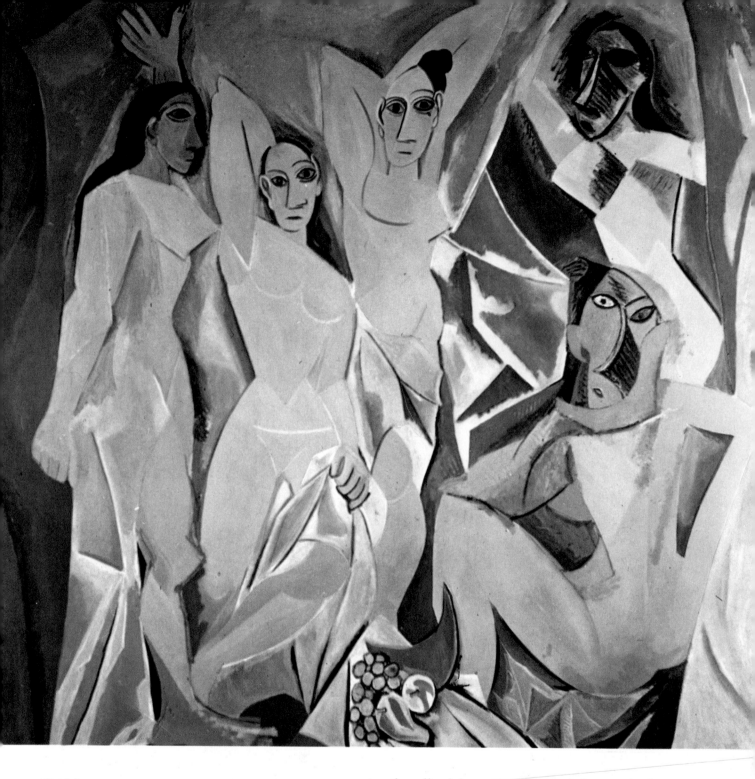

Cubism

Substantially different, being founded on plastic values, was Cubism. It is perhaps the most important of the avant-garde movements, not so much for its actual production, as for its repercussions, subsequently absorbed into our conception of form, as the language of publicity and industrial design today demonstrates. Affirming the rejection of all imitative principles, Cubism is dominated by the problem of the 'object', which has to be reconstituted, as opposed to the dissolving tendencies of Impressionism. But 'the senses deform; only the spirit forms': so the Cubist must eliminate whatever touches on subjective sensitivity (hence its diminution of colour and renunciation of definitions of light) or the limitations of a prearranged and fixed point of view, in order to arrive at an all-embracing, total conception of the form ('I paint things as I think them, not as I see them,' explained Picasso). A main pivot of Cubist experiment was the ardent collaboration between two exceptional personalities, Picasso and Braque.

It was precisely their intuitive resources and their creative power that restrained Cubism from degenerating into mere experimental application of theoretical principles.

'I do not search, I find,' maintains Picasso. Gifted with an exceptional talent for painting and a remarkable aptitude for drawing, driven by a creative passion that has made him an inexhaustible creator of form and formula, the Spaniard Pablo Picasso (1881–1973) settled in Paris at the beginning of the century. He was very quickly attracted to the world of the poor, the destitute, and the circus folk that he depicted with Expressionist distortions in the Blue Period, so-called for its deep, mournful, dominant colour. The same themes reappeared in masterpieces of the Pink Period, of soft and delicate colour, but heartrending all the same. In 1907 doubt and anxiety, provoked also by the primitivism of African sculpture, inspired Picasso to *Les Demoiselles d'Avignon* (Museum of Modern Art, New York), which marks the birth of Cubism. It is a disturbing painting, based on separate planes rather than rounded continuity, on formal deformities, especially in the grotesque masks of the two figures on the right. No one before had ever dreamed of painting in this way. At the same time, Braque renounced Fauvism and, interpreting in his own way the lesson of Cézanne, produced landscapes composed of synthetic geometric masses. One of these – *Houses at L'Estaque* (Kunstmuseum, Berne) – made Matisse exclaim: 'Look at the cubes,' from which the name Cubism is said to be derived.

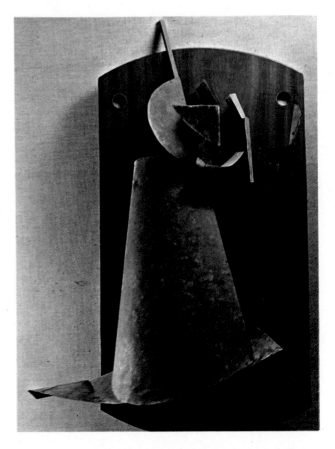

From such beginnings Analytical Cubism was launched, finding a characteristic home in the small studio known as Bateau-Lavoir in Montmartre, frequented by critics and writers such as Guillaume Apollinaire, Max Jacob, Blaise Cen-

Gino Severini, the 'Boulevard' (Sir Eric Estorick Collection, London)

Top: Vladimir Tatlin, 'Relief', wood and zinc on iron (Tret'yakov Gallery, Moscow)

Juan Gris, 'Still-life with Dice' (National Museum of Modern Art, Paris)

650

drars and Gertrude Stein. Here the artists confined themselves to a restricted thematic idiom: still-lifes of domestic objects or of musical instruments; a few figures such as Braque's *Girl with Mandolin* (Penrose Collection, London), or a few portraits (such as that of Vollard by Picasso in the Pushkin Museum, Moscow). Divorced from any surroundings, each form is dissected analytically and then fitted together or superimposed, occupying all the surface area of the painting. Far removed from reality, the picture strives to be entire nonetheless, and to sum up in itself all possible points of view: from the front, the side, underneath, above, from behind – as though one were able to move around it.

Towards 1912 this style of deep articulation and twisted syntax – hard to understand and difficult to practise – calmed down into Synthetic Cubism. There crept into out-and-out fragmentation (though still in harmony with Cubist vision) a type of composition that was more sustained, with integral forms and allusive abstraction. To create a new sense of space and composition, the artists introduced typographic letters, then the technique of *collage*, which in fact brought within the context of a picture such apparently extraneous matter as newspaper cuttings, pieces of material and cigarette boxes.

World War I broke the Braque-Picasso association and created a crisis in the pioneering phase of Cubism. Nevertheless, a vast repertoire of expressions in form already existed. The man

Umberto Boccioni, 'Unique Forms of Continuity in Space'
(Museum of Modern Art, New York)

Edvard Munch, 'Anxiety' (Municipal Collection of Fine Arts, Oslo)

Edvard Munch, 'Village Street near the Beach at Aasgard' (Neue Staatsgalerie, Munich)

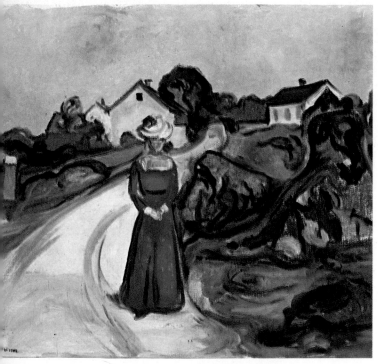

who continued the movement most faithfully, among many unstable adherents, was another Spaniard who had been attracted to Cubism round about 1912. Juan Gris (1887–1927), created synthetic forms ('With imagination I try to make concrete that which is abstract'), painted with a refined sense of colour. The paintings of Roger de la Fresnaye (1895–1946) were only superficially Cubist.

The problem of Cubism was reflected in sculpture, though with a less disconcerting effect. Besides some of Picasso's own works, most impressive are the statuettes of Alexander Archipenko (1887–1964), a Russian who emigrated to the United States; the fragmented structures of two other Russians, Ossip Zadkine (1890–) and Jacques Lipchitz (1891–); the spiral creations in wrought iron of Raymond Duchamp-Villon (1876–1918); and the synthetic, plastic structures of Henri Laurens (1885–1954).

Futurism

Preceded by a whole programme as set out in the famous 1909 manifesto of the radical poet and man of letters Filippo Tommaso Marinetti, Italian Futurism began to appear from 1910 onwards. Mainly under the direction of Marinetti, self-elected leader, manager and propagandist of the movement, the call to sweep away the past and create an art which would reflect the modern world took on a rhetorical and arrogant aspect. It was hampered rather than assisted by the events that surrounded its launching – more in the nature of spectacular entertainments than serious artistic endeavour. Certainly in a country as conventional, provincial, and artistically shy as Italy was at that time, Futurism had the effect of a tornado. However, despite its acceptance abroad (especially in Germany and Russia), the myth of the beauty of speed, energy and the machine, in whose name all art of the past should be banished en bloc, revealed itself as a product of somewhat foolish provincial aspirations. From the artistic point of view Futurism re-attached itself, thanks to the links with Paris forged by Gino Severini (1883–1966), to the anti-naturalistic and structural distortions of Cubism. Futurism accused Cubism of having static vision, and of being inadequate to express the qualities of dynamism, velocity and perpetual transformation characteristic of modern civilisation, which Futurism glorified. Futurism wanted to paint pictures in motion, with successive dynamic moments presented simultaneously. And so, in his early work Severini sought to capture the successive dancing movements of

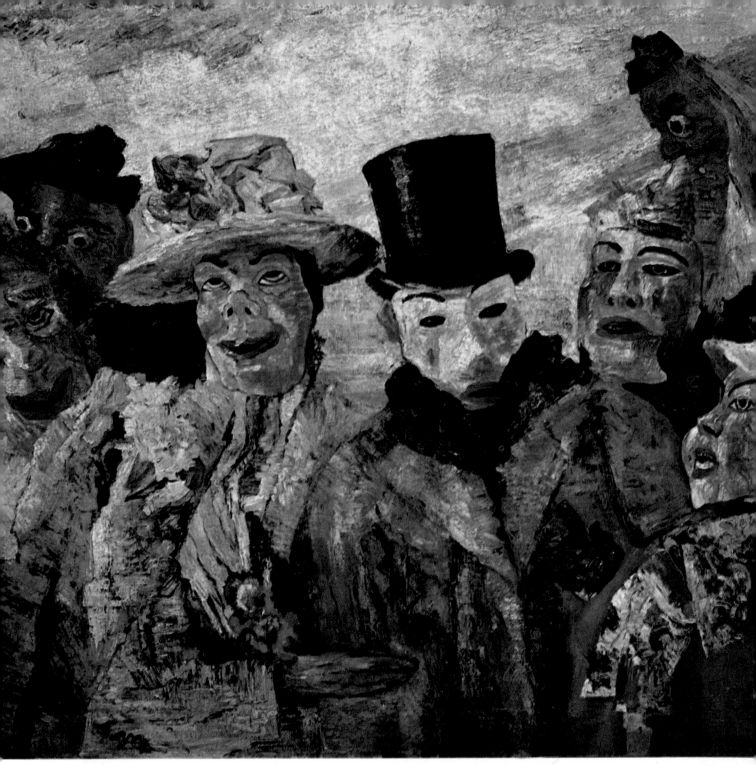

James Ensor, 'Intrigue' (Museum of Fine Arts, Antwerp)

his ballerinas. Likewise, Giacomo Balla (1871–1958) catches the wagging movements of a dog's tail in a flurry of brushstrokes, and the running action of a girl in a many-legged simbolisation.

This method of representing movement, more or less infantile, was discarded in the more mature phases of Futurism. The greatest Futurist, although he never succeeded in overcoming his Neo-Impressionist technique, imbued with Lombard overtones, was Umberto Boccioni (1882–1916). The picture of motion developed with

him suggestively. He expresses the moving image by the interpenetration of planes, the representation of successive movements at the same time, and the construction of line-forces and plane-forces as they develop in space. Apart from Boccioni's merits as a painter he was also a significant sculptor: in *Unique Forms of Continuity in Space*, he expressed the ideal dynamic development of a figure walking energetically, while in *Development of a Bottle in Space* (both in the Museum of Modern Art, New York) he

653

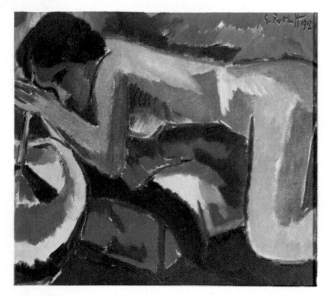

Karl Schmidt-Rottluff, 'Woman Resting' (Neue Pinakothek, Munich)

Ernst Ludwig Kirchner, 'Five Women in the Street' (Wallraf-Richartz Museum, Cologne)

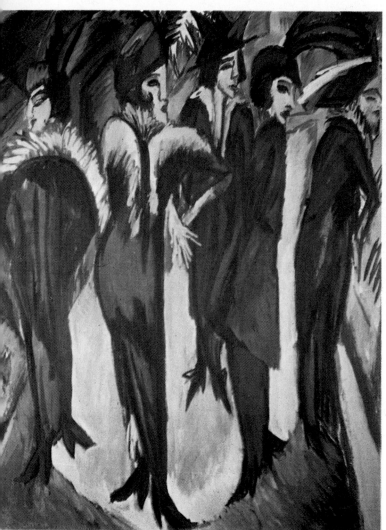

traced the virtual planes of dynamic development of a bottle and the plate beneath it. Other Futurist painters worked in the same style such as Carlo Carrà, Luigi Russolo, Enrico Prampolini. For Futurism, as with Cubism, World War I, especially with the death of Boccioni, was an event that threw the first and really vital phase of the movement into crisis.

Expressionism

Much more complex by comparison, and of more profound artistic and spiritual motivation, was German Expressionism, foretold in a certain sense by Van Gogh, Ensor, Toulouse-Lautrec and, above all, Munch. Expressionism fulfilled in Germanic countries the function of Fauvism, Cubism and Futurism in Latin countries. In fact, in an attempt to escape from its introverted, provincial outlook, German Expressionism turned to Fauvism, Cubism and Futurism, sometimes copying their forms, but without being deflected from its own dialectic, also present in the literary, intellectual and musical aspects of the movement. German Expressionism, which survived World War I, was in fact an indication of a radical spiritual crisis. It was not only opposed to the mediocre artistic ambience of contemporary Germany and the cultural conformity epitomised by Wilhelm II and marked by connivance between commercial interest and aggressive militarism, but it also denounced the sickness of a society, the dramatic alienation of modern man and his solitude in suffering.

The history of Expressionism hinges on two centres. The first was in Dresden, beginning in 1905. There a number of young men formed Die Brücke (The Bridge), a group intended to concentrate the rebellious artistic forces. Their interest in African sculpture, the masks of Oceania and the German primitive masters encouraged open rupture with traditional art. It also had a profound impact on their strong, dramatic drawing and led to their readoption of wood engraving. The new idiom was immediate, brutal and aggressive, with a primitive violence that sought to express the torment, anguish and dilemma of modern man. The harsh, sculptured figures and violent colour of Ernst Ludwig Kirchner (1880–1938), the almost Gothic drawing and acid colouring of Erich Heckel (1883–), the powerful distortion and violent colour of Karl Schmidt-Rottluff (1884–), show the harsh,

Opposite page: *Emil Nolde, the 'Sisters' (Private collection, Essen)*

corrosive style of the founders of the group. To these elements was added the already mature Emil Nolde (1867–1956) with his desolate landscapes, masses of shining colours and crude, brutal figuration. Later Otto Müller (1874–1930) attached himself to the group, bringing to it the atmosphere of the gipsy world. In 1911, after moving to Berlin, *Die Brücke* broke up and its members went their own ways.

The second Expressionist centre was at Munich where, with a less overtly revolutionary aspect but nevertheless determined break with tradition, the movement crystallised in 1910 into the *Blaue Reiter* (Blue Rider) group, under the leadership of the Russian Wassily Kandinsky (1866–1944). Relying on purely internal inspiration, the group moved towards a musical spiritualisation of composition, to the extent of rejecting the real image. In this way Kandinsky arrived at abstract painting, whilst the painting of the other members remained heterogeneous. The Russian Alexei Jawlensky (1867–1941) painted his roughly hewn figures with the colouristic passion of a Fauve,

whereas August Macke (1887–1914) presented a placid, idyllic world, warmed by harmonious colour. Franz Marc (1880–1916), more disturbing and more daring, experimented with complex compositions – *Shapes in Combat* and *Tyrol* (Bavarian State Museum, Munich) – lying between Fauvism, Cubism, dynamic Futurism and abstract inspiration. With this group the Swiss Paul Klee (1879–1940) made his debut.

In Vienna Expressionism appeared in the work of Oskar Kokoschka, with pitiless psychological analysis in portraits and compositions, and a neo-Baroque dynamism. George Bellows (1882–1925), one of the Ashcan School, painted a harsh picture of American contemporary life. The pictures of labourers painted in a heavy Expressionist manner are typical of Marcel Gromaire.

Leaving aside minor movements – such as the 'Rayonism' of the Russians Michel Larionov and Natalia Gontcharova, or the 'Vorticists', a group of English artists led by Wyndham Lewis – it was at this period that abstract art was born.

Chronologically, the first abstract work was a water-colour painted by Kandinsky in 1910, which he called *Improvisation*. Kandinsky has left his own account of how the idea of this new type of theme – free from figurative subject matter – came to him one evening when, returning to his studio at sunset, he found that one of his pictures with large areas of colour had been placed, upside down, on the easel; it no longer portrayed anything, but seen in this way it appeared a very beautiful composition. He realised at that moment that reality could never have inspired such freshness and dynamism.

Having taken Cubism as his point of departure, the Frenchman Robert Delaunay (1885–1941) also arrived at abstract painting, via that freedom from obsession with the object which is evident in works dating from 1911, such as the eurhythmic broken light of *Window* (Guggenheim Museum, New York) and, later, in the vibrant *Circular Forms* (Guggenheim Museum). The Czech Franz Kupka (1871–1957) in his turn arrived, about 1911–12, at his *Picture without an Object*, with multicoloured geometric planes. The acme of

Oskar Kokoschka, the 'Tragedy of Man', poster (Wolfgang Gurlitt Collection, Munich)

abstract painting at that moment, however, was the work of the Russian Kasimir Malevich (1878–1935). 'To liberate art from the flavour of the objective world' he presented in 1913 the famous *Black Square on White Ground*, and then *White Square on White Ground* (Museum of Modern Art, New York), signifying the drastic repudiation of any figurative content whatsoever. A split in the ranks of the abstract painters in Moscow occurred in 1921–22, between those opting for the pure art of Malevich which he named Suprematism, and the Constructivists. The latter, led by Vladimir Tatlin (1885–1953) identified themselves with the social aims of the Revolution, and became artist engineers. El Lissitzky fused both schools of thought in his work.

In Paris, meanwhile, besides the reactions provoked by Cubism, other artistic movements were developing. Rouault was painting, in a vigorous Expressionistic style, works of mystical imagery and melancholy working-class figures. Rousseau (*Le Douanier*), was the first of the naive artists. His innocent and primitive paintings carry a powerful suggestive force, as the *Snake Charmer* (Jeu de Paume, Paris), or the *Dream of the Gipsy Girl* (Museum of Modern Art, New York), where the sleeper is nuzzled by a lion in a desolate lunar landscape. Another exceptional primitive is Maurice Utrillo (1883–1955), completely self-taught, who painted enchanted white views of his Montmartre. In this atmosphere of new poetic ideas, Italian Metaphysical painting emerged with Giorgio De Chirico (1888–), trained in Munich at the school of Böcklin, and came to the fore in Paris in 1910, especially with his *Squares of Italy*. He pours into their sun-filled spaces, with his arbitrary perspectives and abstract colours, a disquieting sense of the mystery of things, of strange omens and sibylline allusions. It was, however, during World War I, in Ferrara, that De Chirico, founder and theoretician of this movement, attracted followers, among whom was Carlo Carrà who had already abandoned Futurism. The forms are entire, even three-dimensional, but they delineate the magical hypothesis of the impossible and the nonexistent. It is a hallucinatory, static world. Against unreal and mysterious backgrounds human figures are replaced by mechanical manikins that move about, ungainly in their artificial structures, with white, egg-shaped heads, imitating the passions and gestures of their human counterparts. De Chirico's *Hector and Andromache* and *Disquieting Muses* (Mattioli Collection, Milan) are among the most significant examples of this singular new 'poetic' art. The restless atmosphere of these unreal compositions, the lack of

Wassili Kandinsky, 'With the Black Bow' (Nina Kandinsky Collection, Paris)

logical and rational connections, and simultaneous appearance of things and forms whose meeting is absurd, these make Metaphysical painting a forerunner of imminent Surrealism.

Art between the wars

The period between the two world wars was bitter and tormented. In an insecure and unbalanced peace, with acute political and social contrasts, the first 'postwar syndrome' was unleashed, amid an inheritance of ruins, misery, monetary inflation and the wild, frenetical pleasure of 'recovery'. Then, in an atmosphere of civil war, came the totalitarian movements, and, in 1929, the worldwide economic crisis, with financial failure, poverty and masses of unemployed. Finally the sequence of events began that led to yet another inhuman conflict.

For art, too, it was a difficult and contradictory period. It was in fact a time of progress and

Giorgio De Chirico, 'Hector and Andromache' (Mattioli Collection, Milan)

Carlo Carrà, 'Hermaphrodite Idol' (Private collection, Milan)

reaction, new impulses and 'calls to order', impatience and stagnation. The result is a confused impression of complicated and contradictory tendencies.

The long and exhausting conflict of 1914–18 threw everything into a state of catastrophe. Civilisation and culture – values which had appeared safe for ever – were forgotten in the brutality and destruction of war. In the domain of art, the war disrupted movements and severed contacts and, apart from a few rare oases, blocked all production.

The only movement to appear during the war, Dadaism, could for that very reason be no more than the response of a desperate nihilism, of a drastic negation, of total rejection. In neutral Zurich, in 1916, a group of young intellectuals, fugitives of various nationalities, under the leadership of the Rumanian poet Tristan Tzara, gave birth to the semi-anarchist and defeatist movement which, for lack of a positive programme, decided to call itself by a name found by chance in a dictionary: 'Dada', the name a child uses for a pick-a-back ride, suitable for whatever attribution anyone cared to give it. The provocative evenings organised by the movement at the Cabaret Voltaire had not, and were not intended to have any meaning. Dadaism simply set out to counterpose a madness of its own – casually, irrationally and absurdly inspired, and repudiating any pretences of meaning – to the much more frightful madness of a civilisation massacring itself in war. Art could not save itself, any more than civilisation had been able to save itself. In fact art appeared as the hypocritical

mask of this civilisation which boasted of rationalism in the midst of bloodshed and destruction. In such a situation Dadaism heaped irrationality upon irrationality to point out the stupidity of that situation.

The artistic output of Dadaism in Switzerland was poor. In fact it did not go much beyond *collages* of paper, or the arbitrary abstract constructions of superimposed layers of wood by the Alsatian Jean Arp (1887–1966). It gathered strength, however, from its encounter with American Dadaism. The last few years before the war saw the irruption in the U.S.A. of European avant-garde art. In 1913, in the halls of the Armory Show in New York a large exhibition took place that brought European avant-garde art to the American public (only the Italian Futurists were absent). One of the most surprising and scandalising works was *Nude Descending a Staircase* (Museum of Art, Philadelphia) by the French artist Marcel Duchamp (1887–1968). Repudiating traditional interpretation, the painting threw a bridge between the breaking up of form, a property of Analytical Cubism, and the need for movement, a property of Futurism. The artist wanted to put into a unified, simultaneous image the successive positions of a figure moving down a staircase. Duchamp moved to New York with Picabia, another avant-garde artist. The artists' reaction to the American myth of mechanisation as the solution to all problems verged between the anarchic and the Surrealist. Duchamp invented, with typical Dadaist *esprit*, objects that he called *ready-mades*: practical objects in every-day use, presented as if they were

works of art, like the urinal which, when signed, becomes a fountain, or a device for draining bottles, proclaimed as sculpture. Francis Picabia (1879–1953) painted designs for the most complicated machines that were totally useless and absurd. The photographer and painter Man Ray (1890–) devoted himself to disordered arrangements into photomontage, or introduced absurd objects into his compositions, like a piece of iron in a style both vulgar and ostentatious which nevertheless, after 1921, was to prepare the way for Surrealism.

Dadaism in defeated Germany was more meaningful and aggressive. In Cologne, Max Ernst produced absurd and disconcerting *collages* with curious associations of newspaper cuttings. Even more daring was Kurt Schwitters (1887–1948), whose *collages* of sensitive colour and deliberately abstract rhythms were made from discarded rubbish, such as used bus tickets, candy wrappers, etc. And so Dadaism showed how the

Robert Delaunay, the 'Runners' (Delaunay Collection, Paris)

Below, left: *Francis Picabia, 'Optophone' (H. P. Roche Collection, Paris)*

George Grosz, 'Twilight', watercolour from the album 'Ecce Homo'

Jean Arp, 'Configuration' (Kunstmuseum, Basle)

most ordinary materials, even rubbish, could be used in works of art – a technique which was to affect other contemporary movements besides Neo-Dadaism.

In the tragedy and confusion of postwar Germany it is easy to understand why it was that German Expressionism made its dramatic, tense, exasperated voice heard above all others. While an intelligent and passionate woman, Käthe Kollwitz (1867–1945) – chiefly in her lithographs and wood engravings – was violently denouncing the social consequences of the war, and Ernst Barlach (1870–1938) was developing his sculpture with its popular idiom, another offshoot of Expressionism appeared: the Neue Sachlichkeit movement ('New Objectivism') with its forced, suffering realism. A forthright interpreter was Otto Dix (1891–1969) who had already, with his pitiless drawing, recorded what were possibly the most terrifying pictures of the war. More famous was George Grosz (1893–1959), mainly for his ferocious caricatures in which a satirical treatment of Prussian militarism was followed by denunciation of those who had been made rich by the war.

France did not recover her prewar artistic ascendancy. Of the original Fauvists, Dufy became an elegant but superficial illustrator of modern life; Van Dongen, a *mondain* interpreter of the carefree life of Montparnasse; Rouault withdrew into his religious painting. Even Matisse seemed inaccessible in his serenity and recognised greatness; Cubism no longer had either following or force. Only Juan Gris remained faithful to former principles, but in a more elegant and decipherable style, with modulated colour. Georges Braque produced a large number of excellent still-lifes, embodying Cubist ideals in rational compositions which emphasised his great ability as a colourist. Picasso – as always – was tirelessly producing new forms, but more disconcerting than ever. He continued, it is true, to explore synthetic Cubism, both in still-lifes (the rosy *Still-life with Ancient Head* in the Museum of Modern Art, Paris or the *Still-life with Mandolin and Guitar* in the Guggenheim Museum, New York) and in flat compositions, such as the grotesque *Three Musicians* (Museum of Modern Art, New York). Yet at the same time Picasso felt the necessity of a *rappel à l'ordre*, a peculiarly postwar symptom. For a while he was even disposed to renounce harsh language of Cubism and return to three-dimensional volumetric forms, where he achieves a monumental effect, with his massive dilated figures with their enormous limbs, as in *Three Women at the Fountain* or *Motherhood*. Fernand Léger (1881–1955), having started from a personal interpretation of Cubism, followed a somewhat similar path, when he transferred his love for the beauty of the machine to the static rhythm of the *Luncheon*. Several painters who remained faithful to the name of Cézanne returned to traditional figuration (Derain, Vlaminck, Dunoyer de Segonzac).

In this situation the most interesting artists were those of the so-called Ecole de Paris, mainly foreigners living in the French capital. The Italian Amedeo Modigliani (1884–1920), after a long search that included sculpture as well, painted the great portraits of his last difficult years. His style, which was highly individual and had no following, produced distorted, stylised faces whose warm surfaces of colour are delineated by a sinuous but stable contour. A friend of Modigliani, with a no less dramatic and tempestuous life, was the

Fernand Léger, 'Women with Bunch of Flowers' (Kahn Collection, New York)

Georges Rouault, 'Apprentice Workman'
(Museum of Modern Art, Paris)

Georges Braque, still-life, the 'Red Rug' (private collection, Paris)

Lithuanian Chaim Soutine (1894–1943). However, his vision was a personal interpretation of anguished Expressionism, with exacerbated colour and restless forms. Marc Chagall (1887–) experienced recurring nostalgia for his native Russia and brought great imagination and candour to his work.

Meanwhile in the United States the development of modern movements was growing apace. It has already been seen how America had been made aware of European avant-garde art in the Armory Show exhibition of 1913. It led to several American painters abandoning the style then in vogue – a modernised version of Realism – that had resulted in painters, such as Robert Henry (1865–1929) and the younger John Sloan (1871–1951), stressing the sad and squalid aspects of American society; or, like Maurice Prendergast (1861–1924), who painted in lively

post-Impressionist colours the bustle and glitter of the modern scene. However, the Dadaist experiments of Duchamp and Picabia failed to raise a flutter among American artists, and their disciple Man Ray fared no better. Even so radical a work as Duchamp's *The Bride Undressed by her Bachelors* (Museum of Art, Philadelphia) – abstract metallic forms placed between two panes of glass which were then smashed – caused more dismay than admiration.

The work of other American artists between the two wars has greater importance, despite its European inflexions. John Marin (1870–1953), schooled in Paris, painted scenes of city life and vast seascapes with supreme freedom of composition and refined use of colour. Joseph Stella (1879–1946), inspired by the modern buildings and dynamic aspects of New York, is the foremost representative of American Futurism.

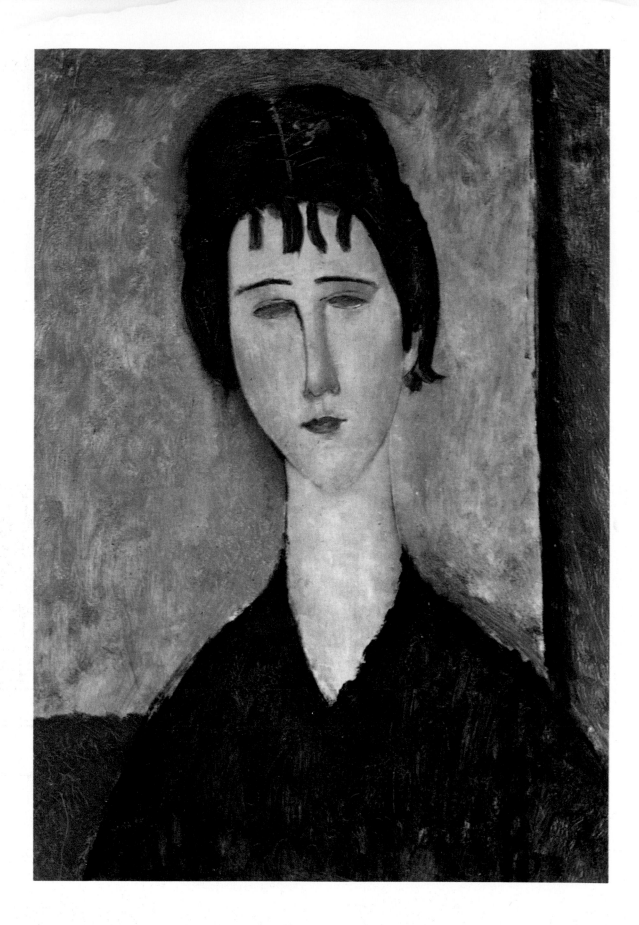

Amedeo Modigliani, 'Girl with Dark Hair' (Private collection, Milan)

Charles Demuth (1883–1935) and Charles Sheeler (1883–) abandoned Cubism for a 'magic realism' of industrial structures. Max Weber (1881–1961), during this postwar period, moved away from a concise and orthodox Cubism to abstract Expressionism, while McDonald Wright (1890–) in his 'synchromic research' returned to the intense abstract colouration of Delaunay.

After the financial crash of 1929 man and his existentialist condition once more dominate current thought. A new kind of Realism is born. We shall speak later of Ben Shahn, who remains its most brilliant representative. Nor should we forget to mention the coldly lucid workaday scenes and nocturnal visions of the city of Edward Hopper (1882–) or the bitter protest of William Gropper (1897–); or Evergood's (1901–) feeling of detached hallucination; and, finally, the crude moral and social satire of Jack Levine (1915–).

A new artistic ferment marks the years preceding World War II. It was partly instigated by those artists who, banned in Germany, had found refuge in the United States. As we shall see, Expressionism, Abstractionism, and Surreal-

Max Ernst, 'Massacre of the Innocents' (Private collection)

ism are to be the inspiration for a new generation of American artists.

In Mexico another type of Realism, born of the ethos of popular revolution, distinguishes the works of Diego Rivera (1886–1957), Clemente Orozco (1883–1949), and David Siqueiros (1896–). The heroic theme is transfigured into a harsh monumental Expressionism, which finds an echoing grandeur in the populist works

Salvador Dalí, 'Temptation of St Anthony' (Artist's collection)

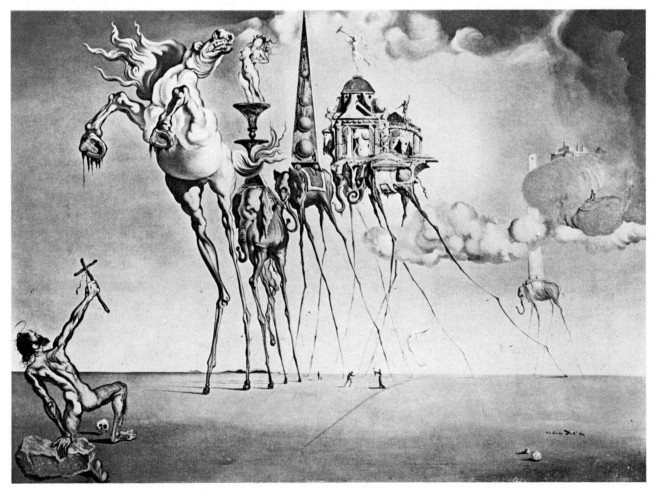

of the Brazilian Candido Portinari (1903–).

The newest and most significant movement between the two great wars was, however, Surrealism. Bound up with the literary movement born in 1924 with the publication of the *Manifeste Surréaliste* or 'Manifesto of Surrealism', under the leadership of André Breton, it centred itself on Paris but spread to several countries. Surrealism received a double inheritance: from one side, the enigma of Italian Metaphysical painting, and from the other, deliberate irrationalism, love of the absurd, the casual, the troubling, and the odd associations that were the base of Dadaism. In an even more premeditated fashion, Surrealism rejects a rational view of things and, drawing on the theories of Freud, calls upon the irrational world of the subconscious to reveal itself via art. Its pictures are removed *a priori* from logical assessment because they claim to be the equivalent figuration of the pictures of dreams, of hallucination, of obsession. Absurdities, monstrous distortions, burlesques, unforeseen and meaningless associations, the association of unconnected things, contradictions and confused and equivocal presentation – all are part of the Surrealist repertoire. The artistic results (almost always hampered by a wish to investigate the unconscious) are varied. Sometimes landscapes are painted in a dream atmosphere, with meticulously realist details contrasting with disturbing images, as in the work of the Spaniard, Salvador Dalí (1904–). Two examples of many are the figure with drawers in its body on the nocturnal horizon of the *Burning Giraffe* (Kunstmuseum, Basle) or the watches melting in the sun in *Persistence of Memory* (Museum of Modern Art, New York). The Temptations of St Anthony as a theme, have always furnished artists with the opportunity to show the strange, the monstrous, the magical, and the diabolical (it is enough to remember Bosch, that unique forerunner of Surrealist art). Salvador Dalí would not want to do less: in his limitless desert, horses and elephants jostle each other, on thread-like legs like menacing locusts.

The Frenchman Yves Tanguy (1900–1955) moved in the same direction, painting limitless horizons, that might be either sublunar or submarine, where every trace of humanity and vegetation is lost. The Belgian Paul Delvaux (1897–) portrayed ambiguous dreams, in which nude women appear unexpectedly. His compatriot René Magritte (1898–1967) brought to Surrealism both an ardent fantasy and the baffling effect of absurd forms executed with a *trompe l'oeil* realism, as, for example, the three metal spheres sailing in a blue sky, in *The Voice of the Winds* (Guggenheim Collection, Venice). More complex, but more robust, is the creative idiom of the German (but Parisian by adoption) Max Ernst (1891–), a leading Dadaist. He has the ability to suggest terror or wonder, with such works as *Celebes* (Eluard Collection, Paris), in which the mechanical monster triumphs, or the *Big Forest* (Kunstmuseum, Basle), with its spectral, petrified world, or the *Horde* (Stedelijk Museum, Amsterdam), with its ominous, broken shapes. Finally, to the myth so dear to Surrealism, automatism was added and, with their happy childishness, the graphic and colourful works of

Paul Klee, 'Red Balloon' (Solomon R. Guggenheim Museum, New York)

Opposite page: *Piet Mondrian, 'Composition'* (*National Museum of Modern Art, Paris*)

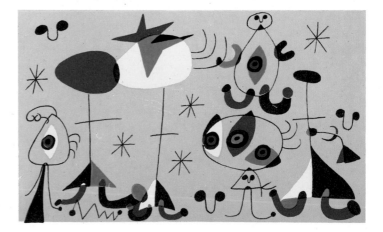

Joan Miró, 'Snob Evening at the Princess's' (*L. G. Clayeux Collection, Paris*)

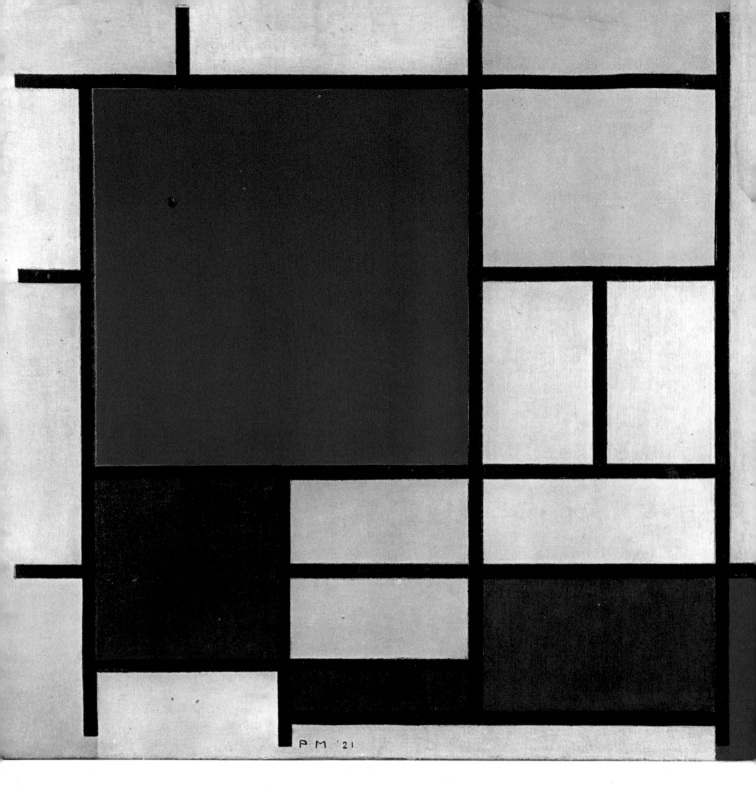

PM '21

the Spaniard Joan Miró (1893–), another Parisian by adoption.

However, the important development of abstract painting at this time, with its determination to avoid figuration at all costs, constituted a pole diametrically opposed to Surrealism. During the World War I, in neutral Holland, the painting of Piet Mondrian (1872–1944) showed an ascetic wish to acquire a clear geometric order and dispense with figuration. After an initial Cubist phase in Paris, he pursued a progressive abstraction of figuration, to the point of stylising abstract rhythms in compositions of short vertical and horizontal segments. Towards 1917, he began his extremely thoughtful compositions based on the square and rectangle, in pure colours (pink, blue, yellow, white, grey, black), between vertical and horizontal parallel lines.

Neo-plasticism took its inspiration entirely from Mondrian, and lasted until 1931. This movement of geometric abstraction grew up in Holland around the review *De Stijl* (*The Style*), through the

activity of Theo van Doesburg (1883–1931). Starting from the premise, 'Strip nature of its forms and you have its spirit,' Neo-plasticism sought a universal idiom of extreme simplification and purity, based on the straight line, elementary geometric forms, simple and pure colours and the elimination of every graphic factor. Neo-plasticism had wide international repercussions in architecture, industrial design, and the development of taste generally.

Dutch Neo-plasticism found response in what was possibly the most interesting artistic experience of the period, under the leadership of the architect Walter Gropius, at the Bauhaus at Dessau, Germany. Bauhaus was a school of genius that formed new builders in the broadest sense: animated by the teachings and the direct creative experience of the most significant contemporary artists, it aimed at producing the creators of new forms, conforming to modern technique and contemporary taste. The Bauhaus rightly laid down a concept of industrial design that envis-

aged mass production of standard products, in which aesthetic demands and practical functions would be combined. Gropius called teachers of an exceptional standard to the Bauhaus: László Moholy-Nagy (1895–1946) who probed the dynamic relationship of forms in space, and the use of 20th-century materials and techniques, Lyonel Feininger (1871–1956), with his fantastic insertion of lyrical landscapes into the framework of a poetic Cubism, and Oskar Schlemmer (1888–1943), master of clear eurhythmic compositions and futuristic scenography. There were two other great teachers. One was Wassily Kandinsky, who transformed his unrestricted and impetuous abstract *Blaue Reiter* period into elementary geometric constructions, in which point, line and surface, whether as graphic elements or colour com-

Below, left: *Constantin Brancusi, the 'Cock' (National Museum of Modern Art, Paris)*

Marc Chagall, the 'Green Violinist' (Solomon R. Guggenheim Museum, New York)

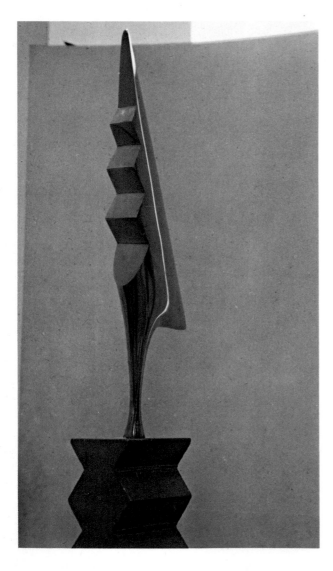

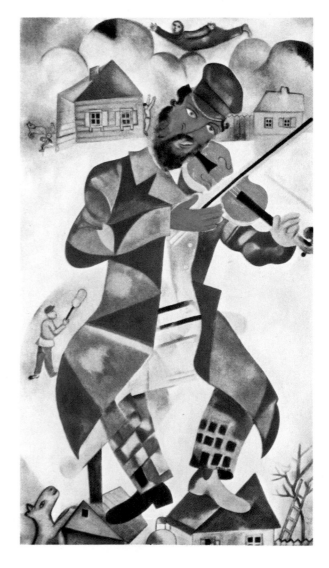

ponents, were integrated into the composition. The other was Paul Klee (1879–1940), with his profound peace, rich with mystery and enchantment. The phrase 'art does not consist of repeating the visible, but in making visible' summarises not only the secret of his enchanted art, which cannot be consigned to any of the accepted categories (not even abstraction) customary in contemporary art. Klee varies, not without a humorous streak, from a supple graphic – hesitant, candid, apparently childish – to a painting founded on abstract associations with a highly elaborated harmony of new forms, new signs, new poetic hieroglyphs. They are non-existent forms and rhythms of an internal lyricism that emerge and 'become visible'.

But in spite of these positive acquisitions, the period between the two wars was marked by serious phenomena of regression, even to the point of stifling any genuine artistic reaction.

The first regressive phenomenon affected Soviet Russia. Hopes that the Bolshevist revolution would make the country into an avant-garde artistic paradise (which had made Kandinsky, Chagall, Malevich, Pevsner and Gabo hurry there) quickly faded. From 1921 Russia, taking a step backwards, closed her doors to contemporary art, moving towards objective and descriptive Socialist Realism, which was the only art accessible to the masses.

The second reaction hit Italy with the advent of Fascism. A *rappel à l'ordre* was the pretext, necessitated by a return to tradition as a national prerogative. With the return to figurative art and the return to the subject (including many concessions to the propaganda of the regime) the '20th-century' movement became official. Weak

Giorgio Morandi, 'Still-life' (Private collection, Milan)

Below, left: *Marino Marini, 'Bust' (Jesi Collection, Milan)*

Henry Moore, 'Madonna and Child' (St Matthew's Church, Northampton)

Pablo Picasso, 'Guernica' (Museum of Modern Art, New York)

and tame, a second wave of Futurism appeared, along with a geometric abstraction, as practised by Soldati, Licini, Magnelli and Reggiani. Italian art plunged into a provincial withdrawal from the most vital European currents, with few exceptions (the balanced stylism of Casorati in Turin, the tense neo-Baroque of Scipione in Rome, and finally the disguised Expressionism of the Corrente group in Milan). In stifled isolation even the best artists, and their not insignificant talents, were brought down – for example, the substantial landscape painting of Carrà; the bare, structural vision of Sironi; the enchanted style of

Campigli; the quiet play on colour tones of the still-lifes of Giorgio Morandi (1890–1964).

More terrible and devastating was the third reaction, inflicted on Germany by the Hitler regime. Dislike of modern art apparent in the persecution of individual artists and in the suppression of the Bauhaus developed, in 1937, into the categorical condemnation of all contemporary art – Expressionism above all – as officially 'degenerate'. Modern works were excluded from museums, sold abroad or burnt. Artists had to go into exile or, if they remained, were banned from any artistic activity. Oskar Kokoschka, ex-

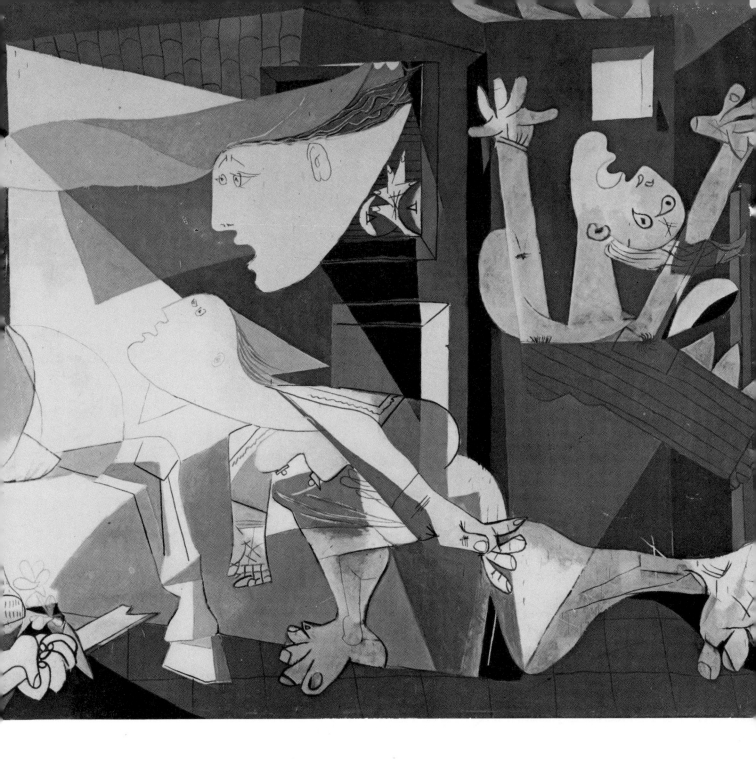

iled in London, abandoned his impetuous land-scapes, partly Expressionist and partly neo-Ba-roque, which had made him famous, to portray himself in *Portrait of a Degenerate Artist*. Another artist, Max Beckmann (1844–1950) predicted, in *Departure of the Argonauts* (Museum of Modern Art, New York), the fate of torture and violence in store for his country. Feininger and Moholy-Nagy emigrated to the United States to found a new Bauhaus in Chicago. The architects who followed them make an impressive list. Gropius, one of the great masters of 'functional architec-ture' and organising genius of the Bauhaus, was invited in 1937 to lecture at Harvard University. He was joined by Marcel Breuer (1902–). Mies van der Rohe, perhaps the most famous of Ger-man architects, left Germany to teach at the Illinois Institute of Technology, Chicago, where he was to design the new campus. This immi-gration of German artists at the centre of the most modern art movements was certainly of immeasurable benefit to America. But Hitler's absurd *diktat* left Germany with an artistic void, and dealt a fearful blow to the hitherto prestig-ious modern German art.

Amid reaction, retreat and stagnation, it was

once again Picasso who expressed, in a highly dramatic manner, a new idiom. The bombing of defenceless civilians during the Spanish civil war drove him to transform the problem of the Cubist double vision (portraying simultaneously the 'front' and 'side' of an object, to which he had by this time returned) to the horrific monochrome of *Guernica* (Museum of Modern Art, New York). The torn, screaming creatures, enclosed within an Expressionist, synthetic and abridged dimension, denounce the tragedy which afflicted the period. The times oppressed Picasso, suggesting to him the monstrous female figures, twisted by double vision, and the lugubrious birds of ill-omen, which appear continually in his paintings during the next war.

Other experiments in sculpture were to follow. The expressive possibilities of Cubist sculpture are shown in the works of Lipchitz and Zadkine, and at times even by Picasso himself, but are brought out, above all, in the concise and strong forms of Henri Laurens (1885–1954). The Spaniard Julio González (1876–1942) forged rugged, imaginative figures from iron bars with a blowlamp. Alone in his dusty Paris studio, the Rumanian Constantin Brancusi (1876–1957), convinced that 'the exterior form of things is not real, but the essence of things', created simple, clear and absolute primordial abstract figures, such as the tapered block of *Bird in Space*, or the jagged, ascending rhythms of the *Cock* (Museum of Modern Art, Paris). The genius of Brancusi is revealed in his ability to absorb and then go beyond formulas of his time. In his sculpture, a reduction to the essential, Cubism, Expressionism, and Abstractionism are united and transfigured. A typical example is the smooth and shiny egg, with one end sliced off, that he calls *sculpture for a blind man*. In Soviet Russia the revolution of 1917 gave impetus to the avant-garde movement of Constructivism that, rejecting traditional figurative sculpture, searched for new effects in metallic structures and mechanical forms. After 1920 the reactionary movement in Soviet art put an end to these ideas. However they were carried to the West, to the United States particularly, by the brothers Anton Pevsner (1886–1962) and Naum Gabo (1890–). They created abstract forms expressing a technical and mechanical world by combining unusual materials (metal, transparent threads, glass and plastics), which they juxtaposed in space with a mathematical

Julio González, 'Woman Combing Her Hair' (Museum of Modern Art, New York)

Opposite page: Jean Arp, 'Shepherd of Clouds' (National Museum of Modern Art, Paris)

Tony Garnier, plan for an industrial city (Museum of Decorative Arts, Lyons)

exactness. Jean Arp (1887–1966), an Alsatian who came from the Dadaist environment of Zurich and settled in France, succeeded in merging Surrealism and Abstractionism. His white, smooth, abstract forms correspond, in the liberty of their rhythms, to an organic expansion and a natural excrescence. More and more sculptors swelled the ranks of the Abstractionists. Among these the Englishwoman Barbara Hepworth (1903–) is remembered for her harmonious forms, whose interiors and exteriors, the concave and convex, come together in a tight relationship. Many other sculptors were working in these directions, but we shall mention only Moore, whose work, as we shall see, was to feed the various currents of the postwar period.

Contemporary art and architecture

The inter-war years saw the establishment of a new architectural style. The movement, launched under the banner of functionalism, recognised the need to create an architecture in harmony with the new technologically orientated civilisation and with the mode of life and work of modern man ('The form must follow the function,' argued Louis Sullivan), in opposition to the 19th-century view that new necessities should be confined within the structures and styles of the past. But 'functionality' was not a mere fashion, nor simply the result of practical considerations, although it was in fact ready to conform to a new system of communication, a different scale of human values, a newly evolving kind of co-existence.

The new architecture required pure forms, geometric expressive force and authentic structures. Rebelling against ornamentation, rhetoric or the restrictions of national or local traditions, architecture took on a universal character, an international scope. In the third place, the gap between architecture and technique which had paralysed the 19th century was eliminated. The new architecture wanted to utilise every possibility – constructive or expressive – offered by new techniques, new materials and new principles. Besides the possibilities offered by a combination of metal and glass, and prefabricated units, architecture now adopted reinforced concrete, which appeared at the end of the last century. It was not only a question of a material

Opposite page: *United Nations headquarters, New York*

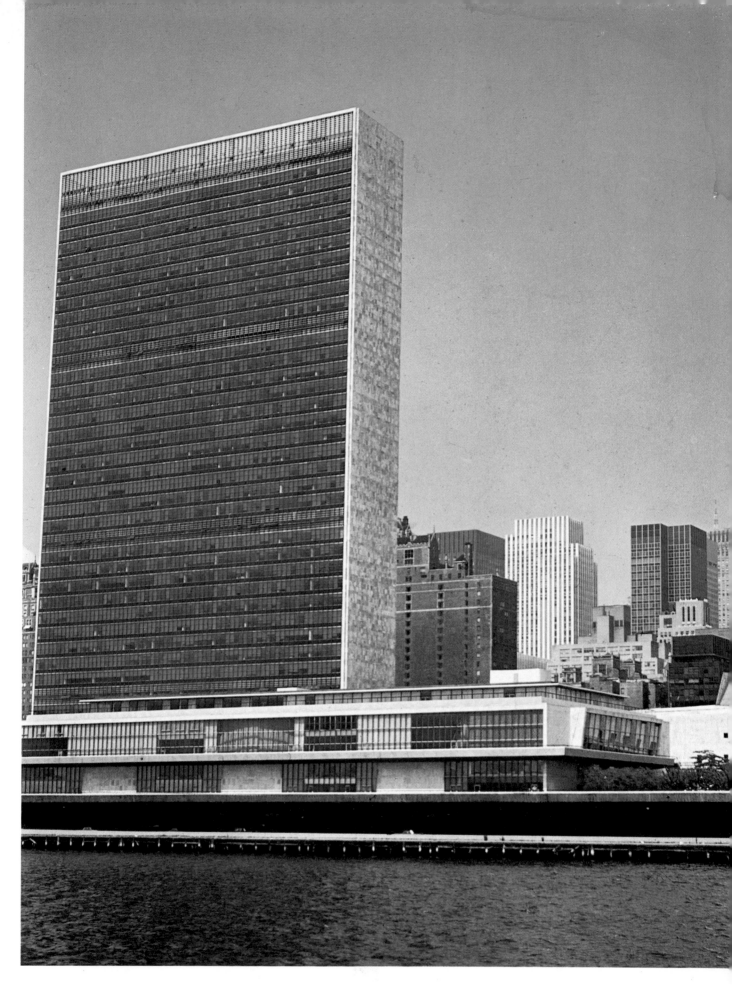

of exceptional resistance, elasticity, and flexibility, whose effects could be calculated, but of a revolution in traditional building methods. The age-old system of thrust and counter-thrust, with load-bearing walls taking the weight of the building, and where for obvious reasons the number of doors, windows, etc., were limited, was replaced by the use of a structural framework of rigid girders. This could support innumerable storeys and resulted in constructions of unprecedented height. Extremely wide, horizontal windows or even completely transparent exterior walls were possible with this new method. Façades were correspondingly more flexible, and the planning of the interior much more simple, since dividing walls were virtually reduced to simple screens between fixed pillars.

But the fourth and major element of the new architecture was its completeness of concept – a building became a reality which, from the aesthet-

Antonio Sant'Elia, plan of a building

Gerrit Rietveld, armchair (Museum of Modern Art, New York)

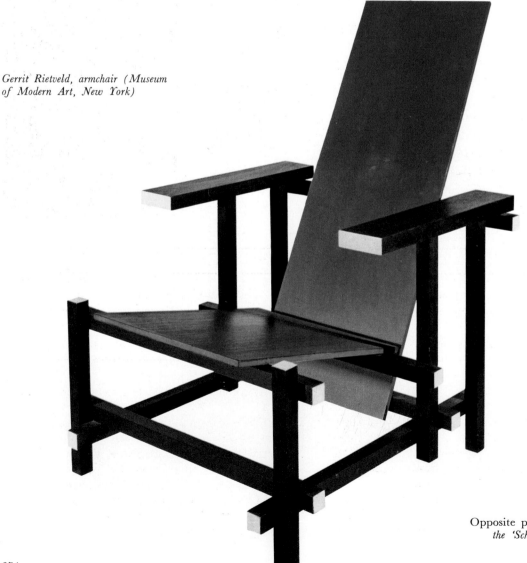

Opposite page: *Gerrit Rietveld, the 'Schröder House', Utrecht*

674

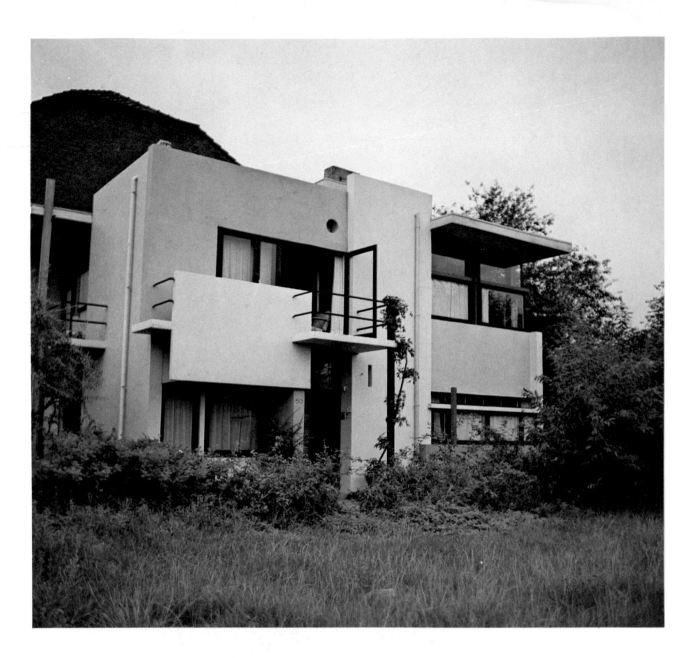

ic point of view, was introduced into an environment and grafted itself, socially, into the fabric of a community or town. Hence the close tie between architecture and town planning that has been formed in recent times.

The developments of contemporary architecture have had an immense influence on decoration, industrial design and furniture. New types of dwelling have revolutionised not only the way of living, but aesthetic taste. On the other hand, it is true that the shapes, rhythms, structures and impulses of contemporary architecture would have been inconceivable without the freedom of composition and renewal of outlook which the avant-garde movements had taught.

What we shall call, for the sake of brevity, 'the architecture of the great masters' is characterised precisely by this participation in the creation of new shapes and new spaces. And it was these innovations which constitute the 'qualitative leap' of the 'proto-rationalist' architecture of the first twenty years of the century.

Towards a new architecture

It was a period, in fact, that was rich in teaching. In France, Auguste Perret (1874–1954) explored the various possibilities of reinforced concrete in private dwellings, industrial buildings, the framework of the Théâtre des Champs-Elysées (1911) and the church of Le Raincy (1923). Henri Sauvage (1873–1932) designed a house terraced in large steps in the rue Vavin, Paris, in 1911. In 1907, Tony Garnier (1869–1948) drew up a project for a large *cité industrielle* in reinforced

concrete, which was partially realised in Lyons. In Germany, Peter Behrens (1868–1940) with his turbine factory of 1909, showed how concrete could be applied to modern industrial architecture. In Vienna, Adolf Loos (1870–1933) started a campaign against all forms of decoration. In his eyes, decoration constituted an aesthetic 'crime', demonstrating that true architecture does not require additional ornament; between 1910 and 1912, with the houses of Steiner and Scheu, he anticipated the rectangular and horizontal lines of rational construction and clean forms.

On the other hand, the architecture of the great masters transcends the various avant-garde movements. Italian Futurism inspired the futuristic plans of Antonio Sant'Elia (1886–1916) for a mechanised city of high buildings. The direct derivations from German Expressionism were very important: the cylindrical glass house built by Bruno Taut (1880–1938) for the Cologne Exhibition of 1914; the Berlin Schauspielhaus of 1919 by Hans Poelzig (1869–1936) with its curtain of stalactites hanging from the roof; the Chilehaus, Hamburg, built in 1921 by Fritz

Höger with its acute angle like the prow of a ship; the Einstein Tower (since destroyed) erected in Potsdam in 1919 by Erich Mendelsohn (1887–1953) architect, at Chemnitz, of a large department store whose curved façade in glass was, at that time, a completely novel design.

The contribution of Dutch Neo-plasticism, connected with *De Stijl*, was remarkable for the clearness of its abstract forms and the intersection of horizontal and vertical planes. This strictness of style is evident in the work of Gerrit Rietveld (1888–1964) with his Schröder house in Utrecht while J. J. P. Oud (1890–1963), in his skilful town planning at the Hook of Holland and in Kiefkoek, near Rotterdam, and W. M. Dudok (1884–) with his work in Hilversum, were more free.

Frank Lloyd Wright

The architecture of the great masters reveals a more universal sense of synthesis, to which each one gives his own special character. In the United States, where the innovations of the Chicago school had faded out into conservatism, Frank Lloyd Wright (1869–1959) was working alone, little known, outside of any school. His 'organic' architecture has no definition other than rejection of all formal preconceived plans and an extreme adherence to the creative undertaking, different every time, stimulated by the specific surroundings and using the most appropriate materials. Hence the extreme flexibility, and natural coherence, that the very varied panorama of his creations presents. The functional demands of his interiors, no doubt seemed to Wright more important than the aesthetics of the exterior. From the very simple constructions of houses and villas, among them the famous Kaufmann house 'Falling Water' at Bear Run, Pennsylvania, he turned to industrial complexes like the Johnson Wax offices in Racine, with the use of umbrella-shaped columns; from adherence to the desert-like nature of Arizona where he created the oasis of Taliesin West, to the Guggenheim Museum in New York, completed after his death, with its cone enclosing a spiral descending ramp.

After the versatile and unpredictable creative power of Wright, the Vienna-born Richard Neutra (1892–1970), a pupil of Loos who moved to California in 1923, brought to architecture a rationalist European discipline which is apparent in works of great purity, such as the Lovell clinic in Los Angeles and the Kaufmann desert house at Palm Springs, California. The migratory wave of European architecture found America in the throes of the ardent impulse which had put up, almost as a symbol, the Empire State Building

Here and opposite page, below: Frank Lloyd Wright, the 'Falling Water', Bear Run, Pennsylvania

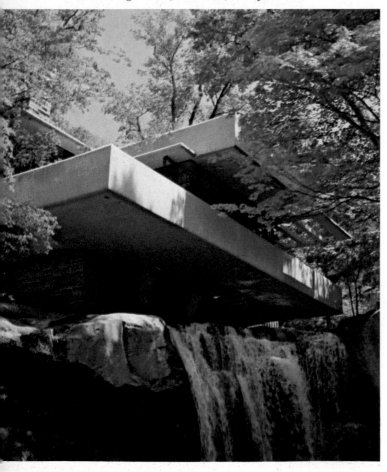

Frank Lloyd Wright, the S. C. Johnson Wax Company Administration & Laboratory Buildings, Racine, Wisconsin

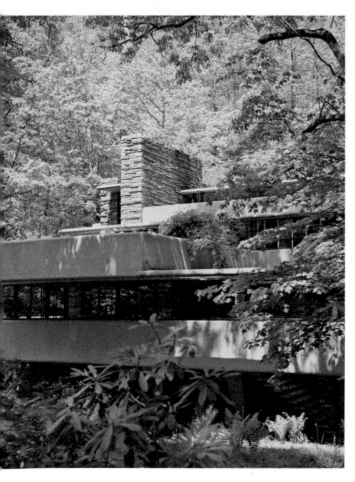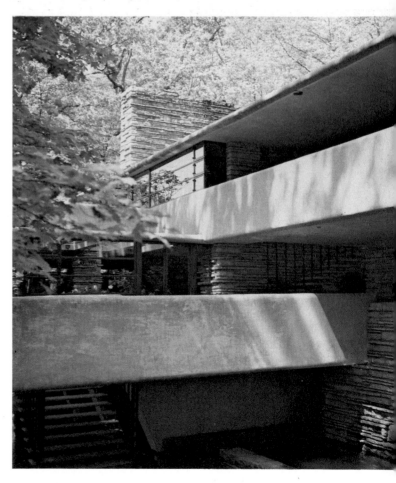

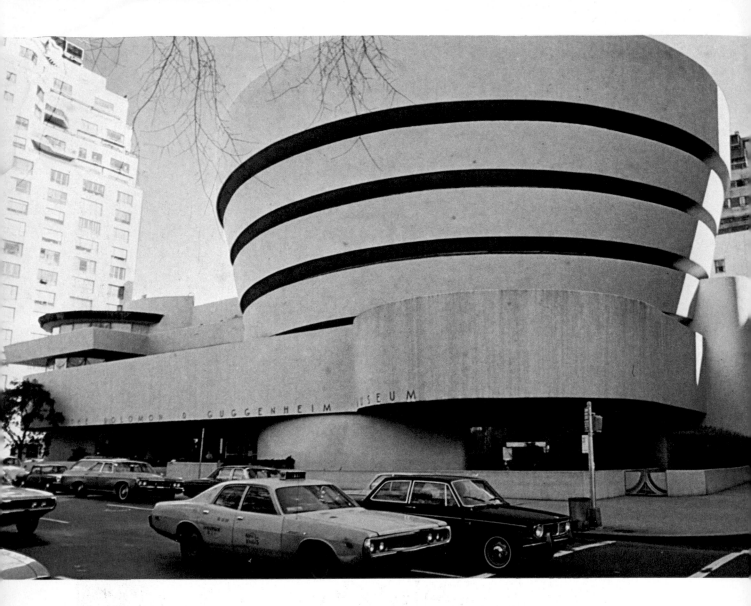

(1930–32) in New York, 1,472 feet high, which taught the young architects of America to combine technical daring with coherence of style. Another famous monumental group in New York is the Rockefeller Center, designed by a group of American architects, a breathtaking complex of lamellar skyscraper structures.

Gropius and the Bauhaus

In Walter Gropius (1883–1969) rational architecture found not only a skilful exponent but also an unsurpassed interpreter of its social character: the reintegration of man into society, the elevation of the human element to a determining factor. Already in 1913, with the Fagus offices in Alfeld, Gropius had marked a new stage in industrial architecture: construction by means of platforms held up by pillars which, abolishing the need for external, load-bearing walls, transformed the outer walls into a continuous transparent screen. However, Gropius' really great contribution, revealing also his teaching talent, came in the postwar period with the establishment of the Bauhaus school. It was due to him that the institution did not become an enclosed academy, involved with the task of building up a Bauhaus style. It remained a stimulating centre of creative experiment in the best liaison between form and material, function, and method of production.

The construction of the Bauhaus building in Dessau (1926), over and above the application of structural methods, represented the adoption of a new principle. In Gropius' own words: 'Our ultimate goal, therefore, was the complete and inseparable work of art, the great building, in which the old dividing line between monumental and decorative elements would have disappeared for ever.' The accessory buildings of the Bauhaus and also the dwelling houses of Siemensstadt in

Above: *Frank Lloyd Wright, the Guggenheim Museum, New York*

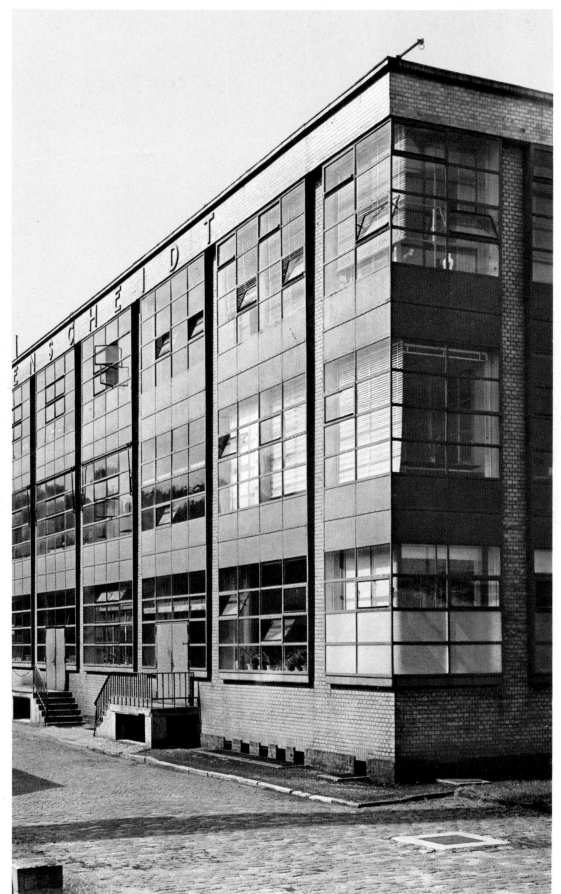

Walter Gropius, the Fagus offices at Alfeld-an-der-Leine

679

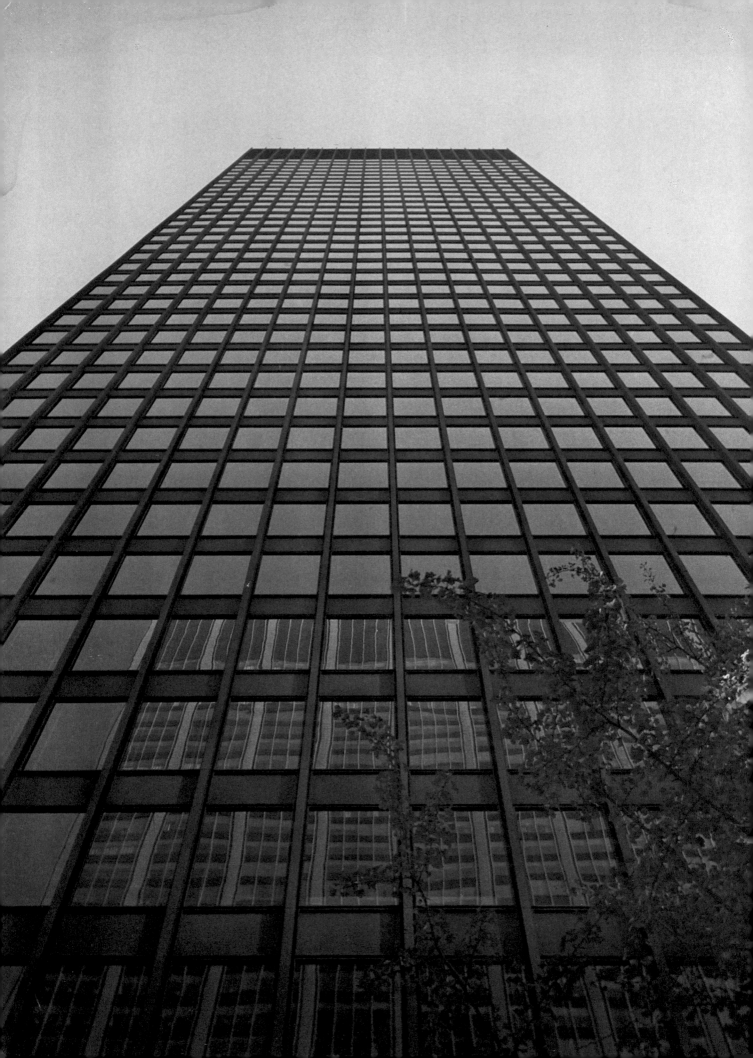

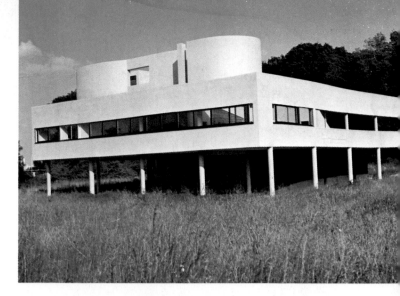

Berlin are clear and simple in form. The Hitlerite reaction, which classified rational architecture as 'degenerate art', drove Gropius into exile. In the United States, where he returned to teaching, his greatest work is the compact Harvard University Graduate Centre (1950).

Another great rationalist German architect, Ludwig Mies van der Rohe (1886–1969) experienced a similar fate. After World War I he perceived intuitively the new outlook with his sheer skyscrapers of glass. He, too, tackled the problem of workers' dwellings, clear cut and bright, in the Weissenhof district of Stuttgart. In the German pavilion for the Barcelona Exhibition of 1929 he worked with horizontal rhythms of simple superficial layers. In 1930, with the wide horizontal glass areas of Villa Tugendhat in Brno, eliminating, almost entirely, external walls, he created new contact between the interior and natural surroundings. Nazism drove Mies to the United States, where he contributed to the architectural re-awakening being brought about by the new generation. While the School of Architecture of the Illinois Institute of Technology is based on the horizontal development of planes and glass areas, the fame of Mies depends above all on his vertical development of bare and prismatic glass skyscrapers, of which those in Chicago (Lake Shore Drive Apartments) are both famous and typical likewise, in its soaring prism of metal and glass, the Seagram Building overlooking Park Avenue in New York.

Le Corbusier

One of the greatest figures in European architecture was Charles-Edouard Jeanneret, better known by his pseudonym Le Corbusier (1887–1965). A great forger of new structures, he made important innovations in the technical sphere with his use of prefabricated and standard components. An indefatigable planner, ardent producer of constructive ideas, and far-sighted town planner, he was found in the front line of all the battles of modern architecture. From the intersecting plane structures of the pavilion designed for his periodical *L'Esprit Nouveau* of 1925, from the development with horizontal planes and practical flat roofs of the villas of Garches and Poissy, from the clear-cut complex of the Swiss pavilion of the Cité Universitaire in

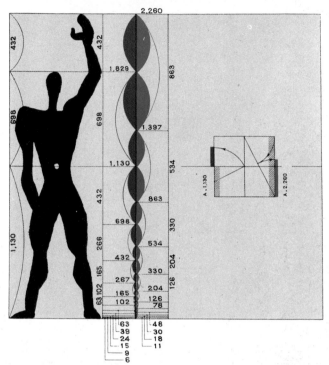

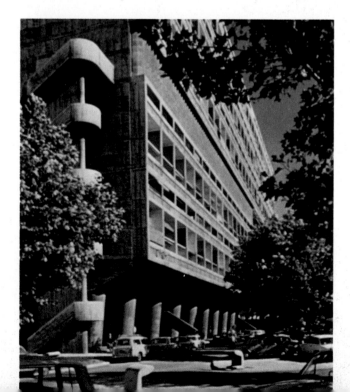

Right, above: *Le Corbusier, Villa Savoye, Poissy-sur-Seine*.
Right, centre: *Le Corbusier, sketch from the 'Modulor'*. Right, below: *Le Corbusier, the 'Unité d'Habitation', Marseilles*

Opposite page: *Mies Van der Rohe, the Seagram building, New York*

Paris, he conceived the idea for a vast collective block, functionally autonomous, and developed as a high building on stilts, with space running underneath and suspended roof gardens or children's playgrounds. After World War II, he realised this concept in the *unités d'habitation* (living units) in Marseilles, Nantes and Meaux. A great freedom of imagination, capable of surmounting the most difficult technical problems, led him to think up complexes essentially different in character: these ranged from the vertically geometric headquarters of the United Nations Organisation in New York, designed in collaboration with other architects, to the spiral Tokyo museum 'of endless growth' which grew out of a project originally intended for Moscow; from the very unusual chapel at Ronchamp (1955), with the irregularity of its carved façades and the curious 'canoe-shaped' roof (complex experience later re-echoed in the 'Speedway Chapel' near Florence, by the Italian architect Giovanni Michelucci), to the original buildings for Chandigarh, a sample of his town planning in India. Le Corbusier's capacity for awakening new ideas is almost as important as his achievement as an architect. The interpretation generally given to his formula for the house as a 'machine for living in' is far too simplified. Nevertheless it challenged the functionality of dwellings, even from the practical and utilitarian point of view, of which in the past too little notice was taken. It also pointed to the necessity of applying to the design of interior spaces, and also to furniture and furnishings, disciplined approach being used in the industrial design of machines. On the other hand, Le Corbusier is especially significant for having understood how the prospects of a really modern architecture must find their beginning and their outlet in town planning.

Rationalist architecture spread with extreme rapidity, and the only countries to resist it in Europe were Nazi Germany and the U.S.S.R. of the Stalin period, which returned to a scrupulous

Opposite page: *Giovanni Michelucci, the 'Motorway Chapel' (Church of St John), near Florence*

Le Corbusier, chapel of Notre-Dame-du-Haut, Ronchamp

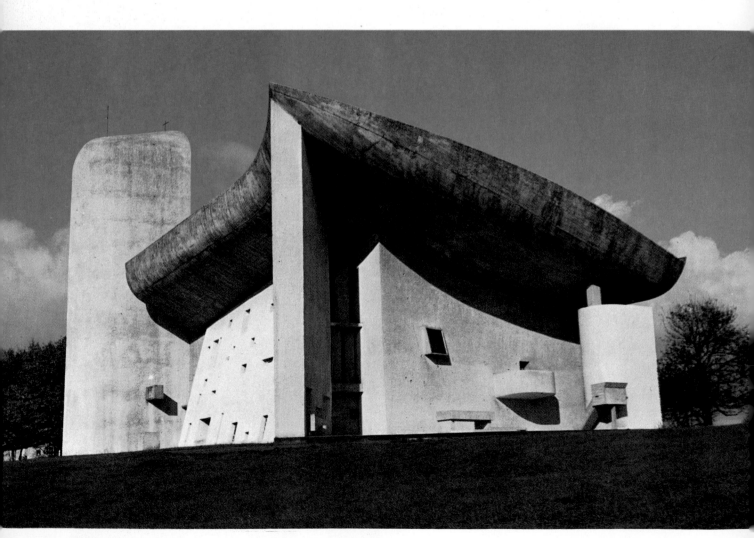

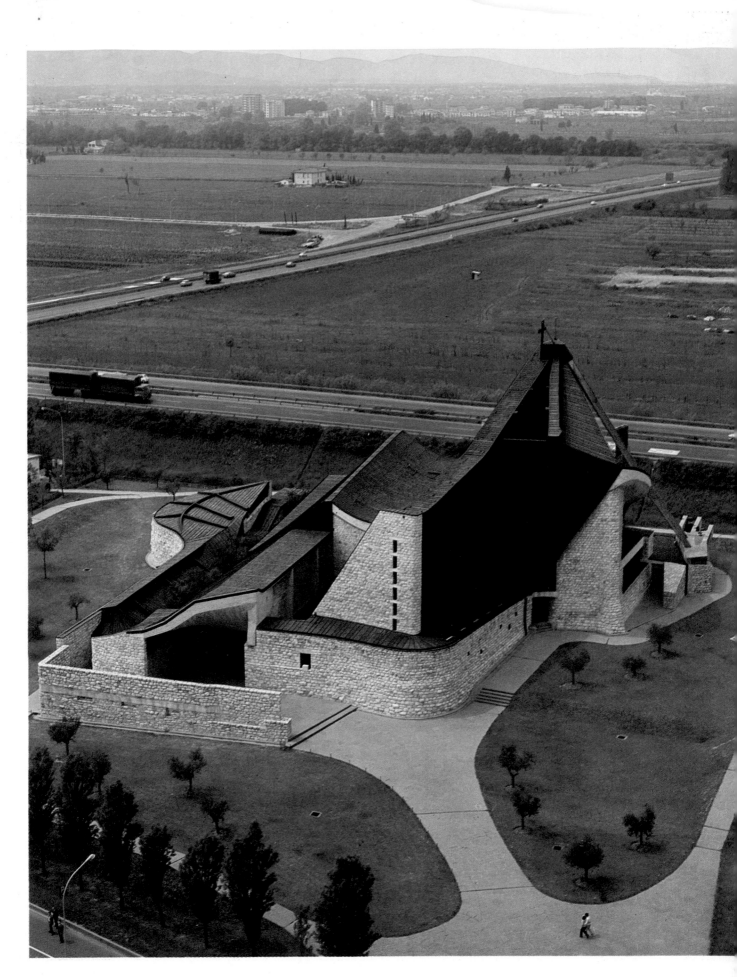

'academicism', even in its monumental undertakings such as the university of Moscow. Even fascist Italy, although invaded by a monumentalistic rhetoric of columns and arches, in the name of a pseudo-Roman tradition, produced some significant instances of rationalist architecture, such as, for example, a few buildings at Como by Terragni; the stadium in Florence by that talented architect of concrete buildings, Nervi; the station in Florence by Michelucci, and the Olivetti offices in Ivrea with glazed walls, by Pollini and Figini.

Smaller countries, such as Holland, Switzerland, Denmark (with Arne Jacobsen), Sweden (with Markelius and Asplund), and Finland made important contributions to the new architecture. Indeed another great master established himself: Alvar Aalto (1898–). If some of his most famous works, like the sanatorium at Paimio, Finland, or the S-shaped students' building completed in Cambridge, Massachusetts, in 1946, are reminiscent of the canons of rationalist architecture, in others there is a local, regionalistic, tone which succeeds in finding coherent expression, sometimes through the technique of certain local structures in wood. In this way, Aalto attaches himself strongly to the popular, national traditions of his native Finland. This is seen sometimes in his imaginative town planning schemes, in which he integrates his structures with nature, as with the town hall at Säynätsalo. Another Finn to go to America was Eero Saarinen (1910–1961), son of a famous architect, Eliel Saarinen, and there he designed the General Motors factory at Detroit and the modulated egg-shell curves of the

TWA Flight Center at Kennedy Airport in New York. Aalto's pupil, Viljo Revell (1910–1964), won the commission for the Toronto city hall in 1958.

The new architecture did not limit itself to the United States. Under Gropius and Le Corbusier, it appeared in Mexico and Argentina, but above all in Brazil. There, led by Lúcio Costa, there arose, in close association with Le Corbusier, a new and very lively architectural school. From it emerged Oscar Niemeyer (1907–), with his extreme plastic flexibility (of which unusual examples are the curved, glazed façade of the Boavista bank in Rio de Janeiro and the wavy roof of the chapel at Pampulha), and Alfonso Reidy (1909–1964) with a surprising serpentine dwelling unit at Pedregulho, near Rio. The new capital Brasilia is, however, the greatest achievement to date of the new Brazilian School. The influence of rational European architecture has produced an important new school of Japanese architects.

The artistic scene of the last twenty years has been one of increasingly numerous diverse trends and movements and it is possible only to indicate some of the more significant developments. Barriers of tradition are no longer important, and the artist can now develop in complete liberty. At the same time, however, his work is no longer anchored to certainties. Often – in the face of

Above: *Eero Saarinen, the TWA Flight Center at the Kennedy Airport, New York*

Pier Luigi Nervi, pillars in the Palace of Work, Turin

crises in the human values of a mechanised society – it becomes an expression of anguish, protest, defiance, or an attempt to escape. If this approach to art puts the accent on the individual, at the same time artistic trends nowadays assume world-wide dimensions.

The principles of rational architecture have won the day, even for ordinary projects, but they are also losing doctrinal strictness, and are enriching themselves through other experiences, through the fertility of architects from all countries, and through new structural and functional problems. The skyscraper system has spread from the United States to Europe with, for example, the crystalline clearness of the Pirelli skyscraper in Milan, by Gio Ponti. Pier Luigi Nervi (1891–), a master of agile reinforced concrete structures, after having collaborated on the Paris Unesco building, threw the light elliptical dome over the Palazzetto dello Sport in Rome. In Mexico Felix

Candela (1910–) designed light structures in umbrella or shell shapes. Notable British architects are the Smithsons, Alison (1928–) and Peter (1923–), whose 'brutalist' style exploited functional structures as design elements in the building.

The tie between architecture and town planning has become closer than ever. This is demonstrated by the reconstruction of many European cities destroyed or damaged by the war, particularly the centre of Rotterdam; the expansion of metropolitan areas by suburbs and satellite cities; the founding of new capitals – Chandigarh in India, by Le Corbusier, and Brasilia, the work of Costa, Niemeyer and young Brazilian architects.

Opposite page: Oscar Niemeyer, the Parliament at Brasilia

Alvar Aalto, sanatorium at Paimio

ART SINCE 1940

Until World War II art remained oriented toward allegiance to the complexities of nature, in intention if not always in form. Even in its most abstract manifestations, as in Malevich, Picasso and Braque of 1911–12, and Mondrian, the image function of art survived mostly in closed shapes on a given plane and unambiguous space defined by above and below. Paintings were still pictures, mounted on canvas within circumscribed boundaries; sculptures, even as assemblages, such as Picasso's *Glass of Absinthe*, 1914, still contained references to subject matter.

But suddenly in the middle 'forties there was a radical change of attitude toward the possibilities of art, and its scope was immensely widened. Artists now began to work with forms that were open, fluid and mobile; space became continuous, expanding beyond the edges of often mural-size canvases. To some extent these revolutionary changes were the outcome of the Surrealist Manifesto of 1924 and Dada, although even Dada had had a declared purpose and direction, whereas art now seemed to have dispossessed itself of every conscious element and delivered itself from the trappings of traditional mediums. In New York in the early 40s the new outlook came largely from the group of European Surrealist expatriates, notably Ernst, Miro, Masson, Matta, and Marcel Duchamp, including also the poet André Breton, the dealers Julien Levy, Peggy Guggenheim, Pierre Matisse, and others.

The most articulate exponent of the new gospel was Marcel Duchamp (1887–1968) who with his irrepressible love of provocative aphorisms often verging on scandal exerted profound influence. Although he had abandoned painting twenty years before, he remained close to the art world, declaring, "I want my art to be life itself, every second, every breath to be a work which is nowhere recorded . . . a perpetual euphoria." But at the same time Duchamp was developing the theory that a work of art remains unfinished until it has been experienced by the onlooker. Stressing the medium-like role of the artist, he conceived the creative act as producing material in a raw state—*art à l'état brut*—which has to be deciphered and interpreted by the artist's audience, and only then reaches mature form. In this climate of effervescent creative activity, critics, collectors and art galleries began to play a major role, following the example of Peggy

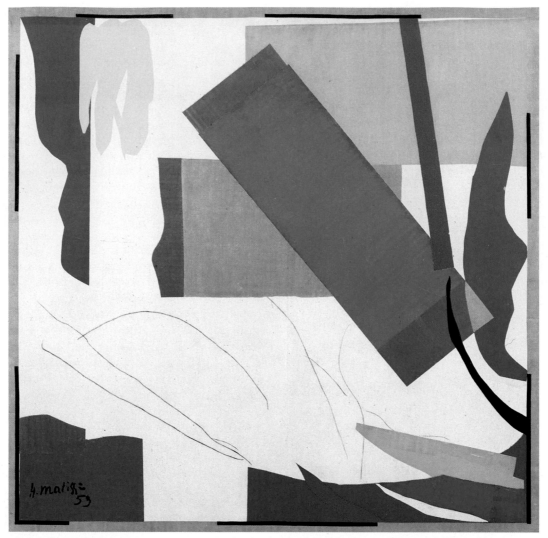

Henri Matisse, Memory of Oceania, 1953, paper cut-outs, 108″ × 112 ⅞″. Museum of Modern Art, New York

Guggenheim in her gallery Art of This Century, from 1942 to 1947.

The recognition of the new modes of artistic expression also attracted the attention of the scholarly community. One of these was the medievalist Meyer Schapiro of Columbia University, who became outstanding in the encouragement he gave to every kind of artistic exploration. In an article on "the liberating quality of avant-garde art," he was to remark that "the idea of art was [now] shifted from the aspect of imagery to its expressive, constructive, inventive aspect . . . a new liberty had been introduced which had, as one of its consequences, a greater range in the appreciation and experience of forms . . . Hence the great importance of the mark, the stroke, the brush, the drip, the quality of the substance of the paint itself and the surface of the canvas as a texture and field of operation—all signs of the artist's active presence." In all this it will be seen that the subject of painting

and sculpture was no longer given, but became the work itself.

Lyrical abstraction in Europe

In Europe the tradition of lyrical abstraction continued with Braque, Poliakov, Vieira da Silva, and de Staël. It was a tradition in which the bold colors inherited from the Fauvist School were still organized around the forms and grids inherited from Cubism.

The French Canadian Jean-Paul Riopelle (b. 1923), for example, works within these enclosed grids, covering every inch of the canvas with a mosaic of regular strokes and patches held together by directional lines of force. In some ways influenced by the American School of Abstract Expressionism (see p. 689), he manages to control the overall painterliness in myriad patches of brilliant

color which he weaves into the surface of the canvas; there is however an absence of violence, a sense of balance which is here closer to the European manner.

Maria Elena Vieira da Silva, born in Lisbon in 1908, is a very sensitive painter who gathers into her grids the muted tones of urban perspectives. She plays with the relationship between the flat plane of Cubist grids and blurred perspective effects, as if the grids were emerging from an atmosphere of greys and beiges.

There is a graphic quality in all these grid paintings which can also be found in the work of the "Tachistes." The artists grouped under this name—derived from the French word *tache* (spot)—insisted on the importance of the brush stroke, of the material, of the drip and of the stain. With abstract calligraphs, as in the case of Wols (1913–1951), or the large black brush strokes of Hans Hartung (b. 1904) or Pierre Soulages (b. 1909), these paintings take on a lyrical but mostly dramatic quality.

Other artists, however, evolved toward a more figurative art, which parallels Picasso's development and post-Cubist painterliness; his series of the *Women of Algiers* (1954–56), executed after Delacroix, celebrates a return to the true painting tradition.

As a tribute to the historical tradition, the social commentary of Bernard Buffet (b. 1908) in France and Ben Shahn (1898–1969) in the United States is reminiscent of the painful years of World War II. Buffet's emaciated figures always strewn with long black lines echo the naive austerity of Ben Shahn's scenes. While the success of these artists was short-lived, Nicolas de Staël (1914–1955) was probably the most prominent figure of the younger generation at work in the late 40s and early 50s in Paris. More than any other artist, he was concerned with problems involving the relation between the visual world and abstraction. His works evolved from the dark, enclosed, hermetic abstractions of the 40s towards figurative forms with symbolic luminosity. In *The Musicians*, painted in 1953 and titled to suggest a jazz theme, Nicolas de Staël juxtaposed bright color patches in a delicately animated composition, which was to be the mark of the School of Paris.

On the other hand, Matisse, up to his death in 1953, remained a lone figure who through his late paper cutouts attained the height of achievement which only his early Fauve paintings had reached. In 1936, Matisse was already returning to the bold colors of Fauvism, to the "purity of means," and to a flatter conception in which drawing and color are set against each other in measured counterpoints. In the big *Pink Nude*, 1935 (Museum of Art, Bal-

timore), Matisse is already moving towards the kind of objects characterized by his later cutouts; they have become signs. His first experiments in cutouts, in the planning of the Barnes *Dance* mural (1932–33) allowed him as he wrote later to "link drawing with color in a single movement." His monumental album, *Jazz*, published ten years later by Tériade in 1947, provides us with the transition between the old and the new Matisse. In the text of *Jazz*, under the heading "Drawing with Scissors", Matisse wrote, "Cutting straight into color reminds me of the direct carving of the sculptor." Matisse had his pages colored with gouaches of his own choosing, and the scissors became the sole instrument to define the shape of the image. The non-painted becomes a point of departure for painting and the flat planes of Matisse's paintings are now *découpages*. They are collages of colored paper, not represented objects such as those of Ernst. And here again, as in his early painting dating from 1911 to 1917, Matisse attempts to create space through color, as in his *View of Notre Dame*, 1914 (Museum of Modern Art, New York); and in that

Nicolas de Staël, The Musicians (Remembrance of Sidney Bechet), 1953, 63 ¾″ × 44 ⅞″. Private collection, Paris

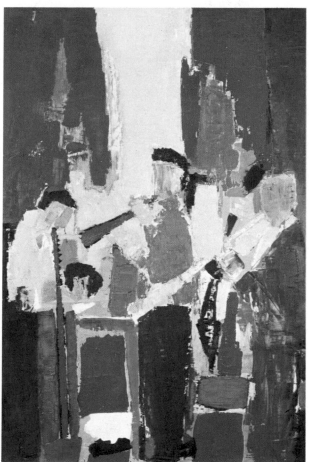

André Masson, *Battle of Fishes*, 1927, sand, gesso, oil, pencil and charcoal
on canvas, 14¼″ × 28 ¾″. Museum of Modern Art, New York

sense this is an early example of what Clement
Greenberg in speaking of the New York School
was to refer to as "area drawing." With his large
paper cutouts Matisse went on to make painting
breathe through the use of whites. In these cutouts
the design of the empty spaces counts more than
the drawing of the actual cut paper. It is not the
arabesque of colored paper but rather the ambient
white that governs the impact of the cutout forms.

Memory of Oceania is one of Matisse's most ab-
stract works where whole uncut sheets of colored
paper are superimposed on the white background,
bursting into light as if the sketchy curves of Ma-
tisse's pencil were competing with these wide color
fields. This command of floating planes of color
and the irruption of light—already present in his
early *Dance* of 1909 and in the *Piano Lesson* of
1916—were later to influence the American paint-
ers of the Color-Field group. His visits to New
York in the 30s, along with those of other Europe-
an artists like Léger who were fascinated by Ameri-
ca, foreshadowed the importance of New York
during World War II.

Surrealism and its consequences in New York

Around the gallery, Art of This Century, which
had been established by Peggy Guggenheim when
she moved from Paris to New York in 1942, Du-

champ and the Surrealist group were to be instru-
mental in the formation of the New York School.
Among them was André Masson (b. 1896), a pas-
sionate revolutionary who had kept the structure
of Cubism in his early experiments with automatic
writing. He saw the mysterious unity of the uni-
verse within the forms of primitive myths. His
work has been described as "delirious germina-
tions complicated to the point of becoming nothing
more than labyrinthine tangles of vegetable, or-
ganic, or mental circuits." With automatic writing
he combines sand-painting, which he may have
picked up from the Indians of the American
Southwest. His early *Battle of Fishes*, executed with
a deliberate mixture of sand, gesso, oil, pencil and
charcoal, is of historical significance in linking ear-
ly American experiences with European Surreal-
ism. Another of the surrealist group in New York
was the Chilean Matta (b. 1912), who developed an
imagery suggesting popular science fiction, but
with a graphic linear pictorialism possessing an
ambiguity largely generated by automatic gestures.

Arshile Gorky (1904–1948), who had come
from Armenia to New York in World War I, be-
longed to the small group of Americans who
turned towards the essentially pre-Surrealist tradi-
tion of modern painting in Europe. He had moved

Opposite page: *Arshile Gorky, Dark Green Painting, detail,
ca. 1948;43 ⅞″ × 55″. Coll. Mrs. H. Gates Lloyd, Haverford, Pa.*

from being influenced by Picasso to the free abstraction of Kandinsky (see p. 655). Then in the early 40s, Gorky became a friend of Kiesler, Tinguely, Ernst and Matta, along with the Americans de Kooning, Gottlieb, Rothko and Pollock. With the exquisite painterly quality inherent in Gorky, the curvilinear forms he now introduced in his canvases confer a Surrealist sense of organic fantasy on the structure inherited from his early Cubist days. There is in Gorky a fragility of shapes against violent or somber backgrounds, as in *Dark Green Painting*, which still possesses a sense of European humanity.

The New York School: Action Painting

While Gorky can be identified as the pivotal figure of the period, his friend Jackson Pollock (1912–1956) is the one who broke with subject matter. Evolving from his early pictographs and influenced by Masson's automatic writing and cer-

Willem de Kooning, Woman I, 1950-52, 75″ × 57″. Museum of Modern Art, New York

tainly by the line grid which Gorky had inherited from the early Analytic Cubists, Pollock now moved toward Action Painting. Spreading the canvas on the floor and stepping right onto it, he painted with the harmonious control of his entire body. The paint dripped, splashed, and spanned the canvas in tight grids, creating the illusion of continuous movement and depth, a total environment and an exaltation of the material which were to become the struggling symbols of authenticity and novelty of the New York School. Explaining the way he painted his large *Autumn Rhythm* (1950; Metropolitan Museum of Art, New York), he wrote: "On the floor I am more at ease. I feel nearer, more a part of the painting, since this way I can walk around it, work from four sides and literally be in the painting. This is akin to the method of the Indian sand-painting of the West. When I am painting, I am not aware of what I am doing. It is only after a sort of 'get acquainted' period that I can see what I have been about. I have no fears about making changes . . . because the painting has a life of its own. I try to let it come through."

Adolf Gottlieb (1903–1974) is probably the last of the Action Painters to have been directly influenced by Surrealism. A trip to Arizona in 1937 triggered his subsequent pictographic style——a grid arrangement filled with Navajo-like signs and primitive images which seemed to result from the observation of Klee's paintings as much as from the experiments in automatic writing. These works evolved later into luminous "bursts" which can also be characterized as Action Painting. With other painters of the New York School, however, such as Willem de Kooning, Franz Kline and Robert Motherwell, the social and human context came once again into play.

Willem de Kooning (b. 1904), a Dutchman from Rotterdam, is mainly concerned with the human figure. He allows flesh and the environment to interweave. In his *Woman I*, tension arises from this overpowering woman which is not without ties with the expressionist tradition of Northern European painters such as Ensor and Munch. From these violent brushstrokes and love of warm colors, de Kooning has evolved today towards a more abstract style, where the same strokes suddenly allow large luminous fields to appear as in some windy landscape. Commenting on the genesis of his major theme, de Kooning once wrote: "The *Women* had to do with the female painted through all the ages, all those idols, and maybe I was stuck to a certain extent; I couldn't go on. It did one thing for me: it eliminated composition, arrangement, relationships, light——all this silly talk about line, color, and form—because that was the thing I wanted to get hold of . . . "

Jackson Pollock, Lucifer, detail, 1947, magma on canvas, 41″ × 105″. Coll. Mr. and Mrs. Harry W. Anderson, Atherton, California

Franz Kline, Figure Eight, 1952, 80″ × 63″. Coll. William S. Rubin, New York

694

Franz Kline (1910–1962), on the other hand, only began introducing color very late in his work. He is known mostly for his powerful black brush strokes on white. Deeply immersed in the tradition of Western painting, from Rembrandt to Goya, and fascinated with contemporary urban movement and scenes, Kline at first drew with passion: from white and black sketches which look like maps, Kline suddenly painted these same designs on enormous canvases with wide, rugged but controlled brush strokes which have the impact of constructivism. *Figure Eight* belongs to that series where the brutality of the social theme has become a powerful ideogram. Although Kline's looming images are often associated with massive urban structures, he himself denied any conscious direct imagery, calling them "painting experiences." One can see that he worked his canvases like a sculptor modeling clay. Clarifying his intentions, he stated: "I don't think of my work as calligraphic. Critics also describe Pollock and de Kooning as calligraphic artists, but calligraphy has nothing to do with us . . . People sometimes think I take a white canvas and paint a black sign on it, but this is not true. I paint the white as well as the black, and the white is just as important. For instance, in this canvas you can see how I've painted out areas of black with white."

Abstract Expressionism and Early Colorfield

Of all the early Abstract Expressionists, Robert Motherwell's work best exemplifies the struggle between the conscious and the unconscious, feeling and intellect, freedom and necessity. Deeply struck by the tragedy of the Spanish War, Motherwell (b. 1915) first painted his *Little Spanish Prison* as a prelude to his *Spanish Elegies*. The scale of this work as well as the general design reflects the moving austerity of its theme, but the colors evoke romantic associations. Motherwell painted over a hundred *Spanish Elegies*, large frontal works where monumental splashes of black divide the canvas as he announces in these Freudian shapes the battle of Eros and Thanatos, the struggle of Life and Death. In the meantime, Motherwell has also worked on collages, which, small in size, have become monumental in their implications. Over the delicate and surrealist quality of a torn cigaret-pack or a used envelope, large color-planes suddenly invade the painting. Motherwell appears now to open up the canvas to space and light, providing structural elements that bind the color field. Such are *Mediterranean Blue* and *In the Blueness of the Blue*, of his "open" series of the 1970s. Motherwell is perhaps

the pivotal figure between the two camps formed by the Abstract Expressionist painters: from Action Painting he emerged into the Color-Field of the 1950s, which comprised painters such as Gottlieb with his late imaginary skies, Barnett Newman, Mark Rothko, and Clyfford Still. Their interest in a more uniform painting field, a monolithic kind of pictorial order, was already visible. Their art disengaged itself from the excited dynamism and fragmentation of forms in Action Painting. Some of these changes can already be read in Adolf Gottlieb's later "Bursts," such as *Duet*, 1962, (High Museum, Atlanta). The bottom half of the painting is animated by turbulent brush strokes: a broken, exploding mass of heavily textured paint is contrasted above by a pair of glowing orange disks floating in an empty sky. In these imaginary landscapes, "cosmic skies" and "Bursts"—series which he developed during the 1950s—the color associations have now replaced drawing as the principal subject of the painting.

Robert Motherwell, Little Spanish Prison, 1941-44, 27 ⅛″ × 17″. Collection of the artist

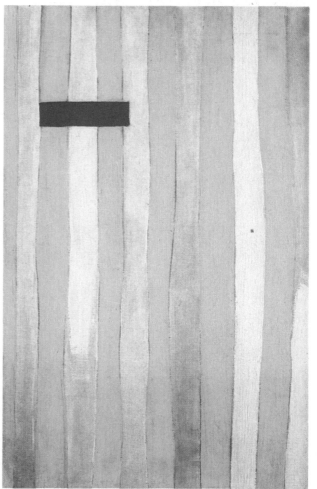

With Barnett Newman (1905–1970), those researches were to border on the wholeness and reserve of Minimalism. Barnett Newman was born in New York of Polish parents. He is certainly one of the most seriously concerned and reflective artists of his generation. He stopped painting a couple of times only to resume his activity after long meditative periods: He had to start all over again, he had at that point to make a Cartesian *tabula rasa*. Barnett Newman, to use Thomas Mann's expression,

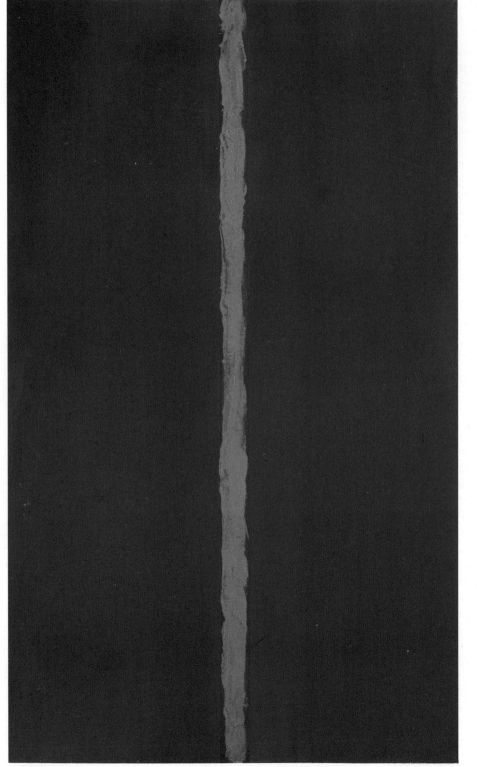

Barnett Newman, Onement I.
1948, 27" × 16".
Coll. Mrs. Annalee Newman,
New York

696

had a feeling and a taste for the infinite. "On his birthday, January 29, 1948," recalls Thomas Hess, "he prepared a small canvas with a surface of cadmium red dark and fixed a piece of tape down the center. Then he quickly smeared a coat of cadmium red light over the tape to test the color. He looked at the picture for a long time, indeed he studied it for some eight months. He had finished questing." In *Onement I*, Newman recognized elements of painting he had used before. By reducing composition, he raised color to its highest level. A painting finished by insight, *Onement I* is the first canvas possessing such organic unity, while yet displaying Newman's introspective severity. The separation line, with its powerful brush strokes of orange paint is Creation out of Chaos, the Onement of the Kabbalah. In a later painting, *Vir Eroicus Sublimis* (1950–51; Museum of Modern Art, New York), the color, a bright red—which is also the red of the earth as quoted in the Kabbalah—envelops the spectator. The vertical strip stands as a presence, a guardian heightening the pressure of one's emotion. Newman has replaced the visible symmetry of *Onement I* by the hidden Talmudic symmetry of his larger paintings. Soon these lose the sense of their own materiality, as Newman evolves towards religious austerity with the forcefulness of his Hassidic background. In his later series, the Stations of the Cross, color has disappeared and the vertical stripes create a quasi-metaphysical tension across the glaring white spaces. Newman has reduced his field to the extreme of the intellect, of the spiritual, which even the Minimalists would later on fail to reach.

Whereas most of the work of the Abstract Expressionist group shows the same seriousness and intensity, that of the Californians Clyfford Still (b. 1904) and Sam Francis (b. 1923) is more relaxed, more closely related to the land and to light. Still was a pioneer of deep, heavily impastoed all-over spaces broken here and there by streaks of blazing color like subterranean fissures.

Sam Francis's work, in contrast to Still's gravity, is about suspension and levitation, with a sense of shifting light and space. "I had a dream of an ocean, an enormous sea came up and spread over the land wiping everything out," Francis once recounted. Lying ill in a hospital bed in his early years, he learned about shifting tones from the play of light on the ceiling. This drove him to enliven the white of the canvas, to crowd the space with energized amorphous forms, creating a whirling, unstable atmosphere at the opposite extreme from Rothko's quiet hues. In an early work, *For Fred*, done for a painter friend, these blazing shapes push a sky-blue fragment to the upper limit of the canvas. This melting, Impressionist atmosphere

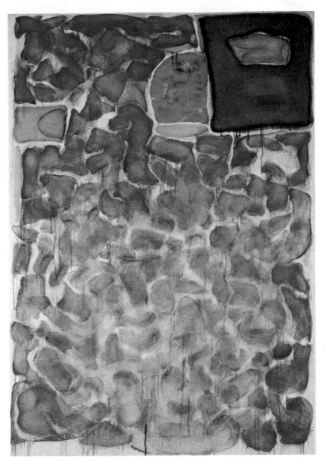

Sam Francis, For Fred, 1949, 59″ × 40″. Private collection

reflects Francis' known admiration for Pierre Bonnard. Until the late 50s his work was evolving towards dark, tense opaque, crowded forms, when Francis suddenly started opening up space in his canvases. The small cellular units became luminous islands of color. New white billowing shapes display an unprecedented resonance. The critic Peter Selz was to call Francis's painting surfaces of meditation.

With a painter like the late Mark Rothko (1903–1970), we return once more to the abstract wholeness of the Color-Field, symbol of transcending unity. For him, as for others of the New York School, Surrealism was a liberating force, through which in the early 40s he began formulating his large floating color-planes. In these oversize canvases light becomes a contemplative space, with luminous rectangles now freed of any Surrealist reference. With a world no longer interested in thematic subject matter, the painting itself emerges as a proclamation; it is an autonomous object, whose very size announces its purpose. In the complete abstraction of these floating images, Rothko was seeking to make painting as powerful and poignant as poetry or music. In *Magenta,*

Black, Green on Orange, the forms are washed in a sensuous atmosphere, as in Oriental meditation. Rothko later moved towards deep and somber tones, which are best seen in the great murals for the Menil Chapel at St. Thomas University, in Houston, Texas. There the spectator finds himself engulfed in a timeless color experience. Exploring the depths of human sensibility and emotion, without regard for considerations of formal presentation, he conveys a feeling of communion between the painter and the picture, and between the spectator and the painter. With this idea of autonomous expression, his refusal to sell two of his canvases to the Whitney Museum in New York in 1961 becomes understandable. He considered it unacceptable to submit to the sampling process of heterogeneous presentation and wrote to the Museum: "My reluctance to participate was based on the conviction that the real and specific meaning of the pictures was lost and distorted in these exhibitions." Here again we find this search for the ultimate and the radical which was characteristic of the New York School as well as of the Jewish background of many of the painters who were associated with it.

It is the work of Hans Hofmann (1880–1966), however, which best exemplifies the lessons of the Abstract Expressionist School. Born in Germany, he had worked earlier in Paris with Matisse. Later on he opened a school in Munich and, after having emigrated to the U.S., continued teaching in America. Besides being a most important teacher of Cubist and Constructivist principles, Hofmann in his work developed an unprecedented degree of painterliness and controlled vigor. Sculptural paint surfaces alternate at times with smooth background on which bright color rectangles seem to glide. In *Fantasia in Blue,* a furor of color-patches gives balance and light to his work. Hofmann in the last eight years of his life absorbed the best of the New York School of Abstract Expressionism and translated it into the self-contained vocabulary of an European artist.

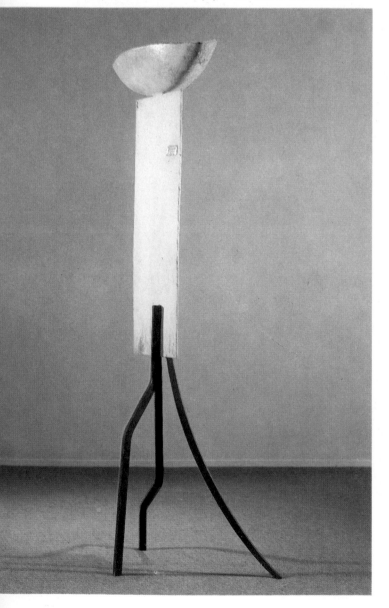

David Smith, Tanktotem IX, 1960, 90" high, painted steel. Estate of David Smith. Courtesy of M. Knoedler & Co., New York

Sculpture in the 1950s

David Smith (1906–1965) remains far the most prominent American sculptor of the period, the first one able to transcend the concept of Duchamp's Ready-Made objects and of mere assemblages into imaginary landscapes or symbols. He had learned welding during a summer working in an automobile factory and, after looking at reproductions of the sculptor Julio Gonzalez' welded works, turned from painting to sculpture. This can be witnessed in his earlier linear work, *Hudson River Landscape,* his response to his fellow artists of the Abstract Expressionist group. But as his work evolved, Smith began to feel the abstract value of geometric forms, as in the Cubi series, where the high polish of the metal transfigures the work into a defiant symbol. In his *Tanktotem* of 1960 we already see how Smith adapted color and natural shapes to the medium of metallic sculpture. By now he had learned to mitigate the glistening polish of the metal with the warmth and variety of a painted surface. Smith's works always gesture and in the upward thrust of this piece, as in his earlier work, he has reached the essence of the symbol with the characteristic bravura of the new American school.

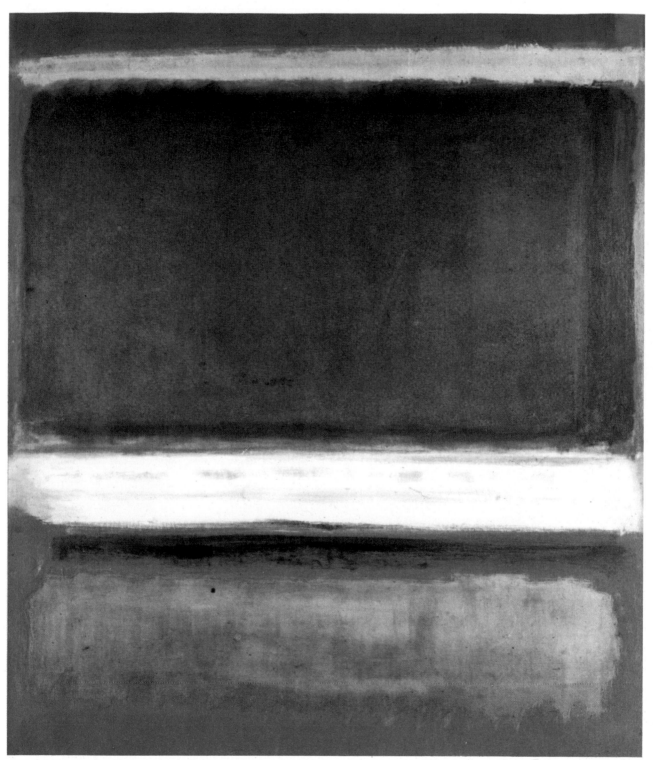

Mark Rothko, Magenta, Black, Green on Orange, ca. 1958.

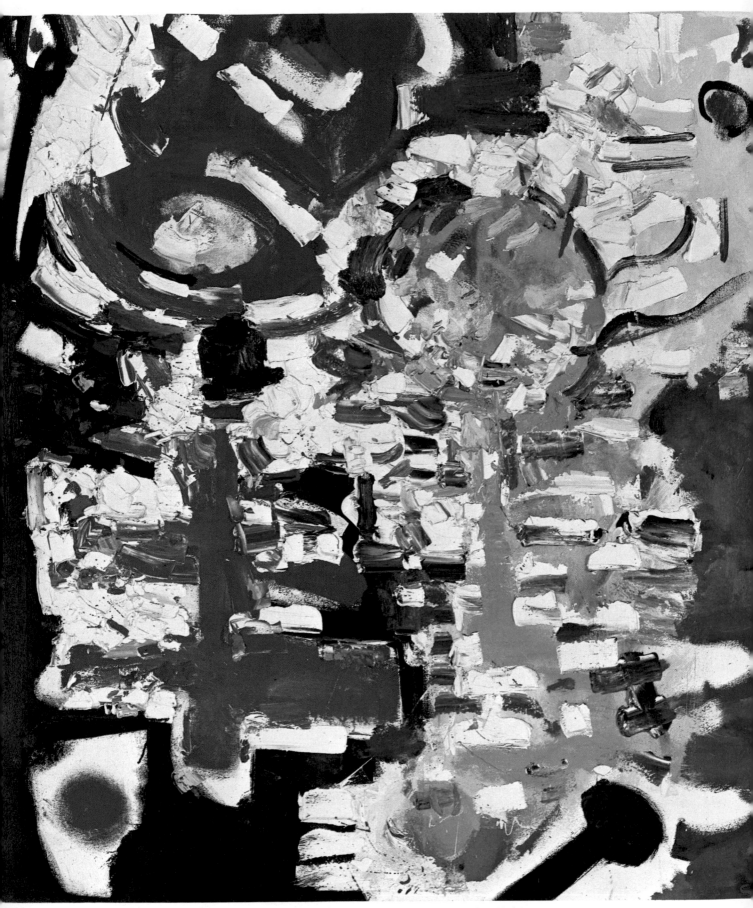

Hans Hofmann, Fantasia in Blue, 1954, 59" × 52". Whitney Museum of American Art, New York

Europe: Return to the figure

In the meantime European sculptors had turned towards figurative subjects and in particular to the human figure. The Englishman Henry Moore (b. 1898) had grown from the massive and generous figures of the early 30s (see p. 667) inspired by classical and Pre-Columbian art which he saw in museums to gradually more abstract forms in which solids functioned as frames for the voids. In the 1950s Moore created monumental works, dispersed into two or three parts, where the human and architectonic dimensions came into play with an often historical or sociological resonance.

Picasso was still to dominate the art scene up to his death in 1974. In his *She-Goat*, as much as in Giacometti's *Dog*, out of the animal comes a sense of humanity, a sense of experience and life. This piece, executed in Vallauris in 1950, was cast from an assemblage of diverse objects, jugs, a palm branch, the impression of a wicker hamper, scrap iron (for the shoulders)—which are all incorporated and unified in the bronze. Picasso here abandons the planar and linear esthetic of Cubist construction for the mass. The assemblage techniques inherited from Gonzalez in the 20s confer on the *Goat* a Surrealist sense of earthy paganism and decadence while still allowing full play to Picasso's gentleness and love of animals. Picasso's natural Arcadia is echoed by the affinity of Jean Dubuffet (b. 1901) with the world of children. His *Noeud au Chapeau* affects a charming nonsensical expression, in which scratches and accidents are obviously left as part of the art work. It is precisely because of Dubuffet's profound belief in the veracity and hu-

Pablo Picasso, She-Goat, 1960, bronze cast from found objects, 46 ⅜″× 56 ⅜″×27 ⅜″. Museum of Modern Art, New York

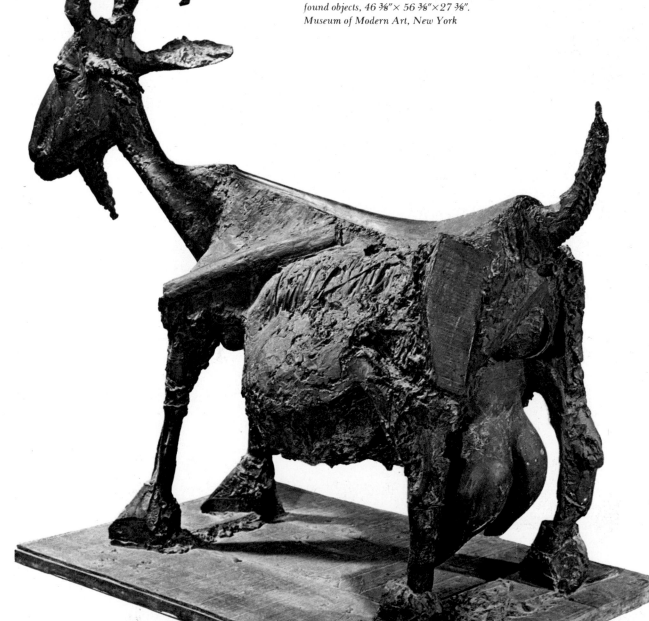

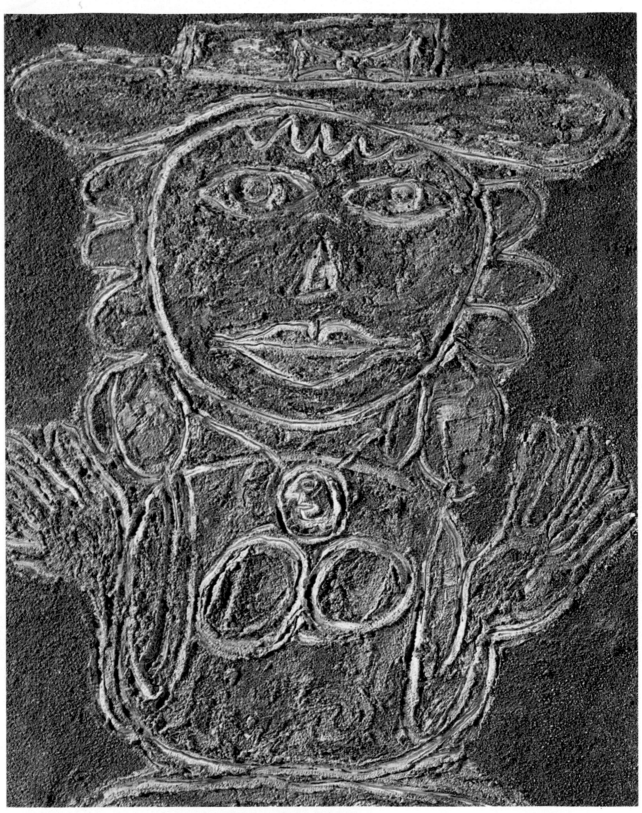

Jean Dubuffet, Noeud au Chapeau, 1946, 32″×25″. Moderna Museet, Stockholm

mor of children as well as of the accidents of na-
ture that his sources of inspiration include primi-
tive art, drawings of the insane, graffitis and Nava-
jo sand-painting. From 1945 on Dubuffet assem-
bled a great collection of *art brut*: he had a passion-
ate interest in materials and their properties. For
many years he painted the silhouettes of mad per-
sonages or animals out of sand, gesso and rubble, a

technique of *"haute pâte"* (impasto) inherited from Fautrier—expressing the struggle and the difficulties of the human condition arising from the primeval chaos of Mother Earth. This aspect of *art informel* finds a parallel in the work of the Spaniard Antoni Tapiés,

In 1962, doodling with a pen, he discovered a world of swirling abstract shapes. These are the genesis of his acrylic, resin-painted creatures to which he gave the name of *L'Hourloupe*. The slang word *"entourlouper"* means to play a trick on someone. In this playful style he now constructed large sculptures and filled oversize canvases with a jigsaw of interlocking figures and objects which still preoccupy him.

Similarly the Swiss Alberto Giacometti (1901–66), who also lived and worked in Paris, was interested in creating a new image of man. Giacometti, a student of Bourdelle's and the son of a quite good Impressionist painter, began placing his sculpture in a network of lines, as if to compose an atmosphere around each figure or object. *Palace at 4 AM*, of 1932, foreshadowed his painting, which began in 1945. Giacometti was especially interested in his own interiorization and identification with the subject matter: "I began to work from memory; to my terror, the sculptures became smaller and smaller, they had a likeness only when they were small." He had at the same time developed a passion for color in sculpture which undoubtedly stemmed from his Impressionist father, in a technique which was extremely dependent on light. And it is this light which shaped the forms of objects through chipping, erasures and employing different kinds of bronze patinas. Along with the portraits of his brother Diego, the fragile and proud figures which crowd his world can be related to the existentialist ideas professed by his friend Sartre. They also tell of the emptiness of man meditating on the Universe.

Belonging to a similar philosophical tradition, Francis Bacon (b. 1910) has been since 1940 the foremost British painter. Early in his career Bacon derived his inspiration from old-master paintings, notably Velasquez' *Portrait of Innocent IX*, after which he painted a whole series of canvases. On the recurrent theme of Rembrandt's and Soutine's *Slaughtered Ox*, again and again Bacon places chunks of raw meat and flesh in his canvases as if to remind us of the nature of our mortal life. Obsessed by the neuroses and the degeneration of man, he paints his sitters as contorting corpses thrown across a bed in the clear geometry of an

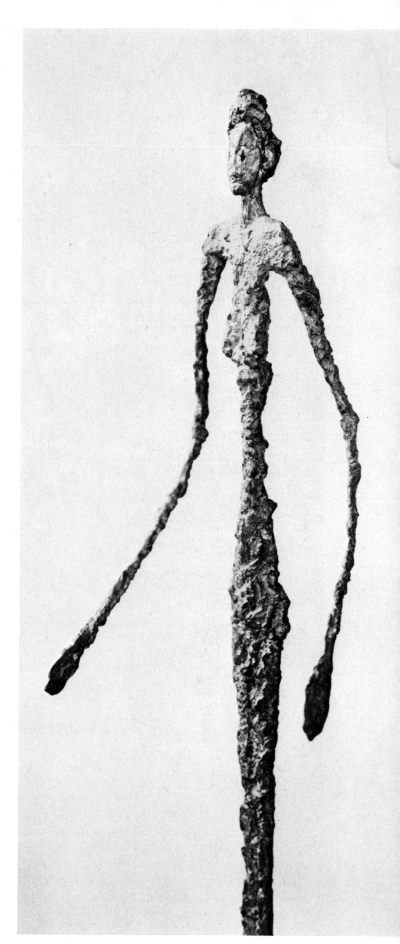

Alberto Giacometti, Chariot, detail, 1950, 57″ high, bronze, Museum of Modern Art, New York

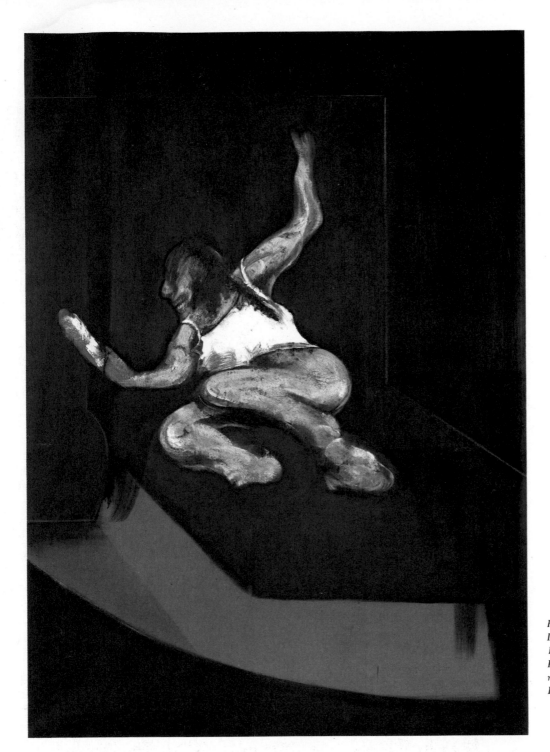

empty room. Such paintings can be interpreted as
Bacon's reaction to the plight of humanity. But
more and more of his canvases have become re-
stricted to his personal world, interrogating his
friends along with his own face in a ceaseless tor-
tured quest and introspection. A lone figure today
in the world of art, Francis Bacon is probably the
only painter to have challenged the masters of the
past by resorting to traditional formats such as
triptychs, and a subtle use of colors and brush. He

also places his figures on the canvas right in the
center, as in a classical painting. Nevertheless Ba-
con's overpowering obsession dominates the ap-
parent balance and order of his works.

Expressionism in Flanders, the Netherlands and
Northern Europe, on the contrary, stems from a
much more childlike world. The Dutchman Karel
Appel (b. 1921), after having first made experi-
ments with elementary forms, came together with
the Belgian Pierre Alechinsky (b. 1927) and the

Dane Asger Jorn (b. 1914) to form an International Expressionist group called COBRA (for Copenhagen, Brussels, Amsterdam). They believed in free-moving abstract shapes, but while Karel Appel is perhaps the closest to the Flemish carnival tradition of Ensor where large colorful faces fill the canvas like raw and playful masks, Pierre Alechinsky is primarily obsessed with interweaving linear shapes to form a grid on which he superimposes a central image, as in *L'Arbre Bleu*. His colors stain the canvas the way ink stains the lithographic stone, and it is no surprise to find that Alechinsky has also worked extensively in this medium. His figures combine something of the world of children with an expression of anguish and pain, as in the Flemish expressionist tradition. But in his later work Alechinsky has developed a delicate palette of pastel colors which are far removed from the

blues and greys and cold wine-reds of his early canvases: to a certain extent he has freed himself from the obsessive language of lines, and the strange sprawling shapes which are now his signature are closer to a world of fantasy.

Assemblage

In a totally different vein, the Swiss Jean Tinguely (b. 1925) has also turned to a world of fantasy. His works, however, are far removed from the painterly or sculptural unity of the other Europeans we have mentioned, whether it is Giacometti in his slender bronze effigies, Alechinsky in his canvases of sprawling forms, or Dubuffet working on his *Hourloupe* creatures, mushrooms and enchanted gardens. Jean Tinguely's work is chiefly the

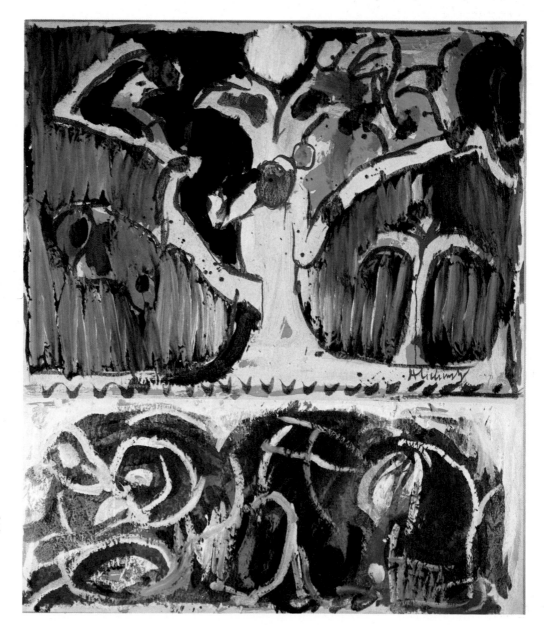

Pierre Alechinsky, L'Arbre Bleu, 1973, acrylic, 71" × 60½". Lefebre Gallery, New York

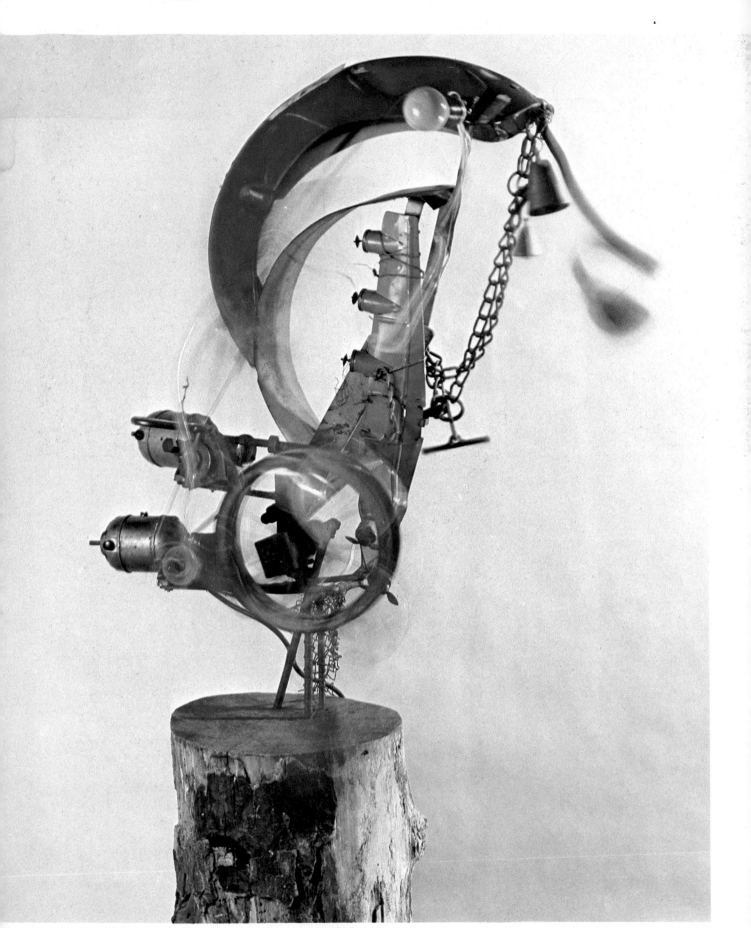

Jean Tinguely, Baluba No. 3, 1959, assemblage, 56 inches high. Wallraf-Richartz Museum, Cologne

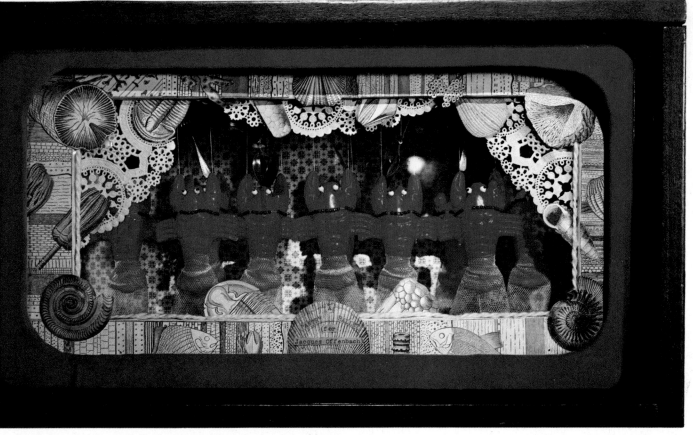

Joseph Cornell, A Pantry Ballet (for Jacques Offenbach), assemblage, 1942,
10″ × 18″ × 6″. Nelson Gallery-Atkins Museum, Kansas City

product of assemblage brought to its greatest potential—a mechanized aggregation of various objects which end by destroying themselves. He has also produced painting machines, such as his "metamatic automobile, odoriferous and resonant" for the First Biennial in Paris. With his wonderful sense of humor, Tinguely remains a poet in declaring "movement is the only permanent thing, the machine more than anything else allows us to attain poetry."

Assemblage was of course not new at the time, and the Surrealist dimensions expressed in Tinguely's sculpture are also manifest in the work of the American Joseph Cornell, although in much more serious and nostalgic form. A recluse and a man of deep culture, Cornell comes closer to the collage "paintings" of Max Ernst who had emigrated to New York during World War II. By the mid 30s he had settled on the box formula which allowed him all kinds of different associations, with paintings, objects, and photographs within the traditional frame of a work of art. Cornell does not, like the Europeans, really transform these assembled pieces into some futuristic artifact; each part keeps its natural and nostalgic meaning, and the boxes possess a kind of flavor once found in medie-

val reliquaries. His *Pantry Ballet*, like most of his collages, becomes the secret garden of one's thoughts. On a grand scale, in the sculpture of Louise Nevelson (b. 1900), assemblage becomes decoration. She piles up boxes containing all sorts of turned-wood objects, pieces of furniture and woodwork from old houses, which she paints in overall colors, usually black, white or gold. These sculptures have a two-dimensional frontality suggesting altarpieces, or sculptured paneling, an effect which is heightened by the uniform color of the painted surface.

But as in the case of Picasso and Gonzalez, collage and assemblage were also to be the ground for true sculpture in the work of Alexander Calder (1898–1976). In 1930, having first gained a reputation as a maker of animated toys, he began experimenting with abstract wire constructions under the influence of Naum Gabo and Joan Miro. From earlier motorized Mobiles the artist moved on to "wind" Mobiles made out of painted disks, or plates of metal suspended on wires in a state of delicate balance. Although the elements employed were often quite abstract, the subject association remained strong. In the 40s, Calder began to explore the possibilities of outdoor Mobiles. For

these, instead of a suspended structure, he resorted to a base which extended solid root-like forms up to a sheer and playful Mobile. In these standing mobiles he achieved the synthesis of an organic whole, a biomorphic creature made out of metal sheets and wires which would be even more stressed in Calder's later monumental Stabiles. The sculptor became more and more interested in architectural environment, in works which would now function in plazas as gesturing sculptures. They represent the last serious efforts by a contemporary artist to carry human meaning and resonance beyond abstract shapes.

Pop Art and the New Public

The world of the playful, of the game, appears to have underlined the work of many twentieth-century artists. And each time, a different aspect of this playfulness seems to emerge, whether it is in Picasso's *Goat*, Calder's Mobiles, Dubuffet's personages or Alechinsky's calligraphy. But not since the early Dadaist movement of the second decade of the century had the assemblage of what seemed to be nonsensical, non-art objects been brought together for their own purpose, with the same kind of reasoning that had allowed paint to become the subject in the paintings by the Abstract Expressionists of the New York School. Rauschenberg and Jasper Johns can be considered pioneers of Pop Art, that is, the kind of art which emerged from the consumer society of the 60s and was to mock the character of instant culture which modern art had acquired through free association of painted or transfigured Ready-Mades.

It was the composer John Cage who suggested to Robert Rauschenberg (b. 1925) "to act in the gap between art and life." In 1955 he created a controversial *Bed* for the festival of Spoleto. "I didn't

Alexander Calder, The Monster, ca. 1948, 52″ × 92″, standing mobile. Courtesy of Perls Galleries, New York

Opposite page: Robert Rauschenberg, Interview, 1955, assemblage, 72″ × 49″. Coll. Giuseppe Panza di Biumo, Varese

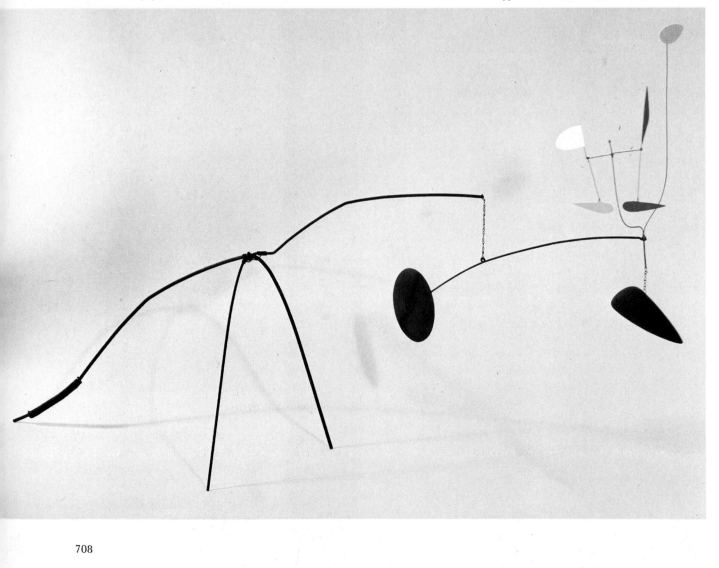

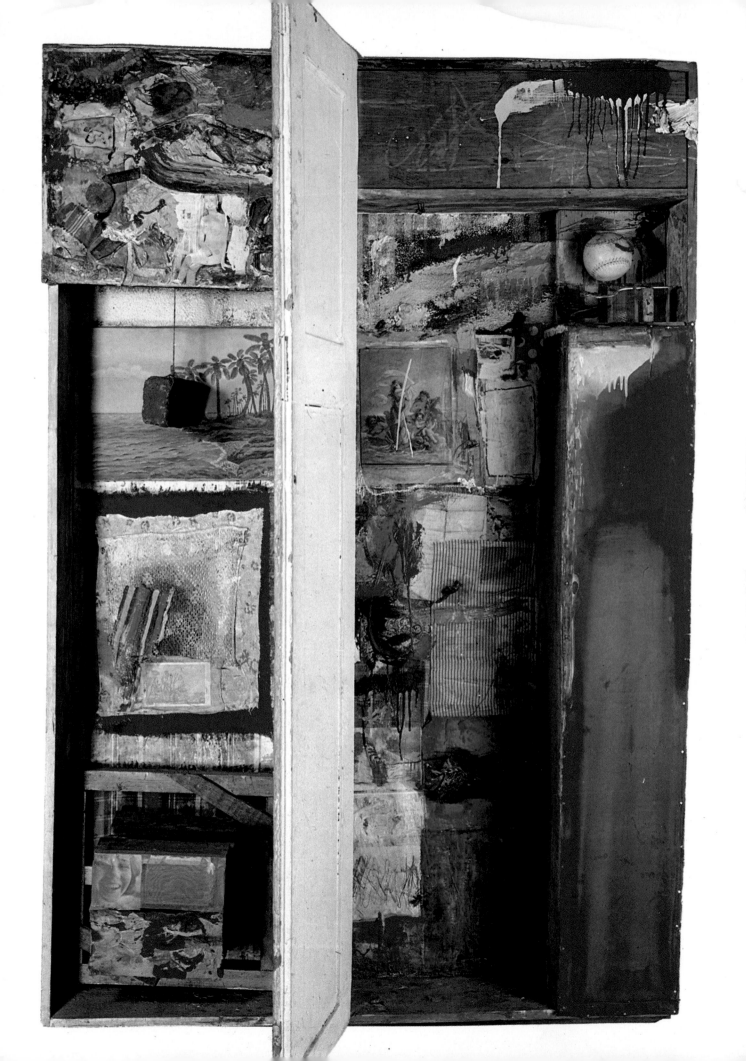

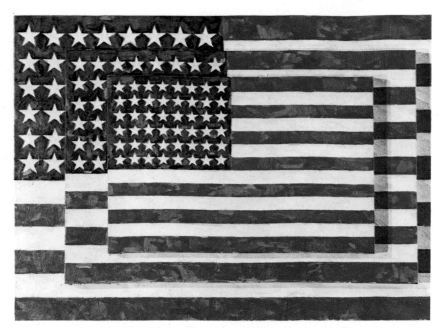

have any money to buy canvas, and I wanted to
paint. I was looking around for something to paint
on. I wasn't using the quilt, so I put it on a stretch-
er. It looked strange without a pillow. So I added
the pillow. It wasn't a preconceived idea." In his *In-
terior*, of the same year, Rauschenberg combines
certain elements derived from the Abstract Ex-
pressionist School with popular imagery. All these
experiments and particularly the most famous, the
Stuffed Goat (1955–59; Moderna Museet, Stock-
holm), contribute to Rauschenberg's reputation.

Johns's (b. 1930) formal innovations have also
had far-reaching influence in the early 60s. His
American Flags showed new possibilities for image
elaboration. The commonplace image—a can, a
target, a flag, a numeral—became an expression of
fantasy and life. Johns converted objects into fac-
similes. But despite his concern with illusion, he al-
ways seems to have included some hidden meaning
in his free associations. At a moment when Ab-
stract Expressionism and the cult of unique auto-
nomous experience were losing their credibility,
Johns's associations enlivened the visual possibili-
ties of these commonplace objects. However, Johns
remains a traditionalist, as the facsimile object re-
tains the illusion of fine art. The traditional sensi-
bility in a way is still respected; but at that moment
in the 60s, with the proliferation of mass communi-
cation and the publication of Galbraith's *The Afflu-
ent Society*, the crisis of individual identity inspired
in the Pop Art movement a new and fresh Ameri-
can experience.

Andy Warhol (b. 1930) captured the new mood
in his own terms: "Someone said that Brecht want-
ed everybody to think alike. I want everybody to

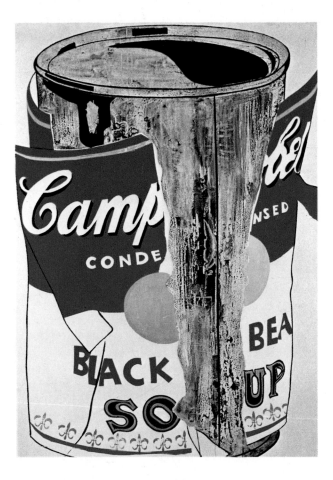

think alike . . . and we're getting more and more that way." Warhol's background, that of a commercial illustrator, had prepared him to create an art absolutely blank of emotions. Warhol began repeating images over and over again, using increasingly mechanical ways of painting, notably silk screens which offered the logical solution to his new series of icons, cans of Campbell soup, *Marilyn Monroes,* etc.

For Roy Lichtenstein (b. 1923), the primary subject was the most banal comic strip or advertising. Lichtenstein faithfully enlarged these in oil or acrylic with a brash but emotionless design that parodies the popular heroes of American life. In a narrow range of cold colors and Benday dots he has also created revised, impersonal, versions of works by Picasso, Matisse and Mondrian.

Claes Oldenburg (b. 1929), while using banal objects of everyday life—bathroom fixtures, cakes, engines, etc.—is perhaps the most paradoxical of these artists, and closer in his monumental sculpture to the world of the Neodadaists. The careful rendering of his giant "Ready-Mades," his *Lipstick* which was placed on view on the Yale campus, or his *Giant Soft Swedish Light Switch* in the Wallraf-Richartz Museum, Cologne, are here far removed from the context of their association with consumer objects. The latter so-called "soft" sculpture made of vinyl loosely stuffed with kapok is transformed into monumental and erotic fantasies. "I am for art that flaps like a flag . . . which is eaten like a piece of pie." In the language of the nursery this art shows us an adult world through the eyes of a child. Oldenburg's sculptures are sustained by their humorous aspect which are also Oldenburg's response to the harshness of contemporary life.

George Segal's (b. 1924) work also functions as a criticism of our increasingly dehumanizing environment. Unlike Oldenburg's "soft sculptures," Segal's plaster casts carry out an acute sense of alienation, of loneliness and mystery. These are placed in a selected environmental setting adapted to each figure. The settings take on new symbolic values when confronted with the roughly finished plaster figures pieced together from casts of Segal's friends. These congealed figures relate to the living the way Pompeian casts relate to the lost Roman world, and go well beyond mere assemblages of objects such as were originally celebrated by the Pop artists. Looking at Segal's work is a different kind of adventure: less has become more, as his lonely figures gaze into the night. He succeeds in telling us more about the way we live and how we react to our habits and surroundings. He has transformed our perception and broadened the experiments of Pop-Art to new poetic and meditative symbols.

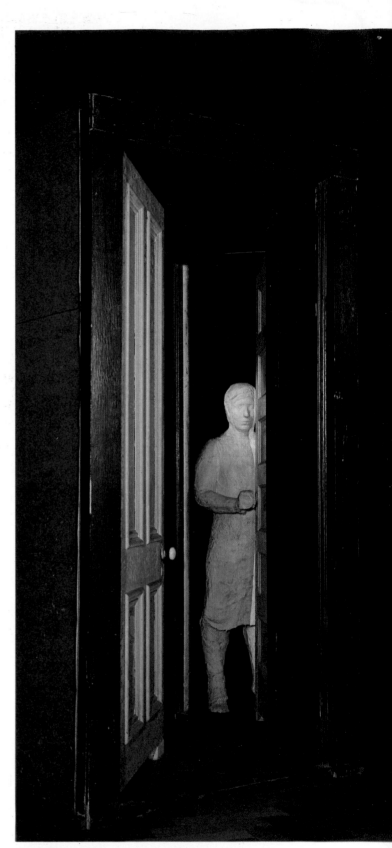

George Segal, Woman in a Doorway II, 1965, plaster and wood. Stedelijk Museum, Amsterdam

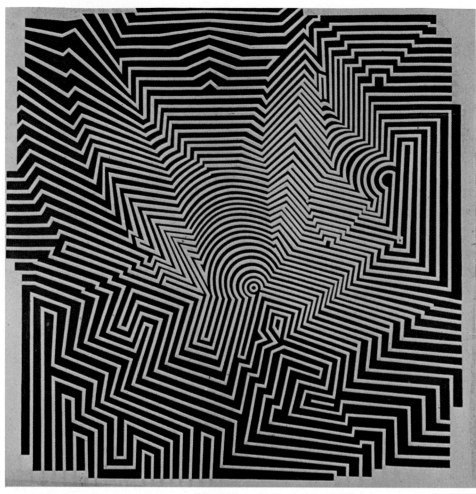

Victor Vasarely, Composition, 1952, lithograph, 42½″ × 39 ⅜″.

Conceptual Art and Optical Illusion

Playing with our perception of light and of the environment had been given a new impetus in the early 1960s. Already Albers and Moholy-Nagy at the Bauhaus had originated experiments in motion and in light. The first exhibitions of Kinetic Art—as this was called because it involved illusion, movement and light—spread across Europe in the late 1950s and early 1960s: Nicolas Schoeffer (b. 1912), a Hungarian-born Frenchman, invented what he called spatio-dynamic works, which consist of assemblages of electronic elements belonging to the world of acoustics, projection and sculpture. Many artists followed in his wake: the Venezuelan Jesu Raphael de Soto (b. 1923) works with large-scale, free-moving linear diagrams which create "Gestalt"-like puzzles. The Israeli-born Yaacov Agam (b. 1928), develops series of modular sculptures which change as the spectator moves. But the most influential master of what was now called Optical Art is probably Victor Vasarely (b. 1908)—also a Hungarian who had moved to Paris. After a seri-

ous study of Kandinsky and Mondrian, Vasarely first published his theories in 1955 in his *Yellow Manifesto*. The work of art as such disappeared; only the artist's original idea remained, which had to be reproduced in a given social context, multiplied in different forms and scale. Abstract, geometric shapes were mathematically organized with standardized colors. These limitations allowed Vasarely to establish the vocabulary of optical illusion which had originally been studied in the Bauhaus, and particularly by Albers.

All through the 40s and 50s Josef Albers (1888-1976) was a key figure who through his teaching and lecturing lent a sense of direction and discipline to the fundamentals of design. In 1933 when the Bauhaus was closed by Hitler, he moved to America and immediately opened his celebrated school at Black Mountain College, North Carolina, and there was the first to bring Bauhaus ideas to the United States. As the interpreter of new ways of seeing, his teaching extended to the very core of his creative work: For it was his persistent dialectic of visual phenomena that yielded those paradoxes of line and plane in his series of geometric configu-

712

rations, notably his "Graphic Tectonics" and "Structural Constellations." In these the concept of volume—i.e. the passage from line to plane, and from plane to space—is constantly subject to disturbing changes of identity. Through these illusions of volume and space the process of perceptual awareness is stimulated.

These ideas found their dramatic application in Albers' investigations in color. In 1949, the year that saw his first *Homage to the Square* he wrote: "A painter works to formulate with or in color. Here color attains autonomy. I am particularly interested in the psychic effect, an aesthetic experience that is evoked by the interaction of juxtaposed colors." Developing these ideas, he wrote: "Every perception of color is an illusion . . . We do not see colors as they really are. In our perception they alter one another. For example, two different colors can look the same or two identical colors can look different. Opaque shades can look transparent and definite shapes can become unrecognizable. This 'play' of colors, this change of identity is the object of my concern . . ."

These experiments revert to the Cubist concepts of simultaneity and fragmentation of vision. It has been said that every creative idea that emerged in American art of the 60s had its origin at Black Mountain.

Josef Albers, Homage to the Square: Fall Fragrance, 1964, 40" × 40". Courtesy of Sidney Janis Gallery, New York

Morris Louis, Têt, 1958, acrylic on canvas, 93½″ × 15½″. Whitney Museum of American Art

Post-Painterly Abstraction

A young generation of abstract painters was now emerging. They were taught to reflect on Mondrian and Klee, as well as on the work of the late Cubists and on the artists around Jackson Pollock. They were taught to analyze, and they progressed from the highly individualized writing which had been the mark of the early Action Painters to the expression of a general, anonymous and enveloping ambiance. Kenneth Noland was quoted as having said: "We were interested in Pollock but could gain no lead to him. He was too personal. But Frankenthaler showed us a way—a way to think about and use color." They aimed at transforming what had first been a graphic structure into a color structure. In a decade which had seen the Hard-Edge Pop-paintings, these artists were ready to accept the freedom, the openness of an image tied to human emotions. In this respect, Helen Frankenthaler (b. 1928) can be regarded as the key artist of her generation.

From early Cubistlike, heavily impastoed easel paintings, her work evolved into staining by pouring diluted pigments onto raw duck canvas laid directly on the floor. Despite the obvious debt of this technique to Pollock, she inaugurated a new way of binding paint to canvas. *Mountains at Sea*, painted in 1952 after a trip to Nova Scotia, is the first major example of what the critic Clement Greenberg was to call Post-Painterly Abstraction. The brush strokes have disappeared, the flat planes of color which owe so much to Matisse have become relaxed and transparent. This is the painting that Greenberg brought Noland and Louis to see in New York, and it was to be an essential pivotal work in the development of their mature style. Morris Louis (1912-1962) said that Frankenthaler was the bridge between Pollock and what was possible. The experience liberated Louis's dormant gift of color. He worked in utter privacy, not wanting his art to be judged by its method. He began experimenting with the pouring technique in his "Veils." The fabric had become color, the "threadness" and the "wovenness" were in the color. In *Têt*, Louis created—in the words of Robert Rosenblum—"an extension of the Symbolist mood . . . the 'Lavender Twilight' of Monet's

gardens." In 1959, perhaps under the influence of Noland who was working on his "Circle" series and to whom he was quite close, he began in his "Florals" to pour the colors towards the center of the canvas. He was now less interested in the frontal, flat character of his earlier "Veils." In 1960, he reversed the process, not pouring the colors in successive layers, but exposing more and more of the raw canvas in the center. In the large "Unfurled" series, he suddenly came to perceive the importance of the white open space. Colors were poured diagonally and symmetrically, becoming like an ensemble of orchestral voices. In 1961, he narrowed down his researches to pure chromatic relationships. This time the colors were poured next to each other in vertical contiguous stripes. From Matisse Louis had learned about openness and space, as well as about the hedonistic power and exaltation of color; he was now absorbing his ultimate lesson: "We must learn," said Matisse, "perhaps relearn to express oneself by means of line. Plastic art will inspire the most direct emotion possible by the simplest tones." At the time of Louis's death in 1962 at the age of 49, abstract painting had once more gained full autonomy.

Louis's friend Kenneth Noland (b. 1924) was primarily interested in pure abstraction; but avoiding the rigidity of Bauhaus, Mondrian-like formalism, he turned towards the work of Paul Klee: abstract geometry was reduced to a few fundamental elements from which Noland derived his vocabulary; color conveyed a mood and not a spatial illusion as in Albers' work, and Noland as well as Louis retained this character. Noland's "Circle" series emerged in the 1950s as essentially frontal dynamic figures in which concentric rings create patterns of energy. In contrast to Pollock's and other Abstract Expressionists' all-over painting, Noland's images converge towards the center. He did not derive his Circles from Johns' *Target* which he first saw in 1958; he was not concerned with making an object, but interested in space and flatness where colors are sensed as areas. In his "Chevrons" he began experimenting with diamond- and lozenge-shaped canvases. Later he also worked with stripes and most recently with irregular polygons. The center of his canvases opens up with a tendency toward mistier atmospheric colors which at times resemble Jules Olitski's spray-paintings (see page 720). Noland's images have become among the most popular designs of our time: we find his Stripes and his Chevrons on the tails of airplanes as well as in advertising posters; through their spare geometry they have become part of the general alphabet of our visual horizon. His art bears the frontality and logic of a symbol made out of space

Kenneth Noland, Rocker,
1958, acrylic, 54½″ × 54½″.
Coll. Peter Sharp, New York

Frank Stella, Ossippe I, acrylic, 1966. Coll. Mr. and Mrs. Ernest Kafka, New York

and color. Unlike Stella's work, his irregularly shaped canvases are never perceived as constructions. Noland retains the painterly qualities which he shared with Louis.

Of the Post-Painterly Abstractionists, it has been noted that Frank Stella (b. 1936) was one of the first major painters of the 60s to have been formed practically entirely through the practice of abstract art. Stella was to carry the objectivization of the painted canvas further than it had yet been taken. In his early series of monochrome and metallic "stripe" paintings, he runs counter to the illusionism of Op-painting, dividing the canvas into equal parallel bands that force the eye concretely to experience his diagrammatic images. In his so-called

"Black" series, he carried this process a step further by allowing the bands to determine the outer contours of the canvas, which is the genesis of his later shaped canvases. Introducing color in *Jasper's Dilemma*, 1962, he constructed a square maze of concentric bands divided into four mitered segments using six colors in spectral order, which the eye is forced to follow to intelligibly "read" the painting. Now with color, he was again to develop the shaped canvas, but in formats with eccentric thrusts and illusionistic perspectives heightened by Dayglo paints, as in *Moultonboro II*, 1966, where a banded triangle plunges into a square. From such images Stella developed his mural-size canvases of the "Protractor" series, with interlocking bands of

brilliant color for which he is best known, such as *Ossippe I*, 1966, but which to some have the decorative connotations of Art Deco.

Hyperrealism

At the opposite extreme is what is rather loosely called Hyperrealism. The subject matter is always clearly recognizable, to the point of competing with photography, as in the seeming photographic exactitude of the glistening urban views of Richard Estes (b. 1936). But in his *Facade*, Estes is found to introduce provocative perspectives, and reflections on glass which ordinary vision filters out. This art, based purely on illusion, is able to convey a wealth of visual data and thus in peculiarly adapted to the arts of communication.

Minimal Art

But to a whole group of artists in the 60s, including Robert Morris, Carl André, Donald Judd, Richard Serra, illusionism and the traditional polarities of painting had become incapable of expressing the complexity of the modern world. They were concerned chiefly with basic geometri-

Richard Estes, Facade, 1974, gouache on paper, 16½″ × 17″. Courtesy Allan Stone Gallery

cal concepts. Donald Judd (b. 1928) was one of the most articulate proponents of this movement, which came to be called Minimal Art. Finding it impossible to convey a sense of pure volume in painting, Judd moved into the manipulation of three-dimensional space, in structures whose color, surface and material are exactly equated with the total shape. In his rectangular boxes—which are the core of his oeuvre—he was the first to employ transparent planes to reveal the geometry of interior space. Using mathematical sequences, the forms in series he started developing in the mid-60s are

spaced in uneven alternations of solids and voids, as in *Untitled* shown here.

This search for order in fundamental design, which goes beyond issues of form and style, is one of the chief characteristics of Minimal Art. One of its major exponents is Sol Lewitt (b. 1928), who aims to demonstrate the conflict between conceptual order and visual disorder. He constructs open cubical shapes with linear edges defining volume, and grids in mathematical series to overcome the visual distortions of perspective, cast shadows, what is hidden behind planes, etc. In his wall

Top: *Donald Judd, Untitled
1974, yellow anodized aluminum, 14″ × 76″ × 25″. Leo
Castelli Gallery, New York*

Opposite page: *Robert Smithson,
Spiral Jetty, 1970.
Great Salt Lake, Utah
Courtesy Gianfranco Gorgoni,
New York*

Left: *Peter Eisenmann, Two
axonometric drawings, 1973
Frank House, Cornwall, Conn.,
Tape, ink and Zipatone,
20″ ″ 24″. Suzanne and
Richard Frank, New York*

drawings, for which he is well known, Lewitt uses numerical systems in combinations and permutations of elements to impose order on random arrangements of pencil-drawn lines.

Likewise the work of the architect Peter Eisenman (b. 1932) explores architectural form in manipulations of volume entirely divorced from the pragmatic considerations of architecture. These relate to actual building in the way that numbers relate to physical reality. He concentrates on the nature of plane, column, and volume; and their relationships are organized by a rule system which he calls "deep structure." The two axonometric projections for the Frank House illustrated here are part of a 15-unit sequence which develops the generative ideas for a private house, but of which the final house is only a by-product. The total form is organized around two grids of unequal size formulated by a module. This method of conceptual planning allows an exploration of all the elements involved for a given space.

Also trained as an architect, the sculptor Anthony Smith (b. 1912) creates delicately articulated steel constructions which have the austere monumentality of his friend Barnett Newman's work.

Applying the same obsessive experimentation with perceptual realities, other Minimal artists, such as Robert Smithson (1938-1973), have sought to obtain a rational image of the endless disorder of raw nature by bringing to the studio samples of earth, stones and other materials to serve as documents which together create a conceptual idea of a given site or environment. In Smithson's *Spiral Jetty*, in Great Salt Lake, Utah, the documentation which preceded the work uncovered a legend about a whirlpool. While the choice of the form may be regarded as a romantic association with the myth, the open spiral is generated from a mathematical order which confers an intelligible design on the tumultuous disorder of nature.

PHOTOGRAPH COURTESY ANDRE EMMERICH GALLERY, NEW YORK

Jules Olitski, Nathalie, Type III, 1976,
water-base acrylic on canvas, 110″ × 146″.
Private collection.

Opposite page: *Anthony Caro, Durham Steel Flat, 1973-74,*
steel, rusted and varnished, 111″ × 98″ × 70″.
Gilman Collection, New York.

Resurgence of the New York School

Two general currents are slowly emerging. Both have their roots in the researches of some early European abstract painters such as Malevich (see p. 656), but while the first current derives from the study of geometric forms, the second movement—and this specially since the lessons of the first Abstract Expressionists—has been attracted by "the Nature of Materials"—to paraphrase Frank Lloyd Wright. Jules Olitski (b. 1922) and Anthony Caro (b. 1924) belong to the second tradition; yet through the sense of control and total abstraction manifest in their work they have retained some affinities with the Minimalists. Olitski was formed in the Parisian ambiance of the *art informel*. He began saturating his canvases with liquid paint, where an empty, free-floating atmosphere of color was controlled by the edges of the canvas. "Paint becomes painting when color establishes surface,"

he says. Later Olitski applied successive layers of paint, modeling the surface with a few lines of pure color; but his works are always contained within the quiet proportions of a classical frame. While these paintings also relate to the open landscapes of the Hudson River School and of course to Impressionism, Olitski has succeeded in resolving the aspiration of the American mood with the techniques utilized by his fellow artists of the Old World. Along with the Russian-born naturalized-American Olitski, his British friend Caro also places himself between two worlds. From massive expressionist bronze figures inspired by his master Henry Moore, Caro moved in the 60s to completely abstract rambling constructions. Caro picks up sculpture where David Smith left it, freeing these iron-welded assemblages from any symbolic reference. Whereas most of his pieces float over and across the ground in a relaxed mood, in *Durham Steel Flat* the massive sheet of rolling steel rises to a near-vertical, in apparent opposition to gravity. Thus Material resumes its intrinsic function.

BIBLIOGRAPHY

General

EICHENBERG, Fritz, *The Art of the Print*, Abrams, New York, 1976

FOCILLON, Henri, *The Life of Forms in Art*, Wittenborn, New York, 1958

GOMBRICH, Ernst H., *Art and Illusion*, Pantheon Books, New York, 1972

HIND, Arthur M., *History of Engraving and Etching*, Houghton, Mifflin, Boston, 1923
————. *An Introduction to a History of Woodcut*, Houghton, Mifflin, Boston, 1935

LEE, Sherman E., *A History of Far-Eastern Art*, Abrams, New York, 1974

MALRAUX, André, *Voices of Silence*, Doubleday, New York, 1953

PANOFSKY, Erwin, *Meaning in the Visual Arts*, Anchor Books, Garden City, 1955

PEVSNER Nikolaus, *An Outline of European Architecture*, Penguin Books, Baltimore, 1960

Prehistoric and Primitive Art

LEIRIS, Michel and DELANGE, Jacqueline, *African Art*, Golden Press, New York, 1968

LEROI-GOURHAN, André, *Treasures of Prehistoric Art*, Abrams, New York, 1967

PERICOT-GARCIA, Luis, GALLOWAY, John and LOMMEL, Andreas, *Prehistoric and Primitive Art*, Abrams, 1967

SANDARS, N.K., *Prehistoric Art in Europe*, Pelican History of Art, Baltimore, 1968

SCHMIDT, Carl A., *Oceanic Art, Myth, Man and Image in the South Seas*, Abrams, 1978

WILLETT, Frank, *African Art*, Praeger, New York, 1971

WINGERT, Paul S., *Primitive Art:Its Traditions and Styles*, Oxford University Press, New York, 1962

Pre-Columbian and American Indian Art

COE, Michael, *The Maya*, Praeger, New York, 1966

FEDER, Norman, *American Indian Art*, Abrams, 1969

KUBLER, George, *The Art and Architecture of Ancient America*, Pelican History of Art, Baltimore, 1962

LAPINER, Alan, *Pre-Columbian Art of South America*, Abrams, New York, 1976

LOTHROP, Samuel K., *Treasures of Ancient America:Precolumbian Art from Mexico to Peru*, Skira, Geneva, 1964

The Art of Mesopotamia

FRANKFORT, Henri, *The Art and Architecture of the Ancient Orient.* Pelican History of Art, Baltimore, 1971
————. *Arrest and Movement: An Essay on Space and Time in the Representational Art of the Ancient Near East*, Hacker, New York, 1978

GHIRSHMAN, Roman, *The Arts of Ancient Iran from its Origins to the Time of Alexander the Great*, Golden Press, New York, 1964

PARROT, André, *The Arts of Assyria*, Braziller, New York, 1961
————, *Sumer: The Dawn of Art*, Golden Press, New York, 1961

ROSTOVTZEFF, Mikhail I., *Iranians and Greeks in South Russia*, Russel and Russel, New York, 1969

WOOLLEY, Charles L., *Ur of the Chaldees*, Norton, New York, 1965

Egypt

ALDRED, Cyril, *Akhenaten and Nefertiti*, Viking Press, New York, 1973
————, *Art of Ancient Egypt*, 3 vols., Transatlantic, New York, 1974

MICHALOWSKI, Kazimierz, *Art of Ancient Egypt*, Abrams, New York, 1969

SMITH, William Stevenson, *The Art and Architecture of Ancient Egypt*, Pelican History of Art, Baltimore, 1965

Aegean and Greek Art

BEAZLEY, John D., *Attic Black-Figure Vase-Painters*, Clarendon Press, Oxford, 1956

———, *Attic Red-Figure Vase-Painters,* 3 vols., Oxford University Press, London, 1963

———, and ASHMOLE, Bernard, *Greek Sculpture and Painting to the end of the Hellenistic Period.* Cambridge University Press, 1966

BIEBER, Margarete, *The Sculpture of the Hellenistic Age,* Columbia University Press, New York, 1961

CHARBONNEAUX, Jean, MARTIN, Roland and VILLARD, François, *Archaic Greek Art,* Braziller, New York, 1971

DEMARGNE, Pierre, *Aegean Art: The Origins of Greek Art,* Golden Press, New York, 1964
———, *The Birth of Greek Art,* Braziller, New York, 1975

GRAHAM, James Walter, *The Palaces of Crete,* Princeton University Press, 1972

RICHTER, Gisela M.A., *A Handbook of Greek Art,* Phaidon, London, 1969

SCULLY, Vincent, *Earth, Temples and the Gods,* Praeger, New York, 1969

Roman Art

BOETHIUS, Axel and Ward-Perkins, John B., *Etruscan and Roman Architecture,* Pelican History of Art, Baltimore, 1970

BROWN, Frank, *Roman Architecture,* Braziller, 1961

CHARLES-PICARD, Gilbert, *Roman Painting,* New York Graphic Society, Greenwich, 1970

RICHARDSON, Emeline, *The Etruscans:Their Art and Civilization,* University of Chicago Press, 1964

WHEELER, Robert Eric Mortimer, *Roman Art and Architecture,* Praeger, New York, 1964

Early Christian and Byzantine Art

BECKWITH, John, *Early Christian and Byzantine Art,* Pelican History of Art, Baltimore, 1970

GRABAR, André, *The Beginnings of Christian Art, 200-395,* Thames and Hudson, Londen, 1967
———, *The Golden Age of Justinian, from the Death of Theodosius to the Rise of Islam,* Braziller, New York, 1971

KRAUTHEIMER, Richard, *Early Christian and By-*

zantine Architecture Pelican History of Art, Baltimore, 1965

HAMILTON, George Heard, *Art and Architecture of Russia,* Pelican History of Art, Baltimore, 1954

VOLBACH, Wolfgang and HIRMER, Max, *Early Christian Art,* Abrams, New York, 1962

WEITZMAN, Kurtz, *Studies in Classical and Byzantine Manuscript Illumination,* University of Chicago Press, 1971

Islamic Art

CRESWELL, Keppel Archibald C., *Early Muslim Architecture,* 2 vols., Hacker, New York, 1976

ETTINGHAUSEN, Richard, *Arab Painting,* Skira, Geneva, 1962

GRABAR, Oleg, *The Formation of Islamic Art,* Yale University Press, New Haven, 1973

GRAY, Basil, *Persian Painting,* Skira-Rizzoli, Geneva, 1976

POPE, Arthur Upham, *Masterpieces of Persian Art,* Dryden Press, New York, 1945
———, *Persian Architecture: The Triumph of Form and Color,* Braziller, New York, 1965

Indian Art

BACHHOFER, Ludwig, *Early Indian Sculpture,* Hacker, New York, 1972

KRAMRISCH, Stella, *The Art of India,* Phaidon, London 1954

ROWLAND, Benjamin, *The Art and Architecture of India:Buddhist, Hindu, Jain,* Pelican History of Art, Baltimore, 1967

WHEELER, Robert Eric Mortimer, *The Indus Civilization,* Cambridge University Press, 1968

ZIMMER, Heinrich, *The Art of Indian Asia,* 2 vols., Princeton University Press, 1960

Chinese Art

CAHILL, James, *Chinese Painting,* Rizzoli International, Milan, 1977
SICKMAN, Lawrence and SOPER, Alexander, *The*

725

Art and Architecture of China, Pelican History of Art, Baltimore, 1968

SPEISER, Werner, *The Art of China: Spirit and Society,* Crown, New York, 1960

SULLIVAN, Michael, *The Arts of China,* University of California Press, Berkeley, 1973

SWANN, Peter C., *Chinese Monumental Art,* Viking Press, New York, 1964

WILLETTS, William, *Chinese Art,* 2 vols., Penguin Books, Baltimore, 1958

Japanese Art

KIDDER, Jonathan Edward Jr., *Japanese Temples:- Sculpture, Paintings, Gardens, and Architecture,* Abrams, New York, 1967

PAINE, Robert T., and SOPER, Alexander C., *The Art and Architecture of Japan,* Pelican History of Art, Baltimore, 1960

SAMSOM, George Bailey, *Japan, A Short Cultural History,* Prentice-Hall, New York, 1962

SOPER, Alexander C., *The Evolution of Buddhist Architecture in Japan,* Hacker, New York, 1977

Carolingian and Romanesque Art

BRAUNFELS, Wolfgang, *Monasteries of Western Europe: the Architecture of the Orders,* Princeton University Press, 1972

CONANT, Kenneth J., *Carolingian and Romanesque Architecture, 800-1200,* Pelican History of Art, Baltimore, 1973

FOCILLON, Henri, *The Art of the West in the Middle Ages,* Phaidon, New York, 1963

GRABAR, André, *Romanesque Painting from the Eleventh to the Thirteenth Century: Mural Painting,* Skira, Geneva, 1958

HUBERT, Jean, PORCHER, Jean, and VOLBACH, W., *Europe of the Invasions,* Braziller, New York, 1969

LASKO, Peter, *Ars Sacra, 800-1200,* Pelican History of Art, Baltimore, 1972

SCHAPIRO, Meyer, *Romanesque Art,* Braziller, New York, 1977

ZARNECKI, George, *Romanesque Art,* Universe Books, New York, 1971

Gothic Europe

BRANNER, Robert, *Chartres Cathedral,* Norton, New York, 1969

FRIEDLANDER, Max J., *Early Netherlandish Painting* 14 vols., Praeger, New York, 1967-73
————, *From Van Eyck to Bruegel:Early Netherlandish Painting,* Phaidon, New York, 1969

GRODECKI, Louis, *Gothic Architecture.* Abrams, New York, 1977

LANDOLT, Hanspeter, *German Painting, the Late Middle Ages (1350-1500).* Skira, Geneva, 1968

MEISS, Millard, *Painting in Florence and Siena after the Black Death,* Princeton University Press, 1951
————, *Giotto and Assisi,* Norton, New York, 1967
————, *French Painting in the Time of Jean de Berry: The Late Fourteenth Century and the Patronage of the Duke,* 2 vols., Phaidon, London, 1967

PANOFSKY, Erwin, *Early Netherlandish Painting,* 2 vols., Harvard University Press, Cambridge, 1958
————, tr.,*Abbot Suger On The Abbey Church Of St. Denis And It's Art Treasures.* Princeton University Press, 1946

POPE-HENNESSY, John W., *Italian Gothic Sculpture,* Phaidon, New York, 1970

PORCHER, Jean, *Medieval French Miniatures,* Abrams, New York, 1960

SAUERLANDER, Willibald, *Gothic Sculpture in France,* Abrams, New York, 1973

VENTURI, Lionello, *Italian Painting,* 3 vols., Skira, Geneva, 1950–52

WHITE, John, *Art and Architecture in Italy, 1250–1400,* Pelican History of Art, Baltimore, 1966

Renaissance in Italy

ACKERMAN, James S., *The Architecture of Michelangelo,* Viking Press, New York, 1966

ANTAL, Frederick, *Florentine Painting and Its Social Background,* Boston Book and Art Shop, 1965

BERENSON, Bernard, *The Drawings of the Floren-*

tine Painters, 3 vols., University of Chicago Press, 1973

———, Italian Painters of the Renaissance, Phaidon, London, 1967

———, Italian Pictures of the Renaissance, Central and North Italian Schools, 3 vols., Phaidon, London, 1968

———, Italian Pictures of the Renaissance: Florentine School, 2 vols., Phaidon, London, 1963

CELLINI, Benvenuto, Autobiography, ed. by John Pope-Hennessy, Phaidon, London, 1960

CLARK, Kenneth M. Leonardo da Vinci, Penguin Books, Baltimore, 1967

FREEDBERG, Sydney J., Painting in Italy, 1500–1600, Pelican History of Art, Baltimore, 1971

FRIEDLANDER, Walter F., Mannerism and Anti-Mannerism in Italian Painting, Columbia University Press, New York, 1957

GOMBRICH, Ernst H., Norm and Form: Studies in the Art of the Renaissance, Phaidon, London, 1966

MURRAY, Peter, Renaissance Architecture, Abrams, New York, 1976

PAATZ, Walter, The Arts of the Italian Renaissance: Painting, Sculpture, Architecture, Decorative Arts, Abrams, New York, 1976

PANOFSKY, Erwin, Studies in Iconology, Oxford University Press, New York, 1939

———, Renaissance and Renascences in Western Art, Humanities Press, New York, 1970

POPE-HENNESSY, John, Italian Renaissance Sculpture, Phaidon, New York, 1971

———, Portraits in the Italian Renaissance, Princeton University Press, 1967

———, Italian High Renaissance and Baroque Sculpture, 3 vols., Phaidon, London, 1963

SHEARMAN, John K.G., Mannerism, Penguin Books, Baltimore, 1967

VASARI, Giorgio, The Lives of the Painters, Sculptors, and Architects, 10 vols., London, 1912–12

WIND, Edgar, Pagan Mysteries in the Renaissance, Barnes & Noble, New York, 1968

WITTKOWER, Rudolf, Architectural Principles in the Age of Humanism, Random House, New York, 1965

———, Palladio and Palladianism, Braziller, 1974

WÖLFFLIN, Heinrich, Classic Art: An Introduction to the Italian Renaissance, Phaidon, 1968

Renaissance in Northern Europe

BENESCH, Otto, The Art of the Renaissance in Northern Europe, Phaidon, London, 1965

BLUNT, Anthony, Art and Architecture in France, 1500–1700, Pelican History of Art. Baltimore, 1970

CHASTEL, André, The Age of Humanism: Europe, 1480-1530, McGraw-Hill, New York, 1964

CHATELET, Albert and THUILLIER, Jacques, French Painting, from Fouquet to Poussin, Skira, Geneva, 1963

OSTEN, Gert von der and VEY, Horst, Painting and Sculpture in Germany and the Netherlands, 1500–1600, Pelican History of Art, Baltimore, 1969

PANOFSKY, Erwin, Albrecht Dürer, 2 vols., Princeton University Press, 1948

STECHOW, Wolfgang, Northern Renaissance Art, 1400–1600: Sources and Documents, Prentice Hall, 1966

SUMMERSON, John N., Architecture in Britain, 1530–1830, Pelican History of Art, Baltimore, 1969

WATERHOUSE, Ellis K., Painting in Britain, 1530–1790, Pelican History of Art, Baltimore, 1969

17th And 18th Centuries in Europe

CHATELET, Albert and THUILLIER, Jacques, French Painting, from Fouquet to Poussin, Skira, Geneva, 1963

———, French Painting, from Le Nain to Fragonard, Skira, Geneva, 1964

CLARK, Kenneth, Rembrandt and the Italian Renaissance, Norton, New York, 1968

FRIEDLANDER, Walter F., Caravaggio Studies, Princeton University Press, 1955

GERSON, Horst, and TER KUILE, E.H., Art and Architecture in Belgium, Pelican History of Art, Baltimore, 1960

KUBLER, George and SORIA, Martin, *Art and Architecture in Spain and Portugal and their American Dominions, 1500–1800,* Pelican History of Art, Baltimore, 1959

LEVEY, Michael, *Painting in XVIIIth-Century Venice,* Phaidon, London. 1959
———, and KALNEIN, Wendgraf, *Art and Architecture in XVIIIth Century in France,* Pelican History of Art, Baltimore, 1973

MAHON, Denis, *Studies in Seicento Art and Theory,* Warburg Institute, London, 1947

NORBERG-SCHULZ, Christian, *Baroque Architecture,* Abrams, New York, 1972
———, *Late Baroque and Rococo Arhitecture,* Abrams, New York, 1974

ROSENBERG, Jakob, SLIVE, Seymour and TER KUILE, E.H., *Dutch Art and Architecture, 1600–1800,* Pelican History of Art, Baltimore, 1972

SUMMERSON, John, *Architecture in Britain, 1530-1830,* Pelican History of Art, Baltimore, 1969

THUILLIER, Jacques and FOUCARD, Jacques, *Rubens' Life of Marie de Medici,* Abrams, New York, 1970

WATERHOUSE, Ellis K., *Italian Baroque Painting,* Phaidon, New York, 1969
———, *Painting in Britain,* 1530–1790, Pelican History of Art, Baltimore, 1969

WHITE, Christopher, *Rembrandt as an Etcher,* 2 vols., Pennsylvania State University Press, University Park, 1969
———, *Rubens and His World,* Viking Press, New York, 1964

WITTKOWER, Rudolf, *Art and Architecture in Italy, 1600–1750,* Pelican History of Art, Baltimore, 1973
———, *Gian Lorenzo Bernini, The Sculptor of the Roman Baroque,* Phaidon, London, 1966

WÖLFFLIN, Heinrich, *Principles of Art History,* Holt, New York, 1932

Neo-Classicism and 19th Century

BARKER, Virgil, *American Painting, History and Interpretation,* Bonanza, New York, 1960

BLUNDEN, Maria and Godfrey, *Impressionists and Impressionism in the Nineteenth Century,* Skira and Rizzoli, Geneva, 1976

CLARK, Kenneth, *The Gothic Revival,* Humanities Press, New York, 1970

DREXLER, Arthur, *The Architecture of The Ecole des Beaux-Arts,* Museum of Modern Art, New York, 1977

FRIEDLANDER, Walter F., *From David to Delacroix,* Harvard University Press, Cambridge, 1952

GAUNT, William, *The Restless Century:Painting in Britain, 1800–1900,* Phaidon, London, 1972

GERNSHEIM, Helmut and Alison, *The History of Photography from the Camera Obscura to the Beginning of the Modern Era,* McGraw-Hill, New York, 1969

HAMILTON, George Heard, *Nineteenth and Twentieth Century Art:Painting, Sculpture, Architecture,* Abrams, New York, 1970

HITCHCOCK, Henry-Russell, *Architecture: Nineteenth and Twentieth Centuries,* Pelican History of Art, Baltimore, 1971

HUNTER, Sam, *Modern French Painting, 1855–1956,* Dell, New York, 1956

MEEKS, Carol L.V., *Italian Architecture, 1750–1914,* Yale University Press, New Haven 1966

NOVOTNY, Fritz, *Painting and Sculpture in Europe, 1780-1880,* Pelican History of Art, Baltimore, 1960

REWALD, John, *The History of Impressionism,* New York Graphic Society for the Museum of Modern Art, New York, 1973
———, *Post-Impressionism from Van Gogh to Gauguin,* Museum of Modern Art, New York, 1962

RICHARDSON, Edgar A., *American Romantic Painting,* Weyhe, New York, 1944

ROSENBLUM, Robert, *Transformations in Late Eighteenth Century Art,* Princeton University, 1967
———, *Modern Painting: Northern Romantic Tradition,* Harper and Row, New York, c.1975

SCHADE, Hubert, *German Romantic Painting,* Abrams, New York, 1977

20th Century Art and Architecture

ARAGON, Louis, *Henri Matisse,* 2 vols., Harcourt, Brace, Jovanovich, New York, 1972

ARNASON, H.H., *History of Modern Art:Painting, Sculpture, Architecture,* Abrams, New York, 1977

COOPER, Douglas, *The Cubist Epoch,* Phaidon, New York, 1971

DUTHUIT, Georges, *The Fauvist Painters,* Wittenborn, Schultz, New York, 1950

GELDZAHLER, Henry, *American Painting in the Twentieth Century,* Metropolitan Museum of Art, New York, 1965

GIEDION, Sigfried, *Space, Time, and Architecture,* Harvard University Press, Cambridge, 1967

GRAY, Camilla, *The Russian Experiment in Art, 1863-1922,* Abrams, New York, 1970

HITCHCOCK, Henry-Russell, *Architecture: Nineteenth and Twentieth Centuries,* Pelican History of Art, Baltimore, 1971

HUNTER, Sam, and JACOBUS, John, *American Art of the Twentieth Century. Painting, Sculpture, Architecture,* Abrams, New York, 1973

PEVSNER, Nikolaus, *Pioneers of Modern Design,* Museum of Modern Art, New York, 1949

RHEIMS, Maurice, *The Flowering of Art Nouveau,* Abrams, New York, 1966

RICHARDSON, Edgar, *Painting in America,* Crowell, Collier, MacMillan, New York, 1965

ROSE, Barbara, *American Art since 1900,* Praeger, New York, 1975

ROSENBLUM, Robert, *Cubism and Twentieth Century Art,* Abrams, New York, 1966

RUBIN, William, *Dada and Surrealist Art,* Abrams, New York, 1968

SCULLY, Vincent Jr., *Modern Architecture,* Braziller, New York, 1974

This Index lists people, places, buildings, statues and other sculptures, and artistic movements and concepts. It does not list paintings except under the names of the artists. Figures in italics, thus *369*, refer to illustrations.

A

Aachen
 Cathedral 316
 Town Hall 317
 Palatine Chapel *233, 234,* 237
Aalto, Alvar 684, *687*
Abbate, Nicolò Dell' *see* Dell'Abbate, Nicolò
Abbati, Filippo 605
Abbeville: St. Wulfram 338
Abbeys *see under* individual names of places
Abstract art 655, 656, 663, 672
Abstract Expressionism 688, 695, 697, 708
Abu, Mount 189, 190
Abu Roash 49
Abu Simbel 65
 Temple of Rameses II *66–67,* 71
Abydos 48, 70
Académie Française 543
Academie Suisse 614
Academy of Architecture 539, 550
Academy of Painting and Sculpture 539
Accademia degli Incamminati 464
Accademia del Naturale 464
Accadian art 28
Action Painting 692–695
'Adaloald, Cross of' 170
Adam brothers 568, *571*
Adam, Robert 461, 564, 574
Adamo di Arogno 282
Addaura, Grotta dell' 12
Aegean art 74–85
Aegina 100
 Temple of Artemis Aphaia 98
African art 644, *644,* 645, *645,*650, 654
Agam, Yaacov 712
Agamemnon 74, 84, *85*
Agilulf, Cross of' *165,* 170
Agliate: S. Pietro 280
Agostino di Duccio 359
Agra: Taj Mahal 190
Agrigentum *92–93,* 101
Aigues-Mortes 304
Ajanta caves *184, 185,* 187
Albani, Francesco 552
Albers, Josef 712, 713, *713*
Alberti, Leon Battista 351, 352, 354, *355,* 359, 365, 379, 547
Albi: Cathedral 310
Alcala: S. Ildefonso College 454
Alechinsky, Pierre 704, 705, *705*, 708
Alexandria 72, 107
 Library 73
 Museum 73
 Pharos 73
Alexandrian Culture *see* Hellenism

Alfeld-an-der-Leine: Fagus offices 678, *679*
Alfieri, Benedetto 491
Algardi, Alessandro 471, 474
Almenno S. Salvatore: S. Tomè *238*
Altamira caves 12, *12*
Altdorfer, Albrecht 437, *439*
Amadeo, Giovanni Antonio *380, 381*
Amalfi 293
Amarante, Cruz 537
Amboise 427
American art, Pre-Columbian 222-228
American architecture 640, 641, 676, 678
'Amfreville Helmet' 170, *171*
Amida Buddha 218
Amiens: Cathedral *305, 309,* 310, 315, 317
Amon *56-57, 59,* 60, 65, 66, 70
el-Amra 47
Amsterdam
 Old Church 416
 Royal Palace 527
 Stock Exchange 643, *643*
Anagni: Cathedral *257,* 292
Analytical Cubism 650, 651, 692
André, Carl 718
Andrea del Castagno 363, *371*
Andrea del Sarto *444,* 445
Andrea del Verrocchio 359, 360, *360, 361,* 367, 386
Andrea Pisano 329, 355
Andromeda (statue) 543
Anet: Castle 450, 451, 453
Angelico, Fra' *see* Beato Angelico
Angera: Castle 346
Angers, David d' 594
Angers: Castle 310
Angkor Thom 190
 Bayon *188,* 190
Angkor Wat 190, *191*
 Bayon *189*
Angoulême: St-Pierre 263
Anguier, Michel 543
Animal art *20 ,* 21
Anis *see* 'Book of the Dead'
Anselm of Aosta 267
Antefixes 117
Antelami, Benedetto 284, *284, 285,* 286, 287
Antioch 107, 154
Antonelli, Alessandro *634,* 635
Antonello da Messina *see* Messina, Antonello da
Antonio del Pollaiuolo 359, 360, 367, 423
Antwerp
 Cathedral 319
 Church of the Jesuits 513

 Hôtel Plantin 416
 Our Lady of Hanswijk 513
 Town Hall 416
Anubis *69*
Angang 194, 198
Aosta 132
apadana 38
Apelles 105, 108
Aphrodite 101
 statues of 105, 108
Apis 51
Apollinaire, Guillaume 650
Apollo, statues of 100, 101
'Apollo and Daphne' (statue) 470, *471,* 502, 544
'Apollo Belvedere' (statue) 108
'Apollo of Civita Castellana' (statue) 121
'Apollo of Piombino' (statue) 98
'Apollo of Tenea' (statue) 98
'Apollo of the Tiber' (statue) 100
'Apollo of Veio' (statue) 117, *117,* 118
'Apollo Sauroktonos' (statue) 106
Apollodorus of Damascus 137
Apoxyomenos (statue) 106
Appel, Karel 704, 705
Appiani, Andrea 577
Apulia 124
Aquileia: Cathedral 295
Aquitaine School 263
Aranjuez: Labourer's House 535
Archipenko, Alexander 652
Architecture, Rationalist *see* Rationalist architecture
Arezzo 111, *114-115,* 287
 S. Domenico *331*
 S. Francesco 366, *369*
Argolides 83
Ariccia: S. Maria dell'Assunzione 469
Arles
 Amphitheatre 164
 St-Trophîme 264
Arnhem: Town Hall 416
Arnolfo di Cambio 326, 328, 329
Arp, Jean 658, *659, 671,* 672
Arpino, Cavalier d' 461
Arras 320
Art, Abstract *see* Abstract art
Art, African *see* African art
Art Brut 702
Art Déco 717
Art, 'Degenerate' *see* 'Degenerate' art
Art, Figurative *see* Figurative art
Art, Kinetic *see* Kinetic art
Art Nouveau 621, 637-643
Art of This Century Gallery 690
Art, Op *see* Op art
Art, Pop *see* Pop art
Art Since 1940 687-721
Arts and Crafts movement 638

Mathura 187
Matisse, Henri 646, *647*, 648, 650, 660, *688*, 689, 711, 714, 715
Matisse, Pierre 687
Matta Echaurren, Roberto 690, 692
Matthew of Layens 338
Matthias of Arras 317
Maulbertsch, Franz Anton 502
May, Hugh 565
Mayan art 223, 224
Mazzafirri, Michele *442*
Meaux
 Cathedral 307
 Unité d'Habitation 682
Mechelen *see* Malines
medersah 178
Medieval architecture 234
Medieval art 230–239
Medieval sculpture and frescoes 234–239
Medinet Habu: Temple of Rameses III 71
Megaliths 15–17
megaron 77, 84, 94
Meidum *48–49*, *49*
Meissen porcelain 503
Meissonnier, Ernest 599
Melendugno 17
Melk: Abbey *494*, 496
Memling, Hans 420, *421*, 430
Memphis 48, 51, 72
 Serapeum 51
Mendelsohn, Erich 676
Menes, tomb of *70–71*
Mengoni, Giuseppe 635, *635*
Mengs, Anton Raphael 572, 577, 581
menhir 17
Menil Chapel 698
Menkure *see* Mycerinus
Menzel, Adolf 604, *604*
Merate: Villa Belgioioso 491
Merit Amon, coffin of Queen *58*
Mesopotamian art 39, 40, *40*
Messina, Antonello da *374*, 375–377, *375*, 402, 404, 440
Metaphysical painting 656, 657
Metsu, Gabriel 524
Metz: Cathedral 317
Meunier, Constantin 604
Mexican art 223–228
Michelangelo 354, 356, *382–383*, 383, 384, 391–400, *394*, *395*, *396–397*, *398*, *399*, 411, 462, 469, 470, 536, 562
Michelozzo 352, 361, *364*, 380
Michelucci, Giovanni 682, *683*, 684
Mies van der Rohe, Ludwig 669, *680*, 681
Mignard, Pierre 547, 551
mihrab *176*, 177, 242
Milan

Arco della Pace 574
Arena 574
Belgioioso Palce 574, *575*
Cathedral 150, 341, *341*, 381
La Scala Theatre 574, *574*
Loggia degli Orsi 327
Major Basilica 149
Palazzo Archinto 482, 491
Palazzo Borromeo 346
Palazzo Brera 481, 576
Palazzo Casati Dugna 482
Palazzo Clerici 482, 491
Palazzo Litta 491
Pirelli Skyscraper 686
Royal Palace 574
S. Alessandro 481
S. Ambrogio 150, 158, *234*, 238, 259, *278*, *278–279*, 280, *280*, *281*, 384
S. Aquilino 150
S. Eustorgio 329, 375, 380
S. Gottardo 327
S. Lorenzo 149, 150, 158
S. Maria delle Grazie 384, *384*, 387
S. Maria presso S. Satiro 384
S. Nazaro (=SS. Apostoli) 149
S. Satiro 237, 384
S. Simpliciano 149
S. Vincenzo in Prato 280
S. Vittore in Ciel d'Oro 150, 158
SS. Apostoli (=S. Nazaro) 149
Vetus Basilica 149
Vittorio Emanuele Gallery 635, *635*
Miletus 90
 Bouleuterion 108
Milizia 572
Millais, John Everett 586, *587*
Millet, Jean-François 546, 600, *602*, 604
Milos 76
 Venus of *107*, 108
Minamoto no Yoritomo 216, *217*, 218, 219
'Minerva Promachos' 118
ming-ch'i *195*, 204, *204*, 205, 210, 212
Minimal Art 696, 718–719
Minoan architecture 79, 80
Minoan art 81
Mique, Richard 553, 554
Miró, Joan *664*, 665, 687, 707
'Miroku Bosatsu' *217*
Mistrá
 Aphendiko 250
 Peribleptos 252
 SS. Theodore 250
Mnesicles 104
mobile
Mocchirolo 346
Mochican art 226
Modena
 Cathedral 282, 284, *284*, 285
 Ghirlandina 284

Modersohn-Becker, Paula 641
Modigliani, Amedeo 660, *662*
Mohenjo-Daro 183
Moholy-Nagy, László 666, 669, 712
Moissac: St. Peter *258*, 264, 273
Möjebro *169*
Momoyama Period 219, 220
Monastic art 233
Mondrian, Piet 665, *665*, 687, 711, 712, 714
Monet, Claude 611-615, *612*, *613*, 617, 620, 715
Monreale: Cathedral 247, *292*, 295
Monte Albán 225
Monte Bego 15
Montmorillon: Notre Dame 268
Mont-St-Michel *306*, 310
Mont-St-Quentin *229*
Monza
 Cathedral 158, *160*, *164*, *165*, *166*, *167*, 170, 236, 346
 Royal Villa 574
Moore, Henry *667*, 672, 701, 720
Morales, Luis de 454
Morandi, Giorgio *667*, 668
Moro, Antonio 454
Morris, Robert 718
Morris, William 638
Mosaics 5, *139*, *142*, *146*, 150, *161*, 291, 293, 295, 330
Moschophoros 88, 100
Moscow 252
 Kremlin *252*
 University 684
Moser, Lukas 432, 433
Moses, Grandma 641
Moses (statue) 392, 399
Moslem art *see* Islamic art
Mosques 174–178
Mother-Goddess 23, 76, 78
Motherwell, Robert 692, 695, *695*
Motonobu *see* Kanô Motonobu
Mount Athos *see* Athos, Mount
Mudéjar Style 245, 320, 338, 439
'Mujaku, Patriarch' 218
Müller, Otto 655
Multscher, Hans 431, 433
Munch, Edvard 624, *652*, 654, 692
Munich
 Amalienburg 496, 498
 Elvira House 643
 Glyptothek 632
 Nymphenburg 496, *496*, *497*
 Propylaea 632
 Residenz 496
 Schleissheim 496, *497*
 St. Cajetan 493
 St. John Nepomuk 502
Münster: Town Hall 317
Murano 377, *400*, *413*

S

Saarinen, Eero 684, *684*
Saarinen, Eliel 684
Sacsahuáman 227
Saenredam, Pieter Jansz 524, *527*
Sagra di San Michele Monastery 280
St. Denis: Abbey 234
'Ste-Foy, Reliquary of' *234*
St. Gall: Abbey 233, 234, 496
St. George (statue) 357
St-Gilles-du-Gard 264
St. Hugh 254
St-Martin-du-Canigou: Abbey *255*,268
St-Nectaire: Church *256*
St. Petersburg *see* Leningrad
St-Savin-sur-Gartempe: Abbey, *266, 267,* 268
Sakkara *see* Saqqara
'Sakyamuni Buddha' (statue) 208
'Sakyamuni Trinity' (statue) 214
Salamanca 320, 454
 Cathedral 439
 Jesuit Clerecia 535
 Plaza Mayor 536
 S. Esteban 536
Salerno: Cathedral 293
Salisbury: Cathedral *312,* 313
Salon des Refusés 609
Salonika
 Holy Apostles 250
 St. Demetrius 153
 St. Sophia 153
 Theotokos 250
Salvi, Nocola 488
Salzburg
 Cathedral 493
 Franciscan Church 341, 431
 Trinity Church 501
Samaria: King of Israel's Palace 143
Samarra *2,* 23, 177
'Samos, Hera of' (statue) *88,* 98
'Samothrace, Victory of' (statue) 108, *109*
Sanchi *182, 183,* 184
Sanctis, Francesco de 488
Sangallo, Giuliano da 354
San Gimignano: Palazzo Comunale 291
Sanmicheli, Michele 400, 402
Sansovino 400, *400*
Sant'Angelo in Formis 239, 291
Sant'Antimo: Abbey 292
Santarém: Seminary 537
Sant'Elia, Antonio *674,* 676
Santiago de Compostela: Cathedral 261, 268, 273, *537*
Santimamiña cave *14*
San Vincenzo al Volturno 239
Saqqara *46,* 49, 51, 54, 55, 59
 Pyramid 53

Scribe (statue) *51,*59
Saraceni, Carlo 464
Saragossa
 Aljafería 244
 Church of Pilar 535
Sarcophagi 146, 147, 150, 166, 169
 Sarcophagus of Junius Bassus 147, *147*
 Sarcophagus of St. Helena *138*
 Sarcophagus of Theodata 169
Sardinia 18
Sartre, John Paul 703
Sarzana: Cathedral 291
Satrico 117
Sauvage, Henri 675
Savignano Venue 10
Säynätsalo: Town Hall 684
Schadow, Gottfried 597
Schapiro, Meyer 688
Schedoni, Bartolomeo 467
Schinkel, Karl Friedrich von 574, 632
Schlemmer, Oskar 666
Schliemann, Heinrich 74, 84
Schluter, Andreas 502
Schmidt-Rottluff, Karl 654, *654*
Schnorr von Carolsfeld, Julius 594
Schöffer, Nicholas 712
Schöne Madonnen 344
Schonfeld, Johann Heinrich 502
Schongauer, Martin 433, 435
School of Paris 689
Schwarzrheindorf 278
Schwind, Moritz von 597
Schwitters, Kurt 659
Scipione (= Gino Bonichi) 668
Scipione Borghese (bust) 470, *473*
Scopas 106
Sculpture in the 1950s 698
Sebekhotep, rock tomb of *49*
Secondary-Byzantine art *see* Deutero-Byzantine art
Segal, George 711, *711*
Segantini, Giovanni *620–621,* 621
Segovia
 Alcazar 244
 Aqueduct 164
 Cathedral 439
Selinus 98–101
Selz, Peter 637
Semper, Gottfried 634
Sendjirli: Acropolis 42
Senlis: Cathedral 307
Sens, William of 313
Sens: Cathedral 307
Sernesi, Raffaele 605
Serra, Pedro and Jaime 322
Serra, Richard 718
Sesostris I (statue) 61
Sesshû 219
Settignano, Desiderio da 359, *360*

Seurat, Georges 620, *620,* 621
Severini, Gino *650,* 652, 653
Severn Bridge 635
Seville
 Alcazaba 244
 Alcazar 244
 Cathedral 341
 Giralda Tower 244
 Great Mosque 244
 S. Telmo 536
Sévres porcelain 561
sfumato 289
Shahn, Ben 663, 689
Shang art 196–201
Shang bronzes 196–201
Shang bronzes 196–198, *196, 197,* 201
'She-Goat' (statue) 691, *691*
Sheeler, Charles 663
Shih-chia-ho 196
Shou-hsien tomb 203
Shubun 219
Siamese art 190
Sicilian architecture 478–481
Sicilian art 245, 246
Siena, Guido da 291
Siena 330
 Baptistry 346
 Cathedral 326, 328–330
 Fonte Gaia 355
 Mangia Tower 326, *327*
 Palazzo Pubblico 291, 326, 336, 337
Signac, Paul 621
Signorini, Telemaco 605, *606*
Sigüenza: Cathedral 344
'Sigwald, Transom of' 170
Siloe, Diego de 454
Siloe, Gil de 439
Silos: S. Domingo 273
Simone del Pollaiuolo 354
Siqueiros, David 663
Sironi, Mario 668
Sisley, Alfred 614, 616, 617
Siva Nataraja (statue) *186*
'Slave' (statue) *398,* 399
Sloan, John 661
Sluter, Klaus 344, 416, *420,* 431
Smirke, Robert 632
Smith, Anthony 719
Smith, David 698, *698,* 720
Smithson, Robert 719, *719*
Snefru Pyramid *46*
Snyders, frans 513
Soane, John 632
Socialist Realism 667, 688
Soest, Conrad von 432
Soest: Wiesenkirche 316
Soissons: Cathedral 307
Solari, Guiniforte 380
Solari, Santino 493
Soldati, Atanasio 668

ACKNOWLEDGEMENTS